MAURICE CRANSTON

JEAN-JACQUES

THE EARLY LIFE AND WORK
OF JEAN-JACQUES ROUSSEAU
1712–1754

W· W· NORTON & COMPANY

ISBN 0–393–01744–3

Set in Bembo
Printed in Great Britain by
Richard Clay (The Chaucer Press) Ltd,
Bungay, Suffolk

Map drawn by Reginald Piggott

CONTENTS

LIST OF PLATES

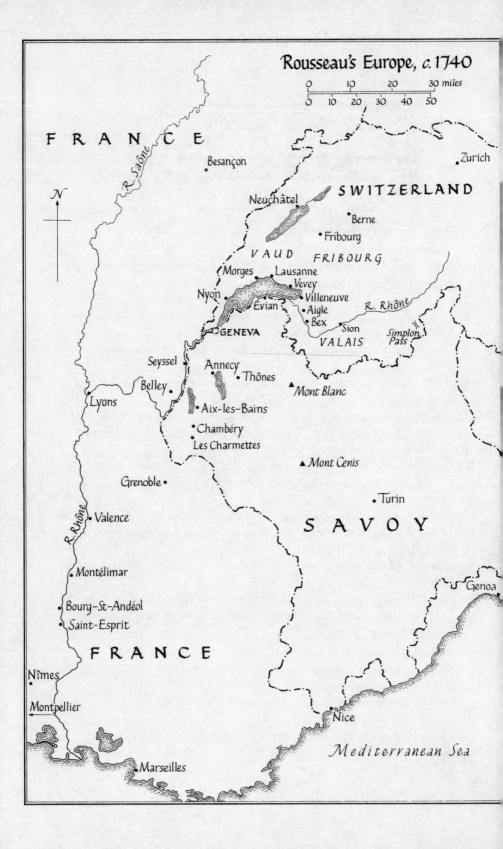

Rousseau's Europe, c. 1740

INTRODUCTION

In recent years Rousseau has returned to public favour. Before the war he was commonly regarded as an evil genius, a prophet at once of fascism and of communism, an enemy of reason and science, responsible both for the romantic revival and the French Revolution, a mountebank, a psychotic and a freak. Fashions, however, change in philosophy as in clothes; and since the invention of the atom bomb has destroyed the progressive illusion that science will save us, and since nature, ever more visibly wounded by man's attempt to conquer it, has begun to hit back, and since the ideologies that Rousseau questioned have lost their old authority, his distinctively original vision of the human predicament has acquired a new, compelling vitality.

Besides, a great deal has been learned about Rousseau in the past thirty years or so. Professor Ralph Leigh has produced a magisterial edition of Rousseau's letters; Rousseau's works are at last being edited in a scholarly manner; and critical studies throwing new light on Rousseau's thought have been published by a whole new generation of Rousseau scholars on both sides of the Atlantic.

Rousseau has been less fortunate in his biographers. He wrote his own autobiography in the form of *Confessions*, partly in order to unburden his conscience, but doubtless also, as he claims, with the aim of enlarging our knowledge of human nature by describing with absolute candour one man's experience of a life on this earth. His memory was not always accurate, and as he himself pointed out, he found it harder to admit to his shameful nasty little deeds than to really bad ones; he expected no absolution, but hoped for understanding; what he has received has been for the most part blame, or the kind of patronizing psychological explanation which takes the place of blame in contemporary deterministic culture. Rousseau's biographers, deploring his emotionalism, have been hardly less emotional themselves. Feasting, moreover, on the rich narrative material provided in the *Confessions*, they have generally neglected other sources of information about Rousseau's life.

The present book attempts to provide, if not an impartial, at least a systematically reasonable, or 'Lockean', biography, collecting the facts that emerge from the evidence available and setting them down as straight-forwardly and fairly as possible. It seemed to me that the time had come for a biography based on manuscript sources, if only to break the chain of books based on books and to interrupt the sheepish repetition of printed folklore. Since this book is written in English and all the materials are in French, the distortion that goes with translation has been unavoidable; but references in footnotes direct the reader in every case to the original manuscript source as well as to the best available printed version when a printed version exists.

It is a commonplace that Rousseau's writings, more than those of most authors, need to be read in the context of his life; the present volume deals with his first forty-two years, the period that culminates in the publication of *La Lettre sur la musique française*, the *Discours sur les arts et les sciences* and the *Discours sur les origines de l'inégalité* and Rousseau's return to Geneva to recover his rights as a citizen. The years of his greatest fame, and his most unhappy exile, the years that witnessed the publication of *Émile*, the *Contrat social* and *La Nouvelle Héloïse*, will be the subject of a second volume.

In writing this book, I have incurred many debts. I must record my gratitude to the Speaker and Librarian of the French Assemblée Nationale for allowing me access at the Palais Bourbon to the manuscript of the *Confessions* which Rousseau's widow presented to that institution. The notes of this biography refer to its pages rather than to the second manuscript of the *Confessions* which is preserved at Geneva, although I have indicated any variations to be noted between these two texts. I am no less indebted to the Librarian of the Bibliothèque de la Ville at Neuchâtel for placing at my disposal Rousseau's first draft of the *Confessions*, together with many other manuscripts in that remarkable archive. My third great debt is to the Librarian of the Bibliothèque Publique et Universitaire of Geneva, for access to another rich collection of Rousseau manuscripts. I wish also to ac-knowledge services provided, and access to material afforded to me by the Bibliothèque Nationale, the Archives d'État de Genève, the Archives de Neuchâtel, the Archives of the *départements* of the Savoie and the Haute Savoie, the archives of Turin and Venice, the Musée of Chambéry, the Musée Rousseau at Montmorency, the Musée du Vieux Vevey, the Biblio-thèque de la Sorbonne, the British Library, the Bodleian Library, Oxford, the British Library of Political Science, London, the Library of the European University Institute, Florence, the Biblioteca Nazionale, Florence, the Widener Library, Harvard, and the Library of Congress, Washington.

At the personal level, I am grateful for the help and kindnesses of numerous friends and Rousseau specialists. My greatest debts are to Ralph Leigh, George Feaver and Robert Wokler, who have read my manuscript and

INTRODUCTION 11

saved me from many errors, although not one agrees with all I say. I owe
much also to Jean Starobinski, Michel Launay, Robert Derathé, Bertrand de
Jouvenel, Ronald Grimsley, Raymond Polin, Sergio Cotta, Roger Masters,
Robert Shackleton, Charles Rowe, Sanford Lakoff, Claire Rosselet, Allen
Bloom, Mario Einaudi, Bernard Gagnebin, John Charvet and Charles Wirz.
I owe a further debt of gratitude to my secretary at the European University
Institute, Madame Patricia Derouaux.

For the generous financial help I have received during the years I have been
at work on this book, acknowledgements are due to the British Academy,
the Nuffield Foundation, the Leverhulme Foundation, the Research Fund of
the London School of Economics, the Rockefeller Foundation at the Villa
Serbelloni, Bellagio, and the Woodrow Wilson International Center for
Scholars, Washington, D.C.*

European University Institute, Florence
September 1981

* Chapter 14 of this book was written at the Woodrow Wilson International Center in
Washington, and I am required to make clear that the statements and views expressed therein
are those of the author and not necessarily those of the Wilson Center.

1

GENEVA

Jean-Jacques Rousseau was born on 28 June 1712 in a handsome patrician house near the Hôtel de Ville of Geneva, at that time an independent state, surrounded by fortified walls, a citadel of virtues, both republican and puritan, the Rome of the Reformed religion. Geneva was, moreover, a city built on a hill, so that people who were equal in their rights but unequal in their condition could be decently divided, the upper classes living on the upper slopes while the humbler families crowded into wooden dwellings on the damp shores of the lake. Rousseau was the second son of a marriage between high and low Geneva, his mother, Suzanne Bernard, belonging to the academic *élite*, his father, Isaac Rousseau, being an artisan. The house where he was born, now known as 40 Grand'rue and bearing a commemorative plaque,[1] was owned by his mother. He was baptized on 4 July 1712 into the established Calvinist faith at the Cathedral of St Pierre, taking his Christian names from his godfather, Jean-Jacques Valençon, a rich merchant-draper and neighbour in high Geneva. Two days later Rousseau's mother, already in her fortieth year, died of a puerperal fever. In an early draft of his *Confessions* Rousseau wrote: 'I cost the life of the best of mothers';[2] but in later versions he removed the hyperbole, doubtless realizing that no mother so soon dead could be the best of them. What perhaps he had done, and was certainly made to feel he had done, was to rob his father of the best of wives. As a widower, Isaac Rousseau's fortunes faltered.

For the first five years of his life, Jean-Jacques continued to live with his father and his aunts and his brother in the same elegant house in the Grand'rue; then his father's inefficacy as a breadwinner forced him to sell up and descend with his family to the parish of St Gervais from which he had risen on his marriage to Suzanne Bernard, and in a third-floor apartment in that unfashionable quarter of Geneva,* Rousseau's education began.

* In the rue de Coutance, on the site of the present No. 28.[3]

Geneva at that time was not the open smiling place it has since become; it was a sombre fortress, 'a prison' Stendhal called it as late as 1811, ruled by the austere, repressive ethos of Calvinism. And yet it was a city with good grounds for pride, for it was a centre of culture and learning, and had a long history of political autonomy. If many cities in medieval Europe could claim to be free in the sense of enjoying civil liberties unknown in seigneurial rural domains, the Genevans exploited the rivalry between their two rulers, the Bishops of Geneva and the Dukes of Savoy, to obtain more such liberties than most city dwellers; by the middle of the sixteenth century the Bishop had virtually robbed the Duke of sovereignty, but he gave the citizens so much political power in his efforts to win them to his side that once the Duke was removed they ungratefully employed that power against the giver, expelled the Bishop and claimed sovereignty for themselves. Geneva's adhesion to the Helvetic Confederation was vetoed by the Catholic cantons of eastern Switzerland, so that the Genevan *conseil général* was transformed into the legislative assembly of an independent republic, and Geneva became a city state like Venice or Florence or Genoa, or, as such imaginative people as Rousseau's father said, like ancient Rome. However, the newly emancipated citizens of Geneva quarrelled among themselves to such an extent that undermined order, and after they had rid themselves of the Bishop, they surrendered their democracy to a small patrician *élite*; they 'gave up their liberty in exchange for tranquillity',[4]* rather as the quarrelsome noblemen of Florence surrendered their republican government to a monarch for the sake of peace.[5] The Genevan patriciate did not, however, behave like the Florentine aristocracy; it divided the political spoils peaceably between its members, and ruled the city efficiently for more than two centuries, all the time keeping alive the myth and rituals of popular sovereignty. The Reformed religion pressed upon the Genevans by the Bernese, together with military aid against former enemies, served both to justify and speed the transformation of Geneva from a medieval bishopric into a city state; and while Lutheranism, that ideology of princes and inspiration of the northern soul, had less to offer republicans bred on a Latin culture, another type of Protestantism was devised for Geneva by the French theologian Calvin, a systematic thinker and a scholar and also something of a prophet in the style of Savonarola with the ambition of realizing on earth the dream of an ideal Christian commonwealth. It was Calvin who finally drove Catholicism from Geneva and inspired its splendidly ambiguous constitution, fusing theocracy with oligarchy and democracy with the aim of making political institutions the instruments of Providence.[6] If more recent historians consider Calvin no more than a draughtsman of the constitution, Rousseau was brought up to

* Geneva became less democratic and more oligarchic throughout the seventeenth century.

think of Calvin as the law-giver who had made the republic of Geneva what
it was; the future philosopher felt himself to be the citizen of a state founded
by a philosopher, and this circumstance seems to have coloured his whole
attitude to politics.

The population of Geneva in Rousseau's time was largely descended from
French Protestant refugees. Geneva was almost as much as Massachusetts a
commonwealth of exiles dedicated to the purpose of building God's city on
someone else's territory; and since land was scarce, even Calvin himself had
been troubled by the extent to which Huguenot refugees came crowding
into Geneva; he feared they could not be fed. Such fears proved unfounded,
for the Huguenots were refugees from persecution, not poverty; they
brought their money, culture, skills and industries with them. They also
brought their social differences. Whereas the Puritan immigrants of
Massachusetts came from the same sort of humble origins and so found it easy
to create a democratic society, the Protestant immigrants into Geneva came
from upper-class as well as from middling and modest backgrounds; and
those families with noble French or Italian blood perpetuated aristocratic
privilege. Calvin introduced a system of public education which improved
the culture of *le peuple* without diminishing the arrogance of *le monde*; wealth
combined with austerity, the postponement of consumption to finance
investment, proved a formula for a flourishing economy, but it exacerbated
the social inequality which accompanied, and was thought by some to
contradict, the formal equality of all Genevan citizens.

Not all the inhabitants were, in any case, citizens. The population of
Geneva when Rousseau was born was about 20,000, or 5,000 adult males,
and of these only some 1,500 were citizens and burgesses, the civil category
into which Rousseau himself, as the son of a citizen, was proud to have been
born. The other – and the lesser – inhabitants were divided into 'natives'
(Genevan-born sons of resident aliens), 'resident aliens' (often newly arrived
refugees from Catholic persecution) and 'subjects' (mostly peasants living on
Genevan land outside the city walls); not only were all these people excluded
from civic rights; they were also denied access to the most lucrative trades of
Geneva, including watchmaking. Grievances simmered behind the almost
Utopian image which Calvin had given to his New Jerusalem.[7]

The social aristocracy was also a political aristocracy. In form, the
constitution assigned legislative powers to the *conseil général*, or general
assembly, to which every citizen and burgess belonged, and executive power
to the *petit conseil*, or council of twenty-five, and four syndics; there were also
a council of 200 and other intermediate bodies of lesser importance. In
practice, the *petit conseil* had over the years assumed almost all powers, and
the general assembly was summoned, if at all, only to confirm its edicts.
Every seat on the *petit conseil* was monopolized by members of the upper-class

families, and no one who did not belong to the social aristocracy could expect to hold office. Naturally, this situation did not pass unchallenged. Towards the end of the seventeenth century, there was a movement on behalf of the several hundred citizens to recapture the political powers which the twenty-five members of the *petit conseil* had seized and used as an instrument of aristocratic domination. We must hesitate to call this opposition a democratic one, since the great majority of the people who lived in Geneva were not citizens – who had been in a minority since the end of the seventeenth century[8] – and these others resented the way in which the citizens kept them out of the best trades and industries. The champions of citizens' rights in Geneva used the language of democracy but they were democratic only in the limited sense that Athenians were democrats; they were not egalitarians, as were the inhabitants of more rustic Swiss cantons; like English Whigs they represented the demand for liberty understood as the traditional liberties of that property-owning tax-paying community which constituted in their view the substance of the nation. Their opponents, champions of oligarchic rule, wished to preserve a system whereby the aristocracy exercised prerogatives conferred by law on the *petit conseil* and in doing so they believed, like paternalistic conservatives, that they represented the entire nation, not just the 1,500 citizens, but the republic as a whole, however metaphysical that entity might be.

In the political conflicts of the seventeenth century, the patricians always won, partly because they were able to exploit the resentment of the disfranchised majority against the citizen class, partly because they governed well, and partly by sheer force. In 1707, five years before Rousseau was born, the patriciate suppressed a vigorous movement of reform by liquidating its leaders: Pierre Fatio, himself an aristocrat, was shot; Lemaître was tortured and put to death; Piaget was drowned while trying to escape. Soldiers were brought in from Berne and Zurich to reinforce the patriciate's authority and liberal dissension was quelled. Rousseau grew up at a period of political peace that these robust methods had brought about; and in his recollections of his childhood, he speaks of nothing but patriotic harmony prevailing in Geneva.

Besides the political aristocracy, there existed in Geneva another upper class, which sprang from the theocratic element in Calvin's constitution, the clerical and academic *élite*. By the early eighteenth century this *élite* had lost its political importance, but it had retained its moral authority and its social superiority, and it was to this class that Rousseau's mother belonged. His mother was not, however, what he says in the *Confessions* that she was, 'the daughter of a pastor';[9] she was the daughter of a pleasure-loving citizen who

died the proverbial early death of a rake when she was nine years old. The pastor was her uncle, Samuel Bernard, a luminary of the Academy of Geneva and a man of property, who adopted her and educated her and bequeathed her the elegant house in the Grand'rue where Rousseau was born. Rousseau may have known nothing about his *roué* of a grandfather; but historians can know because there existed in Geneva a form of moral police known as the Consistory, which Calvin set up to promote private virtue by the surveillance of conduct and the punishment of sin; and from the records of the Consistory modern scholarship[10] has brought to light much that Jean-Jacques is unlikely to have been told about his relations, both Rousseaus and Bernards, and from which it appears that he acquired through his birth a certain inheritance of waywardness and rebellion.

The Rousseaus were a family of French Huguenot origin which had been established in Geneva for five generations when Jean-Jacques was born.[11] The first to enter the city as refugee from French persecution was Didier Rousseau, who is variously described as an innkeeper, wine-merchant and bookseller, and was registered as a resident alien on 15 October 1549. Didier Rousseau did well in trade – better, it seems, as an innkeeper and wine-merchant than as a bookseller – and within six years he acceded to the dignity of burgess. He owed this elevation as much to chance as to merit, for in the year 1555 Calvin was still at work on the remodelling of his New Jerusalem and needed more political support. The French Huguenot immigrants, being more sophisticated and more committed to the new Puritan ideology than the more rustic traditionally-minded born Genevans, were to that extent more useful to Calvin; and Didier Rousseau was one of a number of such immigrants he enrolled with almost indecent haste into the ranks of the burgesses for the sake of their votes.

Didier Rousseau died in 1581, leaving a diminished fortune to his second wife, Mie Miège, a Savoyarde by birth, and to his one surviving son. The latter was Jean Rousseau the elder, who, as the son of a burgess born in Geneva, became a citizen; he married, while rather young, a Huguenot watchmaker's daughter named Elizabeth Bluet, and although he chose for himself the trade of master tanner, he apprenticed his son, Jean Rousseau the younger, to his father-in-law; and watchmaking, by that time the most important industry in Geneva, was for three generations the Rousseaus' family trade. Jean Rousseau the younger did well. He acquired a town house and a country house besides jewels and other possessions; at his death there was an estate of 31,000 florins to be distributed among his children. These children were, however, numerous, and ten of the nineteen born to his wife lived to claim their inheritance. One of these was the philosopher's grandfather, David Rousseau, a fascinating and enigmatic character, who seems to have lived a gentleman's life on an artisan's income. He had a

cultivated taste for music and elegance and society; he liked dancing* and parties and the company of well-bred people; he even used a coat of arms.†

A portrait of David Rousseau bespeaks something grander than a watchmaker, even though the watchmakers of Geneva were a highly cultivated race;‡ with its haughty air and full-bottomed *perruque*, his could easily be the face of a seventeenth-century English Whig. And indeed it seems that David Rousseau was active in politics on the side of the opposition. In the year 1690, the victory of William III in the battle of the Boyne gave great joy to the liberals of Geneva, and bonfires and fireworks were set off in celebration. *'Le sieur David Rousseau, dizenier à la Cité'*[13] is named as having lit one such bonfire dangerously close to the house of the French Resident, thus giving offence to the chief ally of the defeated Irish Catholics, the King of France. The *petit conseil* disapproved of this undiplomatic gesture, and two of its members, M. Sarasin and M. de la Rive, were sent to the Resident to apologize for the episode. Conservatives in Geneva did not share the liberals' ideological attachment to England and Holland; indeed it has been argued[14] that the Genevan aristocrats, notwithstanding their Protestant religion, were generally pro-French for political and social reasons, and perhaps also for financial reasons, since they invested heavily in France. David Rousseau was punished for his political indiscretion by being stripped of the rank of *dizenier*, or subaltern in charge of the units in which men of military age were assembled and a warden responsible for the surveillance of his neighbours' morals and opinions.[15] With his expensive tastes and radical opinions, David Rousseau failed to enrich himself as his father had done. Moreover he produced a numerous family, crowded into a house in St Gervais. After the death of his wife, David Rousseau lodged in the rue de la Coutance with another active liberal, Abraham Cassin, and was at the centre of the group of artisans who supported Pierre Fatio's campaign for citizens' rights in 1707. It was this protest movement which was used to justify the government's execution of Fatio for subversion.[16]

Six of David Rousseau's fourteen children survived: three sons, Isaac Rousseau, the father of Jean-Jacques, David Rousseau the younger and André Rousseau, all three of them watchmakers, and three daughters,

* He was reported to the Consistory for giving a 'ball' a few weeks after the death of his wife.

† His arms were: *un soleil cantonné de quatre étoiles, dans un écusson surmonté d'un casque et entouré de lambrequins.* Heraldic records provide no evidence of his entitlement to these arms, nor did his grandson, the philosopher, use them.

‡ Watchmaking gave much leisure, and as a result of the educational system, there emerged in Geneva what Antony Babel calls 'the petit bourgeois gentilhomme', who modelled himself on the patrician.[12]

Suzanne ('Suzon'), Théodora and Clermonde – the three aunts described by Jean-Jacques in his *Confessions* as 'good and virtuous', as doubtless they were in the eyes of God, although all three had been reprimanded by the Consistory of Geneva for playing cards on the Sabbath, and Théodora, his 'especially virtuous aunt', was suspended from holy communion for 'scandalous anticipation of her marriage', a child being born only a day or two after her wedding.[17]

The personality of David Rousseau, and his involvement in artisan politics, has excited the curiosity of historians[18] eager to place Jean-Jacques in the context of the radical, democratic, populistic struggles of St Gervais; but the fact of the matter is that Rousseau is singularly silent in his *Confessions* on the subject of his grandfather David, and he seems to have received a very different sort of ideological education from his father, Isaac. Both Isaac and his sister Théodora married into the same family in high Geneva, the Bernards. In the *Confessions*, Rousseau writes: 'Gabriel Bernard, my mother's brother, fell in love with one of my father's sisters; she would agree to marry the brother only on condition that her brother married the sister. Love arranged everything; and the two marriages took place on the same day.'[19] The records show that the facts were otherwise. The marriage between Gabriel Bernard and Théodora Rousseau, celebrated just in time to render their child legitimate, took place in the autumn of 1699. The marriage of Jean-Jacques' parents was on 2 June 1704.

The Bernard family had been established in Geneva for rather less time than that of Rousseau. It was in 1596, forty-one years later than Didier Rousseau, that the first Bernard was received as a burgess of the city. He came from Savoy and prospered in Geneva as a merchant. His son Samuel Bernard (born 1597), the great-grandfather of Jean-Jacques, was an exceptionally cultured man who used his inherited wealth to collect a valuable library and made his house a meeting place for scholars; his friends included Jean le Clerc, the friend of the English philosopher Locke during Locke's exile in Holland and the first publisher of Locke's epitome of his *Human Understanding*. Samuel Bernard might well have carried his family into the highest reaches of Genevan society, if only his children had made the right marriages. However, Samuel Bernard's son Jacques disappointed any such hopes, for it was he who was the profligate. Imprisoned for immorality, compelled to pay for the maintenance of at least one illegitimate child, Jacques Bernard had with difficulty disentangled himself from two mistresses when, at the age of twenty-three, in 1672, he married a lawyer's daughter named Anne-Marie Marchard. She gave him three daughters; the eldest, born on 6 February 1673, some six months after the wedding, was Suzanne, who lived to become the mother of the philosopher. It was because the black sheep died when he was thirty-three that his virtuous brother, the

pastor Samuel,* became responsible for the upbringing of Suzanne from the age of nine.

This is evidence enough that Rousseau was correct in saying that his mother had 'brains and beauty'.[20] Her uncle, the pastor, gave her an excellent and a pious education. However, she was her father's daughter and she liked pleasure. It was not until she was thirty-two that she married Isaac Rousseau, and before that time she had more than once been hauled up before the Consistory on charges of impropriety. Accusations that may well seem trivial to the modern reader were taken seriously in seventeenth-century Geneva. Among other things she was reprimanded for 'receiving visits' from a man named Vincent Sarasin; and indeed she continued to receive his visits despite the reprimands.

Like others in high Geneva, Suzanne Bernard was a francophile in cultural matters. She might well have married into the Genevan aristocracy, although there was no question of her friendship with Vincent Sarasin leading to marriage, because he already had a wife and two children. And in later years – after Sarasin had turned his attentions to another girl and been excluded from the Lord's Supper as a punishment – Rousseau's mother became very friendly with M. de la Closure, the then French Resident. Indeed the *mauvaises langues* whispered that M. de la Closure was the philosopher's natural father – a manifest falsehood, since the Resident was absent from Geneva from 1709 to 1713, and Jean-Jacques must have been conceived in 1711.

Suzanne Bernard's liking for things French included a liking for French literature and drama. She could buy French books but not see French plays in Geneva, since public theatres did not exist; they were considered immoral by good Calvinists – and were indeed later considered immoral by her son. She probably felt differently. On at least one occasion she actually disguised herself as a boy in order to go down to the popular quarter of the Molard to see the nearest thing there was to a public theatre, an open-air show put on by a company of fair-ground performers. She was caught despite the *travesti*, hauled up before the Consistory, and again reprimanded publicly.

Rousseau was probably never told this story or any other of the more piquant details of the family history; he was deceived in being led to believe that the good Pastor Bernard and not the bad Jacques Bernard was his grandfather. But Rousseau was doubtless well informed when he wrote that his father had to overcome brisk competition to win his mother's hand; for as well as her rank and beauty she had talent and wit; her son even suggested that she was altogether 'too brilliant for a girl of her status':[21] she could

* Samuel Bernard (1631–1701), while pastor of Saconnex, not only organized a college of mathematics in his parsonage, but gave lectures in mathematics at the Faculty of Philosophy.

draw, sing, play the theorbo – a kind of lyre then fashionable – and even write passable verses.

Isaac Rousseau must have owed his success with her to his charm. He had, as she had, a gaiety of spirit not readily found in Calvinist Geneva, a *legèreté* of character which was regarded with suspicion, in his case perhaps well justified. He and his bride were of the same formal civil status – citizens – and the same age, but there was nevertheless a considerable difference between them. For one thing Suzanne was, in Rousseau's words, *plus riche*. The records show that she had inherited 10,000 florins from her mother, besides 6,000 florins from her uncle together with his library and the house in the Grand'rue, which was worth over 31,000 florins. The estate Isaac Rousseau inherited from his father amounted to no more than 1,600 florins. More important was the fact that Suzanne Bernard belonged to the upper town of Geneva whereas Isaac came from the plain of St Gervais. Even so, if Isaac was thought to have married above his station, he felt himself to be one of nature's gentlemen; he always wore a sword and followed the fashions of high Geneva rather than those of the artisans' quarter. Life among the upper classes was more to his taste, and in high Geneva luxury was no longer outlawed as it had been. With the growth of prosperity, the Calvinist sumptuary laws forbidding the wearing of coloured silks and jewels, as well as rules for entertainment, were relaxed in the interests of 'persons of quality'; and those who could afford fine clothes might display them on their Sunday walks on the higher promenades such as La Treille, where Rousseau says his parents 'made friends as they walked together in the evenings'.[22] Elegant society seldom descended to the shores of the lake, when the popular classes took their Sunday walks and crowded on public holidays to watch rope dancers and band concerts and performances by itinerant players of the kind which Suzanne Bernard had once sneaked out to see.

Unlike his father, David Rousseau, whose gentlemanly tastes went with liberal politics and who enjoyed the company of artisans and workers in their club and taverns, Isaac Rousseau yearned for the aristocratic life: he felt his time was better spent in hunting and dancing than in following the trade of a watchmaker. He preferred his violin to his bench, and at one point actually gave up watchmaking to become a dancing master, a profession tolerated in Geneva for the benefit of foreigners: Calvin's academies and seminaries attracted scholars from all over Europe, and although one or two such visitors in Calvin's lifetime found that they only exchanged one form of persecution for another – Michel Servet, for example, having been burned at the stake for socinianism and Jacques Gruet put to death for atheism – religious fanaticism died down as Geneva grew richer. By the beginning of the eighteenth century, leading Genevan theologians such as Jean-Alphonse Turrettini[23] were advancing broad latitudinarian views which were not far

short of Servet's socinianism; and puritanical restrictions on pleasure were relaxed for visitors of quality to an even greater extent than they were relaxed for the indigenous upper class. Geneva attracted many young noblemen from Protestant English and German families who wanted their sons to learn French without assimilating Popery.

It was such young men who became the pupils of Isaac Rousseau when he set up a dancing school in partnership with his friends, Jean Clément and Joseph Noirel; but there were not enough pupils to make the school profitable, and the arrogance of the young foreign noblemen towards the fiddler who taught them the steps cannot have added to the joy of a man who already felt himself precariously situated in polite society. Isaac Rousseau returned disappointed to the watchmaker's bench. He nevertheless continued to wear a sword (which was unusual for an artisan) and his combative nature led him more than once into fights and brawls. He was imprisoned or fined, on one occasion unfairly if the evidence of bystanders is to be believed, as he was only defending himself against attacks; but since his adversaries were British officers,* the authorities gave them the benefit of the doubt. Besides his itch to draw the sword, Isaac's gentlemanly passion for hunting served equally to bring him into trouble. Marriage for a time restrained him. Even so he found life in the Bernard house in the Grand'rue irksome, perhaps because of sharing the joint *mènage* with his mother-in-law.[25] On 15 March 1705, Isaac's first son was born; this was Jean-Jacques' elder brother François, an unlucky fellow. His birth made Isaac's need for a decent income all the more imperative, especially as it came at a time when there was an economic crisis in Geneva and a slump in the export of watches, largely as a result of the economic havoc caused by the War of the Spanish Succession. For understandable reasons, Isaac seized an opportunity to work as watchmaker to the Sultan's Seraglio in Constantinople, leaving his small son for six years in the care of his wife and his mother-in-law.

Little is known of Isaac's activities in Constantinople, although it seems that he attended dutifully the Calvinist chapel services arranged by the Dutch Embassy there. After the death of his mother-in-law, his wife called him back from Turkey. She was unhappy without him; and it was her love, and not only her virtue, her son assures us, that had kept her faithful to her husband.[26] With his mother-in-law out of the house, Isaac seems to have been glad to return to high Geneva. He arrived back in September 1711: and Jean-Jacques was, as he puts it, the 'melancholy fruit of that homecoming: ten months afterwards, I was born, feeble and ill'.[27]

* Sir Gavin de Beer[24] says that Isaac's adversary was Henry St John, afterwards Viscount Bolingbroke; but this is pure speculation, based on the appearance in the record of the name 'Saint-Jean', which could easily be that of another man.

There followed the death of the mother, and the slow building-up of the strength of the son. Like many other children of ageing parents, Rousseau was born with physiological defects; he had a deformity of the urinary tract which caused him much pain in later life and affected his sexual activities in a way which added to his humiliations.[28] He was small as a child, but vigorous and lively. The several women in the household did all they could to console him for the loss of his mother. Rousseau claims that he was 'cherished, without being spoiled'.[29] He also claims that he was always a good little boy, that he did not even want to do the naughty things that most boys do – the worst deed of his childhood that he can recall in the *Confessions* is having 'pissed in the saucepan of one of our neighbours named Mme Clot while she was at the church'.[30] He retained a particular affection for his Aunt 'Suzon',* who first gave him his love of music, and he says that when he was not reading or writing with his father, or taking a walk with the maid Jacqueline,† 'I was always with my aunt; watching her at her embroidery, listening to her as she sung; and sitting or standing beside her, I was happy. Her playfulness, her sweetness, her pleasant face left such a marked impression on me that I can still picture her now . . .'[31] This aunt, who was thirty years old and a spinster when Rousseau was born and who remained unmarried throughout his childhood, was the nearest thing he had to a mother.

Rousseau was aged five when, in June 1717, his father sold the house in the Grand'rue, for just over 31,500 florins, to the agents of Barthélemy de Pellisari of Saconnex. It was not, strictly speaking, his to sell, since his wife had left it in trust for her two sons. The understanding was that M. Pellisari would be the trustee of the selling price, paying Isaac Rousseau the interest on that sum, until the sons' majority, that is, according to Genevan law, on their reaching the age of twenty-five. In the end Jean-Jacques did badly on the deal,‡ but the move down from the Grand'rue to the popular quarter of St Gervais was not at the time the disagreeable experience for him that it was for his father.[33] Indeed the account of his childhood that Rousseau gives in the *Confessions* glows with nostalgia: 'the children of kings could not have been more zealously cared for than I was.'[34] He speaks with the greatest respect and admiration for his father. And yet he is unable to hide the fact that he was given a very odd upbringing, and that his father did not really deserve the praise which he lavishes upon him. Rousseau says that he was 'not allowed to play in the streets with other children',[35] nor was he sent to

* Suzanne, born 1682, married Isaac-Henri Goncerut of Nyon in 1730.

† Jacqueline Faramond, a cobbler's daughter, born Geneva, 20 January 1695, married 1733, Jacques Danel, dyer, and died, a widow, in 1777.

‡ Rousseau found that the selling price was 'reduced to 13,000 florins' by the time he received his share.[32]

school; he was educated at home, like John Stuart Mill and Kierkegaard, by his father, if education is the word for the instruction that Rousseau received. Rousseau says he could read before he was three; the only books which served for reading lessons were the seventeenth-century French novels that had once belonged to his mother; to be nourished on such literature at that impressionable age was responsible, he believed, for giving him a highly romanticized and sentimental vision of the world. The reading would go on throughout the night, so eager were father and son to get to the end of a story. 'Sometimes my father, hearing the swallows of the morning, said shamefacedly: "We must go to bed: I am more of a child than you are."'[36] From the French novels Rousseau claims that he acquired a precocious knowledge of human passions: when they had been read, he turned to more manly and serious literature – the books his mother had inherited from Pastor Bernard. 'Le Sueur's *History of the Church and the Empire*, Bossuet's *Discourse on Universal History*, Plutarch's *Lives*, Nani's *History of Venice*,* Ovid's *Metamorphoses*, La Bruyère, Fontenelle's *Worlds* and *Dialogue with Death*, and some plays by Molière,' Rousseau recalls, 'were transported to my father's workshop; and I read them to him then while he worked.'[38]

Such serious reading was not uncommon among the artisans of Geneva. As Rousseau himself wrote many years later in a letter to one of his upper-class relations in Geneva, the physician Dr Théodor Tronchin: '... there is a great difference between our artisans and those of other countries. A watchmaker of Geneva is a man fit for any company; a watchmaker of Paris is fit only to talk about watches. The education of a worker in Paris cultivates his hands and nothing else; but in the case of a citizen of Geneva the mind and the heart are developed, for good or ill; and that is what an educational system should provide.'[39]

Research[40] has confirmed the claim that the artisans of Geneva were unusually well read; some scholars have brought to light the titles of the books that were owned by those artisans who lived at the same time as Rousseau in the rue de Coutance: several owned books of ancient history, the works of Virgil, Cicero, Seneca, Homer, Thucydides and Sallust, and one or two owned books by Machiavelli, Locke and Bayle – books calculated to inspire an appreciation of republican virtue and freedom. There is no evidence, however, that Isaac Rousseau bought any such books; as Jean-Jacques says, those he read to his father came from the library of his great-uncle, the Pastor Bernard, whose rank was well above that of an artisan.

Rousseau could praise the public educational system of Geneva, but not claim any direct experience of it; all he was able to suggest in his letter to Dr Tronchin was that he had 'received that education, not through formal institutions, but by means of the traditions and maxims which, transmitted

* Here it seems that history was given priority over literature.[37]

from generation to generation, give to the young at any early age the right kind of understanding and feeling. At twelve I was a Roman.'[41]

In the *Confessions*, too, Rousseau says that the Roman model inspired his dreams of self-sacrificing heroism: 'it helped to create in me that free and republican spirit, that proud and strong character, impatient of any yoke or servitude, which has tormented me all my life in situations where it has been least appropriate.'[42] Plutarch was his favourite author as a boy; and in his *Rêveries* he recalls learning army-style drill: 'I joined ranks with three other children, and together we did military exercises with the militia company of my quarter.'[43] Doubtless this reinforced his image of himself as a 'Roman'.

If he ever regretted not having gone to school with other boys, he never admitted it in print.* He stressed rather the superiority of his education; and even though he might occasionally assert that his rank was that of an 'artisan',[45] he was no less insistent in his claim that he had been born into a family 'whose manners distinguished it from the people'.[46] His childhood was dominated by his father's ideas.

While Rousseau always speaks, in print and private letters, in flattering terms of 'that virtuous citizen to whom I owe my birth',[47] he is unable to conceal the fact that his father was emotionally unstable; when he was angry Isaac Rousseau beat his sons, and when he was maudlin he would lament to Jean-Jacques that his birth had caused the death of his mother. The elder boy, François, who could not be made to feel guilt for the death of his mother, was less docile and therefore beaten with all the more severity. François was already six when his father returned from Constantinople to end his undisputed possession of his mother's attention, and her death a year later must have been a greater blow to him than it was to the new-born child. Moreover, François was *not* the favourite son; as we learn from Jean-Jacques: 'the extreme affection that my father and my aunts had for me made them neglect my brother.'[48] He has little more to say about his brother in the *Confessions*: 'I seldom saw him; I can hardly say I knew him; and yet that did not prevent my loving him tenderly; and he loved me as much as a young "scoundrel" can love anyone. I remember that once, when my father was beating him severely and angrily, I threw myself between them, I covered him with my body and received the blows that were aimed at him, and held myself so stubbornly in that position that in the end my father had to forgive him.'[49]

* Rousseau often praised the Genevan school system. For example, in his *Lettre à M. d'Alembert*, he speaks of the hardiness of Genevan schoolboys 'in my time'. He describes how, never afraid of being hurt or getting scratched and bruised, they would go hunting with their fathers, race and play rough games together; they were polite to their elders, but fought among themselves; untidy young rascals grew up to be good patriotic soldiers – 'unlike our smart little gentlemen, who are men at fifteen and children at thirty'.[44] But from the age of ten Rousseau had a private tutor, Pastor Lambercier.

This is one of the rare passages where Rousseau criticizes his father; and he actually brings himself to say that his brother's education suffered as a result of his father's 'neglect'. He adds that François 'went the way of libertinage even before he was old enough to be a real libertine'.[50] The boy was 'apprenticed at a very early age as a watchmaker to a master, with whom he took the same liberties as he took at home'.[51] Eventually François ran away from Geneva; but if this was the act of a 'scoundrel', it was also one which his father and his brother were each in turn to imitate, and of which many other spirited young men, unable to bear the oppressive puritan atmosphere of the city, were guilty.

The word 'libertinage' in French is ambiguous, indicating free thinking in religion and dissent in politics no less than relaxed moral standards, and, although there is no firm evidence to go by, it may be that François was drawn, like his grandfather David Rousseau, to the citizens' opposition to the patrician régime in the city. On the other hand, there are no good grounds for thinking that Isaac Rousseau was a radical. His snobbish romantic nature might be expected to prompt a sentimental sort of conservatism, and this is confirmed by several things his son tells us about him. For example, in Rousseau's *Lettre à M. d'Alembert sur les spectacles*, written when he was forty-five, there is an eloquent passage which reads: 'I remember being struck in my childhood by a rather simple scene ... The St Gervais militia had completed its exercises and, as was the custom, each of the companies ate together: and after supper most of them met in the square of St Gervais, where the officers and soldiers all danced together around the fountain, with drums and fifes and torch-bearers mounting the stone basin ... it was late, the women had gone to bed; but all re-emerged, the wives to see their husbands, the servants to bring wine, and even the children, awakened by the noise, appeared half-dressed in the company of their parents ... My father, embracing me, was thrilled in a way that I can still feel and share. "Jean-Jacques," he said to me, "love your country. Look at these good Genevans: they are all friends; they are all brothers: joy and harmony reigns among them. You are Genevan. One day you will see other nations, but even if you travel as far as your father has, you will never find any people to match your own."'[52]

Although this describes a scene of popular festivity, Rousseau's insistence on patriotic unity, on officers and men being 'brothers' and 'harmony' prevailing among all Genevans, echoes the ideology which the conservative rulers proclaimed when they put the radical leader Pierre Fatio to death for fomenting rebellion. Isaac Rousseau was in Constantinople in 1707 when Fatio was executed; being away from Geneva between 1705 and 1711 meant that he missed the most active period of opposition and returned to find the settled calm that the government had achieved by force. The radical

movement was to become active again in the 1730s, but throughout Rousseau's childhood in Geneva tranquillity prevailed. It may well be, as some historians have suggested, that this civil peace was 'only apparent, and entirely superficial' among 'people intimidated by the bloodshed of 1707';[53] and that the citizens of Geneva 'suppressed their grievances, their claims, their hatred and their fears only to develop them in more favourable circumstances'.[54] But this can hardly have been the image of Geneva that Rousseau was shown by his father. Isaac presented Geneva to his son as an almost ideal political society, a republic where everything was in order as it was, a model city state;[55] and to this conception of Geneva Rousseau clung stubbornly until he was over forty.

The one form of liberalism which was tolerated in Geneva in Rousseau's childhood was theological liberalism, so that, although he was baptized and bred a Calvinist, the doctrine he inbibed at the services he dutifully attended every Sunday was a distinctly eighteenth-century form of the Reformed religion. The Academy which Calvin himself had founded produced a philosophical school of theologians, including the immensely influential Turrettini, who came near to reducing the Christian creed to the single proposition that Christ is the Messiah. The old Calvinist dogmas about predestination and original sin and election were soft-pedalled to a point of inaudibility. Christianity came to be presented as essentially a way of life: austere, virtuous, candid, industrious, simple, clean and plain. Most Genevans felt themselves to be distinguished from their Popish neighbours in France not only by their form of worship but by their stern morals, their frank and honest conversation, their unsophisticated manners and their dislike of worldly enjoyment. The association of the Catholic religion with pleasure gave it a certain secret glamour to which Rousseau as a boy responded.*

An imaginative child, he was no mere dreamer but lively and spirited and proud like his father, without his father's belligerent irascible vanity.† He judged himself to be courageous less in aggression than in his power of endurance. In the Rêveries, written towards the end of his life, he tells us: 'In the Confessions I described my early years without boasting of the good qualities with which my spirit was endowed, even suppressing the facts which would make them too obvious.'[58] He goes on to mention two episodes which he had deliberately omitted from the Confessions. One took

* While always remaining the Genevan 'avenaire', having a dour, unpolished honesty that bordered on oafishness, which went together with great personal charm.[56]

† The state records show that Isaac was known to the authorities to have drawn his sword on at least four occasions: on 27 October 1699 against four or five English officers; on 9 January 1702 against another Englishman; and, as we shall see, twice in 1722 against Pierre Gautier.[57]

place in the textile factory at Pâquis belonging to Antoine Fazy,* the husband of his aunt Clermonde. Through the carelessness of young Fazy, Rousseau says he caught his fingers in a machine and hurt them badly – the scars remained for the rest of his life; although he screamed at the time, he breathed no word of accusation against the person responsible for the injury. The other episode occurred when he was playing pall-mall at Plain-palais with a friend named Pleince; they quarrelled, Rousseau says, and fought, and 'during the fight he gave me a blow on the head with the mallet, a blow so hard that it nearly knocked my brains out';[59] the friend, terrified at what he had done, begged forgiveness and took Jean-Jacques to his own home nearby to have the wound treated by his mother. Rousseau assures us that he forgave his friend, embraced him and kept the incident a secret.† His father's quarrels had more serious consequences.

One day in June 1722 Isaac was hunting outside the city walls on land which belonged to a patrician named Pierre Gautier, when the owner objected to his presence. Isaac replied indignantly, and angry words were exchanged. Four months later the two men met in the city and revived the quarrel; Isaac suggested that they should settle the dispute with a duel, to which Gautier, who was a captain in the French army, replied, 'I have sometimes drawn my sword, but with men of your sort I use only sticks.'[60] The insult was patent. Isaac promptly hit Gautier on the cheek with his sword. At this point Gautier drew his own sword, but was restrained by onlookers, and both parties were summonsed to appear in court. In the *Confessions*, Rousseau gives an account of the case which casts his father in a good light, but it is evident from the records of the trial that every witness supported Captain Gautier's version.[61] Isaac Rousseau, however, was not at the trial, for on 11 October 1722, two days after the quarrel, he had fled from the territory of Geneva. He was tried and sentenced *in absentia* to three months' imprisonment, plus fines, but rather than pay these penalties he chose to remain in exile for the rest of his life. He found refuge in Bernese territory at Nyon,[62] where he settled down, with a second wife,‡ to a peaceful existence on the income of his first wife's estate.

Jean-Jacques, who was in time to abandon all his own children by sending them at birth to an orphanage, had the good grace not to blame his father for deserting him at the age of ten. In the *Confessions* he simply remarks that he

* Antoine Fazy (1681–1731) introduced, from Holland, the printed cotton industry to Geneva in 1691, opening factories first at Eaux-Vives then at Pâquis. He married Clermonde Rousseau in 1719, when Jean-Jacques was aged seven. The 'young Fazy' mentioned in the *Rêveries* was perhaps a brother of Antoine, who had not been married to Clermonde long enough to have a son of an age to operate machines.

† The story is further evidence that Rousseau gives a false impression when he writes in the *Confessions* of being forbidden to play with other children.

‡ He married Jeanne François at Nyon on 5 March 1726.

was put into the care of his uncle, Gabriel Bernard, who had a son of his own age named Abraham. Like his late mother, the Bernards belonged to the society of high Geneva. It was several years before Rousseau became conscious of the fact that his guardians looked down on him as a child of the artisan quarter of St Gervais. No suspicions clouded Rousseau's first years of companionship with Abraham Bernard; nor indeed did he go at once to live in his uncle's commodious residence in the upper reaches of the city. Colonel Bernard very sensibly decided that something should seriously be done about Jean-Jacques' education, and he put him *en pension*, together with Abraham, in the house of a Calvinist country pastor, Jean-Jacques Lambercier of Bossey.

BOSSEY

The village of Bossey still stands, much as Rousseau knew it, in a fairly unspoiled setting of fields and meadows at the foot of Mont Salève. A railway track and the main road between St Julien and Annemasse now act as barriers against the suburban spread of Geneva; there is also the frontier, for Bossey is in France. In Rousseau's time it was in the duchy of Savoy, but by a curious arrangement it was subject to the City of Geneva in spiritual government, so that the cure of souls was vested in a Calvinist. This divided sovereignty ended in Rousseau's lifetime – by the Treaty of Turin in 1754 which settled all residual disputes between Geneva and its neighbours – and Bossey was restored to obedience to Rome. A nineteenth-century Catholic church now stands where the Calvinist chapel once stood, and a nondescript village building occupies the site of the parsonage where Rousseau, with his cousin, passed more than two years of his childhood. They were happy times. It was in Bossey that Rousseau acquired that passion for nature which was not only to elevate his own soul but, through his writings, to affect the sensibilities of the whole Western world. After the grey crowded streets of Geneva, he was thrilled by the garden of the parsonage, the orchards, the meadows where he could run freely up the banks of Mont Salève. Sometimes he would climb the steep slope to the heights, where wild flowers grew in abundance and where he had a panoramic view of the city, the lake and the mountains beyond, on clear days even seeing as far as Nyon, where his father had gone to live in exile. All this transfused young Rousseau's heart with a joy hitherto unfelt. When he came to write his *Confessions* more than thirty years later, he found he could still picture the parsonage at Bossey: 'I remember all the details of places, people and times. I can see the maid or the man-servant working in a room, a swallow coming in through the window, a fly landing on my hand while I was reciting my lessons: I can see all the furnishings of the room where we were; Pastor Lambercier's study on the right hand, an engraving depicting the Popes, a barometer, a large calendar; and

the raspberry canes which, from a very high garden behind us, penetrated into the back of the house, giving shade to the window, and sometimes even growing right inside the room.'[1]

It was at Bossey, too, that Jean-Jacques enjoyed without constraint the companionship of his cousin; the 'simplicity of country life', as he puts it, having 'opened his heart to the joys of friendship'.[2] Abraham was the taller boy, but thin, lanky, less strong; and Jean-Jacques was allowed to take the lead in the games they played together. If the Lamberciers favoured Abraham, as being the son and not the mere ward of the man who paid, Rousseau says his cousin 'did not abuse too much that predilection';[3] and, in any case, Jean-Jacques had the advantage over Abraham of being better at his lessons. In the house of Pastor Lambercier he began at the age of ten to receive something approaching a systematic education, learning the rudiments of Latin and mathematics and other subjects which his father would not have taught him. Pastor Lambercier, like the other ministers of the Genevan Church, was a man of some considerable learning; for Calvin, himself a formidable scholar, had laid down standards to ensure that his pastors were equal in intellectual culture to the best Catholic priests. In this respect Jean-Jacques was fortunate, for Pastor Lambercier was to give him the only schooling that he ever had.

At Bossey Rousseau made a discovery about his own nature which he was candid enough to reveal in the *Confessions*. He enjoyed being spanked by Mlle Lambercier. He says that while he did not like annoying Mlle Lambercier, he had to control himself to avoid doing things that would make her inflict corporal punishment on him: 'I had found in that pain, in that shame even, an element of sensuality which left me desiring rather than fearing to experience it again from the same hand.'[4] He was disappointed when 'the modest Mlle Lambercier' came to detect that 'the punishment was not achieving its intended purpose' and thereupon, 'on the pretext that it tired her too much, gave it up'.[5] He explains that they had until then 'slept in the same bedroom, and even in winter sometimes in the same bed'.[6] Afterwards Abraham and he were made to sleep in another room, and 'I had henceforth the honour, which I had hitherto been denied, of being treated by her as a big boy'.[7]

Rousseau was always convinced that he had retained his innocence longer than most people, and indeed that his masochistic tastes had helped to keep him pure, since they were such as to be satisfied almost wholly in fantasy: '... I devoured beautiful women with an ardent eye; my imagination conjured them up endlessly, only to put them into action in my own way, and turn them into so many Mlle Lamberciers. Even after reaching maturity, this bizarre and ever-persistent taste preserved in me the sound morals of which it might have robbed me ...'[8]

Rousseau was not always as chaste as he here claims, but there is no reason to doubt what he says about his masochism. He was too timid to ask women to chastise him; and yet, without that stimulant, the ordinary pleasures of sex had for him no savour. He had to seek 'symbolically' what he dared not seek physically: 'To be on my knees before an imperious mistress, to obey her orders, to have to ask her forgiveness, is for me the sweetest of pleasures, and the more my lively imagination inflames my blood, the more I have the air of lover transported. It will be understood that such a way of making love does not produce rapid results, and is no great threat to the virtue of those to whom it is addressed. I have in consequence possessed few women; and yet I have not failed to find pleasure in my own way, which is in the imagination.'[9]

In the earlier draft of his *Confessions*, Rousseau put the same thoughts in other words: 'Love alone has led me astray, never debauchery; my senses were always directed by my heart; shame, the preserver of morals, never deserted me, and as far as I can fathom the depths of my secret passions, my shame was a consequence of my first and still abiding desire. What is the good of being enterprising only in order to obtain half the gratification one seeks? Only those pleasures of which I dared not speak could have conferred any value on the other pleasures. Pleasures that can be shared can be solicited, but who would not scorn to render those ridiculous services which, in giving too much pleasure to the one who receives them, often destroy the pleasure of the one who condescends to bestow them?'[10]

In the same passage, he puts the question: 'Had I then good morals only because I had depraved tastes? Such an inference would be unjust and outrageous.'[11] He insists that a 'modest and wholesome' education had left him genuinely pure; he was never tempted, like others who shared his desires, to pay a prostitute to enact the role of cruel governess; he had an aversion for anything to do with brothels or pornography, and says that even witnessing by chance the rough and rustic couplings of lovers in the caves at Saconnex was something that made him sick.

In the final version of the *Confessions*, after admitting he enjoyed being spanked by Mlle Lambercier, Rousseau asks: 'Who would believe that this punishment received at the age of eight from the hands of a girl of thirty determined my tastes, my desires, my passions for the rest of my life?'[12] The answer to this question* might be more readily given if Rousseau had remembered the ages correctly: he was over eleven at the time, and Mlle Lambercier was forty.

Subsequent research has brought to light certain things Rousseau would

* It is interesting to notice that in the earlier version – the Neuchâtel MS – of the *Confessions*, Rousseau does not put this question at all. Instead he himself comments: *'cette conduite dans une fille de trente ans qui seule sait son motif me paraît digne de remarque'.*[13]

not have known: among them, that Gabrielle Lambercier had already proved herself somewhat lacking in discretion. In the close tense atmosphere created by the Calvinist policing of private morality, Lambercier and his sister had more than once been the victims of denunciations. As in Massachusetts and other rural centres of puritan fanaticism, people in the village of Bossey kept a close watch on their neighbours to make sure that others were not enjoying the satisfactions that they denied themselves, and what they did not see they sometimes imagined.

Jean-Jacques Lambercier excited suspicion from his first arrival in Bossey, for he appeared to live in altogether unsuitable intimacy with his sister Gabrielle. He was observed through the window of the parsonage engaged in such indecent familiarities as helping her dress her hair and put the finishing touches to her *toilette*. Then again, as he could not afford two horses, he had his sister ride on the same saddle with him, a practice which shocked the villagers no less. The word 'incest' was not only whispered, it was alleged before the Company of Pastors, the disciplinary body of ministers.[14] Lambercier was unpopular with the villagers, since he seemed to them to neglect his parish duties in order to have more time to dissipate with his sister. The committee which heard the charges against him decided that, in matters of morals, Lambercier was guilty of nothing worse than a want of discretion, but he was censured for neglect of his parish duties and urged to be more prudent in future.[15] Evidently Lambercier heeded the warning, and by the time Rousseau and his cousin went to their parsonage *en pension* the Lamberciers appear to have lived down the old scandals.

Rousseau's idyllic life at Bossey came to an end some time after the summer of 1724, when he went back to Geneva to live at his uncle's house in the upper part of the town. It is not clear exactly when this move took place, but Rousseau is plainly mistaken in saying in the *Confessions* that he lived thereafter with Colonel Bernard for two or three years.[16] It cannot in fact have been longer than one year, for we know that he left his uncle's house in the spring of 1725,* and he must have been with the Lamberciers in August 1724, because a comic incident he recalls having witnessed at Bossey took place then: he tells us that when the King of Sardinia, the ruling prince of the House of Savoy, drove through Bossey on his way from Thonon to Annecy, Mlle Lambercier became so excited that she fell head over heels and presented her backside to the monarch's gaze. This incident must have taken place on the recorded date of the King's journey through Bossey, 23 August 1724. Rousseau protests that he found no mirth in the good woman's fall: he says he felt only 'alarm for a person I loved like a mother, and perhaps more than a mother'.[18]

His last months at Bossey were, however, clouded; spoiled as a result of an

* Rousseau's contract of apprenticeship to Abel Ducommun is dated 22 April 1725.[17]

unjust accusation. One day a comb was found broken in the kitchen, next to the room where he was working at his studies. When the kitchen-maid denied breaking the comb, Jean-Jacques was charged with the offence; and when he protested his innocence, he was beaten in an effort to extract an avowal of guilt. At about the same time Abraham was accused of some other misdemeanour, and Pastor Lambercier called in Colonel Bernard to give both boys a whipping. The chastisement was fierce, but Rousseau claims that he was not cowed and that 'in the end I emerged from this cruel ordeal in pieces, but triumphant'.[19]

This was a different experience from the beatings he had had from his father and from the sweet slaps he had received from Mlle Lambercier; it was a shock which left him feeling indignant against the injustice of humanity, and which 'marked the end of the serenity' of his childhood: 'I no longer enjoyed pure happiness. I can still recall the sensation of my memories of the pleasures of childhood stopping at that moment. My cousin and I stayed a few more months at Bossey, but we were like Adam lingering in the Garden of Eden after he had ceased to be happy there.'[20]

As a result of their unjust punishment Rousseau recalls that both he and his cousin lost their respect for their tutor; living in dread of more accusations and further beatings, they became mutinous, secretive, untruthful. 'All the vices of our years corrupted our innocence and ruined our pleasures. Even the countryside itself lost for our eyes that sweetness and simplicity which had previously touched my heart. It appeared to us empty and sombre, as if covered by a veil which hid its beauty.'[21] Plainly it was time for the boys to leave. They shared the same desire to go, and yet their departure had for each of them a different significance. Abraham was going to his own home, Jean-Jacques to another refuge.

At Bossey Jean-Jacques and Abraham had lived on equal terms as brothers. At Colonel Bernard's house in Geneva it was made clear that they were only cousins, and, what is more, that Abraham was the son of the house while Jean-Jacques was the poor relation. When the Colonel spoke to the boys of the future and made plans with them for their careers, he explained that Abraham was to prepare to become a military engineer like himself, while Jean-Jacques would have to reflect on his own prospects as a watchmaker, a lawyer or a minister of religion. 'I would have preferred, like all children who fancy the idea of preaching, to become a minister; but the small income of the estate that my mother had divided between my brother and myself was not substantial enough to finance my preparation for such a career.'[22]

Rousseau, who always speaks well of his father's conduct, makes no comment in the *Confessions* on the fact that Isaac was consuming the lion's share of the usufruct of his mother's estate, albeit not the entire income, as he was later to do, for Colonel Bernard exacted a certain sum, about 520

florins a year, for his nephew's board and lodging. For several months, having no definite programme of reading of his own, Jean-Jacques kept company with Abraham, more or less idly, while his cousin embarked on his engineering studies by learning draughtsmanship and mathematics; Rousseau says he enjoyed the drawing more than the algebra. The boys amused themselves making models of houses, shuttlecocks, drums, cages; they even tried to make watches, and ruined their grandfather's tools in the experiment. They also made marionettes after seeing a visiting Italian puppet-show, and staged an entertainment for the grown-ups of the family. Jean-Jacques, still the stronger of the two boys, remained the leader in their activities together. The lanky Abraham was protected by his shorter but more vigorous cousin. When they went out in the streets of Geneva, other children cried mockingly at the willowy Abraham – 'Barnâ Bredanna'* they called him in their patois – but Jean-Jacques says it was he who turned on them with his fists. Abraham did not like fighting: Jean-Jacques says he did. 'I hit, and I was hit. My poor cousin did his best to support me, but one flick of the hand knocked him over.'[23]

From this we may conclude that the boy who says that when he was living with his father and aunts in St Gervais he had not been allowed to play with the children in the streets had somewhere learned to use his fists. In any case, the Bernard family, living in the fashionable quarter of the upper city, had no occasion to dread the company of their neighbours. And if the cousins met rougher lads on their trips to the lakeside to see the Italian puppets and other such popular shows, they had the reassurance of social superiority as they climbed up the hill at the end of the day.

Colonel Bernard was a more easy-going man than Pastor Lambercier; and if his wife was more tolerant than Mlle Lambercier, it was perhaps because she took less interest in the boys' concerns. The situation was complicated by the fact that Colonel Bernard was an unfaithful husband, which prompted his wife to retreat into religiosity. Rousseau reveals this in his early manuscript of the *Confessions*, in a passage he removed from the final text.† His words are: 'my aunt, to console herself for the infidelities of her husband, became sanctimoniously devout; she preferred singing psalms to looking after our education.'[24] In later versions Rousseau limits himself to describing the Colonel as 'a man of pleasure'.‡

The long winter of playing games at Colonel Bernard's house while his

* *Barnâ'* meaning 'Bernard', the name of the ass in La Fontaine's fable, and *'bredanna'* meaning 'bridled'.

† He says nothing in any version about his aunt Théodora herself having been reprimanded by the Consistory for anticipating her marriage to Colonel Bernard and probably did not know about it.

‡ Rousseau adds 'like my father',[25] but this does not authorize us to conclude that Isaac had a similar taste for gallantry.[25]

cousin studied, the period Rousseau afterwards thought of as having been as long as two or three years, ended with his uncle's decision that he must go to work. This was the parting of the ways for the cousins: for while Abraham was destined for a profession, Jean-Jacques, who could afford nothing better, would have to be content with a trade. The first job that was found for him was that of a pupil-clerk to a notary named Masseron,* who had an office at the Hôtel de Ville near the house where the Bernards lived. Colonel Bernard suggested that his nephew might learn about what he called 'the useful trade of *prosecutor*'; Rousseau disliked the sound of the word, and he soon came to dislike the work even more. Masseron, for his part, was equally dissatisfied with his pupil, and within a very short time Rousseau was 'ignominiously sacked' as an 'ass' fit only for an artisan's bench. His uncle accordingly proposed to him a place as an apprentice to an engraver. Rousseau says: 'I was so humiliated by the notary's scorn that I obeyed without a murmur.'[26]

This was another decisive turning point in Rousseau's life. Once again he went down the hill to live in the humble quarter of St Gervais; and this time he was old enough to feel the social downgrading of the experience, even as his father had done seven years before. His situation was indeed worse: for it was not to the St Gervais of the educated artisans, of the high-minded liberal-thinking workers' *cercles*, the milieu to which his grandfather David Rousseau belonged, that Jean-Jacques now moved. He became the apprentice of a coarse and uneducated master named Abel Ducommun.† This man was only twenty, but he had a brutish, violent nature, and his marriage a year later did nothing to soften him. Rousseau felt degraded to be in the presence of Ducommun, yet he was obliged not only to work for him, but to live with him, bound by articles of apprenticeship. This contract, dated 26 April 1725, stipulated that Rousseau should spend five years under his master's roof. Jean-Jacques thus found himself reduced once again not only to St Gervais but to a plebeian way of life he had never known before. By his own account, his character deteriorated in this uncultured environment: 'Never did such a precocious Caesar become so swiftly Laridon.'[27]‡ The Latin and the history he had learned with Pastor Lambercier were forgotten, and what he calls 'the basest tastes and the most abject roguery'[28] took possession of him: he was cowed by his master and, being frightened, began to tell lies and deceive, and in time even to steal. He was found out and beaten, sometimes for his stealing and sometimes with less justification. The things

* Jean-Louys Masseron (1686–1753) was notary public at the Hôtel de Ville from 1710 to 1751.

† Abel Ducommun, born 18 January 1705, established himself at an early age as a master engraver at what is now 13 rue de Ville Neuve, Geneva. After his marriage in November 1726, he removed his workshop and residence to a house in the rue de la Poissonnerie (now rue Croix d'Or) that was demolished in 1905. The present No. 13 occupies the site.

‡ Laridon is the name of a degenerate dog in one of La Fontaine's fables.

Rousseau stole were mostly things to eat such as apples and asparagus, and he says he stole them because he was not given enough food: for example, like other apprentices at the time, he was expected to leave the table before the pudding was served. He had too much pride to accept this discrimination as willingly as others did; he also admits to having 'stolen', or, more exactly, having hidden away for future use, his favourite tools and engravings: such 'thefts', he pleads, were essentially innocent since they were designed to make him work better in his master's service. He never stole money, nor, he declares, was he ever tempted to do so. 'I have always regarded money with more horror than pleasure.'[29]

He tells also a curious story to illustrate his embarrassment at the thought of spending money. 'A thousand times, during my apprenticeship and afterwards, I went out to buy a cake. I reached the shop; I saw the women at the counter, and I believed I could already see them laughing and making fun among themselves of the greedy little customer. I walked in front of another shop; I lavished a sidelong gaze on the beautiful pears; their scent tempted me; two or three young people looked at me; a man who knew me was in front of the shop, and I noticed from a distance a young woman in an apron coming towards me – was it a servant from our house? My short sight and my fears created a thousand illusions. I imagined every passer-by to be someone who knew me; I was intimidated by everyone, thwarted by obstacles. My desire grew with my fears; and I went home like an idiot – consumed with desire, and with enough money in my pocket to satisfy that desire, and yet not daring to buy anything.'[30]

Rousseau's youthful inhibitions against the satisfaction of his hunger as he here describes them bear a striking analogy to his later inhibitions against the satisfaction of his sexual desires. Indeed already at this period of early adolescence he had an experience of falling in love, and with what was to prove a characteristic want of moderation, he fell in love not with one girl but with two. Looking back from the perspective of middle age, he observed that he had always been capable of feeling two distinct forms of love, love in the mind and love in the senses. 'The whole course of my life has been divided between these two different kinds of love; I have in fact sometimes experienced the two kinds of love at the same time, and I did so then.'[31] The two objects of his first love were Mlle Charlotte de Vulson* and Mlle Goton.† He made the acquaintance of both girls on visits to his father at Nyon, where Isaac Rousseau was, according to his son, so popular – 'especially with the ladies'[32] – that Jean-Jacques himself received a warm

* Also spelt, as in the Neuchâtel MS, 'Wilson': in the canton de Vaud, under the rule of the German–Swiss patricians of Berne, French orthography was slack.

† 'Goton' is Marguerite abridged, apart from what Rousseau records in the *Confessions* Mlle Goton remains an entirely mysterious figure.

welcome in local society. Charlotte de Vulson's mother petted the young Rousseau, and encouraged him to flirt with her daughter, although the girl was ten years older than he. Later Jean-Jacques suspected that Charlotte de Vulson might have been teasing him, but at the time he took her attentions very seriously, and he was gripped by a jealous if exalted and platonic passion for her: this was his 'love in the mind'. Mlle Goton inspired the other kind of love, his 'love in the senses'. Nor was this all. Mlle Goton reawakened those desires which had been first aroused by Mlle Lambercier. She played the part of the strict governess and whipped him: 'She was in truth a singular person that little Mlle Goton. Without being beautiful, she had a face that was difficult to forget ... her eyes especially were not a child's, neither was her figure, nor her bearing. She had her own little imposing proud air, very suitable to the role she played and which indeed first prompted the fantasy we shared. But what was most bizarre about her was a fusion of audacity and reserve difficult to imagine. She allowed herself the greatest liberties towards me without granting me any towards her. She treated me exactly like a child; and this makes me think that she had either ceased to be a child herself, or that she was still so much a child that she could see only a game in the danger to which she exposed herself.'[33]

Thus Rousseau writes of Mlle Goton in the final versions of his *Confessions*. In the earlier draft, he describes his 'little school mistress' only in her moral qualities, not her physical appearance; and having done so, he adds: 'That is enough, perhaps too much, about Mlle Goton. A child of that age is certainly of no interest for a person of my age. And yet, in spite of her being a child, I would not wish for anything in the world to see her again, or indeed to think about her for too long.'[34] Rousseau even says that 'on returning to Geneva I soon forgot Mlle Goton',[35] but this is something no reader can believe, especially as Rousseau goes on to recall, analyse and compare the feelings that were stirred in him by Mlle Goton with those inspired by Mlle de Vulson: 'I could have been like a tiger with Mlle Goton if she had given me the opportunity. There was no moderation about anything that originated in her. Her slightest unpunctuality made me furious, but when she appeared, the very sight of her inflamed my blood with an inconceivable ardour, and all else was forgotten. With Mlle de Vulson I was familiar without familiarities; but with Mlle Goton I was trembling and agitated even in the midst of the greatest familiarities. If I thought of Mlle de Vulson to comfort me in melancholy times, it was to Mlle Goton that my thoughts flew in times of contentment, when my heart was full. I could have passed my life with Mlle de Vulson; one hour with Mlle Goton was already too much: I would collapse with exhaustion without having tasted enjoyment, and having already had enough of her, I would flee for fear of hating her. I was equally afraid of displeasing either girl, but I was more

obliging towards the one and more obedient towards the other. For nothing in the world would I have wished to annoy Mlle de Vulson, but if, in the midst of my ecstasies, Mlle Goton had commanded me to throw myself into the flames, I believe I would have promptly obeyed.'[36]

Rousseau tells us that he saw no more of Mlle Goton after he had returned from Nyon to Geneva, but that he kept in touch with Mlle de Vulson, writing her love letters and occasionally meeting her. On one occasion she came to Geneva for the express purpose, she told him, of keeping a rendez-vous with him; when she left after two days in his company, she wept as copiously as he, and a few days later she sent him presents of sweets and gloves from Nyon. Soon afterwards Rousseau learned to his dismay that Charlotte had married a lawyer from the village of Orbe in the Vaud named Jean-Pierre Cristin to whom she had been engaged all the time; he learned also that her visit to Geneva had been undertaken, not for the sake of meeting him, but in order to buy her wedding trousseau.

As for Mlle Goton, Rousseau came to suspect that she had betrayed the secret of their games together, because children in the street came up to him crying softly 'Goton whick-whack Rousseau'.[37] If there is a contradiction between Rousseau's claim in the early version of the *Confessions* that he 'soon forgot Mlle Goton'[38] and his admission in the later version that he remembers her appearance 'too well for an old fool',[39] we must note that lost memories of youth return in advancing years and we can understand that Rousseau might wish both to remember and to forget the one girl in his whole life who both discerned and satisfied his deepest sexual cravings. Both literature and psychology owe much to his courage in writing so frankly and directly about such matters. Other authors might have drawn discreetly on their experience in writing fiction but Rousseau, when he sat down at the age of fifty as an exile in England to write his autobiography, resolved to speak the truth, to go even further than St Augustine in unveiling his soul to the reader. 'What is hardest to confess,' he remarked, 'is not what is criminal, but what is ridiculous and shameful.'[40] Once he had told the story of his finding pleasure in being spanked by Mlle Lambercier, he felt he had broken the barrier. 'I am confident that having written what I have just dared to write, nothing more can stop me. Readers may judge how much it has cost me to make a public avowal of something which, throughout the course of my whole life, has taken possession of me in the presence of those I have loved, robbing me of all power to see or hear, left me senseless and galvanized by a compulsive trembling in my whole body; and yet I have never been able to bring myself to reveal my bizarre desires to those who might satisfy them or to beg even during the most intimate familiarities for the favour that would complete all the others. I had the experience only once, in my childhood with a girl of my own age, and even then it was she who first proposed it.'[41]

One way and another, his was not a happy adolescence. The actual trade of the engraver Rousseau says he did not dislike: he enjoyed drawing, and the fine calligraphy of so many of his manuscripts bespeaks his talent for it. What he hated was the uncouth life at Abel Ducommun's establishment: he could not begin to enjoy the vulgar amusements of his fellow apprentices, even though he speaks of himself as picking up some of their vices. He was a youth of too delicate and sensitive a temperament, too much the 'natural aristocrat' (as his father had felt himself to be), to feel at ease in the plebeian milieu of Ducommun's workshop. Like many another youth in an uncongenial environment, he consoled himself with books. Reading became his main activity, his obsession: he read in bed and in the lavatory, he read while he walked and even while he stood at his work bench. He read avidly, indiscriminately, gave up clothes to be able to pay to borrow books from the commercial library of the celebrated Mme La Tribu, refusing only those she offered him with a lascivious leer, recommending them as 'books* that could be read with one hand only'.[42] Abel Ducommun did his utmost to detach him from his books – he seized them, burned them, threw them out of the window. He inflicted more corporal punishment on his apprentice; but it was all unavailing. Nothing, Rousseau says, could deter him from his favourite recreation. Even so, reading was not his only amusement. He enjoyed walking in his few free hours, and he cultivated little hobbies which gave expression to his fantasies. On one occasion he devised and engraved medals for imaginary orders of chivalry to distribute among his friends: 'the romantic spirit had already entered into my amusements'.[43] Unfortunately his master found him working on the medals, accused him of forging coins and beat him yet again. It was a hard life: flogged in turn by his father, his tutor, his uncle and his master. We cannot be surprised that the image of flagellation came to play a large role in his dreams and the idea of freedom to have a central place in his thoughts.

Of the five years that the contract of apprenticeship required Rousseau to spend with Ducommun, he endured nearly three, but that was all: 'The tyranny of my master ended in making work that I might have enjoyed unbearable ... Nothing could have served better to teach me the difference between a filial and a servile dependence than the thought of the changes which those years brought about in me. As I was by nature timid and ashamed, effrontery was the fault I was farthest from; even so, I had been accustomed to an honest liberty, and that was diminished by degrees and finally eliminated altogether. I had been bold with my father, free with Pastor Lambercier, discreet with my uncle; but I was intimidated by my master, and as a result of that I was lost. Having been used to a perfect equality with my superiors in my style of living, having known no pleasure

* Rousseau adds that he was thirty before he 'cast an eye on those pernicious books'.

that was not within my reach, having seen no food of which I did not receive my share, having felt no desire without giving voice to it and expressing with my lips all the movements of my heart – it will be imagined what became of me in a house where I dared not open my mouth, where I had to leave the table in the middle of a meal, and where, being constantly chained to my work, I could see objects of pleasure reserved for others and privation reserved for me alone ...'[44]

Rousseau's servitude came to an end on a fine Sunday in the early spring of 1728,* some three months before his sixteenth birthday. He went for a walk after church that day with some of his young friends in the countryside outside the city gates. This was something he often did and his country walks sometimes carried him farther afield than his companions. Twice before he had returned to Geneva to find the gates already closed; he had had to sleep in the open air outside, and accept a beating from his master when he got back to the workshop next morning. There was one officer of the gates named Captain Minutoli, who habitually closed the gates half-an-hour before the appointed time; but Rousseau and his friends never knew when he would be on duty. On this particular Sunday afternoon, he was. As Rousseau and the other boys walked home in what they thought to be good time before dark they heard, rather more than a mile from the gates, the signal for closing. Rousseau recalls how he quickened his pace, then ran, his heart beating faster, his breath faltering; he cried out to the soldiers to wait as he saw them put their hands on the levers; but when he was within twenty paces of the gates, they lifted the first drawbridge. 'In the first transport of my despair, I threw myself upon the ramp and bit the earth.'[45] His companions, having less reason to dread the consequences, made light of their ill luck, and laughed. But Rousseau reacted in another way. He resolved then and there that he would never go back to his master. Locked out, he would stay out. He would escape from the bondage of apprenticeship. Like his father and his brother before him, he sensed the infinite possibilities of exile: since there was no freedom for him in Geneva, he would seek it elsewhere.

After a cold March night with his friends outside the gates, he bade them adieu when the drawbridge was lowered at dawn, and asked them to take a secret message to Abraham Bernard: it was to say that he intended to run away and to ask his cousin to help him or to join him. Although he had seen so much less of his cousin since he had gone down to St Gervais to live with Abel Ducommun, he attributed Abraham's withdrawal from his company to the influence of his snobbish mother rather than to any coolness on the part of Abraham himself and Jean-Jacques continued to rely on the warmth and friendliness of his cousin's nature. He says that Abraham did come quickly in

* 14 March 1728.

response to the message – only he came, as Rousseau puts it, 'neither to join me in my enterprise, nor to dissuade me from going, but to say goodbye and help me on my way with a few presents, since my own resources would not have taken me very far. He gave me among other things a little sword which he knew I liked, and which I took with me to Turin, where I was robbed of it.'[46] He was saddened by Abraham's eagerness to see him run away, and by his brisk farewell 'without too many tears'.[47] Rousseau suspected afterwards that Abraham had been prompted by his parents to speed the departure of an unwanted poor relation.

Rousseau's flight from Geneva put his father in breach of contract with Abel Ducommun in the matter of the apprenticeship;[48] and a fortnight later Isaac had to sign another agreement[49] with the engraver stipulating that, if his son did not return to Geneva within four months to complete the apprenticeship, he would pay an indemnity of twenty-five *écus blancs*. Rousseau did not return. A curious aftermath is that his cousin Abraham, after disappointing Jean-Jacques' hopes that he might escape with him, ran away on his own account, and never returned to Geneva.* Rousseau makes no reference in the *Confessions* to the fact that Abraham followed his example: all he says is that he died in 1736 in the service of the King of Prussia. Like Jean-Jacques' brother François, his cousin Abraham disappears abruptly from the screen of Rousseau's memory.

* His mother Théodora Bernard testified on 20 March 1750 that her son Abraham had been absent from Geneva for about twenty years, that she had not heard from him for several years, and that she did not know whether he was alive or dead.

3

ANNECY

There was no need for any young man who ran away from Geneva in the eighteenth century to be friendless. In the duchy of Savoy, whose territory surrounded the southern and western borders of the city, there were earnest Catholics watching for converts to Rome just as there were Protestant missionaries within Geneva waiting to gather up converts to the Reformed Religion. The outstretched hand awaited the wanderer, whichever way he turned. At Annecy, the religious capital of Savoy, the Counter-Reformation had produced in the person of François de Sales* a worthy match for Calvin in intellect as well as in religious fervour. Although François de Sales had been dead for many years when Rousseau sought refuge in Savoy, his missionary work was being continued by his followers with all the persistence and cunning that their prayers could bring them, especially in those areas where the secular rulers of Savoy had been unable by force alone to impose the Catholic faith on their subjects.

It must be remembered that in Rousseau's lifetime Savoy was not France: France lay to the north of Geneva, in the Jura region of Gex, which divided Geneva from the canton of Vaud. Savoy did not become French until 1860. The duchy Rousseau entered in 1728 was one whose rulers had prided themselves since the eleventh century on preserving their sovereign independence, a success they owed largely to their skill in setting the French against the Austrians. Their territory had been occupied from time to time by French armies, and during the Protestant Reformation they had been expelled for good from their Swiss possessions in the Vaud and Geneva; but under Emmanuel-Philibert (1553–80), a fervent Catholic as well as an ambitious prince, the power and fortunes of the House of Savoy had improved; in effect

* François de Sales (1567–1622) was ordained at Annecy, where the Catholic diocese was established after the expulsion of the Bishop from Geneva. He made it his life's mission to win back to obedience to Rome those numerous Christians living in Chablais, Savoyard territory to the south of Geneva, who had been converted to Calvinism, and his endeavours were remarkably successful.

he transformed his domains into a modern nation state. He achieved that end, however, by a move which was ultimately to alter the whole design, for in the year 1563 Emmanuel-Philibert transferred the capital of his realm from Chambéry in Savoy to Turin across the Alps in the duchy of Piedmont, where he was protected by a curtain of high mountains from the French and better placed to extend his empire towards the south and east. What the House of Savoy had lost in Switzerland, it began to recover in Italy. The price of this achievement was that the original duchy of Savoy was increasingly neglected, and finally abandoned to France by a ruling family which had found its destiny elsewhere. In 1712, the year of Rousseau's birth, the then head of the House of Savoy, Victor Amadeus II, acquired, through the Treaty of Utrecht, his first crown: he was recognized as King of Sicily, a title he exchanged in 1720 for that of King of Sardinia. This was the monarch Rousseau had seen with his own eyes in 1724 on the occasion of Mlle Lambercier's somersault at Bossey. Like earlier princes of the House of Savoy, Victor Amadeus II was a fervent champion of the Catholic Church against the Protestant reformers, and the missionaries who worked in Savoy were subsidized by his royal treasury; it was all part of his design to rescue Geneva and the Vaud from their Protestant rulers.

Jean-Jacques, with his Calvinist upbringing and the patriotic sentiment that had been introjected into him by his father, hesitated before he defected. For the first few nights of his wanderings, he found a bed in the cottages of peasants he had come to know in the course of all his rambles in the countryside around Geneva, but, liberal as was their hospitality, his purse was soon empty. Facing the fact that there was no better alternative, he decided to seek the advice of a Catholic priest. The one he chose to visit was the *curé* of Confignon, a clergyman of noble blood. Rousseau says he went there because 'I was curious to see what the descendants of the Gentlemen of the Cuiller were like'.[1] The Gentlemen of the Cuiller had been a company of Savoyard noblemen who assumed the role of knights in the service of the Catholic Church against the Protestant heresy. The romantic side of feudalism had a great appeal for Rousseau: at the engraver's bench, as we have noticed, he designed medals for an imaginary order of chivalry for himself and his friends to wear. The very experience of being pushed down from the upper-class milieu of Colonel Bernard's house to the plebeian misery of Abel Ducommun's workshop had sharpened his sense of being a superior person 'distinguished from the people', to repeat the expression he used to describe the family to which he belonged. His self-image was still close to that of his father: a natural aristocrat aloof from the *hoi polloi*.

The duchy of Savoy remained a feudal place, unlike Geneva, where the patrician class was composed of wealthy townspeople, and unlike France, where the centralizing absolutist monarchy of the Bourbon dynasty had

pulled the French nobility out of their castles and transformed them into courtiers at Versailles, bewigged, elegant and politically impotent. In Savoy, the traditions of the old aristocratic culture lived on. Even though the duchy had declined into being a province of an Italian kingdom, ruled by Intendants and bureaucrats, the *noblesse d'épée* still inhabited its castles. The name of the *curé* de Confignon was Benoît de Pontverre; he belonged to the ancient Savoyard family of Quimper of Chambéry, and he took his name from the seigneury of Pontverre at Cruseilles, which that family possessed. He was an old man, nearly seventy-two, when Rousseau went to visit him in the spring of 1728, and he had spent a lifetime preaching and writing pamphlets against Calvinism. He was one of the most learned and able exponents of the Catholic case against its critics, a successful missionary, and a scholar. In the *Confessions*, Rousseau makes light of all this. He says that the *curé* entertained him to a good dinner and regaled him with criticisms of the Genevan heresy. 'I was wiser than M. de Pontverre,' he writes; 'but I was too good a guest to prove myself a good theologian; and his Frangi wine, which seemed excellent to me, argued so victoriously on his behalf that I would have blushed to close the mouth of so liberal a host. I yielded; or, at any rate, I did not resist to his face.'[2]

Rousseau denies that he was acting hypocritically; he claims that he had no intention of changing his religion, but wanted only to avoid behaving ungraciously to people who befriended him at a time when he needed friends. 'I wanted to cultivate their benevolence by giving them the hope of success, and by appearing less well armed with arguments than I really was';[3] and he adds that his conduct appeared, from the perspective of middle age, less like hypocrisy than like the *coquetterie* of a chaste woman who knows how to provoke in men expectations that she does not intend to satisfy.

Diderot was later to speak of Rousseau as a natural turncoat in religion, but Rousseau's own conception of himself is perhaps more accurate: with his feminine desire for admiration, he yielded easily to opinions which mature reflection made him afterwards reject. Even so, he took a long time to repudiate what he accepted that day from M. de Pontverre, namely an invitation to make a sympathetic study of the Catholic religion. The *curé* gave him an introduction to a Swiss baroness at Annecy who was herself a recent convert, and who was noted for her kindness to young refugees from the Protestant countries. Rousseau says he did not like the idea of seeking charity, but hunger overcame his scruples, and he agreed to go to Annecy. He did not hurry. He could have walked there in a day, but he stretched out the journey to three days, his head still filled with romantic fantasies; he was thrilled by all the vestiges of feudal splendour to be seen in the Savoyard countryside and he never passed a *château* or nobleman's domain without stopping to explore. His dream was to find a castle 'where I could be the

favourite of the lord and lady, the love of their daughter, the friend of the brother and the protector of their neighbours'.[4] Such adventures were denied him, if only because he was too shy to knock on any door. What he did was 'to sing under the most promising windows', only to be 'very surprised that neither ladies nor maidens were attracted by the beauty of my voice'.[5]

He realized that there was no other choice but to call on the Swiss baroness; and with the idea of recommending himself to her more effectively, he added to M. de Pontverre's introduction a letter of his own, composed in his best oratorical style, with borrowed phrases from the most eloquent books he had read. Thus armed, he directed his footsteps towards Annecy and 'that terrifying audience'.[6]

The city of Annecy was in some ways like Geneva, though smaller; it, too, was a fortified, crowded place standing at the end of a beautiful lake, with farmlands outside its walls and mountains beyond and above it. In other respects Annecy was altogether different from Geneva. Built in the shadows of a great medieval castle, it was an entirely medieval city. It had been the seat of the Counts of Genevois since the tenth century, and from the Palais de l'Isle, with its notorious prison cells, the officials of the Duke of Savoy, now King of Sardinia, administered justice. When the Catholic Bishop had been expelled from Geneva in 1535, Annecy became not only the seat of his diocese in exile, but a vigorous spiritual and ideological centre of the Counter-Reformation. In the years between 1602 and 1622 François de Sales as Bishop imprinted his spirit on the city of Annecy almost as perceptibly as Calvin imprinted his on Geneva. The narrow, picturesque streets and footpaths were crowded with priests and nuns; Catholic converts from Switzerland and elsewhere swelled the throng, and church bells were continually summoning the faithful to mass or other Catholic devotions. But it was not a sombre city: François de Sales had shown that piety need not preclude a certain worldliness, and the people of Annecy had kept a *joie de vivre* that had been lost in Geneva. The architecture was also prettier than that of Geneva: the waterways which ran between the houses brought an almost Venetian light and sparkle into the city, while arcades along the streets added a further Italianate elegance to the rustic charm of the simple wooden houses. There were also in the eighteenth century a number of houses with handsome private gardens owned by members of the Savoyard nobility.

It was through one such garden – belonging to Jacques de Boëge de Conflans – that Rousseau walked on 21 March 1728 for his 'terrifying audience'; a bridge across a canal of the Thion connected the garden with M. de Boëge's house* where the baroness had an apartment. The building has

* It is evident from a survey map of Annecy, drawn up two years after Rousseau's arrival, that this property was one of the largest in the city. See *Plan cadastral de la ville d'Annecy*, Annecy, 1730.

long since been demolished to make way for what is now the Commissariat of Police, but when Rousseau first saw it, it stood next to the Cordeliers' monastery and church* which the exiled Bishop had made his cathedral.

In a dramatic passage in his *Confessions* Rousseau recalls how he asked at the house for the baroness, and was told she had just left for mass. 'I ran after her, I watched her; I spoke to her ... I shall always remember that place where I first saw her, for I have often moistened it with my tears and covered it with kisses. Would that a balustrade of gold† should surround that blessed spot.'[8] The baroness was about to enter the church through a side door when she heard the boy's voice, and turned towards him. He had expected to meet a typical good lady of the parish; instead he met a beauty: 'I saw a face radiant with charm, fine blue eyes filled with sweetness, a ravishing complexion, and the contours of an enchanting bosom.'[9]

Her name was François-Louise de la Tour, Baronne de Warens;‡ the estranged wife of a Protestant Swiss landowner, she was living in Annecy as a prominent Catholic convert, enjoying august patronage. She greeted Rousseau with an appreciative look, and he, with a shaking hand, presented her the letter of introduction from M. de Pontverre. According to his recollection, she spoke to him earnestly. '"Ah my child," said she to me in a voice that made me tremble, "you are very young to be wandering around the world. It is a pity, really it is." Then without waiting for my reply, she added: "Go to my house and wait for me. Tell them to give you some breakfast. After mass, I shall come and talk to you."'[11]

Mme de Warens was at that date aged twenty-nine; Rousseau was not yet sixteen. If it was not love at first sight, it was a *coup de foudre* of a more singular kind: two extraordinary souls had met and recognized their kinship – the motherless child and the childless mother, the romantic youth and the sentimental woman, the adventurer and the adventuress. We can believe that Rousseau was a good-looking boy. If not conventionally handsome, the portraits printed in his manhood are proof of a pleasing appearance. He speaks of himself as a well-made youth, notwithstanding his small stature: 'I had a nice foot, a shapely leg, a free-and-easy air, a lively face and a pretty mouth, despite ugly teeth; I had black hair and eyebrows, my eyes small and deep-set, but animated by an ardent soul, of which they flashed the fires.'[12]

Mme de Warens liked young men, and this preference doubtless added to

* In its original form this church was dedicated to St Francis of Assisi, and should not be confused (as it is by Sir Gavin de Beer[7]) with the Church of St Francis (de Sales) near the Quai du Semnoz.

† Admirers of Rousseau have since erected a gilded balustrade near, if not exactly upon, the spot.

‡ Rousseau gives her name as Louise-Éléonore de Warens.[10] Éléonore was the name she received on her second baptism, as a Catholic, from her godmother, Princess Louise-Éléonore of Hesse-Rheinfels.

her charm and made her all the more successful in recovering souls for the Catholic Church. Her religious sentiments were never perhaps wholly distinct from erotic feelings; one form of ecstasy merged easily into another; but if her converts and her protégés, even her servants, were sometimes also her lovers, the patronage of bishops protected her from scandal. She even received a pension from the King of Sardinia in recognition of her work as a missionary. Historians and biographers have been uncharitable towards Mme de Warens,* but those who knew her evidently liked her, for while she had bad luck in many ways, she seldom lacked friends. As for her appearance, we must rely on the written testimony of her contemporaries, since all the so-called portraits which still exist are almost certainly not of her.† Rousseau himself describes her as she looked when he first met her: 'She had the beauty which lasts, because it lies more in the formation of the face than in the details, and hers was still in its first bloom. She had a caressing and tender air, a very soft gaze, an angelic smile, a mouth the measure of my own, and ash-blonde hair of exceptional beauty, worn in a casual style which made it all the more striking. She was small in stature, short even, and a little plump without being ill shaped. It would be impossible to see a more beautiful head or bosom, or more graceful hands and arms.'[17]

Rousseau's picture of Mme de Warens is modified a little by that of a friend who met her for the first time rather later in her life, M. de Conzié, who describes her as being of medium height, but not at all shapely, 'since she had put on a great deal of weight, which had rounded her shoulders and made her alabaster bosom too voluminous'. However, M. de Conzié goes on to say: 'Mme de Warens made one readily forget these defects because of her frank expression and her attractive gaiety. Her laugh was charming, and her complexion of lily and rose, together with her sparkling eyes, proclaimed a lively intelligence, and gave a singular vigour to everything she said.'[18] Her dress, he adds, was always rather casual, without having any of the usual studied negligence of the bluestocking.

Mme de Warens was in time to play a dominant role in Rousseau's life, but on the occasion of their first meeting she did not know what to do with him. When she came back from mass, she caressed him warmly, as he recalls, and listened to his tale. She seemed to him to be divided between a humanitarian urge to make him return to his father, and the duty to speed his con-

* But Rousseau himself was unfailing in his praise of her. In his *Rêveries du promeneur solitaire*, written towards the end of his life, he says that it was through knowing her that he was able to develop the most precious faculties of his soul, to become what he did become, to realize his own destiny.[13]

† The best-known of these alleged portraits are in public museums in Boston, Lausanne and Paris. A. Metzger[14] claims that the one in Lausanne by Largillière is the only genuine one. Mugnier[15] disputes the credentials of both the Lausanne and Boston portraits, and favours the miniature in the Cluny Museum, Paris. H. Buffenoir[16] also prints a portrait which he claims to be of Mme de Warens, but the evidence for its authenticity is exceedingly slender.

version to the Catholic Church. She herself had made her own, dramatic submission to Rome some two years earlier, giving up husband, home and (as she was apt to emphasize) social rank and wealth in the canton of Vaud to live as a refugee in Savoy, where she was entirely dependent on pensions.* She was nevertheless still sensible of the importance of family ties, and she considered Rousseau too young to be out in the world on his own. There were two opinions about Mme de Warens, the opinion of the bishops that she was a 'pious Swiss noblewoman', and the opinion of her estranged husband, and some others, that she was 'a perfect actress',[20] but Rousseau had no occasion to entertain any doubts about her. She was affectionate and generous to him. She not only fed him, she found a place for him to sleep in an odd corner of her apartment, from which he had no wish to depart. However, as Rousseau writes, 'I was approaching the age when no woman on her own could decently keep me, a young man, in the house,' and he realized that he would have to leave. Mme de Warens had already in the house a young man named Claude Anet, but as he enacted the role of steward, appearances were preserved, and it was a considerable time before even Rousseau himself discovered that Anet was also her lover.

Rousseau's problem was essentially an economic one. There was no question of his 'going back to his father', for his father did not want him. To return to Geneva would mean returning to his apprenticeship with Abel Ducommun, and this he was determined not to do. But how was he to earn a living? Having served only half his apprenticeship he was far from being a master of his own trade; and Savoy, an undeveloped province without industries or substantial commerce, offered slender opportunities for work. What was he to do?

One day a fellow-guest at dinner at Mme de Warens' table, a 'yokel' as Rousseau called him, named Sabran, suggested 'on divine inspiration' a way out of his predicament: Rousseau should make a thorough change of his religion: he should go to Turin and enter a hospice where accommodation and instruction were provided free of charge to Catholic catechumens. M. Sabran further conjectured that Monsignor de Bernex, the Bishop of Annecy, would readily pay for the journey, and that Mme de Warens herself would not hesitate to contribute.[21] His unctuous words amazed Rousseau, but the idea was approved, and Rousseau had no choice but to agree to it; and soon afterwards he set off to Turin to complete his conversion to Catholicism, bearing with him his few possessions and a little extra pocket-money that Mme de Warens had added to the Bishop's subsidy.

The day after Rousseau's departure, his father arrived from Nyon, having

* These comprised 1,500 *livres* from the King of Sardinia; 150 *livres* from Monsignor de Bernex, the Bishop of Geneva-Annecy, who had converted her, and 200 *livres* from Bishop Valpergue of Maurienne.[19]

ridden to Annecy on horseback to look for him.* When Isaac Rousseau learned from Mme de Warens that his son was already on the road towards Chambéry, he made no more effort to follow him further than Rousseau's uncle, Colonel Bernard, had made to follow him beyond Confignon a week or two earlier. Rousseau was naturally a little dismayed that his kinsfolk should show so little enthusiasm to reach him; it occurred to him that they 'were conspiring with my star to deliver me to the destiny which awaited me'.[22] Isaac may well have been influenced by the thought that, in the absence of both his sons, he could keep the usufruct of his late wife's estate entirely for himself; for even after he had paid the indemnity to Abel Ducommun for the breach of the contract of apprenticeship, Isaac would still be better off without a son to provide for. Reluctant as Rousseau is to say a word against his father in the *Confessions*, he must have suspected that some such motive had prompted Isaac to give up the pursuit: all Jean-Jacques actually says is: 'My father could easily have followed and caught up with me, since he was mounted and I was on foot.'[23]

Fortunately Rousseau loved walking. Even when he could afford to pay for it, he would never go by horse or carriage if it was possible to go on foot. The journey from Annecy to Turin was a long one; but for a boy of his age, the fatigue of walking was healed by the thrill of adventure and the joy of discovery: 'it seemed to me at my age a marvellous thing to walk across the Alps – to become, so to speak, a little Hannibal'.[24]

Sabran, the 'yokel' who had suggested the hospice in Turin, was Rousseau's travelling companion, together with Mme Sabran; indeed Rousseau soon realized that Sabran had proposed the journey only in order to have his own travelling expenses and those of his wife reimbursed by the Bishop. He proved on better acquaintance to be not so much a 'yokel' as a cunning jack-of-all-trades, who lived on his wits and other people's money, specializing, according to Rousseau, in touching the clergy for alms by the adroit use of pious jargon. Mme Sabran was a cheerful woman, more tranquil by day than by night. Rousseau had to share a bedroom with the Sabrans, and he recalls that their 'noisy wakefulness disturbed my sleep', adding that it 'would have disturbed me even more if I had known what they were up to'.[25] Sex was still a mystery to him.

By day the three of them walked gaily along the road. They made their way between snow-covered mountains to the pass of Mont Cenis, then down to the valley of Piedmont, where the Italian spring was already in blossom. 'No accident troubled our journey; I was in the happiest state of mind and body that I have ever been in my life. Young, vigorous, free from anxiety, full of health and confidence in myself and others, I was at that

* Isaac was accompanied by a friend from Geneva, David Rival (1696–1759), watchmaker and amateur writer. His son was the celebrated actor, Jean Rival (1728–1806).

precious time of life when its rich plenitude expands one's entire being through all one's senses, and embellishes the whole of nature with the charm of one's own existence.'[26] As he walked he thought often of Mme de Warens, and fancied himself as being already 'the object of her workmanship, her creation, her friend, almost her lover'.[27] Time passed quickly, as the dreams, hopes and schemes of youth filled his mind, and everything he saw seemed 'to be the guarantee of my future happiness'.[28]

The 'six or seven days' on the road – if that is really all the time they took to go on foot from Annecy to Turin* – Rousseau considered afterwards to have been among the happiest in his life; the journey sharpened not only his taste for walking, but also his love of mountain scenery, a preference by no means fashionable, since vast and unsymmetrical shapes were alien to classical eighteenth-century taste. Rousseau was in fact so happy that he failed to notice that he was being stripped of all his modest possessions by his travelling companions. Only when he reached Turin and the Sabrans had departed did he realize that they had taken all his money, his clothes, his linen, the little sword his cousin had given him, and even what he says he valued most, the little pink and silver ribbon Mme de Warens had tied to the sword. Thus Jean-Jacques made his way to the door of the hospice bearing nothing but the clothes he stood in and the letters of introduction he had been given in Annecy. He was nevertheless fortified by the 'hope of soon becoming a person worthy of myself'; he already felt himself to be 'infinitely above my former rank as an apprentice'. He was, as he admits, far from foreseeing 'that I was in fact soon to descend to a condition far below the one I was in before'.[29] He was in truth on his way down to the rank which Voltaire, with malicious glee, later described as that of 'a lackey'.

* This is unlikely, since they 'walked at the pace of Mme Sabran'.

TURIN

The Turin that Rousseau entered in 1728 was already a handsome city, and was still being constructed on a lavish scale. The Sardinian ruler, having achieved the status of king only sixteen years before, was improving his capital with all the vigour of ambition and pride. Builders and architects were still at work on *palazzi*, *piazze* and broad avenues, all designed to impress upon the Italian public that here was no provincial prince, but a royal monarch risen in their midst.

The building to which Rousseau directed his steps was one of the older and less splendid palaces, a humble, cheerless house of God. It no longer serves as a hospice for catechumens, but the building itself can still be seen, standing next to the church of the Santo Spirito, and the door on which Rousseau knocked so hopefully is now known as No. 9 via Porta Palatina. Although the records of the Confraternity which administered the hospice were destroyed during the Second World War, facsimiles[1] that still exist register the entry into the institution on 12 April 1728 of 'Rosso, Gio Giacomo, di Ginevra, Calvinista'; they also record his abjuration of the Protestant heresy on 21 April and his baptism two days later. These dates pose a certain problem, since they do not match the story Rousseau tells in every version of his *Confessions*, according to which he stayed in the hospice for two months, putting up a prolonged resistance to the efforts of clergy to induce him to renounce his Protestant beliefs. It is possible that the records are inaccurate; it is also possible that Rousseau's memory deceived him, and the latter is perhaps the more probable. The greater part of the *Confessions* has the ring of authenticity, which is not diminished by his remark in the *Rêveries* that in writing the *Confessions*, 'I related things that I had forgotten as it seemed to me that they must have been, as perhaps in fact they had been; and never contrary to my memory of what they had been.'[2] His account of his experience in the hospice has the air of being forced; of being designed to defend himself against reproaches rather than to give a simple

account of what happened at the time. What cannot be doubted is that he was disappointed by what he found at the hospice, and he disliked the place from the start.

In the *Confessions* he depicts himself as a shrewd and sincerely religious young Protestant standing up to ignorant or artful monks, refuting them in theological argument and causing them great embarrassment. Arguing that religious beliefs are best acquired by upbringing, he insists that he himself came from a virtuous and religious family, and adds: 'I have said, I repeat and I shall perhaps repeat again ... that if ever a child received a strict and reasonable education, it was I.'[3] Such assertions, of course, do not gain conviction through repetition, which rather serves to reinforce the reader's doubts. Rousseau goes on to say that at the hospice he succeeded in confounding one priest after another in theological argument. He admits that the priests were able to quote the Patristic authorities against him, but he says he had an answer to most of their points because he knew 'almost by heart' the *History of the Church and Empire* by the Calvinist author Le Sueur,[4] a book he said he had read with his father in his childhood in St Gervais. He claims that he submitted in the end only because 'too many secret desires militated against my will for it to conquer'. He explains that his obstinate resolution not to return to Geneva, his shame, the very difficulty of crossing the Alps, his embarrassment at finding himself so far from home without friends or resources, all conspired to make him feel that the scruples of conscience were those of one who had repented too late; and so, as he puts it, 'I pretended to reproach myself for what I had done in order to excuse what I was about to do.'[5] He had reached the point where he wanted only to speed the process of his conversion, so as to be able to leave the hospice. From the start he had formed a low opinion of his fellow-catechumens. Among the males, there were 'four or five terrifying bandits' who looked 'more like the archers of the devil than aspirants to become children of God';[6] they included two slave-traders claiming to be Jews and Moors who admitted that they travelled around Spain and Italy offering themselves for Christian baptism as often as it was profitable to do so. As for the female catechumens, Rousseau considered them 'the worst sluts and the filthiest trollops who have ever defiled the sanctuary of the Lord'.[7] Even so, he admits that he liked the looks of one of the girls,* who seemed to him 'pretty and rather interesting' and who had 'naughty eyes' that sometimes caught his glances;[8] the trouble was that he could find no opportunity of speaking to her. The sexes were kept strictly separated at the hospice, an arrangement which, as usual, proved conducive less to chastity than to homosexuality, something to which Jean-Jacques was introduced for the first

* Possibly a Jewish girl from Amsterdam named Judith Komes. She was aged eighteen, and is registered as having entered the hospice four days after Rousseau.

time while he was at the hospice. One of the 'Moors' – who was perhaps a Jew from Aleppo named Abraham Ruben* since no recognizably Arab names appear in the register – kissed and caressed him; Rousseau, who protests that he was then as ignorant as he was innocent, and had no wish to seem unfriendly, did not immediately resist these advances; it was only when the 'Moor' invited him to come to his bed that he reacted energetically: 'the Moor was so unwashed and stank so much of chewed tobacco that he made me sick ... The next morning we two were alone in the assembly hall. He renewed his caresses, and with movements so violent as to be alarming. Finally, he sought to pass by degrees to the most indecent familiarities, and to force me, by directing my hand, to do the same to him. I freed myself energetically, let out a cry and leapt backwards, bewildered, but without either indignation or anger, for I had not the least idea of what it was all about. But I expressed my surprise and my disgust with such vigour that he left me alone; and when he finished manipulating himself, without any respect for the altar or the crucifix which were in front of him, I noticed spurting towards the fireplace and falling on the floor a white and sticky substance which made me feel nausea.'[9]

Baffled as well as shocked by what had happened, Rousseau talked about it in the hospice, with the result that one of the monks felt it his duty to take Jean-Jacques aside and explain the facts of life to him. Rousseau was disturbed, and disturbed not least by the easy-going and tolerant attitude of the monk to the practices that he explained; he even began to suspect that the 'Moor' was by no means alone in the hospice in doing what he did. The whole episode left Rousseau with a lifelong horror of pederasts which he had 'some difficulty in hiding'.[10]

In the *Confessions* he attributes his submission to the exigencies of conversion to his desire to get away at all costs from the odious atmosphere of the hospice. In this sense he considered his conversion a 'political' act. When he put on the grey robe of the candidate for adult baptism and walked in procession to the metropolitan church of St Jean to be questioned by the Inquisitor, Rousseau says he thought of Henri IV, that Protestant prince from Navarre who had become a Catholic convert because there was no other way of preserving the integrity of France, and Rousseau fancied himself to be bowing from a corresponding necessity to the demands of Rome. He speaks of the Inquisitor asking him brusquely whether his mother was damned and his giving the adroit reply that he hoped that 'God had enlightened her in the last hours'.[11]

Some critics have suggested that this does not seem the sort of question an Inquisitor would put at such a moment, and further that the reply that Rousseau says he gave bears the marks of *l'esprit d'escalier*; but in any case, he

* Registered as entering the hospice on 23 March 1728.

must have satisfied the Inquisitor and pronounced all the terrible denunciations of the Protestant religion contained in the act of abjuration, for the baptism took place, as arranged, two days later. From his new godmother, Francesca Cristina Rocca,* Jean-Jacques received the third Christian name of Francesco,† and a collection was taken to help him make a fresh start in the world as a communicant of the Catholic Church. The result was a disappointing bounty for a young man who compared himself to Henri IV; the mass did not win him anything more like Paris than a mere twenty francs. He had to begin looking for work.

In later life, Rousseau proclaimed his dislike of cities, but in his youth he found much to enjoy in Turin. He followed religious processions, watched the changing of the guard, and even wandered inside the royal palace, where, since no one challenged his presence, he could feel himself an important person. He relished the Italian *cuisine* with the appetite of youth, and he had a special liking for the kind of things to be found in Piedmont (the *grissini*, the junkets, cheeses, eggs, salads and wine), all so much more delicious than the Swiss scraps provided at the table of Abel Ducommun. He went daily to the Chapel Royal, largely for the satisfaction of being at the same mass as the royal suite, although he insists that the only attraction the Court had for him was the possibility 'of seeing some young princess who was worth my attention'.[12] Moreover, it was in Turin that Rousseau first heard really good singing and instrumental performances and acquired a love of Italian music that was to last for the rest of his life. At Geneva he would have had no opportunity of cultivating a taste for music, for while Lutheran churches at that time might resound with the compositions of Bach, and Catholic churches with all manner of choral and orchestral music, Calvinists allowed themselves only the chanting of Psalms. In Rousseau's *Dictionnaire de musique*, he himself explains, under the entry 'Le Chantre', the kind of music he heard as a boy in the puritan temples of his native city: 'The Cantor leads and sustains the chanting of psalms ... but as he stands a long way from the centre of the church, his voice has hardly reached the extremities before it has already taken on another tone, and sung a new note, so that the mass of air is divided between different and very discordant sounds, which clash incessantly one against another and outrage the discriminating ear.'[13]

The music he heard at home as a child was probably not much better, despite the tribute he pays in the *Confessions* to the musical talent of his aunt; she with her theorbo, and his father with his fiddle, would have played little besides folk songs and popular tunes. Assuredly Rousseau was later to defend the cultural value of such simple music against the sophisticated works of great composers, but that happened only when he turned against all

* The godfather was one Giuseppe Andrea Ferrero.
† By a curious coincidence, the name of Rousseau's brother.

sophisticated art. Until he reached Turin, he had no idea what such art was.

At Turin he feasted on the kind of music which the King Victor Amadeus II encouraged; and that King had, as Rousseau noted, 'the best symphony orchestra in Europe'.[14]* Mass at the Chapel Royal was virtually an orchestral concert, since the holy office was accompanied by full-scale performances of concertos, symphonies and sonatas – the restrictions placed on church music by later Popes being then unknown. The King regarded the splendour of his music, together with the magnificence of his architecture, as an excellent means of proclaiming the metropolitan culture of his capital. Like Louis XIV at Versailles, he kept his doors open to the crowds, so that Rousseau was able to listen to all this fine Italian music free of charge.

Once he had left the hospice and started to look for work, his first need was for lodgings. He found refuge in a primitive boarding house, run by a soldier's wife and patronized mainly by unemployed domestic servants; there, for a *sou* a night, he could share a bed in the one large bedroom where everybody slept, the landlady and her children as well as the lodgers. Even with this minimal rent, his twenty francs were soon spent. Finding no settled job, he earned a few meals by trudging from shop to shop offering his services as a signwriter or an engraver of coats of arms on silver. It was then that he came to meet a shopkeeper named Signora Basile, about whom he writes tenderly in his *Confessions*, and with whom, he even goes so far as to say, he experienced 'the sweetest as well as the purest pleasures of love'.[15] Signora Basile was about twenty-two years old, Italian and a striking brunette: 'the natural goodness inscribed on her pretty face made her vivacity attractive; her manner was affectionate without being soft; and from the very first, it seemed that friendship was already established between us, and that nothing more could develop from it'.[16] He remembers the effort he had needed to introduce himself to her; seeing her pretty figure sitting in her shop in the via Contra Nova, he had had to overcome his natural shyness to go in and ask her for work. He was kindly received, invited to sit down, and promptly offered the work he asked for. Signora Basile even sent to a neighbouring shop for the tools he required; and later she went into the kitchen and with her own hands brought him his lunch. Thereafter his visits to her shop were frequent.

Unfortunately for Rousseau, Signora Basile had a husband, a soldier who was away on duty, a jealous man, who had left her in the custody of an 'assistant'. This ugly fellow, whose only merit in Rousseau's eyes was that he could play the flute, regarded the young convert's visits to the shop with visible hostility. Neither Signora Basile nor the 'assistant' tried to hide from

* Rousseau also mentions by name some of the celebrated artists he heard: Somis, the great violinist, and his pupil Desjardins, an infant prodigy, and the two brothers Alessandro and Geronimo Besozzi (or Bezzuzzi), virtuosi of the bassoon and oboe.

Rousseau their contempt for one another: 'it seemed to me that she caressed me in his presence deliberately to annoy him,' Rousseau writes. 'Happily,' he adds, 'she did the same thing, which was much to my liking, even more in his absence.'[17]

Rousseau recalls that there was nevertheless a reserve about Signora Basile which intimidated him, so that he dared not make any advances to her: when he was alone with her he continued to feel embarrassed, even to tremble: 'I dared not look at her; I dared not breathe when I was close to her; I devoured with an avid eye all I could see without looking into her face – the flowers on her dress, the end of a pretty foot, the hair on her head, a glimpse of firm white flesh between her glove and her cuff or between her corsage and her scarf.'[18]

One encounter with Signora Basile Rousseau describes in different ways in different versions of his *Confessions*,[19] although he always begins the story in the same way, recalling how he spotted Signora Basile in her bedroom sitting at the window with her embroidery; thereupon, believing that she could not see him or even hear him because of the noise from the street outside, he threw himself on the floor at the bedroom door and 'extended my arms towards her in a passionate gesture'.[20] In a fragmentary draft of the *Confessions*, Rousseau continues the story in these words: 'What I did not know was that while I was devouring her with my heart and eyes, she could see me in a mirror which I had not noticed: she turned round and surprised me in an ecstasy which came out as a sigh as I stretched my two arms towards her. Nothing could match the terror I experienced when I saw myself discovered in this attitude: I blanched, I trembled, I felt faint. She reassured me by gazing upon me with an almost sweet look and by pointing with her finger to a better place at her feet. It will be understood that I did not wait to be invited twice. Up to then, all was perhaps simple enough, but what followed this little game took on a stranger aspect. It was as if there had been a fairly plain declaration on the part of each of us to the other, and that there could be nothing further lacking between us of the familiarity of avowed lovers. But this was far from being the case. On my knees before her, I was, it is true, in the most delectable situation, but it was also the most constrained posture that I have ever been in in my life: I dared neither to breathe nor to lift my eyes, and if I had the temerity to place my hands on her knee, it was so quickly done that I could believe, in my simplicity, that she did not feel it. She, for her part, going on with her embroidery, neither spoke to me nor looked at me. We made not the slightest movement. A deep silence reigned between us. Yet the heart speaks and hears! Our situation will sound very dull to the reader but I have grounds for thinking it did not displease the young woman concerned; as for myself, I could have passed my whole life there, the whole of eternity without wishing for anything more.'[21]

In the later versions of the *Confessions*, Rousseau tells the story with some interesting variations. Instead of saying that he touched the knee of Signora Basile, he says he knelt immobile in front of her 'not touching her, not even daring in that awkward posture to lean for an instant on her knees'.[22] He also speculates more fully than he does in the draft version about Signora Basile's attitude towards him. 'She appeared no more tranquil and no less timid than I. Troubled to see me where I was, abashed at having invited me to place myself in that posture, and beginning no doubt to realize the consequences of a sign given without reflection, she neither welcomed nor rejected me: she did not even lift her eyes from her needlework. She tried to act as if she did not see me at her feet; but all my stupidity did not prevent my seeing that she shared my shyness, shared perhaps my desires, and that she was held back by a shame that resembled my own, but without the conviction which gave me the strength to overcome mine. A residual uncertainty made me hesitate to provoke her indignation and have myself chased out of her house. Her status as a woman five or six years older than myself ought, I felt, to make her the bold one; and I told myself that since she did nothing to fortify my courage she did not wish me to have any. Even today I think I judged correctly, for she certainly had too much intelligence not to know that a novice as silly as I would need not only to be encouraged, but to be instructed. I do not know how this intense, silent scene would have developed, or how long I should have remained immobile in that ridiculous and delightful posture if we had not been interrupted.'[23]

Another curious difference between the draft and the finished versions of this story is that Rousseau deletes his early remark about Signora Basile 'gazing at him with an almost sweet look'. He says instead that she did not look at him at all; in the Neuchâtel manuscript he writes: 'She did not look at me or speak to me, but half turning her head, she indicated, with a simple movement of her finger, the floor at her feet.'[24] In the Paris manuscript, he uses the same words, except that he speaks of her indicating, with her finger, 'the mat at her feet'.[25] In a subtle way, these modifications intensify the image of the imperious governess by which Rousseau's sexual fantasies were haunted.

All the versions of the story end in the same way. The kitchen door was opened noisily, and Signora Basile, flustered, ordered Jean-Jacques to rise because the maid was coming in.[26] And that was that: whatever may have been intimated or understood between them, their friendship was about to end. The 'assistant' had evidently sent word to Signora Basile's husband and excited his jealous suspicion. One day she was giving a dinner at which Rousseau was among the guests when a carriage drew up at the door and Basile himself made a noisy entrance, sat down at the table and started to make caustic remarks about the presence of the youth. Signora Basile's

confessor, who was with them, defended Rousseau, but directly the meal was over Basile instructed the 'assistant' to tell Rousseau to leave the house at once and never come back: 'I went,' he tells us, 'without saying a word, grieving in my heart, less at having to part from this adorable woman than at leaving her prey to her husband's brutality.'[27]

Rousseau claims that he was soon able to 'forget' Signora Basile, even though he kept some clothes she had given him as a souvenir. Disappointed of the expectation that one of her friends might find a congenial job for him, he had to seek one on his own initiative. There was not much choice for a boy in his situation, so when his landlady, who had connections with various servants' halls, provided him with an introduction, he went to see a 'lady of rank' who had an opening for a liveried footman. He was offered the job. Too hungry to say no, he swallowed his pride and accepted. But it was a miserable outcome for an imaginative adventurous youth, the *citoyen de Genève*, the natural aristocrat, the son of the swashbuckling Isaac, the boy who had been 'a Roman at the age of twelve', who had crossed the Alps 'like Hannibal' and changed his religion 'like Henri IV', to end up thus as a *valet de pied*. His one small consolation was to discover that his employers' livery was a very plain one, with no braid, so that it looked, when he wore it, 'almost like a bourgeois suit'.[28]

Rousseau's employer was the Countess de Vercellis, who lived in the Palazzo Cavour, the childless widow of an officer in the Sardinian army. Rousseau describes her as a 'woman between middle and old age, with a very noble face and a discriminating, cultured mind'; he was impressed by her knowledge of French literature, and guessed – rightly – that she must be a Savoyarde,* since she 'spoke and wrote French too well for a Piedmontese'.[29] Now aged fifty-eight, Mme de Vercellis was suffering from a cancer of the breast which made it difficult for her to write with her own hand. She needed help with her correspondence and Rousseau was pleased to find that his main duty in the household was to take down letters from her dictation.[30] He could even depict himself as being more of a secretary than a valet. He admired the letters the Countess dictated to him, and even compared them to those of Madame de Sévigné. He was also greatly impressed by his employer's fortitude towards pain and illness; although he was with her for much of the day, he never saw in her a sign of fear or weakness or any effort to hide the truth about her state of health. 'She was as considerate of others as of herself.' He liked to think that his esteem for Mme de Vercellis was returned and says that she became fond of the young and hopeful person she had constantly under her eyes for the last three months of her life; he was even prompted to expect that the Countess would remember him in her will.

* She was born Thérèse de Chabod at St Maurice in 1670, married Count Hyppolite Vercellis in 1690, and was widowed in 1696.

In this he was disappointed. 'She did nothing for me,'[31] he protests; and then he becomes altogether more critical of Mme de Vercellis, complaining notably of 'her dryness of manner'. Rousseau always yearned to talk to a responsive listener, especially female; and he was dismayed to find that the Countess had a habit 'common among intellectual women', of interrogating other people without reacting to what they were told in reply. 'They imagine that because they hide their own feelings, they can penetrate yours all the better: they do not understand that they rob you of the courage you need to reveal your feelings.'[32] When Mme de Vercellis questioned him about himself in her detached and dispassionate way, his replies were too timid and brusque to be of any interest to her. Rousseau even goes so far as to suggest that this was a reason why she had left him out of her will; he suspected also that the other servants, resenting him because he 'had no inclination to be a valet to valets', influenced her against him. But can we believe that she ever thought of bequeathing Rousseau anything? He had been in her house for only a few weeks when she wrote her last will in August 1728, and for only a few months when she died in December of that year; so his expectations were surely unrealistic. He witnessed the Countess's death, and in his *Confessions* he describes it as the death of a sage. 'She made the Catholic religion lovable,' he writes, 'by the serenity of mind which she fulfilled her duties, without negligence and without affectation. She had a serious nature, but towards the end of her illness, she acquired a gaiety which was too settled to be false; it was a remedy provided by reason itself against the sadness of her predicament. It was only for the last two days that she stayed in bed, and even then she continued to receive everybody. Finally when she had stopped talking, and was already in the agony of dying, she released a big fart. "Good," she said, looking around her, "a woman who farts is not dead." These were the last words she spoke.'[33]

After her death, her household was broken up. Rousseau was given thirty *livres* and the one suit he was wearing. Disappointed and discontented, he thereupon stole an object which pleased him: a little pink and silver ribbon, a trifle which was not even useful. He was found in possession of it, and accused of stealing it. He then did something for which his conscience tormented him for the rest of his life: he protested, blushing, that the ribbon had been given to him by one of the maids, Marion, 'a pretty girl from the mountains who was very modest, sweet and lovable'. The whole household was then assembled in the presence of the new master, Count Octavian della Rocca, nephew of the late Countess, and explanations were demanded. As Rousseau describes the scene, the maid came in and was shown the stolen ribbon: 'I accused her shamelessly. She was dumbfounded and kept silent, casting me a look which would have disarmed the devil, but which my barbarous heart resisted. Finally she denied the charge with confidence, but

without passion; she reproached me, begged me to think again, and not to dishonour an innocent girl who had never done me any harm. And yet, with my infernal impudence, I repeated the accusation: and insisted to her face that she had given me the ribbon. The poor girl began to cry, and all she said to me were these words: "Ah, Rousseau, I believed you had a good character. You are making me very unhappy, but I would not for anything be in your place." That was all. She continued to defend herself with as much simplicity as firmness, and without employing the least invective against me. Her moderation, compared to my emphatic utterance, served only to put her in the wrong. It did not seem natural that there could be on the one side such devilish audacity and on the other such angelic sweetness. She was not absolutely condemned, but opinion was on my side. Amid so many other preoccupations, there was no time for the investigation to go further, and M. della Rocca dismissed us both, saying simply that the conscience of the guilty one would be vengeance enough for the innocent. His prediction was correct; and not a day has passed since then without it being fulfilled.'[34]

Rousseau never learned what happened to Marion. He realized that she would not easily find other employment; for although the ribbon was worthless, the crimes of which she had been accused by him – of theft in order to seduce a young man, and of obstinate false denials of the deed – were enough to destroy her good name. Rousseau understood that he had condemned her both to poverty and to a moral danger, and his guilty memory of what he had done to Marion continued to torment him. It was, he says, a deed that he had never been able to admit to anyone, not even to Mme de Warens; in fact the desire to unburden his soul on this particular subject was one of the motives for his writing the *Confessions*.

From the comfortable quarters in the Palazzo Cavour where he had lived as Mme de Vercellis' servant, he had to go back to the old dormitory where a bed cost one *sou* a night. He spent the next five or six weeks wandering about the streets of Turin looking for another job. It was winter, and the hardships of unemployment were compounded by the emotional upheavals of adolescence: Jean-Jacques was constantly dreaming, yearning, sighing, suffering, longing for satisfactions he could not really understand. One day M. della Rocca was able to tell him he had found a new job for him: once again he was to be a footman, albeit in the household of a man of distinction, the Count de Gouvon,* head of the family of Solaro. It proved to be a welcome opportunity.

Gouvon, being eighty years old, had retired from his more important

* Ottavio Francesco Solaro, Count de Gouvon (born 1648), had been an ambassador at several courts, a minister of state, and a high-ranking courtier. His palazzo, in the via San Domenico (now No. 11), was modernized in 1781.

offices, but was still first equerry to the Queen and still very much a courtier. M. della Rocca took Rousseau in person to the Palazzo Solaro, where M. de Gouvon gave him an exceedingly polite welcome, and offered him a job with the reassuring words that his only duties would be to 'try to be a good boy and try to please everybody here';[35] he was told he would not even have to wear livery. Rousseau was then presented to the various members of the Solaro family: to the Count de Gouvon's daughter-in-law, Mme de Breil,* whose husband, the elder son of the Count, was then away as Ambassador in Vienna; to their daughter, Mlle de Breil,† and their son, the Count de Favria;‡ and to M. de Gouvon's younger son, known as the Abbé Gouvon.§ These polite introductions impressed Rousseau very favourably, for he assumed that no ordinary footman would be presented to members of his employer's family with so much ceremony. What started well continued well. As in the service of Mme de Vercellis, Rousseau found himself doing the work of a secretary rather than of a footman: he took down letters from the dictation of the Abbé Gouvon. What is more, the *abbé*, a scholarly man who had once studied at the University of Siena, recognized Rousseau's talents and tried to improve his education.

He was the second of two *abbés* in Turin who befriended Rousseau. The first, whom Rousseau had met while still working at the Palazzo Cavour, was the Abbé Jean-Claude Gaime, a young, poor and unconventional priest, on whom Rousseau later based, in part, his *Vicaire savoyard*. Gaime, who was living in Turin as tutor to the children of the Count de Mellarède, had been born, in 1692, to a family of peasants in the Genevois region of Savoy. After his studies at the Lazarist seminary in Annecy, he received his degree of *magister artis* from the University of Turin, but had retained his rustic character. Rousseau describes him as an unworldly man, full of good sense, probity and moral excellence. Gaime was too humbly situated to help Rousseau materially, but Rousseau says that he received from him 'the most precious of benefits, and one which has served me all my life; namely lessons in sound morals and the principles of right reason. In the cultivation of my tastes and opinions, I had always flown too high or sunk too low ... the Abbé Gaime took the trouble to put me on the right plane, and to give me self-knowledge without either sparing or discouraging me. He diminished greatly my admiration for grandeur, by proving to me that men who dominated others were neither wiser nor happier than they. He gave me my

* Maria Vassallo di Favria, wife of Giuseppe Roberto Solaro, Marquis de Breil, Sardinian Ambassador at Vienna since 1720.

† Pauline-Gabrielle de Breil (born *c.* 1712) married in 1729 Cesare di Sostegno.

‡ Carlo Giuseppe Solaro, Count de Favria, was later a distinguished Sardinian soldier and statesman.

§ Carlo Vittorio, the Abbé Gouvon, was the second son of the Count de Gouvon by his second wife.

first true ideas of the good, which my own inflated mind had only understood in an extravagant form. He made me see that an eagerness for sublime virtues is of no use in society, and that a man who reaches too high is only liable to fall; that the steady performance of the small duties of daily life requires just as much effort as great heroic deeds, and contributes more to honour and to happiness; and that it is infinitely better to enjoy people's respect all the time than to have their admiration only once in a while.'[36]

Thus, although Rousseau makes no claim for sincerity in the matter of his conversion to Catholicism, he does argue that the friendship and guidance of the Abbé Gaime served him well at a time of life when he might well have been corrupted. The Abbé Gouvon helped in different ways; as indeed one might expect, since the Abbé Gouvon was a very different kind of man, as rich, aristocratic and worldly as the Abbé Gaime was simple, rustic and poor. The Abbé Gouvon was more concerned with Rousseau's culture than his morals, and arguably Rousseau's needs in that sphere were just as great in God's eyes. The instruction Rousseau received from Pastor Lambercier had, he says, been forgotten in the coarse and illiterate environment of the engraver's workshop. The Abbé Gouvon reawakened Rousseau's mind; he taught him Latin and Italian, and imparted some of his own considerable knowledge of modern and classical authors. Although the Abbé Gouvon was destined to become a bishop, since that was to be expected of any son of a great family who entered holy orders, he had little interest in religion and no taste at all for theology: literature – especially Italian literature – was the ruling passion of his life; he wrote poetry in both Italian and Latin, and was an enthusiastic champion of what Rousseau calls 'cruscantisme'* – that is, protecting the purity of the Italian language. Rousseau, who spent every morning with the Abbé Gouvon, was soon more a student than a secretary; and without ever becoming a faultless Latinist, he acquired a mastery of Italian which was to be of great value in his later life. Indeed he had in the Abbé Gouvon a tutor of such high rank and culture that only the son of a king might expect to have. While Rousseau may have exaggerated in speaking of his childhood in Geneva as an 'enfance du roi', the education he received from the Abbé Gouvon was nothing less than princely.

His privileged situation provoked the jealousy of the other servants, but did not prevent his becoming 'the favourite of the family'.[37] Feeling so well liked, he was even imprudent enough to cast an appreciative eye on the abbé's niece, Pauline-Gabrielle de Breil. Rousseau describes Mlle de Breil as a young person of his own age, well made, rather beautiful, with black hair and white skin, and having 'a sweetness of face that usually goes with blondes, and which I have never been able to resist'.[38] The black Court mourning dress then being worn made her an even more erotic figure in

* From the Accademia della Crusca in Florence.

Rousseau's eyes: it left her throat and shoulders bare, and the whiteness of the flesh looked all the more delectable against the black laced silk. In the servants' hall there were vulgar jokes about her seductive looks that made Rousseau wince, but in the presence of the girl, he says, 'I never forgot myself; and my desires were suppressed, perhaps because I did not understand too clearly what it was I desired. I liked to look at Mlle de Breil, to hear her speak a few words which revealed her thoughts, her feelings, her virtue; my ambition never went beyond the pleasure of serving her, but I felt an extreme ardour in the performance of my role. At table I was always alert for an opportunity to attend to her. If her own footman left the back of her chair for a moment, I took his place at once; at other times I tried to stand opposite her: I looked into her eyes to find out what she might want; I watched for the moment to change her plate. I would have given the whole world to have her deign to order something from me – look at me, say a single word to me. She did none of these things. I had the mortification of being nothing to her. She did not even notice that I was there.'[39]

Rousseau had, however, his one moment of glory at the Palazzo Solaro. The occasion was a grand dinner, when the butler appeared wearing a sword and hat;* 'the conversation at table,' Rousseau recalls, 'turned to the motto of the house of Solaro, which was woven in the tapestries with the coat of arms *Tel fiert qui ne tue pas*. As the Piedmontese are seldom great masters of the French language, someone suggested there was a spelling-mistake in the motto and that the word *"fier"* should have no *"t"* at the end. The old Count de Gouvon was about to reply, when he caught my eye, and saw that I was smiling without daring to say anything. He told me to speak. So I hastened to say that I did not think the *"t"* was redundant because *"fiert"* was an old French word derived not from *"ferus"* or *"threatening"*, but the verb *"ferit"*, meaning "he strikes" or "he wounds". Thus the device appeared to mean not "He threatens who does not kill" but "He wounds who does not kill".

'Everybody gazed at me and then gazed at each other without saying a word. Never had such astonishment been witnessed. What flattered me most was to see plainly written on the face of Mlle de Breil a look of satisfaction. This very disdainful person deigned to bestow on me a second look which was worth even more than the first; then, turning her eyes towards her grandfather, she seemed to await with something like impatience the praises which I had earned, and which, indeed, her grandfather showered upon me so plainly and heartily and with such satisfaction that the whole table quickly joined in. The moment was brief, but delicious in every way ... A few minutes later Mlle de Breil lifted her eyes once more towards me, and asked in a voice as timid as it was as affable, if I would serve her some

* Presumably, on this occasion at least, Rousseau himself must have worn some form of livery.

water. I did not keep her waiting; only in going towards her I was seized with such trembling, that after filling her glass I spilled some of the water in her plate and even on her person. Her brother asked me foolishly why I was trembling. His question did not make me feel any better, and Mlle de Breil blushed to the white of her eyes. So ended that romance.'[40]

This story comes from the later version of his *Confessions*. In the earlier text, Rousseau describes the spilling of Mlle de Breil's water as taking place on a different occasion from the dinner when he dazzled the company with his erudition. He writes: 'The following day, at dinner, Mlle de Breil finally noticed that I was present, and, in the absence of her own footman, she asked me – in a very sweet tone – to give her some water.'[41] Rousseau then describes, in more or less the same words, his trembling, the spilled water, the brother's question and the sister's blushes. In both versions he goes on to say that he lingered a great deal in Mme de Breil's antechamber, in the hope of again attracting the attention of her daughter; but he did so in vain, for she appeared to be totally unaware of his presence. He admits he was so 'silly and clumsy' that on one occasion, when Mlle de Breil dropped her glove near him, instead of throwing himself on a glove which he 'longed to cover with kisses', he dared not move, and instead allowed it 'to be picked up by a hulking brute of a footman I could have kicked a hundred times'.[42]

If Rousseau was thus thwarted in the pursuit of the purest love, he had no better luck in his search for more carnal gratification. In another candid page of his *Confessions*, he describes how his blood was inflamed by masochistic fantasies and desires: 'I would have given twenty years of my life to have once again a quarter of an hour with a Mlle Goton.'[43] In the obscure hope of provoking a passing female to spank him, Rousseau lurked in the dark alleys of Turin exposing his bottom to any woman or girl who passed. He came to realize that what he displayed to them was not so much an obscene object as a ridiculous one, and the women who passed, instead of giving him the satisfaction he desired, usually either ignored him or laughed at him, although some became angry or indignant. He describes one occasion at a well where girls came to fetch water: 'I offered the girls who came to the well a vision more risible than seductive; the wiser ones pretended to see nothing, some burst out laughing, others felt insulted and shouted at me. I retreated to my hiding place. I was followed. I heard a man's voice rough enough to cause me acute alarm; I hid in the underground passages at the risk of losing my way; the noise, the women's cries and the man's voice followed me all the time. I had counted on darkness, but there was light; I shivered, I plunged deeper into the labyrinth. A wall stopped me; I could see no further; I could only await my destiny there. In a moment a big man with a huge moustache and a large sabre seized hold of me; he was escorted by four or five old women armed with broom-handles; I noticed among them the little hussy

who had betrayed me, and who was undoubtedly curious to see my face. The man with the sabre grabbed my arm and asked me what I was doing there.'[44]

Once again Rousseau's ready imagination came to his aid. He told the big man that he was a foreigner of noble birth but unhinged mind who had escaped from his father's house to avoid being shut away. He promised the big man that, if he would let him go, he would reward him one day. The prospect of a tip evidently made the man swallow this cock-and-bull story, for he relented and released his captive. The women were not so easily convinced, and Rousseau was grateful to have the big man there to protect him from their anger. A few days later, walking along the street with a priest, he met the same man again. This time the man must have realized that he had been taken in, because he cried out to Rousseau in a mocking voice, 'I'm a prince. I'm a prince. As for me, I'm an idiot! But don't you come back again, Your Highness!' Rousseau was relieved that nothing worse befell him. In the earlier version of his *Confessions*, he says that this adventure 'cured me of the bizarre taste which had provoked it';[45] but in the later text he simply claims that the 'adventure succeeded in making me behave myself for a long time'.[46]

At the Palazzo Solaro he had every incentive and encouragement to behave well. The Abbé Gouvon continued to dedicate much of his time to furthering Rousseau's education. The Count de Gouvon became so appreciative of him that he spoke to the King on his behalf, and Rousseau came to believe, from hints dropped here and there, that there was a prospect of his being trained for a post in one of the Sardinian embassies. Unfortunately, at the age of seventeen, Rousseau was still too immature to relish the prospect of government service: 'It was just too sensible an idea for my brain,' he admits. 'Such a career would involve too long a period of submission to others. My own foolish ambition was to seek my fortune through adventure, and as I could see no woman in the picture of a civil service career, that plan of advancement struck me as slow, painful and depressing.'[47]

It was this itch for adventure which ended Rousseau's comfortable life at the Palazzo Solaro. Even the combined influence of the Abbé Gouvon and the Abbé Gaime could not compete with that of a wild youth named Pierre Bâcle,* who persuaded Rousseau to break loose from the constraints that were imposed on him. Bâcle had once been a fellow apprentice with Rousseau in Geneva and had escaped by much the same route. He was two years younger than Rousseau, but he exercised a remarkable hold over his friend in Turin, leading him to neglect his duties at the Palazzo Solaro in

* Pierre Bâcle (born 1714) started his apprenticeship as an engraver in Geneva in 1726. As a result of an attempt to run away to France without permission in July 1728 he was incarcerated for a month. He ran away to Piedmont, but returned to Geneva, where he died in 1731.

order to enjoy himself in the town. Rousseau's employers reproached him, warned him, implored him to reform, but some stubborn waywardness in Rousseau's character, which Bâcle had awakened, resisted all their efforts. Even after Rousseau had been dismissed and paid his final wages, the young Count Favria made a further effort to repair the situation, only to be haughtily rebuffed; by this time Jean-Jacques had decided he wanted nothing better than to leave Turin in the company of Bâcle. He yearned for independence and experience and had certainly no intention of remaining a domestic servant for the rest of his life. He had yet another motive for leaving his job in Turin: he wanted to go back to the pretty *potelée* Swiss baroness who had received him so warmly at Annecy.

He had written regularly to Mme de Warens while he had been in Turin; he had indeed shown some of the letters to Mme de Vercellis, and had been disappointed that she had expressed no great interest in them. He had continued to write to Mme de Warens from the Palazzo Solaro, telling her about the kindness which the Count de Gouvon and his family had shown him. Thinking again of their kindness, he began to feel uneasy on the road from Turin to Annecy: Mme de Warens had advised him how to respond to the generosity with which he had been treated at the Palazzo Solaro and not to ruin his situation by some folly. 'What,' he asked himself, 'was she going to say when she saw me appear at Annecy?'[48]

Once again Rousseau journeyed on foot. The bright idea the two boys had to pay their way along the road was to give demonstrations of a little toy that the Abbé Gouvon had given Rousseau – a fountain of Heron. This machine, first invented by Heron of Alexandria in the second century A.D., was a fountain with two basins, in which the compression of air produced a play of water. Rousseau and Bâcle believed that by putting their novelty on show in taverns and inns they would be able to collect enough money to pay for their food and lodging. They were soon disillusioned. Innkeepers and their servants might be amused, but they were never disposed to offer the boys free hospitality, nor were the customers eager to pay to see their toy working. After a time the fountain of Heron broke down; but by then they were bored with it, so they accepted the loss stoically and simply tightened their belts.

When they had crossed the Alps and got as far as Chambéry, Rousseau became more anxious. He did not expect that Mme de Warens would shut her door in his face, but he dreaded her reproaches. 'I could think of nothing in the whole universe except Mme de Warens; and to live in disgrace with her would be an impossible thing.'[49] He was also vaguely troubled as to how to separate himself from Pierre Bâcle, once they reached Annecy. In the event, separation proved to be all too easy. As soon as they reached that city, Bâcle said: 'Well you are at home, now. Goodbye,' embraced him, then

turned on his heels and disappeared. Rousseau was never to see him again, for Bâcle was destined to die at the age of seventeen.

It must have been in the early summer of 1729 that Rousseau presented himself for a second time at Mme de Warens' door. His heart, he tells us, was beating; he was trembling; he was worried and afraid. But as soon as he saw her he felt better. 'I threw myself at her feet and in the transports of the most intense joy I pressed my lips to her hand ... I saw no surprise on her face, and no vexation ... "Poor little one," she said to me. "So you are back again. I knew you were too young for that journey. I am relieved that at least it did not turn out as badly as I feared." Then she made me tell her my whole story, which I did very faithfully, suppressing a few details, but without sparing or excusing myself.'[50]

Once again Mme de Warens offered him a bed in her house; but this time she decided that he would stay. He had found a home.

A SENTIMENTAL EDUCATION

Françoise-Louise de la Tour was born at Vevey on 31 March 1699 to a man of property named Jean-Baptiste de la Tour de Chailly[1] and his first wife, Jeanne-Louise Warnéry. Her mother died the following spring in giving birth to another child.[2] Her father remarried in January 1705, his bride being a widow, Marie Flavard, who bore him two children before he himself died in 1709. The future Mme de Warens was thus left an orphan at the age of ten. Her brothers* also died at about the same time; so that she was much alone. Her upbringing was entrusted in part to her stepmother, in part to her aunts; but the most decisive influence in her education was probably that of her tutor, Pastor François Magny,[3] who became well known as a pietist.

Pietism was a religious movement of German origin which had reached the Vaud with other cultural forces accompanying the political domination of the canton by the German-speaking patrician government of Berne. It took more than one form, but was in the main a reaction of ardent souls against the decline of Lutheran Protestantism into a dull routine of plain worship and conventional morality. François Magny was one of the leading exponents of pietism in the French-speaking Switzerland and a personal friend of Mme de Warens' father and other members of the de la Tour family. When her father died, the aunts turned to Pastor Magny for advice on the education of the daughter; she became his pupil, and for a time she was actually placed *en pension* in his house. She thus received, besides the usual education of the daughter of upper-class Vaudois families in literature and music, an early introduction to a philosophy of religion which was at once unconventional and emotionally intense.

* Jean-Étienne de la Tour died before his father, and François Abraham de la Tour soon after his father. The future Mme de Warens had also four half-brothers, children of her stepmother. Two of these died before her father; two afterwards. By a will dated 17 February 1709, M. de la Tour divided his property between his four children then living, on condition that his widow should have the usufruct during her lifetime of the property left to the sons of the second marriage. As the sons predeceased their mother, this property was later the subject of family disputes.

Pastor Magny was mistrusted by the Swiss authorities, especially after he had translated into French a book by a German pietist author Johann Tennhard, which was sharply critical of Luther. For although the German-speaking Swiss authorities were Zwinglian rather than Lutheran, and the French-speaking Swiss Arminian or Calvinist, they were equally conscious of the social danger contained in the pietist doctrine, which seemed either to generate an excess of evangelical fervour and so disturb the public tranquillity or to promote a mysticism so nebulous as to obscure the imperatives of morality. A movement which cultivated religious feeling almost as an end itself was unwelcome to every kind of established church. For Pastor Magny mysticism and the moral law went together, but in the case of others, including his pupil, Françoise-Louise de la Tour, the pietist mysticism did less to reinforce the moral law than to take its place; for her, the principle of 'guidance by inner light' was often a signal to follow the most intense of her inner sentiments. A general belief, however vague, in the supremacy of feeling over reason was undoubtedly given by Pastor Magny to Mme de Warens in her childhood and was perhaps transmitted in some measure by her to Rousseau, although Rousseau, with his stricter Calvinist upbringing, was sometimes puzzled and shocked by Mme de Warens' morals.

Magny's supervision of her education had ended in 1713, when he was banished from Vevey because of his heterodox religious ideas; and in the same year she married. She was only fourteen at the time, and her guardians had disagreed about the wisdom of her being married so young. Magny, called upon to arbitrate, decided in favour of the match, and on 22 September 1713, at Lausanne, she became the wife of Sébastien-Isaac de Loÿs de Villardin, subsequently Baron de Warens. It was less a case of a Juliet finding her Romeo than a sound bourgeois marriage, and perhaps, if it had produced any children, it might have been more successful. The bridegroom was twenty-five, and the elder son of a family well-established in Lausanne. He had served as a Swiss mercenary officer in foreign armies, both Swedish and Sardinian, and was looking forward to a commission in the Bernese militia. He also expected, and in time received, several important official appointments in both Lausanne and Vevey, so that his married life was divided between these two Vaudois towns. The child-bride developed into an accomplished hostess, enjoying, by the Swiss provincial standards of the time, a fairly animated social life.

On the occasion of their marriage, the bridegroom's father decided to buy him the seigneury of Vuarens, an estate which was situated above Lausanne in the direction of Neuchâtel and which carried with it the title of Baron. However, there were delays in the completion of this sale, and it was only in 1723, or ten years after his wedding, that Loÿs finally acquired with the property the right to style himself 'Baron de Warens' – thus entering the

nobility favoured by his employers, the Bernese authorities. His wife continued to call herself the Baroness de Warens for the rest of her life; but when debts forced her husband to sell the seigneury of Warens in 1728, and thus to forfeit the legal right to call himself 'Baron', he resumed the name of Loÿs de Villardin.

His financial ruin was the work of his wife. An enterprising woman, full of ideas, of energy and emotions, she sought relief from the frustrations of a childless provincial life by becoming active in business – attempting single-handed to introduce the Industrial Revolution to the canton of Vaud. She formed companies and built factories for the production of stockings and soap and other useful articles. A born organizer, she set up one industrial enterprise after another for the rest of her life. Unfortunately she was better at inaugurating partnerships than at sustaining them, and more successful at building factories than at keeping them working at a profit. Her zeal for industry earned the reproaches of Pastor Magny, when he returned to Vevey after his exile in Geneva. She assured him that her motives were not commercial: material things really meant nothing to her: 'I do things with an indifference that sometimes surprises me,'[4] she once confessed in a letter to her old tutor.

She had several lovers. Rousseau, deriving his knowledge from what she herself told him, says that she learned more from her first lover than she had ever learned from her family or her teachers. This first lover was one of her husband's best friends, Colonel Étienne-Sigismonde de Tavel.* Rousseau's first reference to him in the *Confessions* is flattering enough: the Colonel is described as a 'man of taste and knowledge who bestowed both upon the person he loved'; later in the book, Rousseau speaks more sternly of Tavel as Mme de Warens' 'master in philosophy', and adds: 'the principles he taught her were those he needed to seduce her; he persuaded her that the act of adultery in itself was nothing, and that it was only the scandal which gave it existence'.[5]

One can readily imagine that Tavel's 'philosophy', which really only encapsulated the fashionable attitude to sex of the French upper classes, could have an electrifying effect on an unconventional and ambitious young Swiss woman, whose mind was already clouded by Pastor Magny's metaphysics. Besides, Tavel was a very handsome man,† and having become a colonel in the French army at the age of thirty, he had doubtless more glamour for Mme de Warens than had her husband, whose military career had been less dazzling. Tavel was a regular visitor to the Warens' house in Vevey; and if he is to be thought reprehensible for having seduced his host's

* Born 1687, son of Jean-Rodolphe de Tavel, lord of the manor of Cuarnens, he had joined the French army while little more than a boy.

† He was reported in 1708 to be a 'young but very handsome fellow'.[6]

wife, he proved to be a faithful friend to Mme de Warens herself when she fell on hard times in later life.[7]

Tavel is said to have been one of several lovers in Mme de Warens' life at Vevey; but adultery proved no better remedy for the boredom and dissatisfaction than did her industrial enterprises. She became a hypochondriac. She had inherited from her father a passion for empirical medicine and herbal remedies, and for the rest of her life she spent much of her time making tinctures, elixirs, balms and powders. Rousseau says that this valetudinarian side of Mme de Warens' nature made her prey to any charlatan she met. In the end, he claims, these quacks destroyed her, 'drying up a spirit that might have been the joy of the best society'.[8] However, a visit she made at the age of twenty-six on medical advice to take the waters at Aix-les-Bains proved to be a turning point in her life; if it did not relieve the frustrations of domesticity at Vevey, it opened her eyes to the possibility of escape. She discovered a happiness in the duchy of Savoy that she had never known in Switzerland. When the German-speaking Bernese had driven the Savoyard rulers from the canton of Vaud, they reinforced their conquest with the institutions of religion to ensure that the good Christian Vaudois would feel more in common with the Protestant rulers of Berne than with the Catholic princes of Savoy; but Mme de Warens' pietism was a kind which diminished confessional differences, and the culture which appealed to her was French culture. The Catholic duchy of Savoy seemed to her an altogether more urbane, sophisticated, lively, tolerant and amusing place than Protestant Switzerland. Her husband had occasion to note, with horror, that on a visit to Geneva, on her way home from Aix-les-Bains in the summer of 1725, she had told friends 'how much she was charmed by Savoy, and disgusted by our country'.[9] From then on Mme de Warens gazed with yearning across the Lake of Geneva towards Évian on the southern Savoyard shore, and she made her plans. At last she knew what she wanted: and she was not a person to hesitate when her aims were clear. She looked for a doctor who would advise her to go once more to Savoy, and found in Dr Viridet of Morges one who readily prescribed the waters of Amphion, near Évian. In July 1726, she crossed the lake to Savoy and never returned to Vevey.

The story of her flight and her conversion to the Catholic Church has been recorded by several historians, and if no two versions are entirely the same the main outlines seem well established. According to Rousseau's account, based on her own testimony, Mme de Warens was propelled by the sorrows of an unhappy marriage to 'take advantage of the presence at Évian of Victor Amadeus II, King of Sardinia, to cross the lake and throw herself at the feet of that prince, thus abandoning for ever her husband, her family, and her country'.[10] Rousseau calls this 'an act of folly similar to my own, and which she has had ample time to weep over'.[11] He goes on to record that

'the King, who liked to play the Catholic zealot, took her under his protection, and gave her a pension of 1,500 Piedmontese *livres* – which was a lot for such a mean prince. Realizing that such generosity would make people think he must be in love with the convert, the King promptly sent her with a detachment of his guards to Annecy, where under the direction of Monsignor Michel Gabriel de Bernex, titular Bishop of Geneva, she made her abjuration at the Convent of the Visitation.'[12]

A Savoyard friend of Mme de Warens, François-Joseph de Conzié, in a letter written many years later,* recalled his having been himself in Évian at the time, attached to the retinue of the King. His story is this: 'The King was going to mass at the parish church, accompanied informally by a few noblemen of his Court, among them the late Mgr de Bernex, Bishop of Annecy. Hardly had the King entered the church, when Mme de Warens seized the prelate by his soutane and threw herself on her knees, saying to him with tears in her eyes: *"In manus tuas domine commendo spiritum meum."* Mgr de Bernex stopped, lifted her up and spoke for about five or six minutes with the young penitent. She then went directly to the Bishop's lodgings, where he joined her on coming out of mass, and after a long conversation with her, he returned to the Court, where he doubtless gave a full account of it all to the King.

'This escapade caused a great stir in the little town of Évian. Some people said it was scene of a Magdalen truly repentant, while others – especially the Swiss who came to Évian to drink the waters or gape at the King – said it was only a feigned repentance and that the real reason for the flight of the baroness to Évian was the chaos she had caused in the financial affairs of her husband by her prodigal expenditures . . .

'Other Swiss arrived by boat after dinner. They had scarcely disembarked when the rumour ran round the town that these newcomers were relations of Mme de Warens, come to take her away. Ill-founded as this rumour was, it received, I think, some credence at Court; for the following morning, the lady was sent off in a carriage belonging to the King, escorted by four of his personal guards, who conducted her in the company of a good lady from Annecy to the Convent of the Visitation to be instructed in our religion.'[13]

Another variant of the story of Mme de Warens' conversion is provided by the biographer of the Bishop who converted her. In his life of Monsignor de Bernex,[14] Claude Boudet records that 'Mme de Warens, a rich and well-educated Swiss noblewoman, began to suspect the truth of the Protestant heresy as a result of her own reading of the Scriptures; then, hearing a sermon preached at Évian by Mgr de Bernex, she was so stirred by his words that she sought an audience with him and asked to be instructed in the Catholic faith. The Bishop suggested that she should return to Vevey in

* Probably 1786 or 1787.

order to settle her affairs and then come once again to Savoy, but Swiss visitors to Évian showed such hostility towards her, that the Bishop feared they might abduct her and take her by force back to Vevey. So he intervened with the King to have her conveyed in one of the royal carriages to Annecy, where her conversion was completed.'

A partisan – but no less believable – account of Mme de Warens' flight and conversion is that given by her injured husband in a letter he wrote from London in the summer of 1732,[15] some six years after the event. Having referred to his wife's visit to Aix-les-Bains in 1725, when she acquired her liking for life in Savoy, he asserts that from that time forward she laid her plans to escape to that Catholic province behind his back. He recalls some prophetic words his wife had addressed to his uncle: that he would soon hear of 'an extraordinary event concerning a lady of the country'. Thereupon, her husband declares, she took advantage of the factory she owned to raise considerable amounts of cash during the winter of 1725–6.

'Towards the end of June 1726,' Loÿs continues, 'a flood caused great damage in and around Vevey ... No sooner had order been restored, than my wife took the opportunity of a general cleaning to set all the best and finest linen aside.' It was while he himself was taken up with assessing the damage done by the flood that his wife decided to take a trip to Évian, 'and to go by night to avoid the heat of the day'. He then describes how his wife had locked all the best silver in a box, saying it would not be needed while she was away, and leaving him for his own use 'only a few old spoons and forks'. Then, on the pretext of setting up a house for the summer in Évian, she had all the kitchen equipment and all the best household effects packed up to take to Évian, together 'with a good part of the merchandise of the factory'.

On the eve of her departure, Loÿs says, his wife urged him to go to bed early, then came to him at two o'clock in the morning, to wake him and say goodbye. She begged him to stay in bed, showed him a 'special tenderness', and left the house in the company of her maid. He came to believe later that she had done all this to prevent him seeing the extraordinary amount of baggage she had put on the boat for Évian. Some days later, Loÿs continues, he went across the lake with a party of friends to visit his wife at the house she had rented at Évian; he found her 'rather melancholy and full of sighs', but he attributed her condition to her usual affliction of 'the vapours'. She asked him for a copy of Bayle's *Dictionary* and for the loan of his beautiful cane for use on her walks. She entertained his travelling companions with coffee, and when the time came for them to leave she walked to the lakeside with him, tears moistening her eyes. Their departure was delayed while several members of the party returned to the shore to watch the King of Sardinia ride on horseback; by this time the weather had changed, and a

storm forced them to shelter on the southern shore of the lake all night, closely watched by a patrol of the Sardinian army.

Loÿs says he sent his wife the cane and the book she wanted; and when the messenger returned, he learned that she had ordered a further load of merchandise to be sent her from the factory. The next day the same messenger came to him saying, 'Monsieur, you no longer have a wife ... Madame left Évian this morning to follow the King to Turin.' Loÿs then describes how he searched the house for the valuables which his wife had said she had locked up for safe keeping, only to find that 'the birds had left the nest'. He pursued his wife as far as Geneva, where he found all the trunks and bundles she had taken with her awaiting transport to Annecy, but he could establish no claim to them, because they were all sealed in the name of the King of Sardinia.

Back at Vevey another blow fell upon the unlucky husband. Under the laws of Berne any person who abjured the Protestant faith to become a Catholic lost all rights to property. 'The Governor of Vevey took the trouble to call on me,' Loÿs writes; 'he told me he was distressed to be obliged to require an inventory of the goods of the departed lady, with a view to their confiscation by the state.'[16] Mme de Warens had thus done more than disgrace her husband; she had, according to his account of the story, ruined him.

However, the process of her conversion moved smoothly enough at Annecy, where she was received on 7 August 1726 by the Superior, Mme Françoise Madeleine Favre des Charmettes, an aunt of M. de Conzié who was later to be a close friend of hers and of Rousseau's. Mme de Warens was given the warmest of possible welcomes. Indeed, her dramatic conversion was treated by the Savoyard Catholics as something worth advertising. In so far as she could be represented as a beautiful young Swiss noblewoman who had sacrificed riches, home and family to submit to the true religion, her story made excellent propaganda for the Counter-Reformation. Bishop de Bernex very understandably took pride in having accomplished her conversion, and was correspondingly solicitous for her welfare. He gave her a pension himself and helped raise funds for her from other sources; he even had her portrait painted as an ornament to his palace.*

Michel-Gabriel de Rossillon, Marquis de Bernex and Bishop of Annecy, was already a man of sixty-nine when he effected the conversion of Mme de Warens. He was by no means the typical worldly aristocratic eighteenth-century bishop; for he had been bred in piety by an extremely religious mother, and he did his utmost in an ever more sceptical age to continue the holy work of François de Sales, whom, according to Rousseau, 'he resembled in many ways, even though he had less intelligence'.[17]

* The 'portrait of Mme de Warens' in the Musée Cluny in Paris is said to be this picture.

At Annecy Mme de Warens was urged to complete her conversion by entering a convent; but the seclusion of the cloister did not appeal to her, and she set about persuading Bishop de Bernex that she could render better service to the Church if she lived in the world, with a decent house of her own, where she could receive visitors from Protestant countries and foster their conversion. The success of her endeavour depended largely on her social value as a woman of noble birth; and she wrote anxiously from Annecy in mid-August to Pastor Magny in Vevey* begging him to help her prove her lineage: 'I find myself in the situation of having to prove that I am an aristocrat, to satisfy His Majesty, who wishes to be informed,' she explains: 'Do me the kindness, my dear Sir, if it is possible, of preparing for me a short extract from my family tree and do it in a manner which is as advantageous to me as you can manage . . . it is not vanity which makes me ask this of you, but the need for bread.'[18] This must seem an odd request for anyone to address to a clergyman; it is also strange that Mme de Warens should give her old tutor in this letter no account whatever of the circumstances of her departure from Vevey and her change of religion. She simply says she assumes that he will have been informed about it by her stepmother. All she has to offer Pastor Magny is a compliment which, as a Protestant, he may not have appreciated: 'I do not doubt that I owe my conversion to the prayers which you have said for me together with many other good Christian souls.'[19]

Her baptism into the Catholic faith took place on the day of the Blessed Virgin Mary in front of the relics of St François de Sales. She was offered an apartment in M. de Boëge's house near that of the Bishop, and was promptly paid a pension on behalf of the King of Sardinia.[20] Her intermediary with the Court at Turin was Lazare Corvezy, Royal Intendant at Annecy. Rousseau has nothing kind to say about Corvezy in his *Confessions*, but it was he who also arranged for the delivery through Geneva of the things that Mme de Warens had taken from Vevey to Évian, and who even went so far as to buy furniture for her new home. Even so, Mme de Warens did not get all this for nothing. It was at once expected of her that she should try to win her husband over to her new religion. On this subject we have the testimony of Loÿs himself. He describes how on 24 September 1726 he went to Annecy in the company of M. St André, who had previously worked for his wife as a manager of her factories. Loÿs recalls that his *'déserteuse'* received him 'in bed, a position she had obviously chosen in order to cover to some extent her confusion . . . She begged my forgiveness all in tears.'[21] Loÿs remarks wryly that his wife had always known how to soften him by this technique. However he insists he did his best to convince her of the errors of her new religion. She, for her part, made no effort to justify her conversion;

* Magny had returned to Vevey in 1722 after nine years' exile in Geneva. He died in 1730.

she only told him of the material benefit she was receiving from the Court of Turin, and suggested that he might be equally favoured if he followed her example. Loÿs says he then tried to make her understand the financial ruin which she had brought upon him, by exposing her property to confiscation by the state and leaving him to meet the debts of her factory. Her first response to this was to urge him to leave Switzerland and claim the money which was already owed to his father in the duchy of Savoy. When he rejected this suggestion, she offered to make over to him all her remaining property in the *pays de Vaud*. This he accepted, knowing that property in his name would not be confiscated so long as he himself remained a Protestant; it would only require a formal donation on her part. After various fruitless efforts were made by his wife's new friends at Annecy to make Loÿs convert, the terms of the donation were drawn up by a local lawyer. Loÿs resisted the suggestion that he should provide an annuity for his wife in return for the donation, and in the end the deed was completed in a form he found acceptable. He returned to Vevey, and soon afterwards he received a letter from his wife saying: 'I beg you to regard me henceforth as dead, and to think no more of me than if I were really dead.'[22]

Loÿs's reaction to these words was to apply to the authorities in Berne for a divorce. He obtained one without much difficulty, but such a divorce was not, of course, recognized by the Church to which his wife had submitted; she remained, in Catholic eyes, a married woman, just as she remained, in her own eyes, a baroness long after her husband had sold the barony.* Her rejoinder to the Bernese divorce was to try to revoke the donation of her Swiss possessions, and also to lay her hands on the property that her husband still owned in Savoy. Loÿs was indignant at her accusation that he had sold and dissipated her goods, when in fact, he protested, he had spent all his own money to pay her debts in the canton of Vaud.[23] His ruin, he said, was so catastrophic that he had to leave Switzerland altogether: and indeed, in the autumn of 1732, he was living miserably in London in Islington.[24]

In the meantime, Mme de Warens had become well established at Annecy. A small detail of the story, so carefully veiled that even Loÿs does not remark upon it in his account of his wife's desertion, is that Mme de Warens was followed to Annecy by the gardener's son from Vevey, a youth named Claude Anet, her steward and later (if not already) her lover.

When Rousseau returned to Annecy from Turin in 1729, he was able to note that Mme de Warens was 'settled at last in her house'.[25] He describes the house as old, but large enough to have a spare room, which was assigned to him. He adored the room, especially for its outlook across the gardens and orchards to the countryside beyond. It was the first time since Bossey that he had had a room with such a view. Not unnaturally this pleasing and beautiful

* Her extant letters are signed 'Baronne de Warens'.

setting added to the tender feelings he had for his protectress: 'I took my place in tranquillity beside her, and I saw her everywhere surrounded by flowers and vegetation: her charms and the charms of spring merged together in my eyes. My heart, which had until then been constrained, opened out in this atmosphere; and my sighs were breathed freely in the orchards.'[26]

Mme de Warens' house at Annecy was very different from the grand *palazzi* that Rousseau had known in Turin; it was also much more to his liking. If the furniture was simple, the kitchen and the cellar were well stocked; and although there was no porcelain, his hostess 'served excellent coffee in earthenware cups'.[27]* Mme de Warens was indeed exceedingly hospitable: any visitor who called was invited to dine, and any workman or messenger was given a drink. Rousseau, yearning to be alone with his benefactress, was often irritated by the number of people who crowded into her house. He did not so much mind her wasting her money on parasites, but he was intensely jealous of the time and attention she gave to them. However, Mme de Warens was a giver and a spender by nature.

The household consisted of the steward, Claude Anet, a housemaid named Merceret, a cook and two sedan-chair bearers, 'a large number', as Rousseau observes, 'for a woman with a pension of two thousand *livres*'. He believed that she might with good management have afforded all this, as prices were low in Savoy, but, alas, 'economy was never her favourite virtue'.[28] Since much of her generosity was lavished upon him personally, Rousseau was in no position to disapprove. Indeed he admits he 'was pleased to take advantage of it'.[29] He only wished for her own sake that she had been a more prudent woman.

According to Rousseau's account the 'sweetest intimacy' was established between himself and Mme de Warens from the very first day he went to live in her house. She called him *'petit'* and he called her *'maman'*, names which expressed the relationship between their two hearts. Mme de Warens inspired in him only the most rarefied kind of sensual love. His behaviour towards her, he assures us, was decorous; the caresses they exchanged were those of a tender mother and a loving child. 'No indiscreet glances of mine,' he writes, 'ever wandered beneath her kerchief, although a certain roundness, often ill-concealed, in that place might well have attracted one's notice.'[30] Significantly, Rousseau acted with less restraint when he was alone with his imagination: 'How many times did I kiss my bed thinking that she had slept in it, kiss my curtains and the furniture of my room, thinking that they belonged to her, kissed even the floor on which I prostrated myself, thinking that she had walked on it?'[31] Very rarely he gave way to little

* Rousseau also says she had only a little silver, which raises the question of what had happened to the silver which Loÿs says she took from the house at Vevey. Had it been sold? Or did she not in fact take it away in the first place?

caprices in her actual presence: 'One day at table, just as she was putting a morsel in her mouth, I cried out that there was a hair in it. At once she spat the food on to the plate. I picked it up greedily and ate it.'[32]

Inevitably those passages have prompted psychologists to speak of oral eroticism, infantilism and other such 'isms'; but the one thing Rousseau tells us he did not practise at this period of his life was masturbation. He admits he had already learned to masturbate, and had even at one time worn himself out with it; and in later years, he was to resume the exercise at inopportune times. But he disapproved of it, and writes of it as a 'vice' which offers a special temptation to men like himself possessed with more imagination than boldness: 'it enables them to dispose of the entire female sex at their will and make any beauty who attracts them serve their pleasure without having to obtain her consent'.[33] In the case of his feelings for Mme de Warens, Rousseau claims that they took away his desire to masturbate, because what he experienced with her was a love without lubricity, a tenderness which filled his entire being: 'Intoxicated by the charms of life with her, and the ardent desire to spend the rest of my days in her company, I always saw in her, whether she was present or absent, a fond mother, a beloved sister, a perfect friend and nothing more. This was how I always looked at her: she was always the same; and I had eyes for no one but her. Her image was continuously present in my heart and left no room there for anyone else. She was the only woman in the world for me, and the utter sweetness of the feelings she inspired left no room for my senses to be stimulated by other women, and so they protected me against her and against her sex. In a word, I was pure because I loved her.'[34]

For the first four weeks of his life with Mme de Warens, Rousseau was kept busy about the house doing odd jobs. He helped the steward Anet by copying out accounts, collecting herbs, transcribing recipes, operating the distillery and helping to make the drugs and medicaments for which Mme de Warens was such an enthusiast. He worked all the time with Anet without for one moment suspecting that Anet was Mme de Warens' lover. Rousseau had no great liking for medicine, but he was made to share *maman*'s interest in the subject, and was sometimes forced to taste her 'odious drugs'. He did not always object: he recalls one occasion when 'I could have run away from her, or defended myself, and yet, despite my protests and my horrible grimaces, when I saw those pretty fingers, all besmirched, come near my mouth, I had in the end to open it and lick them'.[35]

Mme de Warens discerned Rousseau's limitations, and did her best to educate him. She put books in his bedroom – the works of such writers as Voltaire, Saint-Évremond, Addison, Hobbes and Pufendorf – *moralistes* in the broad French sense of that word. She had not the literary culture of the Abbé Gouvon, with his taste for poetry, and she could not direct Rousseau's

studies as he had done, but she was clearly a discriminating reader, and she did her best. Rousseau complains of what he calls her 'somewhat Protestant taste' in literature: and one can well believe that preferences formed by Pastor Magny cannot have been wholly changed as a result of her conversion to the Catholic Church. Rousseau seems not to have shared her high opinion of Bayle, Saint-Évremond and La Bruyère, but it was the kind of books he found in Mme de Warens' library which provided the model he followed when the time came for him to become an author himself.

Mme de Warens was a paradoxical person, and Rousseau did not always understand her. On the one hand, she adored practical organization; on the other, her mind was constantly dwelling on mystical ideas; she was both pure and sexually experienced; she was at once cunning and naïve; selfish and generous; and while she entertained liberally, she bought very few clothes for herself and ate almost nothing. She tried Rousseau's patience with her slow progress at the table. Whereas he had always a robust appetite and took great pleasure in well-cooked meals, she disliked most foods and much preferred talking to eating at the table; so that Rousseau had to endure agonizing delays between courses, tormented by smells from the kitchen as he gazed at his empty plate and heard her rattling on and on about some metaphysical theme. When she turned to practical questions, it was worse, because the chief practical question was: what was to become of him? *Maman* talked at length about this problem to him and to her friends. How was his education to be completed? How was he to be trained for a career? Savouring the good life at *maman*'s house in Annecy, Rousseau wished only to postpone any decision, and was none too pleased when visitors to the house offered advice about his future. One day there appeared at Annecy a kinsman of Mme de Warens from the Vaud named Paul-Bernard d'Aubonne, and his presence disturbed Jean-Jacques. Aubonne was ill-fitted by temperament to appreciate Rousseau: he was a man of action, a soldier, a schemer. He was also a revolutionary of sorts: he had turned against the Bernese rulers of the Vaud after achieving the rank of colonel in their army, and was now seeking favour with other governments. An eager inventor of plans and projects, he had just tried, without success, to sell the idea of a national lottery to the King of France, and was on his way to Turin in the hope of better luck in pressing the same idea on the King of Sardinia. He was also toying with an even grander scheme of liberating the canton of Vaud, with foreign help, from its subordination to Berne. He had come to Annecy in the hope that the princes of Savoy, as former rulers of the Vaud, might be sympathetic to his plans. With a head full of bold ideas like these, Aubonne had not much patience for Rousseau, and after interviewing him pronounced him to be a dullard fit to become nothing better than a country priest.

What made this judgement the more humiliating for Rousseau was the

knowledge that Aubonne spoke for others beside himself. Many people who met him thought him dim-witted because he had no conversation: 'I have an ardent temperament, with lively and impetuous emotions; but my mind works slowly and my ideas are not clear until it is too late ... it is as if my heart and my brain did not belong to the same individual.'[36] Rousseau was too excitable for coherent utterance, and too shy for polite conversation. He felt at home in the *boudoir* alone with a Mme de Warens, or in the library with an Abbé Gouvon; but in the drawing room, he was lost. In time he was to become extremely popular in fashionable salons, but he never overcame the deeply ingrained feeling that he was an alien in such a milieu. One of the reasons for his notorious mistrust of the salons was the feeling that he always showed himself there in an unfavourable light, indeed 'as wholly other than I am'.[37] Nor was it only his social life which was vitiated by the contradiction between his quick feelings and slow thinking: as an author, he worked slowly because of the time it took for the chaotic rush of thoughts in his brain to settle down into any kind of order: 'My scratched, written-over, muddled and illegible manuscripts* bespeak the trouble they have cost me to write them. There is not one that I have not had to transcribe three or four times before sending it to the printer. I have never been able to do anything pen-in-hand, at a desk. It is on my walks, among the rocks and trees, or at night, during my sleepless hours in bed, that I do my writing in my head and it may be guessed how slowly it all proceeds, especially for a man who has no verbal memory and has never been able to learn twenty verses† by heart in his life. There are paragraphs which I have turned over and over again in my mind for five or six nights in succession before they have been in fit shape to be put on paper.'[39]

The profession of authorship, however, was still some way ahead for Rousseau. In 1729, he had no alternative but to yield to the suggestion of Colonel d'Aubonne that he should train to become a priest. Mme de Warens liked the idea; Bishop de Bernex liked it even better, and offered to subsidize his studies. At that time there was a Lazarist seminary in Annecy, and its superior was a friend of Mme de Warens, a thin short man with the inappropriate name of Father Gros; it was he who offered Rousseau a place in his Lazarist seminary as a theological student. Rousseau liked Father Gros well enough, describing him as 'a very amusing man for a Lazarist'; but he was perhaps jealous of Mme de Warens' fondness for the little priest – he recalls, for example, in faintly disapproving language, that she used to let Father Gros lace up her stays as she wandered round the drawing room. Besides,

* Rousseau is less than fair to himself here, for although his drafts are as he describes them, the finished versions are remarkable for their beautiful calligraphy.

† In the later version, Rousseau speaks of himself as a 'man who has never been able to learn six verses by heart all his life'.[38]

Rousseau did not like the idea of leaving his pretty room with a view in Mme de Warens' house for a cell at the seminary: he went there 'as if to a torture chamber'.[40]

Much of the work demanded of him at the seminary was torture, too. He had never learned to study systematically, and he proved an unresponsive pupil. After a bad start with an unsympathetic teacher, Father Gros put him under the most agreeable of instructors, Jean-Baptiste Gâtier,* who was later to serve as one of the two models for Rousseau's *Vicaire savoyard*, the other being Father Gaime, who had befriended him in Turin. Father Gâtier won Rousseau's admiration with his sweetness of nature, his intelligence and his patience, and yet even he did not have much success in teaching Rousseau Latin. Rousseau's own explanation is that he himself was so paralysed by fear of failing that he simply could not learn. Father Gâtier, in any case, had soon to leave the seminary to become regent of his own old college at Cluses,† and although he wrote as favourable a report as he could of his pupil's progress in classical studies, there was no way of concealing Rousseau's incapacity. In the end both Father Gros and Bishop de Bernex despaired of him, and after less than three months in the seminary he was sent back to *maman* as being, in his own words, 'unfit even to be a priest'.[41]

Rousseau had, in any case, no real desire to be a priest; and during his weeks at the seminary he had conceived a different ambition, that of becoming a musician. The only book he thoroughly mastered under the roof of the Lazarists was one he had taken with him: Mme de Warens' copy of the *Cantatas* of Clérambault. Rousseau says he studied this book so assiduously that he was able, without any training in music, to decipher the score and sing correctly the recitative and aria of at least one entire cantata. Mme de Warens, who loved music, was pleased about this, and readily agreed that if her *petit* did not want to train as a priest, he should train as a musician instead. She was always an accommodating woman; and once again she found a friend she could press to help, the master of the cathedral choir school, Jacques-Louis-Nicolas Le Maistre.[42] She asked Le Maistre to find room for her protégé as a student in the choir school, with the result that Rousseau was able to spend the following winter as a boarder, learning at least the rudiments of music. After the austerity and drudgery of life as a seminarian, Rousseau found the choir master's world of music and gaiety entirely congenial, and he always remembered his six months at the *maîtrise* as among the happiest in his life. His days were divided between the school, the cathedral and visits to *maman*, who lived nearby. He was as industrious

* Born Cluses, 1703; educated at the Dominican College, Chambéry.

† Rousseau says in his *Confessions* that Father Gâtier caused a great scandal by getting an unmarried girl with child. In the archives of the diocese there is no confirmation of this story; on the contrary it is recorded that Gâtier was regent of the college at Cluses from 1730 to 1750, then became *curé* of St Pierre-de-Curtille until his death in 1760.

as he was happy; only once again he discovered that he could not sustain the kind of academic work that was expected of him, even in the field of music. Never having been a schoolboy, he could not find his bearings as a student; he could not concentrate: 'My mind wandered; I was a dreamer; I sighed. What could I do about it?'[43]

At this period of his life, Rousseau could fairly claim to have been a good Catholic. Living in the milieu of the Bishop's cathedral, he was indeed constantly reminded of the exigencies of the Counter-Reformation. On one occasion he witnessed what was believed to be a miracle. This happened on a Sunday, when Rousseau was spending part of the day with Mme de Warens. The building next to her house caught fire; it housed the ovens where the Franciscan monks baked their bread, and the flames were intense. Rousseau was frantically carrying furniture and other objects out of *maman*'s house when Bishop de Bernex appeared in the garden, observed the fire, and promptly knelt to pray for divine intervention. Almost at once the wind changed, and the flames which were already licking the edge of *maman*'s house moved in the other direction, so that her house was spared. Some twelve years after the event, Rousseau wrote to Canon Boudet, the biographer of Bishop de Bernex, a memorandum[44] which was used as evidence of the Bishop's miraculous powers. The memorandum was also used some years later by Rousseau's critics to confound him at a time when he had repudiated Catholicism to become the champion of a more 'natural' religion. Later he admitted he had been wrong to speak of the occurrence as a miracle: 'I had seen the Bishop at prayer; and during his prayers I had seen the wind change very fortunately. So much I could state and affirm; but that the one was the cause of the other, I could not certify, because I could not know it.'[45] He went on to say: 'So far as I can recall my thoughts at the time when I was still a practising Catholic, I acted in good faith.'[46]

The hand of fate, if not of providence, might be detected in another incident which occurred during Rousseau's time at the choir school. One cold evening in February 1730, there appeared on M. Le Maistre's doorstep a person who introduced himself as a French musician who had lost his way on the road to Grenoble. M. Le Maistre rose from the fireside where he was sitting with his pupils to greet the stranger; proudly Parisian, M. Le Maistre was always at home to any visiting Frenchman, especially a French musician. The stranger who came in from the snow spoke with a Provençal accent and said that his name was Venture de Villeneuve. Rousseau was instantly dazzled by him. He was not a handsome man; indeed he was so short and misshapen that Rousseau could describe him as a 'hunchback without a hump'. His clothes were worn and dirty, but they were good clothes, and Venture wore them with the air of an aristocrat. Indeed his whole bearing of flamboyant superiority was what impressed Rousseau so much; witty,

worldly, popular and accomplished, Venture was everything that Rousseau at the age of eighteen was not and wished so ardently to be.

Le Maistre was less favourably impressed. Anyone who spoke with a Provençal accent would fall short of his ideal of a cultivated Frenchman; besides, Venture's boastful manner made Le Maistre suspect that he was an impostor with no real knowledge of music. In this last respect, however, Le Maistre was mistaken; for after scarcely any preparation, Venture gave a performance of sacred music in the cathedral next day which Le Maistre had to admit was both graceful and faultless. Rousseau was thrilled by Venture's triumph, and Venture became the idol of the choir school. Only Mme de Warens remained mistrustful. Venture might have proved himself an excellent musician, but she judged him as a man; and she was experienced enough in the ways of the world to entertain doubts about his character. It may be that she herself was, as Rousseau believed, too readily taken in by the quacks and schemers who crowded her drawing room, but Venture was evidently not her kind of mountebank, and she became increasingly worried about the influence he had over her *petit*. She tried to devise some means of separating them.

The opportunity to do so came when M. Le Maistre confided to Mme de Warens that he was planning to break his contract with the cathedral and depart without notice. He had grown to dislike his job as choirmaster, and in particular to dislike his employers, the cathedral clergy. Although their chapter had fallen from its one-time grandeur, it was still exclusive socially, being open only to the sons of noblemen or doctors of the Sorbonne, and Le Maistre was offended by what he felt to be their haughty, disdainful and snobbish attitude towards him. He was not, in truth, an ideal choirmaster; he was epileptic and he drank too much, but he had a proud and independent spirit, and he resolved to endure no more humiliations. One day he told Mme de Warens that he had decided to quit Annecy at the very moment when the cathedral would need him most – in Easter week. Mme de Warens, with characteristic indifference towards conventional morality, encouraged his project; her idea was to have Le Maistre take Rousseau away with him, and so separate Rousseau from Venture. She may also have had other reasons for wanting Rousseau out of the way, for she was about to embark on a mysterious mission to Paris. Le Maistre was only too pleased to have a travelling companion, and Mme de Warens brought Claude Anet into the scheme to help the choirmaster smuggle out of Annecy a heavy trunk full of music: from her own experience of a surreptitious departure from Vevey, she knew the importance of ample luggage in such situations. Under her management, their departure from Annecy went off smoothly and unobserved.

On the road to Lyons, Rousseau proved himself already an apt pupil of

Venture de Villeneuve, as audacious a bluffer as his hero. He suggested that instead of hiding from any clergymen who might know them in the places through which they passed, M. Le Maistre should present himself at their doors and, claiming to be on official church business, seek hospitality for himself and his pupil. At Seyssel and Belley the trick worked well, and the two travellers were handsomely entertained, but when they reached their destination their luck changed. The chapter at Annecy had sent word to Lyons that Le Maistre had absconded with the cathedral music, and the Church authorities of Lyons had all his luggage impounded, not only such music as might have belonged to the cathedral, but all the music which belonged to Le Maistre himself. 'The precious trunk which had cost us so much effort to save was seized,' writes Rousseau. 'Le Maistre tried in vain to claim his possessions, the means of his livelihood, a lifetime's work ... The wretched man lost at once the fruit of his talents, product of his youth and the resource of his old age.'[47]

Looking back on the episode, Rousseau could well commiserate; but at the time he did nothing to help his friend. He admits, in the *Confessions*, with some shame, that he abandoned Le Maistre two days after they reached Lyons: 'As we were walking along a street, not far from our inn, Le Maistre was seized by one of his epileptic fits, a fit so violent that it horrified me. I cried aloud; I called for help; I gave a bystander the name of his inn and begged to have him carried there. Then, as a crowd gathered and pressed round this unfortunate man, who was unconscious and foaming at the mouth, he was deserted by the one friend on whom he ought to have been able to depend. I took advantage of a moment when no one was looking at me to slip around a corner and disappear.'[48]

Rousseau hurried back to Annecy, only to find that Mme de Warens had left the city; nobody seemed to know where she had gone or when she would return. He never learned the purpose of her journey, but subsequent research has thrown some light on the mystery. It was probably a political mission of some kind involving Mme de Warens' kinsman from the Vaud, Colonel d'Aubonne. In the *Confessions*, Rousseau speaks of Colonel d'Aubonne being forced to leave Annecy, but the explanation he gives is that the Sardinian Intendant, M. Corvezy, had him expelled because the Colonel paid too much attention to his wife. 'It was a dog-in-a-manger attitude,' Rousseau comments, 'for although Mme Corvezy was very attractive, her husband lived on bad terms with her. Tastes of another kind rendered him useless to her; and he treated her so brutally that there was talk of a separation. M. Corvezy was an ugly man, black as a mole, dishonest as an owl, and so unbearable that he ended up being dismissed from his post at Annecy.'[49]

There was probably more behind the Colonel's expulsion than a story

of gallantry and jealousy.[50] A report from a Sardinian intelligence agent[51] reveals that Colonel d'Aubonne, together with Mme de Warens and her steward Claude Anet, passed through Seyssel – the frontier post between Sardinian Savoy and the Kingdom of France – at the end of April 1730, travelling in the direction of Paris; Mme de Warens was masked. Rousseau learned later that she had been to Paris, but he says in the *Confessions* that he never really 'discovered the secret' of her journey; his conjecture was that she had gone to seek the patronage of the French Court, 'fearing to lose her pension from Turin because of the abdication of King Victor Amadeus'.[52] This conjecture is ill-founded, because Mme de Warens' journey took place in April 1730, whereas Victor Amadeus did not abdicate until September of that year. A more likely explanation is that Mme de Warens joined Colonel d'Aubonne's conspiracy to promote a revolution in the canton of Vaud against the government of Berne, and that the two of them went to Paris to seek French support for the plot. Colonel d'Aubonne was certainly not the only French-speaking Vaudois who disliked being ruled by the German-speaking patricians of Berne and who looked back with yearning to the days when the Vaud was ruled by the francophone House of Savoy. However, he would have been mistaken in supposing that the French government would welcome a restoration of Savoyard sovereignty in the Vaud, for French policy was informed by considerations of national advantage and not by ideological sympathies, and the enlargement of the Kingdom of Sardinia was not seen as useful to French purposes. If Colonel d'Aubonne wanted French help against the Bernese, his scheme was doomed from the start.

In any case it seems that Mme de Warens was more of a hindrance than a help to the Colonel in Paris. Either he quarrelled with her, or the Sardinian diplomatists in Paris simply mistrusted her. In the archives at Turin there is a letter dated 24 July 1730[53] from Count Annibale Maffei, a Sardinian diplomat in Paris, urging the authorities of Turin to prevent Mme de Warens going to Switzerland. Another letter, in the same hand, dated 17 August 1730,[54] submits to the King of Sardinia three memoranda from Colonel d'Aubonne, explaining that 'in reading these memoranda Your Majesty will find the project of a revolution which the writer proposes'. In the same letter Count Maffei says that he himself has taken no steps to make better acquaintance with the Colonel for fear of provoking suspicions, and expresses the fear that Mme de Warens 'might let something out, even though she is not fully informed of the matter in question'.

Evidently Count Maffei thought Mme de Warens might prove ruinously indiscreet if she were to go to Switzerland, but he suggested[55] that she should at least be allowed, if she wished, to go to Turin. Whatever her exact wishes, she travelled from Paris at the end of July as far as Chambéry, only to change direction there and go northwards towards Annecy. On 9 August 1730,[56] the Secretary of State in Turin, Ignazio Solaro – a member of that

family of which the Count de Gouvon was head, and for which Rousseau had worked as a footman-secretary – wrote to the Intendant of Annecy, M. Corvezy, instructing him to maintain surveillance over Mme de Warens, paying particular attention to any correspondence she might have with Swiss people.

The Baroness had in fact written to the King of Sardinia as early as 9 July 1730[57] seeking permission to visit Turin, in order to communicate in person something she could disclose only to His Majesty. It is a reasonable conjecture that this secret concerned the plot for a revolution in the canton of Vaud, but it is not clear what went wrong between Mme de Warens and Colonel d'Aubonne in Paris. Although she was given formal permission to go to Turin, she was subject to pressure to go home instead: a letter dated 30 July 1730[58] from the Sardinian King's Chaplain, Father François Coppier, suggests to Bishop de Bernex that 'poor Mme de Warens should return to Annecy and take care henceforth to lead a life that is even more exemplary and rather more worthy of the pension with which His Majesty has favoured her'.[59] Her excursion into the world of political intrigue was obviously not appreciated.

As for the proposed conspiracy in the canton of Vaud, it could hardly have been more ill-timed. On 2 September 1730, King Victor Amadeus II of Sardinia acknowledged receipt of the secret memorandum from Colonel d'Aubonne; the next day he abdicated in favour of his son, Charles Emmanuel III. The King had decided to withdraw from the throne in order to enjoy a private life with his new bride, the Countess de Saint-Sébastien. A few months later the ex-monarch, bored with domesticity, tried to regain his throne; but his son resisted and had him imprisoned at Rivoli; all of which events must have driven thoughts of revolution in Switzerland out of everyone's mind, and prompted Mme de Warens to worry only about the security of her royal pension from Turin.

When she reached her home in Annecy, she discovered that Rousseau had been and gone, that he had abandoned the company of M. Le Maistre to return to that of Venture de Villeneuve. Indeed, the first thing Rousseau had done when he found that Mme de Warens had left Annecy was to move into lodgings with his colourful friend and enjoy himself as best he could. According to his *Confessions*, he idled away a good deal of time with young women friends in Annecy, several of whom, he claims, were in love with him. One such girl was Anne-Marie Merceret, the maid Mme de Warens had left in charge of her house. Rousseau describes this girl as being a little older than himself, 'not pretty, but agreeable enough, a good Swiss girl from Fribourg with no malice in her'.[60] Merceret was, in fact, half-French, her father being a native of Salins in Franche-Comté and only her mother being a Swiss from the Catholic canton of Fribourg. Her father was a

musician who had gone to Annecy on his appointment as organist at the church of Notre Dame[61] and then moved on to Fribourg, leaving his daughter as a servant in the household of Mme de Warens. The daughter seems to have inherited some of the musical tastes and talents of her father, because Rousseau speaks of duets they sang together in Mme de Warens' drawing room; and in the absence of her mistress, Merceret gave him meals in her kitchen. She appealed to his stomach but not to his heart.

Another girl, 'also in love with me',[62] was a fellow Swiss named Esther Giraud. She was ten years older than Rousseau and had fled from Geneva in 1726 to abjure the Calvinist faith and be baptized as a Catholic with Mme de Warens as her godmother. The daughter of a printer, she earned her living in Annecy as an upholsterer. Working girls never had much charm in Rousseau's eyes, and Giraud had less than most. His references to her in the *Confessions* are notably ungracious: 'All the tricks she used to attract me only increased the antipathy I felt for her, and when she approached my face with her dry black muzzle, all besmirched with snuff, it was as if she wanted to bite me,'[63] he says. 'I had difficulty in preventing myself from spitting.'[64]

Rousseau is wholly candid about his distaste for girls of humble social origins: 'seamstresses, chambermaids, little shopgirls hardly tempted me. I wanted young gentlewomen. Everyone has his fancies, and this has always been mine ... It is not, however, to be exact, the vanity of rank and status that attracts me; it is a complexion better cared-for, more beautiful hands, more elegant ornaments, the air of delicacy and cleanliness in the whole person, the note of sensibility and culture in a girl's speech, the grace of her bearing, her prettier shoes, ribbons, lace and the hair better done – I would always prefer the less pretty girl if she had more of all this.'[65]

Such an avowal comes strangely from a man whose closest companion in his later years was an illiterate laundry maid; and yet a certain snobbishness was always part of Rousseau's aloof, fastidious and dreamy nature. In the summer weeks of 1730 that he spent in Annecy without the presence of Mme de Warens his romantic soul enjoyed one perfect day, an expedition to Thônes which he describes in such graphic detail in the *Confessions* that numerous artists have attempted to depict it: 'the idyll of the cherry orchard'.

Towards the end of June,[66] there dawned a day so beautiful that Jean-Jacques decided to go for a long walk in the country. He directed his steps towards the sun, and had left the town some miles behind him, when, as he was walking in a valley beside a stream, he heard the voices of two girls and looked round. The girls were evidently having difficulty with their horses, but were laughing, and one of the girls called out to Rousseau by name; she had once met him with Mme de Warens, and recognized him. He in turn recognized her as Mlle de Graffenried; the other girl was her friend Mlle Galley. They asked him to help make their horses cross the stream.

Mlle de Graffenried he describes as 'a very attractive girl from Berne who had been turned out of her country as a result of some youthful folly, and come to Annecy to convert to Catholicism'.[67] Mlle Galley was a Savoyarde, 'a year younger than her friend and even prettier' and also 'somehow more delicate and more cultured; she was both small and well developed, and at an age when a girl is most beautiful'.[68] The girls explained to Rousseau that they were on their way to what he calls 'le château de Toune', which was doubtless the Château de la Tour at Thônes, remains of which can still be seen outside the village in the direction of Glapigny. The estate then belonged to Charlotte, widow of François Marie Galley de Saint-Pierre, a landowner of some substance. Rousseau's young friend must have been their daughter, Claudine, who had just celebrated her twentieth birthday.[69] The other girl, Mlle de Graffenried, an impoverished refugee but belonging to one of the most exalted patrician families of Berne,* had been taken into Mme Galley's household as a companion for Claudine. In the *Confessions* Rousseau recalls how he succeeded in getting Mlle Galley's horse across the river by holding the bridle and fording the stream, with water half up his legs; the second horse then followed of its own accord. 'Having done this,' he continues, 'I said goodbye to the young ladies and started going away like an idiot. They whispered a few words together, and Mlle de Graffenried turned to me saying, "Oh no you don't. You won't escape from us so easily. You have got yourself wet in our service; so it is our duty in all conscience to see that you get dry. You must come with us please. You are under arrest as our prisoner." My heart beat unusually fast as I gazed at Mlle Galley. "Yes, yes," she added, laughing at my look of alarm. "You are a prisoner-of-war. Get on the saddle behind her. We intend to render a good account of you." I protested "But, Mademoiselle, I have not had the honour of being introduced to your mother, and what will she say when she sees me?" Mlle de Graffenried replied that Mme Galley was not at the *château.* "We are all alone. And we are going back to Annecy this evening, so we can all return together."

'Electricity itself,' Rousseau continues, 'could not be swifter than the effect of these words. I leapt on the horse behind Mlle de Graffenried, trembling with joy; and when I had to put my arms around her waist to hold myself, my heart beat so fast that she noticed it; she told me that her own heart was beating just as fast from fear of falling. In the position I was in, this remark was virtually an invitation for me to verify the fact; but I did not dare; and during the entire ride my two arms were fixed like a belt around her – a tight one, assuredly, but never wandering for one moment.'[70]

* In Bishop de Bernex's list of deserving converts, Mlle Grafferiet (*sic*) is described as a '*fille de condition*'. The Graffenrieds were one of the few families with right to burial in the cathedral at Berne.

Happy for once in the presence of two pretty girls, he found himself chattering away merrily all day. The girls gave him a snack as soon as he arrived and then set about preparing a splendid luncheon. Provisions had been sent from Annecy, including several special delicacies; the only thing that had been forgotten was the wine. Since Rousseau was fond of wine, this dismayed him a little, but he assured the young ladies, gallantly, that they could intoxicate him without wine – 'the only compliment,' he adds, 'that I dared pay them all day'.[71]

He recalls how they dined in the kitchen of the farmhouse, the girls sitting on benches at the long table, their guest between them on a three-legged stool: 'And what a feast it was! No banquet served in the mansions of Paris could match that simple meal, not only for its gaiety and the sweet joy of the occasion, but also for the taste of it.' After luncheon they had coffee with the cream and cakes that the girls had brought from Annecy, and they rounded off the meal by going into the cherry orchard to pick the fruit and eat it on the spot. Rousseau climbed a tree and threw down bunches of cherries to the girls; 'Mlle Galley, with her apron thrown far forward, and her head thrown far back, presented so good a target, and I threw so well, that a bunch of cherries fell between her breasts. What laughter! I said to myself "If only my lips were cherries, I would gladly throw them there." '[72]

However, Rousseau did not say such things aloud. The whole idyll of the cherry orchard was one of unspoken intimations. If the girls were perhaps disappointed, Rousseau himself looked back on the day as one that was all the more beautiful because it was so innocent: 'my modesty, or my stupidity as others might call it, was such that the greatest liberty I allowed myself was on one single occasion to kiss the hand of Mlle Galley. Admittedly the circumstances added significance to this small gesture. We were alone. My breathing was constrained. Mlle Galley had her eyes cast down. My mouth, instead of speaking, was pressed against her hand, a hand which she withdrew slowly after I had kissed it, looking at me with an expression that was not exactly displeased. I do not know what I would have gone on to say to her, had her friend not come in just then, appearing to me, at that moment, ugly.'[73]

The day ended with a hurried ride back to Annecy, with Rousseau mounted once more behind Mlle de Graffenried. He would have preferred to have ridden behind the prettier Mlle Galley – 'for her glance had greatly stirred my feelings' – but he had not found the courage to propose a change. He left the two girls at the place where he met them in the morning: 'With what regret we parted; with what joy we planned to meet again! The twelve hours we had passed together were worth more to me than years of intimacy. The sweet memory I have of that day cost those charming girls nothing, yet the tender union which bound us together was a greater prize

than any more physical pleasure might have been, and could not in fact have
been combined with such pleasures. We loved one another without secrecy
and without shame, and we wanted to love each other in this way for ever.
Innocence has its own sensuality which is as precious as the other kind,
because it is uninterrupted and it endures. I know that the memory of that
day still affects me more, still charms me more, and comes back to my heart
more often, than any of the other pleasures that I have tasted in my life.'[74]

This avowal of Rousseau's is remarkable, not least for the light it throws
on the inadequacy of the satisfactions he obtained from sexual experiences
which went beyond the boundaries of flirtation. While he admits that he did
not really know what he desired from either girl, he thinks he might have
found supreme happiness with Mlle de Graffenried, at least as a *confidante*;
Mlle Galley was his favourite, but he did not assign any specific role to her,
even in imagination; he simply says he experienced more intense pleasure in
an amorous adventure which ended with a kiss of the hand than other men
experience in adventures which merely begin with that gesture.

When Rousseau returned to his lodgings at Annecy he looked upon his
companion Venture de Villeneuve with less admiring eyes; for the girls had
at Thônes spoken disapprovingly of him, and their word was still his com-
mand. But Rousseau was in no position to break with Venture, whose help
he much needed. Indeed Venture had just arranged an invitation for him to
write some verses for the newly appointed Judge-Magistrate of Annecy, a
music-lover named Simon.* Rousseau wrote the verses, which were in-
tended to fit a melody by Mouret, in one sleepless night, and he claims 'con-
sidering that they were the first verses I ever wrote, they were passable
enough'.[75] He describes M. Simon as a thin, bent, dwarfish individual with a
broken voice, a man whose personal charm, intelligence and taste more than
made up for his natural defects; he was a lawyer with little love of the law,
but with great enthusiasm for literature as well as music. M. Simon took a
generous interest in Rousseau, and, like Abbé Gouvon in Turin, tried to
direct his appreciation of books, which was something Rousseau afterwards
remembered gratefully. But on that particular day when Venture took him
to dine for the first time with M. Simon, the magistrate offered no practical
suggestions for helping him, and the verses Rousseau had written were not
even mentioned. So the poet returned to his reveries. 'As soon as I was free, I
ran to Mlle Galley's street, fancying I might see someone go in or come out
of her house,† or at least open a window. Not a soul appeared; the house
remained as closed as if it were uninhabited ... Finally I wearied of playing
the Spanish lover without as much as a guitar, so I decided to go away and

* Jean-Baptiste Simon (or Symond) (1692–1748) was appointed Judge-Magistrate of
Annecy on 17 January 1730.
† Mlle Galley's house still stands in the rue Perrière, Annecy.

write a letter to Mlle de Graffenried. I would have preferred to write to her friend, but I did not dare; and politeness required me to begin with the one whom I knew better, and to whom I owed the acquaintance of the other.'[76]

So Rousseau wrote his letter to Mlle de Graffenried and handed it for delivery to Esther Giraud, the snuff-taking upholsterer whom he imagined to be in love with him, and was agreeably surprised by the delicacy and reserve with which she suppressed any feelings of jealousy and undertook the role of go-between. In the *Confessions* he speaks of receiving a reply next morning from Mlle de Graffenried, but does not say what it contained. All he says is that Esther Giraud worked out a solution to his immediate predicament as a penniless homeless unemployed youth, and this entailed his leaving Annecy for Switzerland. He does not seem to have suspected that Esther Giraud's motive may have been to get him away from Mlle Galley and Mlle de Graffenried, but in effect his departure from Annecy put an end to his adventure with these two girls. In the fullness of time Mlle de Graffenried left the household of Mme Galley to become a boarder with the nuns at Bonlieu, where she died in 1748 at the age of thirty-eight. Mlle Galley married, when she was twenty-nine, a Savoyard senator named Jacques Sautet who was thirty years her senior, and she died childless in 1781.

Esther Giraud's suggestion was that Rousseau should go to Switzerland as an escort to Mme de Warens' maid, Anne-Marie Merceret, who, having had no news of her mistress for several weeks, had decided to go home to her parents in Fribourg. She was willing to pay Rousseau's expenses for the sake of his company. He agreed, and the only stipulation he made was that they should travel on foot, sending their luggage ahead by a carrier. While he repeats that he always enjoyed walking in the company of a friend, his remarks about Anne-Marie Merceret in the *Confessions* are oddly ungracious; he describes her as yet another girl who was in love with him, and he depicts himself as a youth too innocent to respond to her discreet overtures: 'Merceret was younger and less brazen than Giraud and never made such forceful advances; but she imitated my voice and my accent, echoed my words, and gave me all the attention I ought really to have given her. She took great care, because she was so easily frightened, that we should sleep in the same bedroom, an arrangement which rarely ends at that point on a journey shared by a boy of twenty and a girl of twenty-five. However, it did so in our case. My simplicity was such that, although Merceret was not displeasing to me, I felt not the least temptation to make love to her; no idea of any such thing as much as entered my head; and if it had, I was far too stupid to know how to act upon it. I could not imagine how a boy and girl could manage to sleep together; I believed it required an infinite amount of time to prepare for that conjunction. Poor Merceret, who perhaps expected some return for having defrayed my expenses, was disappointed, and we arrived at Fribourg exactly as we had left Annecy.'[77]

Once he had delivered Anne-Marie Merceret safely to her father's home, Rousseau noticed that his companion's attitude towards him, already cooling, became cold; and that her father, who appeared to be far from prosperous (though he had a job as an organist at Fribourg), was unwelcoming. So Rousseau lodged at an inn, and after a farewell dinner at the Mercerets' house, parted from the girl without tears on either side. Looking back from the perspective of middle age, Rousseau conjectured that Providence had offered him the chance to find happiness in a marriage to Anne-Marie Merceret and that he had thrown that chance away:

'Merceret was a good girl, not brilliant, not beautiful, but certainly not ugly either; she was none too vivacious, but she was sensible and equable apart from occasional little tantrums which ended in tears and left no stormy aftermath. She had a real liking for me. I could have married her without difficulty and followed the trade of her father, the organist. My taste for music would have made me enjoy it. I would have established myself at Fribourg, a small town and not a very pretty one, but inhabited by excellent people. I should undoubtedly have missed some great pleasures, but I should have lived in peace until my last hour.'[78]

However keenly he may have felt the desirability of peace in his later years, Rousseau when young was eager only for experience and adventure. On the journey with Anne-Marie Merceret from Annecy to Fribourg, he had paused at Nyon to visit his father. Isaac embraced him with tears in his eyes, but disappointed his son by making no visible effort to detain him in Nyon. 'He pointed out the dangers to which I was exposing myself . . . but he did not press me to stay.'[79] Always ready to find an excuse for his father's inexcusable conduct, Rousseau suggests that his father had formed a false opinion – albeit a natural one – about his relation to his travelling companion. He goes on to say that his stepmother, with her false sweetness, pretended to want him to stay for supper; he softened his refusal with a promise to spend more time with her on his journey back.

However, it is clear from Rousseau's correspondence that his relations with his father were even less cordial than the text of the *Confessions* would suggest. For we find him writing[80] to Isaac Rousseau less than a year after the visit to Nyon in the following terms:

'My dear Father, . . .

'In spite of the melancholy assurances that you have given me that you no longer regard me as your son, I venture to turn to you as to the best of fathers; and whatever may be the just causes of the hatred you bear me, the remorse of an unhappy and repentant son should expunge them from your heart, and the lively and sincere regret that I feel at having so abused your paternal tenderness should restore those rights to which blood entitles me. You will always be my beloved father, and when I feel the full weight of my faults, I am punished like a criminal...'

It appears from this, and other evidence, that Isaac Rousseau had at least expressed vigorous disapproval of his son's abjuration of the Protestant faith. Besides, Isaac was soon to find other things to disapprove of in his son's way of life. For, once Rousseau had parted company with Merceret in Fribourg, he embarked on a series of adventures which landed him in serious difficulties and debts. From Fribourg he went first to Lausanne, asking his father by letter[81] to forward to that place the little baggage he had left at Nyon. He says he chose Lausanne in order 'to rest my eyes on the beautiful lake of Geneva at the point where one sees its widest extent'.[82] He also had another purpose: for he had resolved to follow the example of Venture de Villeneuve, and present himself in Lausanne as a Parisian music master. Unfortunately, Rousseau lacked the musical accomplishments of Venture, and he was penniless and had to depend on credit for food and lodging. For a time he was lucky in finding benefactors. Once he offered his coat as a pledge to an innkeeper, but 'the good fellow told me he had never stripped anyone, and said that I should pay him when I could'.[83] Another innkeeper of Lausanne, one Perrotet, not only provided credit but helped Rousseau to find pupils for his music lessons. 'Why is it,' he wondered, 'that having found so many kind people when I was young, I was to find so few when I was older?'[84] He carried his imitation of Venture to the point of calling himself Vaussore de Villeneuve, 'Vaussore' being almost an anagram of 'Rousseau'. Audacity and bluff enabled him to give some passable music lessons, but the moment of truth came when he unwisely accepted an invitation to compose and conduct a piece of chamber music for a local patron of the arts named Treytorens.* Performed before an audience of the polite society of Lausanne by an orchestra of scornful musicians, his work provoked only mirth, derision and humiliation. In recalling this fiasco in the *Confessions*, Rousseau was able to console himself with the thought that twenty years later his compositions were to have a triumphant success in Paris. But at the age of nineteen there was nothing to mitigate the blow to his self-esteem and no prospect of enlarging his circle of pupils, then composed only of a couple of German–Swiss dullards and a 'little snake of a girl' who amused herself by producing sheets of music which her teacher was incapable of reading and 'maliciously singing them to show him how the score should be read'.[85]

In imagination, Rousseau fled from his repulsive pupils to thoughts of the two girls who had shared the idyll of the cherry orchard. 'The charming Mlle de Graffenried is always in my thoughts,' he wrote in a letter[86] to Mlle Giraud, 'and I burn with impatience to receive her news. Do me the kindness of asking her, if she is still in Annecy, if she would accept a letter from my hand.'

* François-Frédéric de Treytorens (1687–1737), a professor of law, lived near the place de la Madeleine in Lausanne.

But what of Mme de Warens? Rousseau insists in the *Confessions* that he had not forgotten her; indeed, living in the canton of Vaud he was surrounded by things which reminded him of her. He hoped he would hear from her, but he recalls that 'one of my stupid oddities was that I lacked the courage to find out about her, or even to pronounce her name, save in the case of absolute necessity'.[87] One thing he did was to undertake an expedition of two or three days on foot to Mme de Warens' home town of Vevey, a journey of emotional intensity, almost a pilgrimage: 'The prospect of Lake Geneva and its marvellous shores has always had a special attraction for me that I cannot explain ... Every time I visit the canton of Vaud I experience a strange feeling made up in part of memories of Mme de Warens, who was born there, of my father, who lived there, and of Mlle de Vulson, who had the first fruits of my heart; a feeling made up also of memories of the excursions I made there in my childhood, and besides all that, another element, more secret and more powerful: for whenever my imagination is fired by a strong desire for the happy life for which I was born but which I have never had, that life is set in the canton of Vaud, in pretty countryside beside the lake. My supreme ideal world would be to have an orchard on the shore of that lake, together with one true friend, a pleasing wife, a cow and a boat.'[88]

What always disappointed Rousseau in the canton of Vaud was the people; the inhabitants and the environment did not seem to have been made for each other, and the women were even less to his liking than the men. However, on his walk to Vevey he enjoyed himself, indulging in his adolescent sentimentalism: 'I sighed and cried like a child. How often would I halt so as to weep at my ease; and as I sat on a rock beside the lake, it pleased me to see my tears falling into water as pure as they were.'[89]

At Vevey he lodged for a few days at an inn called La Clef,* and he took a great liking to the town, which he was to use years later as part of the background of his novel *La Nouvelle Héloïse*. He visited places which reminded him of *maman* and returned with a heavy heart to Lausanne and his charmless music pupils. He continued in that Protestant city to practise his religious duties as a Catholic, walking six miles on Sundays to the chapel at Assens where mass was celebrated. Making the journey in the company of real Parisians, he ran the risk of being exposed as a false one. But what had he to lose in Lausanne? Indeed he was forced before the end of the autumn to face the fact that he had nothing more to gain there either; and that if he expected to make a living as a musician, he would have to go elsewhere.

It is at this point in the story of his life that the early draft of his *Confessions* – the 'Neuchâtel manuscript' – breaks off. The last, unfinished, paragraph

* This inn, in the rue de Lausanne, was demolished in the nineteenth century to make way for a private house.[90]

reads: 'I cannot remember exactly how much time I stayed in Lausanne; I have no particularly vivid memories of that city. I only know that –'[91] and the rest is blank. In the Paris and Geneva manuscripts, the last sentence continues: '– that being unable to make a livelihood in Lausanne, I went to Neuchâtel, and passed the winter there'.[92]

In Neuchâtel, a more northerly, austere but progressive city, Rousseau's luck improved. Neuchâtel was a Swiss principality which had been inherited in 1707 from the Orléans-Longueville family by the Kings of Prussia, and under the 'enlightened' King Frederick II music, with other forms of culture, flourished, so that even an incompetent teacher of singing could find work, at least for a time. Rousseau soon earned enough from his lessons in Neuchâtel to pay off his debt to the kindly innkeeper in Lausanne. However, as he says of himself, he was too restless at that age to be content with such a dull provincial life, and when adventure beckoned he promptly followed.

One Sunday, when he had walked some seven miles from Neuchâtel to dine at an inn in Boudry, he made the acquaintance of a Greek monk who claimed to be the Archimandrite of Jerusalem, travelling round Europe to collect funds for the restoration of the Holy Sepulchre. The Archimandrite knew no French, but Rousseau's knowledge of Italian enabled him to understand the *lingua franca*, or bastard Levantine Venetian, which the traveller spoke. In obvious need of an interpreter, the Archimandrite offered the job to Rousseau, who accepted readily; and the two set off together on a fundraising tour of Switzerland. Their first visit was to Fribourg, where they received a small donation from the local authorities, and then they went to Berne, where Rousseau had to present the Archimandrite's case to a meeting of the Senate, and he surprised himself, considering his usual shyness in private conversation, by delivering an eloquent and effective public speech* which brought compliments for the orator as well as a handsome contribution to the cause.

The true nature of the cause was soon to be exposed. Their next stop after Berne was Soleure, the diplomatic capital of the Swiss Confederation, and it so happened that the French Ambassador, on whom the Archimandrite and his interpreter paid an early call, was the Marquis de Bonac, a former Ambassador to the Porte and a man well informed about the institutions of the Holy Land. It took him only a quarter of an hour in conversation with the Archimandrite to unmask him as an impostor. He next called in the interpreter and urged him to own up to the truth. Rousseau, protesting that he was the innocent dupe of the monk, threw himself at the Ambassador's feet and poured out his soul.

Rousseau's story is that M. de Bonac was so impressed by his frankness

* 'This was the only time in my life when I have made a public speech before a sovereign assembly, and the only time perhaps that I have spoken boldly and well.'[93]

that he took him by the hand and put him into the care of his wife and his staff. He was offered hospitality at the Embassy and put into a bedroom that had once been occupied by the poet Jean-Baptiste Rousseau; Jean-Jacques was flattered when the Embassy secretary, M. de la Martinière, urged him to follow in the footsteps of that great writer 'so that people will one day speak of Rousseau the first and of Rousseau the second'.[94]

Rousseau's narrative in the *Confessions* depicts his staying at the French Embassy in Soleure and being well cared for there until he was sent off with a recommendation for a job in Paris. Other evidence shows that he went from Soleure to Neuchâtel in May 1731 with the intention of resuming his work as a music teacher, only to find that the pupils he had abandoned did not want to have him back. Once again he was penniless and in debt; and it was in this predicament that he wrote to his father at Nyon begging for forgiveness and for help. 'I would not have dared to take the liberty of writing to you were I not forced to do so by compelling necessity ... So, my dear Father, I must confess to you that I am in Neuchâtel, in a miserable condition to which my own folly has reduced me.'[95] He begged his father to send him some money at once because his situation was critical.

At about the same time, Rousseau wrote from Neuchâtel to Esther Giraud, who had evidently informed him that he was in disgrace with Mme de Warens. 'I do not know what faults have rendered me guilty in her eyes,' he protested, 'but the fear of displeasing her has hitherto prevented my taking the liberty of writing to her directly to justify my conduct.'[96] He asked Mlle Giraud to intervene with Mme de Warens on his behalf. Having described his own miserable condition at Neuchâtel – 'I am deep in debt and have not a single pupil' – he begged Mlle Giraud not to reveal anything of this to Mme de Warens – 'I would rather be dead than have her know that I was in the slightest need.' The reader may doubt whether he seriously expected Mlle Giraud to suppress such interesting news; and, in any case, he had never hesitated in the past to show himself to Mme de Warens as a youth in distress.

The sequence of events at this period of his life is not altogether clear, but it seems that he was rescued from his plight in Neuchâtel by his friends in the French Embassy at Soleure, who paid for a journey to Paris and proposed him for the post of tutor there in the family of a Swiss colonel in the French army named Godard. In the *Confessions* Rousseau describes his fortnight's journey to Paris, recalling the fantasies of military life with which his mind was filled. He says he was thrilled by the idea of being attached to the French army. But Paris disappointed him, an ugly place when first seen in the slum suburb of St Marceau, and the Godard family proved intolerable. The Colonel was a miserly old man who expected Rousseau to work without wages, 'aiming really at having an unpaid valet for his nephew rather than a real tutor'.[97]

Rousseau was indignant that such a proposition should have been put to him, and Mme de Merveilleux, who was almost the only friend he had in Paris, urged him to refuse it, without, however, finding him a better job. This Mme de Merveilleux was the sister-in-law of M. de la Martinière, the French diplomatist at Soleure who had provided the introduction to Colonel Godard. She gave Rousseau an open invitation to dine at her house, and seems to have enjoyed listening to his conversation. She even tried to secure news for him of Mme de Warens, which was not easy. All that could be learned of *maman*'s whereabouts was that she was rumoured to be on her way to Savoy or Turin or perhaps to Switzerland. 'I needed no more information,' Rousseau says, 'to make me resolve to follow her.'[98] He left Paris and set off once again on foot for Lyons.

CHAMBÉRY

Rousseau went to Lyons with the idea of visiting a friend of Mme de Warens named Mlle du Châtelet, through whom he hoped to bring about a reunion and a reconciliation with *maman*. Mlle du Châtelet received him warmly, but she could not tell him much about Mme de Warens, not even knowing where she was; she could only undertake to write and inquire. Nor could Mlle du Châtelet offer her visitor much in the way of hospitality, since she lived in a convent at Chazottes,[1] together with a number of other *pensionnaires*, one of whom was a girl of fourteen named Mlle Serre, with whom Rousseau was later to fall in love. He did not, however, pay much attention to Mlle Serre at this stage, preferring to converse, if only through a grille, with Mlle du Châtelet herself, who, though neither young nor pretty, always talked with charm and intelligence:

'She had that taste for moral observation which leads to the study of character; and it was from her that I acquired the same interest. She liked the novels of Le Sage, especially *Gil Blas*. She recommended the book to me, and lent me her copy. I read it with pleasure, but I was not yet mature enough for such reading; I wanted sentimental novels. Even so, I spent my time at Mlle du Châtelet's grille with as much profit as pleasure, for there is no doubt that instructive and discriminating conversation with a cultured woman provides a better education for a young man than does all the pedantic philosophy of books.'[2]

Mlle du Châtelet urged Rousseau to stay in Lyons until she received news of Mme de Warens; his only difficulty in doing so was of a kind he was too shy to admit to her, namely that he had no money. In the circumstances he decided that there was nothing to do but to sleep like a tramp and hope for the best. The weather was kind, and he made a few chance acquaintances among men loitering like himself in the open air; most of them turned out to be homosexuals. First a man he took to be a silk-weaver came and sat close beside him, and having suggested that they should masturbate together,

promptly gave a practical demonstration of what he intended. Rousseau fled, so alarmed 'that it cured me of that particular vice for some time'.[3] On another occasion he was offered a place for the night in a priest's bed, only to find that he had to struggle vigorously to ward off the priest's embraces; he claims that he saved himself by recounting his experience with the Moorish homosexual in Turin, 'in language so full of disgust and horror that I sickened the priest, and made him give up altogether his designs on me'.[4] Although these experiences made Rousseau think that Lyons was the Sodom and Gomorrah of modern Europe, he went on sleeping *al fresco* and he usually slept well. One morning he woke up in such good spirits that he started singing aloud, whereupon a monk accosted him and asked if he had any knowledge of music. Rousseau replied 'a little', hoping to be understood to mean 'a lot', and when the monk next asked him if he had ever copied music he replied brazenly 'often'. This time he was not being picked up by a pederast, but was actually offered work by an Antonine father named Rolichon, who was ready to give him room and board as well as remuneration for copying music. Almost miraculously he had found employment.

Rousseau admits that the work he did was bad – his transcriptions were so inaccurate that they could not be played – but M. Rolichon treated him kindly and paid him more than he deserved. 'I must confess,' Rousseau adds, 'that when in later life I elected again to earn my living as a music copyist, I chose the one trade in the world for which I was least suited.'[5] In Lyons he did not have to impose too long on M. Rolichon's patience, for word arrived through Mlle du Châtelet of Mme de Warens. She had moved from Annecy to Chambéry and she invited Rousseau to join her there. She knew him well enough to send with the invitation a subvention for the journey. Mlle du Châtelet urged him to use the money to hire a horse, but Rousseau preferred once more to travel on foot. It was a hilly road from Lyons to Chambéry, but a pretty one, and afterwards Rousseau spoke of this as 'the last real journey on foot' – or *voyage pédestre* as distinct from a walk – that he was ever able to undertake.

As he travelled, his mind naturally concentrated on thoughts of Mme de Warens. He was to learn that she had moved from Annecy to Chambéry in order to protect, and perhaps to better, herself financially and politically at a time of crisis in the Kingdom of Sardinia. If Chambéry was no longer the seat of a sovereign government, it was still the administrative capital of the province of Savoy; Mme de Warens could expect to meet more influential people there than she would find in Annecy, a mere cathedral city, where the crown was represented by the rebarbative Intendant Corvezy. For a woman with her worldly tastes, moreover, Chambéry was altogether more congenial than a place where all life centred round the church; and having abundantly demonstrated her zeal for religion, she could now admit to being

more interested in such matters as industry, commerce and culture. Yet if Chambéry afforded her these satisfactions, she no longer lived, as she had lived at Annecy, in a beautiful house amid gardens and streams. She had an ugly apartment in what was otherwise a fashionable part of the city.* The house she occupied can still be seen: through a covered alleyway next to the building now numbered as 13 rue de Boigne, the visitor enters a quadrangle of flagstones surrounded by tenements. On the building opposite the entry is a plaque which commemorates the fact that Mme de Warens and Rousseau lived there. The court is narrow, and passages lead to other courts of similar dimensions, so that the houses form a honeycomb of closed-in buildings, grey, lugubrious and dark.

Rousseau detested it from the moment he first saw it. But Mme de Warens had not chosen it for its looks. The apartment belonged to Count de Saint-Laurent, first officer of the Sardinian Treasury,† and because it was so undesirable he had had difficulty in finding a tenant for it. Mme de Warens, with her rather simple cunning, spotted an opportunity of ingratiating herself with the Count by taking a lease that nobody else wanted. Her stratagem worked and an important Treasury official who had previously looked on her with little favour became her friend; and her pension from Turin was made safe once more by his intervention.

Rousseau has left us a description of the room he was given in this house: 'the darkest and gloomiest room in a dark and gloomy dwelling; an outside wall for a view, a blind alley for a street; little air, little daylight, but cockroaches, rats and rotten floorboards'. His only consolation was the thought that he was once again living with *maman*, 'in her house, at her side'.[6]

It was in the autumn of 1731, when he was still only nineteen, that he arrived on foot from Lyons at Mme de Warens' door. To judge from the account he gives in the *Confessions*, their reunion was not marked by tears, as were other dramatic moments of their shared experience: 'She was not alone,' he writes. 'The Intendant-General [Don Antoine Petitti] was with her when I entered the room. Without speaking to me, she took me by the hand, and with that charm of hers which conquers all hearts, she said to him: "Here, Monsieur, is the poor young man. Protect him as long as he deserves protection, and I shall have no more anxiety about him for the rest of his life." Then she spoke to me: "Child, you belong to the King. Be grateful to Monsieur the Intendant who offers you a livelihood."'[7]

The livelihood that Rousseau was offered, and accepted, was that of a clerk in the Survey Office which King Victor Amadeus had set up[8] some years before in Chambéry in order to establish a systematic basis for taxing

* Rousseau himself speaks of several noble families of Chambéry as being 'neighbours'.

† Victor-Amédée Chapel, Comte de Saint-Laurent (1682–1756), entered the service of the Sardinian Kingdom as First Secretary of Finances in 1717, rising to be Controller-General in 1733, First Secretary of State for the Interior in 1742, and Minister of State in 1750.

the landowners of Savoy. Its work involved preparing detailed maps, registers and measurements for the entire province, and by the time Rousseau was taken on, the Office had accumulated a staff of some three hundred, including surveyors, geometers, draughtsmen and clerks. Rousseau's duties there proved at first agreeable enough, and he was pleased to think that 'after four or five years of adventures and folly, I was at last honourably earning a living'.[9] The job required some knowledge of arithmetic, and since he had received no real schooling in any branch of mathematics, he studied the subject at home from books, and he claims that he taught himself so well that he could do the most complicated sums in his head even thirty years later. His work was not entirely confined to figures: he practised drawing maps and water-colouring in the Survey Office, and enjoyed it so much that the painting of flowers and landscapes became a hobby. The painting of flowers might have gone logically together with a more scientific study of plants, and indeed Rousseau did later become a keen amateur botanist, but he tells us that at that time he felt only contempt for the 'apothecary's science'.[10] Perhaps this contempt is explained by the fact that an interest in botany was a great bond of union between Mme de Warens and her steward Claude Anet.

At Annecy Rousseau had not paid much attention to Claude Anet; he had remarked his presence as that of a servant or 'valet'; at Chambéry he discovered that Anet was something more. In the *Confessions* Rousseau describes Anet as 'a peasant from Montreux' who had collected herbs as a youth, and had been offered employment by Mme de Warens because she found it useful to have a herbalist on her domestic staff to help her with her activities as a manufacturer of medicines and potions. Rousseau is charitable enough to suggest that Anet might have developed into a considerable botanist if he had lived longer, and he recalls how Anet became at Chambéry 'a sort of tutor to me, saving me from many follies'.[11] As Rousseau explains the relationship, 'Anet, without claiming the authority over me which his position gave him the right to assume, naturally acquired an authority.'[12]

Solemn, reserved, taciturn, even cold in his demeanour, Anet nevertheless appeared to Rousseau to be a man who was inwardly consumed by strong emotions. Confirmation of this came when Anet attempted suicide. According to Rousseau's own explanation of the episode, Anet had been so wounded by some harsh words of Mme de Warens that he swallowed the contents of a phial of laudanum. In the excitement which followed, Mme de Warens revealed to Rousseau that Anet was her lover: 'She found the empty phial and guessed what had happened. She flew to his rescue, and her screams brought me to the scene. She confessed everything to me, implored my assistance, and with great difficulty made Anet disgorge what he had swallowed. Witnessing this scene I could only marvel at my own stupidity in

having never entertained the least suspicion of the relationship of which she had just informed me.'[13]

The relationship may even have had a longer history than Mme de Warens admitted to him; for Claude Anet was not a 'peasant', as Rousseau calls him; he was the nephew of a gardener who had been employed at Vevey by Mme de Warens' husband,[14] while she was still living with him. Then, at the age of twenty, Anet accompanied her on her dramatic flight to Évian and converted to Catholicism when she did at Annecy in 1726. If Anet was her lover before she left Vevey, her departure becomes all the more intelligible. In any case the situation was one which would have demanded the utmost discretion. Among the feelings which Anet took care to hide from Rousseau, there is likely to have been some resentment of his presence in the household. It has even been suggested that jealousy of Rousseau, rather than any wounding utterance of Mme de Warens, was the occasion of Anet's attempted suicide.[15] Rousseau's own denial that any jealousy existed among them is perhaps too forced to sound convincing: 'We lived together in a union which made us all happy,' he writes; 'a union which death alone could destroy. One proof of the excellent character of that charming woman, Mme de Warens, is that those who loved her loved each other. Jealousy, even rivalry, yielded to the dominant feeling of goodwill which she inspired, and I have never known any person in her circle to be ill-disposed towards any other.'[16]

Be that as it may, Rousseau's record of his life with Mme de Warens is not entirely reliable, even on matters of fact. For example, he says in the *Confessions* that he continued to work at the Survey Office for two years,[17] but the records of the Office show that he left on 7 June 1732, after no more than eight months' service.[18] On the other hand, there is no reason to doubt that the motive for his resignation was the one he mentions, that he was bored and wanted to become a music teacher again.

In the early weeks of his employment at the Survey Office, his work engaged his interest; as soon as it developed into a routine job, his restless soul became unsettled again and he itched for a change. For a while he had found relief from the tedium of the office in reading, his favourite books at that time being works of French history and literature; and he tells us that he passed from a love of French books to a love of the French people. If his admiration for French people diminished on better acquaintance with them, he claims to have remained a life-long francophile, despite his republican principles, his hatred of French despotic government and the ill-treatment inflicted on him by French authorities.

During Rousseau's sojourn at Chambéry war broke out, with Sardinia joining the French against the Austrians, so that Rousseau the francophile had the gratification of seeing the French regiments with their colours and bright uniforms passing through the city; he had even the honour of being

introduced to the commanding officer of the Champagne regiment, the Duc
de la Trémoïlle, who in the manner of such exalted personages, 'promised
me many things, and never thought of me again'.[19] Rousseau's zeal for the
French cause in that war was such, he recalls, as to make his heart beat at
their smallest success and to feel French defeats as his own. Looking back
from middle age, he considered his early enthusiasm for French conquest
stupid, but at the time he had practical as well as sentimental reasons for
wishing the French to win, for 'if the war turned out badly for the allies,
maman's pension would be put at great risk'.[20]

However, even the vicarious excitement of war, added to the pleasures of
reading, was not enough to overcome the boredom of a government job that
'kept me busy for eight hours a day at unpleasant work with even more un-
pleasant people. Shut up in a miserable office that stank of bad breath and the
sweat of those wretched oafs, most of them unkempt and far from clean, I felt
my head spinning with the strain, the smell, the embarrassment and the
tedium.'[21]

So once again Rousseau implored *maman* to let him give up the job and
earn his living as a musician. For was it not she who had first encouraged his
interest in music by sending him to the choir school and making him the
pupil of M. Le Maistre? How could she refuse? Her own love of music was
certainly as keen as ever. She never tired of sitting at the harpsichord, singing
duets with Jean-Jacques. She did not resist when he disturbed her in the
kitchen when she was boiling Anet's herbs to make medicaments and
dragged her to the salon to practise music, even if, now and again, in such
circumstances, 'the extracts of juniper or aniseed were burned to ashes'; for
then 'she smeared my face with them, and everything was wonderful'.[22]
Moreover, Mme de Warens encouraged Jean-Jacques to organize musical
evenings at home, where fashionable as well as musical society assembled. At
such concerts, Mme de Warens herself would sing, the Abbé Palais, a gifted
amateur musician from the Val d'Aosta, sat at the harpsichord, and a danc-
ing master named Roche and his sons played the violins. Giovan-Battista
Cavanas, one of the few friends Rousseau found in the inelegant company of
the Survey Office, played the cello, and Rousseau himself conducted the
ensemble. Another who came regularly to sing at these evenings was Father
Caton from Lyons, remembered by Rousseau as one of the Church digni-
taries who had ordered the confiscation of M. Le Maistre's music, but none
the less something of a hero in Rousseau's eyes. For Father Caton was an
unusually urbane friar who dined well and entertained often, and who con-
tributed his own measure of sophistication to Mme de Warens' *soirées*. In the
course of time, Father Caton was judged to be altogether too worldly by his
fellow friars, and disgraced; but Rousseau knew him at the height of his
good fortune and, conceiving an admiration for him akin to that he had once

felt for Venture de Villeneuve, he felt again his old desire to dedicate his life to music, and could see no reason why he should not earn a living at it.

Mme de Warens pointed out the folly of giving up a steady job in a government office for the hazards of a music teacher's life, especially for a young man with less than a minimal training in the subject. She quoted the proverb 'Neither singing nor dancing is a trade that leads far',[23] hoping perhaps to remind him of his father's mistake in giving up watchmaking to become a dancing master; but it was all unavailing. 'In the end,' Rousseau says, 'I dragged assent from her more by force of importunings and caresses than by rational persuasion.' And so it was to be the life of music once again.

Rousseau's narrative in the *Confessions* conflicts with other evidence as to the dates and sequence of what followed his resignation from the Survey Office, but it seems probable that he went almost immediately to Besançon with the idea of studying under a musician from Provence, the Abbé Blanchard,* who had once been the teacher of Venture de Villeneuve. Rousseau must indeed have done so if the date of 29 June 1732 is correctly transcribed in the printed version[24] of a letter (the original of which cannot be traced) written by Rousseau from Besançon to Mme de Warens, telling her that the Abbé Blanchard had received him cordially, but was about to leave for Paris in the hope of being appointed Master of the King's Music in succession to Monsieur Campra.† Rousseau adds that the *abbé* promised him that if he himself was appointed to the Chapel Royal, he would find him a place there within two years at the most. What Rousseau does not say, and may well not have known, is that the Abbé Blanchard had been dismissed from his post at Besançon for neglect of his duties. All Rousseau says is that while waiting for the job to materialize, he would like to 'return to Chambéry and keep myself busy for those two years by giving music lessons'.[25] He asks Mme de Warens to let him know by letter if he would be welcomed back to Chambéry and whether he is likely to find pupils there; if not, he had decided either to follow the Abbé Blanchard to Paris or turn once more to the French Ambassador in Soleure.

In the *Confessions* Rousseau says nothing of all this, but writes instead of a trip to Besançon made at a time after he had already started giving music lessons in Chambéry. He may have confused in his memory two different journeys to Besançon. In any case, the visit of June 1732 must have been a fairly short one, because there is evidence that he was back in Chambéry, working as a music teacher, well before the end of that same year.[26]

* Esprit-Joseph Antoine Blanchard (born 1696) had been a choirmaster at Marseilles and Toulon before going to be choirmaster at Besançon, where he alienated his employers by neglecting his duties and was dismissed in 1732. He found work afterwards in Amiens, and in 1738 was appointed a choirmaster at the Chapel Royal. He earned a modest fame as a composer of motets.

† André Campra (1660–1744) was one of the leading French composers of the time.

Evidently he enjoyed his work as a music teacher; he had always thought
of that life as one spent delightfully in the company of pretty, elegant young
ladies in drawing rooms filled with roses and song, and this time reality did
not disappoint him; he could always look back with pleasure on the innocent
sweet hours he spent at the harpsichord with the daughters of the aristocracy
of Chambéry. Among the pupils he recalled by name when he wrote his
Confessions were Mlle de Challes,* tall and plump and no longer a beauty,
but sweet-natured and agreeable, and her niece, a red-haired child of eight
named Françoise-Catherine,† whose mother, Mme de Charlier,‡ Rousseau
considered the most beautiful woman in Chambéry. He also taught a young
French girl whose name he forgot, but whose efforts to overcome her
natural laziness and entertain him with bright conversation spurred him to
overcome his own habitual unpunctuality, a defect which he was otherwise
disposed to justify on the grounds that 'in all things constraint and
subjection are unbearable to me'.[27]

The pupil he names first on the list he gives in the *Confessions* of those
remembered from Chambéry is Mlle de Mellarède,§ a slender lively brunette
of fifteen, who put her music teacher in a state of near panic by appearing for
her lessons *en déshabillé*. Then there was Mlle de Menthon,|| an afternoon
pupil, who was always, by contrast, very carefully dressed; a blonde, small,
shy and shapely girl who had, Rousseau writes, 'on her breast, where she
had once scalded herself with boiling water, a scar imperfectly concealed by a
neckerchief of blue chenille. My eyes were drawn to the spot, but they did
not linger, because of the scar.'[28] This girl was the daughter of Mme de
Menthon,** a witty, but, according to Rousseau, a none too chaste woman
who turned against Mme de Warens when a man on whom she herself had
designs was drawn to her. Rousseau speaks of Mme de Menthon's efforts to
discredit Mme de Warens in local society; he recalls an occasion when she
described Mme de Warens to a company of gentlemen as a bluestocking who
dressed badly and who covered her bosom like a woman without class,
whereupon one of the gentlemen present said (as a joke) that she had to
cover her bosom because she had a mark on it shaped like a rat: 'So credulous
does hatred make people,' Rousseau continues, 'that Mme de Menthon
decided to take advantage of this disclosure, and one day when *maman* was

* Gasparde-Balthazarde de Challes (born 1702), daughter of the Marquis de Challes, was
already aged thirty; she died a spinster.

† Françoise-Catherine de Charlier (born 1725) was to marry in 1753 Henri de Chabod,
Marquis de Saint-Maurice.

‡ Catherine-Françoise de Challes (born 1697) married the Comte de Charlier in 1723.

§ Marie-Anne de Mellarède (born 1718) afterwards married first, in 1739, Jean-Baptiste
Morand, and secondly, in 1754, Joseph-François, Comte de la Valdisère.

|| Françoise-Sophie de Menthon (born 1719) was to marry, in 1746, Jean-Louis de la
Saulnière, Marquis d'Yenne et de Chevelu.

** Marguerite de Lescheraines (born 1692) married Comte Bernard de Menthon in 1714.

playing cards with the man she favoured, Mme de Menthon seized an oppor-
tunity of moving behind her rival, and by half overturning *maman*'s chair,
unveiled her bosom. Thereupon, instead of a big rat, the gentlemen saw a very
different object, one which was easier to see than to forget, and which was
not at all what Mme de Menthon had intended.'[29] *

Denied one satisfaction, Mme de Menthon sought another in the person of
Rousseau himself. She invited him to dine alone with her several times, but,
as he himself puts it, she was disappointed in the outcome. She had looked
for wit in him, but found none, since he was still an oafish youth from
Switzerland, an alien in the salon. She lost interest in him, and he reflected in
later life that his shyness had saved him from her clutches. However, Mme
de Menthon was not the only mother in Chambéry who tried to seduce the
music master; there was also Mme Lard.† As the wife of a grocer, Mme Lard
lacked what was in Rousseau's eyes the indispensable ingredient of sex-
appeal, rank, but she had other charms. Her daughter,‡ his pupil, Rousseau
describes as the true model of a Greek statue: 'I would call her the most
beautiful girl I have ever seen if there could be beauty without life and with-
out soul.'§ The mother, by contrast, was full of vitality, a bright, pretty
little woman who greeted Rousseau every morning with a cup of coffee and
cream and a kiss on the lips: 'Her attentions touched me greatly. I spoke to
maman about her kindness as if of something without mystery, but *maman*
did not see it as the simple thing I saw.'[31]

Mme de Warens was a woman of the world; she discerned dangers to
Rousseau alike in the attentions of Mme Lard and those of Mme de Menthon,
the one unacceptable as lower middle class, the other as a predator; this
determined her to make an important move in Rousseau's education, to
terminate his virginity on her own initiative: 'she felt the time had come to
save me from the perils of youth by treating me as a man'.[32] It was probably
in the year 1733, when Jean-Jacques achieved the age of twenty-one, that
Mme de Warens accomplished this feat. Several circumstances had conspired
at this period to draw them closer together. There was, for example, a
garden in the suburbs of Chambéry, which Claude Anet had persuaded Mme
de Warens to buy in order to grow herbs, but which Rousseau had
contrived to turn into a *mid d'amour*, complete with a summer-house con-
taining books, pictures, rugs and a bed. In fine weather he would occasion-
ally dine alone with Mme de Warens in the summer-house, and sometimes

* Rousseau does not remark on the coincidence between the fiction of the mark on the breast of
Mme de Warens and the fact of the mark on the breast of Mme de Menthon's daughter.

† Born Marie Beauregard, she was the wife of Jean Lard, a grocer in Chambéry.

‡ Peronne Lard was to marry in 1749 Joseph Fleury, a doctor.

§ Nevertheless, in Peronne Lard's music book, which has been conserved with annotations in
Rousseau's hand, there is evidence that she studied systematically with him, learning operatic airs as
well as folk music and popular songs.[30]

he passed the night there: 'insensibly I came to adore this little retreat'.[33]
Moreover, it was at this time that Rousseau fell ill, and was nursed by *maman*.
Speaking of another illness, Rousseau recalls how 'by her care, her vigilance, her
boundless exertions, she saved my life as only she could have saved it',[34] and
doubtless the same solicitude was lavished upon him during the autumn of 1732;
and it is natural to assume that the feelings of affection between them became
more tender and that they moved by degrees to an ever greater intimacy.

Yet Rousseau tells us in the *Confessions* that he was taken entirely by surprise
when *maman* put the proposition to him. She made him her lover, he says, 'in
the most singular manner that ever occurred to a woman in such a situation'.[35]
As he describes the experience, she began by assuming a tone of high seriousness
in their conversation, and taking care that they should be left alone in the
suburban garden. He was slow to grasp the message she wished to impart, but as
soon as he understood it, he says, 'it took such possession of me that I could no
longer make myself listen to anything else she said'.[36] He realized she was
making certain stipulations, but in his excitement he could hardly hear her
words: 'In the same strange way, she gave me eight days to reflect on the
proposition. I assured her hypocritically that I needed no such respite, but the
truth is – to crown the peculiarity of the whole episode – that I was very grateful
for the delay.'[37]

He spent the next days in a fever of conflicting emotions. He yearned for
sexual satisfaction, and he was full of tender feelings for *maman*, and yet,
precisely because it was *maman*, his desires were inhibited; what he wanted he
also dreaded: 'How, and by what miracle could I, in the flower of youth, be so
little impatient for my first experience of sexual congress? Why did I
contemplate the appointed hour approach with more pain than pleasure? Why
instead of the joy that should have exhilarated me, did I feel repugnance almost,
as well as fear?'[38]

The day came, and in the little summer-house Rousseau ceased to be a virgin.
'Was I happy? No. I had tasted the pleasure, but some strange invincible sadness
poisoned its charm for me. I felt as if I had committed incest.'[39] This last sentence
may be thought to confirm a Freudian explanation of the problem of Rousseau's
ambivalence towards Mme de Warens; if it also suggests a certain self-
knowledge on the part of Jean-Jacques at the age of twenty-one, he remained
baffled by Mme de Warens' conduct in the affair. And even thirty years later
when he wrote his *Confessions*, his attitude remained perplexed and
disapproving. In these pages he describes her as a woman who instead of
listening to her heart, which was good, listened to her reason, which led her
astray. It was perhaps at this time that she gave Rousseau some account of her
earlier sexual experiences, and so enabled him to write of her being 'corrupted'
by Colonel de Tavel,* who had persuaded her that fidelity in marriage was only

* Étienne-Sigismonde de Tavel. See p. 71 above.

a matter of keeping a husband happy and maintaining good appearances. Tavel, he adds, was 'punished by the most devouring jealousy when he came to suspect that his mistress was behaving towards him as he had taught her to behave towards her husband ... I do not know whether his suspicions were well founded, but Pastor Perret* was supposed to have been his successor as her lover.'[41]

The wording of this last remark suggests that Rousseau may have been told stories, true or false, about Mme de Warens' past by others besides herself, perhaps by Claude Anet. But Rousseau does not provide much detail; he simply asserts that Mme de Warens' dry intellectual temperament, which ought to have protected her from the doctrine of free love, in fact made her the more susceptible: 'she could not understand so much import- ance being given to something that had no significance for her; she never dignified with the name of virtue an abstinence which cost her so little'.

Rousseau is gracious enough to admit that Mme de Warens used her 'false philosophy' for altruistic ends; far from letting herself be seduced by rich or important admirers, 'she reserved her favours for the unfortunate'.[42] He does not add that she also reserved her favours for the young. She was in all things an original adventuress; far from being a *femme entretenue* of the familiar kind, kept by rich lovers, it was she who, in several cases (including that of Rousseau), kept the lovers, abstracting money – as far as she could – from her prosperous friends entirely by the magnetism of her conversation and her personality. She was totally without the instincts of a harlot.

When Rousseau became her lover, it meant that she had, with Claude Anet, two young men to take care of; for Rousseau's earnings as a music teacher were slender, and Anet was on her payroll as her steward. In the *Confessions* Rousseau says that while he was not certain that Anet knew of his own altered relationship with Mme de Warens, he believed that it was 'not concealed from him'.

Anet's personality, he adds, 'was so mature and grave, that he treated *maman* and me as if we were two children who deserved indulgence'.[43] Rousseau speaks again of the three of them being held together by 'a unique and happy bond',[44] but the reader may doubt the truth of this. Anet, so adept at hiding his feelings, may well have been consumed with jealousy; at all events he soon fell victim to a mortal sickness.

Mme de Warens, with characteristic inventiveness, tried to improve Anet's position in the world by persuading the Sardinian authorities to institute at Chambéry a botanical garden and appoint Anet as its first director. She found an unlikely ally in this project in the person of Dr Grossi,†

* The Rev. Vincent Perret, a minister of Vevey, is commemorated elsewhere as a man of the utmost respectability. Rousseau is the only known source of the allegation that he was a lover of Mme de Warens.[40]

† François Grossi (1682–1752), having been physician-in-ordinary to the King of Sardinia, practised in Chambéry after leaving Piedmont on his retirement in 1734.

a former royal physician who had retired to Chambéry, a notoriously un-
likeable and unliked man, but one who was nevertheless charmed by Mme de
Warens, and was on the point of putting her scheme for a botanical garden
to the Court at Turin, when, as Rousseau expresses it, 'Providence struck
Anet down with a fatal blow.'[45]

The story Rousseau tells is that 'on an expedition to the high mountains
to gather *genipi*, a rare plant found only in the Alps, prescribed by Dr Grossi,
poor Anet caught a fever which developed into a pleurisy from which his
genipi could not cure him, efficacious as that plant is supposed to be in such
cases. In spite of the skill of Dr Grossi, who was undoubtedly a very able
man, and in spite of the infinite care that his good mistress and I lavished
upon him, he died in our arms on the fifth day, after the most cruel agony.'*

There is something odd about this account of Anet's death, for the parish
records show that he died on 13 March 1734, a time of year when there are
no *genipi* but only snows to be found on the mountains above Chambéry. It
is tempting to conjecture that Anet's fatal illness was of psychological origin,
brought on, like his earlier attempt to poison himself, by jealousy of
Rousseau. Indeed Rousseau himself recalls, with some shame, the reaction
he had to Anet's death: 'the vile and unworthy thought came to my mind
that I might inherit his used clothes, particularly a handsome black coat
which took my fancy, and thinking this thought, I spoke it aloud, for when
I was with *maman* thinking and speaking were the same ... The poor
woman, without a word in reply, simply turned her head and burst into
tears.'[47] Rousseau declares that her tears 'washed away the contemptible
thought',[48] but he seems nevertheless to have kept the coat.

He also inherited, more reluctantly, Anet's duties as administrator of
Mme de Warens' affairs. In this he admits himself to have been notably less
effective than his predecessor. For Anet had not only been exact and metho-
dical; he also possessed a certain authority over Mme de Warens, which
Rousseau, being eight years younger, could not expect to exercise. Anet
could sometimes curb his mistress's extravagance; Rousseau never. When he
ventured to suggest she be more prudent, she would slap him playfully on
the cheek. She would never take his opinions seriously in practical matters,
so that Rousseau is forced in the *Confessions* to admit that from the time of
Anet's death, 'her finances never ceased to go from bad to worse'.[49] Failing
to convince her of the need for thrift, he says he became parsimonious on her
behalf, saving and hiding little sums of money for future use; 'I became
miserly,' he says, 'from a noble motive'; and he dates from this experience
his own admitted later tendency to meanness.

If Mme de Warens did not expect Jean-Jacques to be an efficient steward,

* Anet was buried on 14 March 1734 at the church of St Léger, now St François-de-Sales, at
Chambéry.[46]

she wanted him at least to be the perfect little gentleman, and she did all she could to groom him for polite society. Here again, she must have had some success, because Rousseau was afterwards always welcome in cultured people's drawing rooms, notwithstanding his reputation of being notoriously 'a bear'. He himself, however, speaks only of the failure of her efforts. He submitted to the dancing and fencing lessons she arranged for him, but says he proved too clumsy to master either art. He had developed a habit of walking on his heels – 'because of my corns'[50] as he puts it – and this made him unable to dance; a weak wrist made him a poor swordsman, and he was in any case, 'not the kind of person to take pride in the art of killing other men'.[51] In this respect at least, he was very unlike his father.

Rousseau believed he had only one gift which fitted him for society, and that was a natural one, his talent for music; and as this seemed enough to make him acceptable, he had no desire to acquire the artificial polish of a cultured *homme de salon*. Yet there is no doubt that he enjoyed the company of the people he came to know in Chambéry; he recalls with gratitude the hospitable and easy-going habits of the Savoyards; the nobility of the province, he observes, usually served in the army when young and then retired to a quiet life in Chambéry, the men seldom rich but generous, and the women, if not always beautiful, always attractive. Apart from Mme de Menthon, no one in Chambéry showed any coldness towards Mme de Warens, despite her equivocal social status and her somewhat unconventional way of life. Rousseau depicts her indeed as one of the luminaries of society in the city, and even if, as one suspects, there were murmurs of disapproval he did not hear, he is able to name a stream of distinguished visitors who accepted invitations to her house.

There was, for example, the Comte de Lautrec,* Marshal of France, who was later to play an important role as Mediator in the civil strife in Geneva, and who made, but failed to keep, a promise of a job to Rousseau; there was also the young Marquis de Sennecterre,† who was a good enough musician to spot a deficiency in Rousseau's knowledge of music but too much of a gentleman to draw attention to it. Music, organized by Rousseau, was a magnet which drew to Mme de Warens' salon all such illustrious personages, young and old. The Noyel family, which was among the most exalted in the Savoyard aristocracy, came in strength; the head of the family, the Marquis d'Entremont,‡ and his eldest son, the Comte de Bellegarde,§ were regular attenders, while the younger son, the Comte de Nangis,‖ played the

* Daniel-François de Gélas de Voisins d'Ambres, Comte de Lautrec.
† Jean-Charles de Sennecterre (1714–85).
‡ Jean-François Noyel (1661–1742), Marquis de La Marche et Cursinge, Comte d'Entremont, known as the Marquis d'Entremont.
§ Claude-Marie Noyel (1700–1755), Comte de Bellegarde.
‖ Jean-Baptiste Noyel (1701–78), Comte de Nangis.

violin in the concerts Rousseau organized, and the daughter, the Comtesse de la Tour,* sang. Since these musical evenings at Mme de Warens' house also commanded the participation of priests such as the Abbé Palais and Father Caton, there can be no doubt about her social position in the city. The continued support she received from the bishops must also have helped to cast a veil of sanctity over a life which, in reality, fell short perhaps of the highest ideals of Catholic morality. As to her standing in society, we have the testimony not only of Rousseau but of M. de Conzié, a Savoyard nobleman who became a close friend, and who in a letter[52] says of Mme de Warens' arrival in Chambéry from Annecy that 'her conduct was exempt from all suspicion, and escaped the kind of calumny which commonly accompanies newcomers when they have intelligence and good looks'.

The only thing which clouded Mme de Warens' success as a fashionable hostess was the cost of entertaining, a problem which became increasingly acute after Rousseau took charge of her finances. She began to fret more and more about money. Her pension from Turin came in fairly regularly (although she had to write[53] to officials there to remind them to pay her) at least until 1734. In April of that year, her chief benefactor, Bishop de Bernex, died,[54] and although in his will he left her an annuity of 150 *livres*, this sum was trivial in relation to her needs. With the outbreak of another war, that of the Polish Succession, when Sardinia again joined the allies against Austria, Mme de Warens had a further reason for anxiety about her royal pension; this time she wrote[55] to the King of Sardinia in person, to wish His Majesty victory in arms and to beg for his continued charity.

Even so, she was not the kind of woman who would be content to live on charity alone; she had lost none of her old enthusiasm for industrial enterprise, or any of her confidence that there was a fortune to be made from shrewd investment. Rousseau himself deplored this side of Mme de Warens' nature: 'The more pressing her domestic worries became, the more she gave herself over to her fantasies. The less she had in the present, the more she imagined for the future. The passage of time served only to increase this folly, and when she began to lose her appetite for the pleasures of society and of youth, she developed an added zeal for secrets and projects. The house was never free of charlatans, inventors, alchemists, and promoters of every sort, all of them talking in millions but ending up by asking for a silver coin. No one ever left the house empty-handed, and it still astonishes me that she was able to waste so much money without exhausting either the source of supply or the patience of her creditors.'[56]

Some evidence of Rousseau's efforts to rescue *maman* from parasites is provided by a letter[57] he drafted to one such person, explaining that while

* Jeanne-Lucie Noyel, who married in 1725 the Comte de la Tour, future Sardinian Ambassador to Spain.

Mme de Warens had been pleased to read the memorandum he had sent her, the contents were too high-flown for her, and that the courteous attention she had given to it should not be interpreted as entailing any commitment to it. All such endeavours to protect Mme de Warens from the consequences of her folly proved fruitless, and Rousseau himself began to show greater signs of stress than she did. So long as her drawing room was dedicated to musical *soirées* and upper-class society, he was happy enough; when it was infested by business promoters and mountebanks, he was maddened with irritation, and all the more so because he believed that 'their real purpose in coming was to swindle *maman* in one way or another'.[58] Life at Chambéry became 'a torture'.[59]

Even the musical evenings came to an end with the departure in 1734 of the Abbé Palais and in the following year of Father Caton. And yet at the age of twenty-three Rousseau was still eager to dedicate his life to music, and with the aid of such books as Rameau's *Treatise on Harmony* kept trying to teach himself the technicalities that he had failed to learn at the choir school. He seems to have given up the hope of becoming the pupil of a qualified musician. In the *Confessions* he speaks of going to Besançon in 1735 with the intention of taking lessons in composition with the Abbé Blanchard, and then having to abandon the project because his trunk was seized by the French customs at the frontier post of Les Rousses in the Jura, a misadventure which 'prompted me to return to Chambéry at once without having done anything with the Abbé Blanchard'.[60] Here his memory is plainly at fault. We have already noted on the testimony of Rousseau's own letters that he went to Besançon in the hope of receiving music tuition from the Abbé Blanchard in 1732; by 1735 the Abbé Blanchard was far from Besançon, and Rousseau knew he had left that place three years before. Rousseau could nevertheless have embarked upon a journey to Besançon in 1735, and the seizure of his trunk at Les Rousses may well have halted it. But there is an air of mystery about the whole thing.

The reason Rousseau gives for the confiscation of his trunk is that the French customs discovered inside it a satirical publication – 'a feeble Jansenist parody of the great scene from Racine's *Mithridates*',[61] as Rousseau describes it – which they suspected he was bringing from Geneva to be printed in France. Rousseau denies that he had any such intention; the parody was a trifling thing that he had been lent by a friend and left absent-mindedly in a pocket.

But had he something else to hide? In a letter[62] to Mme de Warens, written some four years later, he refers to 'that cursed journey to Besançon, of which, for the sake of my happiness, I thought it wise to disguise somewhat the motive – an endless and ill-starred journey if ever there was one'. We are left in the dark about the real purpose of the trip, although it

may have had something to do with one of Mme de Warens' abortive secret projects. He had, in any case, at this time fully committed himself to her service: 'weighing everything up, and seeing that bad luck dogged all my own enterprises, I decided to attach myself entirely to *maman*, to share her fortune, and not to trouble myself fruitlessly about a future I could not control'.[63]

This resolution did not mean that Rousseau stayed continuously at home with *maman* in Chambéry, but it does seem to have meant that he gave up his work as a music teacher to the young ladies of the city. Mme de Warens sent him on various missions to other places, and he says he was pleased to go because it enabled him to avert his eyes from the extravagances he was unable to prevent in the household: 'Pretexts were easily found for the journeys I made; and *maman* herself could provide any that were needed; so many business matters, negotiations, deals and commissions had she to entrust to a reliable agent. She asked for nothing better than to send me off, and I asked for nothing better than to go.'[64] We may assume that he was unsuccessful as the agent of enterprises in which he had no faith, and the 'wandering life', as he calls it, produced signs of strain, which in turn led to illness. As he himself describes his condition, 'I was seized not by boredom, but by melancholy; nervous exhaustion succeeded passion; my languor turned into sadness; I wept and sighed for no reason; I felt my life slipping away from me without my having ever really experienced it.'[65] A large part of his trouble, as he himself realized, was sexual: 'I had a tender mother, a beloved friend, but I needed a mistress.' In his imagination he gave the mistress he desired a thousand shapes, but never the shape of *maman*, for the image of *maman* killed all erotic feelings. What he felt for her was another kind of love. Illness provided one escape from his predicament; for as soon as he was ill he needed a mother rather than a mistress, and in this role Mme de Warens never failed him.

Once again he took to his bed. Once again he persuaded himself that death was near. Mme de Warens tended and nursed him night and day. Sometimes he would leave his bed and go to her room to talk over with her the anxieties that disturbed him; he would shed copious tears as he held her hand; and only after she had succeeded in soothing his fears, would he go back to his own room and sleep contentedly. Sickness had become a road to happiness with *maman*: 'Our mutual attachment did not increase during my illness, for that was impossible, but it became somehow more intimate and more moving in its great simplicity. I became entirely her creature, more of her child than if she had been my real mother. We began, without thinking about it, to become inseparable, to share our whole existence ... and to confine all our happiness and all our desires to our mutual possession of one another, something which was perhaps unique among human kind.'[66]

In a letter[67] to his father, which he drafted during this illness, he says 'my chest is affected, and there are signs that it will soon develop into a phthisis'; he goes on to say: 'It is the care and goodness of Mme de Warens which has sustained me, and which may yet prolong my life.' Having said this, Rousseau reproaches his father for his coolness towards Mme de Warens: 'All I have asked of you is that you give some small sign of appreciation of the generosity and benefits which she has so liberally showered upon me.' He says that since he knows his father is not a religious bigot, he cannot understand his failure to acknowledge Mme de Warens' kindness.

Another draft letter in the same notebook, dated 26 June 1735, indicates that Isaac Rousseau had responded to his son's prompting, for here we find Jean-Jacques writing: 'I was infinitely appreciative of the tender manner in which you wrote to Mme de Warens.' Even so, Jean-Jacques reminds his father somewhat sharply about the need to be prompt in answering letters, explaining that Mme de Warens is used to corresponding with kings and statesmen and receiving swift replies. This draft of June 1735 also reveals that Jean-Jacques had by that date recovered from his illness – 'as a result of the good care of Mme de Warens' – and that he had also been on a journey. The original wording (afterwards corrected in Rousseau's own hand) begins: 'Here I am, thank God, back at the house of Mme de Warens.' This particular journey was conceivably the mysterious trip to Besançon; the wording of the draft, obscure as it is, suggests that Rousseau had lately been engaged on some foolish enterprise which was known to his father: 'The more short-lived our faults,' he writes, 'the more they are forgivable. If this maxim is sound, never was a man more deserving of pardon than I.'

Isaac Rousseau was not unnaturally disturbed by his son's failure to settle down to some trade or profession, and evidently wrote to him in forceful language on the subject, for in the autumn of 1735 Jean-Jacques drafted a long reply[68] in which he seeks to justify his behaviour. He points out that preparation for a career in the Church or the law demands financial resources which he does not possess; and that learning a trade entails an apprenticeship and the investment of capital, and even though he has had some training in engraving, 'that trade has never been to my taste'. He can envisage only three possibilities open to him: to practise music, to be the secretary of an important person, or to be the private tutor of a gentleman's son. However, Jean-Jacques ends his letter by telling his father that his obligations to Mme de Warens are such that he feels he must remain with her, and 'render her whatever services are within my powers for the rest of my life'.

Rousseau had come to realize one thing which he did not mention in his letter to his father, and that was that he needed to improve his general education. Mme de Warens gave him some help in this direction, and

M. de Conzié* gave him some more. When Rousseau abandoned giving music lessons to the young ladies of Chambéry, he kept on his one male pupil, M. de Conzié, but M. de Conzié was really more interested in literature than in music and he transformed their daily music lessons into conversations about books, conversations wherein, one can imagine, the roles of teacher and taught were discreetly reversed. M. de Conzié had a particular liking for books of philosophy, and it was on his recommendation that Rousseau read Voltaire's *Lettres philosophiques*, which he says first stimulated his interest in such studies. He began, moreover, to buy books as well as read them. For example we find among his papers a letter[69] addressed to the Genevan bookseller and publisher Jacques Barrillot† ordering on credit a substantial number of books, including Bayle's *Dictionary* (which he urges Barrillot to take care in sending 'for I shall have difficulty in importing it'), the works of Cicero, *Géométrie pratique* by Manesson-Mallet, *Récréations mathématiques* by Ozanam, Johann Hofmann's *Lexicon universal*, Newton's *Arithmetica*, James Usher's *Annales veteris*, Bernard Lamy's *Éléments de mathématiques*, the ninth volume of Charles Rollin's *Histoire ancienne*, together with further volumes of Marivaux's *La Vie de Marianne* and Prévost's *Clèveland* to add to those he already possessed. Clearly, in the matter of buying books, Rousseau did not set a good example of the thrift he preached to Mme de Warens, but, on the other hand, this little library was the necessary instrument of his design of self-education. That he had such a design he explained in a letter written towards the end of 1736,[70] Rousseau being then in his twenty-fifth year, to his old benefactor, M. de Bonac, French Ambassador to the Swiss Confederation: 'I have now embarked on a programme of studies which I am pursuing as systematically as my health permits.'

An intellectually active life gave Jean-Jacques a new incentive to keep fit, and he came to believe that the chief reason why his health was bad was that he was obliged to live in 'the dark and melancholy house in Chambéry', a place which became the more unbearable after Mme de Warens had been forced by need for money to sell the little garden with the summer-house. Since her social life had lost its old sparkle, Mme de Warens herself also found less to enjoy in Chambéry, and she continued to live where she did only from fear of offending her landlord, Count de Saint-Laurent. Rousseau suggested a solution to the problem: that they should keep the lease at the Count's house for winter use and acquire a second residence in the country

* François-Joseph de Conzié (1707–89), Comte de Charmettes, Baron de Rumilly, having inherited Les Charmettes from his mother, installed himself in the estate near Chambéry in the winter of 1733–4. He had travelled widely and served at the Court of the King of Sardinia, but was only five years older than Rousseau.

† Jacques Barrillot (c. 1684–1748), a Lyonnais by birth, was received a burgess of Geneva in 1726, after having been established in trade in that city for twenty-one years. He published, among other authors, works by Montesquieu and Burlamaqui.

for the summer. It was a curious proposal to come from a champion of thrift, but Mme de Warens accepted it. With the help of M. de Conzié they found a modest retreat in the pretty valley of Les Charmettes, near M. de Conzié's own manorial dwelling. As Rousseau observed, 'the place was as secluded and solitary as if it had been three hundred miles away'.[71]

LES CHARMETTES

The valley of Les Charmettes is not very different today from what it was in Rousseau's time: at the foot of the hill the suburbs of Chambéry give way abruptly to unspoiled countryside, a peaceful, green landscape rising towards pre-alpine hills. In the *Confessions*, Rousseau writes: 'Along the valley of Les Charmettes, half way up the hill, there are several scattered houses very pleasing to anyone in search of an untamed and isolated sanctuary. After trying two or three houses, we finally chose the prettiest, belonging to a gentleman in the army named M. Noëray. The house was very habitable. In front of it, there was a terraced garden, with a vineyard above it and an orchard below. Opposite there was a little chestnut wood with a spring nearby, and higher up towards the mountains were meadows where cattle could graze: everything was available for the little country household we proposed to set up.'[1]

Even today, as the visitor climbs towards Les Charmettes, in the shade of numerous trees, between hedges scattered with wild flowers and a mountain stream rippling down beside the road, the scene which unfolds itself is ideally 'Rousseauesque', for this is just the kind of rustic and roughly cultivated nature which Rousseau taught the world to appreciate and to see through his eyes. About a mile up the hill, beyond the inn, a gate on the right-hand side of the road leads to what is now conserved as a Rousseau museum. The estate consists of a smallish gentleman's house, with a humbler dwelling connected to it, the buildings being surrounded by gardens, with orchards and meadows beyond. There are no longer any vineyards or beehives, as there were in Rousseau's time, but, for the rest, the place is very much as he describes the setting of 'the short happiness of my life'.[2]

After the dark misery of the apartment in Chambéry, everything at Les Charmettes was infused with joy. 'I rose with the sun, and I was happy. I saw *maman* and I was happy: I left her alone and I was happy, I explored the woods and the hillsides, I wandered in the valleys, I read, I was idle, I walked

in the garden, I picked fruit, I worked in the house, and happiness followed me everywhere. That happiness did not come from any one thing; it was entirely inward, and it did not forsake me for a single instant.'[3]

The exalted language of Rousseau's account of the days he spent at Les Charmettes has made some readers suspicious, and indeed several leading Rousseau scholars have claimed that the story in the *Confessions* of his life *en tête-à-tête* with Mme de Warens at Les Charmettes is largely fictitious,[4] even that the 'idyll of Les Charmettes' was a 'false idyll'.[5] The main evidence for this assertion is a lease of Captain Noëray's estate at Les Charmettes, signed by Mme de Warens on 6 July 1738. The publication of this lease by Guillermin[6] in 1856 not only cast doubt on Rousseau's statement that he moved into the house at Les Charmettes with Mme de Warens in 1736, but seemed to rule out the possibility of his ever having been alone there with her, for by the end of 1737 she had found another constant companion. More recent research[7] has vindicated Rousseau's testimony, by disclosing that the lease signed in 1738, and published by Guillermin, was a contract authorizing the exploitation of land belonging to Captain Noëray as distinct from a rental agreement for his furnished house. 'Les Charmettes' is the name of a valley, not, as has often been supposed, that of a single dwelling; and Mme de Warens can be shown to have occupied at different dates more than one house there. There is no reason to doubt that Rousseau spent the summer and autumn of 1736 with her at Les Charmettes as he says in the *Confessions*; he may well indeed have stayed with her there as early as the summer of 1735, and thus have experienced months of happiness with her in this peaceful valley before their life *à deux* ended in 1737.

In his *Confessions*, Rousseau speaks of their 'trying two or three houses' before they 'finally chose the prettiest'. They probably stayed in those less pretty houses no longer than this wording suggests. The situation of Captain Noëray was that of a landowner who was unable, because of military duties elsewhere, to live on his own estate, and who was obliged to depend on tenants. Until 1734, the farmhouse at Les Charmettes was occupied by a peasant named Jean Girod, who farmed the land on Captain Noëray's behalf. Then, in 1734, the Captain let the property, including the main house, to a man named François Fillou who, finding himself too poor to maintain the whole estate, sub-let part of it. It was probably as a sub-tenant of Fillou that Mme de Warens first lived at Les Charmettes. In 1737, Captain Noëray found a better tenant than Fillou, and in May of that year he signed a lease with Pierre Renaud. In September of the same year Mme de Warens rented a smaller house in the valley of Les Charmettes, on the other side of the stream. This house, known as the Maison Revil because it belonged to a Demoiselle Revil, was a simple dwelling, something between a cottage and a farmhouse. Mme de Warens probably kept it until the end of June 1738

when, by the terms of the lease published by Guillermin, she was able to take over the tenancy of the main Noëray estate, and to live there, not only as a summer resident, but as tenant-farmer with a domain to exploit. Her ambitions as an agriculturalist proved ruinous, but the only thing that Rousseau recalls in the *Confessions* as troubling him during his earlier months at Les Charmettes was his health. He grew weak and languid. A milk cure suggested by Mme de Warens proved ineffective; a course of mineral waters had even more unfortunate results, for giving up the wine he appreciated so keenly only served 'to ruin my stomach completely'.[8] There followed palpitations, insomnia and 'buzzings in the head, which have continued to afflict me for thirty years'.[9] The shortness of breath that was produced by any physical exertion convinced him that he had not long to live. But even this illness Rousseau was able to consider as a blessing in disguise, if only because it renewed his interest in religion and so provided another bond of union between himself and *maman*; for, while he could not follow her on matters of morals, he felt close to her in his views on metaphysics. 'Finding in her all the principles I needed to guarantee my soul against the terrors of death and the after-life, I drew a sense of security from that source of faith. I attached myself to her more closely than ever. I would have gladly transmitted to her the life which I felt would soon cease to be mine.'[10] Even so, Mme de Warens was not the only source of Rousseau's Christian inspiration at this period of his life. His most frequent reading then was of Jansenist authors; such books, he says, 'made me half a Jansenist'[11] – an avowal which may seem to confirm the judgement of those critics who see Rousseau as a successor of Pascal. On the other hand, during those early months at Les Charmettes, Rousseau had as his confessor, as had Mme de Warens, a Jesuit, Father Hémet,* and he also enjoyed at that time† the friendship of another Jesuit priest, Father François Coppier,‡ 'who often came to see us at Les Charmettes'. Rousseau explains: 'So intimately is my memory of that happy time connected with my recollection of those Jesuit fathers, that I love them because of it, so that while I have always considered the teaching of the Jesuits to be dangerous, I have never really found it in my heart to hate them.'[12]

In the winter, when Rousseau returned with *maman* to Chambéry, he found another antidote to Jansenism in conversation with his physician, Salomon,§ a keen amateur philosopher and a champion of the rationalist metaphysics of Descartes. Rousseau considered Dr Salomon's talk about

* Charles Hémet (1680?–1738).

† Father Hémet died on 22 May 1738, a date which provides further confirmation of the residence of Mme de Warens and Rousseau at Les Charmettes before the famous lease of 6 July 1738 was signed.

‡ François Coppier (Grenoble, 1679–Chambéry, 1768).

§ Jean-Baptiste Salomon (*c.* 1683–1757) was in practice in Chambéry from 1728 until his retirement.

Descartes more beneficial than his prescriptions; in the lugubrious apartment in Chambéry, no medicine did him much good. However 'as soon as the snows melted, we went back to Les Charmettes in time for the first song of the nightingale',[13] and there his health immediately improved. And just as Mme de Warens inspired in him a love of God, so did he seek to inspire in her a love of nature. Since she was by temperament a worldly woman, at home in the salon and averse to rusticity, he may not have found her a ready pupil, but he says he succeeded at Les Charmettes in making her love her garden, her farmyard, her pigeons, her cows; and in doing so, he came to love them all the more himself. Moreover, in the springtime at Les Charmettes, Rousseau no longer dreaded an early death, even though he still felt weak and could not contemplate digging the soil or any other heavy work. He was content to watch over the bees and the dovecot, look after the garden, and devote most of his time to reading. He has left us an account of how he spent the hours of the day. He rose every morning before sunrise and went up through the orchard to a path in the meadows, and then, as he walked, he prayed: 'those prayers were the true voice of a heart going up to the Creator of the Nature whose beauty my eyes beheld'.[14] Rousseau could never pray inside a room: he felt he could speak to God only when he was close to God's works, and even then, he says, he never asked God, either on behalf of himself or *maman*, for anything more than 'an innocent and tranquil life, free from evil and pain and dire need, and then to be allowed to die in justice and live in the world to come'.[15] For the rest, he says, his prayers were composed more of expressions of adoration than of appeals for divine favour.

Returning to the house from his morning walk, he would look to see if *maman*'s shutters were open; and as soon as he received that signal he hurried to her room to give her a kiss in bed; then they lingered over a breakfast 'served at the table in the English or Swiss manner',[16] and after an hour or two of conversation he returned to his books and studied until midday. If luncheon was not then ready, he would pass the time doing light gardening. He always ate heartily – 'for however ill I might be, I always had a good appetite'[17] – and he ate quickly while Mme de Warens made her usual dilatory progress through the meal. At least two or three times a week, if the weather was fine, he would sit with *maman* after luncheon in the arbour he had made behind the house, happily lingering over their coffee. This would be followed by a leisurely inspection of the flowers and vegetables, and a visit to 'my friends the bees', about which he writes: 'we soon became so well acquainted that they never stung me. All animals mistrust man, and rightly so; but once they are sure he does not mean them any harm, their trust becomes so great that it would be barbarous to abuse it.'[18]

In the afternoons, Rousseau returned to his books, reading at that time for

amusement rather than instruction. One way and another, every hour was filled with happiness: 'my heart, still young, surrendered itself to the joys of a child, or, if I may dare to say so, to the raptures of an angel; for in truth those tranquil pleasures of Les Charmettes had the serenity of paradise itself'.[19]

The routine would occasionally be varied by picnics in the meadows, and sometimes Rousseau and *maman* helped the peasants strip hemp or pick fruit, or take part in the harvesting of grapes, this last being a melancholy duty which heralded the end of the season in the country and their return to Chambéry.

Since Rousseau's recollection of his life at Les Charmettes has been dismissed as fantasy by so many authors, it is worth noting the testimony of another witness, his neighbour at Les Charmettes, M. de Conzié:

'The grace of Mme de Warens' conversation, the quality of a mind already cultivated by wide reading, made her exceedingly attractive and agreeable to talk with, and drew me closely to her house in Chambéry, where I went daily, and where I often took meals with Jean-Jacques, whose education she had already begun. She treated him always in the spirit of a tender and benevolent mother, combined with that of a benefactress, to whom he responded with docility and even submissiveness.

'After staying for some years at Chambéry, she took a country property close to mine, and this enabled me to continue to pay my respects to her and to meet Jean-Jacques almost daily. His marked taste for reading prompted Mme de Warens to urge him to devote himself wholly to the study of medicine, but this was something to which he would never agree . . .

'It was in this country house that Jean-Jacques started scribbling, both in prose and in verse, on different subjects. He used to read his writings to me, rather, I think, as to a neighbour than to someone from whom he wanted any critical appraisal – and in this he was right.'[20]

M. de Conzié's memoir suggests that Rousseau was more industrious at Les Charmettes than he himself recalls in the *Confessions*, and it seems to be the case that it was during his period of happiness there with Mme de Warens that Rousseau discovered his own true *métier* as a writer.* It is not difficult to visualize him in that setting. M. de Conzié's house has long since been demolished, as has the Maison Revil; but the Maison Noëray, now the Musée Rousseau, has been fairly well preserved, and the visitor to Les Charmettes can still contemplate a scene that numerous engravings of the nineteenth century have made part of the imagery of romanticism. The house is conventional and geometrical in its design, following the best cartesian principles of seventeenth-century French domestic architecture, but

* Rousseau made his debut in print in 1737 as the author of a song entitled 'Un papillon badin' in the *Mercure de France*.

the surroundings of trees and meadows proclaim the supremacy of nature, and the patina of time has made the grey stone walls of the house itself merge all the more discreetly into the landscape. Above the front door can still be seen the arms, carved in stone, of the Noëray family. There are not many rooms, but all have the size and balanced proportions of a gentleman's residence, as distinct from any kind of farmhouse or cottage. On the ground floor, paved with earthenware tiles, there are Italianate mural decorations which seem to date from the eighteenth century, but no fireplace or stove, which may explain why Mme de Warens considered the house to be uninhabitable in winter. On the first floor, there is a smallish bedroom, said to have been Rousseau's, with a bed set in an alcove, very like the arrangement at the cottage he later occupied at Montlouis, Montmorency. The two windows afford a splendid panorama of the Savoyard landscape. Nearby is a room, arranged as a chapel, which may well have served for *maman*'s devotions, while Rousseau preferred to say his prayers in the open air. This chapel leads to the best room in the house, which was probably Mme de Warens' bedroom; it has a fireplace and three large windows commanding magnificent views. Paintings of doubtful authenticity now on view must have been added at a later date, while the wallpaper, furnishings and other fittings to be seen there are unlikely to be anything that belonged to Mme de Warens. Even so, enough remains of the house and of the environment to make Les Charmettes one of the very few places known to Rousseau which time has not ruined or annihilated, and where today's visitor can, for once, believe that he is seeing something which Rousseau himself might recognize.

The year 1737 was to be a crucial one in Rousseau's life. Events began literally with a bang. He was trying to make, according to instructions given by Ozanam in his *Récréations mathématiques*, some sympathetic ink, when a bottle half-filled with quicklime, sulphide of arsenic and water exploded in his face. Rousseau says he swallowed so much of the sulphide that it almost killed him: 'I was blinded for more than six weeks: and I learned from this experience not to meddle in experimental science without any knowledge of its principles.'[21]

Rousseau was so panic-stricken by this episode that he promptly wrote a will,[22] naming the 'Comtesse de Warens' as his heir, and bequeathing sixteen *livres* each to three religious orders to say masses for the repose of his soul. He left to his father that portion of his estate which the law required, and he acknowledged, among his debts, two thousand *livres* owing to Mme de Warens 'for board and lodging over the past ten years' and 'seven hundred *livres* owing to Jean-Antoine Charbonnel, merchant of Chambéry, for loans and for merchandise'. The reader may well wonder what estate Rousseau had at that time to bequeath to anyone, but the fact is that in 1737 he had at last some property within his grasp: for in that year he

achieved what was held in Geneva to be his majority, the age of twenty-five. Unlike the harsh laws of Berne, which deprived all who converted to Catholicism of their rights to property – laws under which Mme de Warens herself had suffered – the laws of Geneva stripped converts only of their rights to citizenship; and Rousseau was now entitled to claim possession of the estate which had been bequeathed to him by his mother. His birthday fell on 28 June 1737, and he set off promptly to claim his own – and to claim, in addition, that moiety of his mother's estate which had been left to his brother, François, of whose death he was now convinced, and hoped to be able to convince the authorities of Geneva.

As an apostate, Rousseau was not, in principle, permitted to reside in Geneva; and although he had stayed in the city on previous occasions since his conversion, and was to do so again, he was advised this time to follow the letter of the law and remain outside the city gates. He installed himself at an inn on the frontier, and there he fretted. The time was inopportune, Geneva being on the brink of civil rebellion. Rousseau's attitude to his native city remained ambivalent; and although he speaks in the *Confessions* of patriotic feelings that were stirred in him whenever he set eyes on Geneva, this time he was worried more about his property than about the city. The confrontation within the republic between the conservatives, supporting the existing system dominated by the patrician families, and the liberals, who were once again demanding recognition of citizens' rights, might be supposed to have excited Rousseau's interest as it approached its climax. His letters show that he was concerned about those happenings only because they delayed the settlement of his inheritance. He had given power of attorney to the bookseller Barrillot, whom he described as the 'worthiest man I have ever known'[23] and who sometimes called him his 'grandson'; but he felt that Barrillot, who was deeply involved in politics, was not moving swiftly enough in attending to the matter of his money. Some time in July, Rousseau began a letter[24] to *maman* complaining that he had not seen M. Barrillot since the previous Thursday, and that he was still 'shut up in my inn like a real prisoner . . .' The letter continues:

'Yesterday, impatient to know the state of my affairs, I wrote to M. Barrillot to tell him in rather strong language about my anxiety. His answer was "Rest assured, my dear Monsieur, all is going well. I believe that every-thing will be completed by Monday or Tuesday. I am in no condition at present to come out to you: but I will do so as soon as I can." So you see, *Madame*, how I am placed. I am as little informed of my affairs as if I were a hundred leagues from here, and I am forbidden to present myself in the city. What with all this – being always alone, paying out large sums, plus the fee charged for me to get hold of my wretched money, plus the cost of a visit to the doctor and the medicines he prescribed, you may well imagine that my

purse is empty; in fact I am pretty heavily indebted to this tavern ... To tell the truth if all this goes on much longer I shall begin to believe that they are all fooling me, and that I shall end up with only the shell of the oyster.'

Fortunately for Rousseau, M. Barrillot appeared at the inn before he had finished this letter, bringing with him an assurance that his case was being dealt with expeditiously thanks to the intervention of the French Resident. Once again Rousseau was lucky, for the French Resident was his friend M. de la Closure, his mother's old admirer (he who was alleged by the *méchantes langues* to have been her lover during his father's absence in Constantinople).

After more than twenty-five years, M. de la Closure was still at Geneva and still mindful of an old friend: 'he often spoke to me kindly,' Rousseau writes, 'about my mother.'[25] M. Barrillot promised Rousseau that he would receive his share of the estate within two or three days, as Rousseau reported to Mme de Warens, adding: 'I have not yet written to my father, nor seen any of my relations, and I have been told to maintain the same *incognito* until the cash is actually paid.'[26]

Rousseau received the money on the appointed day, but he was disappointed with the amount he received. The sum of 30,000 florins which had been paid in 1717 for the house belonging to his mother had somehow diminished to 13,000 florins. Moreover, he was unable to establish his claim to his brother's share: so all he received was 6,500 florins. He evidently realized that his father, continuing to enjoy the usufruct of the brother's moiety, would do nothing to help him obtain that capital. But at least Rousseau had some money of his own in his pocket and, with the immediate problem settled, he went into the city of Geneva, putting up, in all probability, at the house of his aunt Mme Bernard. He arrived in time to witness the dispute between the government and the discontented citizens flare up into violence: he was there on the historic 21 August 1737 when the rebel liberal forces stormed the garrison. He was, however, more shocked than thrilled by those events, and what shocked him most was seeing M. Barrillot and his son* coming out of the same house armed to fight on opposite sides in the civil war 'with the prospect of cutting one another's throats'.[27] In his *Confessions* Rousseau says: 'This terrible sight made such a deep impression on me that I swore there and then never to take part in any civil war, and never, if I were to regain my citizenship, to struggle for liberty by taking up arms, either in person or through a proxy.'[28]

Rousseau did not omit while he was in Geneva to pay his respects and express his thanks to M. de la Closure, and was duly impressed by the Resident's efforts to persuade both sides in the Genevan conflict to accept French mediation. Rousseau made his own plea for reconciliation in a poem he

* Jacques-François Barrillot (1709–50) was a partner of his father in the same bookselling and publishing business.

wrote soon afterwards entitled *Le Verger de la Baronne de Warens*,* but his concern for the travail of his homeland was not intense enough to make him linger in Geneva. M. de la Closure's efforts were, in the end, successful, and the French mediator appointed was none other than the Comte de Lautrec, whose acquaintance Rousseau had made in the salon of Mme de Warens, and who had once held out to him the possibility of a job. Mme de Warens thought the appointment of M. de Lautrec in Geneva presented a golden opportunity for Rousseau to take up the offer, and urged him to apply for the post of secretary. But by that time Rousseau had lost interest in the idea. For no sooner had he ceased to worry about his inheritance than he began to worry once more about his health. He became ill again.

In the *Confessions*, he describes his return to Chambéry in triumph as the owner for the first time in his life of a fair sum of money: he had invested a part of his inheritance in books bought at Geneva; 'the rest,' he says, 'I flew to put at the feet of *maman*'.[29] He recalls how his heart beat with joy on the road and afterwards: 'the moment when I placed the money in her hands was a thousand times sweeter than the moment when the money had been placed in my hands. She received it with the simplicity of those pure souls, who, doing such things without effort themselves, feel no admiration when they see them done by others. The money was put almost wholly to my own use: and this, too, was done with an equal simplicity.'[30]

Rousseau's visit to Geneva had one curious aftermath: earlier in the year 1737, he had been flattered to be asked to stand godfather at the christening in Chambéry of Jean-Jacques Rateri, where the godmother was Mme Coccelli, wife of the Inspector-General of Customs. This led him to seek to ingratiate himself with M. Coccelli, and in spite of having written in his poem *La Verger de la Baronne de Warens* such patriotic lines as *'Genève jadis sage, ô ma chère Patrie'*,[31] he actually gave Genevan state secrets to an official of the Kingdom of Sardinia.

In the *Confessions* he says he found among the papers of his Uncle Bernard in Geneva a classified memorandum on the fortifications of that city prepared by Micheli du Crest,† a military scientist and topographer as well as a member of the Council of Two Hundred and a radical opponent of the government. Rousseau's uncle had, it will be recalled, worked as a military engineer in Geneva; later he emigrated to America to help with the building of the city of Charleston, where he died in July 1737. His death, and that of Rousseau's cousin Abraham in the service of the King of Prussia, softened somewhat the attitude towards Rousseau of his Aunt Bernard, and she

* Published, in a small edition, in 1739.

† Jacques-Barthélemy Micheli du Crest (1690–1766), after service in the French army, returned to Geneva and drew up a memorandum criticizing the defences of the city. Privately printed at Strasbourg, the memorandum was impounded in Geneva. The author was driven into exile because of his radical utterances.[32]

allowed him to 'rummage among the papers'[33] his uncle had left at home in Geneva. It was there, Rousseau says, that he found the copy of Du Crest's memorandum that had escaped confiscation by the Genevan police. He explains that he foolishly handed this document to M. Coccelli, mainly 'to show him that I was connected with important people of Geneva, who were privy to state secrets'.[34] Rousseau claims that he tried afterwards in vain to recover the memorandum, but realized that it had already been forwarded to Turin. He adds: 'I shall never cease to reproach myself for the stupid vanity of revealing the weakness of the defences of Geneva to Geneva's oldest enemy.'[35]

If Rousseau really did obtain Du Crest's memorandum while 'rummaging' among his late uncle's papers, he could not have given it to Coccelli until a considerable time after the christening of the infant Rateri because it was not until a year later that he learned of his uncle's death. In a letter[36] written not earlier than August 1738 we find Rousseau sending condolences through his Aunt Fazy to his Aunt Bernard on her bereavement. However, this letter prompts the suspicion that Rousseau was even more culpably unpatriotic than he admits in the *Confessions*, for it actually contains a request to be passed on to his widowed aunt: 'If she still has any manuscripts belonging to my late uncle which she does not wish to preserve, she can either send them to me or keep them for me. I will try to find the means of paying what they are worth.' What renders this message the more suspicious is that there appear on the back of the same sheet of paper some studies of fortifications with notes. Had Rousseau been drawn by Mme de Warens into the world of espionage?[37]

We do not know. We only know that having cast his inheritance at the feet of *maman*, and picked most of it up again, he was soon out of the house once more. The reason he gives in the *Confessions* is that he went off in search of health. 'I was visibly fading away: I was as pale as a corpse and as thin as a skeleton.'[38] Moreover, Rousseau had read so many works about physiology and anatomy that he believed he could diagnose his own condition; and what he diagnosed was 'a polyp on the heart'.[39] Mme de Warens told him that Dr Fizes* of Montpellier had once successfully treated such a case, and this was enough to determine Rousseau to go at once to Montpellier; the new inheritance would cover the expenses, and '*maman*', as Rousseau puts it, 'implored me to go'.[40]

There may well have been another reason, both for Rousseau's desire to leave and for Mme de Warens to speed him on his way; and that was the arrival in Mme de Warens' household of a young man named Wintzenried. In the *Confessions* Rousseau says he did not take much notice of Wintzenried

* Antoine Fizes (1690–1765), Professor of Medicine at Montpellier and author of books on the diseases of the various human organs.

when that young man first appeared on the scene, but the letters he wrote at
the time reveal that he already knew that things were not as they had been
between Mme de Warens and himself. His first letter[41] to *maman* from
Grenoble, where he stopped on his way to Montpellier, is cheerful enough,
even euphoric: 'I could not be more satisfied with any town than I am with
this one. I have received so many marks of friendship and invitations that I
feel that in leaving Chambéry I have entered a new world.' Again he repeats
that his only worry is about his health. The night before, he tells *maman*, he
was taken ill at the theatre, at a performance of Voltaire's *Alzire* which,
though poorly acted, excited him so much that it brought on palpitations.
He expresses the hope of receiving soon a letter from *maman*.

That hope was disappointed. Over five weeks later[42] we find him writing
to Mme de Warens from Montpellier protesting that he has not received a
word from her: 'You will believe that I have not had much peace of mind
... and that my greatest anxiety arises from the fear that some accident may
have befallen you.' However, it seems that before he had finished writing
this letter, he received at last from *maman* a letter in which she must have
addressed some reproaches to him, for we find him protesting his innocence
and promising to prove it in person, 'not, if you please, next June, but at the
beginning of January or February'. He continues in the same indignant tone:
'You urge me to stay here until St John's Day [24 June], something I would
not do if I were covered in gold ... I have decided to leave here towards the
end of December, and take the cure of asses' milk in Provence, at a pretty
place six miles from Saint-Esprit.'

The significance of this last project, if concealed from Mme de Warens, is
revealed to readers in the *Confessions*, where Rousseau tells of an adventure
he had on the road from Grenoble to Montpellier. What had happened was
that he had fallen in with a party of agreeably upper-class travellers which
included a Mme de Larnage and the Marquis de Taulignan. Mme de Larnage
was, according to Rousseau's description, very attractive without being
either young or beautiful – she was indeed, though he does not say so, forty-
four years old and the mother of ten children – and his only criticism of her
is that she spoiled her complexion with too much rouge. The marquis, old
but sprightly, had designs on Mme de Larnage, but evidently she preferred
young Rousseau, and was undeterred by his excessive bashfulness. Rousseau
told his fellow travellers that he was going to Montpellier for health reasons
and, fearing that a Swiss convert would be despised in elegant French
society, he said he was an English Jacobite named Dudding. The marquis
had some knowledge of the Pretender, but Rousseau says he was able to keep
up the bluff on the strength of what he had read in a book about the
Jacobites, and that, by good fortune, no one asked him to speak English, 'a
language of which I knew not a single word'.[43] However, he adds that he

almost ruined his charm for Mme de Larnage by appearing excessively
devout at mass. Almost, but not quite; and she pressed her attentions on him
despite his bewilderment and shyness. The sarcastic remarks of M. de
Taulignan, who quickly noticed her preference for youth, provoked no sense
of triumph in Rousseau; they only made him think the two of them were
conspiring together to make fun of him.

When their carriage stopped for the night at Valence, Mme de Larnage
made herself understood at last by taking Rousseau for a walk after dinner,
pressing his hand to her heart while he recited to her all the details of his
illness; then, as her increasing solicitude made him fall silent with embarrass-
ment, she threw her arms round his neck and gave him, on the lips, a kiss
which ended all doubts. 'If I were to live a hundred years,' Rousseau writes,
'I should always remember this charming woman with pleasure ... One
might see her without loving her, but one could not possess her without
adoring her; and that proves, I think, that she was not always as generous
with her favours as she was towards me. She had been stirred by a desire too
sudden and too intense to be excusable, but it was a matter of the heart as
well as the senses, and during the short and delicious time that I spent with
her, I had reason to believe, from the restraint she imposed on me, that
however sensual and voluptuous she might be, she attached more importance
to my health than to her own gratification.'[44]

M. de Taulignan, evidently a sporting loser, gave no sign that he realized
what was going on: indeed, says Rousseau, 'he treated me more than once as the
poor bashful lover who was a martyr to his lady's cruelty';[45] not only was the
marquis courteous, even in his raillery, he actually paid for all the meals the three
of them took together on their journey. Even so, it seems that the marquis was
optimistic enough about his own chances with Mme de Larnage to send his valet
ahead on the road to secure him a bedroom next to hers at the inns where they
stayed and to reserve a room for 'Mr Dudding' as remote from hers as possible.
This arrangement, says Rousseau, only made his nightly rendezvous with Mme
de Larnage 'the more exciting';[46] and soon their days together became as
delightful as their nights, for Mme de Larnage contrived to have him travel in
her carriage alone with her, in place of her maid. Comparing his experience of
sexual congress with Mme de Larnage to that with Mme de Warens, Rousseau
wrote: 'With *maman* my pleasure was always overcast by a feeling of
melancholy, and a constriction of the heart which I could not easily overcome.
Instead of priding myself on possessing her, I reproached myself for degrading
her. With Mme de Larnage, on the contrary, I was proud to be a man and to be
happy; I surrendered myself to my senses with joy and with confidence; I shared
the feelings I stirred in her. I had enough self-possession to contemplate my
triumph with as much vanity as sensuality, and to derive from this the strength
to repeat it.'[47]

By the time they reached Montélimar, the marquis had gone off in another direction, and the lovers lingered alone in that town for three delectable days, before they resumed their journey. At Pont Saint-Esprit, where they crossed the Rhône, their roads parted. 'Travellers' love-affairs,' says Rousseau, 'are not meant to last.' He, being physically exhausted by this time, was not wholly sorry to leave his mistress for a while and go on to seek Dr Fizes in Montpellier. Besides, it was not intended to be a final parting; Rousseau promised that he would rejoin Mme de Larnage in her own town of Bourg-St-Andéol for the rest of the winter to continue his cure in her company. Sweet memories of his new conquest kept Rousseau happy as he travelled on to Montpellier: 'The rest of the universe meant nothing for me any more: even *maman* was forgotten.'[48] His health continued to worry him, despite the fact, as he admits, that the adventure with Mme de Larnage had cured all the symptoms of a polyp on the heart; but Mme de Larnage herself made him promise to see the best doctors in Montpellier and do whatever they advised. 'Before our parting she tried to share the contents of a fairly well-filled purse with me, and I had much difficulty in refusing.'[49]

On the way to Montpellier, Rousseau found time to visit, as a life-long admirer of things Roman, the Pont du Gard, which thrilled him, and the arena at Nîmes, which disappointed him because it had been allowed to fall into such disrepair: 'the French,' he complains, 'preserve nothing, and have no respect for ancient monuments';[50] but once at Montpellier he hastened in search of Dr Fizes. 'On the road I had forgotten I was ill; on reaching Montpellier I remembered it.'[51] He had no difficulty in finding the celebrated professor of medicine but he does not tell us how the consultation went, recalling only that he was put on a diet based on china root, whey and mineral waters. He soon came to realize that Dr Fizes and the other doctors of Montpellier considered him a hypochondriac: 'they had no knowledge of my illness: therefore they concluded I was not ill'.[52] He felt he was being cheated. Even so, the account he gives in the *Confessions* of his stay in Montpellier is a cheerful one. He describes how he went *en pension* with an Irish doctor named Fitzmorris, who took in a number of medical students as boarders; Rousseau was pleased to be in a place where the charges were low and medical advice given free, but the frugality of the victuals, if in accordance with Dr Fizes' dietary instructions, he appreciated less. Nevertheless, he found the company lively; and after he had spent his mornings drinking mineral waters and writing letters to Mme de Larnage, he would, as he recalls, 'go for a walk with one or other of the students, who were all very good fellows, to Le Canourge, and at that place we dined together. After dinner most of us were taken up with important business until the evening; that is to say, we went out of town for refreshments and two or three games of pall-mall. I did not play myself, having neither the strength nor the skill,

but I placed bets on the games, and as I followed the players and their bowls with all the enthusiasm of a gambler across rough and stony paths, I enjoyed a vigorous and healthy exercise that suited me. We took our refreshments at a tavern outside the town, and I have no need to say that those sessions were gay; I will only add that they were exceedingly proper, although the girls at the tavern were pretty enough. Dr Fitzmorris, a great pall-mall player, was our leader, and I can testify that despite the bad reputation of students, the manners and morals of these young people were better than could be easily found among as many older men. They were noisy rather than dissolute, merry rather than bawdy, and since I can adapt easily to any way of life that is not forced on me, I could not have wished better than to see this go on for ever.'[53] The one serious activity Rousseau mentions here is his trying to learn some English from the Irish students in preparation for his resumption of the role, with Mme de Larnage at Bourg-St-Andéol, of 'Mr Dudding'.

Such is the account of his life at Montpellier which he gives in the *Confessions*. The letters he wrote at the time strike an altogether different note. He has not a good word to say about Montpellier in any of them; and he does not even mention Dr Fitzmorris. In one letter[54] he says he is lodging with M. Marcellan, *huissier* of the Stock Exchange, in the rue Basse near the Palace; and in another[55] he speaks of his hostess as Mme Mazet; it is possibly the case that M. Marcellan provided only the bed and that his board was supplied at Dr Fitzmorris's house by Mme Mazet, who ran the *pension* on behalf of the doctor; or perhaps he moved from place to place. At all events, there is nothing in those letters to suggest that Rousseau was enjoying himself at Montpellier in the company of medical students.

Writing in November 1737 to Jean-Antoine Charbonnel, the draper of Chambéry who had lent money to him as he had lent it to Mme de Warens, Rousseau expressed only disgust with life at Montpellier: 'It is a large and heavily populated city divided into a labyrinth of dirty winding streets, six foot wide, where splendid mansions alternate with wretched hovels full of mud and dung; half the inhabitants are very rich and the other half live in extreme misery: all are equally wretched in leading a life that is as base and mean as you could imagine. The women are divided into two classes – there are the ladies, who pass the morning painting their faces, the afternoon at cards, and the night in debauchery; and there are the others, whose only occupation is the last of these three.'[56] Rousseau went on to complain that strangers in Montpellier were treated worse than Protestants in Italy or Jews in Spain; 'they are simply seen as a species of animal expressly designed to be pillaged, robbed and bludgeoned'.[57]

In the same letter Rousseau confided to Charbonnel that he had run out of money, hoping, no doubt, for another loan. He explained that his landlady, Mme Mazot, had died and that he had had to settle his debts with her heirs;

and although 'a decent Irishman has lent me sixty *livres*', his debts had driven him to sell all the belongings he could part with, and to gamble with the proceeds – to gamble, perhaps, on the games of pall-mall arranged by Dr Fitzmorris: 'It is not that I have any taste for gambling: but my situation cannot be worse than it is if I lose, and it will be saved if I win.'[58] Rousseau also told Charbonnel of his intention to leave Montpellier 'for a little place near Saint-Esprit where for less money and in a better climate, I can resume my little cure in greater tranquillity, comfort and success, I hope, than I have experienced in this town'.[59]

A month or so later, Rousseau drafted a strikingly ill-tempered letter to Mme de Warens,[60] in which he reproached her for not dating her letters to him, for not acknowledging his letters to her, and for having muddled the transfer of a letter of credit for two hundred *livres* in such a way that it could not be cashed. Again he spoke of his poverty, of his having not enough money to buy the medicines that had been prescribed by the doctors at Montpellier; and without mentioning the name of Mme de Larnage, he announced his intention of going to Saint-Esprit.

It is evident from the wording of this letter that things were not what they had been between Jean-Jacques and *maman*; despite what he says in the *Confessions* about his having no inkling of the significance of Wintzenried's advent in her household until he returned from Montpellier the following spring, he must have already known by the end of 1737 that he had lost his monopoly of her heart. In a postscript to this letter, the tone changes from one of reproach to one of self-pity: 'O my dear *maman*, I would rather be with D.* and set to the most humble labour in the world than possess the greatest fortune in other circumstances. It is untrue to think that I could live otherwise. I have been saying this to you for a long time, and I feel it now more ardently than ever. If I have that one privilege, it is a matter of indifference to me what condition I am in. Thinking like this, it is not difficult for me to avert my mind from those things that you do not wish to tell me. In the name of God, arrange matters in such a way that I do not die of despair. I will agree to everything. I will submit to anything, except to that one article to which I am in no state to consent to, for then I would be the prey to the most wretched fate. Ah, my dear *maman*, are you then no longer my dear *maman*? Have I lived a few months too long? You know there is one case in which I would accept the situation with the full joy of my heart. But that case is unique. You will understand what I mean.'

Another sentence in the same letter refers to Mme de Warens' efforts to secure a post for Rousseau on the staff of the Comte de Lautrec, the French mediator in Geneva, whose negotiations, started in November 1737, were to

* The identity of the person indicated by the letter 'D' is uncertain. Leigh suggests Dumoulin, the valet.[61]

end in the settlement of April 1738. Rousseau says: 'You have already received my reply with regard to M. de Lautrec.' It must have been a negative reply, for Rousseau did not then believe himself to be well enough in health to undertake any arduous work.

According to the *Confessions*, he left Montpellier with the intention of going to Bourg-St-Andéol to rejoin Mme de Larnage, whose letters to him in Montpellier had been more numerous than those from Mme de Warens. On the road, he began to have doubts. He says that thoughts of *maman* banished his desire for more adventures. Besides, he became anxious about his own imposture; for he had kept up in his correspondence with Mme de Larnage the pretence of being an English Jacobite. What if he were unmasked at Bourg-St-Andéol? What if Mme de Larnage's family objected to his presence? Supposing he were to fall in love with Mme de Larnage's daughter? Why, he asked himself, should he run all these risks for the sake of repeating a sexual experience he had already enjoyed?

The *Confessions* continues in that faintly priggish vein which betrays the Calvinist in Rousseau: 'On top of those reflections came the thought of my station and its duties, reminding me of my poor *maman* weighed down with debts and incurring more with her extravagance, my generous *maman*, draining herself dry for my sake while I was deceiving her so shamefully. My remorse became so intense that in the end it triumphed. When I reached Saint-Esprit I decided to give up the idea of turning off towards Bourg-St-Andéol and to go instead straight on to Chambéry.'[62]

In these pages, Rousseau paints a dramatic picture of his homecoming at Les Charmettes. He says he had sent word ahead of his arrival, in the hope that *maman* would come out to greet him. 'My heart beat faster as I approached the house. I was out of breath from walking, because I had left the carriage in the town. When I saw no one in the courtyard, at the door or at the windows, I began to feel anxious; I feared that some accident had happened. I went inside. Everything was quiet. Some workmen were eating in the kitchen, but no preparations had been made to welcome me. The maid seemed surprised to see me: she did not know I was expected. I went upstairs, and at last I saw my dear *maman*, whom I loved so tenderly, so ardently, so purely. I ran to throw myself at her feet. "Ah there you are, *petit*," she said, kissing me. "Have you had a good journey? How are you?" This reception disconcerted me a little. I asked if she had received my letter. She said she had. "I would have supposed you had not," I said: and explanations ended there. A young man was with her. I recognized him from having seen him in the house before my departure, but this time he seemed to be established there, and indeed he was. In short, I found my place taken.'[63]

The young man was Jean-Samuel-Rodolphe Wintzenried, about whom

Rousseau has, very naturally, little good to say. He describes him as a hair-dresser, the son of the caretaker – 'or self-styled captain' – of the *château* of Chillon on the shores of Lake Geneva. Wintzenried was thus, like Mme de Warens herself, a Vaudois. He was six years older than Rousseau, who saw him as a 'tall, pale, rather well-built man with a flat face and dull wits, whose conversation betrayed all the affectation and bad taste of the hair-dresser's trade, remembering only half the marchionesses he has slept with, and claiming never to have dressed the hair of a pretty woman without cuckolding her husband.'[64] Rousseau nevertheless hastens to add that for all Wintzenried's vanity, stupidity, ignorance and indolence, he was a likeable fellow, always eager and dutiful in carrying out errands for Mme de Warens. Rousseau could see clearly enough that Wintzenried was everything that he himself was not. An enthusiastic, noisy worker in the house and fields, happily swinging an axe or loading a wagon, the newcomer made a great show of muscular strength. He was only inadequate in the more delicate aspects of gardening, where Rousseau excelled. Plainly Wintzenried might offer Mme de Warens greater satisfaction as a lover than Rousseau could: equally plainly Mme de Warens could not satisfy Wintzenried as a mistress and he soon started sleeping with a chambermaid. Even so, Rousseau says in the *Confessions* that he would not have suspected that Wintzenried was Mme de Warens' lover if she had not told him; and then he was less shocked by the truth than by the calmness of her avowal and by her casual suggestion that Rousseau should continue to enjoy his intimacy with her, living *à trois* in a spirit of harmony. 'No *maman*,' he recalls replying, 'I love you too much to degrade you.'[65]

Mme de Warens nevertheless made it clear to him that the condition of his remaining at her house was that he should treat Wintzenried as a brother. The role that Claude Anet had been called upon to enact for him was now the role that Rousseau was expected to perform for Wintzenried. It was not a part that appealed to him; as Rousseau points out, he was younger, not older, than the newcomer; he had nothing of Anet's calm, authoritative, patient temperament; and Wintzenried had none of Rousseau's docility, nor any of the affection and respect that Rousseau claims he had for Anet. Indeed, Rousseau complains that Wintzenried quickly assumed the airs of a gentleman, not only towards the peasants, but towards Mme de Warens and himself, and in time 'even the name of Wintzenried seemed insufficiently aristocratic for him, so he gave it up for that of Monsieur de Courtilles'.[66]

It should perhaps be said on behalf of Wintzenried, against these bitter words from a rival he had displaced, that his social status as a former hair-dresser was scarcely inferior to that of Rousseau as a former footman; and that his development into a gentleman under Mme de Warens' tuition was not very different from Rousseau's own transformation; besides, the name of

'de Courtilles' was one to which he was perfectly entitled, since his birth certificate[67] in the Vaud records his being the son of 'M. le Châtelain et justicier Wintzenried de Courtilles'. The French part of the name was obviously more useful in the duchy of Savoy than the German part; and to say the least, he had as good a claim to call himself 'M. de Courtilles' as his mistress had to call herself the 'Baronne de Warens', and a far better claim than Rousseau had ever to call himself 'Vaussure de Villeneuve' or 'Mr Dudding'.

However, there can be no doubt that the advent of Wintzenried had spoiled Rousseau's happiness with *maman* for ever. The 'idyll' of Les Charmettes was over. Another chapter of his life there began, with Rousseau living alone, almost as a hermit, while Mme de Warens and Wintzenried were at Chambéry. It was a bleak period. In his solitude and misery, it appears that religion consoled him. Among the papers which date from this time is a prayer,[68] copied out carefully in Rousseau's beautiful handwriting, in which he begs divine forgiveness for all his sins and mistakes: 'My conscience tells me, O Lord, how much I am guilty. I see that all the pleasures which my passions have prompted me to seek, at the expense of wisdom, have been worse than illusory, and are turned into odious bitterness. I know that the only true pleasures are those which are found in the exercise of virtue and the practice of duty. I am filled with regret at having made bad use of the life and the liberty which Thou hast accorded me in order that I might make myself worthy of eternal happiness.'*

It is instructive to compare this prayer with an earlier one conserved in the same collection[69] and which begins: 'We humble ourselves in Thy Divine Presence, almighty God, Creator and Guardian of the universe, to render Thee the homage we owe Thee ...' The 'we' of the earlier prayer has become 'I'; Rousseau was no longer praying together with *maman*; he was now praying, as he was living, alone. Fortunately, he had a certain liking for his own company. M. de Conzié – admittedly writing much later, at a time when Rousseau had acquired the reputation of a hermit – is one witness here: 'As I saw him every day, and as he confided in me, I could not doubt that he had a decided taste for solitude, and, I may say, an innate scorn for other people, a fixed tendency to condemn their faults and weaknesses; he nursed in himself a constant mistrust of men's integrity.'[70]

We have evidence of his attitude from Rousseau's own hand in the poem he wrote in 1738 entitled *Le Verger de Madame la Baronne de Warens*. Apart from the song he had had published the year before in the *Mercure de France*, this poem was the first work of Rousseau's to be printed. The title page bears the date 1739, and the publisher is named as 'À Londres, chez Jacob

* The prayer continues with a plea for the same grace to be bestowed 'on my dear *maman*, my dear benefactress, and my dear father'.

Tomson', but it was probably printed at Annecy by Burdet.[71] The poem is ostensibly a tribute to that wise woman, Mme de Warens:

> O vous sage Warens, élève de Minerve
> Pardonnez ses transports d'une indiscrète verve.[72]

What the text actually celebrates, however, is the life of solitude and quiet study that the poet is able to enjoy in Mme de Warens' orchard. In the preface he makes much of his own ill health: if readers are astonished to see a sick man – 'a man two inches from the grave' – writing verses, he tells them that it is precisely for this reason that he is writing poetry; 'if I were not ill, I should feel obliged to work for the good of society. My present condition permits me to work solely for my own satisfaction.'[73]

The poem confirms M. de Conzié's judgement that Rousseau had learned to like a hermit's life:

> Solitude charmante, Azile de la paix,
> Puissai-je, heureux verger, ne vous quittez jamais.[74]

And again

> Sans crainte, sans désirs, dans cette solitude
> Je laisse aller mes jours exempts d'inquiétude.[75]

In other lines the poet describes how he passes the warm hours of the day in the shade of a tree, smiling at the human comedy with Montaigne or La Bruyère, or improving his mind with the aid of 'the divine Plato'. Others he names as his companions are Huygens, Fontenelle, Leibniz, Malebranche, Newton, Locke, Descartes, Kepler, Wallis, Barrow, Rainaud, Pascal, Hôpital, Racine, Horace, Claville, St Aubin, Plutarch, Despréaux, Pliny, Livy, Cicero, Pope, Rollin, Barclay, La Motte and Voltaire. On the evidence of this list, it would seem that Rousseau read more philosophy than literature at this time. If he had what many people would consider a poet's soul, he had a philosopher's mind. He also had no memory at all for verses, although he tried hard to memorize poetry by repeating the lines as he worked in the garden.

'I must have learned and re-learned a good twenty times Virgil's *Eclogues*, of which I remember not a single word,' he recalls in the *Confessions*. 'I lost or dismembered a multitude of books, because of my habit of carrying them everywhere with me, to the dovecot, to the garden, the orchard, the vine-yard. While I was doing some other job, I put my book at the foot of a tree or a hedge, and always forgot to pick it up afterwards, and often, after a fortnight, I would find the book rotten, eaten by ants or slugs. This passion for memorizing was one which made me look stupid, because I was always muttering something under my breath.'[76]

He had his own way of reading the philosophers. He says that after trying

hard to reconcile the contradictory opinions of different schools, he hit on the method of adopting the standpoint of whatever author he was reading, without modifying or challenging the argument. He thus felt able to enter the mind of each philosopher in turn, and only when he had mastered them all did he begin to criticize any. He made good progress by this method of self-education, but one can hardly believe that line in his poem which proclaims:

Je laisse aller mes jours exemts d'inquiétude.

In truth Les Charmettes itself became a source of anxiety. As soon as Mme de Warens acquired from Captain Noëray the right to exploit the domain agriculturally, she was lost. The zeal for farming, which Rousseau himself had first inspired in her, prompted her to take on more fields and meadows. The more these activities increased, the more her debts accumulated and the more she became dependent on Wintzenried. For at least that robust and virile steward could put up a show of running a farm and controlling the workers with an authority that Rousseau all too obviously lacked. And thus, as Les Charmettes was transformed from a modest summer retreat into an agricultural estate, Rousseau felt less and less at home there.

The worse part of it all, he says in the *Confessions*, 'was the growing coldness of *maman* towards me'. He suggests that her pride had been wounded by his decision to end sexual relations between them; and in consequence 'she no longer opened her heart to me except when she wanted to complain about the newcomer. When they got on well together, I received very few confidences. Finally, by degrees, she adopted a way of life in which I had no place ... Gradually I felt myself isolated and alone in this same house of which I had once been the soul; and so I began to live, so to speak, a double life. I accustomed myself to keeping apart from anything that was done there, and from those who inhabited the house; and in order to spare myself continued agonies, I shut myself up with my books, or went off to sigh and weep at my leisure in the depth of the woods.'[77]

Very little correspondence survives from this melancholy period of Rousseau's life. What we have are letters[78] written in the early autumn of 1738 on behalf of a young kinswoman named Jeanne-Françoise (Fanchon) Fazy, whose sexual indiscretions had put her in disgrace with the Consistory at Geneva, and who had turned up penniless and pregnant on his doorstep at Les Charmettes. In these letters, Rousseau urges his aunt Clermonde Fazy, who was also the girl's mother-in-law, to help her, both for reasons of charity and in order to prevent the girl dishonouring the family and its name. To her brother, Jean Fazy, Rousseau wrote suggesting that he should come to Chambéry and rescue Jeanne-Françoise, Mme de Warens having in the meantime taken care of her. Evidently Rousseau's intervention was effective.

because a few weeks later the unfortunate girl was given money by her brother and found refuge in France.[79] It is curious to notice that despite this declared interest in the honour of the family name, neither Rousseau nor his aunt Clermonde Fazy seem to have taken an interest in the fate of Jean-Jacques' grandfather, the old liberal artisan David Rousseau, who died in 1738, a pauper. Clermonde Fazy had undertaken in 1733 to be responsible for David Rousseau for the rest of his life, but less than two years later she had him put on the city's charity roll. He was ninety-five years old when he died.

Rousseau was beginning to think more and more at this time of writing for publication. In September 1738, he sent a long letter[80] to the editor of the *Mercure de France* challenging an article in that journal on the question of whether the earth is a sphere. Although Rousseau's letter is wordy and diffuse, it is better argued and better informed than the article itself. It was never published, but several points he made were also put forward in a letter that was printed; and Rousseau's letter is proof that he had acquired at that time at least a rudimentary knowledge of astronomy. In the *Confessions* he tells an amusing story of his efforts to study the heavens from the terraced gardens at Les Charmettes. He bought an astronomical chart, fastened it on four legs and placed himself underneath it at night, on his back, observing the sky through a telescope and studying the chart by the light of a candle to help him identify the stars and planets. Some local peasants – seeing him in this strange posture, wearing a floppy hat and one of *maman*'s dressing gowns – supposed him to be engaged in witchcraft. Scandal broke out, and the intervention of two priests was needed to pacify the peasantry.

Despite the cold of the winter at Les Charmettes, Rousseau was on his own there in the early months of 1739, while Mme de Warens was with Wintzenried at Chambéry. They communicated by letter. She had evidently made it clear to him that her financial situation did not permit her to go on keeping him and that he must think seriously about supporting himself. Feeling too ill at that time to look for a job, he saw two other possibilities open to him: securing possession of his dead brother's inheritance in Geneva and obtaining a pension from the Sardinian Treasury. Neither, he realized, would be easy. With a view to acquiring his brother's unclaimed estate, he drafted a letter[81] to the Abbé Gabriel Arnauld, *chargé d'affaires* at the French Residence in Geneva in the absence of M. de la Closure, asking him to present his claim to the Genevan authorities. In support of his case, Rousseau argued, first, that his family had heard nothing of his brother François for twenty years (a slight exaggeration, since the brother had left Geneva only sixteen years before); secondly, that there were reports from Germany that his brother had died in the Breisgau; thirdly, that his brother had always had poor health; fourthly, that if the brother had been alive, he would certainly have claimed his moiety of the estate during the eleven years that had passed

since he attained his majority. The letter ends with a mournful recital of Rousseau's own poverty and sickness: 'Weighed down with languors and illness, I drag out what remains of my life as a burden to others and myself, having no longer the strength to move or even to stand up, and deprived in my wretched condition of all the help I need, except for the charity of Mme de Warens, who has deigned hitherto to anticipate my needs with her generosity and to look after me beyond her own strength. But now being fully aware of the financial embarrassment to which her continued benefactions have reduced that lady, I can no longer allow her to exhaust her resources to support what remains of my miserable life.'

At the same time Rousseau drafted a letter[82] to Count Joseph Piccone, Governor of the duchy of Savoy, begging for a pension. He explains that he left Geneva as a very young man to convert to the Catholic Church, and has since worked hard at his studies to justify the confidence placed in him by Bishop de Bernex and Mme de Warens, but illness has afflicted him, and he is now a dying man. Feeling that he can no longer trespass on the generosity of Mme de Warens, he supplicates the Governor for a pension from the funds established by the King for such pious uses.

Rousseau sent both those begging letters to Mme de Warens for her approval, with the curiously worded promise that any pension that might be awarded to him would go to her: 'Whatever happens, I hope never to soil my hands with the money.'[83] In another letter,[84] written two days earlier, he asked ironically: 'Since you have been settled in town, have you never had the idea, my dear *maman*, of undertaking one day a little journey to the country? Should my good genius inspire this desire in you, you would oblige me by giving me three or four months' notice so that I can prepare to receive you, and do you the honours of my house.'

This time he said nothing to her about his health, the drama of his mortal illness being reserved for the begging letters addressed to Turin. In addition to such appeals for charity, he made one spontaneous effort to recommend himself to the Sardinian authorities by devising a scheme for a regular service of freight carriages to run through the Savoyard mountains in competition with the service provided by the Swiss through Mont St Plomb.[85] One way or another, he seems to have been fairly active that spring at Les Charmettes. There is again no mention of any illness in the letter he wrote to Mme de Warens on 18 March 1739[86] protesting that it was more than a month since he had had the happiness of seeing her. In the summer it was her turn to be ill, as we learn from a letter[87] from Rousseau to one of his musician friends,* who had sent him a cantata he had composed. Mme de Warens, Rousseau explains, cannot sing the cantata because of her continuing illness: 'Now she

* Leigh suggests the Piedmontese Canavas (or Canavazzo), whom Rousseau had met at the Survey Office and who played the cello.[88]

has a chronic fever, frequent vomiting and a swelling of the legs which remains a very bad sign.' Rousseau offers his correspondent in return for the present 'my two or three remaining copies of *Le Verger de la Baronne de Warens*, an indication that the *tirage* of this publication must have been very limited.

Mme de Warens and Wintzenried were with Rousseau at Les Charmettes throughout the summer and autumn of 1739, and all three were still there at the end of October, as we can tell from a document in the handwriting of Wintzenried which is conserved in the public library at Chambéry:[89]

'A list of what was found in the pockets of Bernard Dumoulin, valet employed by Madame de Warens, on 23 October 1739, this inventory being drawn up in his presence: first a measure of chestnuts in one pocket of a grey jacket, and a good measure of beans in the other. In a blue jacket, a head of Turkish wheat and a measure of fine chestnuts together with a good measure of beans, all of which the undersigned recognized as coming from the household stores. In witness whereof we have hereby set our names, this Sunday, 24 October 1739.

<div align="right">

J. J. Rousseau
De Courtilles.'

</div>

There is a certain irony in the thought of a man with such a lively memory of his own experience in domestic service, a man who had stolen things – and was indeed to steal again – from his employer's stores, enacting thus the role of policeman with a fellow adventurer he despised* at the expense of a poor valet. Rousseau does not mention the episode in his *Confessions*, but he does say there that life at Les Charmettes in the company of Mme de Warens and her entourage became 'altogether unbearable' to him: 'The physical proximity and the emotional distance of a woman who was so dear to me only aggravated my suffering; and I thought that if I ceased to see her, I might feel less cruelly separated from her. I formed the project of leaving the house for good. I told her about it, and far from opposing the idea, she favoured it.'[90]

So it was that, at the age of twenty-seven, Rousseau decided to go out into the world once more and try again to earn his living.

* Rousseau sent friendly greetings to his 'brother' in letters to Mme de Warens, but one must doubt that his feelings were ever sincerely fraternal.

LYONS

Mme de Warens accepted, and probably welcomed, Rousseau's decision to leave Les Charmettes; and being, in her own way, a practical woman, she helped him on his way by finding him a job in Lyons as tutor to the young sons of Seigneur de Mably, Prévôt-Général – or chief of the gendarmerie – for the provinces of Lyonnais, Forez and Beaujolais. The intermediaries in this arrangement were *maman*'s friends in Grenoble, M. and Mme d'Eybens. Rousseau himself, in a somewhat haughty letter[1] about the job to M. d'Eybens, told him that he expected to be adequately paid, arguing that while he personally gave little thought to material things, no man could be a successful tutor if he was distracted by financial anxiety, nor could a tutor command the respect of his pupils if he was not decently dressed. Writing[2] to M. de Mably directly, however, Rousseau struck a note of greater humility, expressing his gratitude for the offer of employment and his hope that zeal and care in the work would make up for the mediocrity of his scholarship and knowledge. 'I shall endeavour, Monsieur, to be worthy of your adopting towards me the attitude of a father, even as I intend to adopt towards you the attitude of a dutiful and respectful son ... If I should happen to commit any faults while I am with you, I can assure you in advance that they will deserve forgiveness, because they will never be intentional – which does not mean, Monsieur, that you should not have the goodness to tell me of them, so that I may learn to avoid repeating them.'

On 20 April 1740, as a new spring was blossoming in the countryside around Les Charmettes, Rousseau left that cherished place to renew his acquaintance with city life in the industrial metropolis of Lyons. On the journey, he lingered for a few days at Grenoble to visit the d'Eybens. He wrote[3] from there to *maman* imploring her to look after her health and to take care of the library at Les Charmettes; and he did not omit to send warm greetings to 'Monsieur de Courtilles'. He also reported, with evident disappointment, that he had learned that M. de Mably was going to pay him

only 350 *livres* salary plus 50 *livres* gratuity. 'It seems a thousand years since I left Les Charmettes,' he added.

On his way from Grenoble to Lyons, Rousseau visited the spectacular monastery of La Grande Chartreuse, and was inspired to write some verses[4] in praise of the cloistered life of the Carthusian brothers in that wild and beautiful place. *'Oui, je consacre à Dieu le reste de mes jours'* was one line in this poem. More prosaically, he wrote[5] to Mme de Warens as soon as he arrived in Lyons to report his impressions of the new job. He was evidently pleased with everything, except having to share his pupil's bedroom. What Rousseau did not immediately realize was that, in entering the household of M. de Mably, he was entering a new world, that of the French Enlightenment. The young man who had just resolved to dedicate the rest of his days to God found himself among the leading votaries of Reason.

M. de Mably was no ordinary functionary, but the head of a distinguished intellectual family. They had been lawyers for generations; Bonnot was the patronymic, and the branch known as Bonnot de Mably had been newly founded by Gabriel Bonnot, born in 1675, one of the French King's secretaries, who acquired with the domain of Mably the title of Vicomte. He was later obliged by financial necessity to alienate the land and title, but he kept the name of Mably. His eldest son, Jean Bonnot, born in 1696 and known as the Seigneur de Mably, was Rousseau's employer. The other sons were Gabriel, born in 1709, known as the Abbé de Mably and later famous as an early theorist of socialism; and Étienne, born in 1714, known as the Abbé de Condillac and celebrated as a philosopher, the most prominent French disciple of Locke. The mathematician and scientist d'Alembert, though formally a foundling, was acknowledged to be a natural cousin of these three brothers.

In the year 1740, when Rousseau went to live at M. de Mably's handsome house in the rue St Dominique, none of the brothers had as yet published a word, but no doubt their conversation presaged their later achievements. The Abbé Condillac was already a keen student of Locke, and the Abbé Mably, if not yet a socialist, was already an enthusiastic student of Sparta and ancient republican Rome; both may have stimulated similar interests in Rousseau. Rousseau did not meet d'Alembert until a later period of his life but the Abbé Mably often visited his eldest brother's house and the Abbé Condillac actually lived there, although he was excessively taciturn, not merely a silent member of the household, but thought to be dim-witted.

Portraits of Jean de Mably show him to have been handsome, intelligent, sensitive. If he was never to write books as his brothers did, he was a man of considerable literary culture. He had married in 1732 a girl fifteen years his junior named Antoinette Chol. Of the twelve children she bore him, only two boys were of an age to take lessons with a tutor when Rousseau arrived

at the house on 1 May 1740. These pupils were François-Paul Marie, aged six, known as M. de Sainte-Marie, and Jean-Antoine, aged five, known as M. de Condillac. There was also a seven-year-old daughter, Catherine-Françoise, but as a girl in an age of sex discrimination she was not expected to take lessons with her brothers. They were all pretty, cheerful, lively children; indeed Rousseau found them altogether too lively. He admired and respected his employer, and got on well with him; moreover he claims to have 'fallen in love as usual'[6] with his employer's wife, although she appears in the portraits as plump, stern and no beauty. Rousseau recalls that Mme de Mably had been advised by Mme d'Eybens to instruct him in good manners and improve his social graces; and if Mme de Mably did not appreciate his attempts to flirt with her,[7] she was always kind to him. Indeed everyone was kind to him; and his only real problem in the household was the boys, for he found he could not teach them.

The elder brother, Sainte-Marie, Rousseau describes as a nice-looking, vivacious, witty and cheerfully naughty boy while the younger, little Condillac, was a giggling, mule-headed half-wit who could learn nothing. 'With patience and self-control,' Rousseau writes, 'I might have succeeded as their tutor, but without either, I could do nothing right and my pupils turned out badly ... I knew only three methods to use with them, all useless and often pernicious when applied to children – sentimental pleading, reasoning and anger. Sometimes I would plead with Sainte-Marie until I wept in my efforts to touch his feelings, as if a child was capable of genuine emotion; sometimes I exhausted myself by reasoning logically with him as if he could understand me; and since he sometimes employed subtle arguments, I took him for a reasonable being, just because he was a reasoner. Little Condillac was even more of an embarrassment, since he understood nothing, answered nothing, and was moved by nothing; at the same time his calm stubbornness was such that his greatest triumph was to put me in a rage, so that he became the philosopher and I the child ... Everything I did was exactly what I should not have done.'[8]

Out of the schoolroom Rousseau enjoyed himself in the Mably household, where he was introduced to intellectual society of a highly cultivated kind. Moreover, the whole city was alive; Lyons was a centre of culture, and Rousseau took prompt advantage of the doors that M. de Mably opened for him. He was welcomed everywhere and met interesting people. Among other things, it was a new sensation for Rousseau to be earning his own living, and with it he acquired a certain self-confidence. Others, too, were pleased. His father wrote a grateful letter[9] to Mme de Warens saying: 'I cannot thank you too much for having found my son employment that will keep him from idleness. Study is a good thing, but when it is prolonged beyond a certain point, and when a man has no property, he must do

something that brings in a livelihood.' Isaac Rousseau went on to express his anxiety lest his son should be meddling in chemistry and his hope that Mme de Warens might turn him away from that dangerous activity. Characteristically, Isaac added a recital of his own woes: he said that his wife was going blind and that he himself had broken a hip and would be 'crippled for the rest of my life'. In fact things were not as bad as he feared. His own fracture was soon healed[10] and his son had no temptation to 'meddle in chemistry' at Lyons, where science was approached in a much more systematic manner.

The Mably household subscribed to that doctrine which the French Enlightenment learned from Francis Bacon, that science will save us, or at any rate solve the more pressing problems of the human race. Rousseau was encouraged to attend the sessions of the Academy of Sciences of Lyons, when scientific papers of high quality were presented and discussed; and he also attended the Academy of Fine Arts, where there were concerts as well as lectures on literary and humanistic subjects. In both places he made friends, among them Charles Bordes, the 'Voltaire of Lyons', who was later to engage in public controversy with Rousseau on the side of progressive rationalism when Rousseau attacked it in his *Discours sur les arts et les sciences*.

When Rousseau and Bordes first met, they were both less than thirty years old; and Bordes,* who had only recently returned to Lyons from Paris with all the ideas of the free-thinking *avant-garde*, dazzled Rousseau with his sceptical, urbane and sophisticated conversation; he also seems to have made Rousseau more conscious of himself as a farouche rustic Swiss, an outsider in polite French society. A poem[11] Rousseau wrote in the form of an *Épitre à Monsieur Bordes* contains some revealing lines:

> Mais moi, qui connais peu les usages de France,
> Moi, fier républicain que blesse l'arrogance,
> Du riche impertinent je dédaigne l'appui.
> S'il le faut mendier en rampant devant lui,
> Et ne sais applaudir qu'à toi, qu'au vrai mérite.[12]

This poem also contains some lines in praise of the manufacturing industries and economic prosperity of Lyons, which indicate that Rousseau, far from holding the hostile views on modernity set forth ten years later in his *Discours sur les arts et les sciences*, was as a young man just as progressive as his Baconian friends on the subject of technological development.

However, the *Épitre à Monsieur Bordes* contains a certain contradiction, for having protested that he scorns the help of the powerful and the rich, the

* Charles Bordes (1711–81), a Lyonnais by birth, subsequently published a number of rationalist and anticlerical works including *Le Catéchisme* (1768), *La Papesse Jeanne* (1777), *Tableau philosophique* (1767).

poet goes on to pay an exceedingly fulsome tribute to the Intendant of Lyons, Bertrand-René Pallu:*

> On reconnait tes soins, Pallu, tu nous ramènes
> Les siècles renommés et de Tyr et d'Athènes:
> De mille éclats divers Lyon brille à la fois,
> Et son peuple opulent semble un peuple de rois.[13]

Pallu was a friend and colleague in the French bureaucracy of Rousseau's employer, M. de Mably.† He was also an amateur man of letters who enjoyed the esteem of Voltaire (who had addressed him a letter in verse in 1729); on the other hand, Pallu's morals were notoriously loose and he ran up heavy debts which he failed to pay.[15] In fact, the Intendant was one of those clever scoundrels who make themselves popular by being colourful and amusing, and, as in the case of Venture de Villeneuve, Rousseau succumbed once more to meretricious charm. Evidently Pallu pleased Rousseau by telling him things he liked to hear; for example he told him that Mme de Fleurieu had been attracted by his intelligent looks, and this emboldened Rousseau to send that lady a *billet doux* in verse ending:

> La Divine Fleurieu m'a jugé du mérite.
> Ma gloire est assurée, et c'est assez pour moi.[16]

We do not know how the lady responded. In the *Confessions*, Rousseau mentions Pallu only as the man who presented him to the Duc de Richelieu, another of those great persons who made promises to Rousseau and then promptly forgot them.[17]

A more useful acquaintance Rousseau made in Lyons was the composer Jacques David, then aged fifty-seven and well established as the leading musician living in that city. Having for years been looking for a professional musician who would help him master the technicalities of composition, Rousseau seized the opportunity of friendship with David. As a result he learned many useful things, including how to play the recorder.[18] In his *Confessions*, Rousseau says of David: 'he had done me a kindness in my distress during one of my previous visits to Lyons. He had lent, or given, me a cap and stockings which I had never returned to him, and which he never asked for, although we saw one another often after that occasion.'[19] David was the inventor of a new method for learning music,[20] and Rousseau was particularly indebted to him for help in composing his tragic opera *La Découverte du nouveau monde*. This was Rousseau's second attempt to write an opera. Already at Chambéry, he recalls: 'I wrote a tragic opera entitled *Iphis et*

* Bertrand-René Pallu (1693–1758) was Intendant of Lyons from 1739 until 1750, when he was elected to the Conseil d'État.

† Rousseau, in a letter to Mme de Warens dated 24 October 1740, mentions that M. de Mably was 'touring the province with M. l'Intendant'.[14]

Anaxarcte, which I had the good sense to throw in the fire. I wrote another at Lyons called *La Découverte du nouveau monde*, which, after reading the libretto to M. Bordes, the Abbé de Mably, the Abbé Trublet* and others, I disposed of in the same way, even though I had already written the score for the prologue and the first act, and M. David had said the music contained pieces that were worthy of Buononcini.'[21] If the score was burnt, the libretto[22] survives and although a work of no great merit it tells us something of Rousseau's interests at this period of his life. From internal evidence, it seems to have been written substantially in 1739 when Rousseau was still at Les Charmettes, for it refers to an existing political situation – of France at peace – which had ceased to be the case in 1740, when war was resumed between France and England. *La Découverte du nouveau monde* is an intensely francophile work about the impact of Europe on America; at the same time it evokes the idea of the noble savage; and although the noble savage was not an entirely new figure in literature, the delicate moral sensibility exhibited by the characters of this opera is already recognizably 'Rousseauesque'.

One literary work of Rousseau's which he undoubtedly started to write while he was with M. de Mably is his *Épître à Monsieur Parisot*,[23] once again a letter in verse, similar to, but rather longer than, his *Épître à Monsieur Bordes*. Among other things, this poem shows that Rousseau at that time was far from entertaining any egalitarian views of the kind attributed to him by so many commentators. What he says here is that more equality would not be a good thing.

> *Il ne serait pas bon dans la société*
> *Qu'il fût entre les rangs moins d'inégalité.*

The recipient of this letter in verse was the well-known surgeon Gabriel Parisot,† described by Rousseau as 'the best and most benevolent of men',[24] who showed him many kindnesses during his stay in Lyons. Besides Parisot, there was another leading figure in the intellectual society of Lyons with whom Rousseau became good friends – and it will be noticed that he had a remarkably full social life for someone who was a foreigner and mere private tutor by trade – the ex-Mayor of the city, Camille Perrichon,‡ a passionate book-collector. Perrichon was also a friend of Mme de Warens, indeed one of those numerous experienced men of business who invested money in her industrial schemes and lost it. In his *Confessions*, Rousseau writes of Perrichon: 'I reproach myself for not having paid enough attention to him in view of his kindnesses to me.'[26] After he left the city Rousseau says he lost

* Nicholas-Charles-Joseph Trublet (1697–1770).

† Gabriel Parisot (1680–1762) was a noted authority on gall-stone surgery.

‡ Camille Perrichon (1678–1768), town clerk of Lyons, 1698–1729, Mayor, 1730–39, and a fellow of the Academy of Sciences from 1720.[25]

touch with nearly all his Lyons friends simply because he lacked the capacity for regular letter-writing: 'Parisot and Perrichon always remained the same good friends in spite of this; but M. Bordes took offence and turned against the friend who neglected him.'[27] It is perhaps relevant to observe that Bordes, unlike the other two, was a writer, and one who adopted in public controversies views opposed to those of Rousseau. Bordes, in fact, stuck to his progressive opinions when Rousseau repudiated his after what he was to call his 'reform'. Future quarrels, however, cast no shadows over Rousseau's life in Lyons. He was content to be under M. de Mably's roof, and he got into only one scrape. His story is that he was 'tempted' by a light white Arbois wine, which he liked so much that, having been given the key to the cellar, 'I helped myself to two or three bottles now and again to drink in my bedroom',[28] for he had by this time persuaded his employer to let him have a bedroom of his own. 'I have never been dissolute or intemperate, nor have I ever been drunk in my life, so my little thefts were not so very indiscreet. However, they were discovered – the empty bottles gave me away. I was not accused. But I ceased to have the supervision of the cellar. In all this, M. de Mably behaved honourably and wisely. He was a very courteous man with a professional air of severity which concealed a great sweetness of nature and goodness of heart. He was judicious, equitable and – oddly for a chief of police – very humane. As I became conscious of his indulgence towards me, I became more attached to him, and I remained longer in his house than I would otherwise have done.'[29] The truth was that he had no other job to go to, and Mme de Warens could no longer offer him a refuge. She was indeed running so short of money that she had started to sell her household plate. As early as the autumn of 1740 she sent a silver pot to Rousseau, hoping he might find a buyer in Lyons who would give five *louis* for it. In the event, he managed to sell it to Mme de Mably for four and a half *louis*; he sent the money to *maman* together with what he described as 'such little extra as my present poverty allows me to add to it'.[30]* At the same time he promised *maman* to ask M. de Mably for an advance on his wages so as to be able to send her more.

There is no known record of what M. de Mably thought of Rousseau's abilities as a tutor, but Rousseau himself, feeling a failure in the practical art of teaching, adopted the familiar expedient of becoming a theorist of education. He drew up for presentation to M. de Mably a lengthy 'Project for the education of M. de Sainte-Marie',[31] which may be seen as his first step towards the writing of *Émile*. Rousseau anticipates the central argument of that revolutionary treatise by demanding that paternal authority be vested in the tutor. Even so, the whole conception of education that is put forward in

* In this same letter, dated 24 October 1740, Rousseau sends his greetings to 'Zizi', presumably Wintzenried.

the 'Project' is altogether more rationalist than that of *Émile*. In these passages Rousseau recommends that the tutor should reason with the pupil, a method he was later to reject energetically, urging instead that the tutor should work on the sensibilities of the pupil. Rousseau also pleads in this early text for a curriculum of useful subjects. It is absurd, he argues, that children should waste three or four years writing useless Latin compositions; absurd that they should study Greek and Latin history instead of the history of their own country, and even more absurd that they should study such abstruse theological concepts as the trinity and transubstantiation while neglecting the study of moral principles and the general duties of humanity. – Rousseau's actual programme[32] of studies is based on these ideas, so that, for example, the pupil is to be taught to understand Latin but not to write it. A boy destined for the army, Rousseau argues, will never need to write Latin prose, while every gentleman needs a taste for good classical literature and an appreciation of such great authors as Livy, Virgil and Cicero. History and geography should be made interesting to the pupil by a simple approach, which would postpone the technicalities for later study. To his argument that modern history, in general, is preferable to ancient history, Rousseau adds the suggestion that the study of French history is especially important for a future French army officer. As for logic, rhetoric and scholastic philosophy, Rousseau would banish them from the curriculum, save for a very few books such as the *Logic* of Port-Royal and the *Art de parler* of Father Lamy. Natural science, on the other hand, he considers an important part of education, together with mathematics, 'without which scientific studies cannot go far'. He adds that if the pupil remains with his tutor long enough, he will go on to study ethics and natural law, with the aid of such authors as Grotius and Pufendorf. Rousseau does not forget physical education: lessons in riding and fencing should be given – presumably by qualified instructors, and not by Rousseau himself in view of his avowed incapacity.

This educational programme can hardly have startled a rationalist such as M. de Mably when Rousseau presented it to him in 1740, for the proposals do not go far beyond the then fashionable wisdom of Locke, whose *De l'Éducation des enfants* had been available in French translation since 1695, and of Locke's French disciple, Charles Rollin, author of a well-known *Traité des études*. Even so, there are some intimations in these early writings of ideas on education which Rousseau developed later in *Émile*. He suggests already, for example, that a child's mind is directed less by logic than by sense impressions. He urges that the heart, as well as the intellect, of the child must be educated; that the child must be set at an early age in a mould of docility, and also that new techniques of reward and punishment must be carefully contrived. Although Rousseau recommends avoiding corporal punishment altogether, there is nothing soft or indulgent in his method: here, as in

Émile, he seeks to aim the penalty (some readers might think the more cruelly) at the child's self-esteem rather than at the child's body.

Besides this 'Project' for the education of M. de Mably's son, Rousseau addressed to his employer a *Mémoire*,[33] which is altogether more curious and more distinctively 'Rousseauesque', especially in those paragraphs where the author discards eighteenth-century notions of decorum and lays bare his soul: 'I know, Monsieur, that people have tried more than once to represent me to you as a mournful and misanthropic character, as a man ill suited to transmit polish and good manners to your son; in a word, as an uncultivated pedant unfit for polite society and still less fit to prepare a pupil for it. All these accusations appear so plausible that I cannot be surprised at their being made by persons concerned about the education of your son. However, I observe with delight that they have made no great impression on your mind, and I shall do all I can to prove them to be ever more unfounded. I am not unaware that I have certain defects: a constrained and diffident manner, a dry and charmless style of conversation, a stupid and ridiculous bashfulness – all faults that are hard to correct.'[34]

Rousseau goes on to explain that three obstacles hinder his efforts to improve himself: first of all, he has a melancholy nature, which he cannot alter; a life spent mostly in solitude, often in sickness and the proximity of death, has increased his inner sadness. Secondly, he suffers from an unconquerable shyness which prevents his conversing easily 'even with people as silly as I am'. Thirdly, he has a deep-rooted indifference towards 'everything that is called brilliant'.[35] He is unconcerned with other people's opinion of him, unless those others are persons he cares for.

'Given such a temperament,' he continues, 'it is very difficult for anyone to acquire a marked degree of success in personal relationships and in society; but people should not do me the injustice of concluding that I have a hard and unsociable character, or that some mean and servile anxiety makes me an outsider in good society. However alien I may have the appearance of being, I have never known any other kind of society; and in order to avoid ill-bred company, I have always chosen in preference to be alone. I would make bold to say that there is nothing in my character which does not show that I was born to live in the company of the most cultivated people.'[36]

If M. de Mably ever received this memorandum, he might fairly have concluded that Rousseau was more suited to a literary career than a preceptorate. It is also possible that Rousseau, having written it, decided to keep it to himself. He was nevertheless confident that his employer understood him. 'M. de Mably,' he remarked in one of his letters to *maman*, 'is a very cultured man, whose great familiarity with the world and the Court* and its pleasures taught him to philosophize at an early age, and who is not sorry to find in me opinions that fairly accord with his own.'[37]

* M. de Mably had been Master of the Hunt to the French King (1727–9).

These words may prompt the conjecture that Rousseau was doing his best to become an *homme de salon*, and if not to shine – since he was so indifferent to 'brilliance' – at least to thrive and enjoy himself in the society of what was, after Paris, the second capital of the French Enlightenment. In the spring of 1741,[38] we find him writing a hurried note to Mme de Warens, saying: 'Your message came this morning, the day of a public colloquium at the Academy of Fine Arts, when I had an engagement with several friends, Fellows of that Academy, who met to examine the papers which are to be presented this afternoon . . .' He was in the thick of the intellectual life of Lyons.

But that life was not to last. When the first twelve months of Rousseau's service as tutor to the sons of M. de Mably expired, the contract was not renewed. In his *Confessions*, Rousseau says he resigned: 'Disgusted in the end by a profession for which I was not fitted, and by a situation which embarrassed me, I decided after a year's trial, during which I had spared no pains in the work, to leave my pupils: I was sure I would never succeed in educating them properly. M. de Mably realized this as well as I did, but I believe he would never have taken it upon himself to dismiss me if I had not saved him the trouble of doing so.'[39]

Rousseau also claims in the *Confessions* that he was still yearning for *maman*: his life at M. de Mably's house was overshadowed by 'memories of my beloved Charmettes, of my garden, my trees . . . and above all of her for whom I was born, who was the soul of everything there . . . In the end I could no longer resist those tender memories which summoned me to her side, at whatever cost.'[40]

The letters he wrote to *maman* from Lyons are not conspicuously affectionate, but he evidently needed a renewal of maternal tenderness; he wanted to be with her, whether she could afford to keep him or not. He persuaded himself that if he could only be more patient, understanding and loving towards his *maman*, all could be again as it once had been between them. With his career as a private tutor ended for ever, he took his leave of M. de Mably and his family and hurried once more to Les Charmettes. He flung himself at Mme de Warens' feet with tears in his eyes and eager expectation in his heart, only to be swiftly disillusioned. For although her greeting was as warm as usual, it took him only half an hour to realize that the 'old happiness' he had known with her was 'dead for eternity'.[41] Wintzenried was more than ever the man of the house, and he was plainly there to stay. 'He was not at heart a bad fellow; and he seemed then more pleased than sorry to see me back again,'[42] but 'how', Rousseau asked himself, 'could I endure being one too many in the house of a person to whom I had once been everything, and who would never cease to be everything to me?'[43] He lingered on at Les Charmettes, but retreated into as much solitude as he could, meeting

the other members of the household only at meal times, and devoting his energies first to reading and then to writing. He found the most effective relief from his depression in work as an author, and began to develop an ambition to win fame with his pen. Perhaps his life at Les Charmettes was not altogether as solitary and introspective as the wording of the *Confessions* suggests. He made several trips to Lyons, even though he could ill afford them. Having no income, he had to sell some of his books to pay his expenses, to live frugally in lodgings, and depend on being liberally entertained. He had no lack of friends in Lyons, and perhaps the main attraction there was a young lady named Suzanne Serre, believed by some scholars to have been the love of his life and original of Julie in *La Nouvelle Héloïse*.[44] What Rousseau says in the *Confessions* neither confirms this belief nor refutes it, but there is no doubt that he had strong feelings about her. She was not just a draper's daughter, she was the granddaughter of an exiled Catalonian painter named Michel Serre, from whom she would have inherited her Spanish looks. This was the girl Rousseau had seen when she was a child in the same convent at Lyons as Mlle du Châtelet. He did not pay much attention to her then, 'but eight or nine years later,' he tells us, 'I was thrilled by her, and rightly, for she was a delightful girl.'[45] She was eight years younger than Rousseau.* 'My heart was captured,' he says, 'and very forcefully so. I had reason to believe that her feelings were not contrary to mine; at the same time she confided in me in a way which removed all temptation to take advantage of her. She had no property, and neither had I. Our situations were too similar for us to unite; and I had other ambitions in mind at the time which were far from thoughts of marriage. She told me that a young merchant named M. Genève seemed to want to marry her. I had seen him with her once or twice. He looked an honest fellow, and was reputed to be one. And so, persuaded that she would be happy with him, I wanted him to marry her, and he did. In order not to disturb their innocent lives, I hastened away, offering prayers for the happiness of that charming girl; prayers which were, alas, answered only for a short time in this world, for I learned later that she died only three or four years after her marriage.'[46]

Rousseau's recollection here is faulty. The records show that Suzanne Serre was indeed betrothed to Jean-Victor Genève on 24 February 1742, but she did not marry him until 26 February 1745, by which time she had already borne him – on 12 November 1744 – a son, which suggests that their love was not so 'innocent' as Rousseau claims. Besides, Suzanne did not die within four years of her marriage, she was still alive ten years later, in 1755.[47] If those scholars are correct who believe Suzanne Serre to be the addressee of a love letter[48] written by Rousseau in Lyons, he must have continued to correspond with her after he had left M. de Mably's house, for Rousseau

* She was born 22 March 1720.

writes here: 'I am lodging with the Widow Petit in the rue Gentiane at the Épée Royale.' It is the letter of an unhappy lover:

'I have exposed myself to the risk of seeing you again; and the sight of you has all too well justified my fears of reopening all the wounds of my heart. With you, I have contrived to lose the little security that remained to me, and I feel that in the condition to which you have reduced me, I am fit for only one thing, and that is to adore you. My malady is all the worse in that I have neither the hope nor the desire to cure it, and at all costs, I shall love you for ever. I understand, Mademoiselle, that I cannot hope for any requital of my love. I am a young man without fortune. I have only my heart to offer you, and a heart, however full of passion, tenderness and feeling it may be, is certainly not a gift you would consider worthy of acceptance.'

The letter goes on to speak with added bitterness about the 'liaisons' the writer knows her to be having: 'I have even learned the name of that happy mortal who knows how to make himself heard.' Rousseau also tells the girl that it is no good her talking about becoming a nun, because he knows she is in no way made for such a life. He begs her to have at least some pity for him, and let him have an address at which to reach her. He says reproachfully: 'I had resolved to pass the rest of my days philosophizing in a retreat that has been offered me – but you have destroyed that beautiful prospect.' He expresses the hope that she will show some kindness 'to a passionate admirer who has committed no crime against you, save that of finding you too lovable'.[49]

There is no conclusive evidence that this letter was addressed to Suzanne Serre; but if it was, it contradicts Rousseau's claim in the *Confessions* that he 'wanted' her to marry the other, richer man. At all events one may believe that it was written to the same girl who prompted Rousseau to declare in his *Épitre à M. Parisot*

> L'amour malgré mes soins, heureux de m'égarer,
> Auprès de deux beaux yeux m'apprit à soupirer.[50]

When, in December 1741, cold weather came to Lyons, Rousseau fell ill again, and, as usual, sickness made him yearn for the maternal solicitude of Mme de Warens. So once more he returned to Les Charmettes, where *maman* was now installed in winter as well as summer. It is from Les Charmettes that we find him writing in January 1742[51] to his neighbour M. de Conzié to thank him for the loan of Alexander Pope's *Essay on Man* in a French translation. Rousseau criticizes the translation, and also develops a philosophical objection to Pope's use of the idea of the Great Chain of Being. He argues that the Chain cannot logically end in God by means of a proportional graduation because of God's essential difference from finite creation: 'we cannot find a mediating principle between God and any other being,

between the Creator and what is created, between time and eternity, between the finite and the infinite.' It is interesting to notice that Rousseau does not dissent, as did Voltaire, from Pope's assertion that the world is the best of possible worlds and that 'all seeming evil is good not understood'.

Indeed the sick young man at Les Charmettes seems to have been a better Catholic than his *Confessions* might lead one to suppose; for there is a letter[52] he wrote then to Father Charles Boudet, the biographer of Bishop de Bernex, recalling in pious language the conversion of Mme de Warens and the miracle of the fire at Annecy which the late Bishop had effected. Nearly twenty-five years later, when Rousseau had published a rebuttal of the doctrine of miracles, this letter to Father Boudet was dug out* by one of his unfriendly critics, Élie Fréron, and published in the *Année Littéraire* of 1765 to embarrass him. Rousseau did not reply to Fréron, but in his *Confessions* he reproaches himself for having said that Bishop de Bernex *caused* the wind to change, when all he could properly have said was that the change of wind followed the uttering of the prayer. In the intervening years Rousseau had ceased to be Catholic. But he was still a Catholic at the age of twenty-nine; and for all his having come in contact at Lyons with the Voltairian rationalism of the early Enlightenment, the sentimental piety of Mme de Warens still prevailed at Les Charmettes. Moreover, by the spring of 1742, the careful nursing he received from her seems to have restored him to health. In a letter[53] to M. de Conzié written in mid-March Rousseau reported that Mme de Warens had once again brought him back from death's door, and he sent his neighbour a copy of a poem he had just written to her – addressed this time to 'Fanie'† rather than 'maman':

> *Malgré l'art d'Esculape et ses tristes secours*
> *La Fièvre impitoyable alloit trancher mes jours;*
> *Il n'êtoit dû qu'à vous, adorable Fanie*
> *De me rappeler à la vie.*[54]

Thus 'recalled to life' he was able to repay some of Mme de Warens' kindness by helping her with practical matters: among other things she was having trouble just then with her neighbour at Les Charmettes, one Pierre Renaud. When, some four years earlier, she had exchanged her smaller house, the Maison Revil, for the Maison Noëray, Renaud must have been satisfied with the bargain; but evidently as she improved the larger estate and cultivated the land, however unprofitably, he came to regret the deal, and started to harass her. According to Mme de Warens, Renaud sent hunting parties and dogs across her cornfields and blocked the path which Captain Noëray's cattle had customarily used on their way to drink; she also alleged

* Boudet's book was published in 1751.
† Her Christian name was Françoise.

that he encouraged his workers to cut down her trees and to spoil the water in the stream by using it for washing clothes; and generally to interfere with her farm workers. Rousseau took up his pen and drafted a letter[55] on behalf of Mme de Warens to the Royal Commandant and Syndic of Chambéry, Baron de Lornay, begging him to take action against M. Renaud not only on her behalf, but on that of her landlord, Captain Noëray, who was absent on military duty in the King's service.

Rousseau also drafted for her a letter to Captain Noëray[56] himself warning him that M. Renaud was 'conspiring conjointly with Mlle Revil to do us – you and me – all the harm that it is possible for anyone to do – for what could be worse than depriving an estate of water, paths and wood?'[57] It seems that Mme de Warens had also had trouble with another neighbour, Mme de Sourgel, who accused her of taking possession of belongings she had left in her care; this time Rousseau wrote in his own name an eloquent rebuke to Mme de Sourgel for her ingratitude and injustice to his 'god-mother'.[58]

Mme de Warens' basic problem was the familiar one: she was chronically short of money, and her efforts to make farming pay at Les Charmettes were proving no more successful than any of her projects in industry and commerce. Rousseau could not fail to see that she was in no position to house and feed him, and when his optimism returned in the summer months of 1742 he decided again that the only way to help her effectively was to go out into the world and make money, to seek fame and fortune, not so much as ends in themselves, but as means of saving his beloved protectress from ruin. He decided moreover that the only place in which he could satisfy this ambition was Paris. To finance the journey he sold all his possessions at Les Charmettes: in the *Confessions* he speaks only of selling 'geography books'; in fact he also sold musical, classical, philosophical and other books, as we learn from a letter[59] to a friend[60] written on the eve of his departure for Paris. In the same letter he speaks of disposing of 'a large celestial globe of Copernicus, and other odds and ends that you will see, and among which you may choose what might be useful to you and your friends'.[61] The wording suggests that Rousseau was this time really intending to leave the household of Mme de Warens for good; and in the event he did.

On his way to Paris he stopped for a short while in Lyons, to sell books and to collect more letters of introduction from his friends there. Those from the Abbé de Mably were especially useful: they included an introduction to the doyen of French authors, Fontenelle, of whom Rousseau afterwards said 'he continued until his death to show me friendship, and to give me in our private conversations good advice of which I ought to have taken more advantage'.[62]

The books Rousseau sold in Lyons did not raise much money, but his

friend Camille Perrichon, still as generous as ever, paid for his seat in the coach to Paris. In his baggage Rousseau had the assets on which his hopes for glory and fortune were based: his scheme for a new musical notation and his play *Narcisse*. It was already August when he reached Paris, but Paris in the eighteenth century was not deserted in the summer by its inhabitants as it was to be in later years. And although Rousseau criticized their stubborn attachment to city life, he was only too pleased to find everything going at full swing when he arrived, like the hero of a picaresque novel with his little bundle at the gates of the metropolis.

PARIS

Rousseau had come to Paris in search of fame and fortune. Money he sought only in order to be of use to Mme de Warens in her adversity, but *gloire* he wanted for himself. At the age of thirty, he was an ambitious young man whose appetite for worldly success had been whetted by what he had experienced in Lyons. France in the middle of the eighteenth century was a country of infinite opportunity for clever, gifted and determined people, and if Paris was already full of young men on the make, there was always room for one more. The aristocratic society of Versailles might be enslaved by tradition and protocol, but Paris, prosperous, bourgeois, progressive, sceptical, volatile, was eager for change, stimulation and amusement, for new faces and new ideas.

Rousseau was luckier than most in having introductions to leading personalities of the literary and academic worlds he hoped to conquer. He installed himself at once in the Hôtel Saint-Quentin near the Sorbonne, and although he had 'an ugly room in an ugly house in an ugly street',[1] it was the *hôtel* favoured by the Abbé Mably, the Abbé Condillac, Charles Bordes and other friends from Lyons; and while none of them was in Paris then, another guest of the *hôtel*, M. de Bonnefond, proved a useful acquaintance, introducing him to, among others, Daniel Roguin,* a fellow Swiss who became a staunch friend, and to Denis Diderot, with whom his destiny was to be closely bound.

Rousseau set out on the day of his arrival to present the letters of introduction he had been given by the Abbé Mably. Three at least of the new acquaintances proved useful: first there was Monsieur d'Amézia,† described by Rousseau as a 'gentleman from Savoy who had been the equerry and, I

* Daniel Roguin (1691–1771) was a Vaudois who had served in the Dutch army.

† Jean-Baptiste-Louis Vulliet de la Saulnière, Comte d'Amézin (1704–94), equerry to Anne-Thérèse de Savoie-Carignan, wife of Prince Charles de Rohan-Soubise. On the death of the Princess he retired to Chambéry in 1746 and married Rousseau's former music pupil, Françoise-Sophie de Menthon.

believe, the lover of the Princesse de Carignan';[2] secondly, there was Father Castel,* a worldly Jesuit priest and controversial philosopher, who is remembered today only as the inventor of a colour keyboard for the harpsichord and similar instruments, and thirdly there was M. de Boze,† Permanent Secretary of the Academy of Archaeology, who immediately took an interest in Rousseau's project for a new notation of music. Boze invited him to a dinner with the celebrated scientist Réaumur, and although Rousseau says he blushed throughout the meal because Mme de Boze was too deliciously pretty, Réaumur arranged for him to submit his project to the Academy of Sciences. Within a matter of days, Rousseau appeared at a meeting[4] which included such illustrious Academicians as d'Alembert,‡ Monceau, Nicole, Fontaine and Pajot as well as Réaumur himself. Rousseau afterwards recalled that 'although the eminent assembly was most imposing, I felt less intimidated there than I had felt in the presence of Mme de Boze, and I think I did fairly well in reading my paper and answering questions. The paper was a success, and earned compliments which were as surprising as they were flattering, for I did not expect that before an Academy any non-member would be thought to possess even commonsense.' His hopes were raised only to be dashed, for a special committee set up to consider his project in detail recommended rejection. Rousseau afterwards complained that none of the committee's members – Mairan, Hellot and Fouchy – 'knew enough about music to judge my project properly'.[6] This criticism is less than fair, for both Mairan, a mathematician, and Fouchy, an astronomer, were gifted musicians, and the report[7] they drew up with Hellot on Rousseau's project is well reasoned and well informed; it also contains some generous praise of Rousseau's work. However, their conclusion was that Rousseau's scheme of musical notation was not entirely new, and that it was less practical in certain respects than the system of musical notation already in general use in Europe.

What Rousseau had proposed to do was to simplify everything, to banish lines, staves, crochets and quavers, and to register all musical notes by means of numerals, taking the *Ut* or *do* as the basic sound and representing the higher notes by the numbers 2 to 7, with dots above or below the figure to indicate any change of octave. The committee noted that several earlier attempts had been made to use numerals for musical notation, but conceded that Rousseau had given the idea a new scope and greater utility than any of his predecessors. The committee also recognized its value to singers; on the

* Louis-Bertrand Castel (1688–1757), well known in his time as an anti-Newtonian philosopher, mathematician and inventor.[3]

† Claude Gros de Boze (1680–1753), numismatist.

‡ D'Alembert's presence is recorded in the minutes, but Rousseau does not mention his name. Nor had he an introduction from the Mablys, d'Alembert's natural cousins. He first made d'Alembert's acquaintance several years later through Diderot.[5]

other hand, they considered it seriously deficient for representing instrumental music. The report ended with congratulations to the inventor on his lucidity, and a recommendation to him to undertake further research in the field he had chosen.

The bitterness Rousseau felt at his disappointment was still evident many years later when, in writing his *Confessions*, he said of his judges, 'as soon as they tried to explain the basis of my system, they produced nothing but nonsense'.[8] The only person that Rousseau acknowledges as having made valid criticism of his scheme is Rameau, who pointed out to him that while a vocalist might read his new notation easily enough, an instrumentalist, needing to see all the notes at a glance, would have difficulty; and this, says Rousseau, 'was the only serious objection which could be raised against my system'.[9] What Rousseau does not say is that this was precisely the objection which the committee of Academicians spelled out in their report and which prompted their rejection of the project.

However, Rousseau had not yet learned to take criticism silently, and decided to hit back at the Academy by appealing, as he puts it, 'directly to the public'; he wrote a long letter in defence of his project to the *Mercure*, which that journal published in its issue of February 1743.[10] He then went on to write a book which he called *Dissertation sur la musique moderne*. Once again his friendly neighbour at the Hôtel Saint-Quentin, M. de Bonnefond, who seems to have had a very wide acquaintance in Paris for someone remembered only as a lame country squire, found him a bookseller, G. F. Quillau, who was willing to publish his work, and it was brought out within the year.[11] Rousseau expressed the proverbial author's dissatisfaction with his publisher: 'Quillau made a fifty-fifty profit-sharing agreement with me, which did not even cover the cost of the licence, for which I paid out of my own pocket. Such were the business methods of the said Quillau that I lost what I spent on the licence, and made not a *sou* from sales of the edition.'[12]

Rousseau's only source of income at this time was the music lessons he gave to two amateurs, Antoine-Alexandre de Gasq,* a successor to Montesquieu as vice-president of the *parlement* at Bordeaux, and the Abbé de Léon,† who afterwards left the Church for the army and shone briefly in society as the Vicomte de Rohan before his death at the age of thirty-one. Both wished only to study composition, and as both already knew the established system of musical notation, Rousseau was not able to practise his new method with them. In truth, they were useful to him only for the fees they paid. In an effort to prove the value of his new notation, he took on another pupil free of charge, an absolute beginner called Mlle Desroulins, an American friend

* Also known as Baron de Portets (1712–81), he achieved some renown as a violinist.
† He offered Rousseau a job as his secretary, but the salary was too little to tempt him.

of Roguin's. 'After three months,' he claims, 'she was able to decipher by
my method any music that was put in front of her, and even to sight-read
better than I could myself a reasonably uncomplicated score. This was a
remarkable success: but it did not become known ... I had a talent for in-
venting useful things but none for exploiting them.'[13]

The wording of his preface to his book *Dissertation sur la musique moderne*
suggests that he fully expected failure: 'To have reason on one's side is to
engage in an unequal struggle because prejudice is almost bound to defeat it;
and in my experience self-interest alone is capable of overcoming prejudice.'[14]
Even so, Rousseau's failure was only relative. He had at least the satisfaction
of having a book in print. If it produced no money, it attracted attention and
introduced the author to the public. On the other hand, he was exhausted by
the effort of writing the book in so short a time, and despite what he earned
from occasional music lessons, his funds were low. He had his own way of
keeping cheerful. 'I surrendered myself calmly to my own laziness, and to
the care of Providence . . . consuming in a leisurely way the few *louis* I had
left.'[15] He had still the buoyancy of youth; he economized on his pleasures
without giving them up completely, going to the café only every other day
and to the theatre only twice a week. At the same time he began to feel too
embarrassed by his very need for patronage to continue calling on illustrious
men of letters, and even ceased to see most of those he had already met, keep-
ing up with only three, the Abbé Mably, newly arrived in Paris, Marivaux
and Fontenelle. The contact with Marivaux was especially useful, because
that eminent dramatist not only read the comedy which Rousseau had
brought with him in his bag to Paris – *Narcisse* – but put some finishing
touches to the dialogue and inspired in the author the hope that success in
literature might make up for his setbacks in the world of music.

Marivaux had long been one of Rousseau's favourite authors. In 1742,
when Rousseau first met him, he was fifty-four and had been a successful
playwright since the performance in 1720 of his *Arlequin poli par l'amour*. His
work was spontaneous, gay, sentimental; and most of his comedies were
staged at the Théâtre des Italiens, a rival to the traditional, classical and
courtly Comédie Française. Marivaux's endeavours to promote the 'Italian'
style of acting against the conservative 'French' style prefigured Rousseau's
later efforts to promote the 'Italian' music against the 'French' music. In
both cases the virtues claimed for the Italian style were that it was natural,
expressive and free, whereas the French style was artificial, rhetorical and
rigid.

Rousseau's *Narcisse* turns on a plot of mistaken identity and double decep-
tion such as Marivaux himself might have devised. The hero Valère is a
dandy whose love for himself exceeds his love for his fiancée Angélique.
Angélique conspires with her sister to have his portrait painted in the clothes

of a woman, and put it in his room to tease him. When Valère sees the portrait, he falls in love with it so passionately that he breaks off his engagement with Angélique. Finally, in the fashion of all such eighteenth-century comedies, misunderstandings are cleared away, and Valère, duly reproached for vanity, marries the heroine.

Psychoanalytic commentators have feasted on the narcissism, homosexuality and transvesticism discernible in this play, but Marivaux could appreciate it as an amusing little comedy and long tried unsuccessfully to have it performed at the Théâtre des Italiens; paradoxically, it was eventually staged at the Comédie Française.

Fontenelle, who was to live even longer than Hobbes, Shaw and Bertrand Russell to die in his hundredth year, was already eighty-five when Rousseau first met him. If he appeared like a dinosaur from the distant age of Racine and Corneille (who was, indeed, his uncle), Fontenelle prided himself on his modernity. He never accepted the rationalist belief in the supremacy of reason, maintaining, as Rousseau was to do, that men are more often guided by imagination. Even so, Fontenelle retained a characteristically seventeenth-century mistrust of the passions; to such an extent that Mme de Tencin once said to him: 'It is not a heart you have in your breast, but a brain.'* Fontenelle believed that the mind, unable itself to govern men, could at best bring about some equilibrium among the conflicting passions which drove men to act; Rousseau was later to hear a more sophisticated version of this theory from David Hume. Fontenelle's enthusiasm for science also stopped short of the Enlightenment's faith in its limitless potentialities: he thought science would enlarge men's knowledge but not their happiness. He recognized in Rousseau a young man impatient for fame, and handed him a little cautionary verse he had written for others like him, ending with the lines: 'Proffer your brow to the laurel-wreath and your nose to the fist.'

Rather less stoical advice was given Rousseau by Father Castel, who suggested that since he had failed to conquer the musicians and Academicians of Paris he should try to conquer the women: 'Nothing in Paris,' he said, 'is accomplished without their help.'[16] The shrewd Jesuit priest accompanied the advice with some letters of introduction, which Rousseau, overcoming his timidity, used. He went first to visit Mme de Besenval,† a Polish-born baroness with royal connections, and her daughter, Mme de Broglie.‡ The

* We do not know Fontenelle's reply: he would have been too polite to have asked what kind of heart Mme de Tencin herself had that allowed her to have her child exposed on the steps of the church of St Jean de la Ronde; for it was she who was afterwards identified as the mother of d'Alembert.

† Countess Catherine Bielinska, the widow of Baron Jean-Victor Besenval (1671–1736) from Soleure, a colonel of the Swiss Guards in France.

‡ Théodora-Catherine de Besenval had married (1733) Charles-Guillaume Louis, Marquis de Broglie.

visit developed into a little drama of the kind which Rousseau's personality tended to provoke. Mme de Besenval received him kindly, and her daughter turned out to be an eager reader of his *Dissertation sur la musique moderne*. Mme de Broglie not only complimented him on the book, but took him to the harpsichord to prove that she had been studying his method of notation. At one o'clock, when he rose to leave, the mother invited him to stay for dinner. As soon as he realized that the meal she offered was to be taken with the servants in the kitchen, he announced that he had another engagement. Young Mme de Broglie saved the situation by whispering a word in her mother's ear. Mme de Besenval, thus prompted, persuaded Rousseau to stay and dine in their company, with another guest, Guillaume Lamoignon,* president of the Paris *parlement*. Lamoignon, whose son Malesherbes† was to become a famous liberal statesman, was such a witty and accomplished talker that Rousseau remained silent and inhibited throughout the meal, but feeling he must do something in return for Mme de Broglie's interest, he pulled himself together after dinner, took out his poem *Épitre à Monsieur Parisot*, and read it aloud to the company.

'The poem,' he says, 'was not without warmth, and I added more by the way I read it, and I made all three of them weep.' He felt he saw a look of triumph in the glance Mme de Broglie cast in the direction of her mother. 'Up to this moment my heart had been rather heavy; but having been thus vindicated I was happy.'[17] Rousseau had made a conquest, but it was one which he was still too green to exploit. When Mme de Broglie handed him, as a present, a novel by Charles Duclos entitled *Les Confessions du Comte de ***, saying 'here is a mentor you will need in society', she was giving him a hint, for that novel is effectively a guide to seduction. But Rousseau did not respond as she may have hoped. He was never to be a hero in love; it was the literary life, not a life of gallantry, to which he aspired. The only action the book prompted in Rousseau was a move to seek the acquaintance of the author.

Charles Duclos was a historian as well as a novelist; he followed up his early, somewhat sensational writings with systematic investigations into French social life which contribute much to our knowledge of that world, especially the milieu of the Paris salons to which Rousseau had just gained entry. From what Duclos tells us, we can understand why Rousseau was welcomed in those salons. All the shyness and awkwardness of which he was so painfully conscious would not hinder his success there. He was known to be Swiss, and rustic manners would be overlooked. What mattered was that he was different; that he had ideas; that with his book about music and

* Guillaume Lamoignon de Malesherbes (1683–1772).

† Chrétien-Guillaume Lamoignon de Malesherbes (1721–94), known as Monsieur de Malesherbes.

his communication to the Academy, he had established his credentials as a man of letters; and that he was not a bore. In polite society Rousseau was either silent or outrageous, and both forms of behaviour were acceptable. The one great crime in the salons, as Charles Duclos observes, was tedious conversation, and of this Rousseau could never be accused.

Eight years older than Rousseau, Duclos progressed from humble origins in Brittany to the highest distinctions in France, despite a great deal of dissipation in his early manhood. He had been brought up by his widowed mother and remained a bachelor; a 'mother's boy',[18] he was called because of his effeminate looks, though he was never suspected, as was d'Alembert, of being a pederast or a eunuch. He also cut a vigorous and manly figure in what passed for politics in France at the time, becoming at the age of forty Mayor of his local town of Dinan, having already won fame in Paris as the author of *Les Confessions du Comte de* ✱✱✱, in which he put to good use his considerable experience of the alcove. He had a notoriously loud voice and talked a lot, seeming to dominate any gathering he attended; only what he said was always interesting.

He wrote a ballet which had no success at the Opéra, but his rise to high office in the cultural institutions of the kingdom was swift. He enjoyed the patronage of Mme de Pompadour, which surprised some observers because of his candour, rectitude and uncompromising attitude in social dealings. In truth, as his biographer puts it, Duclos was not only *droit* but *adroit*,[19] and on Voltaire's departure for Prussia in 1750 he had himself appointed Royal Historian, and on the retirement of Mirabeau he secured the place of Permanent Secretary of the Académie Française, receiving *lettres de noblesse* and official residences at the Louvre and the Tuileries.

His later books, *Considérations sur les mœurs* and *Mémoires pour servir à l'histoire des mœurs du XVIIIe siècle*, were less popular than his first, and after his appointment in 1751 as Royal Historian he dedicated his whole life to official duties. In effect, his literary career came to an end just as Rousseau's was beginning, although he contributed from time to time to Diderot's *Encyclopédie*. He earned Rousseau's appreciation by the generosity he displayed towards him; and despite his own failure at the Opéra, he took it upon himself to promote Rousseau's success there, and, as we shall note, at one point he reached the brink of fighting a duel to ensure it.

Near the end of his life, Rousseau was to say of Duclos that he was 'the only honest man of letters that I know',[20] and in the *Confessions* he describes Duclos as 'the only true friend I have ever had among literary men'.[21] By this Rousseau does not mean that Duclos was his most intimate friend but that he was the only one with whom he never quarrelled. Rousseau's closest literary friend by far was Denis Diderot, to whom M. de Bonnefond introduced him soon after he arrived at the Hôtel Saint-Quentin, and with whom

much of his time was spent while he was living in Paris. Rousseau and Diderot had much in common: they were about the same age, Rousseau being thirty and Diderot twenty-nine when they first met; they had similar backgrounds and both had come up from the provinces with the aim of taking the literary world of Paris by storm.

Diderot was a likeable, popular, easy-going man. The portraits we have of him – by Greuze, Garand, Levitsky, Fragonard, Barthélemy and Van Loo – are remarkably similar: all depict the same big inquisitive nose, the bright, clever eyes, the same bright smile; there is no constraint in the expression, neither the cynicism of Voltaire nor the ardour of Rousseau disturbs the relaxed and cheerful tolerance, the self-confidence, determination and openness of Diderot's face. And yet we know enough about Diderot to be sure that he would compose his looks for the portraitist as carefully as he arranged his dress, which was always, like that of Charles Duclos, plain, black and bourgeois. In reality, he was not a man at ease with others or with himself. 'If ever Nature formed a soul in the mould of sensitivity,' he once said, 'that soul is mine'; and he added 'a man who has received such a disposition from nature will concern himself ceaselessly with trying to dominate it'.[22] Diderot's whole life was a conscious struggle of will over temperament.

He was born in Langres, the son of a prosperous cutler, and had received in his family a more conventionally middle-class upbringing than Rousseau; he was also better educated, having attended an excellent Jesuit college. On the other hand, the classics he had learned from the Jesuits meant little to him, and the religion even less. Like the other rationalists of the Enlightenment, Diderot believed in science even though he had a training in science no better than Rousseau's. They were both amateurs. Besides science there was music, and according to Rousseau music figured largely in their conversations. Rousseau knew at least as much about music as Diderot, and he nearly always beat him at chess, a game they played at the coffee houses they frequented together, notably the Café Mangins.

Diderot's chief ambition when Rousseau and he became friends in 1742 was to excel as a playwright, by producing a new kind of bourgeois domestic drama to replace the earlier classical drama of Racine and Molière. In this particular endeavour, Diderot failed – his plays were not good enough – but his belief that the arts of the age of Louis XIV no longer reflected the experience and values of mid-eighteenth-century France prompted him to pursue other and more success-ful activities. The desire for cultural innovation was a strong bond of sympathy between Diderot and Rousseau. Diderot had not at that stage developed the more radically empiricist and materialist opinions he was later to acquire under the influence of Baron d'Holbach; he was a deist, still, and not an atheist. Nor had Rousseau as yet undergone the conversion or 'reform' which was to generate the extreme anti-progressive views of his *Discours sur les sciences et les arts*.

It seems that in the earlier 1740s Diderot and Rousseau were more or less agreed in holding the moderately empiricist Lockean views which Montesquieu and Voltaire had introduced into *avant-garde* circles and which Rousseau had picked up in Lyons. Both Diderot and Rousseau were children of the early Enlightenment.

In time Rousseau was to reject the Enlightenment and Diderot to carry it to further extremes, but as young men their minds were in such harmony that they planned literary projects together as partners, not rivals, in the search for fame.

Rousseau did not neglect the advice he had received from Father Castel: that success in France was to be sought in the salons through the patronage of *les femmes du monde*. After the good impression he had made on Mme de Broglie, he was emboldened to call on Mme Dupin. This lady was by no means as nobly born as Mme de Broglie, but she was very much richer. Louise-Marie-Madeleine was one of three daughters born to the financier Samuel Bernard by his mistress, Mme Fontaine, the former actress, Manon Dancourt. Mme Dupin's husband, Claude Dupin, to whom she remained unfashionably faithful although he was old enough to be her father, made an enormous fortune and owned, among much else, the palatial Hôtel Lambert in Paris and the most enchanting of all French *châteaux*, that of Chenonceaux, in the valley of the Loire. Mme Dupin had looks as well as money: Rousseau says that when he first saw her she was still, at the age of thirty-six, 'one of the most beautiful women in Paris'.[23] He took a copy of his *Dissertation sur la musique moderne* to present to her at the Hôtel Lambert:

'She received me at her dressing table. Her arms were bare, her hair dishevelled and her dressing-gown untied. Such a welcome was a new thing to me, and my poor head could not bear it. I became embarrassed and bewildered; in short, I fell in love with Mme Dupin. My confusion did not seem to diminish me in her opinion; she did not even notice it. She received both the book and the author kindly; and she spoke about my scheme for musical notation as someone well informed. She sang, accompanying herself at the harpsichord, and she kept me to dinner, placing me next to her at the table. All this was likely to drive me mad with excitement, which it did.'[24]

With Mme Dupin he was bolder than he had been with Mme de Broglie; perhaps because her greater freedom of manners had encouraged him, perhaps, being always class-conscious, he felt less intimidated by an illegitimate daughter of an actress than by a *marquise* with royal connections. He visited Mme Dupin every day, and then wrote her a love letter – a rash thing to have done to the most chaste wife in Paris. He recalls in his *Confessions*:

'Mme Dupin kept my letter for two days without speaking to me about it. On the third day she handed it back to me with some words of admonition which froze me. I wanted to speak, but the words died on my lips. My

sudden passion ended with my hopes, and after a polite declaration I continued
to behave as before, without speaking to her of anything, even with my
eyes.'[25]

Mme Dupin's salon was one of the most fashionable of all. As Rousseau
puts it, she liked the company of celebrities: dukes and ambassadors, princes
and statesmen jostled with such stars of the literary world as Fontenelle,
Marivaux and Buffon. Here was all the wit and glitter that money could buy
in Paris, and which the dull court life at Versailles so signally lacked.

Rousseau was beginning to make the most of it, when suddenly he was
banished from the salon for reasons he could not understand. Through Mme
Dupin he met her stepson, Charles Louis Dupin de Francueil,* who shared
his interest in music and science. Rousseau formed a solid friendship with
Francueil and it was he, Rousseau says, 'who suddenly gave me to under-
stand that his stepmother considered my visits too frequent, and desired me
to discontinue them'.[26]

For a time, Rousseau seems to have suffered this rebuff in silence. Then,
on 9 April 1743,[27] he wrote Mme Dupin a letter asking for her forgiveness
and applying for the post of tutor to her son Dupin de Chenonceaux, then
aged twelve: 'I realize with the utmost sadness that I have earned your dis-
pleasure. I feel the effects of this even as I am sensible of your goodness, and I
cannot doubt that only your generosity has spared me in the past the harsh
treatment I deserve.'

Rousseau goes on to promise Mme Dupin to merit her forgiveness, and
offers her a memorandum on education – the one originally destined for M.
de Mably – which he hopes may interest her as she is looking for a tutor for
her son. The next day[28] Rousseau wrote to the boy's father a rather longer
letter, which is no less sentimental. He says he is neither so stupid nor so
vain as to suppose he might be much use in M. Dupin's household, but he
pins his hopes on the kindness that M. Dupin and his wife have shown him
in the past: 'Full of shortcomings and defects as I am, at least I know that I
have them. It is possible to feel remorse for one's mistakes, and I think that
is better than not committing any mistakes at all. If the faults of a character
such as mine appear to you worthy of some forgiveness, I beg yours and that
of Mme Dupin. It is enough for me to know that the sight of me is not
abhorrent to her beyond a certain point for me to work hard to make my
presence bearable.'

It is not clear from these letters for what particular fault Rousseau is
asking to be forgiven; but evidently he was forgiven, and was even offered
the place as tutor to the boy Chenonceaux, if only on a temporary basis. He

* Born in 1716 from Dupin's first marriage to Marie-Jeanne Bouilhat. He was said to have
preferred the company of his beautiful stepmother to that of his plain wife, Suzanne Bollioud
de Saint-Julien.

soon wished he had never applied for the job: 'I passed a week of torture which would have been unbearable but for the satisfaction of doing a service to Mme Dupin; for poor Chenonceaux had already that bad nature which was to disgrace his family and lead to his death on the Île de Bourbon. While I was with him, I prevented him doing actual harm to himself or anyone else, but that was all; but it was a heavy task, and I would not have carried on for another week even if Mme Dupin had offered herself to me in payment for it.'[29]

In the meantime, Rousseau had made a useful arrangement with M. Dupin's stepson, Francueil: they attended together a course in chemistry given by Professor Guillaume-François Rouelle, under whom Diderot had also studied. Rousseau wrote up most of the notes, but before the end of the course he caught pneumonia, of which he says he 'nearly died'.[30]

On his sick-bed his mind turned once again to music; strange melodies filled his imagination while his fever was high, and afterwards he was able to recover some of the tunes in a less delirious form. In his convalescence he sketched out the three acts of the opera he was to call *Les Muses galantes*.

He approached the task methodically: writing the first act first, and working so intensely that he was able 'to enjoy for the first time the delights of rapid composition'.[31] A few days later, shutting himself behind drawn curtains, he completed a whole act in seven or eight hours. Then something else intervened.

Mme de Broglie – the charming *marquise* who had lent him Duclos' book about gallantry – had not forgotten him; she knew something of his financial predicament and, wholly unexpectedly, she found for him what sounded like a marvellous job, that of secretary to the newly appointed French Ambassador to the Venetian Republic, the Comte de Montaigu, thus offering him the opportunity – or so it seemed to Rousseau – of becoming a diplomatist in the service of France. The only thing he insisted on was a reasonable salary: he asked for 1,200 *livres* plus expenses. The Ambassador offered him 1,000 *livres* and no expenses, which Rousseau promptly rejected as 'ridiculous'.[32] Francueil, who wanted to keep him in Paris, was delighted, and Montaigu set off for Venice with another secretary, one Follau, assigned to him by the Ministry of Foreign Affairs. However, the ambassadorial suite had reached no further than Chambéry when Follau was implicated in a case of smuggling and promptly dismissed. His Excellency was thus in urgent need of another secretary, and his brother, the Chevalier de Montaigu, approached Rousseau once more, offering him this time expenses as well as a thousand *livres* salary, together with the prospect of other privileges.

On 29 June 1743[33] the Chevalier wrote to his brother to report that he had formed a favourable opinion of Rousseau's appearance and dress, adding that the young man had asked for three to five days to reflect before giving a final

reply. In the end, Rousseau accepted, explaining that he would need a fort-night to prepare for his departure. Fancying himself as entering the diplo-matic service of the French King, he felt obliged to order some elegant clothes and accoutrements. He assumed that the Ambassador would expect a secretary who would be a credit to the Embassy and *fa' figura* in Venetian society. He was soon to be disillusioned.

In the *Confessions*, Rousseau says he travelled to Venice by way of Marseilles and Genoa. 'I would have preferred to go across Mont Cenis, so that I could visit *maman* on the way, but I went down the Rhône and boarded a ship at Toulon.'[34] In fact, there is evidence that he turned off the road at Lyons to pay a flying visit to Chambéry, without apparently finding Mme de Warens there,* for the cost of a journey from Lyons to Chambéry figured in the accounts[36] Rousseau afterwards presented – unsuccessfully – to the Ambassador for reimbursement.

Rousseau had been told to travel through Provence, partly in order to pick up a passport from M. de Mirepoix, who was stationed there, partly in order to save money. In practice, it proved an uneconomical itinerary. The journey by sea from Toulon to Genoa was 'long and tedious',[37] and once he reached Italy, Rousseau was promptly put into twenty-one days' quarantine because the plague was raging in the south and the Genovese authorities were imposing strict controls. The Comte de Montaigu, who had been led to expect that his secretary would travel through Switzerland,[38] could not understand the delay.

At Genoa the port authorities gave travellers the choice of spending their quarantine aboard their ships in harbour or going into an unfurnished *lazzaretto* ashore. Rousseau, alone among the passengers on his felucca, went ashore. He reckoned that the air would be cooler and that an unfurnished building would be less likely to have vermin in it; he had not the least objec-tion to being alone. He installed himself resourcefully. As he made a mattress out of his clothes, and sheets out of towels, he thought of himself as another Robinson Crusoe:

'I made myself a chair out of one trunk set flat, and a table out of another trunk set on its end. I took out paper and writing equipment and arranged a library out of the dozen books I had ... My meals were served with great pomp; two grenadiers with fixed bayonets escorted me. The staircase was my dining room, a stool my table, and the bottom stair my seat. Between meals, when I was not reading or writing or attending to my furnishings, I took walks in the Protestant cemetery which served as my garden, and sometimes I climbed a lamp-post which overlooked the harbour, so that I could watch the comings and goings of ships'.[39]

* Soon after he arrived in Venice Rousseau wrote to M. de Conzié begging for recent news of Mme de Warens.[35]

In this way a fortnight passed, and Rousseau says he would have been content to spend the rest of his quarantine in the *lazzaretto* if his release had not been arranged by the French Minister, M. de Jonville, who invited him to stay at his house. François Chaillou de Jonville was a career diplomatist who had been hoping after ten years as minister in Brussels and four years in Genoa to be made an ambassador; he had indeed applied for the post of Ambassador to Venice, which had gone to the Comte de Montaigu, who had no diplomatic experience but had better connections at Versailles. Rousseau found in Jonville everything he failed afterwards to find in Montaigu – efficiency, generosity, charm, good nature, friendliness. Jonville was also a handsome man, and elegant, with the reputation indeed of being a fop. We cannot doubt his liking for Rousseau, for he wrote an enthusiastic letter to Montaigu in Venice saying: 'I was delighted to make the acquaintance of your secretary. I congratulate you on having such a good fellow, who has not only intelligence and talent, but is also a most pleasing conversationalist.'[40]

If Rousseau could earn such praise from the dandyish Jonville, he cannot have been anything like the oaf he is so often assumed to have been. Rousseau also made friends with Jonville's secretary Dupont, 'who introduced me to several houses in Genoa and the country nearby, where one enjoyed oneself'.[41] In the *Confessions* Rousseau mentions that he was put up at Jonville's house for the last eight days of his quarantine,[42] but among the accounts he presented to Montaigu in Venice for reimbursement the following items appear:

Transport of luggage from *lazzaretto* to inn	£1 8s.
Eight days of lodging at inn	£28 0s.[43]

It might be wrong to conclude on the basis of this that Rousseau tried to cheat on his expenses, but he certainly did not economize on the journey that he made from Genoa to Venice, for he felt almost duty-bound to travel in style and to make the acquaintance of the cities that were on his way, Milan, Verona and Padua.

In the meantime, the Ambassador grew daily more impatient. He had the help of the French Consul in Venice, Jean le Blond, who had been acting as *chargé d'affaires* since the departure of the previous Ambassador; but evidently the Consul had not welcomed his arrival, and the Ambassador soon took a dislike to the Consul, resenting perhaps his dependence on him. He looked forward to having the assistance of a man of his own choosing, a willing subordinate, a capable, obedient clerk, for such were his hopes, indeed his expectations, of Rousseau. His expectations were fortified by the good word about Rousseau he received from M. de Jonville in Genoa; experience was to disappoint him, as it was to disappoint his secretary.

VENICE

Rousseau arrived in Venice at the beginning of September 1743. The beauty of the city seems not to have excited him as it has excited others; his love of wild nature diminished perhaps his appreciation of fine architecture; and if he did not positively disapprove of painting, he had no enthusiasm for it. On the other hand, he responded eagerly to the Venetian way of life, and not least because of its sophistication. At the age of thirty-one, Jean-Jacques was still seeking his identity as a man of the world. Indeed, he could feel he was beginning to achieve it: for had he not acquired the status, promised him years before by the Abbé de Gouvon, of a diplomatist in the service, if not of the King of Sardinia, better still, of the King of France? The Rousseau who is best known to posterity, the solitary wanderer, the hermit, the ascetic moralist, was not the Rousseau who disembarked in Venice at the palazzo which then housed the French Embassy. His 'reform', or conversion, which began on the road to Vincennes in 1749, was a thing of the future. In Venice he was eager to shine, to show himself off in as conspicuous a style as possible, to meet important people and do important things, to be someone of consequence. He also wanted to enjoy himself; and in Venice he was to find that enjoyment was an art well understood, almost an industry, elaborately and skilfully organized.[1] Pleasure was there for the asking, and Rousseau accepted it. He also worked; for in those summer weeks that he had spent on his journey from Paris to Venice, things had been happening in Europe which had repercussions on the Embassy in Venice, and Rousseau was not to find it the sleepy place he had been led to expect. A few days after his arrival, France joined Spain in its war against Sardinia – a part of the war of the Austrian Succession. The death of the last Emperor of the ancient house of Austria without male issue had provoked the ambitions of several princes; for although the rights of blood and the so-called Pragmatic sanction bestowed the succession to the imperial territories on the Archduchess Maria Theresa, the Emperor's eldest daughter, others laid claim to the imperial

throne or to parts of the imperial domains. Charles-Albert, Elector of Bavaria, Augustus II, King of Poland, and the Kings of Spain and Sardinia all invoked a right to inheritance; the King of France, while aware that he had as good a claim to the imperial throne as any of these, was shrewd enough to see that he would never receive it, and sought advantage for himself in dismembering the Austrian dominions by abetting the claims of another, Charles-Albert of Bavaria, who, with French support, was crowned Emperor of Frankfurt in 1742.

Italy was an important theatre of this war. The two Bourbon Kingdoms of Spain and Naples sought to enlarge their power in Italy by diminishing that of Austria. The third Bourbon Kingdom, France, became in the autumn of 1743 their ally in this enterprise. On the other side, Maria Theresa, an exceedingly popular monarch in her home lands of Austria and Hungary, was not without friends in Italy. The King of Sardinia, despite his being a traditional enemy of Austria because Austria was the main obstacle to Savoyard expansion in northern Italy, had been bribed with English money and Austrian territory to enter the war on the side of the Queen of Hungary, as Maria Theresa was then known. Sympathy for the Austrians, thinly disguised as neutrality, came from Tuscany, where Maria Theresa's husband, Francis of Lorraine, was Grand Duke; while open or covert support was provided by several other principalities or republics which preferred the familiar Austrian connection to any new expansion in Italy of the Bourbon kingdoms. In this conflict, the diplomatic manoeuvres were as important as the military, one of the main aims of French policy being to detach the King of Sardinia from his alliance with Maria Theresa. Venice was less important to France; but it was by no means unimportant. The Venetian Republic had declared itself neutral, and the French Embassy was instructed to ensure that Venice respected the duties of neutrality. The French Embassy in Venice was also called upon to act as a listening post in the gathering of wartime intelligence.

In September 1743 when Rousseau reached Venice, there was little actual fighting in progress in Italy. After the battle of Campo Santo in February of that year, the Spanish and Austro-Sardinian armies faced each other immobile between Pesaro and Rimini. The French army was held back by the Alps. There was to be no substantial military action until the following spring. Diplomatic activity, on the other hand, was intense; and the Comte de Montaigu received his new secretary behind a desk which was piled with papers. He had been frankly told in the instructions he received at Versailles the previous May that 'Venice has now so little part and influence in the principal affairs of Europe that the residence of an Ambassador there is rather the consequence of a tradition flattering to that republic ... than for any important purpose'.[2]

The war in Italy had altered this situation,[3] and Montaigu was confronted

with important-looking letters and dispatches. He was desperate for help in answering them, even in understanding them, for the most pressing were those composed in the diplomatic ciphers, which the Ambassador had not yet mastered. Like many another high official in the service of the King of France, the Comte de Montaigu* owed his appointment to his social rank rather than to any qualifications for the post; although some said he owed his job in Venice to the military authorities who, to avoid promoting him from brigadier to general, had pressed for his translation to the diplomatic service. He was ill-fitted for the Embassy in Venice. He knew scarcely a word of Italian, and he found it almost as difficult to compose an Ambassador's dispatch in ordinary French as to decipher the Foreign Office codes. He was also relatively short of money in a job where a private fortune was tradition-ally considered a necessity: Montaigu, parsimonious even more than impecunious, was horrified to find how expensive was the upkeep of an Embassy and how dilatory were his superiors at Versailles in the payment of his salary and allowances. He had many reasons to be fretful and discon-tented. Indeed he had already written to Versailles in August 1743, a week or two before Rousseau arrived in Venice, asking for permission to return to France to collect his family.

'It is natural that I should want to have my wife and children with me,' he wrote in a rambling letter to the Foreign Secretary, Jean-Jacques Amelot, 'not only because of my feelings for them, but because of the expense, having them separate from me, and the cost of my establishment here being so very heavy that I have to be careful about everything else.'[4]

The permission was refused, and Montaigu had to wait more than a year for his family to join him in Venice. The manner in which, as a 'grass widower', he conducted his Embassy provoked bitter criticism from Rousseau and from others. Montaigu had for some reason been unable to instal himself in the Palazzo della Vecchia which previously housed the French Embassy, and had taken a lease of the Palazzo Querini near the bridge of S. Giobbe in Canareggio, a long way from the centre of Venice at St Mark's. This remoteness made the use of a gondola almost imperative; yet Montaigu complained when his secretary arrived from the mainland by gondola, and protested again when Rousseau asked to have a gondola put at his disposal for regular use. Rousseau may well have made the demand in a high-handed way.

In a letter[5] he wrote months later, Montaigu recalled that 'the day after he arrived, M. Rousseau complained bitterly that, having been taken in my

* Pierre-François, Comte de Montaigu (b. 1692), received his first army commission at an early age, but was thirty-five on his promotion to rank of captain and forty-eight on becoming brigadier. He then sought a diplomatic appointment. He was named Ambassador in Venice in January 1743 and served in that republic from July 1743 until September 1749, when he was sped on his way by stones.

gondola to go and hear some music, my gentlemen did not put him above them in my gondola, since he said he was the first man in my mission.' However, at the time it seems that Montaigu was so grateful for Rousseau's presence that he gave way to his wishes. We may deduce this from a letter from Montaigu's brother, who, having evidently heard the Ambassador's account of his new secretary's arrival, wrote, 'I am struck by the temperament of M. Rousseau, and hope that his harpsichord and his gondola will charm away his troubles.'[6] The harpsichord is something which Rousseau, in the *Confessions*, speaks of as having paid for himself; and at least one gondola which Montaigu refused to pay for was the gondola in which Rousseau first arrived. For when Rousseau gave him the bill[7] for his travelling expenses, Montaigu went through it carefully, striking out every item he considered unjustified, deducting not only the cost of Rousseau's side trip to Chambéry and his seven days' lodging at Genoa (which, if ungenerous, was not unjust), but cutting out perfectly reasonable items such as the cost of his lodgings at Lyons, Avignon and Milan, and reducing to two *livres* (the cost of seat in a public conveyance) the sixteen *livres* Rousseau had paid for the gondola from the mainland to Venice. However, this fierce arithmetic was not undertaken until several months had passed; at the beginning Rousseau received a decent welcome, and for a time both the Ambassador and his secretary got on tolerably well. Rousseau was clearly delighted that his first official task was to order the Embassy's boxes at the five main opera houses of Venice, knowing that he would be able to count on a seat for himself. Montaigu, on his side, was greatly relieved to have someone to help with his work. Diplomacy was new to him, and the peculiar protocol which governed diplomatic life in Venice was bewildering, especially when the French Consul, Le Blond,* ceased to be helpful. In the last week of August, Montaigu had written to the Venetian Senate a memorandum to announce his arrival, and the Senate had sent a secretary to the Embassy to dictate the official reply (it being considered incorrect at that stage for the Senate to send written messages to an Ambassador). Montaigu asked Le Blond to take down the letter, but Le Blond declared that it was beneath the dignity of a French Consul to take dictation from a humble Venetian functionary, and refused.[8] Le Blond, having enjoyed the status of a *chargé d'affaires*, was not to be treated as a clerk. According to what Rousseau says in the *Confessions*: 'M. de Montaigu, jealous that another should do his job, even though incapable himself, took against the Consul, and as soon as I arrived, relieved him of the duties of Embassy secretary to give them to me. The duties were inseparable from the title: he told me to take it.'[9]

* Jean Le Blond was the son of a previous French Consul in Venice and the father of a future one. He was born in Venice and understood Venetian ways better than French. He came to detest Montaigu, especially when the Ambassador refused the customary certificates to permit him to import his wine duty-free.

Rousseau enjoyed the work for a time, and he was undoubtedly capable. Unlike the Ambassador, he knew Italian, having learned it as a youth in Turin, and he soon mastered the Venetian dialect. He also says he found the task of deciphering dispatches easy, as well he might, since the code in use was a fairly primitive one, based on a series of numbers which required patience rather than wit to translate into words. In the *Confessions*, Rousseau says scornfully 'the French Embassy in Venice was never sent anything really important and Montaigu was a man no one would trust with serious negotiations';[10] but the evidence available in the archives of the French Foreign Office does not altogether bear out this claim. These archives include papers written in Rousseau's own hand for each week that he was at the Embassy between 14 September 1743 and 25 July 1744: two dispatches a week to the King on matters of state and one letter (on subjects of less importance) to the Foreign Secretary, Amelot, or to an under-secretary at Versailles. The messages from Versailles to Montaigu conserved in the same archives obviously deal with matters which were taken seriously by the French government. Besides the replies to those messages, Rousseau had also to write letters every week on behalf of the Embassy to other French diplomatic missions in Italy. Altogether it was a considerable load, and even though he had the help of the chaplain, the Abbé de Binis, who served as a second secretary, the main work of the Embassy was done by Rousseau himself.

There was, however, a profound misunderstanding between Rousseau and his employer. Montaigu looked upon Rousseau as a man whose wages he paid out of his own pocket, a clerk, indeed a sort of manservant; and in this opinion the Ambassador was not entirely wrong. Rousseau, encouraged by the Ambassador's welcome, looked upon himself as a diplomatist of the French foreign service; and he was not wholly mistaken either, although the rank of Embassy secretary had not yet been given formal definition anywhere. With enough goodwill, Montaigu and Rousseau might have worked well together, each with his own image of Rousseau's situation. Such goodwill, however, was not there on either side.

It took Rousseau no great time to discover that his employer was excessively thrifty. The Ambassador liked investing in antiquities (and was easily duped by Italian dealers in consequence), but he kept a frugal table; in fact he himself ate no supper at all. Rousseau supped with the male staff of the Embassy and the Abbé de Binis. They did not eat well. 'In the most squalid tavern,' Rousseau protested, 'one has a cleaner, a more decent, service, less dirty linen, and better food than we had at the Embassy, with our one little blackened candle, the pewter dishes, and the iron forks.'[11]

With no woman to run the household, it rapidly decayed into a lamentable state under the direction of a *major domo* named Domenico Vitale, 'a professional brothel keeper', according to Rousseau, 'who created such a

disorderly house that there was not one corner a decent man could endure'.[12]
Outdoors, Rousseau was able to keep up appearances, and there is no doubt that
he relished the opportunity of promenading along the Grand Canal in the Am-
bassador's gondola, attended by an entourage in livery. It so happened that
Montaigu had the most beautiful gondolas in Venice. He had bought them, at a
bargain price – a thousand ducats – from the Resident of the King of Sardinia,
and was later painfully embarrassed at being unable to pay for them, especially as
France and Sardinia were at war.[13] It was a unique privilege for foreign ambassa-
dors in Venice to have gilded or coloured gondolas, all others being plain black,
and it is understandable that Rousseau was proudly conscious of his distinction
as he travelled in the highly decorated boat all the way down the Canale Grande
between the Embassy and the Venetian government offices. Montaigu might
grumble about Rousseau's use of the new gondola, but a journey to the seat of
government was not one that the Ambassador himself was allowed to make.
Diplomatic protocol in Venice imposed many interdictions. The presentation of
letters of credence was expected to be done at an elaborate inaugural ceremony,
which began with the new Ambassador moving to the island of Santo Spirito in
the lagoons, where a delegation of sixty Venetian Senators in full regalia would
be rowed out to greet him and escort him back to his Embassy in Venice; then an
all-night masked ball would take place, after which the senators would take the
Ambassador to the ducal palace, and only then would he present his letters of
credence to the Doge and be introduced to members of the government.

The enormous cost of these ceremonies and festivities prompted several
ambassadors to postpone their inauguration as long as possible. Montaigu
postponed his so long that it never took place at all. He may not have lost
much by this characteristic act of thrift, for even an ambassador who did all
that was expected of him was never allowed to meet the Doge or his
ministers after the inaugural ceremony. An ambassador had to communicate
with the government either by letter, or *viva voce* through a representative of
the Venetian State known as a *conférent*. When Rousseau joined Montaigu, a
Venetian *conférent* had not yet been appointed to his Embassy; everything
had to be done by the written word; all of which meant that the Ambassa-
dor's secretary was kept considerably busier than the Ambassador himself.

'I am well, and I love you more than ever,' Rousseau wrote in a letter to
Mme de Warens about a month[14] after he arrived. He was hardly pining for
her; he was enjoying Venetian life too fully. But no doubt he told the truth
when he said he yearned for news from her, and he went on to suggest
various means whereby, in spite of the war between France and her own
Kingdom of Sardinia, she might get a letter to him in the bag of the Spanish
Ambassador to Venice. This Ambassador was Estalban Mari Centurion, the
Marquis Mari, with whom Montaigu had orders from Versailles to maintain
close relations in view of the alliance between France and Spain. Montaigu,

in Rousseau's opinion, did well when he listened to Mari, and only went wrong when he ventured to contribute ideas of his own. Rousseau himself was fortunate in finding a congenial colleague in the Spanish Embassy secretary, François-Xavier de Carrio, who, with the French Consul Le Blond, initiated him into the mysteries of the Venetian administration. Behind the forms of republican government there sheltered a patrician régime that was as secretive as it was despotic; executive power was exercised by the College and in particular by the six of its members known as the Savii-Grandi who, being elected for six months, took it in turns to be head of the administration for a week at a time. Their deliberations were conducted behind closed doors, and the whole system relied heavily on a secret intelligence service. Not unnaturally Rousseau was prompted to compare the republican system of Venice with that of his native Geneva; and after making this comparison he went on to start writing a book about political institutions, from which unfinished project his *Contrat social* was to emerge as a monumental fragment.

The differences and similarities between the two political systems required some careful study to explain, but no great perspicacity was needed to see the contrast between the stern Puritan austerity of Geneva and the bright gaiety of Venice. Rousseau, as a young man of the world, was immediately infected by that *joie de vivre*. He loved the masked balls, the carnivals, the theatres and the cafés where night-life continued until dawn: we have evidence of Rousseau's nocturnal habits in a letter written in December 1743[15] by the Abbé Nauti promising to give Rousseau a book 'at your café tomorrow at one o'clock in the morning'. Among the two hundred cafés in Venice, Rousseau had fixed on his favourite place. The one Venetian amusement he did not enjoy was gambling. He played at the casino once, won, but was too bored to go on: 'Chess, where one does not bet, is the only game that gives me pleasure.'[16]

What Rousseau enjoyed most of all in Venetian life was the music. In Turin he had heard the music of the Court; in Venice he heard music that belonged to everybody – not only the opera houses, but the churches, the schools, the taverns, the private *palazzi*, the cafés and the brothels were all places where music could be heard. Moreover, people sang in the streets and in their gondolas. Festivities, masked balls and dancing in the open air were regular occurrences, encouraged by the hidden hand of a régime which worked on the time-honoured principle that *panis et circenses* are better loved than liberty. Rousseau never expressed the least doubt that the Venetian government was popular.

The archives of the French and Venetian authorities, and those of the Comte de Montaigu conserved by his family at the Château of La Bretesche, throw a considerable light on Rousseau's work at the Embassy during the

period of rather less than a year which he spent there. On the whole they confirm all he says in the *Confessions* about his experiences; and although it is possible to take a more charitable view of M. de Montaigu than Rousseau takes, the fervent defence of the Ambassador offered by his descendant, Auguste de Montaigu, in his book *Démêlés du Comte de Montaigu ... et son secrétaire Jean-Jacques*, published in Paris in 1904, is more admirable than persuasive.[17] In the first place, the archives confirm that Rousseau drew up all the Ambassador's dispatches and letters on the basis of a few words thrown out to him, as points to be developed. The style is Rousseau's, clear and eloquent. Montaigu himself could hardly compose a coherent letter.

The archives also confirm Rousseau's claim that Montaigu's defective political sense made him accept Venetian protestations that neutrality was being preserved when it was not the case. The very first dispatch to the King that Rousseau wrote for Montaigu, dated 14 September 1743, contains the sentence: 'As for this republic, it persists in its resolution to remain neutral, whatever its Ambassador in Vienna may say.'[18] The same assertion is repeated in numerous subsequent dispatches to Versailles.

Some of Rousseau's criticisms of Montaigu, however, may well seem in the light of the evidence, if not unfounded, at any rate exaggerated. Rousseau says that the Ambassador insisted that all his dispatches be coded, even though 'they contained nothing that needed concealment'.[19] The archives show that in fact only a small proportion of the dispatches were coded. Again, Rousseau protests that Montaigu had the 'absurd'[20] idea of having him prepare on Thursdays dispatches which would serve as replies to letters from Versailles which arrived on Fridays. If 'absurd' this practice was, it was one which Montaigu openly admitted in a letter to the Foreign Secretary dated 5 October 1743:[21] 'The bad weather which delays the postal services obliges me to begin writing any dispatch before the mail arrives, saving the end of my letter to reply to what you do me the honour of writing to me.'

Rousseau also says that 'His Excellency had another silly trick which made his dispatches unbelievably ridiculous, and that was to send back each item of information to the correspondent who had sent it to him, instead of passing it to another'.[22] Again, justice requires us to say that the dispatches themselves give little proof of this, and that the only complaint concerning Montaigu's dispatches from Venice recorded by the Foreign Office in Versailles concerns the quality of the work for which Rousseau himself was responsible, the ciphering. In a signal sent at the end of November 1743,[23] an official begged the Ambassador in Venice to advise his secretaries to be more attentive to their work: 'It is more difficult to decipher their dispatches than any others that originate in Italy.'

In the *Confessions* Rousseau insists that he was 'until the very end most

orderly and most punctilious in everything that concerned my essential duties. Except for one or two errors in ciphering because of enforced haste, which one of M. Amelot's clerks complained of once, neither the Ambassador nor anyone else had occasion to reproach me for a single act of negligence in any of my duties, something remarkable in the case of a man as negligent and absent-minded as I am.'[24]

There was one thing that Rousseau did not neglect, and that was to remind highly placed people of his own existence. Thus we find him adding personal greetings in a letter[25] from the Embassy to the Comte de Lautrec, French Ambassador to the Emperor at Frankfurt and former Mediator in the Genevan civil war, that great personage to whom Mme de Warens had introduced him with the idea of finding him a job some years before. Rousseau had omitted to push himself forward at that time, but now he was eager to get on.

In late November 1743,[26] rather more than two months after his arrival, Rousseau wrote to the Comtesse de Montaigu, who was then planning to join her husband in Venice, asking her to bring with her a consignment of clothes that his friend Roguin had packed for him in Paris. It is a cheerful and fairly intimate letter in which he tells Mme de Montaigu that her husband is taking his Glauber salts regularly and keeping well. Of himself, Rousseau says: 'I have somewhat modified my philosophy here to make myself like the others, to the extent that I run about the *piazza* and the theatres in mask and domino as proudly as if I had spent my life in that costume.'

In the event, Mme de Montaigu did not join her husband in Venice until after Rousseau had departed, and all the smart clothes Roguin had prepared for him to wear in Venice were never worn there. But, as he told the Countess, he was happy enough in the local fancy dress, and when there was no ball to go to, there were the opera houses, a choice of several where a box was reserved for the French Embassy. 'I had brought from Paris,' he writes in the *Confessions*, 'the French prejudice against Italian music, but I had received from nature a sense of discrimination which is impervious to prejudice. I soon developed for Italian music an enthusiasm which is shared by all those who are fit to judge. Listening to barcarolles sung in Venice, I realized that I had never heard real singing before then.'[27]

He was so enchanted by the music at the opera that he would creep away from the boxes, where the *beau monde* of Venice passed the time chattering, eating or playing cards, to find some corner of the theatre where he could listen undisturbed. He was no less thrilled by the sacred music sung by the convent pupils and orphan girls behind the grilles of the *scuole*; he tells us that as he heard their angelic voices, images of their faces passed before his mind, and he fell in love with their beauty. Unfortunately, when

M. Le Blond took him one day behind the grille into a *scuola*, he discovered that the beautiful voices belonged to girls who had smallpox or some other hideous defect, and his love evaporated. And yet, he adds, whenever he heard those girls sing, 'I still found them beautiful, no matter what I had seen with my eyes.'[28]

Besides Le Blond, Rousseau made other friends in Venice who shared his enthusiasm for music and who entertained themselves by arranging concerts in their rooms. In the *Confessions* he mentions Manuel Ignacio Altuna as well as Carrio from the Spanish Embassy, a M. de Saint-Cyr together with 'an Italian from Friuli and some Englishmen'[29] as companions at these musical evenings: 'Music in Italy costs so little that it is not worth depriving yourself of it, if you like it. I hired a harpsichord, and for a small fee I had four or five musicians come to my quarters to play the pieces I liked best at the opera. I also got them to rehearse the orchestral parts of my own opera *Les Muses galantes*. The ballet-master of the theatre of San Crisostomo, either because he really liked them, or simply in order to flatter me, asked for two of my pieces, and I had the satisfaction of hearing them performed by that excellent orchestra, and danced by Bettina, a pretty, petite and above all charming girl, *entretenue* by one of our Spanish friends, called Fagoaga, at whose house we often spent the evening.'[30]

At the time he wrote his *Confessions*, Rousseau had become a celebrated adversary of the theatre as an institution; and it is with a certain wry humour that he recalls, as a younger man, having provided for the playgoers of Paris two of their favourite actresses, Coraline and Camille. What had happened was that the Duc de Gesvres on behalf of the French Court had made a contract with the girls' father, Carlo-Antonio Veronese, to have them perform in Paris, but their employer in Venice, Senator Grimani,* would not release them. When all other efforts to secure the girls' release had failed, Rousseau intervened personally and succeeded.

Montaigu in a letter (which Rousseau may have drafted) to the Duc de Gesvres dated 7 December 1743 wrote: 'I took steps to approach M. Grimani according to your desires, something not easy in a republic where dealings between foreign ambassadors and the Venetian nobility are strictly forbidden. I sent my secretary in a mask to communicate your memorandum to M. Grimani, who promised a reply which I have not yet received.'[31]

The story Rousseau himself tells in the *Confessions* is this: 'The carnival was in progress. I put on a domino and a mask and had myself taken to the Senator's palazzo. Everybody who saw my gondola arrive with the livery of

* In the *Confessions*, Rousseau gives Giustinian as the employer, but all the evidence shows it was Grimani. On the other hand, Giustinian was the owner of the theatre – the San Moise – where Camille worked, so he may have had to negotiate with him as well as with Grimani. The Palazzo Giustinian and the two Palazzi Grimani are close to each other on the Grand Canal.

the French Embassy was impressed. Venice had never seen anything like it. I disembarked and had myself announced as a masked lady. As soon as I was admitted, I removed my mask and gave my name. The Senator turned pale and stood amazed. "Monsieur," I said to him in the Venetian dialect, "I am sorry to disturb you with this visit, but you have at your theatre a man named Veronese, who is under contract to the King of France. He has been claimed from you without success. I demand him in the name of His Majesty" ... Veronese was released that very day. I told him that if he did not leave for Paris within a week, I would have him arrested. He went.'[32]

If Rousseau here seems to exaggerate the celerity of the Senator's compliance, Veronese and his daughters did indeed make their *débuts* on the Paris stage at the Théâtre des Italiens in May 1744. It was the beginning of an immensely successful career on the stage and in society; and in a roundabout way, Rousseau's interest in the Veronese family was rewarded, for Coraline, before she crowned her career with marriage to the Marquis de Silly, was for several years the mistress of the Prince de Conti, who was to protect Rousseau in a time of need.

Another star of the stage in Venice was wanted elsewhere at about the same time, but rather less charming methods were employed to secure her departure. This was Barbara Campanini, known as La Barbarina, one of the most famous dancers of her time. After a brilliant success in the Paris theatre, she had made an agreement to go to Berlin and dance for Frederick II; but falling in love with a young Scotchman named Mackenzie, she eloped with him to Venice instead. Feverish diplomatic activity ensued, and Montaigu's Embassy was called upon to intervene. As Montaigu explained in a letter prepared by Rousseau for the Foreign Secretary Amelot, La Barbarina wished to break her engagement with the Prussians in order to marry her Scotchman. The Prussian envoy in Venice had asked the Venetian government to arrest the dancer, but it had refused. 'The Prussian envoy had taken it into his head,' the letter continues, 'to put the girl under the protection of the Spanish Ambassador and myself, asking us to use strong arm measures if necessary: neither of us has thought it right to accept this commitment without knowing the wishes of our Courts.'[33]

Montaigu had to take the matter seriously because French policy at the time was directed to pleasing Frederick II, a crucial ally against the Austrians; Great Britain was an enemy, so there was no reason to consider the sensibilities of La Barbarina's Scotch fiancé.

Montaigu was diplomat enough, according to reports,[34] to invite the dancer to dine at the Embassy and 'persuade her by soft means' to keep her engagement. But persuasion did not work, and eventually the Prussian envoy was able to make the Venetians act roughly, as reported in a dispatch to the King written by Rousseau for Montaigu:

'Last Sunday the government had La Barbarina arrested and has asked the King of Prussia by what means he wishes to have her conducted to Berlin . . . The Englishman who is said to want to marry her is forbidden to see her, even though he says he is engaged to her.'[35]

The unfortunate dancer remained under arrest for several weeks, as Montaigu reported, with marked disapproval, to Versailles: 'The Minister of the King of Prussia has behaved so badly in the affair of La Barbarina, that I believe, as you do, Monsieur, that he spoke to the Spanish Ambassador and myself without being authorized . . . the Senate has notified the King of Prussia that it cannot keep the girl in custody indefinitely.'[36]

A week later[37] Montaigu was able to report that La Barbarina had left Venice for Berlin. Curiously enough, despite the regular reference to the case of La Barbarina in dispatches, Rousseau does not speak of her in the *Confessions*. No doubt he lost interest in her, for hers was henceforth less than a romantic story. Her fiancé followed her to Prussia, only to be promptly expelled from the country, where La Barbarina herself settled for a handsome pension from Frederick II and eventually married an immensely rich Prussian count.

The Foreign Office at Versailles was constantly worried by fears that the Venetians would either break the rules of neutrality and help the Austrians (which Rousseau says they did) or even openly enter the war on the Austrian side. Messages from Versailles to Venice show that the French government was not readily persuaded by Montaigu's assurances. For example Amelot wrote to Montaigu, in October 1743,[38] saying there was reason to suspect that the Treaty of Worms signed by the Austrians and the Sardinians had a clause expressly inviting Venice to join their alliance; he feared that Venice might do so.

Montaigu replied,[39] in code, assuring the Foreign Secretary that his suspicions were unfounded, and that Venetian intentions of neutrality had been reaffirmed to the Spanish Ambassador on the highest authority. At this stage Montaigu had to rely on his Spanish colleague for information because he had not yet been assigned a *conférent* of his own by the Venetian state.

Amelot wrote back[40] urging Montaigu to watch the matter closely, despite the assurances obtained by the Spanish Ambassador through his *conférent*. Montaigu's next step was to press for a *conférent* of his own. At first he was afraid the Senate would appoint M. Foscarini, 'a Piedmontese' with sympathies for Turin, but was pleased in the end that the *conférent* appointed to his embassy was Niccolo Erizzo. It took Montaigu some time to wake up to the fact that this Senator's sympathies were even more decidedly pro-Austrian; Erizzo had in fact been Venetian Ambassador in Vienna from 1735 to 1737 and was so much liked by Maria Theresa that he was sent to her Court again in September 1744 at the end of his service as *conférent* to Montaigu.

Versailles was suspicious of Erizzo, but the slow-witted Montaigu assured the King, in March 1744,[41] that his *conférent* rejected all accusations of pro-Austrian sympathies: 'He tells me he was born in France, when his father was Ambassador, that he received a thousand marks of kindness from the late King, and that he is filled with all the sentiments of respect due to your Majesty.'

Again, in April,[42] Montaigu wrote to Amelot saying that Erizzo had come on behalf of the Senate to assure him that Venice was determined to maintain the most perfect neutrality and to continue the most correct and intimate correspondence with the King of France.

At the end of May, however, Montaigu was writing coded messages to Versailles in terms which show that he had come to realize that Erizzo had 'Austrian sentiments'[43] or 'Austrian inclinations',[44] something which Rousseau, with his quicker wits, had detected long before.

Rousseau's quick wits, unfortunately, only served to embitter his relations with Montaigu, who was apt to regard cleverness as a mark of dishonesty. One incident which Rousseau recalls arose out of the sale of French visas at the Embassy. Rousseau, looking after this service, charged each applicant a sequin, which, according to precedent, he pocketed. It was only when French citizens came to be exempt by Rousseau from this fee that the Ambassador discovered that foreigners paid it; and he promptly claimed the money for himself. Rousseau refused to hand it over, whereupon Montaigu told him that if he took the profits of the chancery he would have to pay for the paper and ink and candles that were consumed in the office.

Rousseau was in fact entirely dependent on his perks, because he did not receive his salary. 'When I asked the Ambassador for the money,' he says in the *Confessions*, 'he spoke to me of his esteem and his confidence, as if that would have filled my purse and provided for everything.'[45] It must in fairness be noted that the Ambassador was also kept without money. 'I'm so hard up I have to darn my own socks,' Montaigu once complained to Rousseau; Rousseau is said to have replied, 'I do too, Your Excellency, but when I darn them I must pay someone else to write your dispatches.'[46]

Montaigu's salary was 30,000 *livres* per annum, but he waited a long time to be paid. Thus we find him thanking the Foreign Secretary in February 1744[47] for a quarter's salary, but pointing out that two quarters' instalments were still due to him. His letter had no effect. In May he informed Versailles that he had not received any emolument for eleven months, and that his financial embarrassment was extreme: 'I am here without resources and without credit for what I need. I should be exceedingly obliged if you would have me paid. My journey, my establishment, the outlay I had when I was brought here in the first place, and the daily outgoings up to now have cost me over fifty thousand *livres*, plus the eighteen thousand *livres* debts that I have here.'[48]

Among the expenses he had to pay, he reckoned 6,000 *livres* for 'secret funds' in June 1744, and six months later he put the figure at 14,595 *livres*.[49] This expenditure was presumably incurred in his endeavour to make his Embassy an effective 'listening post' in a time of war.

Montaigu had instructions[50] from Versailles to insist on the diplomatic precedence due to the Ambassador of the King of France, and especially to tolerate no pretensions from the Austrian Ambassador, now reduced from an Emperor's representative to that of an ordinary Queen. Montaigu was very willing to stand on his dignity, but the impossibility of free conversation with the Venetian senators, and his own limited resources for a social life, meant that he had few occasions to enact the role of the first diplomatist in Venice.

In January 1744, Montaigu was urged by the French-born Duchess of Modena* to attend some of the balls which were taking place all over Venice. According to a letter[51] he sent to Versailles, he had notified the Senate of his intention to do so, and was assured by Senator Erizzo that he would be formally received at such balls as an Ambassador; when Montaigu learned he would have instead to attend as a private person, he refused to go. However, it seems that Montaigu was referring in this dispatch to one of the *festins*, or small balls, where guests were expected to pay the musicians on arrival: he did not miss the more fashionable ball, given at the opera house of San Crisostomo at the end of the carnival. He went, as he reported to Versailles, together with the Spanish Ambassador. 'As for illuminations,' he wrote, 'I have never seen anything in my life more beautiful.'[52]

Montaigu did not, however, care for the climate of Venice; and despite all his protestations of financial embarrassment, he obtained the lease of a secondary residence on the mainland which became his favourite retreat. Rousseau was denied this escape from duty, and the damp winter climate of Venice – coupled perhaps with long hours at the office and late nights on the town – had a bad effect on his health. The fatigue of his difficult journey from Paris already produced early symptoms of that urinary disease which was to torment him in later life, and the cold weather made things no better. He complained of the 'unhealthy Venetian air' in a letter drafted in February 1744,[53] but there is none of the old talk of sickness and death in his correspondence of this period; so we may assume that his mind was too concentrated on work and pleasure for him to pay much attention to the pain in his bladder.

We find him writing[54] at about the same time to his Swiss friend in Paris Daniel Roguin about the supplies he is ordering on his behalf to send to Venice; Rousseau asks him to 'choose really good Paris stockings at a

* Born Charlotte-Aglaé d'Orléans, the Duchess of Modena went to Venice as a refugee with her husband and children when the Sardinian army invaded the duchy of Modena.

reasonable price', but says there is no need to order linen or suits 'as I have found good workers here'. This and other letters he wrote during the winter give no indication of the storm that was brewing with Montaigu; indeed in an unfinished letter drafted in February Rousseau actually speaks of 'all the goodness of M. the Ambassador to me';[55] he was never to say such things again.

Spring brought renewed activity in Italy, both military and diplomatic. The Austrian army under Prince Lobkowicz resumed the offensive on the battlefront; the Spanish–Neapolitan army under the Comte de Gages made a skilful strategic retreat to Velletri; and then both held their lines. The Bourbon interest in Italy was thus, if not advanced, at all events secured. Another Austrian stratagem in the conflict was likewise frustrated, that of prompting those Neapolitan elements which were discontented with an alien monarchy to rebel against the Bourbons. In his *Confessions* Rousseau makes the bold claim that he was personally responsible for thwarting this conspiracy:

'It was at the time that Prince Lobkowicz was marching towards Naples, and the Comte de Gages made that unforgettable retreat, the most brilliant war manoeuvre of the century, too little acknowledged in Europe. Intelligence reached me from M. Vincent (French *chargé d'affaires* in Austria) describing a man leaving Vienna and passing through Venice to go clandestinely to the Abruzzi to raise the people on the approach of the Austrians. In the absence of the Comte de Montaigu, who neglected everything, I passed that very pertinent intelligence to the Marquis de l'Hôpital (French Ambassador in Naples); hence it is perhaps to poor Jean-Jacques, so much despised, that the House of Bourbon owes the conservation of the Kingdom of Naples.'[56]

Nothing in the archives of the French Foreign Office justifies acceptance of this bold claim. There is a dispatch from Venice to Naples dated 2 November 1743[57] which refers to intelligence from M. Vincent received on 26 October 1743; and it may well be that what is signed in the name of Montaigu was written in his absence by Rousseau. But in the *Confessions* Rousseau speaks of acting at the time of the Comte de Gages's strategic retreat, which was in the spring of 1744. Moreover, stories of plots afoot in Naples against the Bourbon monarchy reached M. de l'Hôpital from numerous sources; there seems in fact to have been more talk about conspiracy than conspiracy itself. So Rousseau's suggestion that he saved the Bourbon kingdom by forestalling a revolution must be taken as a whimsical fantasy. However, Rousseau could fairly boast in his *Confessions* in respect of one affair – the release of a French sea-captain named Olivet, 'by my own efforts and without anybody's help'.[58] The evidence[59] bears out what Rousseau says. Captain Olivet's ship had been involved in a collision with a Slavonic vessel flying the

Venetian flag; there was an altercation, including some violence, between the two crews, after which Olivet's ship was put under arrest with no prospect of an early release. Rousseau says he persuaded Montaigu to report the matter to Versailles as an affront to the French King's flag, knowing that his dispatch would be intercepted by the Venetian intelligence service, and by this stratagem to stir the Venetians to action. Next Rousseau says he went in his gondola to interrogate Olivet's crew, dragging with him the Abbé Patizel, chancellor of the French Consulate, to help him take down their depositions. In the event Rousseau says he had to do all the questioning himself and then draw up a report, which Patizel reluctantly signed. By these means he secured the release of Captain Olivet much sooner than expected.[60]

Certain documents bearing on this case have led some scholars to question Rousseau's story. For example, a report of the interrogation, drawn up in the hand of the Abbé Patizel − first published in 1885[61] − asserts that Patizel himself did all the questioning and does not mention Rousseau's presence. However, it must be remembered that the rivalry between the Embassy and the Consulate in Venice was something which went with the ill-feeling between the Ambassador and the Consul, and the Abbé Patizel might be expected to be as jealous of Rousseau's intervention as Rousseau was scornful of the Abbé's competence. A contemporaneous record of Rousseau's action appears in a memorandum[62] he addressed to the Ambassador on 15 July 1744 reporting that: 'Yesterday I passed the day at Poveggia with M. Le Blond's chancellor and Captain Olivet, taking down the depositions of the crew.' There can be no doubt that it was Rousseau who prompted Montaigu to send a dispatch to the Foreign Office at Versailles on the subject.

Moreover, on 1 August 1744, M. Le Blond wrote on the subject to another Minister at Versailles, the Comte de Maurepas, secretary for the Navy, a dispatch which described the Ambassador's share in the matter, but did not mention either Rousseau or the Abbé Patizel: 'I have the honour to inform your Excellency that the incident which happened to Captain Olivet at Poveggia has ended to his satisfaction. A settlement was signed last Sunday whereby the sum of two million Venetian *livres* was paid by the proprietor of the Slavonic boat in compensation for damages, and the following day the Captain set sail for Salomits, his destination.

'As for reparations for the insult done to the French King's flag on that occasion, I am persuaded that M. de Montaigu will not relax his efforts to obtain them, and doubtless the Court will instruct him not to lose sight of a matter which touches the glory of the King and the honour of the Kingdom.'[63]

It seems that Montaigu had asked for the Slavonic crew to be sent to

galleys and for the offending hand to be cut off the sailor who had struck a Frenchman – demands which Maurepas considered wholly inopportune. It is interesting to speculate whether Rousseau had put this idea into Montaigu's head, or whether it was one of the foolish ones which Rousseau ascribed to the Ambassador's own invention: he does not speak of it in the *Confessions*. Rousseau does however provide a detailed account of the celebrations which Captain Olivet arranged in his honour on the evening of his ship's release – the only reward that Rousseau would accept for his service. He took with him to the party his colleague from the Spanish Embassy, Carrio, and was disappointed, he admits, that they were not given a salute of cannon when they arrived. Rousseau was still very mindful of his rank as a diplomatist, and considered that two Embassy Secretaries deserved the 'traditional' honours. 'I could not disguise my feelings,' he writes, 'because I never can; and although the dinner was good, and Captain Olivet was an excellent host, I started off in a bad humour, ate little and spoke less.'[64]

It soon emerged that the Captain had planned a pleasant surprise for his guest. A ravishing young lady was brought out by gondola to the ship and placed at the table next to Rousseau. She was the Captain's present to him. She was a lively brunette, aged about twenty, with large, oriental eyes which Rousseau found extremely exciting. Her name was Giulietta, and pretending to mistake Jean-Jacques for a former lover in Tuscany, she threw her arms around him, placed her lips to his and pressed herself against him. When he protested that he was a stranger, she told him that, because he was so like her Tuscan lover, he must love her too.

After dinner Giulietta took Rousseau and Carrio on an excursion to Murano, where she made them buy glass trinkets, and then took them back to her rooms. Rousseau noticed two pistols on her dressing table, and asked why she had them there. '"When I do things for men I don't like, I make them pay for the boredom I have to endure," she told me. "It's only fair. If I have to put up with their caresses, I won't put up with their insults."'[65]

Had she some intuition that an insult was in store for her? Rousseau made a rendezvous to visit the girl next day, and describes it in the *Confessions*: 'I found her in *vestito di confidenza*, that more than seductive *déshabillé* which is only worn in southern countries, and which I will not amuse you by describing although I remember it all too well. I will simply recall that the garment around her shoulders and her breasts was edged with silk thread and decorated with rose-coloured pompons, all of which seemed to me to enhance the beauty of her skin . . . I had no inkling of the sensual delights which awaited me. I have spoken of Mme Larnage, and the rapture which the memory of her still sometimes kindles in me – but compared to my Giulietta, how old and ugly and cold she was! It is no use trying to imagine the charms and grace of that girl. Never was such sweet pleasure offered to the heart and the senses of a mortal man.'

Unfortunately, Rousseau goes on to say, he was unable to enjoy the delights he was offered: 'Nature has not made me for sensual delight. In my head, she had placed a poison which destroys that same ineffable pleasure for which she has planted a hunger in my heart.'[66]

And so it came about that in the very moment of his embrace, his desire for Giulietta turned deadly cold; his legs trembled, he felt faint, and began to weep like a child. He says he was suddenly struck by the incongruity of the fact that this beautiful woman in his arms, this masterpiece of Nature, this good, charming, generous girl who ought to have been the pride of kings was only a common prostitute. But he had to find some better reason to explain his revulsion for her. He did not think at the time that it might be syphilis, for she seemed so clean. Yet somehow he needed to find a flaw in her.

He remembers that the girl tried to comfort him, to dispel his fears and relieve his sense of shame. 'Then,' he continues, 'just as I was about to rest my head on a breast that seemed to be receiving for the first time the touch of a man's lips and hands, I noticed that she had a malformed nipple. I struck my forehead, and examined the nipple more closely, and saw it did not match the other one. I racked my brains for an explanation of this deformity and decided it must be due to some serious defect of nature, and turning this idea over in my mind, I came to see that I had in my arms, not the most ravishing person imaginable, but some kind of monster, rejected alike by nature, man and love. I carried my stupidity to the point of speaking to her about her nipple. At first she treated my remark as a joke, and in her light-hearted way she did things that should have made me die of love. But as I continued to betray a residue of unease which I could not hide, in the end she blushed, adjusted her clothes, and moved without saying a single word towards the window. I wanted to sit there beside her, but she turned and sat on a sofa, then quickly rose and walked around the room fanning herself. Finally, she said to me in a cold and scornful voice: "Jacko, give up women and study mathematics."'[67]*

A day or two later, Rousseau took a gondola to her house, only to be told that Giulietta had gone to Florence: 'Although I did not feel the fullness of her love while I was embracing her,' he protests, 'I felt it cruelly when I lost her. My irrational regret did not leave me. I could console myself for having lost her, lovable and delightful as she was, but I could never console myself for the knowledge that she must remember me with contempt.'[68]

He tells another story in the *Confessions* about his sexual experiences in Venice which, in its way, is also curious. His Spanish friend Carrio, wearied of pursuing girls who were *entretenues* by other men, proposed to Rousseau

* He adds the strange suggestion that anyone who reads his account of the incident of Giulietta's nipple 'will have a complete understanding of J. J. Rousseau'.

that they should share the cost of keeping a girl for themselves alone, an arrangement not uncommon in Venice. Carrio found a girl of twelve, blonde and 'sweet as a lamb'; the two of them gave the mother money and arranged for the daughter's education. She had a good voice, and for two sequins a month apiece they were able to provide her with a spinet and singing lessons, 'so that she might eventually have a profession other than prostitution'. Since she was so very young, her patrons had, as Rousseau put it, to sow a great deal before they could reap. 'And yet,' he adds, 'we were content to go and spend our evenings with her, talking and playing with the child, and perhaps enjoying ourselves more than we should have done if we had actually possessed her; for so true is it, that what attracts men to women is not sexual gratification but the pleasure of being in their company. Insensibly my heart became attached to little Anzoletta, but with a paternal affection in which the senses played so small a part that the more my tenderness increased the less it was possible for sensuality to enter into it; I felt I should be as horrified to approach the child once she was mature, as of an abominable act of incest. I noticed the feelings of the good Carrio taking the same turn. We obtained for ourselves unwittingly pleasures no less sweet than, but very different from, those we had originally envisaged, and I am sure that however beautiful that poor child might have grown up to be, we, far from being her corrupters, would have proved to be her protectors. My disaster, which came shortly afterwards, deprived me of any opportunity to participate in this good work.'[69]

The 'disaster' Rousseau mentiones here was his breach with the Ambassador and his departure from Venice. Many circumstances combined to undermine the possibility of good relations between Rousseau and his employer. On several of these matters we are fortunate to have the written testimony of both parties; and however impartial one's perspective, it is not difficult to feel a greater sympathy for Rousseau. One incident they both describe is the arrangement in January 1744 of a dinner for the Duke of Modena,* an Italian sovereign prince who had been driven from his principality by the Sardinian army and had sought refuge in Venice with his French-born wife. When the Ambassador informed his secretary that he could not expect to dine with them, Rousseau protested that he had a right to a place at the table. According to Rousseau's account, Montaigu answered indignantly: 'Does my secretary, who is not even a gentleman, claim to dine with a sovereign, when my gentlemen do not?'[70] Rousseau says he answered: 'Yes, Monsieur, the post with which Your Excellency has honoured me ennobles me for as long as I occupy it; this gives me precedence over your gentlemen, or so-called gentlemen, and admits me where they cannot go. You will know that when you make your official inauguration

* François-Marie d'Este.

[Rousseau is here referring to that expensive ceremony which Montaigu was constantly postponing] I am required by protocol and immemorial custom to follow you in full uniform and to have the honour of dining with you in the Palace of St Mark; and I do not see why a man who had the right to dine in public with the Doge and Senate of Venice may not sit down in private with the Duke of Modena.'[71]

Rousseau does not record the Ambassador's rejoinder to his eloquent and impassioned utterance, but we have Montaigu's version of the incident in a letter[72] he wrote that same year to the Abbé Alary: 'As for M. Rousseau's attitude in the matter of the Duke of Modena, who was to have dined with me, I told my secretary that he would have to eat with my gentlemen-in-waiting, to which he objected in a manner so impertinent that I thought he must be mad. I said everything I could to calm him down, reminding him of the confidence I had in him, and of the way I had treated him. He replied that confidence and so forth was all very well, but he would be more impressed by a few silver coins.'[73] In the event, the Duke of Modena did not come to dine at the Embassy, so the crisis was averted; Montaigu threatened to dismiss Rousseau, but, as we have noted, Rousseau was still writing in February 1744 of 'all the Ambassador's goodness' to him.

By the end of April,[74] Rousseau was so dissatisfied with his situation at the Embassy that he wrote to the Ambassador's brother in Paris, the Chevalier de Montaigu, who had first arranged the job for him, asking him to intervene on his behalf with his employer: 'It is with infinite reluctance that I have decided to trouble you. I reckoned that the zeal and goodwill I put into my work for M. the Ambassador could make up for my defects, and I have spared nothing to compensate His Excellency with industry for what I may lack in talents. I see now with sorrow how useless my efforts to please him have been. I could not fail to be aware of the ill success I have had, for His Excellency has told me of it squarely, and more than once, and the way he behaves to me confirms it every day.' Rousseau goes on to admit that his discontent with his employer is mutual, but adds that he has always avoided complaining to the Ambassador, 'first, because he makes it plain that he has no intention of remedying my grievances, and secondly, because he told me three months ago that he was giving me six weeks' notice, and I felt that discretion demanded patience during an interval so short'. However, Rousseau continues, 'this interval has prolonged itself imperceptibly without my having heard His Excellency speak of the matter again, and since he seems no more pleased with me than he was before, it is only fair that I should know whether I must leave or wait to have a successor, so that if His Excellency prefers not to be rid of me immediately, I may make to him those representations which I believe to be desirable about my situation'. Rousseau asks the Chevalier to ascertain his brother's intentions and act as his inter-

mediary, since he is confident that the Chevalier 'will not make use of my letter in any way which will add to my difficulties'. In this last respect, Rousseau was once again to be disappointed.

The Ambassador gave his version of his experience with Rousseau in a letter he wrote to the Abbé Alary in mid-August,[75] after he had, in his own words, 'dismissed the man like a bad valet for the insolence he allowed himself'. It is in this letter that Montaigu speaks of his irritation with Rousseau's demands for precedence and for the use of the gondola; he also complains of Rousseau's haughty manners in the office, remarking that a chair at the end of the Ambassador's desk had not satisfied his secretary: 'from the start he sat himself in my armchair, and while I was dictating to him, racking my brains sometimes for a word that did not come to me, he would pick up a book to read or gaze at me in pity.' In spite of all this, Montaigu says he put up with his secretary's insolence for two months before telling him he would have to dismiss him. And then, having recalled the episode of the dinner for the Duke of Modena, Montaigu says that Rousseau had the effrontery to refuse to bring Embassy papers to the country house that he had rented on the mainland, saying he was unwilling to travel on a public conveyance 'fit only for servants, and not for a man like himself'; which meant that he, the Ambassador, had to leave his country house and work in Venice. Another story Montaigu tells is that Rousseau, having taken down a memorandum to the Senate which Montaigu had dictated to him, had it afterwards transcribed by the second secretary, the Abbé de Binis. 'I asked him if he was indisposed, since he had not written out the memorandum himself; he replied with a sneer that he was quite well but that the Abbé had a more elegant handwriting. This marked the end of my patience. I told him calmly to go back and re-write the memorandum. I made him hand me the document that same afternoon, calling him to my office when he had finished it. I then informed him that he was no longer in my service.'

Montaigu does not disguise the fact that at this point he lost his temper with Rousseau. He says that his secretary made outrageous demands in respect of his expenses: 'I reminded him that there was a time when any impudent upstart like himself would have been thrown out of my office window, and that the wretched condition from which I had delivered him in France ought to have been a warning both to myself and to those who had introduced him to me to think differently of him from what we had thought. I told him he had all the bad qualities of a very bad servant, and that it was on such a footing that I would consider the account he had given me of the expenses of his journey.'

In what follows, Montaigu betrays his own meanness to an extent which seems to justify all Rousseau's criticism of him. For Montaigu admits that,

apart from having paid no wages to his secretary, he had deliberately delayed the settling of Rousseau's account of his *voyage d'installation*. Not only did he deduct, as we have noticed, the sums Rousseau had paid for food, lodging and travelling at a more luxurious level than Montaigu considered necessary, he also decided to charge Rousseau the 138 *livres* he had paid for the transport of his baggage from Paris.

Rousseau, learning that Montaigu was writing to Alary about his dismissal, also wrote[76] to the *abbé* saying, 'I can hardly believe that any gentleman, and you, Monsieur, less than anyone, would approve of the indecent and scandalous manner in which His Excellency has thought fit to get rid of me.' He says he would have liked to have kept the matter private, but since the Ambassador 'has insulted me publicly, the defence of my honour requires that I vindicate myself before the public, and this I shall do with all the ardour and resolution which befits a gentleman in such a case'. He ends his letter by expressing the hope that his moderation will not count against him.

Telling the story in the *Confessions* of his breach with Montaigu, Rousseau says that it was his letter to the Ambassador's brother which provoked His Excellency's most violent outburst: 'After abusing me wildly, and at a loss for what to say, he accused me of selling the Embassy ciphers. I burst out laughing, and asked him in a mocking tone if there was anyone in the whole of Venice stupid enough to give a crown for them. This made him foam with rage. He even made a show of having his servants throw me out of the window.'[77] At this point, Rousseau says he bolted the door firmly on the inside and informed His Excellency that the matter would be settled between the two of them. 'My action and my look calmed him at once: he betrayed his surprise and alarm. When I saw that he had recovered from his fury, I bade him farewell in a very few words and without waiting for a reply, I opened the door and went out ... I left the Embassy, never to return.'[78]

Rousseau's departure from the Embassy appears, in fact, to have been rather less precipitate than these words suggest. In a letter dated 4 August[79] to the French Embassy in Switzerland he mentioned that he had ceased to exercise the functions of Embassy secretary in Venice and proposed to return to France as soon as possible; and it was two days later that he left the Embassy for good. The letter to Switzerland was about a man calling himself M. de Montigny and claiming to be an escaped prisoner-of-war from Hungary who needed help in rejoining his regiment. Rousseau had already drafted a letter[80] to the man's mother, telling of his escape and suggesting that she send him money through M. Gallantin in Geneva. Montaigu was predictably unwelcoming to escaped prisoners-of-war who came begging for money, and Rousseau had some doubts about the genuineness of Montigny; but at least one positive outcome of his dealings with such people in Venice was a short play he wrote entitled *Les Prisonniers de guerre*.

Two days after he had quit the Embassy, Rousseau wrote a long letter[81] to
M. du Theil, the under-secretary who was running the Foreign Office after
Louis XV had dismissed Amelot in order to take foreign affairs into his own
hands.[82] Here Rousseau says that the Ambassador threatened to have him
thrown out of the window – or even to throw him out himself – because
'he could not force me to agree with his calculation of my expenses'.
Rousseau adds: 'I left the room, congratulating myself that I had not been
carried away by the emotions His Excellency had aroused in me to the extent
of replying in kind and forgetting the deep respect I owed to the high office
he bears. When he saw me going out of the room he ordered me to leave the
Embassy at once and never to set foot in it again . . .'

'And so,' Rousseau continues with characteristic eloquence, 'here I am on
the streets, worn out, ill, without help or money, without a homeland,
twelve hundred miles from all my friends, weighed down with debts which I
have had to incur because His Excellency has broken the contract between
us.' The letter ends with an appeal for M. du Theil's protection.*

His predicament in Venice was not altogether as wretched as this letter
pretends. For Rousseau had several friends in Venice who were swift to help
him in his time of need. They included the French Consul Le Blond, whose
contempt for the Ambassador was more than matched by his liking for his
secretary; Le Blond, a *bon vivant* with a large family,[83] not only took
Rousseau into his house, but organized a dinner at which Rousseau was
fêted by the entire French colony. Loans were pressed upon him, and invi-
tations came from all sides. Montaigu, informed of what was happening,
went to the lengths of asking the Venetian Senate to expel Rousseau from
the republic. This encouraged Rousseau to show his contempt for Mon-
taigu's behaviour by lingering in Venice for a fortnight longer than he had
originally intended: 'My conduct was observed and approved. I was univers-
ally respected. The Senate did not deign to reply to His Excellency's absurd
request . . .'[84]

There is no word in the *Confessions* of the things he wrote to Du Theil
about being 'on the streets, worn out, ill, without help or money'. On the
contrary, he says: 'I went on seeing my friends. I took leave of the Spanish
Ambassador, who received me very kindly and of the Neapolitan Minister,
Count Finochietti, whom I did not find at home, but who replied most
courteously to the letter I wrote him. Finally, I departed . . .'[85]

* A vain appeal. M. du Theil was too busy in the service of an ailing Louis XV to pay
attention to the grievances of M. de Montaigu's ex-secretary. Rousseau's letters to Du Theil
were later stolen from the Foreign Office file and handed to Voltaire, who distorted the
contents to support his allegation that Rousseau had been a mere valet at the Embassy, not a
secretary. The only basis for this malicious charge is that Rousseau, in writing to Du Theil,
refers to his predicament in terms of the duties of a *domestique* (servant), whereas in writing to
Alary he refers to the duties of *un honnête homme* (gentleman).

The State Archives of Venice contain evidence of the truth of Rousseau's story. A memorandum[86] dated September 1744 refers to an approach made to the Senate by the French Ambassador to have his former secretary deported, but notes that the man had already left Venice on 22 August. The French Consul Le Blond is named as being asked to convey this information to his Ambassador. A curious feature of this memorandum is that it shows how openly Le Blond had expressed to the Venetian authorities his opinion of M. de Montaigu: 'The Consul Le Blond undertook to convey the message; he said he had already informed the Ambassador of the facts, but that His Excellency, in his stubbornness, had chosen not to believe him . . . knowing the character of the Ambassador, he was not in a position to give him advice; while on the other hand, he reported that Rousseau had expressed the utmost zeal for the Republic since he had been dismissed.'

According to the same memorandum, the French Consul accompanied Rousseau to his boat and lent him money for his journey back to Paris. A week before his departure, Rousseau had written a second letter[87] to M. du Theil at Versailles speaking of further ill-treatment at the hands of the Ambassador, saying he was having him chased from house to house and forbidding people to offer him lodging. The Ambassador, unable to find anyone cowardly enough to beat him to death, was threatening to have him thrashed day and night until he left Venice. Moreover, His Excellency was not only refusing to pay him his wages, he was detaining his belongings at the Embassy. For these reasons, Rousseau says, he would come to France as soon as he could collect the money for the journey in order to seek both 'the protection of the Foreign Office and the justice of the King'. He was fated to obtain neither the one nor the other.

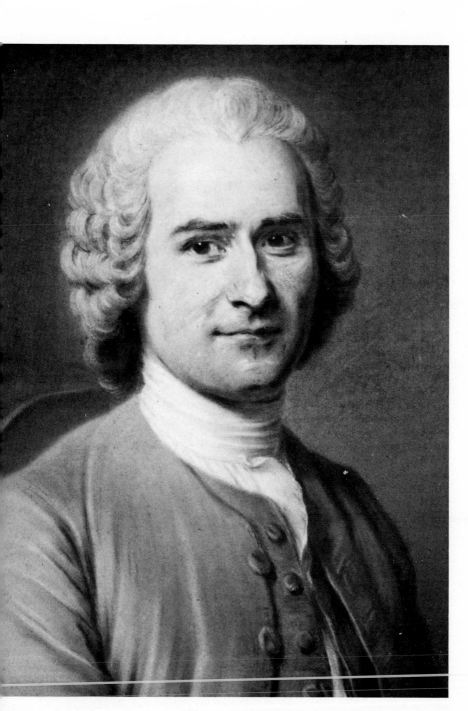

1. Jean-Jacques Rousseau, aged forty, by Maurice-Quentin de Latour.

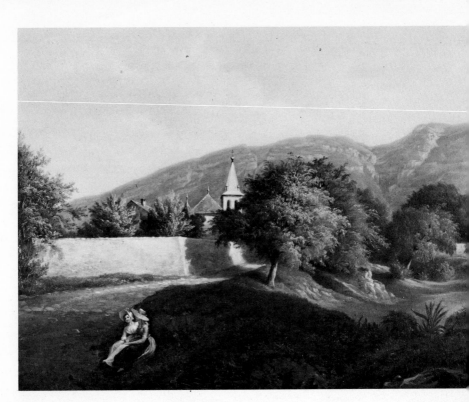

2. Bossey, near Geneva, by J.-L. Agasse.

3. Les Charmettes, near Chambéry, by J. Werner.

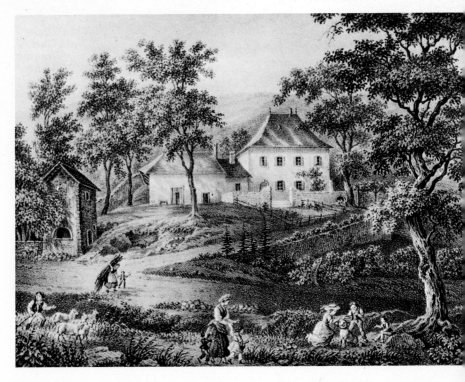

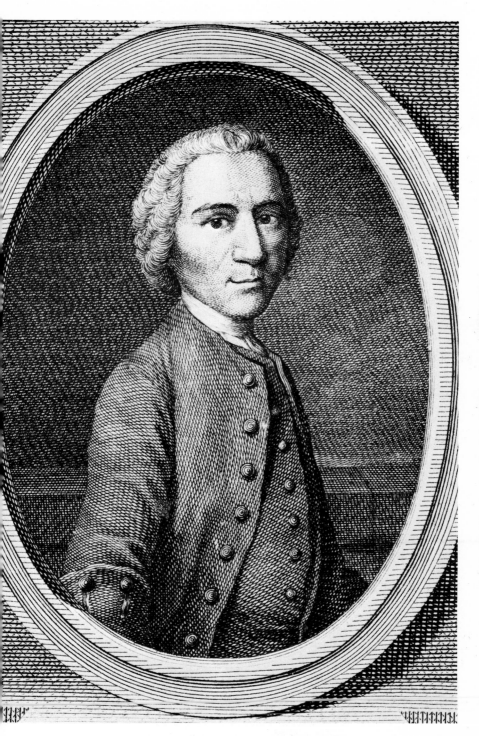

4. Rousseau, aged forty-two, after a painting by R. Gardelle.

5. Isaac Rousseau, Jean-Jacques' father.

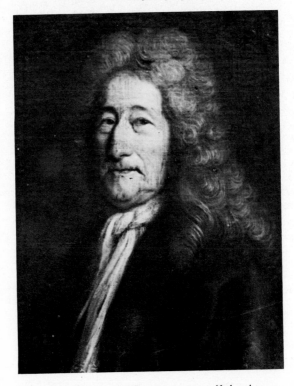

6. David Rousseau, Jean-Jacques' grandfather, by
R. Gardelle.

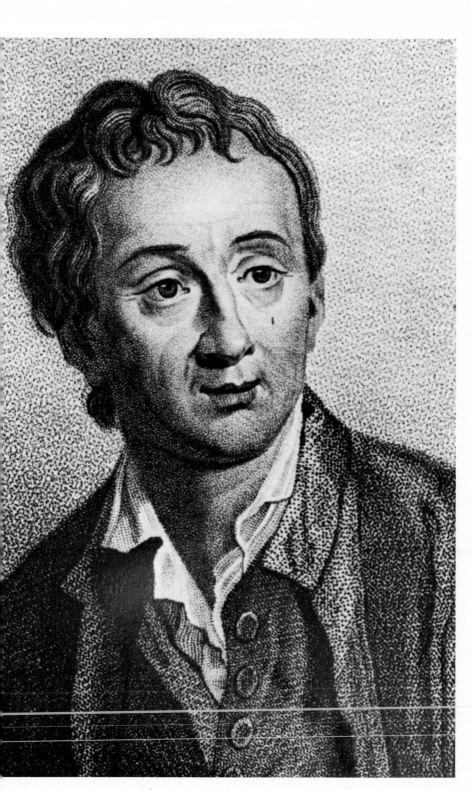

7. Diderot, after a painting by Van Loo.

8. Grimm, after a drawing by Carmontelle.

9. D'Alembert, by de Latour.

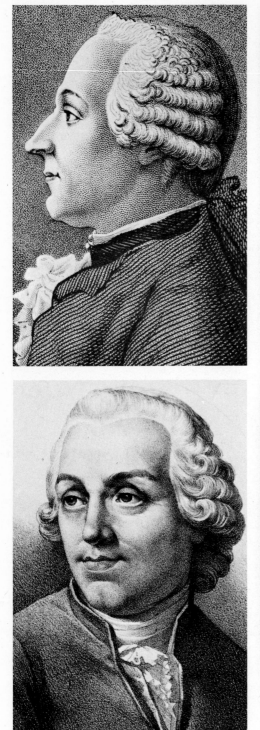

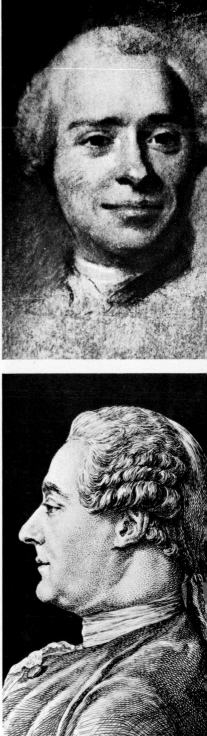

10. Condillac, after a drawing by Danlou.

11. Charles Duclos, after a drawing by Cochin

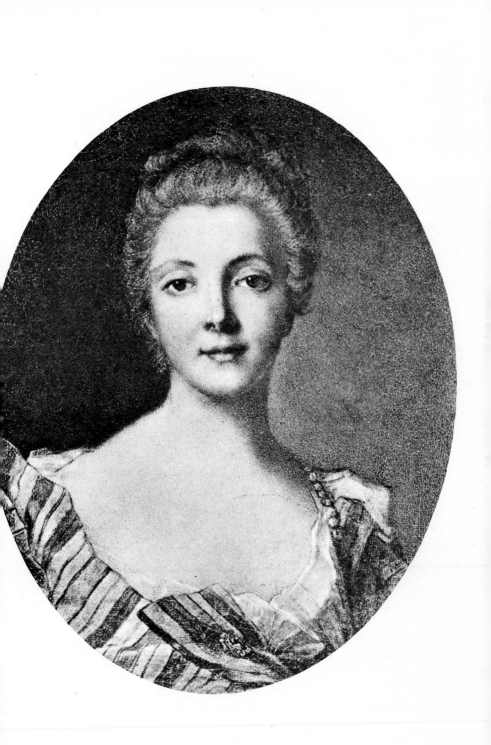

12. Madame Dupin, after a painting by Nattier.

13. Dupin de Francueil, from a contemporary pastel.

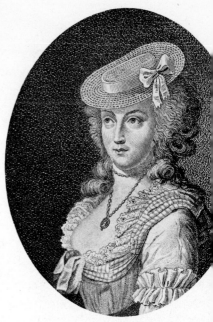

14. Madame d'Épinay, after a painting by de L

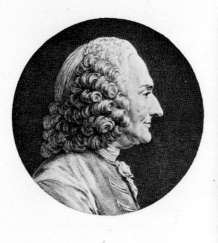

15. Jean-Philippe Rameau, after
J. J. Caffieri.

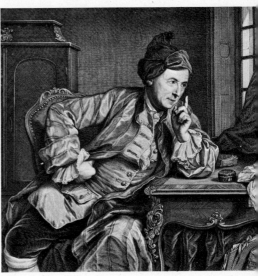

16. Capperonnier de Gauffecourt, after a painting by
Nonnette.

'LES MUSES GALANTES'

Rousseau's journey back to Paris took him nearly seven weeks. The Venetians believed he had gone through the Grisons[1] into Switzerland; in fact he went to Domodossola by coach and boat across the lakes, and then walked over the Simplon Pass into the Valais.* He rested for a while at Sion, where he recalls that M. de Chaignon,† the French Resident, received him in a friendly way. He then set off for Geneva, passing through Nyon without stopping to visit his father because he felt too ashamed after his humiliation in Venice to show himself to his stepmother. But once in Geneva, he was persuaded by the bookseller Duvillard,‡ an old friend of his father, to make an excursion in his company to Nyon, putting up at a tavern, where they could feel free to invite Isaac to dine without also inviting his wife. 'Duvillard sought out my poor father, who came running to embrace me,' Rousseau writes in the *Confessions*, making no mention there of Isaac being 'crippled'. The three of them dined together, and after an evening which he said 'warmed my heart',[4] Rousseau spent the night at the inn and hurried back to Geneva the next day without meeting his stepmother.

In Geneva he found more friends. His mother's old admirer, M. de la Closure, was still French Resident, and again showed his usual 'great kindness'; what was even more important, his secretary M. de Gauffecourt§ supplied Rousseau with money. Rousseau's original intention had been to stay in Geneva until 'a happier fate should, by removing obstacles, enable me

* 'On this long road, I had little adventures at Como and in the Valais and elsewhere. I saw several places, including the Borromean Islands, that deserve to be described. But time passes, and spies pursue me,' he writes in the *Confessions*.[2]

† Pierre de Chaignon (1703–89) was French Resident at Sion for forty-three years. Montaigu warned him that Rousseau was an 'adventurer'.[3]

‡ Emmanuel Duvillard (1693–1776), bookseller in Geneva since 1721.

§ Vincent Capperonnier de Gauffecourt (1691–1766) was not only secretary to the French Resident: he held also the salt monopoly for the Valais and Geneva, which brought in a substantial revenue. He was later to become a friend of Rousseau and the *philosophes* in Paris.

to rejoin my poor *maman*',[5] but the storm caused by his breach with Montaigu made him feel he must hurry to Paris to clear his name. Even so, he did not take the shortest route; he went first to Lyons, in order to collect evidence that Montaigu was swindling him in charging him 138 *livres* for baggage weighing 1,150 pounds. Rousseau claims that he found proof at the Customs House that the baggage he had sent weighed only 45 pounds: 'I attached the official certificate to M. de Montaigu's memorandum of charges, and armed with these documents and several others equally impressive, I went to Paris, very impatient to use them.'[6]*

As soon as he reached Paris, Rousseau wrote a third and even more emotional letter to M. du Theil at the Foreign Office: he promised it would be his last on the subject of M. de Montaigu, and he apologized if it were a breach of correct form: 'I beg you to forgive me because of the terrible distress and despair into which such strange treatment has plunged me. Is there anything more wretched for an honourable man than to see himself infamously slandered in the eyes of the public, and put in danger of his life, without a shadow of good reason and all because of a wretched dispute about money, without his being allowed either to defend or to justify himself? I realized I must make myself ridiculous, since an inferior is always wrong vis-à-vis a superior, but I could see no means other than making just and respectful representations to protect my outraged honour. It is not M. de Montaigu's treatment of me that affects me in itself; for I have reason to know that he is too poor a judge of merit for me to care to have his good opinion. But, Monsieur, what will the public think, the public that is accustomed to judge by appearances, and seldom troubles to ascertain whether anyone who is ill-treated deserves what he gets? It is the duty of those persons who love justice, and who are in a position to investigate things fairly, to rectify the public's false notions and restore the good name of an honourable man who holds his life worthless once he has lost his reputation.'[8]

This *cri de cœur* received no reply.† M. du Theil had left Versailles to join the ailing King with his armies, and had more important matters of state to

* It should be said in fairness to Montaigu that Rousseau collected evidence in Lyons of charges imposed on only one piece of luggage – for besides 'the little case containing a gold-embroidered waistcoat, several sets of ruffles, six pairs of white silk stockings and nothing more', which Roguin had dispatched from Paris through Lyons, Roguin must have sent other, and heavier, things, for Rousseau's letter to Montaigu of 23 November 1743 speaks of his having sent Roguin 'a fairly considerable list of various purchases to be made in Paris for myself and my friends in Venice', and Roguin himself in a letter to Rousseau dated 6 December 1743 says he has been happy to have had 'opportunities' (in the plural) of being useful to him. Rousseau had many real grievances against Montaigu, but this particular charge of swindling is not well founded, since Montaigu was probably quoting the figures for other and much heavier items than the 45-pound case that had come through Lyons.[7]

† Rousseau's letters to Du Theil were worse than useless, for they were destined to be filched from the Foreign Office files and used by Voltaire to denigrate Rousseau.

think about. It so happened, however, that M. du Theil was destined to suffer soon afterwards under the new Foreign Secretary, the Marquis d'Argenson, some of the same kind of bitter humiliation that Rousseau had suffered under the Comte de Montaigu.

Rousseau's account in the *Confessions* of his return to Paris strikes a more buoyant note than his letter to M. du Theil: he says in those pages that everybody in Paris – officials and public alike – was scandalized by the behaviour of the Ambassador, and that the only person who received him coldly was one 'from whom I should have least expected such injustice', the Polish-born Mme de Beuzenval, who had first introduced him to M. de Montaigu. It seems that she could not, as a Countess, bring herself to believe that a Count could be in the wrong in a matter of good conduct. Rousseau never called on this lady again. He was also disappointed to find that even those who were sympathetic towards him were unwilling to take any action on his behalf. He had much the same experience as Voltaire had after he had been beaten up by the servants of the Chevalier de Rohan; he found that the upper classes closed ranks on the side of the aggressor. People might agree that M. de Montaigu was mad, but he was still a nobleman and an ambassador, and Rousseau was only a clerk; and 'the good ordering of society – or what was considered such – required that I should obtain no justice, and I obtained none'.[9] In disappointment, Rousseau passed from nursing his own grievances to more general reflections on the injustice of the established social system. The experience, as he put it, 'sowed the seed of indignation in my soul against our stupid civil institutions, in which the real public interest and genuine justice are always sacrificed for the sake of any kind of apparent order which is actually detrimental to real order, and only adds the sanction of public authority to the oppression of the weak and the iniquity of the strong'.[10]

These reflections, to be developed later in Rousseau's *Discours sur l'origine de l'inégalité*, were banished from his mind at the time by the generosity of a rich young friend who invited him to live with him in his apartment in Paris: this was Ignacio Altuna, one of the Spanish noblemen that Rousseau met in Venice.* Altuna assured Rousseau that his apartment in Paris was much too large for one man to live in alone; Rousseau accepted the invitation gratefully, and the arrangement lasted until Altuna left for Spain the following spring.

Altuna was one friend with whom Rousseau never quarrelled, and he

* Don Manuel Ignacio Altuna y Porta, born 1722 at Azcoitia, studied at a seminary for sons of noblemen in Madrid and afterwards travelled in Italy. At Venice he was introduced to Rousseau by Carrio. He left for Paris a short while before Rousseau and remained there until spring 1745. He returned to Spain to become Mayor of Azcoitia. In 1749 he married Doña Maria Brigida de Zuluaga, who bore him one son and one daughter before his death, at the age of forty, in 1762.

writes of him in the *Confessions* with singular affection. It is true that Rousseau lived under the same roof as Altuna for less than a year and saw no more of him after that date, and that he speaks in the *Confessions* about a friend who had died at the age of forty; but the tender feeling he expresses is clearly sincere. In Venice, Rousseau had advised Altuna to go to Paris to study science in order to augment the study of fine arts which he had already undertaken in Italy, and he was proud of having awakened in his friend a thirst for learning. Since Altuna was ten years younger than Rousseau and still only twenty-two when they lived together in Paris, Rousseau was probably able to enact to a certain extent the role of tutor. He describes Altuna as having neither the usual Spanish phlegm nor the usual Spanish complexion; he had fair skin with ruddy cheeks and light brown hair: 'He was big and strongly built, with a body well formed to house his mind.'[11] As for his character, Altuna appeared to Rousseau to be one of those men 'that Spain alone produces; too proud to be vindictive, gallant without being sentimental. He enjoyed the company of the mistresses of his friends, but I never saw him with a mistress of his own, nor with any desire to have one . . . Outwardly he was devout in the way all Spaniards are, but inwardly he had the piety of an angel. Apart from myself, he was the only really tolerant man I have known in all my life.'[12]

Rousseau was no less impressed by Altuna's method of working, which was more strictly timed by the clock than anything he had ever seen, even in Switzerland: 'Altuna divided his studies into hours, each allocated to a different branch of learning, and each so planned that he would break off in the middle of a sentence when the clock struck in order to transfer his attention to another subject. Nothing was permitted to interfere with his schedule: he never disturbed anyone else or allowed anyone else to disturb him, and he showed no patience with people whose civilities bored him . . . And yet he had the most cheerful disposition imaginable and he loved jokes.'[13]

Rousseau and Altuna took their meals together at an inn near the Palais Royal run by a tailor's wife named Mme La Selle, who was said to offer poor food but lively company; her regular customers included army officers, merchants, financiers – 'anyone but priests or lawyers'.[14] The atmosphere, says Rousseau, was always gay; stories of sexual conquest and other such *risqué* conversation set the tone of the place, and pretty girls could be found next door at the famous dressmaking establishment of Mme Duchapt. Both Rousseau and Altuna enjoyed the talk at Mme La Selle's without visiting the girls. 'I would have amused myself like the others if only I had been bolder,'[15] Rousseau admits. He does not tell us what held Altuna back, but says he believed that Altuna was a virgin when he married in Spain at the age of twenty-seven.

When Altuna decided to leave Paris for his estates at Azcoitia, he invited

Rousseau to accompany him, as we may judge from a letter Rousseau wrote on 25 February 1745[16] to Mme de Warens: 'the friend at whose house I am staying has been afflicted this winter with an illness of the stomach, from which he has finally recovered against all expectation on my part. This good and generous friend is a Spanish aristocrat, fairly well off, who presses me to accept a refuge in his house in Spain so that we may philosophize together for the rest of our days. Much as kindred tastes and opinions attach me to him, I have not taken up the idea, and I leave you to guess why.'

Presumably Rousseau wanted Mme de Warens to believe that he still yearned to pass the rest of his days with her; and indeed he says as much in a later part of the letter:

'Do you ask what I am doing? Alas, *Madame*, I love you. I complain about my brute of an Ambassador. People sympathize with me: they offer me esteem, but they do not give me justice. I have not abandoned hope of being revenged one day on M. de Montaigu by making him see that I am not only the better man, but the better-respected man than he. For the rest, I have many projects and few hopes, and my ambition is always to have the happiness of ending my days with you.'[17]

Having found a friend who would take this letter to Chambéry for Mme de Warens, Rousseau added to it on 1 March a few more sentences, telling her of the festivities in honour of the Dauphin's marriage that he had just witnessed in Altuna's company at Versailles and Paris: 'My Spanish friend, seized with all the poetic exhilaration of his country, exclaimed that Mme la Dauphine was a sun whose radiance liquefied all the gold of the kingdom into a river in which the whole Court was swimming.' Rousseau himself had been less excited: 'I saw all the riff-raff of Paris dancing and prancing in those superb and magnificent illuminated tents they put up in the public squares to amuse the people. Never have such festivities been seen. The people shook their rags so much, and drank so much, and stuffed themselves so much that most of them were sick.'[18]

The prospect of the populace rejoicing did not bring out the democrat in Rousseau. The departure of Altuna for Spain, however, brought his own condition nearer to theirs; for it meant that he was no longer able to live graciously as the guest of a nobleman. In the spring of 1745, he was once more reduced to the level of *le peuple*, entering what was to prove to be one of the most arduous periods of his life. He moved once more to the Hôtel Saint-Quentin near the Sorbonne – that 'ugly street, ugly hotel, ugly room',[19] as he had once described it; although this time he speaks of choosing it for its 'tranquillity'[20] rather than its cheapness. He also says in the *Confessions* that he continued to dine 'fairly often'[21] at the convivial establishment kept by Mme La Selle, but his correspondence does not bear this out: 'I go very seldom to our old inn,' he wrote to Du Plessis in the

autumn.[22] He cannot have had the money at that time to dine there more often. Indeed, in a letter written in July[23] to Daniel Roguin, Rousseau admitted that, as a result of failing to collect what was owed him by M. de Montaigu, he was wholly unable to pay his debts; he was even reduced to asking Roguin to inquire whether the merchant who had sold him the gold-braided waistcoat could be induced to take it back at a loss. More cheerfully, he reported that he had embarked on a project from which he hoped to make all the money he needed: 'I am determined to imprison myself in this hotel until it is finished.' This work was his opera *Les Muses galantes*, which he had started before he went to Venice. He admitted to Roguin that his expectations did not match his hopes: 'I am so disgusted with the society of my fellow men, and my dealings with them, that honour alone keeps me here; should I ever achieve my dearest wish and be free from debt, I would not be seen in Paris for more than twenty-four hours afterwards.'

Roguin hastened to reassure his friend that he was in no hurry to be repaid: 'Indeed, if you are in difficulties, I will always happily share with you the little that I have.'[24] Clearly Rousseau was not friendless. Nor was he alone, for during this miserable period at the Hôtel Saint-Quentin he formed an intimate attachment which was to last for the rest of his life: he met Thérèse Levasseur and became her lover. Far from being a second Baronne de Warens, or one of those cultured upper-class young ladies to whom alone Rousseau professed himself attracted, Thérèse was an illiterate laundry maid who worked at the hotel. She was aged about twenty-two, and although she did menial work she came, Rousseau assures us, from a 'good family',[25] being the daughter of François Levasseur, a former 'officer coiner' at the mint at Orleans who had fallen on evil times when that mint was closed. Thérèse worked at the hotel to keep both her father and her mother, after the latter had gone bankrupt in business. Rousseau gives an elevated picture of the Levasseurs' social status: but, no doubt, Thérèse was a person who had 'come down in the world', as Rousseau had himself, and this may help to explain his sympathy for her: indeed Professor Starobinski suggests that what Jean-Jacques 'saw' in Thérèse was 'someone with whom he could identify himself', not another person, but an 'auxiliary of his own flesh'.[26]

At the Hôtel Saint-Quentin, Thérèse took her meals at the same table as the landlady and the guests. 'The first time she appeared,' Rousseau tells us, 'I was struck by her modest demeanour and even more by her lively and sweet expression; I had never seen anything like it.'[27] He recalls how the company at the table, which included old M. de Bonnefond, several Irish priests and the landlady herself all took pleasure in teasing the poor maid. Rousseau claims to have been her only defender, and says that, even if he had not found her attractive, pity alone would have drawn him to her: 'I have always liked decorous language and behaviour, especially in the fair sex, and

I could see that Thérèse was conscious of my solicitude. Her looks, animated by a gratitude she could not express in words, became ever more penetrating. She was very shy, as I was. A relationship which such shared timidity might well have thwarted, in the event developed rapidly. The landlady, who spotted it, was angry, but her ill-treatment of the poor girl only improved my prospects with her; and since she had no other champion in the house besides myself, she was sad to see me go out, and sighed for the return of her protector. The kinship of our hearts, the harmony of our dispositions had soon the usual outcome. She believed that she saw in me an honourable man, and she was not mistaken; I believed I saw in her a sensitive girl, simple and without coquetry, and I was not mistaken either.'[28]

Rousseau's claim that he acted as an 'honourable man' towards Thérèse has been disputed by his critics; it is, in any case, a curious boast, and it is followed in the *Confessions* by words no less puzzling: 'I declared to her in advance that I would never abandon her and never marry her.' It is perhaps arguable that Rousseau is here using the expression *'honnête homme'* in the sense of 'gentleman' and is only claiming to have played fair as a person of a superior class in making a girl from *le peuple* his mistress; but this reading conflicts with Rousseau's insistence that Thérèse was not socially inferior. In any case, when Rousseau wrote his *Confessions*, he had different moral standards from those he had when he first met Thérèse. Before his 'reform', his scruples, like his ambitions, were those of a young man of the world.

Indeed Rousseau tells us that when Thérèse first resisted his efforts to make love to her his immediate thought was that she must have a venereal disease; Thérèse realized what he suspected, burst into tears, and confessed her only fault, having been seduced as an adolescent. Rousseau says he promptly brushed this trifle aside: '"Virginity," I exclaimed. "Imagine looking for that in Paris, and in a girl of twenty! Ah my Thérèse, I am only too happy to possess you as a good and healthy girl."'[29]

At first Rousseau looked to Thérèse only for sexual gratification, but he soon discovered she could give him a certain tenderness and evoke in him a compassionate attachment, which together transformed pleasure into happiness. It seemed he had at last found someone 'to take the place of *maman*'.[30] Could this be true? Thérèse had none of the brains or the culture of Mme de Warens; she was, indeed, in the opinion of most of those who knew her, moronic. Rousseau himself admits that he wasted his time when he tried to improve her mind. She could write, but scarcely read; she could not count or even tell the time. Her misuse of words was notorious, and even her loving protector admits he made a list of her malapropisms to amuse Mme de Luxembourg. Rousseau claims for Thérèse, on the other hand, that she had a sound store of common sense, which enabled her to give him good advice in difficult situations and sometimes to protect him from the dangers to which his own passionate and impulsive nature exposed him.

Rousseau says different things at different times about the sexual aspects of his *liaison* with Thérèse. In the early years there must have been fairly regular sexual congress between them, since several children were born (a circumstance which has not deterred several commentators from suggesting that Rousseau was impotent, and the children fathered by another);[31] he no doubt also obtained from her that form of gratification to which his masturbatory habits disposed him, manual stimulation such as he was ashamed to solicit from those women of higher social status to whom he paid court. In a curious phrase he says: 'I found in Thérèse the *supplément* which I needed.'[32] This may only mean that he found in her a substitute for Mme de Warens; yet one notices that *'supplément'* is one of Rousseau's words for masturbation; not only in the *Confessions* but also in *Émile* he refers to the practice as 'that dangerous *supplément*' (Book IV). Later in the *Confessions* he says of Thérèse: 'from the very first moment I saw her I never felt the least spark of love for her, and I had no more desire to possess her than I had had to possess Mme de Warens; and the needs of the senses which I satisfied with her were solely those of sex, and had nothing to do with her as an individual'.[33] Those are harsh words; but if they rule out love, they do not rule out pity, companionship, dependence – and the older and more sickly Rousseau became, the more dependent he was on her care; the lost child in him may have recognized in her a kind of plebeian foster-mother who would feed him and nurse him as well as give him from time to time *la petite branlette*.[34]

And yet Rousseau and Thérèse did not immediately set up house together. She was living with – and supporting – her father and mother while he was concentrating on the composition of his operatic ballet, *Les Muses galantes*, which took him three months to complete. When the score was finished, he had to find some way of having it performed, something that could not be accomplished by sitting alone in his hotel room. He realized that 'no one who leads a solitary life can achieve anything in Paris',[35] so he went into society once more. Gauffecourt, who had gone from Geneva to Paris, gave him an introduction to M. de La Poplinière,* an exceedingly rich tax-farmer and patron of the arts, at whose splendid mansion in the rue de Richelieu the best chamber music in Paris was to be heard. Unfortunately for Rousseau, La Poplinière's zeal for music had already prompted him to patronize another composer, Jean-Philippe Rameau, and Rameau did not welcome any rivalry. Born in Dijon in 1683, Rameau was nearly thirty years older than Rousseau, and well established as the leading composer in France. He first made his name as a musicologist with the publication, at the age of thirty-nine, of his *Treatise on Harmony*, and the financial support of La Poplinière thereafter enabled him to devote his time to composition. In La Poplinière's household Rameau was 'the sun and the stars', and there was not much room for anyone else.

* Alexandre-Jean-Joseph Le Riche de La Poplinière (1693–1762).[36]

In a letter Rousseau wrote to a friend in Brittany* in September 1745[37] he said that La Poplinière had arranged for the score of his *Les Muses galantes* to be performed by an orchestra and described how Rameau, who was there, had reacted to it: 'Do you know that my music put him in a bad temper, that he maintained it was too good to have been written by me; and that as a consequence I had to make revisions, of which the success only made him more bitterly angry; so that finally I, who have always been his most fervent champion, see myself becoming, unless something is done about it, the victim of his brutality?'

Rousseau's apprehensions were well founded; Rameau was henceforth an enemy; and their disagreement (as we shall see) was to assume in time more than personal dimensions. Recalling, in the *Confessions*, the first rehearsal of *Les Muses galantes* at La Poplinière's house, Rousseau wrote: 'After the overture, Rameau began by excessive praise to intimate that the work could not be mine. He did not let the smallest thing pass without some sign of impatience; and after the air for counter-tenor, which was sung in a manly melodious way to a brilliant accompaniment, he could contain himself no longer; he spoke to me with a brutality which scandalized everybody there, saying that one part of the music he had just heard was by a genius and the other by an ignoramus, who did not begin to understand music.'[38]

Unfortunately for Rousseau, Rameau was idolized not only by his patron La Poplinière, but equally by La Poplinière's young wife,† who was Rameau's pupil at the keyboard. Mme de La Poplinière was related to Mme Dupin, being the grandchild of Mimi Dancourt, sister of Mme Dupin's mother Manon Dancourt. Mme de La Poplinière, a *grande horizontale* who had never got on well with her chaste kinswomen, did not share her liking for Rousseau, and was never very cordial towards him; however, her current lover was the Duc de Richelieu, to whom Rousseau had been introduced at Lyons by M. Pallu, and he proved altogether more friendly. Richelieu arranged to have *Les Muses galantes* played in its entirety at the house of M. de Bonneval, Intendant des Menus Plaisirs, and was so pleased with the ballet that he promised to have it performed at Versailles. When this promise failed to be fulfilled, Rousseau contrived to have *Les Muses galantes* performed by the orchestra of the Paris Opéra. According to the *Confessions*, he became dissatisfied with the piece after hearing it rehearsed several times and 'withdrew it without saying a word'.[39] According to Rameau, the ballet 'was offered to the Opéra and rejected'.‡

In later years, Rousseau came to dislike *Les Muses galantes* even more

* Jean-Baptiste Bouchaud du Plessis (b. 1715).

† Born Thérèse Boutinon Deshayes (1714–56).

‡ *Erreurs sur la musique*, 1755, p. 41. In this paragraph, Rameau refers to Rousseau's ballet without naming it as that of 'an individual ... who had combined Italian taste with the worst in French music'.

heartily: 'The work is so mediocre of its kind,' he wrote, 'and its kind is so bad that in order to understand how it could ever have pleased me, one must recognize the full force of habit and prejudice. Being trained from childhood in the French taste, and the sort of poetry which goes with it, I mistook sound for harmony, the striking for the interesting, and airs for an opera.'[40]

If the Duc de Richelieu failed to have *Les Muses galantes* performed at Versailles, he found other work for Rousseau to do in 1745. The sensational victory of the French army at Fontenoy, which enabled the Marshal de Saxe to occupy most of Flanders, was celebrated in France by several theatrical galas, and the Court authorities proposed to have Voltaire's patriotic *La Princesse de Navarre* revised and adapted for one such occasion with the new title of *Les Fêtes de Ramire*. On Richelieu's recommendation, Rousseau was invited to work on both the words and the music. Any constraint he felt at the thought of revising a score by Rameau was offset by joy at the prospect of working on a libretto by Voltaire, at that time still a hero in Rousseau's eyes. In December,[41] he sent his revised text to the author for approval. 'For fifteen years,' he wrote to Voltaire, 'I have been striving to make myself worthy of your attention and of that solicitude which you offer to young poets in whom you detect some talent. However, having composed the music of an opera, I find myself somehow metamorphosed into a musician and it is as such, Monsieur, that the Duc de Richelieu has entrusted me with the dramatic scenes with which you have linked the *divertissements* of *La Princesse de Navarre*. He has in fact required me to introduce such changes in the text as are necessary to make it appropriate to the new theme. I protested respectfully, but the Duke insisted and I have obeyed him, which, given my financial circumstances, is all I could do ... I beg you, Monsieur, to be so good as to examine those revisions, or rather to substitute others more worthy to serve the purpose.' Voltaire replied[42] in the friendliest possible language: 'Monsieur, you unite two talents which have hitherto been always distinct. These are two reasons why I should esteem you and seek to be your friend. I am distressed that you should have to waste both your talents on a work that is less than worthy of them.' Voltaire went on to explain that he had written the libretto in a great hurry and, being displeased with it, had banished it from his thoughts; he was therefore wholly content to leave the material in Rousseau's hands to do what he thought best with it.

In later years, Rousseau attributed the cordiality of this letter to an assumption on the part of Voltaire that he, Rousseau, was a protégé of the Duc de Richelieu, rather than to any genuine friendliness of Voltaire towards a young writer; but this suspicion entered Rousseau's mind only after he had quarrelled with Voltaire about other matters. The work on *Les*

Fêtes de Ramire took him two months to finish and then was delayed at rehearsal, where alterations were made by Mme de La Poplinière, and Rousseau himself was instructed to make further changes in consultation with the composer. The stress of all this interference, Rousseau says, made him 'ill for six weeks'. In the end, the opera was staged at Versailles with only the name of Voltaire attached to it. Rameau kept his name out of it, and Rousseau's name was not put into it. However, Rousseau considered the performance a success, especially the overture he had composed in the Italian style: 'a style very new then for the French'.[43] Unfortunately he did not receive a *sou* for his work, either as author or composer, on *Les Fêtes de Ramire*. He was too ill to apply for his dues immediately after the performances at Versailles, and by the time he was well enough to leave his room the Duc de Richelieu had gone to Dunkirk to prepare for an invasion of Scotland. Rousseau was convinced that Mme de La Poplinière had undermined the Duke's goodwill towards him, although he did not attribute her hostility to the influence of Rameau; he heard from Gauffecourt that she was prejudiced against all Genevans because a certain Genevan had once tried to dissuade M. de La Poplinière, whose mistress she had been for several years, from marrying her.[44]

In the spring of 1746, Rousseau started frequenting Mme Dupin's salon at the Hôtel Lambert more often, and he resumed with her stepson, Francueil, the study of chemistry which the two of them had embarked upon before Rousseau left Paris for Venice. They went to lectures together, and Rousseau took part with Francueil in experiments at the laboratory his friend had set up at the Hôtel Lambert. All this led to Rousseau's being invited to join the Dupin household as a paid secretary. He hesitated to accept. On the one hand, he needed money, for not only had he started to support Thérèse and her mother, he was being called upon to keep other relations of hers who came to Paris expecting to be fed. On the other hand, he still hoped to be able to earn a living as an author or musician. He refurbished his play *Narcisse* on the lines recommended by Marivaux and offered it to the Comédie des Italiens. The play was accepted 'for future production' and Rousseau was given an author's free pass to the theatre, but he received no money. There remained the Paris Opéra, where he still dreamed of success with *Les Muses galantes*. He says in the *Confessions* that he made a bargain with Francueil: he promised he would work for Francueil if he used his influence to have *Les Muses galantes* staged. It was its failure in rehearsal which finally persuaded Rousseau to give up the idea of living as an independent writer and composer and to accept a job with the Dupins so as to be sure of a regular salary. It was not a handsome salary despite the immense wealth of his employers. 'The eight or nine hundred francs a year which I earned in the first two years,' Rousseau complains in the *Confessions*, 'was

hardly enough to provide for my pressing needs, especially as I had to take a room in the rather expensive neighbourhood where the Dupins lived as well as pay the rent for a place at the other end of Paris, at the top of the rue Saint-Jacques, where, whatever the weather, I went to have supper every evening.'[45]* In the rue Saint-Jacques, Thérèse and her family were housed, and Rousseau's life was now squarely divided between the glittering luxury of the Hôtel Lambert and humble domesticity with his *petite amie*, an arrangement of a sort not uncommon in Paris at the time or inconvenient for most of the parties concerned; and it might have worked well if only Rousseau had been better paid. His life with the Dupin family offered certain advantages – good food, good wines, good conversation – but it also had its drawbacks. He had to work not only for Francueil himself but for his father and stepmother as well – to work for them, moreover, not only as secretary but as a research assistant for their books, since all had literary ambitions. When Rousseau agreed to join their household, Claude Dupin, the father, was aged sixty-four, and having made all the money he wanted, turned to authorship and published that year, in a limited edition, a book called *Économiques*.[46] Rousseau makes no reference to this work in his *Confessions*, but among his notebooks at Neuchâtel[47] there is a fragment headed 'Laws' which is a comment on Dupin's remark in that book about the Roman state having confiscated bequests made to unworthy persons. 'In these happy times,' Rousseau writes bitterly, 'no one is considered unworthy to inherit.' Claude Dupin's book is very much the work of a dilettante as distinct from that of an economist, but at least Dupin could write about money with the authority of a man who had acquired a great deal of it.

Inheritance had contributed only partially to his fortune. He owed most of his wealth to his second marriage, his marriage to the Mme Dupin that Rousseau knew and who had been born Louise-Marie Madeleine de Fontaine, for not only did that chaste and intelligent beauty emerge from a convent to marry Dupin when she was seventeen and he was a widower of forty-three, but her natural father, Samuel Bernard, secured for the bridegroom the post of farmer-general of taxes and secretary to the King, and so transformed him from a fairly rich man in Alsace into a very rich man in Paris. When he turned from practice to theory, Dupin had every reason to wish to uphold the interests of the moneyed bourgeoisie, of finance no less than property. His wife's literary ambitions were of another kind. Being not only the daughter of an actress, Manon Dancourt, but also the grandchild of a dramatist, Dancourt, she had literary blood in her veins, and she felt herself to be a born writer. Only she did not wish to write for the stage. Her pious

* To have a room near the Dupins, Rousseau lodged successively in the rue Jean-Saint-Denis, near the Opéra, the rue Neuve des Petits-Champs, and the rue Plâtrière, at the Hôtel du Saint-Esprit.

upbringing had provoked in her a strong reaction against the loose morals of the theatre; and being, as we have noticed, an unusually high-principled and high-minded figure in fashionable society of her time, she turned to literature with the aim of promoting virtue and reform.

Her stepson, Dupin de Francueil, issue of Claude Dupin's marriage to Marie-Jeanne Bouilhat, was interested only in science. He was aged twenty-nine in 1745, and after eight years of marriage to Suzanne Bollioud de Saint-Julien, he still lived at his father's house, where there was indeed no lack of space. Francueil's great aim in life was to become a Fellow of the Academy of Sciences and, since at least one published work was a condition of election, he sought Rousseau's help in meeting that requirement. Rousseau thus found himself in the Dupin household as secretary and assistant in the essays into authorship of an amateur economist, an amateur moralist and an amateur chemist. He could find no lasting satisfaction in a servile relationship to persons so much less gifted than himself, but at first he complained of nothing but the pay, since he found the work – or at any rate the subjects – interesting.

Mme Dupin's intention was to write essays in the manner of Montaigne and Saint-Évremond, hoping to revive in a frivolous and cynical age the loftier principles of earlier generations. On the other hand, her reformist ideas were rather ahead of her times; she anticipated much that was to be written in the nineteenth century by her great-granddaughter, George Sand. To have combined the high sentiments of the past with the bold opinions of the future might have been a formula for success; but Mme Dupin lacked the necessary talent and the staying power. Even with Rousseau to assist her, she could never finish what she began.

Rousseau's collaboration in the laboratory with her stepson failed to yield the desired publication, although the two of them somehow put together a substantial manuscript entitled *Institutions chimiques*, which was probably more the work of Rousseau than of Francueil. It has been pronounced no worse than most books that were published at that period on the same subject,[48] for while it is almost wholly derivative, the authors leaning heavily on the *Nouveau Cours de chimie* of Jean-Baptiste Sénac, it at least serves to set out simply and systematically, and without too many errors, the prevailing orthodoxy in the chemical sciences.

The extent of Rousseau's contribution to the literary work of M. and Mme Dupin has been the subject of much conjecture. Because he served them as an amanuensis, a great many of their thoughts may be seen set down in his handwriting. He worked for the family almost continuously from 1746 to 1751, and on occasions subsequently; and there is no doubt that they kept him extremely busy. Manuscripts dating from this connection – a connection often spoken of misleadingly as a 'collaboration' – may be found

in libraries in scattered places and sometimes still turn up on the booksellers' market.

As recently as the autumn of 1980 there was offered at auction in Monte Carlo a substantial bound volume[49] in the handwriting of Rousseau on the subject of feminism. It was evidently a series of notes that Mme Dupin had dictated to him, or had him copy from other authors' books. There are numerous small corrections in her hand. The manuscript is evidently the material for the big book she intended to write in vindication of the rights of women, but never finished.

What Mme Dupin did accomplish, years later, was to collect all her papers and documents, including the things she had dictated to Rousseau, and put them together in an archive at the *château* of Chenonceaux. That archive no longer exists. Some of the papers were deliberately burned during the French Revolution by the *curé* of Chenonceaux, who feared that they might prove compromising to Mme Dupin, she being still alive at the time of the Terror. (She died, aged ninety-three, in 1799.) Even so, a large number of papers remained at the *château* until the archive was dispersed in the 1950s.[50] The Monte Carlo manuscript is one which disappeared from view for a time; what it contains is clearly the work of Mme Dupin's brain and not Rousseau's; it represents her ideas, not his. He penned the words as the employee, the secretary, the amanuensis of another. His experience with Mme de Warens had taught him to admire remarkable women, but it is plain enough from all his published writings that he was never a feminist. He considered the proper place for women as being subordinate to men, and we cannot well doubt that he held that view at a time when he was himself, perforce, subordinate to a woman.[51]

Mme Dupin wanted to prove that women were as good as if not better than men in every respect, including physical prowess, and that women had done prodigious deeds in the few societies where they were allowed equality with men. In the material Rousseau gathered – for his duties included searching through books to find evidence to support Mme Dupin's thesis – we may notice the greatest absurdities of mythology and the most bizarre anecdotes of narrative literature set side by side with the sober data of history and anthropology, as if the researcher felt that in such a study it was hardly worth separating the nonsense from the science.

And yet it must be remembered that Mme Dupin was neither a foolish nor an uneducated woman. She paid Rousseau to read books which were worth reading and which helped in the formation of his own mind as a social thinker. In her library he had to make a systematic study of works by Plato, Bodin, Hobbes, Locke, Grotius, Domat, Fénelon and a great many other books he could not, as a poor man, have acquired himself. However much Mme Dupin may have demanded that he work on things that interested her,

she also enabled him to work on things that interested him; she did much to improve his education.

Besides, Rousseau was not only given access to an excellent library. The Dupins spent a great deal of money at Chenonceaux setting up a laboratory, where Rousseau could keep up his scientific studies with Francueil. For in the summers the Dupins left (and sometimes let) the splendid Hôtel Lambert in Paris and went to the valley of the Loire and there, in that exquisite *château* which had once housed the mistresses and widows of kings, they lavished their bourgeois wealth on splendid living.* 'I grew as fat as a monk at Chenonceaux,' Rousseau recalls;[52] he also amused himself writing plays and music for the entertainments Mme Dupin liked to stage. Among other things he wrote – in a fortnight – a three-act comedy *L'Engagement téméraire*, a poem entitled *L'Allée de Sylvie*, and several trios for voices. None of this literary activity, he declares, interfered with his work on chemistry† for Francueil, or his research for Mme Dupin. *L'Engagement téméraire* is not a very good play, and in a preface written years later for a published version Rousseau himself admits that 'nothing could be duller'.[54] He adds – as if to justify its publication – 'I have nevertheless kept a certain fondness for it because of the gaiety of the third Act, and the facility with which the play was written in three days – thanks to the contented state of mind in which I was living at that time'.

The story of *L'Engagement téméraire* turns on a rash pledge given by the hero that he will never proclaim his love to the heroine; he regrets the pledge when a rival provokes his jealousy. The plot is tricked out with forged letters and other devices familiar to theatrical audiences of the time. Lacking subtlety, the play was doubtless all the easier for amateurs to act at the Château de Chenonceaux. The subject of undeclared love may have reminded Mme Dupin that Rousseau had once declared all too precipitately his 'love' for her. The other work he wrote at the time, *L'Allée de Sylvie*, contains yet another treatment of the same theme. The *allée* of the title is an avenue beside the river Cher at Chenonceaux, the beauty of which can still be admired. The poet protests that he has come to walk among the trees and reflect on moral philosophy, but his thoughts turn to love, and he can think of nothing else:

* Chenonceaux was actually built by a bourgeois, Bohier, but taken over by Henri II for his mistress Diane de Poitiers. She was driven out by Catherine de Medicis, who bequeathed the *château* to Louise de Lorraine.

† Evidence of Rousseau's activity in the laboratory can be seen in a letter he received in February 1746 from Claude Varenne asking his advice on a problem of chemistry: that of determining the nature of salts by the configuration of their crystals. Claude Varenne, Baron de Béost (1722–88), was the author of several scientific books, a Fellow of the Academy of Dijon, which was to propel Rousseau to fame by awarding him the prize for his first *Discours*, and founder of the Botanical Gardens at Dijon. Gambling ruined him, and he died in obscurity.[53]

Une langueur enchanteresse
Me poursuit jusqu'en ce séjour;
J'y veux moraliser sans cesse,
Et toujours j'y songe à l'amour.[55]

One is left to speculate: of whose love was he dreaming? It cannot have been an intensely passionate love, or he would not have enjoyed the tranquil and contented state of mind he remembers. Perhaps it was some lingering fantasy of love for Mme Dupin. Perhaps it was a nostalgic movement of the heart towards Mme de Warens, although this latter is unlikely to judge from the frankly bitter tone of a letter he wrote to *maman* from Paris in December 1747,[56] on his return from Chenonceaux: 'As for myself I tell you nothing, and that is to tell you everything. In spite of the injustices you have done me inwardly, it is for me to make you change your everlasting mistrust of me into esteem and compassion. A few explanations should be enough for that; but your heart has too many of its own burdens without having also to carry those of another. I always hope that one day you will know me better and love me more.'

One person of whom Rousseau most probably did not think as he dreamed of love in the allée de Sylvie was Thérèse Levasseur, still slaving away to keep her family in the rue Saint-Jacques. Thérèse had good reason to think of Rousseau, for she was pregnant with his child. As Rousseau puts it with uncharacteristic levity in the *Confessions*, he returned to Paris in December 1747, 'to find that while I had been putting on weight at Chenonceaux, my poor Thérèse had been putting on weight for another reason. I found the work of which I was the author more advanced than I had expected.'[57] He goes on to admit that the matter would have caused him the most extreme embarrassment, in view of the situation in which he was placed, 'had not some companions with whom I was dining pointed out the sole means of escaping from it'.[58]

These dinner-table friends were probably fellow customers of Mme La Selle's inn near the Opéra, which Rousseau had started to patronize again; in that pleasure-loving society, there was thought to be only one thing to be done with an unwanted bastard – send it to the Foundling Hospital. 'And that,' Rousseau admits, 'was just the expedient I needed. I made up my mind cheerfully and without the least scruple. The only scruples I had to overcome were those of Thérèse; I had all the difficulty in the world in making her adopt this one means of saving her honour. Her mother, who had a different fear – that of another brat to feed – came to my aid and finally Thérèse gave in.'[59]

Rousseau then did the deed which most shocked the world after he became famous and that deed became known. He sent the child to the orphanage. We

must remember that the Rousseau who became famous was Rousseau as he was after his 'reform' began on the road to Vincennes in 1749. When Thérèse bore his first child he was still the young aspirant to fame and fortune, living in the *mondain* and materialistic environment of the prosperous bourgeoisie, and he did nothing unusual in sending an unwanted child to the orphanage. In the year 1746 no fewer than 3,274 infants were received at the Foundling Hospital in Paris, and of that number all but 950 had been picked up in the street.[60] A generation earlier, d'Alembert had started life in a basket on the steps of St Jean le Rond; at least Rousseau's children had the privilege of being delivered to the Orphanage itself.

There was nothing singular about Rousseau's opinion that Thérèse and her family were already a burden enough to him, without another mouth to feed. Besides, there was also *maman*; however much he may have been upset or hurt by the tone of her letters to him, he knew of her financial needs and still hoped to be able to help her. The idea of having money to share with her remained a central feature of his dream of making a fortune in Paris. He did not want riches for himself; he had no intense desire to distribute largesse to members of Thérèse's family; but he remembered his debt to *maman* and yearned to be able to repay it.

Her situation continued to go from bad to worse. One result of the war of the Austrian Succession was that Spain occupied the duchy of Savoy and Don Felipe was installed as ruling prince with his court at Chambéry. Mme de Warens lost her pension from Turin, and she had difficulty in getting help from the new government; she was forced to live on her wits. In 1745, after the death of her stepmother, she made a journey to Switzerland calling herself the Comtesse de Conzié, in the hope of laying hands on some part of the estate, even though the harsh Bernese laws which authorized the State to confiscate the private property of all subjects who converted to Catholicism afforded no grounds for such hopes. But having greater faith in sentiment than reason, she sought out the senior magistrate in Berne, M. Erlach, and wrote him an emotional letter,[61] saying that she was the victim of a cruel husband, and begging for help, notably in ensuring that 'the little portion of my father's estate, of which my stepmother enjoyed the usufruct until her recent death, is not awarded at my expense to anyone else until I have been able to lay my claim before Their Excellencies'. The property concerned was in the Vaudois parish of Basset, where Mme de Warens had spent her childhood. She was afraid that the property would now pass to her only surviving relation, her niece Marie-Françoise, who had married Captain Jean-François Hugonin of Vevey. As soon as she realized that her plea to M. Erlach in Berne would fail, she wrote[62] to Captain Hugonin assuring him of her friendship and suggesting that they should settle their conflicting claims amicably between them. By this time she must have returned to Savoyard

territory, because she proposes in her letter that the captain should cross the lake to meet her in Évian. It is not clear whether this meeting took place, but in December that year her old friend the Abbé Léonard wrote her a wounded letter[63] in which he said he had heard from a 'person in Thonon' that she had gone (without telling him) as far as Évian 'under the name of the Comtesse de Conzié to try to secure some of her lost Swiss inheritance'.

Mme de Warens made no secret of the fact that she was in dire straits. News of her situation must have reached Colonel Tavel, the friend who was said by Rousseau to have seduced and corrupted her as a young married woman, for Colonel Tavel wrote from Berne in March 1746[64] to Captain Hugonin in Vevey sending fifty Bernese francs to be discreetly forwarded to the unfortunate Baroness: 'It is a trifle; I am ashamed, but I cannot do better.' Mme de Warens had still not lost her old optimism. Deep in debt as she was, she launched yet another and even bolder industrial enterprise: she moved from the manufacture of soap to mining, and once again she persuaded various friends to invest their money in the scheme. She appointed Wintzenried, uninstructed as he was in mines and engineering, as her manager;* her idea was to exploit the deposits of iron, lead and copper which were known to exist in Savoy, and when these minerals fell short of her expectations she launched yet another company for mining coal. Her debts and her anxieties multiplied daily.

The death of Rousseau's father at the age of seventy-five in 1747 gave him access at last to his inheritance. 'I was too preoccupied just then,' he says in the Confessions, 'to feel bereavement as I would have done in other circumstances.'[66] He was clearly very glad to come into that part of his mother's property of which his father had enjoyed the usufruct. Once again he had to convince the authorities in Geneva that his brother François was really dead, and this time, with the help of Gauffecourt, who had become a close friend, and a lawyer named Jean-Louis Delolme, he succeeded. Rousseau describes the excitement he felt when the letter from Geneva came: 'I picked it up trembling with an impatience of which, deep down, I was ashamed. "What," I said to myself with disgust, "has Jean-Jacques become so much enslaved to self-interest and curiosity?" I put the letter back on the chimney-piece. I undressed and went to bed quickly, slept better than usual and rose next day rather late, without giving a thought to the letter. I spotted it while I was dressing. I opened it without haste and found a bill of exchange inside. I felt many different sensations of pleasure at the same time, but I can swear that the keenest of all was that of having won a victory over myself.'[67]

He received about six thousand florins, and says he sent a small part of it to Mme de Warens, 'regretting, with tears in my eyes, the happy days when

* In a letter dated 12 March 1750 Rousseau refers to 'the dear Miner, whom I love with all my heart'.[65]

I would have thrown it all at her feet'.[68] This time he was, of course, faced with the competing claims of Thérèse and her family. In letters still extant written by Rousseau to Mme de Warens at this period there is no reference to the inheritance. Writing to her on 17 December 1747[69] Rousseau mentioned that a M. Descreux would visit her and offer her his purse, 'although I hardly think it is in any better shape than my own'. Writing the following August, from the same Hôtel du Saint-Esprit in the rue Plâtrière (where he had his furnished room), Rousseau said nothing at all to Mme de Warens about sending her money and a great deal about his own wretched condition. In this letter he spoke of having been afflicted by two terrible illnesses one after the other: 'I had first an attack of renal colic, fever, burning pains and urine retention. The agony was calmed by baths, nitrate and other diuretics, but the difficulty of passing water still continues, and the stone which has moved down from the kidney to the bladder can only be removed by an operation, which neither my health nor my purse allows me to contemplate. All that remains for me is patience and resignation, remedies which are always to hand, but which have no great powers to heal.

'On top of all this I have been afflicted with violent pains of the stomach, accompanied by continuous vomiting and extreme diarrhoea. I have tried a thousand useless cures; I have taken emetics and as a last resort simaruba bark; the vomiting has calmed down but I cannot digest anything. Food passes out of me as soon as it goes in. I have even had to give up the rice which was prescribed for me, so I am reduced to doing without any nourishment at all. After all this, I am in a condition of inconceivable weakness. However, necessity drives me from my bedroom, and tomorrow I intend to go out for the first time. Perhaps the fresh air and a little walk will restore something of the strength I have lost. I have been advised to try extract of juniper, but that is something much less good here – and much more expensive – than it is in the mountains.'

Rousseau goes on to inquire after *maman*'s own health and asks whether her business troubles are in any way diminished and whether she is at all appeased on the subject of 'an unfortunate son', who 'foresaw her difficulties without being able to relieve them'. He says he would like to have some dependable means of communication with her 'to reveal to you my true situation', since he has the greatest need of her advice: 'I am wearing myself out in mind and health trying to conduct myself wisely in difficult circumstances so as to escape if possible from this condition of disgrace and poverty.' He says nothing about sending her money.

It is clear from this letter that Rousseau's situation in the summer of 1748, that is at the age of thirty-six, was still one of humiliation. The Dupins may have fed him well at Chenonceaux, but they paid him badly and his work was that of an intellectual labourer in the service of lesser brains than his

own. Thérèse might have given him some comfort, but she was living too far away from the Hôtel du Saint-Esprit to have nursed him through his illnesses; she was surrounded by a rapacious family who demanded money from him and, moreover, she was pregnant for a second time. It is hardly surprising that Rousseau's health deteriorated.

This letter to Mme de Warens of August 1748 contains the earliest account we have of the nature of his illness. He had often spoken of being ill before and was often to speak of it again, but here he names the symptoms. What he reports confirms that his sickness was not venereal, as malicious tongues suggested, but urinary. In the *Confessions*,[70] Rousseau says he was born with a physical deformity which caused him in his early childhood an almost continuous retention of urine, but that his aunt Suzon had taken such good care of him that he reached the age of thirty with scarcely any awareness of his natural defect: 'The first realization I had of it,' he goes on to explain, 'was on my arrival in Venice. The fatigue of the journey and the terrible heat that I had endured caused a burning sensation in passing urine and pains in the kidneys which lasted until the winter. After my visit to the Padoana I thought I was dead, but I did not have any actual discomfort.[*] When I had worn myself out – more in imagination than in reality – over my Giulietta, I felt better than ever. It is only since the imprisonment of Diderot, when the overheating caused by my walk to Vincennes in that terribly hot weather brought on a violent renal attack, that I have ceased to recover my health.'[72]

Here Rousseau's memory seems at fault: Diderot was not imprisoned until July 1749, and Rousseau was, as we have seen, sending details of his sickness to Mme de Warens a year or so earlier.[†] In any case, he was to suffer miserably from this urinary complaint for the rest of his life; it may even be that worsening health played a part in the transformation of Rousseau's views on morality which took place about this time, and which he himself dated from his walks to visit Diderot at Vincennes. But what exactly was wrong with him? On the available evidence medical science cannot offer more than a conjectural diagnosis of Rousseau's affliction, but it seems probable that he had a malformation of the penis which impeded his sex life and made him subject to chronic urinary pain, inflammation and infection.

Paris, evidently, was bad for his health; the summers were too hot, and the winters too wet. He seems to have felt well, at this period of his life, only in the country, at Chenonceaux. In that situation he was able at least, living as one of the Dupin household under their roof, to escape the financial

[*] Fearing he had picked up a venereal disease, Rousseau visited a surgeon who told him he 'was built in a peculiar way and could not be easily infected with V.D.'.[71]

[†] Earlier still, if a letter said to have been written by Rousseau to Altuna on 30 June 1748 is genuine: there he speaks of *'une violente rétention d'urine'* and *'une colique néphrétique, la plus effrayable qu'on aie jamais sentie'*.[73]

pressures of Paris, where he had to pay the rent for his room, buy many of his meals, and provide for Thérèse and her family.

The appearance of Montesquieu's *L'Esprit des Lois* in October 1748 provoked a new burst of literary activity in the Dupin household. In the *Confessions* Rousseau does not mention taking part in all this, but there is ample evidence that he was caught up in the endeavours of the Dupins to produce a critique of Montesquieu's theory.[74] Once again he worked as research assistant or secretary and not as a joint author. M. and Mme Dupin both worked on the book since both, for different reasons, were disturbed by Montesquieu's argument and wished to have it refuted.

Montesquieu was acquainted with the Dupins, and when he was in Paris he would be invited to the dinners which Mme Dupin gave once a week at the Hôtel Lambert for the pleasure of entertaining such celebrities as Fontenelle, Voltaire, Marivaux and Buffon. These dinners always took place, according to Grimm, on the days when 'Rousseau was off duty, so that no one would wonder what he was doing there';[75] and we have no grounds for believing that Rousseau and Montesquieu ever met in the flesh. Nowhere in the published works of either is there any reference to a meeting, but it is evident that Rousseau admired Montesquieu's writings, admired them too much, perhaps, for him to have found any satisfaction in assisting the Dupins to attack them.

Claude Dupin, with the help of other minds, published not one but two substantial critiques of *L'Esprit des Lois*. The first, written at considerable speed, he called *Réflexions sur quelques parties d'un livre intitulé 'De L'Esprit des Lois'*. Montesquieu heard of this book, for he wrote on 23 July 1749 in a letter[76] to Count Solaro, who was, incidentally, of the family for which Rousseau had worked as a footman twenty years before in Turin, that Claude Dupin's critique of his *De L'Esprit des Lois* was to be published within a week. In the event, publication was delayed, but curiosity was kept alive. In mid-November d'Argenson noted in his journal that the Dupins' reply to Montesquieu was 'about to appear'.[77] D'Argenson seems to have believed that Mme Dupin was at least a joint author of the book, because he predicted that it would make her name as a political theorist.

Some time towards the end of 1749[78] the *Réflexions* was published in two volumes by Serpentin in Paris, only to be promptly withdrawn after only eight copies had been manufactured. Dupin afterwards explained that he had stopped the printing in order to prepare a revised version.[79] Some time late in 1751 or early in 1752,[80] Dupin finally brought out the revised critique of Montesquieu, this time in three volumes, bearing the title *Observations sur un livre intitulé De L'Esprit des Lois*.[81] Rousseau helped in the preparation of both the *Réflexions* and the *Observations*.

It seems that Claude Dupin was not capable of writing the whole book on his own. Rousseau in the *Confessions* refers to the Jesuit father Guillaume-François Berthier 'working at full strength with M. Dupin in his refutation of Montesquieu'.[82] Others name the Abbé Noel-Antoine Pluche as a collaborator.[83] In the preface to the *Réflexions*, Dupin himself refers to it as the work of 'four friends'; in the *Observations* he acknowledges 'two friends'; his wife is mentioned in neither preface. As for Rousseau, the best evidence of the part he played can be seen in that portion of the scattered Dupin archive from Chenonceaux which now reposes in the municipal library[84] at Bordeaux, a series of files in Rousseau's handwriting containing materials on which Dupin's two books were based. This is not the manuscript either of the *Réflexions* or the *Observations*, but rather the data and notes and quotations which were used in the preparation of the text. It is equally clear from these notes and from the printed books that the Dupins had strong feelings about Montesquieu's ideas, if nothing like Montesquieu's genius.

Claude Dupin's criticisms of Montesquieu are recognizably those of a bourgeois against an aristocratic author. Montesquieu attacks tax-farming; Dupin defends it. Montesquieu is hostile to finance; Dupin defends it. There is a great deal in both the books and in the notes at Bordeaux about Montesquieu's views on women; and here we may detect the presence of Mme Dupin. Montesquieu suggests that all rights are a matter of convention; his critics claim that there are natural rights, and that women are entitled by natural law to equality with men. Some of the comments are more personal than theoretical: 'Montesquieu seems to proclaim himself the champion of polygamy and of the enslavement of women. I do not know what women have done to him. He never loses a chance of humiliating them.'[85]

It is inconceivable that Rousseau can have sympathized with the main lines of the Dupins' thesis, however much work he may have done for them as a research assistant. For example, apart from the general defence of finance and feminism, the two Dupin books uphold, against Montesquieu, a Hobbesian view that the state of nature is a state of war; they uphold monarchy as the best imaginable form of government, and they claim that slavery is justified. On all these questions we know that Rousseau had radically different views.[86] In a letter to Montesquieu,[87] written in 1752 after Rousseau had become well known, Charles Hénault reported that Rousseau had helped the Dupins write their books; in a sense it was true, except that his help was that of a paid employee and not that of a free collaborator.

Indeed we cannot doubt that Rousseau was in far greater agreement with the views of Montesquieu than with those of his bourgeois critics. Rousseau's *Discours sur les arts et les sciences*, written when he was still working for the Dupins, does not name Montesquieu, but when in the

course of that essay he wrote 'the statesmen of antiquity spoke continuously of morality and virtue; ours speak only of trade and finance',[88] he puts himself discreetly on the side of Montesquieu against the Dupins,[89] although the time had not yet come when he could afford to attack their ideas more directly.

At the time he embarked on research on Montesquieu, Mme Dupin eased, but did not end, Rousseau's financial embarrassment by raising, without his asking, his pay to fifty francs a month. In the spring of 1749 she did more, offering him the job of governor or 'companion' to her son Chenonceaux, now aged nineteen. With bitter memories of his unsuccessful efforts to act as tutor to the same boy some years earlier, and a keen awareness that the boy's temper had not since improved, Rousseau found this offer less than seductive; but feeling he could not afford to refuse, he reluctantly agreed.[90] A marriage had been arranged for Chenonceaux with a bride of noble birth who was torn, none too willingly, from the convent where she had expected to become a nun, to enter this alliance of aristocratic blood and bourgeois money; Rousseau, like the tutor in his *Émile*, was called upon to provide the moral guidance which the bride and bridegroom were expected to need. Chenonceaux's need of such guidance proved to be extremely acute; but despite all his tutor's efforts, he wasted his time and fortune in gambling. In one night he lost 700,000 *livres*, so that his family had to sell the Hôtel Lambert to pay his debts. Rousseau had more influence over the bride, whom, in any case, he found more sympathetic. She was the only daughter of the Vicomte de Rochechouart-Pontville, which made her interesting to Rousseau; she was also physically attractive, although he responded to her charms without repeating the mistake he had made with Mme Dupin and attempting any flirtation.[91]

Looking back on his experience with Mme de Chenonceaux from the perspective of middle age, Rousseau had only happy memories of it: 'M. de Chenonceaux's marriage made his mother's house still more agreeable to me because of the virtues and the wit of his bride, a very charming young person who seemed to single me out for favour among M. Dupin's secretaries'.[92] Rousseau goes on to say that Mme Dupin was displeased with the way the marriage turned out; the wilful spirit of her daughter-in-law made her a poor companion: 'Mme de Chenonceaux, proud of her merit and perhaps also of her birth, preferred to renounce the pleasures of society and stay in her room rather than submit to a yoke which she did not feel she was born to endure. This kind of exile increased my attachment to her, through that natural inclination which always carries me towards the unhappy. She had a metaphysical and reflective turn of mind, if somewhat given to sophistry. Her conversation, which was not what one would expect of a young woman fresh from the convent, was very appealing to me. And yet she was only

twenty. Her complexion was marvellously fair, and her figure would have been tall and splendid if only she had held herself more gracefully; her hair, which was ash-blonde and unusually beautiful, reminded me of my poor *maman* in her best years, and sent a tremor through my heart.'[93]

In the *Confessions* Rousseau recalls spending three or four hours a day with young Mme de Chenonceaux teaching her arithmetic, and enjoying it. On the other hand, his letters give a less idyllic picture of his life in the Dupin household. 'My situation is singular,' he wrote[94] to Mme de Warens. 'I do nothing, and yet none of my time is my own because I have to keep constant company with people who have nothing to do.'

One cannot doubt, however, that Rousseau found more pleasure in doing nothing with Mme de Chenonceaux than in being an amanuensis, taking dictation from M. and Mme Dupin.

THE ENCYCLOPAEDIST

'A little illness, a little laziness – that's my story, that's my excuse,'[1] Rousseau wrote to Mme de Warens from Paris, yet it seems that in fact he was as busy as ever; first there was the work he did for members of the Dupin family, then there was his own work; there was also his *liaison* with Thérèse and the many hours he spent in the company of Diderot and Condillac and other friends who were destined to be leading *philosophes* of the Enlightenment. Such *philosophes*, except for Condillac, were intellectuals rather than systematic philosophers in the style of Hobbes or Descartes; they were essayists in the manner of Francis Bacon, proclaiming a new way of life and a new set of values, an ideology, as we should nowadays call it, designed to change the world no less than to understand it. Of all the *philosophes*, Diderot was the most efficient journalist, the boldest controversialist and the most capable practitioner of Bacon's creed of organization. He was also the one to whom Rousseau was closest. In later years, Rousseau complained that he had found Diderot intolerably bossy – 'I could not stand a younger man than myself trying at all costs to govern me like a child';[2] but in those early years, they seem to have got along well enough, and the difference in age between them was, in any case, only fifteen months. Diderot has the reputation of being as easy a man to deal with as Rousseau was difficult, but he was certainly not an uncomplicated person.* His beliefs were ambiguous: in metaphysics, he moved from Voltaire's kind of deism to the full-blooded atheism of Holbach; in politics, he wavered between the constitutionalist liberalism of Montesquieu and the doctrine of enlightened despotism inspired by Francis Bacon.† In middle age he experienced a curious kind of change or 'crisis' which transformed him from a very open man into one who kept his

* He was also surprisingly shy: 'I always stammer from timidity the first time I meet people.'[3]

† But Diderot had too great a loathing for despotism to go all the way with Holbach, and his experience in Russia increased that loathing.[4]

best work hidden and unpublished; so that the best books by which the world now knows Diderot – *Le Neveu de Rameau, Jacques le Fataliste* and *Le Rêve de d'Alembert* – were not known to his contemporaries. Having failed in his ambition to become the Molière of the eighteenth century, Diderot thought of himself as dramatist *manqué*, and behind the cheerful face that he showed the world there was always a certain sadness. Like Voltaire, he was proudly bourgeois, and in his writings for the stage – writings destined to provoke the passionate disapproval of Rousseau – Diderot pleaded for a theatre which would express the values of modern bourgeois society as opposed to the out-dated aristocratic ethos of seventeenth-century classicism upheld by Racine, Corneille and Molière. And yet the kind of books that Diderot wrote in his younger years, books such as the mildly indecent *Les Bijoux indiscrets*, are closer to such works as Montesquieu's *Le Temple de Gnide*, and seem to serve the same purpose of scourging from an aristocratic perspective the twin despotisms of Church and State, while providing a pleasing erotic *frisson* for the fashionable reader. This was the kind of book which Rousseau, almost instinctively, detested.

Nevertheless in the 1740s Diderot and Rousseau collaborated happily together: they dined regularly at a tavern called the Panier Fleuri, and even agreed to launch a periodical on the model of that produced in England by Addison and Steele. It was to be called *Le Persifleur*, *'persifler'* being then a fairly new French word for 'banter', and the aim was to produce the lightest kind of literary journalism. Condillac was invited to contribute, but declined, being altogether too serious a writer for such an enterprise. Condillac had evidently emerged as something of a conversationalist in Paris in the company of Diderot and Rousseau, but he was taciturn by nature, if no longer the mute he had been in the Mably household in Lyons. He also suffered from bad eyesight, and preferred to husband his faculties for more strictly philosophical work. It was Rousseau who introduced Condillac to Diderot, and Diderot who found a bookseller who was actually willing to pay to publish Condillac's book *L'Essai sur l'origine des connaissances humaines*;[5] so Rousseau could truthfully boast it was thanks to his efforts that the 'great metaphysician' saw his first book in print and received from his publisher a fee he could hardly have hoped for of 'one hundred *écus*'.[*6]

Diderot and Condillac enjoyed philosophical arguments when they met at the Panier Fleuri, and Rousseau was usually the silent listener while these two Jesuit-educated dialecticians disputed vigorously together. Condillac had the more analytical, Diderot the more speculative turn of mind, but they met on the same level; and while Rousseau had no corresponding aptitude, or enthusiasm, for abstract metaphysical argument, he was always interested in what the other two had to say and was proud of being, as he said, 'the

* One *écu d'or* was worth three *livres*.

first perhaps to have recognized the merits of the Abbé Condillac and to esteem him at his true worth'.[7] Rousseau appreciated Condillac's friendship and, in the *Confessions*, he recalls the days when Condillac used to lure him away from his work in his room, and take him to an inn where they would dine *en tête-à-tête*, each paying his own bill.[8]

Although Condillac was reported never to have said a mass, he was too much of a priest to become a materialist in philosophy. He was a disciple of Locke. Refusing to write for the frivolous *Persifleur*, he refused also to contribute to Diderot's more serious enterprises. His development of Locke's ideas was closer to the work of the Irish Christian philosopher Berkeley than to that of the French Encyclopaedists, whose master was in any case Bacon rather than Locke. Condillac could not bring himself to share the prevailing anti-religious attitudes of the Enlightenment; and neither, in the end, could Rousseau.

In those early years, however, it was Rousseau and Diderot who worked together and Condillac who kept himself somewhat apart. Denied his help, they decided to take it in turns to compose the entire text of *Le Persifleur* themselves. In the end, the project did not get beyond the manuscript stage of the first issue; this was entirely written by Rousseau, and its chief interest lies in a light-hearted self-portrait, which tells us how he saw himself at the age of thirty-five:[9]

'Nothing is more unlike myself than myself; that is why it would be useless to attempt to define my character by anything other than variety; mutability is so much part of my mind that my beliefs alter from one moment to the next: sometimes I am a sombre misanthrope, at others I am intensely happy amid the charms of society and the pleasures of love. At one time I am austere and pious ... then promptly I become a candid libertine ... In a word, a Protean, a chameleon and a woman are all of them creatures less changeable than I.'[10]

Here we have a self-portrait of Rousseau which contrasts both with the solemn figure he depicted in his letter to M. de Mably in Lyons and with the humourless self-analyses of his later autobiographical writings. It is one more piece of evidence that in his thirties Rousseau was doing his best to be a man of the world; and if he is correct to describe himself as a person divided within himself, and characterized only by contradictory qualities, in that respect he was very like Diderot.

Le Persifleur came to a halt because Diderot had more important things on his mind. His marriage in 1743 to Anne-Toinette (known as Nanette) Champion had not gone well; a child, born a year later, died within a few weeks. Nanette, according to Rousseau, 'was a shrew and a fish-wife with nothing to compensate for her ill-breeding';[11] he could not help contrasting her with his own 'sweet and docile'* Thérèse, without, however, being tempted to follow Diderot's example and actually marry Thérèse. None of Diderot's friends could

* 'Even so,' Rousseau continues, 'he married her, which was an excellent thing, if he had promised her. But I, having made no such promises, was in no hurry to follow his example.'[12]

endure Nanette, and he himself sought consolation, two years after the
marriage, in the arms of a mistress named Madeleine de Puisieux. Unfor-
tunately, that affair only added to his need for money, and Diderot was
always kept intensely busy, more often doing literary hack work for pub-
lishers than writing the books he wanted to write. When he planned *Le
Persifleur* with Rousseau he had just finished translating Robert James's six-
volume *Universal Dictionary of Medicine and Surgery* into French. His 'obscene'
little novel, *Les Bijoux indiscrets*, he claimed to have written in a fortnight to
prove to Mme de Puisieux that such things were easy to write; it was on
sale, under the counter, in 1748, and earned the author 1,200 livres.[13]

Diderot, considered by Voltaire to be lacking in the prudence necessary to
be a writer of enlightened opinions in eighteenth-century France, was begin-
ning to have trouble with the authorities. In July 1746, his *Pensées philoso-
phiques* was publicly burned, and in June of the following year he was
denounced by the *curé* of his parish as a dangerous man. A few months later,
the police raided his house and seized a manuscript he was working on. And
yet Diderot was full of confidence at this period of his life. He was planning
what was to prove the most substantial achievement of his career, to prove
indeed to be the greatest monuments of the French Enlightenment, the
Encyclopédie. This began as a simple project of the publisher André Le Breton
to translate and adapt for French readers the *Cyclopaedia* that Chambers had
produced in Scotland. Diderot was called in when the first editor dropped
out, and he set about preparing something altogether different from, and
more ambitious than, the dictionary of information which Chambers had
published. Diderot saw in the *Encyclopédie* the possibility of realizing Bacon's
dream of a compendium which would bring all the sciences together and so
open men's eyes to a new vision of the world and a new way of organizing
it. Diderot's *Encyclopédie* was to be both ideological and educational; and the
ideological part, especially the demolition of traditional philosophy and
religion, was certainly not the least important. The publisher, Le Breton, if
more interested in the educational side, saw the commercial potentialities of
Diderot's scheme and agreed to it. Since Diderot's belief in the power of
science to save mankind was not matched by more than minimal training in
science itself, he needed a collaborator who was a professional scientist; he
found that person in d'Alembert.

At this period of time, around 1747, d'Alembert was not an intimate
friend of either Diderot or Rousseau, although he sometimes dined with
them at their favourite inn. Rousseau had seen him at the Academy of
Sciences when he had first presented his scheme for a new musical notation,
but did not meet him socially until some time later. In any case, d'Alembert
did not shine in society; a small self-disciplined man, who lived with his
foster-mother until he was aged forty-seven, he had relatively few friends. It

was his formidable scientific achievement which had imposed his presence on the world from an early age; for although d'Alembert was four years younger than Diderot and five years younger than Rousseau, he was already a well-established figure in scientific circles.

His background was singular. He started life as one of the hundreds of unwanted babies left abandoned every year on the streets of Paris. He was found on the steps of the church of St Jean Le Rond, and Jean Le Rond was the name first given him, but he was identified as the natural child of Mme de Tencin, a fashionable hostess, by her lover the Chevalier Destouches. His mother repudiated him, but his father traced him, gave him the name of Daremberg, later altered to d'Alembert, and had him decently brought up by a foster-mother and paid for him to be educated at a fashionable Jansenist college. An annuity from his father of 1,200 *livres* enabled the boy to dedicate his life to scientific study, and he excelled in both physics and mathematics. At the age of twenty-four – in 1741 – he was elected to the Academy of Sciences, and he followed this up two years later with his *Traité de dynamique*, a pioneering work in Newtonian physics which earned him a European reputation. The importance of d'Alembert's collaboration was crucial to Diderot's scheme of an encyclopaedia built as it was on the empiricist belief that all true knowledge is scientific knowledge. D'Alembert's appointment as co-editor of the *Encyclopédie* assured its success from the start. Although the whole burden of editorship was in time to be shifted on to Diderot, in the early years d'Alembert supervised the editing not only of the scientific entries, but also the articles on musical, historical, literary, social, legal and philosophical subjects, which Diderot was determined to put to polemical ends, introjecting, forcefully if slyly, attacks on established beliefs whenever the opportunity occurred. The more prudent d'Alembert tried to put a brake on Diderot's audacity, but he did not always succeed.

Rousseau's share in the scheme for the *Encyclopédie* was mainly – but not exclusively – that of writing the articles on musical subjects, as he informed Mme de Warens in January 1749:[14]

'An extraordinary task has fallen to me, coupled with very bad health in which to undertake it; together, my very good *maman*, they have prevented me from fulfilling my duties towards you for a month. I have been entrusted with writing several articles for the great Encyclopaedia of arts and sciences which is going to be published. The material lengthens as I write it, and I must deliver it on the appointed day. In order to undertake this extra work, without interfering with my ordinary job, I have been forced to cut down on my hours of sleep. I am worn out. But I have given my word, and I must keep it.'

Rousseau goes on to say something which shows how much he shared the

polemical spirit in which Diderot had conceived the *Encyclopédie*: 'I am out to get my own back on people who have done me harm, and bile gives me strength; it even gives me wit and knowledge: *"La colère suffit et vaut un Apollon."** I am reading a lot, and learning Greek. Everyone has his own weapons. Instead of writing songs against my enemies, I am writing articles against them for the *Encyclopédie*. I believe that my method is as good as the other, and will have more credibility.'

The 'enemy' that Rousseau had in mind may well have been Rameau, whom he had not forgotten or forgiven. Whatever it was, the cautious d'Alembert intervened to have the words softened or removed before the articles were printed.

Rousseau yielded to d'Alembert's pressure with a decent grace. Sending back to him a revised packet of *Encyclopédie* articles,† he told him in a letter:[15] 'I have come round to all your opinions, and I approve of the changes you have judged fit to make. I have, however, reinstated one or two sentences that you suppressed, because in following the guidelines that you yourself established, it seemed to me that the original remarks were much to the point, neither betraying anger nor containing anything wounding. However, it is my wish that you should be absolute master, and I submit everything to your judgement and your wisdom.'

D'Alembert was indeed very knowledgeable on the subject of music, including the measurement of sound, which he studied from the point of view of a physicist, and in 1752 he was to publish a book called *Les Élémens de musique* in which he tried to give a simple formulation to Rameau's theory of harmony, but he was destined in the end, no less than Rousseau, to provoke the hostility of Rameau.

Rousseau's social life in Paris was by no means confined to the company of *philosophes*; he continued his pursuit of fame and fortune where Father Castel had urged him to seek it, through the friendship of fashionable women; he was still the eager *salonard*. He made the acquaintance at the age of thirty-five of yet another hostess who was to play an important role in his life, Mme d'Épinay. Like Mme Dupin, this lady was a financier's wife who enjoyed entertaining writers and artists and who had literary pretensions of her own. She was not as rich as Mme Dupin, nor as chaste, nor as beautiful – in the celebrated portrait by Liotard, she looks intelligent, attractive, witty, without being at all seductive. Diderot once gallantly described Mme d'Épinay as 'the embodiment of tenderness and voluptuousness', but Rousseau expressed the judgement of most when he said she was altogether too thin and plain. And yet Mme d'Épinay had certain advantages over Mme Dupin. She was

* A quotation from Boileau, *Satires*, I, 146.

† They all began with the letter 'C'. Rousseau was responsible for the articles on *Cadence, Canon, Cantata, Cantabile, Chant, Chiffres, Cœur, Composition* and *Consonance*.

younger, being barely twenty-one when Rousseau met her, and she was to prove herself a more industrious writer, producing a whole book while Mme Dupin, even with Rousseau's help, could not turn out more than endless notes and drafts. Moreover, she had that quality which Mme Dupin signally lacked and which Rousseau never failed to notice and appreciate, an aristocratic pedigree. Born Louise-Florence-Pétronille de Tardieu d'Esclavelles, she had married at the age of nineteen, in December 1745, the tax-farmer Denis-Joseph Lalive d'Épinay; it was not a love match, but one of many marriages of impoverished noblemen's daughters into the rich bourgeoisie, and only more colourful than most.

Rousseau's introduction into the household of Mme d'Épinay came about soon after her marriage, and not long before, if at all before, her first big adulterous affair; for her lover was Rousseau's friend and employer, Dupin de Francueil. Both her house in Paris and her *château* in the country were places of intrigue.

In his *Confessions*, Rousseau recalls the love affair between Mme d'Épinay and Francueil, saying that both the two lovers and Francueil's wife confided in him, and adding that he 'kept their secrets'.[16] Loyalty to Mme de Francueil, a nice if ugly woman, prompted him to express some disapproval of the affair, and he says he once refused indignantly when Mme d'Épinay asked him to take a letter to her lover. One thing he does not tell us in the *Confessions* is when the affair began. In *L'Histoire de Madame de Montbrillant*, Mme d'Épinay gives 1749 as the year of the narrator's seduction by 'Formeuse' (Francueil), but the date is misleading, and doubtless deliberately so: Mme d'Épinay would not wish to prompt speculation that Francueil was the father of her second daughter, Pauline, the future Mme de Belzunce. It was perhaps to preserve the coherence of this story that Mme d'Épinay ascribed to the same year, 1749, the introduction of Rousseau or 'René' to Montmorency; Rousseau's introductions to La Chevrette took place in 1748.[17]

La Chevrette was a *château* on the edge of the forest of Montmorency which belonged not to Mme d'Épinay's husband, M. Lalive d'Épinay, but to his brother, M. Lalive de Bellegarde; it was she, however, who undertook the duties of *châtelaine*. Her husband was seldom there. He preferred living in Paris, where he could be close to his mistress, Mlle Rose, a dancer at the Opéra, or where he could amuse himself with prostitutes. La Chevrette was nevertheless a lively place,[18] where the company included M. de Bellegarde's daughter Elisabeth, only seventeen and very plain and pock-marked when Rousseau first met her, but later to blossom out as the ravishing Comtesse de Houdetot and to conquer Rousseau's heart completely.

While La Chevrette had none of the splendour of Chenonceaux, it was only fifteen miles from Paris, and Rousseau was happy in the summer

months to escape from the heat and noise of the metropolis to enjoy the beauties of nature. Mme d'Épinay welcomed him. In *L'Histoire de Madame de Montbrillant*, she describes her 'René' as a 'dark-skinned man with flashing eyes which animate the face', and adds: 'When you are with him, and listen to him talk, he looks handsome, but when you think about him afterwards, he always seems ugly.' As for his character, he 'is a great payer of compliments, not polished, or rather *seeming* not to be polished; one who plays the part of an unworldly man, but is in fact extremely shrewd'.[19]

Despite these words, there is evidence enough that when she was young she liked him, and enjoyed her walks and conversation with him in the park at La Chevrette. The winter of 1747–8 had been an unhappy time for her, marked by the death in infancy of her first daughter – a legitimate child, by all accounts, of her husband; and one can believe that the simple sincere friendship which Rousseau offered was as welcome in its way as was the sophisticated court that Francueil paid to her; she saw Rousseau then as a lovable 'bear'.

In the summer of 1748, Francueil thought of another means of improving the spirits of his mistress, staging at La Chevrette amateur theatricals of the kind which had kept the company amused at Chenonceaux. He persuaded M. de Bellegarde to fit up a theatre in the orangery of the *château* and suggested a production of *L'Engagement téméraire*, which Rousseau had written for the Dupin family to act. Rehearsals went ahead, with Francueil as Dorante, Mme d'Épinay as Isabelle and Rousseau himself as the valet Carlin. 'In spite of my stupidity and awkwardness,' Rousseau writes in the *Confessions*,[20] 'Mme d'Épinay wanted me to participate in the entertainments that were put on at La Chevrette ... There was a theatre where they performed plays, and I was given a part which I studied for six months without a break. At the performance I had to be prompted from beginning to end. After that ordeal, I was given no more parts.'

In *L'Histoire de Madame de Montbrillant*, Mme d'Épinay says nothing about 'René's' bad acting, but speaks instead of 'the poor devil of a playwright being as destitute as Job, but having enough wit and enough vanity for four authors'.[21]

Mme d'Épinay's second daughter was born in August 1749 – the natural child of Francueil. For all her efforts to alter the record, the timing of the affair was a badly kept secret, and Rousseau in the *Confessions* says he would not have mentioned it at all 'if it had not become so public as to be known even to M. d'Épinay'.[22] One secret which Rousseau does not disclose in the *Confessions* but which Mme d'Épinay herself, rather surprisingly, reveals in her novel is that she contracted a venereal disease from her husband and passed it on unknowingly to her lover.

Rousseau had a flair for meeting the right people, especially for making

friends with young writers who were later to become luminaries of the Enlightenment. On a visit to the *château* of Fontenay-sur-Pois, at the invitation of Baron von Thun, governor of the young Prince Frederick of Saxe Gotha, Rousseau was introduced to two members of the royal suite, Emmanuel Christophe Klüpfel and Frederick Melchior Grimm, and quickly struck up a friendship with both. His friendship with Klüpfel proved to be a fairly tranquil one; with Grimm he embarked on a relationship 'which was at first so very delectable but afterwards so disastrous'.[23] Klüpfel, best known as the founder of the *Almanach de Gotha*, was born in the same year as Rousseau, and he had once lived in Geneva as minister of the Lutheran Church there; he had been a chaplain to Prince Frederick before being appointed one of his tutors. Grimm, an impoverished German baron, was eleven years younger than Rousseau and attached to the Prince's suite as temporary reader, while looking for a more permanent job. He had originally come to France as tutor to the youngest son of the Count von Schomberg, and liked the country well enough to want to settle there. What attracted Rousseau and Grimm to each other was a shared passion for music; on Rousseau's first visit to Fontenay they played and sang together for hours at the Prince's harpsichord. A few weeks later Grimm found an undemanding job in Paris as companion to the Count von Friesen, a dissolute nephew of the Maréchal de Saxe, and this enabled Rousseau and Grimm to meet almost daily:

'Grimm had a harpsichord, which drew us together, and around which I spent all my free moments in his company, singing Italian airs and barcarolles without rest or interval from morning until evening, and when I was not at M. Dupin's house, I was sure to be found at Grimm's, or at least with him, either taking a walk or going to the theatre. I gave up going to the Comédie Italienne, even though I had a free pass, because he did not like it, and I went with him, paying, to the Comédie Française, which he adored. In the end such a strong friendship attached me to this young man that we became inseparable, and even my poor Thérèse was neglected.'[24]

It was in the company of his German friends that Rousseau sampled for the last time in his life, according to the *Confessions*, the pleasures afforded by a *fille de joie*. Klüpfel, no less than Grimm, was a congenial companion at dinner; his cosmopolitan wit, added to Grimm's more earthy and teutonic humour, filled their evenings with laughter. Klüpfel kept – or helped to keep – a mistress; and meeting him with her in a café one evening, Rousseau and Grimm teased him to such a point that he invited them back to his room and offered them, in turn, the opportunity of retiring to the bedroom with his companion. Rousseau, who describes her as 'a pleasant, rather sweet girl, ill suited to her trade', accepted the invitation. As for Grimm, says Rousseau, 'he always swore he never touched her, and that he stayed in the

bedroom with her for a long time only for the fun of making Klüpfel and me impatient. However, if he did abstain, it can hardly have been from any moral scruple, because before he went to work for the Count von Friesen, he actually lived in a brothel.'[25]

Rousseau was ashamed of himself after this incident and remembered the experience long enough to draw upon it when he wrote *La Nouvelle Héloïse* and wanted to describe Saint-Preux's feeling of shame after getting drunk. That same evening Rousseau told Thérèse what he had done: 'And it was as well that I did so, for the next day Grimm arrived in triumph to tell her an exaggerated story of my offence ... Never have I been more conscious than I was then of the goodness of heart of my Thérèse; for she was more shocked by Grimm's treachery than wounded by my own unfaithfulness, and I received from her only sweet and tender reproaches, with not the least sign of resentment.'[26]

Rousseau does not mention – and perhaps did not know – that Thérèse was widely believed to be unfaithful to him. What he does say in the *Confessions* is that her goodness of heart was matched by dimness of wits. He gives an example of this in connection with Klüpfel. He had told Thérèse that his friend was a Lutheran minister; she, associating the word 'minister' with exalted rank, conceived the idea that Klüpfel was the Pope. 'I thought she was mad one evening when she told me that the Pope had come to see me,' Rousseau writes. When all was explained, Klüpfel became known to his friends as 'the Pope', and his mistress as 'Pope Joan'. 'Laughter over the absurdity of the thing nearly choked us,' Rousseau adds. 'And no one who knew me then would believe – as people have believed – the report that I have only laughed twice in my life.'[27]

In the meantime, Diderot had run into trouble. The whole political situation worsened in Paris in 1749, when the war of the Austrian Succession ended in a peace unfavourable to France. Louis XV lost his Flemish provinces, and his government increased taxation to pay for the war. Public disillusionment and scepticism provided fertile gound for radical pamphleteering, and the government and courts responded by stepping up the censorship. Even the scientist Buffon was forced to deny having said anything at variance with Catholic orthodoxy. Then, on 23 July 1749, Count d'Argenson, as Director of Publications, signed a *lettre de cachet* for the arrest of Diderot. At 7.30 the following morning two police officers climbed the stairs to his apartment in the rue de l'Estrapade, with instructions to search for any manuscript 'contrary to religion, the state, or morals'. According to his biographer, Professor Wilson, 'It is possible that Diderot had expected such a visitation, for the police found nothing but twenty-one cardboard cases that they thought pertained to Chambers's *Cyclopaedia*.'[28]

Diderot was arrested. Under oath, he denied having written the *Lettres sur*

les aveugles, Les Bijoux indiscrets, Les Pensées philosophiques or *L'Oiseau blanc*, but admitted having written *La Promenade du sceptique*. It was rumoured that Réaumur, attacked in the *Lettres sur les aveugles*, had informed the police against Diderot.[29] Despite his protestations of innocence, Diderot was promptly imprisoned in the dungeons in the *château* of Vincennes. Rousseau says he wrote a letter[30] to Mme de Pompadour, imploring her either to have Diderot released or to have him put in prison himself at Vincennes with his friend; he received no reply. However, after one month Diderot was released from his cell and installed comfortably in the *château*, allowed to take exercise in the park and to have his wife with him. It is probable that a letter on behalf of Diderot written to the governor of Vincennes, the Marquis du Châtelet, by his cousin, Mme du Châtelet, who was Voltaire's mistress, did much to improve his situation. According to Diderot's daughter, the governor showed her father every kindness 'and invited him to his table'.[31] Furthermore, the Count d'Argenson, the Director of Publications, was privately in sympathy with the liberal and anticlerical opinions which Diderot and Voltaire professed, and did not wish to authorize the persecution of philosophers.

Among other privileges, Diderot was allowed to receive visitors; and on 25 August 1749[32] Rousseau set out for the first time to see his friend in prison. 'The summer of 1749 was excessively hot,' he writes in the *Confessions*. 'Vincennes is about six miles from Paris. As I had not the means to pay for a cab, I went on foot, setting out at two in the afternoon, alone, walking quickly so as to get there sooner. The trees along the roadside, lopped according to the custom of the country, afforded hardly any shade, and several times I was so exhausted by the heat and fatigue that I lay down on the ground, unable to walk another step.'[33] When he reached Vincennes, Rousseau found Diderot with two other visitors, d'Alembert and a priest, but he had eyes only for his old friend. He leapt forward to embrace Diderot silently, his eyes filled with tears and his throat choking with tenderness and joy: 'I found him much affected by his imprisonment. The cells had had a terrible effect on him, and even though he was now living very comfortably in the *château*, and allowed to take walks in a park which had no walls, he needed the company of his friends to deliver him from his black moods. Since I was assuredly the friend who sympathized most deeply with his sufferings, I believed I was also the one whose company would give him the greatest consolation, and at least on every other day I went alone or with his wife to pass an afternoon with him.'[34]

On one of his walks to Vincennes to visit Diderot, Rousseau had an illumination which has been compared to the vision seen by St Paul on the road to Damascus. In the *Confessions*, he describes it fairly briskly. He explains that in order to moderate the pace of his walk, he had the idea of taking with

him something to read on the road. 'Once I took the *Mercure de France* with me, and reading it while I walked, I came across the subject proposed by the Academy of Dijon as a prize essay for the following year: "Has the progress of the arts and sciences done more to corrupt or to purify morals?" The moment I read these words, I beheld another universe and became another man.'[35] What he claimed to have seen in this flash of inspiration was that progress had not purified morals at all, but corrupted them disastrously.

Rousseau gave a more detailed and eloquent account of this revelation in a letter he wrote to Malesherbes in 1762.[36] There, he said of his reaction to the question posed by the Academy of Dijon: 'if ever anything resembled a sudden inspiration, it is what that advertisement stimulated in me: all at once I felt my mind dazzled by a thousand lights, a crowd of splendid ideas presented themselves to me with such force and in such confusion, that I was thrown into a state of indescribable bewilderment. I felt my head seized by a dizziness that resembled intoxication. A violent palpitation constricted me and made my chest heave. Unable to breathe and walk at the same time, I sank down under one of the trees in the avenue and passed the next half hour in such a state of agitation that when I got up I found that the front of my jacket was wet with tears, although I had no memory of shedding any. Ah, Monsieur, if ever I had been able to write down what I saw and felt as I sat under that tree, with what clarity would I have exposed the contradictions of our social system, with what force would I have demonstrated all the abuses of our institutions, with what simplicity would I have demonstrated that man is naturally good, and has only become bad because of those institutions. All that blazed in my mind for a quarter of an hour under that tree has been thinly scattered in my three principal works – my first discourse on the arts and sciences; my second discourse on the origins of inequality and my treatise on education [*Émile*]* – all three works are inseparable and form a single whole. Everything else is lost, and the only thing I wrote down there and then was the oration of Fabricius. So it was that, thinking least about it, I became an author, almost in spite of myself.'

In the *Confessions*, Rousseau continues the story in these words: 'When I reached Vincennes I was in a state of excitement bordering on delirium. Diderot noticed it and I told him the cause, and I read him the oration of Fabricius, which I had written down in pencil under an oak tree. He encouraged me to let my ideas flow and compete for the Dijon prize. I did so, and from that moment I was lost. All the rest of my career and all my afflictions have been the inevitable outcome of that moment's frenzy.'[37]

The oration of Fabricius indeed epitomizes the theme of the essay Rousseau wrote for the Dijon Academy: 'Heavens,' he has the Roman hero

* It is curious that Rousseau, writing in 1762, does not mention either *Du Contrat social* or *La Nouvelle Héloïse*, both then completed.

say to a people who have turned aside from the ardours of war to a life of luxury in peace, 'what has happened to those thatched roofs and rustic hearths which were once the dwelling place of frugality and virtue? What deadly ostentation has taken the place of Roman simplicity? What is this strange language? What are these effeminate customs? What is the meaning of these pictures, these statues, these grand buildings? Fools, what have you done? You, the masters of nations, have made yourselves slaves of the frivolous men you have conquered ... Romans, be swift to demolish your amphitheatres, break your marbles, burn your pictures, banish the slaves who dominate you and whose fatal arts corrupt you.'

If these are the words which Rousseau had already pencilled down and read to Diderot in Vincennes, Diderot must have seen plainly enough what Rousseau's argument was going to be. He was going to attack not only decadence but the whole progressive ethos of the Enlightenment, and specifically the Baconian idea which had inspired his great project of the *Encyclopédie*. One might well have expected Diderot to be startled, even scandalized, by what Rousseau proposed to say. It seems it was not so. According to Rousseau, 'Diderot encouraged me to give flight to my ideas and compete for the prize.'[38] Others[39] have alleged that Rousseau showed the advertisement to Diderot, without knowing whether he should argue in favour or against the proposition that progress had improved morals, and that Diderot urged him to take the pessimistic view, for since most other competitors would take a fashionably optimistic view, it was likely that the exceptional opinion might well seem to the judges the most original. Although such a suggestion would not be alien to Diderot's witty and ironical turn of mind, there is no evidence among his papers to justify our believing that he made it. Indeed, Diderot's own version of the story, as published, is simply this:

'When the programme of the Academy of Dijon appeared, Rousseau came to consult me as to the side he should take.

'"The side you will take," I said to him, "is the one that no one else will."

'"You're right," he replied.'[40]

We can reasonably assume that Diderot, an easy-going, tolerant man, did not at first take Rousseau's *volte face* against the Enlightenment entirely to heart, and may have regarded Rousseau's reactionary argument as an entertaining paradox. Indeed Rousseau himself was slow to realize all the implications of the point of view he had adopted on the road to Vincennes. He did not see how far he was turning against everything that Diderot and Diderot's *Encyclopédie* stood for; his 'reform' was real enough, but it was a gradual rather than a sudden process.

THE MORALIST

Diderot was released from imprisonment at Vincennes in November 1749. He owed his freedom in part to his publisher, André-François Le Breton, who, truthfully or otherwise, told the Director of Publications, Comte d'Argenson, that he and his partners would lose the eight thousand *livres* they had invested in the *Encyclopédie* if the editor were not released to continue the work which he was uniquely able to undertake;[1] they could not expect d'Alembert to assume alone the tedious and dangerous role of editor-in-chief.[2] Probably Diderot owed his liberation no less to his own bright idea of offering to dedicate the *Encyclopédie* to the same M. d'Argenson if only he were allowed to get it into print;[3] since d'Argenson was known to be privately in sympathy with Voltairian opinions, he may well have felt flattered by this proposition, which he accepted gracefully.

Back in his rooms in the rue de l'Estrapade, Diderot worked hard through the winter months to make up for lost time. With bitter quarrels[4] raging between his wife and mistress, his desk may have provided a welcome haven of tranquillity. He had the prospectus of the *Encyclopédie* ready for the press within a year of his release from prison; he commissioned and edited articles for the first few volumes and wrote several substantial ones himself. He also completed more than one book. What is more, in keeping with his belief that practical knowledge is as important as theoretical, he spent a fair amount of time in the workshops of artisans in order to study their methods, 'becoming an apprentice', as he put it, and turning out poor pieces of workmanship in order to teach others what good workmanship should be like.[5] His prospectus for the *Encyclopédie* appeared in print at much the same time as Rousseau's prize-winning *Discours sur les arts et les sciences*, a double event which was not only to prove of capital importance for their own careers but to make a lasting impact on Western thought. The only irony is that the ideas put forward in the one publication are flatly contradicted in the other.

Diderot's prospectus is a manifesto of the Baconian creed that salvation lies

in science. Looking back to Bacon's own time, the author asks what progress has been made since the end of the sixteenth century. He suggests that it has been considerable: 'True philosophy when Bacon wrote was in its cradle; the geometry of the infinite was not yet in being; experimental physics was only just beginning to show itself; the laws of sound criticism were entirely unknown. Descartes, Boyle, Huyghens, Newton, Leibniz, the Bernoullis, Locke, Bayle, Pascal, Corneille, Racine, Bourdaloue, Bossuet, etc., had either not been born or had not written.'[6]

Diderot's prospectus went on to explain that the idea of the *Encyclopédie* sprang from a recognition of 'the inter-relationship of all the sciences' and was designed to provide 'a map of every branch of learning'. His encyclopaedia was not simply to be a compendium of information, but a systematic abridgement of the total available knowledge; and since true knowledge was understood, according to the precepts of Baconian empiricism, as useful knowledge, the encyclopaedia would give particular attention to the applied sciences, technologies and crafts; and volumes of engravings illustrating such disciplines or skills were to form a substantial part of the set. The prospectus promised eight folio volumes of text and two of plates; in the event, Diderot was to produce seventeen volumes of text, eleven volumes of plates, and seven supplementary volumes, thus making the encyclopaedia the greatest single monument of the French Enlightenment. The achievement cost Diderot years of determined effort and many bitter struggles against the hostility of the Church and Sorbonne authorities and against the unreliability, the pusillanimity and occasional treachery of his friends. By its nature the encyclopaedia was a profoundly controversial exercise designed not only to propagate knowledge but to promote an ideology; in Locke's phrase, Diderot aspired 'to clear away the rubbish' which stood in the way of science, that 'rubbish' being understood to be traditional beliefs about religion, philosophy and morals. This further purpose had to be achieved by more devious means than direct exposition, although by the year 1750 fashionable opinion in France had lost much of its old attachment to traditional beliefs; the scepticism of M. d'Argenson was widely shared in the upper classes, perhaps, as Voltaire liked to think, because his books had been so influential, or perhaps, as David Hume suspected, because the champions of religious orthodoxy had made it all too boring. Diderot's *Encyclopédie* was, as his prospectus makes clear, to be wholly committed to the new materialist gospel of progress.

Rousseau's *Discours sur les arts et les sciences* was no less plainly directed to a refutation of the same gospel. In spite of the fact that he refers in its pages to Bacon as 'perhaps the greatest of our philosophers', Rousseau attacks everything that Bacon – and Diderot – stood for. He asserts without reservation that science is evil in its origins and harmful in its effects. Every branch of

science, he says, is rooted in some vice, arithmetic in avarice, mechanics in ambition, physics in idle curiosity. Other branches of learning spring from corresponding moral defects. If men were not unjust, they would have no use for jurisprudence; and history is the consequence of wars and conspiracies and tyrannies. The Baconian dream of improving man's life on earth by creating material abundance, Rousseau condemns as a culpable craving for luxury; and luxury, he says, is not a simple evil but one which has always been recognized by the wisest men as an especially corrupting evil. Frugality, he claims, is good both for the state and the individual, while luxury undermines nations just as it undermines men. Rousseau invites the reader to compare the fortunes of Sybaris with those of Sparta; whereas a handful of peasants defeated the Sybarites, the Spartans became the terror of Asia. 'Can it be denied that good morals are necessary to the endurance of empires, and that luxury is diametrically opposed to good morals?'[8]

In thus condemning luxury, Rousseau also condemns the whole culture of rich and advanced societies: he depicts Athens as a seat of politeness and taste, a city of poets and orators, with buildings as elegant as its literature; and he argues that precisely because Athens was a model of high culture, it was a model also of vice and corruption. As for the supposed glories of Athenian philosophy, Rousseau simply notes that Socrates was forced to drink hemlock and he quotes the authority of Plato for saying that empirical knowledge is not true knowledge and that artists ought to be banished from a just republic. Rousseau claims that the experience of Rome teaches the same lesson: 'When Rome came to be filled with philosophers and orators, military discipline was neglected, agriculture was despised, society was divided into rival factions, and patriotism came to be forgotten.'[9] A love of good living took the place of the love of duty, and 'the Roman philosophers themselves declared that since scholars had appeared among them, honest men had been in eclipse'.[10] Having thus condemned advanced culture as being inimical to religion and morals, Rousseau goes on to accuse it further of being injurious to freedom. The arts and sciences, he says, 'cast garlands of flowers over the chains that men bear, crushing in them that sense of original liberty for which they are born, making them like their slavery, and turning them into what is called a civilized people'.[11]

Modern culture is further blamed for destroying men's natural sincerity: 'Nowadays, when the most elaborate education and the most cultivated taste have reduced the art of pleasing to a set of rules, our manners are governed by a base and deceptive servility, so that every precept of politeness demands constant obedience: good manners are dictated to us; we must always follow commands, never our own nature. Under this endless constraint, we no longer dare to appear as we are; in that flock of sheep we call society, each man in the same situation does exactly the same thing as others . . . So there

is no longer any sincere friendship, no true esteem, no secure confidence. Suspicion, resentment, fear, coldness, reserve, hatred and treason are always concealed under a veil of a fixed and treacherous civility; feelings are hidden by the much-admired urbanity which we owe to the enlightenment of this century.'[12] Towards the end of his *Discours*, Rousseau becomes almost frenzied, suggesting that the future development of modern culture will finally prompt men – unless they are even more foolish than the present generation – to beg God to deliver them from science: '"Give us back our innocence, ignorance and poverty," will be their prayer, "for that alone can make us happy and precious in Thy sight."'[13]

In a preface written for the published edition of the *Discours*, Rousseau admits that he does not expect to be readily forgiven for his attacks on modern arts and sciences: 'Setting myself against everything that excites admiration today, I can only await a universal outcry.'[14] This remark, however, is less than candid, for at the time he wrote those words, he knew that his essay had won the prize at Dijon. Besides, the idea of progress that he attacked was 'universal' only in certain circles. Elsewhere, there were many persons to whom the sentiments expressed in his essay could be expected to be congenial. The Dijon Academy itself was a bourgeois and provincial institution of recent foundation; the panel of judges for the prize Rousseau won was composed of two clergymen, two bureaucrats and three lawyers, none of whom would predictably share the Voltairian ideas that were favoured in the smart Paris salons. Besides, Rousseau softened the extremism of his argument (or, as some would say, contradicted it) by adding at the end a paragraph[15] suggesting that science, for all its dangers, could still be an excellent thing for a few men of superior genius, and that kings should not despise the advice of philosophers, important as it was for ordinary people to be content with their ignorance.

In later years Rousseau came to dislike his first *Discours*: 'It is full of warmth and energy, but totally lacking in logic and order,' he says in the *Confessions*,[16] 'and of all the writings that have come from my pen, it is the weakest in reasoning and the poorest in balance and harmony.' The excuse he offers is that it is the work of a beginner who had not yet mastered the art of authorship. And yet despite such self-criticisms, this *Discours* served to introduce a central theme, perhaps the central theme of all Rousseau's philosophy, namely that man, by nature good, has been corrupted by society.[17]

A curious feature about the appearance of this *Discours* is that it was not immediately repudiated by Diderot and d'Alembert as a flagrant betrayal of the philosophy of the *Encyclopédie* to which Rousseau, as a prominent contributor, would have been expected to subscribe. In fact Diderot did much to help Rousseau in preparing his *Discours* for the press. It might be thought that this was simply a case of Diderot, with his generous nature, putting

friendship above ideological convictions, or of his admiring Rousseau's essay for the sake of its eloquence and overlooking its content. But the fact is that we find Grimm reporting from Paris nearly two years after the publication of Rousseau's *Discours sur les arts et les sciences*: 'The most singular thing is that M. Rousseau has converted almost all the philosophers here. With some reservations, they all agree that he is right. I might name among others, M. d'Alembert and M. Diderot.'[18]

What perhaps rendered Rousseau's *Discours* more acceptable to those two philosophers was its apparent paganism. If it was a reactionary pamphlet, it was not a conservative one; it assigned no virtue to the Catholic Church or the Christian tradition; nothing good was said of those ages when Christendom had succeeded antiquity; on the contrary, the discourse looked back to Sparta and Rome for models of moral superiority. A polemic so cold towards Catholicism could perhaps be forgiven for being hostile towards science and learning. Moreover, in the case of d'Alembert, his enthusiasm for science had never been so great as was his hatred of a Christian theology he believed to be false. Science was his profession rather than the ideology it was for Diderot. D'Alembert believed in progress, but did not consider it an unmixed blessing: 'Men,' he wrote in one of his essays,[19] 'seldom acquire any new knowledge without losing some pleasing illusion; so that our enlightenment takes place at the expense of our pleasures. Our ancestors were more forcefully stirred by the crude performances of primitive actors than we are moved by the finest plays of our dramatic theatre. The nations which are less instructed than we are no less happy. They have simpler wants and simpler needs, and coarse pleasures are good enough for them ... However, if our enlightenment diminishes our pleasures, it flatters our vanity, and we look upon our sophistication as if it were itself a virtue.'

There was a certain pessimism in d'Alembert which responded to Rousseau's arguments, despite his general adherence to the ideas of the *Encyclopédie*: nevertheless in the *Discours préliminaire*[20] which he wrote for the first volume of the *Encyclopédie*, d'Alembert said he felt it his duty in a work of such a character to defend the arts and sciences against the attacks which 'an eloquent writer and philosopher' had lately launched against them, 'especially', d'Alembert added with a delicate touch of irony, 'in view of the fact that the worthy man of whom we speak seems to have given his approval to our enterprise by the zeal and success to which he has contributed to it'. Politely, d'Alembert asks whether the evils which the author in question has attributed to the arts and sciences ought not to be seen as the results of other causes: 'Is it not to climate, to human temperament, to lack of opportunity, to unfavourable circumstances, to the economy of government, to customs, to laws and all sorts of other factors besides science that we must attribute the differences we observe in the morals of different peoples at different times in history?'

If d'Alembert's reaction to Rousseau's *Discours* can be understood,[21] Diderot's attitude has given rise to much speculation. Marmontel,[22] Morellet[23] and others[24] claimed that Diderot told them that when Rousseau mentioned at Vincennes his intention of competing for the Dijon prize, Rousseau did not know whether to argue that the sciences and the arts had improved or corrupted morals, and that he, Diderot, had advised him to take the unfashionable negative side to improve his chances of winning. Diderot's own written testimony, as we have seen, gives no authority for this story. Diderot, by his own account, regarded Rousseau's opinions as paradoxical but he did not doubt his sincerity. In a reply to Helvétius's theory that Rousseau became the writer he was by pure chance, Diderot wrote: 'Rousseau did what he did because he was Rousseau . . . Suppose it was not I who had been a prisoner at Vincennes, but the Citizen of Geneva, and suppose I came to visit him and put to him the question he put to me and he gave me the same reply as I gave him.* Do you think I would have spent three or four months bolstering up a feeble paradox by means of sophisticated arguments, that I would have clothed these arguments in the rhetorical eloquence that he gave his, and that I would have gone on to spin out a whole philosophical system from what had been no more than an intellectual game?'[25]

These words were written years after the event; at the time it happened Diderot did not allow any doubts he may have had about the intellectual value of Rousseau's *Discours* to hinder his efforts to promote its success or diminish his desire to have Rousseau write articles for the *Encyclopédie*; nor, on the other side, did Rousseau's attack on the philosophy which animated the *Encyclopédie* alter his willingness to contribute to its pages or cloud his friendship with the two editors. It did not even moderate Rousseau's eagerness to keep on good terms with Voltaire; for just as he was putting the finishing touches to his reactionary discourse, Rousseau found an occasion to write a long and ceremonious letter[26] to that prince of progressives. It seems that another M. Rousseau, probably the Pierre Rousseau who later founded the *Journal encyclopédique*, had published an attack on Voltaire, and Jean-Jacques was anxious to correct the victim's belief that he was the man responsible: 'I do not wish . . . to break, even with you, Monsieur, the rule I have imposed on myself of never praising any man to his face, but I will take the liberty of telling you, Monsieur, that you have misjudged a decent man in thinking him capable of repaying with ingratitude and arrogance the kindness and courtesy you showed him in the matter of *Les Fêtes de Ramire* . . . You have also misjudged me as a republican, Monsieur, since I was known to you as such. I am devoted to liberty; I hate domination and servitude equally, and I have no desire to impress anyone. Such sentiments do not go together with insolence, which is more suited to slaves, or those even baser creatures, petty authors

* That reply was: 'You will take the line no one else will take.'

who are jealous of great ones. Hence, I protest to you, Monsieur, that Rousseau of Geneva did not make the remarks you attribute to him, because he is incapable of any such thing . . .'

He signed the letter 'J.-J. Rousseau, Citoyen de Genève', thus employing, apparently for the first time, the style he was to use on the title page of published works, even though he had technically no right to claim the citizenship he had forfeited when he renounced the Reformed religion in Turin. His letter to Voltaire elicited a short but friendly note in reply:[27] 'With your frankness, Monsieur, you rehabilitate the good name of Rousseau. The person concerned is certainly not a citizen of Geneva, but from what I hear a citizen rather of the quagmire at the bottom of Mount Parnassus. He has acted in a way you are incapable of acting, and he does not appear to have your gifts.'

Voltaire had not yet read Rousseau's *Discours sur les arts et les sciences*; when he did so his response was one of unmitigated disapproval and distaste. Unlike Diderot and d'Alembert, Voltaire could find no reason for tolerating the reactionary views it contained, and very few kind words were to be spoken or written by him about the author. Henceforth, he was Rousseau's enemy.[28]

The winter of 1749–50 in Paris was not cold, but as usual Rousseau was in poor health at that time of year. In March[29] he explained in a letter to Mme de Warens that he had had colds and fevers and attacks of the old urinary complaint, so that even his 'convalescences are simply intervals between one illness and another'. In the same letter he refers to the Dupin family consuming most of his time: 'The little leisure that remains to me, I devote to the theatre, which my melancholy nature needs, and to walking, which my health needs even more. Outside the demands of duty, I see absolutely nobody, and I live always alone in order to be, at least in thought, with the best and dearest of *mamans*.'

If these last words were true at the time he wrote them, they did not long remain true, for within a few weeks Rousseau had given up his bachelor room to live permanently with Thérèse. He may well, of course, have regarded this as one of the demands of duty, since the revelation on the road to Vincennes had awakened moral scruples he had not felt before. And while his 'reform' did not prompt him to marry Thérèse, he did at least commit himself more fully to her protection. He rented from a tailor named Faby a fourth-floor apartment in the Hôtel de Languedoc in the rue Grenelle-St Honoré* for Thérèse and himself and he installed the Levasseurs under the same roof.

Thérèse thus ceased to be a *petite amie*, visited from time to time by a smart young lover, and became a resident mistress, a settled companion, in all but name a wife. They lived together at the Hôtel de Languedoc for the next seven years, as Rousseau puts it, 'peacefully and agreeably'.[30] Mme Dupin knew of

* The building has since been demolished, and the present No. 27 rue Rousseau occupies the site.

the arrangement and indeed provided some of the furniture which was needed to set up the establishment. Thérèse's mother was by this time in regular contact with Mme Dupin, soliciting gifts and proffering gossip, which may or may not have been appreciated, about Rousseau's relationship with her daughter. Mme Levasseur was an interfering, formidable woman, and Rousseau's nerves were strained by her constant presence; on the other hand, she was useful. For one thing, she regularly helped him with his writing in a way that Thérèse was too illiterate to have been of service. Rousseau's method of composition was to think out his ideas as he lay awake in bed at night, 'shaping and reshaping each sentence with infinite pains';[31] then in the morning he would dictate the text to Mme Levasseur when she came into his room to light the fire and attend to his needs.

By this time, he had resigned himself to seeing Thérèse constantly surrounded by members of her family, most of them, in his opinion, parasites, and few of them attractive: 'One of her nieces named Goton* was a nice, good-natured girl, but even she was ruined by the lessons and the bad examples of the others. Since I saw Thérèse and Goton often together, I used to call the niece "niece" and the aunt "aunt": both addressed me as "uncle". Hence the name "aunt" which I still use in speaking to Thérèse, and which my friends sometimes use in jest.'[32]

Rousseau goes on to describe Thérèse's father as a very odd fellow who was afraid of his wife and called her 'the Judge', a nickname which Diderot afterwards transferred to the daughter. Mme Levasseur herself, according to Rousseau, 'was not without intelligence or shrewdness; and she even prided herself on having the manners and polish of polite society, but she had a curiously unctuous tone which I found unbearable. She gave much bad advice to her daughter, and tried to make her less than honest with me. She also tried to turn my friends against one another and against me. In other respects, she was a good enough mother, if only because it was to her advantage to be one.'[33]

Apart from the problems created by Mme Levasseur and Thérèse's other relations, Rousseau enjoyed domestic life at the Hôtel de Languedoc. After living for years in lodgings, or other people's houses, however grand, he appreciated having a home of his own. His memories of Thérèse, he recalled when writing his *Confessions*, were entirely sweet: 'our affection grew with our intimacy, and every day we felt more keenly how much we had been made for one another.'[34] Their greatest pleasures together were the simplest: 'our walks together in the country, when I would lavishly spend eight or ten *sous* at a tavern; our little suppers at my open window, sitting opposite one another

* Goton Le Duc, born Orléans, 21 June 1727, was the eldest daughter of Thérèse's sister Marguerite and her husband Nicolas Le Duc. Perhaps the identity of this girl's Christian name with that of Goton *la fouetteuse* preserved it in Rousseau's memory.

on two chairs placed on a box as large as the embrasure ... Who could describe, who could even imagine the charm of those meals, made out of nothing more than a loaf of coarse bread, a few cherries, a small piece of cheese and a half-bottle of wine which we drank between us? Friendship, confidence, intimacy, peace of mind – what seasonings they are! Sometimes we stayed by the window until midnight, and would never have moved if Thérèse's old mother had not disturbed us.'[35]

The pleasure Rousseau found in simple domestic life was noticed by those who visited him, including Bernardin de Saint-Pierre, a friend of later years who published a short memoir[36] depicting the philosopher at home. He describes the simple furniture of Rousseau's room, little beds covered in blue and white striped cotton, a table, chairs, a chest, a spinet and a canary in a cage. Bernardin was impressed by the first dinner Thérèse cooked for him: pasta, a Swiss dish made of mutton-fat, vegetables and chestnuts, roast beef and salad, cheese, biscuits, coffee and two bottles of wine. He says Rousseau told him he drank a good half-bottle of wine when he was alone, but more when he had a guest. Bernardin also provides a striking description of Rousseau's appearance as 'slender, not tall, but well proportioned, darkish complexion, some colour on the cheeks, a fine mouth, the nose very well shaped, the forehead round and high, the eyes full of fire ... The oblique lines that fall from the nostrils towards the extremities of the mouth, and which always characterize a physiognomy, expressed in his case great sensitivity and something still of suffering.'[37] Rousseau's face would of course have been less lined in 1750, when he was only thirty-eight, but it must always have been open and expressive: 'Every passion,' Bernardin recalled, 'was written one after the other on his face as different subjects of conversation affected his spirit, and then, when he was in repose his face kept the imprint of all his feelings, and offered at the same time a fusion of the lovable, the delicate and the touching, of dignity, compassion and respect.'[38]

Rousseau's domestic happiness at the Hôtel de Languedoc was darkened by one small shadow soon after he had settled there. Thérèse became pregnant again, for the third time. Rousseau realized that as a man who had reformed himself, who had publicly repudiated the corruption of modernity, he could no longer deal with the problem of an unwanted birth in the brisk insouciant manner of his friends at Mme La Serre's dining rooms. He began to brood. According to what he says in the Confessions, 'I was too sincere with myself, too proud in my soul to betray my principles in my actions.'[39] Moreover, he insists that he was filled with tender affection for his unborn child: 'Never for a single instant could Jean-Jacques be a man without feeling, without compassion, or be an unnatural father.'[40] Nevertheless, after all his soul-searching, Rousseau decided in the end to disembarrass himself of the third child in precisely the same way as he had disposed of the others: he had the midwife take it as soon as

it was born to the orphanage. In the *Confessions* Rousseau says he does not propose to publish the reasons which led him to act as he did lest they should persuade others to do the same thing. Then, in one of the least compelling passages in that book, he adds: 'I will content myself by saying that in handing over my children to be brought up to the public authorities, for lack of means to bring them up myself, and by making it their destiny to become workers or peasants rather than adventurers or fortune-hunters, I believed myself to be acting as a citizen and a father would act, and I looked upon myself as a member of Plato's republic. More than once since that time my heart has told me I acted wrongly, but my reason, far from delivering the same judgement, has made me bless heaven for having saved my children from their father's fate.'[41]

Rousseau's decision to dispatch his first two children to the orphanage had been executed swiftly, in secret, and was unobserved; but he was soon to cease to be a person of no importance, and once he became a public figure he could no longer expect the same respect for his privacy. He was going to have to justify his actions, not to himself, but to others.

In was in July 1750 that the judges of the Dijon Academy announced that their prize had been awarded to the essay bearing an epigraph from Horace, '*Decipimur specie recti*', which concealed the identity of Jean-Jacques Rousseau. The winner, writing to thank the judges, allowed himself to congratulate them on their 'courage' in rewarding an author whose arguments were contrary to the interests of an academy: 'Yes, Messieurs, what you have done for my fame has added further laurels to your own.'[42] Rousseau did not actually go to Dijon to receive the prize – a gold medal worth three hundred *livres* – but authorized a certain Jacques Tardy to accept it in his name at the ceremony where his *Discours sur les arts et les sciences* was read aloud in public. All this might have passed unnoticed outside Dijon, but for the fact that the *Discours* received publicity in Paris.

Rousseau was fortunate in having a friend of his as the newly appointed editor of the *Mercure de France*, which was by far the most influential literary journal in the kingdom. This friend's name was Guillaume Raynal, a former Jesuit priest who had given up his clerical duties in 1747 to become editor of the *Nouvelles littéraires* and was now wholly engaged in literary journalism. The Abbé Raynal was the one and only friend Rousseau owed to an intro-duction from Grimm, and he proved a good friend, as Rousseau gratefully testifies in the *Confessions*.[43] No one knew exactly what Raynal believed, since he defended contradictory opinions in his various published articles, and it was perhaps his liking for the paradoxical which attracted him to Rousseau's *Discours sur les arts et les sciences*. At all events, he became its most effective publicist.

Rousseau's earliest known letter to Raynal is dated 25 July 1750[44] and is

clearly a reply to an invitation from the Abbé to write something for the *Mercure*, an invitation doubtless prompted by the success of the essay at Dijon. In his reply,[45] Rousseau protests bashfully that he has no wish to acquire the reputation of a mediocre author: 'I have hastened to return to that obscurity which is suited equally to my talents and my character, and where you must allow me to remain for the honour of your journal.' Raynal did nothing of the kind. He published Rousseau's letter in a September number of the *Mercure* together with some of his verses. A November issue carried a short elogium of Rousseau's *Discours*, probably written by Raynal, and in January there appeared extracts from the *Discours* itself. Even this was only a beginning.

Rousseau was ill in bed in January 1751 when Diderot informed him that his *Discours* was having an unparalleled success. Thanks to Diderot's own efforts, the entire text was published in pamphlet form by a Paris bookseller Noel-Jacques Pissot. It came out without an official licence, a formality with which both Diderot and Rousseau felt they could dispense, since a friend of theirs, Malesherbes, had just been put in charge of the censorship by his father, Lamoignon, the new Chancellor of France. Even so, Pissot was too nervous to publish the pamphlet under his own name,[46] and he did not give the author a penny from the profits he made. The edition was soon sold out, and the *Mercure* continued to draw attention to it. In an issue dated June 1751, Raynal printed some critical *Observations* (very probably his own) on Rousseau's essay, together with a reply by Rousseau. In September 1751, the *Mercure* carried a substantial critique of the *Discours* written at least in part by King Stanislas of Poland. Further criticisms of Rousseau's essay were published by the Abbé Gautier, Professor of Mathematics at Nancy, by Charles Bordes, Rousseau's friend during his months in Lyons, and by Claude-Nicholas Lecat, posing as an Academician from Dijon who had voted against awarding the prize to Rousseau, but in fact a Professor of Anatomy from Rouen. Thus for over a year, Rousseau's *Discours* occupied the centre of the stage in the *Mercure*.

These criticisms[47] had a bracing effect on Rousseau. They prompted him to withdraw some of his more untenable assertions on minor points and to re-affirm the main theme of his argument by carrying it to a deeper level of analysis. Rousseau is often spoken of as suffering from persecution mania, but he cannot be accused of regarding the critics of his first *Discours* as enemies, or reacting with excessive emotion to their strictures; his replies were reasoned and reasonable; they were also detailed, taking up – if we include the preface to *Narcisse* among them – something like three times as much space as the *Discours* itself. Admittedly Rousseau's critics were most respectful. Charles Bordes and d'Alembert and Raynal (if it was Raynal who wrote the *Observations*) were personal friends; Stanislas bore the title of king and as Duke of Lorraine was father-in-law of another king, Louis XV, and for all Rousseau's republican sentiments he could not fail to be flattered at having excited the

interest of such an exalted personage. The one critic who irked Rousseau was Gautier, who accused him of advocating in effect the abolition of cultural institutions, the burning of libraries and the restoration of a rustic barbarism.[48] Rousseau adopted the lofty posture of replying to Gautier only indirectly, in the form of a *Lettre à M. Grimm*.[49] Lecat also stung Rousseau uncomfortably by asking him to specify precisely the sorts of art and science that were responsible for the corruption of societies: 'We hope he does not include music in the list,' Lecat protested, '. . . because M. Rousseau knows better than anyone else the utility of music, since he has made music his study and produced those brilliant parts of the *Encyclopédie*.'[50]

On some points Rousseau yielded gracefully to his critics. Bordes, for example, suggested that he had been wrong to praise the 'military qualities'[51] of primitive men, since such zeal for war was more of an animal-like aggressivity than a 'virtue worthy of human beings',[52] and Rousseau in his reply conceded the force of the argument, saying he would wish to justify only wars fought for liberty, not wars fought for conquest; he agreed with Bordes that soldiers were less admirable men than hunters, shepherds and labourers. In his later writings Rousseau condemns war, including 'national wars';[53] his horror of civil war, as we have seen, had been sharpened by events in Geneva and was almost as deep-seated as that of Hobbes. It is not that he ever became a pacifist or lost his admiration for the kind of 'military virtues' exhibited by a Swiss-type militiaman or a citizen-soldier bearing arms. Rousseau came to love peace above all things, 'provided', as he wrote in one of his unfinished manuscripts of the early 1750s, 'that by the word "peace" we understand not only the security that constitutes external peace and the moral order that constitutes internal peace, but also freedom, without which there can be no true peace'.[54]

The King of Poland's criticisms, prepared with the help of his chaplain, Joseph de Menoux, made some particularly telling points; among other things, he demonstrated that there was no historical evidence for believing that primitive men were more virtuous than civilized men, and indeed that such evidence as there was all pointed to earlier men being ferocious, brutish and cruel.[55] Others also challenged Rousseau's historical knowledge; Gautier, a historian himself, accused him of plain inaccuracy.[56] Several critics reproached him for treating the myth of the golden age as fact. All suggested that the ignorant men of antiquity were by reason of their lack of culture less and not more virtuous than modern men.

Rousseau made no attempt to defend his historical scholarship. He simply maintained that his critics had misunderstood him. He said he had no desire to defend that kind of ignorance which was degrading and criminal and reduced a man to the level of a beast; he wished only to champion another and very different kind of ignorance, that which consisted in restraining one's curiosity according to the measure of one's faculties, a modest and innocent ignorance,

'a sweet and precious ignorance, the treasure of a pure and self-sufficient soul',[57] and this alone was the ignorance in past men which he wished to praise. To those of his critics who defended the inherent value of the arts and sciences, Rousseau said he agreed with their views: science was a good thing in itself, but it was unsuited to human nature: 'sublime as it is, science is not made for man; for man has too limited an understanding to make good use of science, and too strong passions in his heart to avoid making bad use of it'.[58] Rousseau went on to say that he had never denied the possibility of a person being both a scientist and a good man; the whole point of his argument had been to show that the general effect of science on society as a whole was to undermine virtue.

It is, however, clear from Rousseau's replies to his critics that while he adhered to his belief that the arts and sciences were deleterious in their overall effects, something more general and more fundamental must have propelled men towards moral ruin; not simply the arts, as manifestations of culture, but culture itself, or civilization in its broadest sense.

This idea that man is naturally good but corrupted by culture was to be a central theme of all Rousseau's subsequent works, the basis of what he called his 'great and melancholy system'.[59] Diderot was not wrong to say that Rousseau had 'spun out a whole philosophical system' from the question about the arts and sciences posed by the Dijon Academy.[60] Rousseau was able to make it a system by going beyond that question of the arts and sciences, and he did so in response to the challenge put to him by the critics of his first Discours.[61]

To d'Alembert's suggestion that there were other factors besides the arts and sciences which produced changes in men's morals, Rousseau responded by considering what those factors might be; King Stanislas's suggestion that wealth rather than science was responsible for softness and luxury could hardly fail to appeal to an author who had only ever seen wealth in the hands of other people. Having once agreed that the arts and sciences were the consequence rather than the first generators of riches, Rousseau had no great difficulty in agreeing to name wealth as an earlier cause of moral decay, and he even went so far as to indict the institution of property as such: 'A savage is a man; a European is a man. The demi-philosopher concludes at once that neither is worth any moe than the other. But among the savages the love of their fellows and the concern for their common defence are bonds that unite them; the word "property", which costs so many crimes to our honest people, has hardly any meaning for them. They have no conflicts of interest to divide them; nothing prompts them to cheat one another . . . I say with regret that the good man is he who has no need to cheat anyone, and the savage is that man.'[62]

But even in this controversy, Rousseau did not limit his indictment to property. He pushed the charge even farther back. Beyond and before that evil

was the evil of inequality among men. In his rejoinder to the criticisms of the King of Poland, Rousseau explained how he visualized the several stages of the process by which culture had destroyed men's natural goodness: 'This is how I would set out that genealogy. The first source of evil is inequality. From the inequality came wealth, for those words "rich" and "poor" are relative, and wherever men were equal there were no rich or poor. From wealth was born luxury and idleness. From luxury the fine arts were born. From idleness the sciences were born.'[63]

It will be noticed that in this remarkable passage Rousseau uses the the word 'genealogy', and this indicates the logical character of his enterprise. He was not writing history; and hence the reproach of such a critic as Gautier that his historical facts were wrong was of minor significance. Rousseau's sights were directed rather towards pre-history; he was concerned to develop a philosophical (and necessarily speculative) anthropology to explain how human society had reached its present corrupt state from an original condition of innocence, a process which must date from an earlier period than recorded time or written chronicles. This same enterprise, begun in response to the critics of his first *Discours*, was to dominate Rousseau's intellectual labours in the coming years.

It was, as he tried to make people understand, a theoretical exercise, not a practical one. He had no policy proposals to make. To the objection in (Raynal's?) *Observations* that he offered no remedy for the corruption he diagnosed,[64] Rousseau's reply was really no different from his reply to Gautier's objection that he was in effect calling for the abolition of cultural institutions.[65] The answer to both was that Rousseau had no remedy. 'I have seen the evil and tried to discover the causes. Others bolder or more injudicious than I may seek the remedy.'[66]

Elsewhere Rousseau gave an even more pessimistic reply, namely that there was no remedy to be found: 'A vicious people can never return to virtue,'[67] he wrote in his preface to *Narcisse*, and years later he was still saying the same thing: 'One can never go back to the time of innocence and equality, once one has departed from it.'[68] This was one of the reasons why he wished to keep the arts and sciences intact; in a society already corrupt, they performed a useful service in moderating the excesses of corruption; so it would be madness to think of abolishing them: 'Beware of concluding,' he warned the King of Poland, 'that we ought today to burn the libraries and destroy the universities and academies. We should only plunge Europe into barbarism and our morals would benefit in no way.'[69]

It could well seem paradoxical to assert that the arts and sciences which had helped propel men towards corruption could now serve to mitigate its evils; but as Rousseau himself declared, 'I would rather be a man of paradoxes than a man of prejudices.'[70] It was this reflection which justified his own continued

engagement of literary and artistic activity. What was more important for the development of his 'system', however, was the need he now felt to investigate the origins of corruption in a more scientific way than he had done in his first *Discours*, and it was to this project that Rousseau now committed himself.

The year 1751 was the one in which Rousseau became a literary celebrity: it was also the year in which his great secret became known. It is more likely than not that Mme Levasseur, among the other gossip she related to Mme Dupin, told her what had happened to the illegitimate offspring of Rousseau's union with Thérèse. It was not, however, Mme Dupin but her daughter-in-law, Mme Francueil, who confronted him with the accusation, and it was to her that he wrote in April 1751 a long letter[71] admitting and justifying what he had done. He kept a copy of the letter in code.*

'Yes, *Madame*,' he wrote, 'I put my children in the Foundling Home. I entrusted their education to the institution set up for that purpose. Since poverty and ill health have robbed me of the power to undertake a cherished duty, I should be pitied for my misfortune and not reproached for a crime. I owe my children a living, and I secured for them one that is better, or at least more secure than what I could have given them myself. That is the first consideration. There was also the duty to avoid dishonouring their mother.

'You know my situation: I earn my living from one day to the next with some difficulty; so how could I feed a family as well? And if I were compelled to resort to the trade of a writer, how could I find the peace of mind necessary to do profitable work in an attic disturbed by domestic cares and the noise of children?'

Rousseau then turns the finger of accusation against his correspondent: 'Do you say one should not have children if one cannot feed them? I beg your pardon, *Madame*: nature wishes us to have children because the earth produces enough to feed everybody; it is the style of life of the rich; it is your style of life which robs my children of bread. Nature also desires that we should provide the maintenance of our children; and this is what I have done. Had there been no refuge for them, I would have done my duty by starving to death myself rather than fail to feed them.

'Is it that the name "Foundling Home" gives you the idea that these children of mine were picked up in the street where they had been exposed to die unless rescued by chance? I assure you that you could feel no more horror than I do for the unworthy father who could stoop to such barbarity: it is too alien to my heart for me to deign to answer such an accusation. There are established rules at the Foundling Home; inquire and you will learn that the children leave the hands of the midwife only to pass into those

* He used an unsophisticated code, the letter 'A' being represented as '1', 'B' as '2' and so on.

of a nurse.* I know that these children are not delicately reared, and so much
the better for them that they are not; they become more robust, they receive
what is necessary and nothing superfluous; they are brought up to be not
gentlemen, but workers and peasants – I see nothing in such an education that
I would not choose for my children even if I were master of the situation. I
would not by pampering them expose them to the illnesses which fatigue and
bad weather cause to children who are not prepared for hardship . . .†

'Thus in his Republic does Plato wish all children to be brought up: that
each should remain unknown to its father and that all should be children of the
state. Such an upbringing seems to you evil and base! Hence the great crime –
the belief affects you as it does others; only you do not realize that in adopting
the prejudices of society you mistake the disgrace of poverty for the dishonour
of vice . . .'

We do not know how Mme Francueil reacted to this eloquent, impassioned
and cruel letter. She must have observed that if Rousseau's 'reform' had not
yet turned him into the virtuous man, it had at least made him a guilty one.
We have only one clue to the conclusions she drew: Mme Francueil's grand-
daughter George Sand in a published article wrote: 'Twenty times I have heard
my grandmother say to those who accused Rousseau in her presence of being
an unnatural father: "Oh, as for that, we know nothing, and Rousseau him-
self knew nothing." Once she asked, shrugging her shoulders, "Could
Rousseau have had children?" '[74] George Sand also alleges that 'Mme
d'Houdetot declared that Rousseau did not believe he was the father of
Thérèse's children'.[75]

George Sand's testimony is not entirely reliable, but there were certainly
many who believed that Rousseau's urinary disease had rendered him impo-
tent and sterile, that Thérèse's much publicized infidelity to him in later
years was reason enough for thinking she was unfaithful to him from the
start,[76] and that other men were fathers of Rousseau's supposed children. No
biographer, of course, can give proof of paternity, but there is compelling
evidence to show that Rousseau believed himself to be the father, and no
evidence to suggest that Thérèse, when young, was other than faithful to him.
Her adventures – at least, the stories of her adventures – belong to a later
period, when the worsening of his disease had, by his own account, caused him
to abstain from sexual relations with her.

Rousseau never ceased to be troubled by the memory of what he had done

* This doubtless happened in the case of Rousseau's children, who were delivered to the
orphanage. But 2,324 children were abandoned in the streets of Paris in the year of the birth of
Rousseau's first child, 1746, compared to 950 actually taken to the Foundling Hospital and put
in the hands of a nurse.[72]

† Rousseau overlooks the fact that an enormous proportion of children taken to the two
Paris orphanages perished from illness. In the year 1741, for example, 68 per cent of the
foundlings died in infancy.[73]

with his children. Ten years after writing his letter to Mme Francueil he wrote on the same subject in a rather different tone to the Duchesse de Luxembourg; this letter is dated 12 June 1761[77] and is addressed to a protectress at a time when the writer believed himself to be dying: 'So many things I would have to say to you before I leave you; but time presses; I must abridge my confession, and confide to your good heart my last secret. You will know that for sixteen years I have lived in the greatest intimacy with the poor girl who shares my home, except that since my retirement to Montmorency, my state of health has forced me to live with her as brother and sister. Even so, my tenderness for her has in no way diminished; and but for you, the idea of leaving her unprovided for would have poisoned my last hours.

'From this liaison were born five children, who were all sent to the Foundling Hospital, and with so little precaution for ever recognizing them afterwards, that I have not even kept the dates of their births. For many years remorse for that negligence has disturbed my repose, and I shall die without being able to rectify it, to the great regret of the mother and myself. All I did was to put in the linen of the first-born a mark of which I have kept the duplicate; he must have been born, it seems to me, in the winter of 1746–7 or thereabouts. And that is all I can remember. If there were means of recovering that child, that would make for the happiness of his loving mother; but I have no hope of success, and I do not promise myself that consolation . . .'

The 'mark' which Rousseau left in the child's linen he also speaks of in the *Confessions* as a 'number' which he wrote in duplicate on two cards, putting one in the bundle in which the midwife carried the child to the office of the Foundling Hospital. However, he did not tell the Duchesse de Luxembourg what the number was and after fourteen years there was nothing that she or anyone else could do to trace the boy; so that the fate of that child, and of the other four born to Rousseau's union with Thérèse, remains a total mystery.

It was at the end of June 1751 that the first volume of the *Encyclopédie* appeared on the market. Since Rousseau was not only an intimate friend of the two editors, but the author of numerous articles on musical subjects, he shared in the glory of its success. As we have observed, Rousseau could see no contradiction between collaborating with an institution and disapproving of its ideals, between being at once an *encyclopédiste* and an enemy of progress. He was also still very much under the spell of Diderot's intellect; his references to Diderot in the *Confessions*, written long after he had been disappointed in that friendship, give no inkling of the esteem in which he had once held Diderot as a thinker; but in an autobiographical fragment written at the period of his life with which we are now concerned, Rousseau refers to Diderot as 'that virtuous philosopher whose friendship constitutes the glory and happiness of my life' and as 'that genius, universal and perhaps unique, of which his own century

does not know the price, but of which the future will hardly be able to find more than one example'.[78]

The influence of Diderot is evident in the one article Rousseau wrote for the *Encyclopédie* on a non-musical subject.* This is entitled '*Économie politique*', and in the manner of such eighteenth-century writings is as much about politics as it is about economics. It is some twenty thousand words long, elegantly and eloquently composed, as is all Rousseau's published work; but it is not entirely consistent in its reasoning, and may well have been written at intervals over a long period in the 1750s. For much of the time it reads rather more like a piece by Diderot himself than one by Rousseau, and at one point Rousseau refers his readers to Diderot's own article in the same encyclopaedia on '*Droit*', or Right, for 'the source of that great and luminous principle, of which this article is the development'.[80] Even so, the principle which Rousseau ascribes to Diderot was one he developed in his own way in other writings and which is always associated with his name: namely the principle of the general will being the foundation of law; and doubtless Rousseau was expressing views he held in common with Diderot when he wrote in this article, that 'the body politic is a moral being which has a will, a general will which tends always to the conservation and the well-being of the whole and of every part, and is the source of the laws . . .'[81] The fact that Diderot published some ten years later in Volume X of the *Encyclopédie* another article on what appears to be the same subject with a different spelling, '*Oeconomie politique*' instead of '*Économie politique*', has prompted some scholars[82] to suggest that Diderot was dissatisfied with what Rousseau wrote; but the fact of the matter is that the article '*Oeconomie politique*', drawn from the writings of Nicolas-Antoine Boulanger, is on a different subject, namely theocratic despotism; for it was part of Diderot's cunning as an editor working under persecution to give articles in his *Encyclopédie* titles which had nothing to do with the real substance they contained. He would have been in no way averse to Rousseau's introjecting provocative political opinions into a supposedly scientific article about economics, nor does he seem to have objected to the particular opinions that Rousseau contrived to express.

Diderot cannot, however, have agreed with them all, if only because Rousseau contradicts in one place what he asserts in another. For much of the time, Rousseau stays close to Locke and upholds a right to property. Speaking of taxation, for example, Rousseau writes: 'We must remember here that the basis of the social contract is property, and its first stipulation is that everyone be assured of the peaceful enjoyment of what belongs to him.'[83]

* The dating of this work is a matter of controversy. Rousseau probably finished the text after his return to Paris in October 1754, but it is equally probable that he started it much earlier; as Derathé has reminded us, Rousseau had been working on the materials of his *Institutions politiques* since 1750, and 'at the time he wrote his *Économie politique*, he must have been in possession of the essential ideas of his system'.[79]

In a manuscript draft of the article, Rousseau noted 'See Locke'.[84] But Rousseau cannot really have agreed with Locke that there is a natural right to property, since, as we have seen, he had already come to regard property as a source of evil. In later writings, he makes his rejection of Locke specific. Even in this article his adherence to the doctrine falters perceptibly, and towards the end he writes: 'We must calculate the advantages which each man derives from the social union, which rigorously protects the immense possessions of the rich and hardly allows a poor wretch to enjoy the cottage he has built with his own hands.'[85]

There follow some impassioned words about the laws enabling the rich to treat the poor like dirt while exploiting their services: 'Let us sum up in a few words the social contract of the two estates: "You need me, because I am rich and you are poor; let us therefore make an agreement between us; I will allow you to have the honour of serving me, on the condition that you pay me the little that remains to you for the trouble I take to command you."'[86]

The bitter radicalism of this passage, which echoes what Rousseau says about the rich in the Discours sur les origines de l'inégalité, may not entail a complete rejection of the Lockean belief that property is the basis of civil society, but it does bring about a startling transformation of Locke's concept of the social contract as a mutually advantageous contract between fair-minded men into a fraudulent agreement imposed by the rich on the poor as a means of perpetuating their privileges and dominion. And this is perhaps what amused Diderot most about Rousseau's article on political economy: that in the midst of a fairly orthodox exposition of liberal economies he plants the explosive suggestion that property, the so-called 'natural right', is injustice institutionalized.

To some extent, he had been pushed towards this line of thinking by d'Alembert's criticism of his Discours sur les arts et les sciences. But these thoughts did not come immediately. When Rousseau first wrote[87] to thank d'Alembert for a copy of his Discours préliminaire for the Encyclopédie, he made no reference to d'Alembert's comment on the Dijon essay; he simply said: 'I cannot thank you enough for your Discours préliminaire. I cannot believe it gave you as much pleasure to write as it has given me to read. The "encyclopaedic chain" above all has enlightened and instructed me, and I propose to re-read your essay more than once.'

This 'encyclopaedic chain' was d'Alembert's version of Bacon's idea that all human sciences and disciplines are linked together in a systematic network, so that each can be understood only in relation to the others; behind the suggestion is the unstated empiricist belief that all genuine knowledge is scientific knowledge, and that what cannot be verified by the same sort of procedures is not knowledge at all. At this time Rousseau was only just beginning to realize how far his own new way of thinking must put him at odds with the ideology of the Enlightenment.

In this same letter to d'Alembert, of June 1751, Rousseau apologized for the delay in his work on articles for the *Encyclopédie*, d'Alembert having been entrusted by Diderot with the editorial supervision of material connected with music, since the science of music was one of his specialities. Rousseau explained that his poor health had held up the writing of articles beginning with the letter 'C' and at the same time he agreed to the changes d'Alembert had proposed to make to the articles he had already submitted. Rousseau's original wording had been, as he confided to Mme de Warens, deliberately aggressive; d'Alembert, prudent in all things, softened the edges.

When Rousseau moved under the same roof as Thérèse he looked forward to enjoying the pleasures of domesticity; but as that move coincided with the detonation of his fame, he found himself expected to go out into society more than ever. In the *Confessions* he complains about this: 'The success of my first *Discours* made me fashionable. The point of view I had defended excited curiosity. People wanted to meet this strange man who sought no society and wanted nothing but to live freely and happily in his own way – and their curiosity was enough to prevent his doing it. My room was packed with people who came to waste my time. The women used a thousand ruses to get me to dine at their houses; and the more ill-mannered I was, the more persistent they became . . .'[88]

Thérèse, the illiterate mistress, did not, of course, go to the salons with Rousseau. In the *Confessions* he complains that her mother encouraged visits from rich and fashionable admirers, who might arrive with presents. For Rousseau it was a matter of pride to refuse all gifts. In his memoir of Rousseau, Bernardin de Saint-Pierre recalls that he once brought him a bag of coffee beans he had collected on his travels; Rousseau told him he must either 'take back your coffee or never see me again'.[89] However, Bernardin adds that Mme Levasseur and her daughter sometimes conspired behind Rousseau's back to lay their hands on presents that were offered him.

Rousseau allowed himself to accept invitations into polite society on the understanding that he was not going to try any longer to adopt the manners of the *beau monde*, but be as oafish as he wished. Looking back, he realized that he affected to despise good manners largely because he did not know how to practise them: 'It is true that this disagreeableness was ennobled in my mind to conform to my new principles, and took on the bold guise of a virtue . . . but in spite of the reputation of a misanthrope which my looks and some of my remarks earned me in the world, in private life I could not sustain the role; and my friends and acquaintances led the rough bear around like a lamb.'[90]

He was, in fact, extremely popular in society. His letters also reveal that he took active steps to keep up with fashionable friends. For example, in October 1751 we find him writing to the widowed Marquise de Créqui* expressing his

* Renée-Caroline de Froullay (1714–1803) married Louis-Marie de Créqui (1705–41) in 1737.

eagerness to visit her but warning her that he will run away if she has anyone with her other than his friend and her admirer M. d'Alembert. Mme de Créqui was the daughter of the Comte de Froullay, Montaigu's predecessor as French Ambassador in Venice, and some business Rousseau had done on her father's behalf in Venice may have led to his first meeting with her; but evidently their friendship was improved by a letter she wrote him in 1751 in praise of his *Discours sur les arts et les sciences*: in his reply[91] he wrote, 'I flatter myself, Madame, on having a soul which is proof against praises.' Mme de Créqui's praises nevertheless encouraged him to pay court to her for twenty-five years; her house on the Quai des Quatre Nations, near what is now the Institut de France, was one at which he regularly dined, and of the twenty-six letters in Rousseau's hand which survive from the period between October 1751 and the end of December 1752, no less than fourteen are addressed to Mme de Créqui.

His home life was very different from that of the salons. He had very little money and the financial burden of the Levasseur family added greatly to his worries and poor health. Then one day[92] Francueil offered him an escape from the poverty and drudgery of the life he was leading. In Francueil's office as a Receiver-General of Finances, or tax-farmer, there was a cashier named Dudoyer who wanted to retire. Would Rousseau care to take his place? With some reluctance, Rousseau agreed, and presented himself at the office to be initiated into the work. Dudoyer, who appeared to Rousseau to want another man to have the job, instructed him without enthusiasm. Nevertheless, Rousseau learned to do the job competently, and he was well paid. To another man the position would have held glittering prospects of personal enrichment, but Rousseau did not respond to the charm of gold. 'Don't congratulate me on my fortune,' he wrote to Mme de Créqui.[93] 'Never have I been so miserable as I am since I have become rich.'

Rousseau was kept so busy by his work for Francueil that he had time to frequent only two salons, that of Mme d'Épinay, who was Francueil's mistress, and that of the young Baron d'Holbach. In the *Confessions* Rousseau speaks somewhat ungraciously of Holbach* as 'the son of a parvenu', with whom 'I found myself linked . . . almost in spite of myself'.[94] Holbach was in fact one of the most important philosophers of the Enlightenment and Diderot's most valued contributor to the pages of the *Encyclopédie*. He was a German who had studied the sciences in Holland before he moved to Paris in 1749 at the age of twenty-six. As a result of his training he was able to provide Diderot with even more useful help than d'Alembert; for while d'Alembert was a master of such abstract sciences as mathematics and physics, Holbach's specialities were the empirical and applied sciences which lent themselves most readily to the Baconian scheme

* Paul-Henri Dietrich (afterwards Thiry), Baron d'Holbach (1723–89).

of conquering nature with technology. Holbach wrote no less than four hundred entries for the *Encyclopédie*, as well as at least thirty-five highly controversial books.[95] He cultivated intellectual rather than fashionable society; his guests were mostly the *philosophes* or *encyclopédistes*; they constituted what Rousseau later called the 'Holbachian clique'.

Naturalized a Frenchman, Holbach remained very much the German in his temperament and tastes. He kept his earnestness and thoroughness and industry and he never lost his German fondness for pushing things to extremes. The deism of Voltaire and Diderot he developed into an uncompromising atheism. The Baconian cult of science he magnified into a thoroughgoing positivism: all knowledge that was not scientific he regarded as nonsense. In politics, too, he went beyond liberalism to radicalism, forsaking the English model of representative government so dear to Montesquieu in favour of an unabashed despotism of the expert. All such opinions – and they each represent different ideas of the Enlightenment carried to their logical conclusion – must have shocked Rousseau; but in the *Confessions* he speaks only of being put off by Holbach's wealth.

'A natural repugnance long prevented my responding to his invitations,' Rousseau writes. 'One day he asked me why, and I told him "You are too rich." But he persisted, and in the end he conquered. My greatest weakness has always been that I could not resist his entreaties.'[96] And thus for some time Rousseau was a regular habitué with Diderot, d'Alembert and the other *encyclopédistes* of Holbach's hospitable table, but it was a friendship that could not, and did not, last. The closer Rousseau found himself to money, in acting as Francueil's cashier, the more acute became his aversion to the whole rich bourgeois world of Paris. He felt at home only with simple people, like Thérèse, or with the *noblesse de race*, with aristocrats of ancient lineage such as Mme d'Épinay, who was destined to become in Rousseau's life an even more bitter adversary than Holbach, but who could never be considered, like him, 'a parvenu'.

In the high summer of 1751 Rousseau escaped once more from Paris to stay with Mme d'Épinay at her *château* near Montmorency, La Chevrette. He was again in poor health, and when he returned to Paris to resume his duties in Francueil's office he felt even worse. He began to find the job intolerable. While Francueil was with him, he felt able to cope with it, but when his employer went away and left him in charge of the office, the responsibility and the anxiety proved too much for him. He fell sick with worry.

'This time, it was worse than before, and I stayed in bed for five or six weeks in the most melancholy condition that anyone could imagine. Mme Dupin sent me to the famous Morand, * who for all his skill and delicacy of hand, made me suffer unbelievable pain and then did not succeed in probing me. He

* Savery-François Morand (1697–1773), surgeon.

advised me to consult Daran,* who succeeded in inserting his more flexible waxed catheters.'[97] What exactly was wrong with Rousseau? He was unable to empty his bladder at regular intervals; and passing only a few drops of urine at a time, he found himself both in constant need, as he put it, of a chamber pot and unable to relieve the agony of an over-extended bladder. There was also a blockage in the canal of the urethra which Daran's waxed catheters, inserted by a painful procedure, helped at first to relieve. Unfortunately, continued use of them became with the passage of time both more difficult and less effective.

When he wrote his will in 1763, Rousseau added a note[98] about this life-long physical affliction: 'My retentions of urine are not at the point of access as in the case of stone, where one either micturates through an open channel or not at all. My disease is a chronic state. I never micturate through an open channel, and the urine is never totally suppressed; the passage is always more or less blocked without at any time being entirely free, with the result that I suffer a discomfort, an almost ceaseless need that I can never satisfy ... Baths, diuretics, all that is ordinarily used to relieve this sort of affliction has never done anything but add to my suffering, and no blood-letting has ever given me the smallest relief.' Rousseau adds to this note an interesting assertion: 'On no account must one seek the cause of all this in some earlier venereal disease. I declare I have never had anything of the kind. I have said this to those men of medical art who have treated me. I realize that some of them did not believe me: but they were wrong.' By the time he wrote these words, Rousseau had given up consulting doctors altogether.

Even when he was first referred to the surgeon Daran, his case had already been given up as hopeless by Morand. 'He told Mme Dupin,' Rousseau recalls, 'that I should be dead in six months. This prognosis, which reached my ears, made me reflect seriously on my condition, and on the folly of sacrificing the repose and peace of the few days that remained to me to the slavery of a job for which I felt nothing but disgust. Besides, how could I reconcile the austere principles which I had lately adopted with a position which had so little congruity with them? Could a cashier to a Receiver-General of Finances preach disinterestedness and poverty?'[99] In his delirium, Rousseau's answer was no; and in the cool hours of his convalescence the conclusion was the same. 'I resolved to pass the little time that remained to me on earth in independence and poverty.'[100] So Rousseau resigned his appointment at Francueil's office and resolved to live henceforth on the proceeds of music copying.

In the autumn of 1751, it was Grimm's turn to be ill, if only with nothing worse than a bad case of lovesickness. It seems that Grimm, a regular patron, like Rousseau, of the lyrical theatre in Paris fell in love with a star of the opera, Marie Fel. She was, however, faithful to her lover, Louis de Cahusac, a librettist and contributor, like Rousseau, of articles on music to the *Encyclopédie*. When she

* Jacques Daran (1701–84), surgeon.

did not respond to Grimm's advances, the frustrated admirer simply lay down on his bed and did not sleep, eat or even move for several days. Rousseau stayed with him by day and Raynal by night. Writing to Mme de Créqui on 26 October 1751[101] to apologize for not coming to visit her, Rousseau explained: 'I have a friend dangerously ill, and all my attention must be devoted to him.' Later, Rousseau came to think that Grimm's sickness was not so much physical as wilful: he recalls in the *Confessions* how Grimm rose from his bed one morning, dressed and went out of the house, 'without a word to me or to the Abbé Raynal or anyone else about his singular affliction, or about the care we had taken of him while it lasted'.[102] Rousseau notes with a certain impatience that Grimm acquired as a result of this episode a romantic reputation 'as a man who loved so deeply that he had nearly died of despair'.

These words were written some fifteen years after the events with which we are now concerned, at a time when Rousseau felt that Grimm had betrayed him shamefully, but the letters he wrote in the early 1750s give no sign of any tension between Rousseau and Grimm or any other old friends. He evidently made several new ones, and became more closely attached to Charles Duclos,* that exceedingly fashionable *homme de lettres* whose works of social history† are still an unmatched contemporary source of knowledge of eighteenth-century France. Far from being put off by Rousseau's lack of social grace, Duclos recognized in him a blunt sincerity akin to his own, and their friendship was unclouded.

Duclos introduced Rousseau to another writer, then very much in fashion, Mme de Graffigny.‡ At the age of fifty, after years of unhappy marriage to a brutish husband, she had taken to literature and won fame with her *Lettres d'une Péruvienne*, published in 1747. When Rousseau first met her, Mme de Graffigny had allowed herself the added consolation of a love affair, ill concealed, with Antoine Bret, who was twenty-two years younger than she. She was a hostess as well as a writer; the philosopher Helvétius was her nephew, and her salon sparkled with both wit and fashion. Bret recorded a vivid impression of Rousseau as he appeared at her receptions:[103] 'Although always modest, always inward, and giving himself only with the utmost reserve to conversation and the various amusements of society, he was sometimes seen being very cordial and once even extremely flirtatious. It was all a matter of awakening his interest. A foreign girl, with plenty of intelligence, no longer very young, but who had an open, smiling face, and whose bright conversation was spiced with a pretty Italian accent, attracted our philosopher, in whom she doubtless discerned a secret sensibility behind the eager eyes which

* Charles Pinot Duclos (1704–72) was Voltaire's successor as Royal Historian.

† *Considérations sur les mœurs de ce siècle* (1750) and *Mémoires pour servir à l'histoire du XVIIIe siècle* (1751).

‡ Born Françoise d'Issembourg Appencourt (1695–1758).

kept glancing at her, eyes of which the fires became always more ardent as he abandoned himself to his nature and his senses. Mlle Bagarotti was not mistaken. M. Rousseau came out of himself, so to speak, expanded and improved before our eyes; a thousand agreeable traits revealed themselves. He was well received, and I still recall with astonishment the whole change which was brought about in him by the passing desire to please: the incident had no sequel, but for two or three hours, it revealed our philosopher deploying social graces which no one suspected he had, and which would have provoked the envy of a gifted courtier accustomed to conquest in that sort of galant game.'

In the same memoir, Antoine Bret recalls an episode which probably led to a cooling of Mme de Graffigny's regard for Rousseau. She had been engaged by Maria-Theresa to send to Vienna French plays to be performed by the young people at Court there and had started putting together one called *Les Saturnales* on a suitably exalted theme; taken ill before she could finish it, she begged Rousseau to take over the commission. Reluctantly, since writing to order was alien to him, he agreed to help, but, according to Bret, the work he did was so unsatisfactory that it was of no use to her. Bret concluded tolerantly that Rousseau spoke the truth when he said of himself: 'I would a hundred times rather agree to do nothing than do something against my will.' Besides, Bret was only too pleased when disappointment with Rousseau prompted his mistress to assign the work to him instead.

It seems that it was in the salon of Mme de Graffigny that Rousseau had his one meeting with Voltaire. We have no details of the occasion, but evidently Voltaire gave the younger philosopher every assurance of his friendship, and then went away to speak many spiteful words against him and to do several cruel deeds. The reactionary ideas proclaimed in Rousseau's *Discours* had alienated Voltaire from the start; and, liking only witty polished conversation, he had no patience with the bearish role that Rousseau assumed in the salons. Rousseau, to his credit, never repaid Voltaire's hostility in kind. According to Bernardin de Saint-Pierre: 'Rousseau spoke ill of no one, not even of Voltaire.'[104] Rousseau told Bernardin: 'M. de Voltaire did not deceive me in making me believe he liked me; his first impulse is good; it is reflection that turns him malicious.'[105]

One result of Rousseau's literary fame was that he found himself being sought out by fellow exiles from Geneva. One such was François Mussard, a kinsman, who had made his fortune as a jeweller in France and now lived in retirement in Passy, collecting shells. Passy was then a village outside Paris, noted for its mineral waters, and when Rousseau was recommended to try them as a remedy for his urinary troubles, Mussard offered him the hospitality of his house. The waters did not do Rousseau much good,* but Passy provided a welcome retreat from the noise and confusion of the Hôtel de Languedoc.

* But they did not harm him as Voltaire said they did him: 'They have almost killed me.'[106]

Rousseau met interesting people and he had an opportunity to enjoy music, for Mussard himself played the cello, and impromptu concerts were part of the entertainment he provided. Among other guests were the Abbé Prévost, the novelist whose *Clèveland* had so impressed Rousseau when young; the actress Coralline Veronese, whose departure from Venice for Paris he himself had organized at the Embassy; Marie-Louise Denis, the niece and future mistress of Voltaire; and Van Loo, the portrait painter. It was also at Passy that Rousseau first made the acquaintance of Toussaint-Pierre Lenieps, who had been banished from Geneva for his radical political activities. Lenieps did not immediately undermine Rousseau's belief that Geneva was a model republic; the two exiles may not even have discussed politics at all when they first met. But they liked each other well enough, and in December 1751 we find Rousseau writing[107] to Lenieps to express his regret that it was too late in the season to go on foot to Passy and his hope that he might meet him again with M. Mussard in Paris.

Another Genevan with whom Rousseau renewed contact at about this time – success in France having evidently greatly improved his standing with his countrymen – was Isaac-Ami Marcet,* who was as much a conservative as Lenieps was a radical. Marcet suggested an exchange of literary correspondence, and in his reply[108] Rousseau recalled: 'your old friendship with my good and virtuous Father' (Rousseau never falters, it will be noticed, in filial hyperbole). 'You know, Monsieur, that I am the child of an excellent Citizen; and all the circumstances of my life have served to give more fire to that ardent love of country which he inspired in me. It is as a result of living among slaves that I have felt the value of liberty. How happy you are to live in the bosom of your family and your country, to dwell among men who obey only the laws, that is to say, Reason!'

These words about Geneva were undoubtedly sincere. Success in France did not diminish Rousseau's nostalgia for his homeland, and, as we shall see, he began to think more and more about returning. He wanted his correspondence with Marcet to be inspired by Genevan candour rather than French politeness: 'It must be conducted without ceremony or compliments,' he insisted, and he proposed to be a severe and serious critic: 'We shall try to evaluate all the marvels of this century, so vaunted for its enlightenment and so justly decried for its bad taste, so fertile in clever minds and so lacking in geniuses. We shall lay some flowers on the monuments of those great and neglected men who built the foundations both of the Temple of the Muses and of that great philosophical edifice on which such pretty castles of cards are built today.'

Nothing much came of this project. Rousseau warned Marcet that he might

* Isaac-Ami Marcet (1695–1763), prominent in Geneva politics, was also an undistinguished dabbler in literature.

not be able to keep up the correspondence; he was worn out by 'a deadly and very painful illness' and might not find the strength to overcome his natural repugnance to write. In the event, he did not find that strength, although within a year or two he was to see Marcet in person in Switzerland.

In Paris Rousseau enjoyed literary fame without material rewards. As we have seen, the publisher Pissot gave him nothing for the *Discours sur les arts et les sciences*, and although Raynal sometimes found money for Rousseau out of his pocket, the *Mercure de France* did not pay Rousseau for his contributions. Unless a writer had the wit and determination of a Voltaire, he was unlikely to receive a fair payment for his labours from any French publisher; and since writing took up time that might have been devoted to better-paid work, Rousseau found himself in 1751 poorer than ever. To add to his miseries most of his fine shirts and other linen* were stolen at Christmas-time from his rooms in the Hôtel de Languedoc. He suspected Thérèse's brother of the theft, and although Mme Levasseur rejected the accusation indignantly, her son was never seen in the rooms again. Rousseau tried to make the best of the situation by telling himself that wearing rough shirts was more in keeping with his new moral principles; 'the adventure cured me of my passion for fine linen'.[110] He began to reflect more seriously than ever upon his attitude to money.

In the *Confessions*, he says that as a result of these reflections he resolved to 'renounce for ever all ideas of fortune and advancement in the world'.[111] Fame he had won; the rest he would do without. It may have been at this juncture in his career that he wrote one of his most interesting and least-known essays, his unfinished *Discours sur les richesses*.

This paper is among the manuscripts of Rousseau conserved in the Public Library[112] at Neuchâtel, where the fragments were pieced together by a former librarian, Felix Bovet, and published by him, with some omissions, through a small Paris bookseller in 1853.[113] It has only once been reprinted.[114] The discourse is addressed to one Chrysophile – who is doubtless Rousseau himself – and is designed to persuade the recipient to give up his project of making a fortune. Chrysophile, we learn, desires to become rich only in order to have the means to do good in the world. His wealth is going to be used to relieve the sufferings of his less fortunate fellow-men. The author agrees that this project is one that can never be accomplished. First, he points out that a poor man can accumulate a fortune only by saving every *sou* he acquires; he must cultivate habits of avarice, and thus, in preparing for the distant future when he will give away liberally, he must harden his heart against any kind of generosity. Secondly, when that remote day dawns and his fortune is made, the newly rich man will no longer look upon the world from the perspective of a poor man. The poor man is sensitive to the evils of poverty precisely because he is poor

* In the *Confessions* he says that forty-two shirts were stolen, but a list drawn up at the time accounts for only twenty-two.[109]

himself; but once he is rich, why should he continue to have the same feelings? Then again, by what means is a fortune to be made? A poor man can be honest, but it is not so easy to be honest while devoting one's life to the activity of getting rich, for the readiest ways of making a profit are often the least ethical ways. So Rousseau concludes that the idea of becoming rich in order to do good in the world is an impossible project, because the process of getting rich will deprive a man of the desire to do good as soon as he acquires the power to do it.

It is fair to note that this essay is not an attack on hereditary wealth; it is not an attack on the values of the aristocracy, but on those of the acquisitive bourgeoisie, of the people to whom Rousseau had hitherto looked for patronage in Paris, the Dupins and such well-heeled bourgeois intellectuals as Voltaire. One reason for thinking that Rousseau addressed the essay to himself is that he had hitherto looked upon his own project of making money as one designed solely to enable him to provide material help for his former benefactress, Mme de Warens, in her years of sickness and need, and, in addition, to support Thérèse and her avaricious family as best he could. He now persuaded himself that these good motives could not redeem the corrupting effects of material ambition, so he made a virtue out of the necessity of poverty. His fine linen having been stolen, he could no longer cut an elegant figure in society, so he went to the other extreme: he began to dress in shabby clothes and sometimes did not even shave. All this was perhaps less important than he thought; for, once he had become a celebrity, society was entirely willing to tolerate his 'original' appearance. A nobleman was expected to dress like a nobleman, a bourgeois like a bourgeois, but a philosopher – at any rate, a recognized philosopher – could dress as he pleased. Since Rousseau was no longer employed as a secretary – or a treasurer – by the Dupin family, they had no reason to expect him to look the part, and they probably did not even desire it. Only Diderot seems to have disapproved of Rousseau's determination to make a virtue out of poverty and tried to remind him of his duties towards Thérèse and her mother. Diderot's reminders were not well received.

Rousseau did, nevertheless, undertake occasional odd jobs besides music copying so as to earn a little more money. One such was writing a funeral oration on the death of the Duke of Orléans to be spoken by the Abbé d'Arty, a nephew of Mme Dupin. Rousseau kept a perfect copy of this text,[115] which years later he passed to Paul Moultou,[116] saying it was not to be printed because it was a commissioned piece, done for money, in circumstances where the writer could not have written what he thought if the speech was to be of use to the Abbé Arty, who paid for it (but who did not, in the end, use it). The Duke of Orléans, who died in February 1752 at the age of forty-eight, was a prince of singular piety, scholarship and benevolence, the founder of many charitable institutions and of university chairs, a student of Hebrew, Greek and Assyrian,

a man more at home praying at the Abbey of St Geneviève than idling in the Palais Royal. Rousseau could, with a clear conscience, praise him, but his praises took the embarrassing form of saying how greatly this prince differed from other princes and contrasting his virtue with their corruption. The eloquence of the oration is magnificent, and the Abbé d'Arty might well have rejoiced in pronouncing it, but he could hardly allow himself before a courtly congregation to utter Rousseau's strictures on the courtly life. The merits of the Duke of Orléans are said in this oration to be all the more remarkable because a prince of the blood is not educated like ordinary people in an environment conducive to morality, but in a place where he is surrounded from birth by evil flatterers who do all they can to close his eyes to truth; the Duke's sincere devotion to the public good is said to be unique in a milieu where the words 'public good' in every other mouth mean only private interest, egoism, jealousy and greed. The genuine religious faith of the Duke is further contrasted with insincere attachment of the fashionable clergy to the doctrines they preach. Rousseau even puts into the mouth of the orator a reproach to those clergy who pretend to teach the Holy Scriptures but are actually more attached to 'proud philosophy' – an expression, twice used, which would certainly have been understood as a reference to the philosophy of the *Encyclopédie*.

The situation here is distinctly ironical. We find Rousseau writing for money for somebody else to say things he did not have to believe and being unable to prevent himself saying what he did believe; so that this funeral oration, written in February 1752, may even be seen as evidence not only of a revulsion against materialistic philosophy but of a vague yearning in Rousseau for the kind of pious, rather jansenistic holiness to which the life of the Duke of Orléans was consecrated. He was clearly beginning to develop a different attitude towards religion.

The Catholic review *Le Journal de Trévoux* in its issue dated April 1752 published an item which was to cause him some embarrassment at this juncture. This was a notice of Father Boudet's biography of Bishop de Bernex, published the previous year, which contained the story of the miracle at Annecy when the Bishop's prayers were supposed to have directed the flames of a fire. According to the reviewer 'the facts of the miracle are attested by M. Rousseau, who holds a distinguished place in the republic of letters'. It will be remembered that Rousseau had written to Father Boudet on the subject some years earlier, but Rousseau the *encyclopédiste* of 1752 was no longer Rousseau the *petit* of Mme de Warens: at the age of forty, he had not only won a 'distinguished place in the republic of letters', he held that place in the company of pagans and sceptics such as Diderot, d'Alembert and d'Holbach. Surely he did not believe in miracles? And indeed it seems that he did not. But what was his attitude to other and more essential elements of the Christian faith?

We do not have much concrete evidence, but we do have some. In the spring of 1752, a clerical friend of Rousseau's, the Abbé Cordonnier de l'Étang,* curate of Marcoussis in the valley of the Orge, was nominated to the benefice of St Filbert en Brétigny, and Rousseau wrote to him[117] something more than a letter of congratulations. 'In spite of my contempt for all titles and for the fools that bear them,' he wrote;[118] 'in spite of my hatred for what are called positions and for the scoundrels that occupy them, I believe I shall even see you becoming a bishop without ceasing to love you.' Rousseau affirmed his confidence that his friend would do good work as a country priest; 'vicars in towns,' he added, 'have become far too grand and lordly to be decent men; they are too remote to discover in their parishioners the simplicity and docility that is necessary to make them live wisely.'

The manuscript of this letter is preserved in the same dossier of Rousseau's papers at Neuchâtel with a fragment[119] of a letter which may have been intended for the same Abbé Cordonnier de l'Étang; here Rousseau writes: 'I agree with you that you should teach your people all the nonsense of the catechism, provided that you also teach them to believe in God and love virtue: make Christians of them, since you must, but do not forget the most indispensable duty, which is to make them decent men.'†

One can hardly fail to discern in these words the spirit of that Protestantism Rousseau had learned in Geneva and repudiated in Turin; as he began to turn away from the worldly materialism of his fellow *encyclopédistes* he began to look back to the simple values of his puritan upbringing. Rousseau admired Cordonnier de l'Étang because he represented an unworldliness which contrasted sharply with the sophistication of his smart Parisian friends. The *abbé* was one of the very few acquaintances he owed to an introduction from Thérèse's family, and in the *Confessions*[120] he records happy memories of excursions made with Thérèse to spend two or three days with him at Marcoussis, a village less than fifteen miles from Paris but at that time in the depths of the country. His love of nature increased as the development of his moral 'reform' made him feel more and more estranged from the life of the town.

For Rousseau to be close to nature was to be close to God. 'Atheists' he once said to Bernardin, 'do not like the country. They like the outskirts of Paris where they have all the pleasures of the town, good food, amusements, pretty women; take all that away, and they would die of boredom. They see nothing. And yet there are no people on earth in whom the simple contemplation of nature would not stir a sense of divinity.'[121]

The enjoyment of nature in the valley of the Orge was coupled with the added pleasure of music; for Cordonnier de l'Étang, who had a good singing

* Antoine Cordonnier de l'Étang (1716–92) was appointed *curé* of St Filbert en Brétigny on 5 March 1752.

† In the same fragment he writes: 'No one doubts that in obliging the clergy to be celibate, chastity has been made impossible for them.'

voice, liked to arrange little concerts in his house. On at least one occasion Grimm joined them for trios. Since Thérèse participated very little in Rousseau's social life, her excursions with him to Marcoussis brought her an unaccustomed happiness, and Rousseau recalls that she once looked so relaxed and merry after such a visit that he was inspired to write, in gratitude, a letter in verse to Cordonnier de l'Étang.[122] The result is not great poetry, but it does express forcefully Rousseau's growing distaste for everything that Paris represented. In these lines, he speaks of Paris as a town where arrogance reigns, where the worst scoundrels of France rule honest men, where the virtuous poor are objects of mockery, a town where charlatanry, pride, and insolent manners crush humble talents and where guttersnipes become statesmen. The poem goes on to urge the *abbé* to extend his hospitality to his real friends, not to flatterers, poseurs, men with small talents, or those who boast of their ancestry, or snobs or nagging women; to admit no Croesus and no *canaille*:

> *Above all none of that riffraff*
> *Who are called great gentlemen*
> *Rogues without scruples*
> *Who scoff at poor common folk ...*
> *Proudly consuming our possessions,*
> *Demanding everything, giving nothing*
> *And whose false politeness*
> *Endlessly tricks and flatters,*
> *And is only a clever trap*
> *For the fool who lets himself be duped.*

The poem ends with a catalogue of all the virtues which Rousseau admires in the *abbé*: a man who has wit without malice, who is upright but not austere; simple, generous, good-humoured, learned without showing off his learning, measured in his words; a temperate fun-loving man who knows how to entertain his guests and command the love of his friends.

One does not have to read between the lines of this poem to detect how strongly Rousseau had come to resent his dependence on the rich bourgeois Dupin family; it gives a clue to his motives in giving up work for them to pursue the humble trade of a music copyist. In the *Confessions*, Rousseau says he was not a very competent copyist, but in fact, having once adopted the trade, he adhered to it for the rest of his life. He charged a fair price for this work, and beyond that demanded nothing from anyone: he had no commercial instincts, and was sometimes reproached by Diderot for his lack of them. On the other hand, there was something of the artisan in Rousseau's blood; like his forebears, making watches in their Genevan workshops, he was capable of precise, reliable and honest routine industry.

The method of work he eventually devised for himself was to get up early –

at five o'clock in the summer – and settle down to his music-copying until half past seven; then he would have breakfast and afterwards work again at his copying until dinner at half past twelve. In the afternoon, he liked to visit friends or meet them in a café, or go for walks alone, and after supper he would go to bed at half past nine.[123] In his first years as a copyist, however, he had often to work continuously from morning to night.

Fortunately, his tastes became more frugal. He never smoked, and he ate more modestly. Apart from asparagus, which affected his kidneys, he had no strong dislikes, but his preference was for simple things – artichokes, peas, beans, especially broad beans, ripe fruit, cheeses, wine, of course, and 'little cakes brought from the famous *patissiers* of the Palais Royal'. He could hardly afford much more. At the age of forty he was as poor as he had ever been, and he looked it. To the fastidious Swiss eyes of Isaak Iselin, a visitor from Basle, who was introduced by Grimm to Rousseau in 1752, the sight of his thread-bare clothes and generally shabby appearance was something of a shock.[124]

His rich friends tried to help him. The one way they found they could do this was by giving him music to copy. One such friend was Mme de Créqui, and we find him writing to her, some time in 1752,[125] explaining: 'To live, I must earn forty *sous* a day.' On the basis of this he explained that she would owe him sixteen francs for the eight mornings he had worked for her. Evidently after this Mme de Créqui tried to give him more money than he asked, for he wrote[126] to her again saying: 'You force me, *Madame*, to address a refusal to you for the first time in my life. I know myself, and I have always felt that indebtedness and friendship are incompatible in my heart ... I am free; this is a form of happiness I wanted to enjoy before it is time for me to die. As for wealth, there would be no sense in my being a philosopher if I had not learned to do without it. I will earn my living and I will be a man. There is no wealth greater than that.'[127]

Years later Bernardin asked Rousseau why, after he had added so much to the pleasures of the rich, he always refused their liberality; to which Rousseau replied: 'a Duke once sent me four *louis* for about sixty-six lines of music which I had copied for him; I took what was owing to me and sent him back the rest: he spread the word that I had rejected good fortune. Besides, does one not have to respect a man to accept him as a benefactor?'[128]

In another of his letters[129] to Mme de Créqui, Rousseau expressed alarm at her suggestion that she might visit him at the Hôtel de Languedoc: 'It is doubt-less not seriously that you speak of coming to my attic: not that I doubt you are philosopher enough to do me the honour, but as you know I have not the wherewithal to receive you without embarrassment, I do not imagine you would want to make me suffer it. Besides, I must warn you that at the time you propose to come, you would still find my other guests here, and they would not fail to suspect that there was some complicity between you and me,

and if they pressed me to tell them the truth about that, I would not have the strength to hide it from them.'

The 'guests' referred to in this letter were probably Grimm and Raynal, for Rousseau had mentioned[130] an engagement with them as a reason for declining an invitation to dine with Mme de Créqui on a particular Monday. Rousseau did not entertain many other friends at home: the atmosphere of the place was no longer pleasing enough. The fact of the matter was that while Rousseau himself was determined to live in freedom and poverty, Thérèse's family had no such spartan ideals. Having fastened on to him as parasites, they were disturbed by his failure to nourish them as they desired, and they did not hide their discontent. Of Thérèse herself at this time, Rousseau has only words of appreciation: 'Her heart was that of an angel.'[131] The trouble was caused by Thérèse's family, and Rousseau was increasingly tormented by the cruel thought that he was no longer master of his own house. 'I begged; I entreated; I was angry; but it was all unavailing. The mother made me out to be an eternal grumbler, a churlish lout. With my friends, there were constant whisperings. Everything was mysterious and kept secret from me in my own home; and in order to avoid endless storms, I no longer dared to inquire what was going on. To overcome all this trouble would have required a strength I did not possess. I knew how to protest, but not how to act; they let me speak, and then carried on as before.'[132]

Rousseau's only remedy was to escape, either with Thérèse or, more often than not, without her. A favourite place of refuge was provided by Mussard at Passy, where he went for a holiday in the spring of 1752. The house was close to the Seine, on a spot now dominated by the massive urban architecture of the sixteenth *arrondissement* and known as the Square Alboni, but at that time, when Passy was a tiny village with a mineral spring as far from Paris as Hampstead was from London, Mussard could offer his guests the amenities of a handsome garden, trees, meadows and riverside walks. Moreover, like the Abbé Cordonnier de l'Étang, Mussard provided musical entertainment, and since he was much richer than the curate of Marcoussis, he could do so on a grander scale.

Mussard loved Italian music. He had travelled in Italy and knew something of the operatic repertory: grand operas such as Colombo's *Cesar in Egitto* or Porpora's *Serenata*, and *opere buffe* such as Latilla's *La finta cameriera* and *La gara per la gloria*, or Pergolesi's *Orazio* or *La serva padrona*. An enthusiasm for *opera buffa* was one bond of sympathy between Rousseau and his kinsman. A particular favourite with both of them was *La serva padrona*, which was to inspire one of Rousseau's more remarkable achievements. He tells us in the *Confessions* that after one of his conversations about the Italian opera with Mussard, he lay awake in bed at night wondering whether it would be possible to compose something in the same style for French audiences. 'In the morning,' he

writes, 'I sketched out some verses and fitted tunes to them in my head as I strolled along and took the waters.'[133] Later in the day, in a little gothic summer house in Mussard's garden, he put the words and music on paper. 'Over tea I could not help showing these arias to M. Mussard and his house-keeper ... Their encouragement so stimulated me that within six days my libretto was complete except for a few verses and all the music was there in draft.'[134] The result was *Le Devin du village*.

Although the music of this opera owes much to the inspiration of Pergolesi, the work as a whole is distinctly original; it is also recognizably, as we should nowadays say, 'Rousseauesque'. Whereas *La serva padrona* combines melodic music of delicate refinement with a drama of farcical absurdity, in *Le Devin du village* the score and libretto bespeak the same sensibility. It is a work of compelling aesthetic unity. It is not mere entertainment, but a charming pastoral drama of true love. Colette, the heroine, is a pretty little shepherdess whose sweetheart has forsaken her to pursue a lady of the manor. She appears on the scene almost broken-hearted: *'J'ai perdu mon serviteur'*, she sings, and the melancholy lyricism of the soprano voice stirs the hearts of her audience, so that their tears join hers. But she is not without hope. There is a soothsayer in the village, who is known, for a small fee, to help people with problems like hers. She finds him, pays him; and his bass voice promises she will have her sweetheart back: *'Je vous rendrai le sien'*. The soothsayer exercises his art by the simple device of making the sweetheart Colin think Colette has fallen in love with a handsome gentleman of the town. Colin is startled; he realizes who he really loves, and so we hear an aria for tenor voice: *'Adieu châteaux, grandeurs, richesses'*. In the next act, shepherd and shepherdess are reunited, and their joy is expressed in the most spirited of duos: *'À jamais Colin je t'engage'*. To hear it is to share their happiness. The stage directions provide for a graceful measure of background singing and dancing by a chorus of villagers, but the whole opera is designed to avoid the over-elaborate theatricality, which, in Rousseau's opinion, was the bane of the Paris opera.[135] His aim was to achieve sincerity through simplicity, and he succeeds; it is just this which makes this little opera at once so original and so 'Rousseauesque'. In the *Discours sur les arts et les sciences* Rousseau condemned the false values of a sophisticated culture: in *Le Devin du village* he demonstrated the aesthetic, and indeed the moral, qualities of a less sophisticated culture – close to nature, to the heart and to the purity of uncorrupted man. The ironical outcome was that the most sophisticated public in the world adored it.

As soon as he finished *Le Devin du village*, Rousseau was impatient to hear it performed. He wished he could have it staged for himself alone, as Lulli had been able to do with his *Armide*,[136] but that was impossible; his only hope was to see it put on for the public by the Paris Opéra. He was afraid that after the fiasco of his *Muses galantes* the Paris Opéra would reject out of hand another

work by him. The solution he found was to have *Le Devin du village* submitted without his name attached to it. He was lucky in having as an intermediary, Charles Duclos, who, as Royal Historian, had a certain influence everywhere. Things moved fast. On 24 June 1752, only a few weeks after the work was completed, it was given its first rehearsal at the Chaillot. Even the two musical directors, Rebel and Francoeur, were not told who had composed it. It was only when, as Rousseau charmingly expresses it, 'a general acclamation had established the merit of the work'[137] that his identity was revealed. The success of the opera was indeed prodigious: it was not only to have a signal effect on Rousseau's own fortunes, healing the wounds left by his earlier humiliations, as a musician and composer; it was to help propel music itself into a new direction. It provoked great excitement even at the first rehearsal. A piece of such charm and originality was demanded at once by M. de Cury, Intendant des Menus Plaisirs, for performance at Court. There was a quarrel, for Charles Duclos, having promised the composer to have it performed at the Paris Opéra, resisted; and the two left the Chaillot with their hands on their swords; they were separated; the Duc d'Aumont, first gentleman of the bedchamber, intervened, and Duclos had to yield to the wishes of the royal authorities. Rousseau could not pretend to be anything but delighted that his work was so much in demand. The Paris Opéra would have its opportunity later to perform *Le Devin du village*; it was agreed that the work should have its *première* before the King and the Court at Fontainebleau that autumn.

At Fontainebleau Pierre Jelyotte, the leading French tenor of his generation, the star of the Paris Opéra for twenty years, was put in charge of the production and, although decidedly old for the part, he himself assumed the role of Colin; Marie Fel, the girl who had made Grimm fall sick with love, was cast as Colette, and Cuvillier *fils*, bass, was chosen as the village soothsayer.

On the day of the dress rehearsal, the composer travelled with Marie Fel in a royal carriage to Fontainebleau to watch the proceedings. Grimm, who had overcome his passion for Mlle Fel, though not yet become the lover of Mme d'Épinay, went with them in the same carriage, as did the Abbé Raynal. Rousseau was pleased with the rehearsal and, protesting that he had no wish to interfere with Jelyotte's production, sat quietly throughout. He says in the *Confessions*: 'In spite of my assumed air of Roman serenity, I was as bashful as a schoolboy amid all those people.'[138] After his display of dignified restraint, he was startled the next day to hear an army officer in the Café du Grand-Commun describing the rehearsal and boasting of all the things he had seen the composer do and say. Rousseau says he was so upset at hearing such fantasies and false-hoods about himself, so afraid that someone would expose the officer as a liar, that he gulped down his chocolate and fled from the café: 'I found I was soaked with sweat . . . I experienced the shame and constraint of a guilty man simply because I felt what that poor wretch would have felt if he had been found out.'[139]

Rousseau's nerves were plainly on edge. Nevertheless, on the day of the performance,[140] he was determined to treat the whole thing with as much nonchalance as he could summon; he put on his shabby clothes and, hoping that an unkempt appearance would be seen as a mark of courage, arrived at the theatre at Fontainebleau in good time to take his seat before the entry of the royal party. He was placed in the stage box, exactly opposite the one where the King was due to sit with Mme de Pompadour.

When the house lights were raised, he began to feel ill at ease. 'Was I in the right place? Was I properly dressed? I answered "Yes" with the boldness of a man who has no way of going back rather than from the conviction of reason.'[141] He tried to persuade himself that he was, after all, dressed as he always dressed; his clothes were simply plain, not actually dirty or slovenly; and if he was unshaven, could not a beard be considered an ornament? He was reassured to observe nothing hostile in the curiosity of his neighbours, and only began to worry lest the opera should disappoint them. When the performance began, such fears were quickly banished; he did not notice any enthusiasm for the acting, but he could not fail to see that the audience adored the music and the singing. He was surrounded by murmurs of delight and applause: 'The growing excitement soon reached a point where it infected the entire audience, and in a phrase of Montesquieu's, "it increased its effect by its effect". In the final scene between the two young people, it reached its climax. Clapping is not allowed in the presence of the King, and this meant that everything was heard without interruption, to the advantage of the work and its author. I noticed all around me the whispering of women, who all appeared to me as beautiful as angels and who said to one another under their breath, "It's delightful; it's delicious, there's not a note that doesn't speak to the heart." The pleasure of inspiring so much emotion in so many people moved me to tears . . . I was then thrown back on myself for a moment, recalling the concert at M. de Treytorens' house in Lausanne. The memory made me feel like the Roman slave who held the crown above the head of the conqueror; but the recollection was fleeting, and I soon surrendered myself fully, and without distraction, to the pleasure of the taste of glory.'[142]

Rousseau was not mistaken about the success of the opera. Everyone, including the King and Mme de Pompadour, loved it. For Rousseau it was a double triumph: for himself as a composer, a triumph the more pleasing after the failure of *Les Muses galantes*; and equally a triumph for the Italian style, which Rousseau had now proved could be successfully imported into a French opera. Besides, this victory for Rousseau was a defeat for the man who had made himself his enemy, Rameau, the Rameau who scoffed at *Les Muses galantes* and who was later to pour scorn on Rousseau's articles on music in the *Encyclopédie*. The success of *Le Devin du village* at Fontainebleau was to have far-reaching consequences, and yet at the time Rousseau came near to spoiling it.

The King enjoyed *Le Devin du village* so hugely that he sent for the composer, and the Intendant des Menus Plaisirs, M. de Cury, who brought Rousseau the summons, intimated that he would probably be offered a pension. Rousseau was paralysed by shyness. The disease of his bladder had now reached the stage where he needed constant access to a chamber pot. Already, during the performance at the royal theatre, the impossibility of retiring to urinate had caused him much suffering; and he dreaded the prospect of having to stand wriggling foolishly amid a throng of courtiers waiting for the King to arrive. He knew that withdrawal would not be allowed and he blushed at the thought of wetting his breeches in such august surroundings. 'This infirmity,' he explains, 'was the chief reason for my keeping away from society; and it prevented me even being in a room with ladies behind closed doors.'[143] Then again, Rousseau was terrified lest his bashfulness should overcome him when the King spoke to him. Ought he to prepare a ceremonial speech and memorize it? If he did, would the set speech prove to be a suitable reply to what the King said? And might he not completely forget the speech when the time came to pronounce it? 'What would become of me if, in the presence of the whole Court, I should let slip one of my usual silly remarks?'[144]

As he lay awake through the night, turning such thoughts over in his mind, he began to find more substantial reasons for disobeying the King's command, moral reasons, reasons dictated by his conscience as a 'reformed man'. To accept a royal pension would mean accepting the obligations that such a pension entailed. Could he both take a pension from the King and keep his integrity as an independent and disinterested soul? The answer was no: for if he accepted, he would have either to flatter the giver or remain silent, and in any case bid adieu to freedom, truth and courage.

After reflecting thus, he decided to leave Fontainebleau early next morning without obeying the King's summons. He told Grimm his real motives; to everyone else, he pretended that he had been taken ill and was compelled to hurry back to Paris. 'My departure caused some stir, and general disapproval,' he recalled;[145] and indeed the next day[146] the producer of the opera Jelyotte wrote to him from Fontainebleau reproachfully: 'You were wrong, Monsieur, to have left in the midst of your triumphs. You would have enjoyed the greatest success that has ever been witnessed in this place. The whole Court is enchanted with your work. The King, who, as you know, does not like music, sings your airs all day with the worst voice in the Kingdom, and he has asked for a second performance of your opera within a week.'

Back in Paris, Rousseau met Diderot, who showered further reproaches on him for letting slip the chance of a pension: 'he spoke to me with a fervour I would not have expected from a philosopher on such a subject . . .

He said that while I might very well be disinterested on my account, I had no right to be so on behalf of Mme Levasseur and her daughter; he said I owed it to them not to neglect any honest means of earning a living.'[147]

Sitting together in a cab outside Mme d'Épinay's house, Rousseau and Diderot had their first real quarrel, Rousseau defending his decision to refuse the pension and Diderot accusing him of irresponsibility. Other quarrels came later, and they usually followed the same pattern, each thinking he knew better than the other where duty lay. After their first argument, Rousseau urged Diderot to go with him to supper with Mme d'Épinay, but at that time Diderot had a low opinion of her and, assuming a disapproving air, refused; a few years later, however, Diderot became one of her most intimate friends.

Rousseau reported his decision to refuse the pension in a letter he wrote to the radical Genevan exile Lenieps on 22 October 1752:[148] 'The little opera I had just finished when you left [Paris for Lyons in June] is being performed now at Court. The success is prodigious and it astonished me. I went to Fontainebleau for the first performance. The next day they wanted to present me to the King, but I have returned to music-copying. My obscurity pleases me too much for me to wish to emerge from it, even if I were free from those physical infirmities which make seclusion necessary.'

In the same letter Rousseau asked Lenieps if there were any music lovers in Lyons who would like to buy copies of La serva padrona at a price to be fixed between six and nine francs. It seems that this venture of Rousseau's into music publishing had not been especially profitable, for in a contract he made in January 1753 with the bookseller Pissot, granting him the rights to publish Le Devin du village, he surrendered to him the remaining copies of La serva padrona. Rousseau was determined to enjoy his independence, however spartan. Drafting a letter to an unnamed correspondent,[149] Rousseau described himself as 'ill and lazy and free', adding: 'Today I do not give a damn for any of the people of the Court; today all the kings of the world, with all their arrogance and their titles and their gold put together, would not make me move one step.'

If Rousseau had thus turned his back on kings, he had not yet turned his back on the theatre. He followed up the success of his opera by offering the Comédie Française the play he had brought with him to Paris some years before, Narcisse, and on 18 December 1752 it was given its first performance. Unfortunately, the second performance on 20 December was also the last. Rousseau's resounding success as an operatic composer was not repeated as a dramatist.

The text of Narcisse had been lingering among his possessions for a good many years. In the preface to the published version of the play he speaks of it as having been written 'at the age of eighteen',[150] but in the Confessions he admits that he distorted the date 'by several years',[151] having actually written it while

he was living at Chambéry, when he was between twenty and twenty-eight. The play may well have been inspired by Voltaire's *Indiscret* (1725) and Marivaux's *Petit Maître corrigé* (1736), both of which are stylish comedies of manners with narcissistic heroes or 'anti-heroes'; and, as we have noticed, Marivaux himself did Rousseau the kindness of reading the script and touching up the dialogue here and there. The Théâtre des Italiens, having first accepted the play, then kept it for years without using it.

Narcisse was performed at the Comédie Française as a result of the efforts of the actor Lanoue,* who was later to pay Rousseau the added compliment of writing a play entitled *La Coquette corrigée*, which is manifestly based on *Narcisse*, with the minor difference that it has a narcissistic heroine instead of a narcissistic hero. Lanoue, notoriously ugly, wisely entrusted the part of Rousseau's handsome and foppish Valère to another and better-looking actor, Bellecour.

Just as he had asked Duclos to keep his name a secret in recommending *Le Devin du village* to the Paris Opéra, Rousseau persuaded Lanoue to make sure that his identity as the author of *Narcisse* was not revealed to anyone. However, Rousseau himself, in a letter to Mussard dated 17 December 1752, wrote: 'I am breaking a promise, Monsieur, in telling you that on Monday there will be the first and probably the only performance of my *Narcisse*. If you really absolutely desire to see it, I would advise you to come tomorrow; but if you are as indifferent to its fate as I am myself, then do not come. All I beg of you is to keep the secret, however people may try and drag it out of you. Messieurs de Gauffecourt, d'Holbach, Grimm, Lanoue and yourself are the only ones who know the author's identity; others have suspicions, but their suspicions must not be confirmed.'[152]

The performance of *Narcisse* at the Comédie Française was politely, if not enthusiastically, received. Rousseau says he was only surprised at the indulgence of the public in watching it from beginning to end and even demanding a second performance, while he himself found it so boring that he left before the end. He hurried from the theatre to the Café de Procope, where he proclaimed aloud that *Narcisse* was a bad play and that he was the author of it. 'This public confession,' he recalls, 'was much admired, without being painful to make.'[153] Yet despite such beating of the breast, Rousseau hurried to his publisher and arranged to have *Narcisse* put quickly into print.† Two editions of the play came out within a year, so that in the end *Narcisse* proved to be a minor financial asset, if not the money-spinner which the young author had believed it to be when he first took it in his baggage to Paris.[154] In keeping

* Joseph-Baptiste Sauvé (1701–61), known as Lanoue or La Noue, was a playwright as well as an actor. As a champion of actors' interests he had more than one brush with the authorities.

† On 11 January 1753 he obtained from the Censor the necessary permission to publish the play in book form.

with his new attitude of indifference to material considerations, Rousseau promptly gave away the money it earned him.

For the opening performance of *Narcisse* at the Comédie Française, the author's royalties were 74 *livres*, and for the second, 82 *livres*; Rousseau made a present of the lot to the actor Lanoue, urging him to spend it on 'the several small repairs which the theatre needs', adding 'I should like to see among other things some cloth or leather attached to the door of the stalls to protect the people who sit there from the cold'.[155]

At about the same time,[156] Rousseau received from the bookseller Pissot 240 *livres*, the first instalment of the 592 *livres*[157] he was to be paid for the rights of *Le Devin du village* and the unsold copies of *La serva padrona*. This time he sent the entire advance to Mme de Warens, whose circumstances at Chambéry he knew to be worse than ever. In a letter[158] he told her: 'You will find enclosed, my dear *maman*, a bill of exchange for 240 *livres*. My heart is afflicted both by the smallness of the sum and by the need you have of it. Try to use it for your most pressing needs, something more easily done where you are than it would be in Paris, where everything, especially fuel and bread, is horribly expensive.' He goes on to warn her that her 'son' is advancing with swift strides towards his last resting place: 'My illness has got so much worse this winter that I can no longer expect to see another one. I go to the grave with the sole regret that I leave you unhappy.'

On a more cheerful note, the letter conveys the news that *Le Devin du village* is to have its Paris *première* at the Opéra on the first of March, and will be mounted again in the presence of the King at the *château* of Bellevue, with Mme de Pompadour as one of the principals. Rousseau says he is looking forward to attending the Paris performance, but will certainly not go to Bellevue to hear his opera performed by lords and ladies of the Court, who are sure to sing it badly; nor does he wish to give the impression of seeking a further occasion of being presented to the King. 'For all this glory,' he adds, 'I continue to live by my trade as a copyist, which gives me independence and which would make me happy, if only I could find any happiness without your having it too . . .'

Despite his ungracious words about the bad voices singing his opera at Bellevue, Rousseau sent a copy of *Le Devin du village* to Mme de Pompadour inscribed 'by her humble servant' and later received from her a present of fifty *louis* after she had sung the role of Colin. According to a footnote (not in Rousseau's hand) to a draft letter[159] of thanks to Mme de Pompadour, his first impulse was to refuse the gift, but he yielded to the pressure of Gauffecourt to accept it.

Despite a 'violently sore throat',[160] Rousseau attended the dress rehearsal of *Le Devin du village* at the Paris Opéra on 28 February 1753 and on the next day witnessed its triumphant success. The production was even more elaborate

than was that at Fontainebleau: the overture and the *divertissements* which Rousseau had composed were included in it, whereas at Court, work by other hands than Rousseau's had been introduced to fill out the entertainment. In the published version of *Le Devin du village*, which Rousseau dedicated gratefully to Charles Duclos in recognition of his having first secured its performance, he printed the work as he had created it, not as the producer had improved it. In the preface he proclaims, with a certain arrogance: 'as I wrote this piece for my own amusement only, its real success is to please me.'[161] In the event it pleased others as well, and remained in the repertory of the Paris Opéra for many years. Louis XV remained one of its most eager admirers, despite his reputed indifference to music, and went on singing Rousseau's airs.[162] Nevertheless, according to gossip, the King was offended by Rousseau's refusal to receive his congratulations. 'When the King was told of Rousseau's insolent remark about his opera being written only to please himself, his Majesty said "And what if it pleases me to send the gentleman Rousseau to the prison of Bien-être?" – "And to have him flogged there?" asked Monsieur le Comte de Clermont.'[163]

One mark of Rousseau's fame was that the gossip-writers found it worth while to record even the most trivial tales about him. For example, in July 1753, an anonymous chronicler[164] recorded that the Comte de Bissy, a military man with literary pretensions who ventured to invite Jean-Jacques to dine with him, had received the reply that 'if the Count was eager to see him he had only to come and visit him, and if he wished to dine with him, he could take pot luck, for M. Rousseau had some excellent calves' liver, which he had already tried himself'.[165] The same chronicler later alleged that Rousseau's 'pretended contempt for riches is sheer hypocrisy. He plays at refusing the money he is offered only in order to strip fools the better. In fact because he is often ill – or says he is – there are people who go to visit him, and so as not to offend the philosopher they slip gold coins discreetly under candlesticks, or boxes or among loose papers. M. Rousseau takes good care to recover the money.'[166]

In such rumours one may fairly suspect one element of truth: that Thérèse and her mother were putting their hands on any presents that Rousseau himself refused, thwarting his own endeavours to avoid the onset of wealth by giving everything away. In any case, wealth was more easily eluded than publicity. Rousseau said he desired 'obscurity', but what he really wanted was to have publicity for his ideas and his writings, not publicity for himself: if he had to be seen, he hoped to be seen as he was, not to be distorted, falsified and misrepresented by malicious journalists and gossipmongers. This hope was doomed to disappointment, both throughout his life and afterwards.

THE PHILOSOPHER
OF MUSIC AND LANGUAGE

The *Encyclopédie* was an immense success; almost everyone who wrote for it became more or less of a celebrity in Paris, so that the arrival of Rousseau on the scene coincided with that of a whole group of his friends, and his own fame as a scourge of the arts and sciences in his first *Discours* was matched by his fame as an exponent of the arts and sciences in the volumes edited by Diderot and d'Alembert. The intellectual, or *philosophe*, as a type of person suddenly became fashionable. Voltaire, who was himself the model on which that type was based, observed in an article he wrote for the *Encyclopédie*[1] that whereas in the early eighteenth century 'men of letters were not admitted into polite society, they have now become a necessary part of it'. The salons of the past had been inhabited exclusively by persons of birth and rank; now class no longer mattered. The *philosophes* came from diverse backgrounds:[2] Helvétius, LeRoy, Saint-Lambert and Chastellux belonged to the old nobility, Holbach to the new, Condillac and Buffon to the *noblesse de robe*, Diderot, Raynal, Marmontel, Duclos, Morellet came from various levels of the bourgeoisie, Grimm was a German baron, while d'Alembert was a foundling. All that mattered was that a man should have published something interesting and know how to talk. The *philosophe* had not only to be intelligent, he must also be amusing; Voltaire, by precept and example, had made that a duty.

Style was everything. When a fashionable hostess entertained in Paris, food and wines were generally excellent and were served with all the elegance of the age of Watteau and Fragonard. Formality was as strict as it had ever been, but went with a new ease of manner. Conversation was governed by unwritten laws of decorum and propriety, and no one was allowed to say anything embarrassing or tedious. Any subject could be talked about so long as it was discussed with wit; for nothing was sacred, except the rules of the salon. The few *philosophes* who could afford to have their own salons might encourage a measure of earnestness, as did Holbach

and, to a lesser extent, Helvétius,* but the general rule of society was that there should be bright conversation and no dull argument. Entertainment of one kind was offered in return for entertainment of another; and in general the *philosophes* did not disappoint their admirers. Traditional ideas – especially religious and moral ones – could still be kicked. Established institutions – especially the Church – were still strong enough to warrant mockery, and by their very harshness made themselves perfect targets for men who considered themselves, above all else, humane.

Politically the *encyclopédistes* were all critics of the *ancien régime* and they all wanted liberty, but they did not all favour the same alternative. There were at least two distinct and conflicting currents of political opinion among them: the liberalism of Locke and Montesquieu, whose votaries wanted to reform France on the English model of parliamentary monarchy and secure the rights of estates and individuals, and the school of Bacon and Voltaire, which combined belief in freedom with a programme of enlightened despotism, which meant adapting the absolutist institutions of the Bourbon monarchy to inaugurate a planned society ruled by experts. Enlightened despotism found its most vigorous and extreme exponent in Holbach, and was indeed the political programme that seemed to follow logically from the central idea of the *Encyclopédie* that science could save society if only it were given the power to do so. Not surprisingly, this became the more dominant of the two schools of Enlightenment political thought, and even Diderot moved in his opinions from Montesquieu towards Holbach. Rousseau stood apart from both, striving to create his own system of political philosophy.

Historians may say that in becoming more 'extreme' the *philosophes* were carrying France closer to revolution, but the régime of the time had no such perception. The Bourbon government did not much care for Montesquieu, who seemed to represent the claim of the nobility to recover the rights which the absolutist monarchy had stripped from that estate; on the other hand, the Baconian idea of an enlightened despotism was not especially unpleasing to a government which knew itself to be a despotism and believed itself to be already enlightened. The *Encyclopédie* was received with a certain relish at Versailles. Of course, the Church was being attacked remorselessly and relentlessly by the *philosophes*, and the government had a formal duty to protect the Church. It discharged that duty with ill-concealed half-heartedness. The Bourbon monarchy had used the Church in the seventeenth century to subdue the nobility; by the eighteenth century, the Church had served its purpose and was ripe to be subdued in its turn. If the *philosophes* could hardly enable the government to suppress the Church, they offered it the opportunity of witnessing its humiliation. Hence, the *philosophes* were seldom persecuted by

* Mme Helvétius imposed her own *mondain* standards and was less willing than Mme d'Holbach to have her house turned into a scientific academy.

the *ancien régime*, and although Voltaire, Diderot and Marmontel were each imprisoned for a time, their conditions were made comfortable, and when Rousseau's turn came to be driven into exile, the Paris *parlement*, not the Versailles government, was responsible. Indeed, most of the contributors to the *Encyclopédie* were swiftly assimilated into the State, gaining places in the academies and other official institutions which permitted them to dominate the cultural life of France between the 1750s and the Revolution.

It must be said that neither Diderot nor d'Alembert was a typically Voltairian *philosophe*. D'Alembert was a marvellous conversationalist, raconteur and mimic, but he was frank and uncompromising and honest to a degree that polite society could find embarrassing. He was also aloof and reserved, and without any personal ambition. He had made his name as a scientist years before the *Encyclopédie* was launched, and it was largely to the efforts of his sponsor, Mme du Deffand, that he owed his election to the Academy and other official honours. He was also notoriously lacking in elegance; a thin, small man – it is said that when his father discovered him at the orphanage, he described him as having 'a head as tiny as an apple and fingers like needles'[3] – d'Alembert never reached normal size. He was rather ugly, badly dressed, and had a voice so high-pitched that he was generally supposed to be either a eunuch or a pederast. He had clearly no taste for gallantry; his heart was dedicated rather to friendship, and he was intensely loyal to a very few women: to his old foster-mother, to Mme du Deffand, who set him up in society and on whom he lavished his attention when she went blind and all her other friends forsook her, and finally, to the jealous dismay of Mme du Deffand, to Julie de Lespinasse, an illegitimate child like himself and another of Mme du Deffand's protégées, a plain, penniless woman who became with d'Alembert's support the most brilliant hostess in Paris.

Diderot was more open, more companionable, more relaxed and easy-going than d'Alembert, but he was equally free from personal ambition. Although he was in time to become a Court philosopher of sorts to the Empress of Russia, he refused all offices and honours within the French system. Diderot was far too committed to the ideals of reform to accept a place within a political order which he, for all his urbanity, detested with deep moral fervour.

Rousseau's own attitude to worldly success was still somewhat equivocal. In the preface to *Narcisse* he attacks the prevailing ethos of upper-class French culture in language where distant echoes of Genevan Calvinism can perhaps be discerned. For example, we find him condemning the way the educated parents of eighteenth-century France bring up their families. Children, he writes, are taught to be agreeable, not to be good; they are given a knowledge of books instead of an understanding of duty. As a result, the cultivated tastes of modern man have softened him; useless knowledge has become the mark of breeding; in general, education has undermined social ties and made all other

attachments insipid: 'Family and country have become words devoid of sense; one is not a parent, a citizen or a man, one is a philosopher.'[4] Rousseau goes on to protest that modern literature has ceased to elevate, but at best to please, so that authors, aiming only to amuse, are corrupted in their souls.

He is no less harsh towards the fashionable economists than he is towards men of letters. Such theorists, he observes, assert that men's economic interests generate a mutual dependence and useful commerce within society, and this proposition Rousseau declares to be wholly false: economic interests, he says, divide men to a far greater extent than they unite them, and men's pursuit of interest instead of duty or virtue produces nothing other than violence, perfidy and betrayal.

Again we meet the radical Rousseau. Modern societies, he claims, are divided into two classes: the rich, educated minority, corrupted by its own culture, and the uneducated majority, depraved by misery and poverty. Rich and poor are 'all equally slaves of vice'.[5] In other parts of the same preface we meet another Rousseau, the flippant, almost cynical homme de salon. For example, he says that in recovering Narcisse from his juvenile literary activity and offering it to the world, he is equally indifferent to the public's praise as he is to its censure; he is acting only to please himself. He adds a remark particularly unfortunate in view of his domestic circumstances: 'One's first writings are like the illegitimate children one caresses with pleasure while blushing to be their father.'[6]

The preface to Narcisse is also one of the places where Rousseau seeks to defend himself against the charge of hypocrisy. He claims here that it is perfectly consistent for a man to attack the arts while practising them, and he declares his intention to go on writing books, plays and music 'while at the same time saying all the ill that I can about literature and those who cultivate it'.[7] In short, the policy that Rousseau proposed to adopt was that of a reformer of culture as distinct from what the critics of his Discours sur les arts et les sciences had taken him to be, an enemy of culture. As such he was entirely at home with the other encyclopédistes, all dedicated, in different ways, to the same end; and indeed in a portrait of Rousseau that was painted at this time we see him depicted as the perfect eighteenth-century philosophe. The portrait was by Maurice Quentin de la Tour and exhibited in Paris at the summer salon of 1753 together with portraits of d'Alembert, Duclos, La Condamine and other celebrities of the Enlightenment. La Tour was known for his attachment to the ideas of the Encyclopédie and for his love of Italian music, and since he had a country house close to that of Mussard at Passy, it is likely that he met Rousseau there. The portrait,* the earliest we have of Rousseau, presents a young, fresh, eager and by no means unhappy looking man with dark,

* Several copies of this portrait exist: the one in the museum of St Quentin is perhaps the one exhibited at the salon of 1753.

sparkling eyes and a witty half-smile. It is not really a handsome face, but it is intelligent, sensitive and pleasing. If it portrays the polished *encyclopédiste* rather than the troubled sage of later portraits, that may show us more of La Tour's conception of Rousseau than of Rousseau as he was. Rousseau himself is said to have expressed some dissatisfaction with the portrait, but only because he was shown seated on a drawing-room chair instead of a rock.[8] Diderot was more critical: 'La Tour has made his portrait of M. Rousseau a beautiful object, instead of the masterpiece he could have made it. I looked for the Censor of our literature, the Cato, the Brutus of our age ... instead I saw the composer of *Le Devin du village*, well dressed, well powdered, and ridiculously seated on a cane chair.'[9]

These words come from an essay Diderot wrote in 1765; in 1753 Rousseau *was* the composer of *Le Devin du village*; he had not yet become 'the Cato or the Brutus of the age', but was only at the beginning of the process of assuming that role – a role that was bound in the end to put him in an adversary position towards Diderot and the rest of the *philosophes*. However, a curious event in the history of French culture served to bring Rousseau closer to Diderot and the *Encyclopédie* at just this moment when his conscience was urging him away from them, and also to propel him towards greater fame at the very time when he had resolved to seek obscurity. This was the *querelle des Bouffons*, or war of the opera companies.

The *querelle des Bouffons* divided the theatre-going public of France into two excited camps, supporters of Italian opera against supporters of French opera. The *encyclopédistes* entered the fray as champions of Italian music, and Rousseau, who knew more about it than the others after all the hours he had spent in the opera houses of Venice, and who was in any case the principal contributor on musical subjects to the *Encyclopédie*, emerged as the most forceful and influential combatant. He did not start the quarrel, but he made it at once more abstract and more bitter.

The *querelle* began with the arrival in Paris in the summer of 1752 of an Italian opera company, led by Eustachio Bambini, which brought with them works of *opera buffa* (hence the name 'Bouffon') by Pergolesi, Scarlatti, Vinci, Leo, Jommelli and others. Their work aimed to entertain; it required no elaborate stage machinery and relatively few singers and a small orchestra; it was scored to light and melodic music, of which the song, or aria, was the most conspicuous feature. If the *opera seria* was a form of tragedy, the *opera buffa* was a form of comedy, as the very titles of the pieces Bambini's company performed proclaim: *Il giocatore, Il maestro di musica, La finta cameriera, La donna superba, Il medico ignorante,* and – most popular of all – *La serva padrona,* with which the company opened their season in Paris.

They had been there before with indifferent success, but this time the ground was prepared for their visit. In February 1752 Grimm produced a

fanfare for the new Italian opera, coupled with an attack on old-fashioned French opera, in the form of a pamphlet entitled *Lettre sur 'Omphale'*,[10] *'Omphale'* being the title of an opera by Destouches which had just been performed in Paris. Among other things, Grimm complained that the French composer's music had no connection with the text of the libretto, that the singing failed to express the sentiments of the protagonists and that the composition was altogether two complicated. He compared Destouches unfavourably with the Italian operatic composers, saying that their music was 'European' while his was only 'national'.

Grimm's attack on French music was nevertheless a discreet one. Destouches had died the previous year at the age of seventy-five, so that Grimm could safely abuse him without offending any living composer. Indeed Grimm combined his condemnation of Destouches with lavish praise for the foremost living French composer, Rameau, and there is no doubt that Grimm's admiration for Rameau was sincere. Even so, such an attack by a German journalist on a French cultural institution was unlikely to pass unanswered, and in March there appeared in print a reply entitled *Remarques au sujet de la lettre de M. Grimm sur 'Omphale'*.[11] It was at this point that Rousseau entered the controversy with an essay in support of Grimm: *Lettre à M. Grimm au sujet des remarques ajoutés à sa lettre sur 'Omphale'*,[12] which is both more eloquent and more forceful than Grimm's original piece. Rousseau draws on material he had prepared for the *Encyclopédie* to illustrate the merits of Italian opera, and he attacks French music without equivocation; he says, for example, of the *recitativo* of French opera that it is 'a sort of chant mixed with cries', obscuring all distinctions of feeling which music might be supposed to express.

These pamphlets all helped to make the arrival of Bambini's opera company the occasion for general excitement; one half of Paris was entirely won over to the *opera buffa*, while the other half remained passionately loyal to the national *théâtre lyrique*. At the Paris Opéra, the leading supporters of Italian music assembled near the Queen's box and became known as the *coin de la reine*, while defenders of French music rallied near the King's box and became the *coin du roi*. From each corner there emerged a stream of articles and pamphlets. The pen of Holbach[13] produced a *Lettre à une dame . . . sur l'état present de l'opéra*[14] which pretends to deplore the introduction of comedy into the opera and suggests that the French musicians are ruining the new music by playing it badly. Grimm then produced one of the more memorable documents of the *querelle*, his *Petit Prophète de Boehmischbroda*,[15] which puts the message across in the form of a parable about a Bohemian boy being sent to Paris to see the lamentable state into which the French opera has descended. The young hero learns that the French, once a chosen people of music, have lost the art; even Rameau has been unable to restore it. However, Providence sends a saviour

(Pergolesi) to rescue French music by his example, and a warning voice adds that, if this saviour is ignored, French opera will be annihilated.

Grimm was not the world's most perspicuous stylist, but a dozen patriotic Frenchmen were stirred by his parable to defend their music. One of them – probably Mairobert de Pidansat[16] – produced a tolerably amusing parody of Grimm's effort called Les Prophéties du grand prophète Monet,[17] together with a well-argued essay[18] defending the French opera as something solid and substantial, with the ability to communicate profound human passions, and attacking the Italian opera as all froth and air; the author compared Lulli's Armide with Rinaldo di Capua's La donna superba to demonstrate his argument.

Diderot intervened at this point. With considerable cunning he posed as an impartial arbitrator seeking to end the quarrel while in fact he was entirely partial to the Italian side, stressing all the features which put French music in a disadvantageous light.[19] In September 1753, Rousseau rushed into print once again with a Lettre à un symphoniste,[20] in which he singled out the musicians of the Paris Opéra for attack. The Italian company had just had its one failure with Il paratojo (based on a work by Jommelli), and Rousseau protested that the failure was entirely due to the bad playing of the orchestra.

Diderot, Rousseau, Grimm, Holbach – and in time d'Alembert joined them as a pamphleteer – all the celebrated names appear on the Italian side;* against them were Pidansat, Blainville, Fréron, Jourdain, Cazotte, Castel and other forgotten men. Admittedly, the champions of Italian opera were known as philosophers, not as artists, as one supporter of the coin du roi pointed out:

> Are men of science fit arbiters of artistic pleasure?
> Must we defer to them on what concerns artistic taste?[22]

It was a fair question, but the truth of the matter is that the querelle was as much ideological as it was artistic. This the encyclopédistes realized in making the cause of the Italian opera their own particular cause. The French opera was not simply national, it was traditional, authoritarian, academic. Its intellectual complexity has much in common with Descartes's philosophy of mathematical elaboration and rational order; its pomp expressed the self-esteem of the French kingdom. Moreover, the libretti of French operas proclaimed the same cartesian principles of order and the same Bourbon myth of gloire, the splendour of earthly princes being represented on the stage in the image of gods. Superior beings were impersonated by the actors and celebrated in music which appealed to superior minds or which evoked patriotic sentiments by the sound of trumpets and drums. French opera spoke to the ear in the same manner in which the architecture of Versailles appealed to the eye.

* Voltaire remained neutral in the querelle. Asked if he was for French or Italian music, he replied: 'Je suis pour mon plaisir.'[21]

In all these respects the Italian *opera buffa* was very different from the French. It was not imposing, it was pleasing. In place of the declamation which provided the substance of the French opera, actors delivering sonorous words against a background of music, the Italian opera introduced songs. And whereas French opera was both ceremonious and highbrow, Italian opera was tuneful and simple.* In Italian operas there was more melody and less counterpoint, more sounds of the human voice and less harmonies of the orchestra, more vitality and less intellectual construction. Its music had an unmistakably popular quality; almost anyone could sing the arias, and in Naples and Venice almost everyone did. The themes of the *opera buffa* were domestic and familiar; instead of gods and kings, ordinary people occupied the stage. The heroine of *La serva padrona* is a maidservant and the hero a bourgeois bachelor who ends by accepting the maid as his wife. One might well imagine that even the plot of Pergolesi's opera would alarm conservative circles in Paris, if such people took seriously the moral of the tale that a maid is as good as her mistress.

D'Alembert, in a pamphlet to which he gave the significant title *De la Liberté de la musique*, wrote: 'I am astonished in a century where so many authors busy themselves writing about freedom of trade, freedom of marriage, freedom of the press and freedom in art, that nobody has so far written about freedom in music ... for freedom in music implies freedom to feel, and freedom to feel implies freedom to act, and freedom to act means the ruin of states; so let us keep the French opera as it is if we wish to preserve the kingdom – and let us put a brake on singing if we do not wish to have liberty in speaking to follow soon afterwards.'[24]

The theme was taken up in a history of France by Lady Sydney Morgan: 'Paris was divided into formidable musical factions which were not without their political colour. The privileged class cried out against innovation, even in crotchets and quavers, and the noble and the rich, the women and the court clung to the monotonous discords of Lulli, Rameau and Mondonville as belonging to the ancient and established order of things; while the musical connoisseurs and amateurs, the men of talent, genius and letters were enthusiastic for nature, taste and Italian music.'[25]

Lady Sydney repeats in this passage some words that Rousseau himself employed in the *Confessions* in speaking of the *querelle des Bouffons*: 'The most powerful and most numerous party, composed of the highly placed, the rich and the ladies, supported French music; while the other, more lively, bolder, and more enthusiastic, was composed of the true connoisseurs, the people of talent and men of genius.'[26]

* As Grimm pointed out, the Italians had no vigorous dramatic theatre to hold back the development of a lyrical theatre, whereas in France the great tradition of seventeenth-century tragic poetry weighed heavily on the opera. Lulli, who did much to shape the French opera, worked in collaboration with a librettist, Quinault, a *poète manqué* of the school of Racine and Corneille, who composed his *recitativi* in Alexandrine couplets.[23]

It would be a mistake, however, to suppose that Rousseau was in the same ideological camp as those encyclopaedists who supported the Italian music because of its 'progressive' aspects; the author of the *Discours sur les arts et les sciences* could not reasonably do so. It is instructive to compare the libretto of his *Devin du village* with that of Pergolesi's *La serva padrona*. As we have seen, Rousseau's opera depicts a shepherdess who is distressed because her sweetheart has gone off with an aristocratic lady. In the end, true love prevails, and shepherd and shepherdess are happily and properly united – a very different tale from that of Pergolesi's opera, where the servant is shown to be the right bride for the master. *La serva padrona*'s message is egalitarian; in Rousseau's opera, the argument is that people can best find love among their own kind, and that it is a mistake to try to trespass across the barriers of class.

It is hardly astonishing that *Le Devin du village* should appeal to Louis XV and to Mme de Pompadour; for however 'liberal' the musical score, the story in the libretto is plainly conservative. And although the champions of French music gathered in 'the King's corner', the fact of the matter was that the King did not often appreciate anybody's music, and Mme de Pompadour had a certain dislike of Rameau, whereas there was something in Rousseau's simple arias which appealed to both of them. So while the King and his mistress were duty-bound to protect French opera against the Italian innovators, they could hardly conceal the fact that privately they enjoyed Rousseau's music more than that of the French composers.

Rousseau's situation was no less paradoxical. He was thrilled to have given pleasure to the King and his entourage, but he was a republican; he could not approve of kings, and he had no intention of becoming a Court musician. Having renounced the idea of making his fortune under bourgeois patronage he did not feel he could decently enjoy success as a royal protégé. To this extent he was entirely consistent. What he did next was less so. He took over the leadership of the Italian party in the *querelle des Bouffons* and transformed it from a journalistic dispute about taste into a serious argument about aesthetics and even metaphysics, but in doing so he assumed a strangely contradictory posture, that of a reformer of French music who demonstrated at length that French music could not possibly be reformed.

In one respect, however, Rousseau was more logical than the other encyclopaedists. They had all condemned the French opera while praising the leading living French operatic composer, Rameau. Rousseau decided to deal squarely with Rameau, and long after the *querelle des Bouffons* had ended, the controversy between them continued. Rousseau had no reason to like Rameau personally; he had not forgiven the humiliation inflicted on him by Rameau when *Les Muses galantes* was rehearsed for M. de la Poplinière. On the other hand, Rousseau respected Rameau's achievement, and he could not fail to recognize his merits. Rameau, in any argument about music, was bound to be

a formidable adversary. Disagreeable, boorish and far from universally popular as a person, his genius was acknowledged by everyone. As a composer, Rameau's success was prodigious and unmatched; he had had as many as six operas performed in Paris within a period of twelve months between 1748 and 1749, a triumph halted only because Mme de Pompadour, who disliked his manners, contrived to have productions of his operas limited to two a year. Moreover, Rameau was a theorist of music as well as a musician; his writings on harmony and other technical aspects of music placed him at the head of his profession in Europe; he was considered the most accomplished, the most proficient musicologist of his time. Rousseau himself had over the years made a number of deferential references to Rameau's work, as well he might, since it was Rameau's books that he had used when he was trying to teach himself the rudiments of composition. Respect, however, was not reciprocated. Rameau regarded Rousseau as a mountebank, a fraud, and an ignoramus in matters of music; and Rameau, being the man he was, said so.

Considered as protagonists in a dispute about music, Rousseau and Rameau must appear very unevenly matched; on the one side a universally revered composer and musicologist, over seventy years old, on the other a self-taught amateur and newcomer to the scene. But the truth of the matter is that, in changing the dispute about music into a debate about philosophy, Rousseau moved it to a level where he could prove himself at least Rameau's equal.

The other encyclopédistes had hesitated to criticize Rameau because they regarded him as being one of their kind. He was an intellectual in music, and moreover he had been in his time a progressive force in French opera. He had broken away to a considerable extent from the sombre formalism of Lulli and the seventeenth-century theatre; he had added ballets and divertissements to the entertainment, and brought almost as many shepherds and shepherdesses as gods and princes into his dramatis personae. He also proved himself capable of composing an amusing opera buffa in the Italian style as a form of relaxation from more serious work.

There are good grounds for thinking that Diderot asked Rameau to write the articles on music for the Encyclopédie before he offered the commission to Rousseau,[27] while d'Alembert's enthusiasm for Rameau was such that in 1752, the year the querelle des Bouffons began, he brought out a book called Élémens de musique,[28] which was nothing more than a popularized version of Rameau's theories. The Encyclopédie itself contained numerous references to Rameau's ideas, all entirely respectful, whether in articles by d'Alembert, Diderot, Jaucourt, Cahusac or Rousseau himself, who was responsible for no fewer than two hundred entries.[29]

It may well be that Rousseau's original texts had contained less flattering references to Rameau, which d'Alembert, as editor, excised, but the evidence we have suggests that up until 1752 Rousseau accepted Rameau's views on

music as uncritically as did the others. Rousseau paid specific tribute to Rameau in the articles he wrote for the *Encyclopédie* on *'accompagnement'* and *'basse fondamentale'*. His entry on *'chœur'* names the French as the best chorists in Europe, and in his article on *'mélodie'* he supports Rameau's doctrine of the priority of harmony over melody. In addition to these contributions to the *Encyclopédie*, Rousseau's other early writings on music were in line with Rameau's thinking, and in one of them[30] he expressed a distinct preference for the French *tragédie lyrique* over Italian *opera seria*, suggesting that while Italian music gave more delight, French music did more to stir the emotions.

By the year 1753, however, Rousseau had come to think very differently on all these questions, and in his most substantial contribution to the *querelle des Bouffons* – a ninety-two-page monograph entitled *Lettre sur la musique française* – he carried the doctrine of the *coin de la reine* on the superiority of the Italian opera over the French to the point of denying any merit whatever to French music. In the process of doing so he adumbrated a theory of music, which he was later to develop in greater detail, refuting that of Rameau on its most crucial points. Rousseau built this argument around a philosophy of language which seems to have emerged from his reflections on the nature of human society rather than the technicalities of music.* Rameau, realizing that the most cherished principles of his philosophy were being called into question, broke his silence and prepared a rejoinder – the first of several – to Rousseau's criticisms.

Rameau's reply was neither the first nor the only one which Rousseau's *Lettre sur la musique française* provoked; indeed that monograph brought upon the author a storm of abuse which, considering the extreme views he had expressed, is really not altogether surprising. People began to hate him.

Rousseau as a reformer of French music, Rousseau as the composer of *Le Devin du village*, demonstrating the possibility of producing a French opera in the Italian style, could hope to persuade at least a part of the public. But Rousseau the author of the *Lettre sur la musique française*, denying all possibility of improving or redeeming French music even with the help of Italian innovations, could not reasonably expect to be popular in France. Besides, Rousseau did not choose to put his message over, like Grimm and Holbach, in the veiled forms of parable or satire; he wrote with all the fierce, direct, unequivocal eloquence of which, as a stylist, he was such a master.

In his *Lettre sur la musique française* he introduces a theory of music which challenged Rameau's on almost every fundamental point without, at this stage, any ungracious words about Rameau himself. He begins by arguing that every nation has its own music, and that the national music derives from the national language.[32] The Italians have a musical language, in the sense that

* Wokler makes the point that Rousseau did not decry the faults of French music in any general way until he had first established the deficiencies of the French language.[31]

the sounds of its words are soft and mellifluous, the modulations exact and sonorous, and the accents clear; Italian has 'all the qualities most appropriate to song'.[33] The French language, on the other hand, he suggests, is harsh, guttural and monotonous, full of nasal consonants and lacking sonorous vowels; so that French has none of the qualities necessary for song. In the scientific spirit of the *Encyclopédie* Rousseau recommends the experiment of taking an Italian air and a French air, and stripping each of its ornaments and external cadences; 'the difference,' he claims, 'will soon declare itself'.[34] In the case of the Italian air, the melody will remain intact, whereas in the case of the French, the whole thing will vanish with the decoration. 'You need to be a Fel or a Jelyotte,' he adds, naming the stars of the French opera, 'to sing a French song, but anyone can sing an Italian song.'[35]

Rousseau seeks next to explain how the French, possessing a totally unmusical language, come to have any music at all. What has happened is that the composers, for want of melody, have turned to harmony: 'In the absence of real beauties they have provided fictitious "style" . . . in place of good music, they have invented a scholarly music; to make up for the lack of song, they have multiplied accompaniments . . . to disguise the insipidity of their work they have increased the confusion. They believe they are making music; but they are only making noise.'[36]

Harmony, in short, is condemned by Rousseau as a 'gothic' invention of cerebral composers, trying to construct music out of material from which music cannot be made, namely the French language. He admits that harmony may have some virtue as accompaniment, but only in so far as it serves 'to fortify the expression of the subject'.[37] He sees in the history of music an example of the process he had depicted in the *Discours sur les arts et les sciences*, of an art getting worse as it becomes more 'advanced'. With new instruments and bigger orchestras, with different instruments playing different tunes at the same time, modern composers, he says, have lost touch with 'the essential rule, which is the unity of melody'.[38] He adds: 'The more music improves itself in appearance, the more it spoils itself in reality.'[39] Rousseau admits that even Italian music itself had once been distorted by sophisticated innovations, but fortunately 'it has since been purified'.[40]

At the end of his *Lettre sur la musique française* Rousseau writes: 'I believe I have shown that there is neither measure nor melody in French music, because the French language does not permit it; that French song is only a continual clamour unendurable to any ear unprepared for it, that its harmony is crude and unexpressive and proclaims only a scholar's padding; that French arias are not arias, that French recitative is not recitative, that the French have no music and cannot have any; and that if they ever do, it will be so much the worse for them.'[41]

Harsh words, and naturally they gave offence. In his newsletter, Grimm

reported that Rousseau's *Lettre sur la musique française* had created as much stir in Paris as had his own *Le Petit Prophète* twelve months before. Rousseau's pamphlet actually created much more of a stir; and Grimm, unable altogether to dissimulate a certain jealousy, criticized Rousseau's monograph as too aggressive: 'The French will forgive anything if it is amusing, but the Citizen of Geneva reasons earnestly, and with great hatchet blows overthrows all the altars that have been solemnly erected to the genius of French music.'[42]

All the agitation provoked by earlier pamphleteering in the *querelle* now became centred on Rousseau himself. His *Confessions* contains a passage which has puzzled many readers: 'In 1753 the *parlement* had just been exiled by the King; unrest was at its height; all the signs pointed to an early uprising. My *Lettre sur la musique française* appeared, and all other quarrels were immediately forgotten. No one thought of anything but the danger to French music, and the only uprising that took place was against me. The battle was so fierce that the nation was never to recover from it ... If I say that my writings may have averted a political revolution in France, people will think me mad; nevertheless it is a very real truth.'[43]

It is ironical that the philosopher most often named as being responsible for the French Revolution should have seen himself as a man who prevented a revolution taking place,[44] but there is no reason to think him mad for making the claim. The attempt of the King in November 1753 to dissolve the great chamber of the Paris *parlement* and replace it with a Royal Chamber met with such fierce resistance among the magistrates that the capital appeared to responsible observers[45] to be on the brink of a rebellion.

It was not a rebellion to command the sympathy of the *encyclopédistes* in general or Rousseau in particular. The French *parlements* were judiciary bodies (not to be confused with a parliament of the English kind to which the nearest French equivalent was the Estates-General, which had not been allowed to meet since 1614); the magistrates were often Jansenists, taking their religion with dour seriousness and more eager than the King to enforce the censorship. No *encyclopédiste* would regard the defence of the magistrates' privileges as the defence of liberty; and Rousseau, soon to suffer at the hands of the Paris *parlements*, had never any reason to sympathize with their cause.

But is it conceivable that a musical dispute could have diverted aggression that would otherwise have gone into a political revolt? Others beside Rousseau believed it. Mercier, in his *Tableau de Paris*, writes: 'Ah, how the government ought to cherish the opera! The theatrical factions made all the other factions disappear.'[46] Even Grimm reported in his *Correspondence littéraire* that the public was 'much more interested in the quarrel provoked by Rousseau's *Lettre* than in the Royal Chamber and its affairs'.[47] Cultural questions were taken seriously in mid-eighteenth-century Paris, and Rousseau's attack on French music put many people into a frenzy of anger. He claims in the

Confessions that the orchestra at the Paris Opéra actually plotted 'to have me assassinated as I left the building',[48] and although this is probably sheer fantasy it is a well-attested fact that the musicians at the Opéra burned him in effigy and that the Mayor of Paris withdrew the free pass to which he was entitled as a composer. There is evidence also that so many complaints about Rousseau were made to the Comte d'Argenson, the minister responsible for the theatres, that an order was drawn up to have Rousseau expelled from France; the order was revoked, probably as a result of the intervention either by d'Argenson's son, the Marquis de Voyer, 'who loved Italian opera',[49] or by certain 'woe-begone artists'.[50] A chronicler reported on 5 December 1753 that Rousseau was deliberately jostled in the crowded pit of the opera house; 'he cried out that he was being suffocated; and on being told that that was no bad thing, he left the theatre'.[51]

Despite this persecution, Rousseau refused to give up going to the opera. M. Ancelet, a friendly officer of the Mousquetaires, provided a bodyguard for him and he continued to attend even when his free pass was taken from him 'in the most shameful manner', and the municipal authorities ordered him 'publicly to be refused admission'. Rousseau refused to swallow an injustice 'that was the more scandalous since the only fee I had claimed for the performing rights of my work was a permanent free pass'.[52] Indeed, Rousseau observed that the management behaved so brutally to him that the public itself, 'then at the height of its hostility towards me, protested at such injustice being done to any author'.

Dozens of replies to the *Lettre sur la musique française* were written. Fréron, the editor of the *L'Année littéraire*, who had produced fairly measured criticisms of Rousseau's earlier writings, attacked the *Lettre sur la musique française* unmercifully. He described Rousseau as a 'Swiss missionary' who had no right to speak about '*our* Language' and '*our* music', and he went so far as to assert that the *Le Devin du village* was no more than a patchwork of tunes the composer had pillaged from Italian musicians during his 'three years in Venice'.[53] Rousseau was also mocked on the stage at the Comédie Française in a satire called *Les Adieux de goût* by Portelance and Patu, but, at least in this instance, he was put together with other *encyclopédistes* as an object of ridicule.

Some supporters of the Italian opera feared that the aggressive polemical tone of the *Lettre sur la musique française* did more harm than good to the cause. The Président de Brosses, for example, wrote to his brother saying that 'Jean-Jacques with his frenzied essay has done us a great injury, antagonizing the whole nation by the intemperate manner in which he had defended the right ideas'.[54] All such objections to Rousseau's *Lettre* were of small importance, however, compared to those of Rameau, who burst into print in the spring of 1754 with a brochure called *Observations sur notre instinct pour la musique*[55] and kept up the attack on Rousseau until his death in 1764.

There is no denying a certain grandeur in Rameau's system. Although he disagreed with Descartes's theory of music, he was very much the cartesian in his conception of the universe as a systematic whole intelligible to reason and in his belief that the principles of music were as mathematical as those of geometry or physics. The aim of music, he maintained, was not simply to please the ear, but to provide through the testimony of hearing a 'double confirmation'[56] of the harmonious structure of reality.

'When one considers the infinite relations the fine arts have to one another ... is it not logical to conclude that they are governed by one and the same principle?' he asked. 'And has one not today discovered and demonstrated that this principle is to be found in harmony?'[57]

As for melody, to which Rousseau assigned priority, Rameau saw it simply as a derivation from the harmonic structure of music. Harmony came first, and melody a long way afterwards. Harmony was not only the underlying principle of music, it was that of 'all the fine arts'.[58] Rameau argued that since harmony was more readily discernible in music than in the other arts, music could rightly claim to be the first of the arts. Indeed Rameau went so far as to assert that music was the first of all the sciences as well: 'It is to music that nature seems to have assigned the physical principles of those purely mathematical first notions on which all the sciences rest, that is to say, the harmonic, arithmetic and geometrical proportions from which all related proportions derive.'[59]

Given his belief that the universe constituted a single rational whole, Rameau would be expected to insist on the unity of all the sciences; he differed from other rationalists only in the priority he attributed to music. But once Rameau had decided that knowledge of the rules of music afforded a knowledge of the principles of reality in general, he insisted the more emphatically on the importance of his subject. Measure was the rule of all things, and music, which disclosed the principles governing physical sound, introduced the mind to a knowledge of universal truth.

This, then, was the basis of Rameau's objection to Rousseau. Rousseau, elevating melody, diminished harmony. This meant that Rousseau was denying what Rameau considered the cardinal principle of 'the mother of the arts and the sciences',[60] namely music. Rameau claimed that one could not 'deny the principle of harmony without at the same time denying those quantitative sciences which are based on the same proportions and progressions'.[61]

Rousseau built his case for the priority of melody over harmony on another conception of reality. For Rousseau, reality was not the metaphysical construction of cartesian philosophy; reality was nature itself. No less than Rameau he looked for truth in music, but he saw it in the capacity of music to become the authentic voice or expression of human experience. Again he agreed with Rameau in considering music to be superior to all the other arts:

'It is one of the great advantages of the musician to be able to depict things that we cannot hear, while it is impossible for the painter to paint things we cannot see, and it is the great genius of an art which acts only by movements, to be able to use movement even to provide the image of repose. Slumber, the calm of night, solitude, even silence are among the scenes that music can depict. Sometimes sound produces the effect of silence, sometimes silence the effect of sounds; just as a man dozes during a steady monotonous reading and then awakes, startled, when the reading ceases: and it is the same with other effects ... the art of the musician consists in substituting for the invisible image of the object that of the movements which its presence excites in the mind of the spectator ... Not only does the musician move the waves of the sea at will, fan the flames of a fire, make streams flow, rain fall and torrents rush down, he can magnify the horror of a burning desert, darken the walls of a dungeon, or he can calm a storm, soften the air and lighten the sky, and spread, with his orchestra, a fresh breeze through the woods.'[62]

Reality for Rousseau is visible palpable nature, and music, he says, can conjure up that nature. It can also, of course, express human feeling which is nature, so to speak, within us; and the expression of feeling is achieved through melody. Thus, when Rousseau and Rameau quarrelled over the priority they assigned respectively to melody and to harmony they were concerned with something more than music: their dispute was about reality itself.

Where Rameau, in his cartesian manner, demanded unity, Rousseau was content with variety; where Rameau looked for fixed rules in music as in mathematics, Rousseau claimed that music was logically different from mathematics and that musical styles must vary as nature varied. It was the genius of melody that it could express what was natural, whereas harmony was essentially artificial, an invention of the mind.

Rousseau returned to this theme again and again. Thus we find him, for example, in the article on 'mélodie' in his Dictionnaire de la musique, arguing that whereas harmony serves a subordinate purpose in holding the different parts of a musical composition together, melody provides the force and energy and the flow of music; while harmony may speak to the ear, 'melody speaks to the heart'.[63]

The controversy between Rousseau and Rameau became more embittered as it became more personal. Rameau had never hidden his contempt for Rousseau, and in his pamphlet called Erreurs sur la musique dans l'Encyclopédie he went out of his way to find mistakes that might be attributed to Rousseau. Rousseau, for his part, began to attack Rameau by name.*

* Rousseau's most detailed scrutiny and criticism of Rameau's theories is his Examen des deux principes avancés par M. Rameau, written in 1755 but not published until after Rameau's death in 1764. However, other works that Rousseau began writing at this stage, such as his Principe de la mélodie and his Essai sur l'origine des langues, form part of his reply to Rameau.[64]

'We must recognize,' he wrote,[65] 'a great talent in M. Rameau, and much ardour, a musical mind, a great knowledge of harmonic movements and all kinds of effects; plenty of skill in adapting, distorting, ornamenting, embellishing the ideas of others and making them his own; not much facility for inventing new ones; more cleverness than creativeness; more knowledge than genius; or a genius suffocated by too much knowledge; yet always strength and elegance, and very often good vocal music.'

Rousseau admits that Rameau has produced a remarkable comic opera, *Platée*, but says it is not to be compared to Italian works of *opera buffa*: 'a fat goose cannot fly like a swallow'. He commends Rameau's *recitativi* with faint praise: they are 'less natural, but more varied than those of Lulli, admirable in a very few scenes, bad in almost all the others'; as for Rameau's 'over-elaborate accompaniments', all these 'beautiful refinements of the art, all these imitations, repetitions, bass harmonies and counterpoints', are so many 'deformed monsters, monuments of bad taste which ought to be relegated to the cloister as their last resting place'. Rousseau is no more gracious about Rameau's theoretical works: 'what is most singular about them is that they have made a great reputation without being read'.[66]

Rameau was disappointed by the reception of his *Observations*. Although a certain coolness was beginning to be felt between Rousseau and the *encyclopédistes*, Diderot, d'Alembert and most of the others rallied to Rousseau's side against Rameau. They prided themselves on their cosmopolitanism and wanted to distance themselves from the chauvinism of those who defended French music just because it was French. Besides, they did not really care for Rameau's metaphysics. D'Alembert, a professional geometer, protested in his article *'Fondamentale'* in the *Encyclopédie* that it was ridiculous to confuse the rules that govern geometry with the features which give pleasure in music.[67] Diderot, in a preface to the sixth volume of the *Encyclopédie*, scoffed at the suggestion that geometry is founded on music and that all sciences must be compared to harmony: 'If these are the truths that we are accused of ignoring, neglecting and dissimulating, then we shall have the misfortune of deserving this accusation for a long time to come.'[68]

D'Alembert's attitude was particularly wounding to Rameau, after all the admiration he had previously expressed for Rameau's musicology.* Even though Rameau interpreted 'd'Alembert's treachery as a generous desire to shield Rousseau',[69] he never forgave him. Indeed, the whole controversy with Rousseau and the *encyclopédistes* supporting Rousseau cast a black shadow over Rameau's last ten years of life. Wasting his energy on pamphleteering, he

* In his *Discours préliminaire* to the first volume of the *Encyclopédie* (pp. xxxii–xxxiii), d'Alembert had written: 'M. Rameau, in carrying the practice of his art to such a high degree of perfection, has become both a model and an object of jealousy for a great many artists ... and what distinguishes him most particularly is that he has reflected so fruitfully on the theory of art.'

seemed to have little left for composition. He produced one or two ballets, a pastoral, a comic opera and even one more *tragédie lyrique*, with two *encyclopédistes*, Marmontel and Cahusac, working with him on the libretti; but nothing he wrote in this period compared in substance with his earlier two creative periods.[70] As Diderot expressed it, unkindly and somewhat unjustly (for Rameau's works continued to be very popular), Rameau had 'outlived his reputation'.[71]

Even Rameau's great patron, M. de La Poplinière, deserted him to support the *encyclopédistes* in the controversy,[72] and although that Maecenas of the arts had become a figure of ridicule in Paris because of his jealousy of his wife (even bringing in the police to uncover a secret doorway Mme de La Poplinière had installed in her boudoir to connect with her lover's house next door),[73] Rameau was deeply attached in friendship to the man who had made his career possible, and correspondingly saddened by his defection, as he saw it, to the enemy.

Despite the bad feeling on both sides, the dispute between Rousseau and Rameau was a deeply serious one; two distinct and well-considered philosophies of music confronted one another. Unfortunately, it was largely a dialogue of the deaf; Rousseau did not really recognize what was valuable in Rameau's system, nor did Rameau understand the case that Rousseau was trying to make. Rousseau, however, benefited from the experience more than did Rameau; for in developing an answer to Rameau's metaphysics, he was able to enlarge his own system in a significantly fruitful direction.

If Rameau was defeated in the controversy, can Rousseau be said to be the victor? Professor Edward Dent, historian of the opera, makes some such claim: 'The "Italians" won the "war of the Bouffons", as it was called – a war mainly of journalists as we might imagine – because their little operas were human and alive, while Rameau was an ageing man, a supreme master, but master of a dying tradition.'[74]

Rousseau, by the example of his *Le Devin du village* and his doctrine of the supremacy of melody over harmony, did much to change musical taste. Rameau's many compositions have stood the test of time; they have become classics; even so, they marked the end of a phase in musical history, while Rousseau's opera introduced a new 'moment'; it prepared the way indirectly for Mozart, whose *Bastien und Bastienne* is based on *Le Devin du village*, and directly for Gluck, who brought new life to the French opera after the death of Rameau. Gluck himself paid lavish tribute to Rousseau's teaching; he said he had tried to do what Rousseau would have done if Rousseau had devoted his life to music.[75]

Historians of music, in talking of romanticism and classicism, commonly contrast the romanticism of Weber and his successors with the classicism of Mozart, but in a more general sense of romanticism, as something to be

contrasted with rationalism, romanticism as the lyrical expression of feeling, transcending the constraints of formal categories, this quality, which comes increasingly to characterize the music of the later eighteenth century and after, dates from the success of *Le Devin du village* and the influence of Rousseau. Yet Rousseau could claim no such triumph, for in the *Lettre sur la musique française* he abandoned the role of a reformer of French music and declared that French music could not be reformed.

Logically only two courses were open to Rousseau: either to compose music to a language other than French, preferably Italian, or to give up composing music altogether. He chose the latter course.* In effect he decided to concentrate on being a philosopher. In doing so he was able to make good use of the work he had done in replying to Rameau, so that his writings on music form part of what he called – and could reasonably call – his 'system'. The idea of the decay of culture played a pivotal role in that system. In his *Discours sur les arts et les sciences* he examined the decay of knowledge, in his replies to Rameau, the decay of music; this led him to investigate the decay of language, and, with it, the decay of society. His most substantial work on the problem of language – his *Essai sur l'origine des langues* – was not published until after his death; like his writings on music, it remains the province of specialists. The dating of the *Essai* is uncertain;[77] there seem to be good reasons for believing that parts of it were written in the early 1750s and that other parts were written in the early 1760s. Some points he makes in the *Essai* contradict points made in the *Discours sur les origines de l'inégalité*, which we know he wrote in 1753–4; but taken as a whole, the *Essai* forms part of the same enterprise as that *Discours*, part of Rousseau's attempt to explain how men, naturally good, came to be, in society, corrupt.

His interest in music led to the writing of the *Essai sur l'origine des langues* because he understood music as a form of language, a medium through which heart speaks to heart. In the *Essai* he carries his conjectures about the differences between 'musical' and 'unmusical' languages to a deeper level of analysis, and emerges with a theory about the origins of the French language which is even more unflattering to the French than what is said about its unmusical qualities in the *Lettre sur la musique française*. This time he speaks of 'northern' and 'southern' languages, but it is obvious that he is thinking of French as a prime example of the former category.

Rousseau argues in the *Essai* that men first spoke to each other in order to express their passions, and that at the early stages of human society there was no distinct speech apart from song. Earliest languages, he suggests, were chanted; they were melodic and poetic rather than prosaic and practical. He

* He did, however, bring out in 1753 a slim collection of Italian songs, *Canzoni di batello*.[76] In later life Rousseau devised in collaboration with Corancez a four-act *pastorale* called *Daphnis et Cloé*, together with various short pieces of vocal music.

also claims that it was men's passions rather than their needs which prompted their first utterances, for passions would drive men towards others, whereas the necessities of life would impel each to seek his satisfaction alone. 'It is not hunger or thirst, but love, hatred, pity and anger which drew from men their first vocal utterances.'[78] Primitive men sing to one another in order to express their feelings before they come to speak to one another in order to express their thoughts. At this point in his conjectures, Rousseau develops the idea, already to be found in Bodin and Montesquieu, that different climates generate different cultures in different parts of the world. In southern climes, Rousseau suggests, men's needs were fairly adequately supplied by nature, so that they were able to preserve the 'poetic' or 'musical' character of the sounds by which they addressed one another. In the colder, unkinder climes of the North, however, needs became more oppressive and men were driven to develop their languages as instruments of communication in their efforts to organize mutual aid. Thus in the North 'the languages, unhappy daughters of necessity, betray their harsh origin ... in those places where the earth yields nothing except in response to work and the source of life appears to be more in the arm than in the heart, the first words are not "love me" but "help me".'[79] This is the reason why the languages of the North came to be dull, uncouth, articulated, shrill and monotonous, while those of the South came to be lively, sonorous, accentuated, eloquent and energetic.'[80]

Rousseau develops his argument in a manner which recalls the theme of his first *Discours*: language, like civilization, gets worse as it develops. As men's relations with each become more complicated, they cease – even in the South – to sing to one another and start to talk to one another. Instead of feelings, men begin to communicate thoughts: as they become more interdependent, they have more to say about needs and interests: 'To the extent that needs grow and relations develop, and knowledge is enlarged, language changes its character: it becomes more judicious and less passionate; it replaces feelings with concepts; it no longer speaks to the heart but to the mind. As the accentuation diminishes the articulation increases: language becomes more exact and clearer, but more droning, dull and cold.'

Even modern Italian, Rousseau claims, has lost its original purity as a language of passions. At this stage he is no longer willing to say that Italian is a musical language in itself: it simply lends itself to music because it has kept some of the melodic quality it had once possessed as a primitive 'southern' system of utterance. As for the 'northern' languages – French, English, German – they are simply systems of communication for the use of men who have messages to transmit to one another. Such languages are intellectual constructions, remote from nature. The music of northern people is the same. Their music is an artificial system, which can only be mastered by an academic study; it is 'a language for which you need to have a dictionary'.[81] Instruments

can give expression to northern music better than can the human voice; and, for the same reason, the languages of the North are better written then spoken. The human voice is rendered unnecessary by the invention of writing and the construction of musical instruments. Harmony is born of the decay of melody separated from language. Thus with progress, a northern man ceases to be a creature of nature and becomes a creature of convention. His decadence becomes evident in every field.

The argument carries Rousseau somewhat beyond the concerns of Rameau; but not beyond a question raised in his first *Discours*, and later to be explored in greater depth and detail; it carries him into the realm of politics. 'There are languages favourable to freedom, and these are sonorous, poetic, harmonious and which can be clearly heard from a distance. Ours are made for the buzz of the council chamber . . . Indeed I would say that any language which cannot be heard by the people assembled is a servile language.'[82] He says more about the decay of language: public utterance has become empty rhetoric, neither sincere nor believed to be sincere; exchanges of goods have become more important than the exchanges of thoughts, and the older cry of 'help me' has declined to 'give me money'. Society's chief concerns are mercenary. Whether Rousseau seriously considered Italy to be any less corrupt than France in this last respect is not clear. His argument about 'southern' languages being the languages of freedom could not have been confirmed by anything he had seen in Turin or Venice; so he can only be assumed to have had in mind those 'southern' languages that were spoken in the ancient world.

The former Citizen of Geneva who had once thought of himself as a 'Roman' came increasingly to seek his ideal society in the history of antiquity. His pleasure in living in the modern world of Paris diminished correspondingly. When the season of *opera buffa* ended in March 1754* and the Italian company was sent home, Rousseau was also thinking of packing his bags. He wrote to the Comte d'Argenson[84] asking him to forbid any further performances at the Paris Opéra of *Le Devin du village* and to have the score returned. His letter received no answer; even so, he reflected long afterwards that *Le Devin du village*, which took him only five or six weeks to write, brought him in fees† considerably more than he earned from *Émile*, which cost him 'twenty years of meditation and three years of writing'.[85]

* Their departure was postponed from February to please the Duchesse d'Orléans.[83]
† In all he received a hundred *louis* from the King, fifty *louis* from Mme de Pompadour, fifty *louis* (unsolicited) from the Paris Opéra, and five hundred francs from the publisher Pissot.

ON THE ORIGINS
OF INEQUALITY

In the late autumn of 1753 the Academy of Dijon announced yet another essay competition, this time on the question 'What is the origin of inequality among men, and is it authorized by Natural Law?' Rousseau responded promptly: 'if the Academy had the courage to raise such a question,' he decided, 'I would have the courage to write about it.'[1] In order to work on this new theme, he felt he must end his debate with the various critics of his first *Discours*. He had started a rejoinder to Charles Bordes' latest defence of the arts and sciences,[2] but left it unfinished; as he explained to Mme de Créqui: 'I shall have an opportunity of developing my ideas without replying to him directly.'[3]

Rousseau's second *Discours* for the Academy of Dijon was, in part, his indirect reply to Bordes and to his other critics. There is indeed a definite continuity between what Rousseau wrote on the question of progress and what he afterwards wrote on the origins of society, adding the perspective of science to that of moral philosophy. Already in his unfinished reply to Bordes there is a commitment to the service of knowledge as such: 'I have no pleasurable illusion of reforming men ... my duty is to tell men the truth, or what I believe to be the truth; it is for a voice more powerful than mine to make them love truth.'[4] He proposes to write 'as a solitary being who desires nothing and fears nothing from anyone'.[5]

As soon as he saw the announcement of the Dijon competition, Rousseau went to the country for a week to meditate 'in solitude' on what he was to say. He was not in fact entirely alone, for Thérèse and two other women went with him to take care of him and prepare his meals; but he spent the days walking by himself in the forest of Saint-Germain, and it was there, he tells us, under the trees in an unusually sunny November, that he first reflected on what the life of men must have been like before civilizations had been introduced: 'there I sought, and there I found, the image of that early time of which I had afterwards the temerity to write the history ... I dared to strip man's nature naked,

to follow the evolution of those times and things which have disfigured him; I compared man-made man with natural man, and I discovered that his supposed improvement had generated all his miseries.'[6] In short, passing from the view put forward in his other early writings about the decay of culture, Rousseau now set out to show that both nature and natural man were good. 'Out of these meditations,' he says, 'there emerged the Discourse on Inequality.'[7]

Rousseau finished the *Discours* when he got back to Paris, wandering in the Bois de Boulogne to think, then hurrying home to write down his thoughts. The subject set by the Academy of Dijon might have been expressly designed to excite Rousseau's interest. The inequality existing among men was a subject which had long obsessed him; investigating the 'origins' of a phenomenon was a method of inquiry that already attracted him, and the status of natural law was something he was eager to have clarified. The result was an essay which is remarkable both as philosophy and science. In less than a hundred pages, Rousseau outlined a theory of the evolution of the human race which prefigured the discoveries of Darwin; he propelled the study of anthropology and linguistics into new channels, and he made a seminal contribution to political and social thought. Even if his argument was seldom fully understood by his readers, it altered people's ways of thinking about themselves and about their world; it even changed their ways of feeling. Of all his books, Rousseau's *Discours sur les origines de l'inégalité* – often referred to as his second *Discours* – has perhaps been the most influential. The books of his later years – *Émile, Du Contrat social*, his *Confessions* and *La Nouvelle Héloïse* – are more 'substantial', but it is as the author of the second *Discours* that Rousseau has both been held responsible for the French Revolution* and acclaimed as the founder of modern social science.† It is the masterpiece of his early years.

He begins his inquiry by noting that there are two kinds of inequality among men. The first are natural inequalities, arising from differences in strength, intelligence, agility and so forth; the second are artificial inequalities, which derive from the conventions which govern society. Rousseau suggests that it is because of these artificial inequalities that some men are richer than others, some more honoured than others, and some obeyed by others. He takes the main problem of his discourse to be to explain the origins of such artificial inequalities, since there would be no point in asking why Nature had come to bestow its gifts unequally. He therefore sees his first duty as that of distinguishing what is properly and originally natural to man from what man has made for himself. This Rousseau thinks can only be done by going back in time to ascertain what man was like *before* civilizations were introduced. The way to learn about natural man is to rediscover original man. Although

* By Burke, Napoleon and Hegel among others.
† By Claude Lévi-Strauss among others.

Rousseau allows that men may have been related to orang-outangs,[8] he does not hold the view later taken by Darwin that man has evolved from cousins of the apes; he does suggest that man developed from a very primitive biped into the sophisticated creature of modernity, and that the evolution can be largely understood as a process of adaptation and struggle.

Rousseau does not claim to be the first to try to explain human society by referring to a pre-social 'state of nature'; he only argues that earlier thinkers, such as Hobbes and Locke, have simply not been scientific enough: 'Philosophers who have examined the foundations of society have all felt it necessary to go back to the state of nature, only none of them has actually got there . . . In the end, all of them, constantly talking about "need", "greed", "oppression", "desire" and "pride", have transposed to the state of nature concepts that they have derived from man's social state; they speak of savage man, but what they describe is civilized man.'[9]

The philosopher whom Rousseau has most in mind here is Hobbes. In Hobbes the state of nature is represented as one of war of each man against all men; human beings are depicted as aggressive, avaricious, proud, selfish and afraid; and on the basis of this picture of natural man Hobbes goes on to claim that without the moral solicitude of a civil ruler men's lives would be 'solitary, poor, nasty, brutish and short'.[10] Rousseau asserts, against Hobbes, that all the unpleasant characteristics of the human condition derive not from nature but from society; and that if we look back far enough in our search for the origins of man, we shall find a being who is, admittedly solitary, but healthy, happy, good and free.

Rousseau envisages earliest man as a being removed only to a limited extent from the life of a beast, 'an animal less powerful than some, less agile than others, but, taken as a whole, the most wonderfully organized of all'.[11] Natural man is not complicated. 'I see him feasting under an oak, drinking at the first stream, making his bed at the foot of the same tree which has furnished his meal; and thus his needs are satisfied.'[12]

In claiming that original man had a sound constitution, Rousseau contrasts the health of savages, as observed by travellers, with the diseases which afflict men in modern society, where the rich are overfed and the poor underfed, and everyone is harassed by the wants, fatigues, anxieties, excesses, passions and sorrows which civilization generates. Domesticated men, like domesticated animals, says Rousseau, become effeminate. In the state of nature, men are fit, if only because they have to be fit to survive. 'Accustomed from childhood to the inclemencies of weather, and the rigour of the seasons, to overcoming fatigue, and being forced to defend their lives and their prey while naked and unarmed against other wild beasts, or to escape from such beasts by running faster, men develop a robust and almost unvarying temperament. Children, bringing into the world the excellent constitution of their fathers, and

strengthening it by the same exercise which produced it, thus acquire all the vigour of which the human race is capable. Nature treats them precisely as the laws of Sparta treated the children of its citizens; it makes strong and robust those who are already well constituted, and it makes all the others perish.'[13]*

But while Rousseau identifies natural man to a large extent with original man and sees no great difference between the life of original man and that of a beast, he nevertheless regards man as a unique species, unique among animals, that is, in possessing freedom and a capacity for self-improvement. Both these defining characteristics of man need some explanation.

Natural man is free, for Rousseau, in three senses of the word 'freedom'. First he has free will. This is a crucial sense for Rousseau. Hobbes and most of the *encyclopédistes* were determinists, believing that man was a 'machine', albeit more complicated than any other machine in nature, but subject to the same laws of cause and effect. While it is true that Rousseau himself invokes the metaphor of a machine in describing living creatures, he stresses the fact that the 'human machine' differs from the 'animal machine' in being autonomous; among beasts, nature alone 'operates the machine'; in the case of a human being, the individual contributes to his own operations in the capacity of a free agent. 'The animal chooses and rejects by instinct; the man by an act of freedom.'[14]

This metaphysical freedom, or freedom of the will, as a defining characteristic of man as such is possessed by men in all conditions, whether of nature or of society. But there are two other forms of freedom which men had, according to Rousseau, in the state of nature; one is anarchic freedom and the other personal freedom. The anarchic freedom was, of course, absolute, since by definition the 'state of nature' is a condition where there is no government and no positive law. When Rousseau came, some years later, to write the *Contrat social*, he condemned anarchic freedom with almost the same fervour as did Hobbes; but only to exalt the idea of 'freedom under law' as an alternative to Hobbes's recipe of absolute sovereignty. In Rousseau's second *Discours*, by contrast, pre-political freedom, though absolute, is depicted as a happy enough condition precisely because original man is not seen by Rousseau, as he is seen by Hobbes, as an aggressive creature, but rather as a harmless solitary being, who, having no experience of society, has no need of political regulation.

The third form of freedom experienced by man, according to Rousseau, in a state of nature is the one to which he assigns the highest importance and value, personal freedom in the sense of having no master, no employer, no immediate superior: original man is *not* dependent on anyone else for his livelihood. Speaking of the state of nature, Rousseau puts this question: 'Is there a man

* Readers may be prompted to reflect that this was also how Rousseau treated his own children; so perhaps, in a devious way, he is pleading here for the 'naturalness' of his own alleged 'unnatural' conduct.

who is so much stronger than me, and who is moreover depraved enough, lazy enough and fierce enough to make me work for his subsistence while he sits idle? If there is, he must make up his mind not to lose sight of me for a single instant ... for fear that I should escape or kill him.'[15]

Original man is economically independent, and it is hardly surprising that Rousseau, with his own bitter memories of a lifetime of economic dependence, should emphasize this kind of personal freedom (the absence of masters or employers) which, together with anarchic freedom (the absence of civil rules and rulers), distinguishes the life of men in a state of nature.

Besides his *liberté* (in these several senses) original man, as Rousseau sees him, differed from beasts in possessing *perfectibilité*. This capacity for self-improvement was a characteristic of man which other theorists of the Enlightenment emphasized. It was indeed most emphasized by those who expounded the doctrine of progress which Rousseau had attacked in his first *Discours*. Turgot, for example, had some four years earlier given a lecture at the Sorbonne, 'The Successive Advances of the Human Mind', in which he 'contrasted man, equipped with this instinct of self-improvement and enabled to conserve in his culture each fresh advancement of mind, with the sub-human organic creatures, each generation of which is obliged to start at exactly the same place occupied by each preceding generation'.[16] However, this faculty of self-improvement in man which Turgot and the other ideologues of progress considered wholly beneficial, Rousseau saw as a faculty no less for self-destruction. Just as man's first defining characteristic, his freedom of choice, enabled him to choose either good or evil, so this second defining characteristic, his *'perfectibilité'* – which means not at all a potentiality for perfection, but simply a capacity for betterment – was equally a faculty which could be turned in the wrong direction and carry men towards the worse. This latter is what Rousseau believed had actually happened when men had reached a certain stage in their evolution; and he sets out to explain how this unhappy outcome came about.

Original men, or 'savages' as Rousseau sometimes chooses to call our forebears, as they lived in the first state of nature, were simple beings, with no language, very little capacity for thought, with few needs and, in consequence, few passions: 'since savage man desires only the things which he knows and knows only the things of which the possession is either within his power or easily obtained, then nothing ought to be so tranquil as his soul or so limited as his mind'.[17] For such an uncomplicated being, 'to will and not to will, to desire and to fear will be almost the only operations of his soul'.[18] Even the fears of such a being are limited to apprehension of known danger. A savage can fear pain but not death, because he has no concept of death; anxiety, that disease of the imagination, is unknown to him.

Conceptual thinking, Rousseau suggests, developed only with speech. Even

so, he argues against certain other theorists, some primitive kind of thinking must have preceded the birth of languages. Man in the first state of nature needed to think, but he needed no language: 'having neither houses nor huts, nor possessing property of any sort, everyone depended on chance for his lodging, and often slept only one night in any one place; males and females united fortuitously, according to encounters, opportunities and desires. They required no speech to interpret the things they had to say to each other; and they separated with the same ease.'[19]*

Here we have a denial of the view that the family is a natural society; and in a long footnote Rousseau offers a detailed criticism of Locke's suggestion that nature itself impels human males and females to unite on a more or less settled basis to feed and shelter their young. Rousseau agrees with Locke that a man may have a motive for remaining with one woman when she has a child, but he protests that Locke fails to prove that a man must remain with one woman during the nine months of her pregnancy, 'For it is not a question of knowing why a man should be attached to her after she has given birth but why he should stay with her after her conception. His appetite satisfied, the man has no longer any need of the woman, nor the woman of one particular man. The man has not the least care and perhaps not the least idea of the effects of his action. He goes off in one direction, she in another, and there is no likelihood at the end of nine months that either will have any memory of having known the other.'[21]†

The point Rousseau insists upon here is that while it is undoubtedly advantageous to the human race that there should be permanent unions between males and females, 'it does not follow that such unions are established by nature'.[23] Strangely enough, in his other writings, Rousseau himself asserts that the family *is* a natural society. Not only does he do so in the *Contrat social*, which he published several years later, but in the *Essai sur l'origine des langues*, which he started at much the same period as the second *Discours*, he says 'in the earliest time men . . . had no other society than the family'[24] and even in a later section of the *Discours sur l'inégalité* itself we find Rousseau writing: 'By the law of nature the father is master of the child for only so long as his care is necessary to him.'[25] However, in the last quotation Rousseau is doubtless referring to 'the law of nature' in the sense of that 'natural law' which governs, or ought to govern, the conduct of man, not the natural laws which are recorded by scientists. What he is plainly seeking to argue in his second *Discours* is that the family is a creation of human will and agreement and not of human instinct; and he dates the institution of the family from that period of evolution which he calls 'nascent society', and not from the original 'state of nature' in which individuals lead solitary lives.

* Voltaire called this a 'ridiculous supposition'.[20]
† Voltaire shared Locke's view that man has a social instinct.[22]

Rousseau says he will leave unsolved the problem of 'which was more necessary, previously formed society for the institution of languages, or previously invented languages for the establishment of society',[26] and he limits himself to repeating briskly what he argues at length in the *Essai sur l'origine des langues* – that men's first words were natural cries. General ideas came into men's minds with the aid of abstract words, so that the development of language itself helped to create the difficulties with which civilized man torments himself. The savage, living by instinct, has no moral problems; he has no ideas of right and wrong. In the state of nature man is good; but there is no question of his being virtuous or vicious. He is happy, free, innocent; and that is all. 'One could say that savages are not evil precisely because they do not know what it is to be good, for it is neither the improvement of understanding nor the restraints of law which prevent men from doing wrong, but the calm of their own passions and their ignorance of vice.'[27]

There is here in Rousseau the germ of idea developed more fully by his contemporary David Hume, namely the idea that all men's actions are prompted by passions and that while calm passions generate good conduct, violent passions drive men to do harm to themselves and to others. Rousseau wishes to emphasize that men's passions in the state of nature are both calm and few, and are therefore harmless, and further that it is society, to the extent that society both multiplies and intensifies men's passions, which corrupts men morally.

The savage has one sentiment or disposition which Rousseau is prompted to call 'a natural virtue' and that is compassion or pity. Rousseau suggests that this virtue can be witnessed even in animals, not only in the tenderness of mothers for their young, but in 'the reluctance of a horse to trample a living body underfoot'. He suggests that this natural sentiment of pity is the source of the most important social virtues, such as kindness, generosity, mercy and humaneness. Unfortunately, Rousseau observes, these virtues are seldom found in the modern world, because modern men have become so far removed from their own natural feelings; and Rousseau cannot let pass the opportunity at this point of chastizing modern culture and its rationalistic philosophy: 'Commiseration becomes all the more intense as the animal which observes identifies itself with the animal which suffers; and manifestly such an identification must have been infinitely closer in the state of nature than it is in the state of reason. Reason breeds *amour-propre* and reflection strengthens it. Reason turns a man inward upon himself and separates him from everything which troubles or disturbs him. It is philosophy which isolates a person, because it prompts him to say, secretly, to a suffering man: 'Perish if you will; I am safe.'[28] In the modern world it is the least educated people, the ones in whom the power of reasoning is least developed, who, according to Rousseau, exhibit towards their suffering fellows the most lively commiseration.

Earlier theorists who had spoken of a 'state of nature' in contrast with 'civil

society' had nothing to say about the history of man's progress from the one condition to other, if only because for them the 'state of nature' was generally a fiction, an intellectual construction achieved in the mind by stripping the human condition of everything it owed to the civil order. But Rousseau, who argued that men had once actually lived in this 'savage' and solitary state, had perforce to explain how men had come to leave it.

His suggestion is that men passed by stages from the original state of nature into what he calls 'nascent society', a process that evolved over a very long stretch of time. Although Rousseau is not always as clear in his exposition as the reader might wish, he locates as the central feature of this stage the institution of settled domiciles or 'huts'. Having a home facilitated the co-habitation of males and females on a more or less permanent basis, and so introduced the family. From Rousseau's point of view, this innovation signalled men's departure from the true state of nature, where the individual was solitary and sexually promiscuous, and his initiation into a primitive social state.

Rousseau speaks of this passage of man from the state of nature to 'nascent society' as 'the epoch of a first revolution which produced the institution and differentiation of families' and which introduced 'property' of a sort.[29] This 'property of a sort' must, however, be distinguished from the full concept of property, which emerges only at a later stage of evolution. All that man has in 'nascent society' is a *feeling* of possession of the hut he occupies. This feeling may have 'produced many quarrels and fights', but, Rousseau adds, 'since the stronger were probably the first ones to build homes which they felt capable of defending, one can believe that the weaker found it swifter and safer to imitate them rather than to try to dislodge them, and to have abstained from attempting to dispossess them from fear of blows rather than from any respect for ownership'.[30] The concept of a right to property came into being only with the invention of agriculture. 'Nascent society' is the period of human history which Rousseau regards as the nearest to the ideal, but he does not describe it in detail, nor even does he say enough to make his admiration for it fully intelligible to the reader.

Eloquence at this stage takes the place of reasoned argument. Rousseau describes man in 'nascent society' as being both gentler and more loving than he had been in the state of nature: for no longer did men and women copulate casually and go their separate ways indifferent to each other's fates; settled homes produced settled relationships: 'The first movements of the heart were the effect of this new situation, which united in a common dwelling husbands and wives, fathers and children.' The habit of living together gave birth to the noblest sentiments known to man, namely conjugal love and (Rousseau does not hesitate to add) paternal love. 'Each family became a little society all the better united because mutual affection and liberty were its only bonds.'[31]

Man in 'nascent society' is no longer alone nor is he yet the enemy of his

fellow creatures. Midway between 'the stupidity of brutes and the disastrous enlightenment of civil man', man at that stage was 'restrained by natural pity from harming anyone'.[32] It was the *'juste milieu'* between the 'indolence of the primitive state of nature' and 'the petulant activity of our own *amour-propre*'; it was the time 'when there were no laws but only the terror of vengeance to restrain men';[33] and altogether it was the best time men have ever known: 'the true youth of the world, from which all subsequent progress has appeared to be so many steps towards the perfection of the individual, but has in reality been so many steps towards the decrepitude of the human race.'[34]

The reader is bound to ask why, if the primitive condition of 'nascent society' was so ideal, did men leave it? In the *Essai sur l'origine des langues*, Rousseau suggests that primitive men were driven to organize more developed societies as a result of 'natural disasters, such as floods, eruptions of volcanoes, earthquakes and great fires'[35] which forced them to unite for mutual aid in common distress. Finding it difficult to understand how 'men could spontaneously renounce the happiness of their primitive freedom', Rousseau invokes what Professor Polin[36] calls a 'miracle' to explain their 'catastrophic passage to a condition of unhappiness'. In the *Discours sur l'inégalité* Rousseau provides an alternative explanation for the development of organized society: economic shortage. As the number of persons on the earth increased, the natural abundance of provisions diminished; the individual could not feed himself on the herbs he could find so he had to unite with others to overcome scarcity by hunting game in groups and by other such collective activities.

It was then that men moved, Rousseau suggests, from 'nascent society' to a more developed but still pre-political society. Social changes produced important moral and psychological changes in the individuals. Ceasing to be a solitary person, man not only became gentler and more affectionate in the milieu of the family, he became more egoistic and more corrupt in the milieu of society.

Even within the family, the human race is seen moving away from nature. Differences between the sexes increased as the women became sedentary in the home and the men became ever more active as they moved around to find food, learning in the context of shortage to augment their natural diet of herbs with new forms of nutrition, including meat. As men began to collect and enjoy in their homes more refined commodities, they began to develop 'needs', that is, an attachment to things 'of which the loss would be more cruel than the possession is sweet'.[37]

Language, too, developed with the demand for communication, first between members of the same family, then between neighbours. Contact between neighbours led in time to the formation of communities; and then 'men became accustomed to looking critically at different objects, and making comparisons. Imperceptibly they acquired the ideas of merit and of beauty,

which in turn produced feelings of preference. As a consequence of seeing one another men could no longer do without seeing one another. A tender and gentle feeling insinuated itself into the soul, but at the least obstacle this feeling turned to an impetuous anger: jealousy was awakened with love; discord triumphed, and the sweetest of human passions received the sacrifice of human blood.'[38]

As ideas and sentiments were cultivated, the human race became more sociable. People met in front of their huts or under a tree; singing and dancing became their amusements; and everyone looked at the others, knowing that others looked at him. Each wanted to excel in his neighbours' eyes.

'He who sang or danced the best, he who was the most handsome, the strongest, the most adroit or the most eloquent became the most esteemed; and that development marked the first step towards inequality and, at the same time, towards vice. From these first preferences were born, on one hand, vanity and contempt, and, on the other, shame and envy; the fermentation caused by these new leavens finally yielded compounds ruinous both to happiness and innocence.'[39]

Men began to base their conception of themselves on what other people thought of them. The idea of 'consideration' entered their minds; each wanted respect, indeed demanded respect as a right. The duties of civility emerged even among savages: a man who was wounded in his pride was even more offended than one who was wounded in his body; and each 'punished the contempt another showed him in proportion to the esteem he accorded himself'.[40] Man's corruption is the result of his being 'denatured'. In the state of nature man had what Rousseau calls *amour de soi-même*, an instinctive self-protective, self-regarding disposition which animated his efforts to stay alive, enjoy life and avoid injuries. In society this *amour de soi-même* was transformed into what Rousseau calls *amour-propre*, a form of self-love which is largely composed of vanity and the desire to be superior to others and be admired by them: '*Amour-propre* and *amour de soi-même* must not be confused; they are passions which differ in their nature and in their effects. *Amour de soi-même* is a sentiment which prompts every animal to look after its own conservation, and which, being directed by reason and modified by pity, produces in man humanity and virtue. *Amour-propre* is only a relative, artificial sentiment, born in society, prompting every individual to fancy himself above everyone else and inspiring all the injuries men do to themselves and to others; it is the true source of honour.'[41]

Here, then, is what Rousseau sees as the beginning of artificial inequality among men: the desire to be better than others and the desire to be esteemed by others. Such inequality already emerges with those communities or pre-political societies which Rousseau calls 'nations' – that is, groups 'united by custom and character rather than by regulation and laws, groups having the

same style of living and eating and the common influence of climate'.[42] In the early stages of society, inequalities were limited and tolerable. They became ruinous when men introduced agriculture, the use of iron and the division of labour, which Rousseau depicts as a further 'revolutionary' innovation in the evolution of mankind: 'As long as men were satisfied with their rustic huts, as long as they restricted themselves to clothes made of skins and sewn with pine-needles or fish-bones, and were content to ornament themselves with feathers and shells, to paint their bodies with all sorts of colours, to perfect and decorate their bows and arrows or to cut out with stone tools a few fishing canoes or a few crude musical instruments – in a word, so long as they were satisfied to apply themselves only to work which any man could do alone, and to activities which did not require the co-operation of several hands, people's lives were as free, healthy, good and happy as they could be according to their nature; and they continued to enjoy among themselves the sweetness of independent relations. But from the moment that one man needed the help of another, and it was realized that it would be useful for one man to have enough supplies for two, equality disappeared; property was introduced, work became a necessity, and vast forests were transformed into smiling fields which had to be watered with the sweat of human beings, fields where slavery and misery were soon seen to germinate and grow with the crops.'[43]

Agriculture, then, together with metallurgy, led to those unequal master–servant relationships which Rousseau saw as most inimical to freedom and to nature: 'It is iron and wheat which have civilized men and ruined the human species.'[44] As Rousseau reconstructs the past, the division of labour began between smiths, forging tools, and farmers cultivating the land to produce food for both. The cultivation of land entailed claims being made for rightful ownership of the land that a particular farmer had cultivated, and this introduced the 'fatal' concept of property:

'Things in this state might have remained equal, if talents had been equal, and if, for example, the use of iron and the consumption of foodstuffs had always been perfectly balanced; but in fact an equilibrium that nothing sustained was soon broken; the stronger men did more work, the cleverer men did more profitable work, the more ingenious men found ways of economizing labour; the farmer had a greater need of iron, the smith had a greater need of wheat, and working equally, the one earned much while the other had scarcely enough to keep alive.'[45]

These differences in men's capacities and in their circumstances produced even greater inequalities in men's conditions, which in turn led to a war between each and all.

At this point, Rousseau's argument is like Hobbes's. Indeed, while Rousseau rejects Hobbes's claim that the state of nature is a state of war between each and all, he gives a Hobbesian picture of the state of society as it

was before the introduction, by a 'social contract', of political institutions. One great difference between Rousseau and Hobbes is that Rousseau claims in the *Discours sur l'inégalité* that a social condition and not a state of nature immediately preceded the introduction of a civil order. Rousseau, as we have seen, claims that the state of nature existed, that it was peaceful and innocent, and that it was after the introduction of society that men were led to institute governments and laws because society itself ceased to be peaceful. 'Nascent society,' writes Rousseau, 'gave way to the most horrible state of war.'[46]

This state of war in pre-political society as seen by Rousseau is also rather different from the war between aggressive individuals depicted by Hobbes when he writes of a state of nature. Hobbes speaks of a war between equals; Rousseau sees a war provoked by inequality: by 'the usurpations of the rich and the brigandage of the poor'.[47] War begins in society when the idea of property is born and one man claims as his own what another man's hunger prompts him to seize; and when one man has to fight to get what he needs while the other man must fight to keep what he has. For Hobbes war springs from natural aggressivity; for Rousseau war first began with the unequal division of possessions in the context of scarcity, coupled with a corruption of the human passions which was the work of culture rather than of nature.

Both Hobbes and Rousseau conceive of men finding the same remedy for the state of war among them: namely a social contract; both philosophers see as the rational alternative to the violence and destructiveness of anarchy, the institution by common agreement of a system of positive law which all must obey. But whereas Hobbes's social contract is a rational and just solution equally advantageous to all, Rousseau's social contract as it is described in his *Discours sur l'inégalité* is a largely fraudulent contract imposed on the poor by the rich. In the book he called *Du Contrat social* Rousseau was later to depict a just covenant of a kind to which all might subscribe so as to combine liberty with law, but in the *Discours*, where he is writing about what *actually happened* – or 'must have happened' – in the past, he describes a social contract that marked the passage from anarchic society to political society in human evolution. Here, Rousseau imagines the first founder of civil institutions as a rich man saying to the poor: 'let us unite to establish just laws and put our separate forces in the hands of a common sovereign to enforce those laws on us all.'[48] The poor, who can appreciate that peace is better than war for everyone, agree: they do not fully see that in setting up a system of positive law they are transforming existing possessions into permanent legal property, and so perpetuating their own poverty as well as the wealth of the rich. Hence, as Rousseau puts it, 'All ran to accept their chains, thinking they were assuring their freedom, for although they had brains enough to see the advantage of civil institutions, they had not experience enough to foresee the dangers.'[49]

We may notice that in his description of the 'fraudulent social contract'

Rousseau always speaks of the rich dominating and deceiving the poor, not of the strong dominating and intimidating the weak. It is the economic inequality which arises from some men having assured possessions and others having nothing which Rousseau identifies as the central evil: 'The first man who enclosed a piece of land and took it upon himself to say *"This is mine"* and found people simple enough to believe him was the true founder of civil society. What crimes, what wars, what murders, what miseries, what horrors the human race might have been spared if someone had pulled up the stakes and filled in the ditch crying out to his fellow men: "Beware of this impostor: you are lost if you forget that the fruits belong to all, and the earth to no one."'[50]

Of course Rousseau knew that the past could not be undone. He was not recommending anyone to go back to 'nascent society' or to primitive anarchism: he was a philosopher who deplored the choices men had once made; he nowhere suggested, as did later socialist theorists, that the same choices could be made all over again at the present time. On the contrary, Rousseau insisted that pre-political societies belonged to a past that was exceedingly remote in Europe and Asia; and he went on to argue that political societies had gone through further stages of evolution, altering with time no less than had pre-political societies.

Political societies began with the institution of government and rulers; the power thus conferred on magistrates led to the division of men into weak and strong. In the next stage, legitimate power was converted into arbitrary power, and this produced the division of men into masters and slaves. Although Rousseau does not go into details, he obviously sees the degeneration of political systems from primitive government into absolute despotism as the continuation of the pre-political degeneration of the human animal from natural man to social man. Unfortunately, political society did nothing to arrest the moral corruption of the individual. It ended the war of each against all by introducing a kind of unjust peace initiated by the rich, but in the end this proved to be a peace which did no real good to anyone, not even the rich. This is because social man cannot be happy. The savage, Rousseau suggests, has only to eat and he is at peace with nature, 'and the friend of all his fellow men'.[51] Even if a savage has to fight with his neighbour for his meal, it will be a short struggle; 'pride is not involved, so it ends in a few punches; the winner eats, the loser goes off to seek better luck elsewhere and he is pacified'.[52] In the case of social man, it is another story altogether: 'First of all it is a matter of providing necessities, then providing the extras; afterwards come the luxuries, then riches; then subjects, then slaves – there is not a moment of letting-up.'[53] As men's needs become less natural, the desire to satisfy them becomes more impassioned, so that social man is never satisfied: 'He wants to cut every throat until he is master of the whole universe.'

This is why civil society, according to Rousseau, provides happiness neither

for the rich nor for the poor: 'Men are wicked,' he writes; 'melancholy and continual experience spares the need for proof; yet man is naturally good, as I believe I have demonstrated. What then can have depraved him to this extent if not the changes that have taken place in his constitution as a result of the progress he has made and the knowledge he has acquired? Admire human society as you will, the fact remains that it necessarily leads men to hate one another in proportion to the conflict between their interests, so that while appearing to render services to each other, men in reality seek to do each other every imaginable harm.'[54] In society, all pay lip-service to benevolence; but each in his heart welcomes the misfortunes of others because those misfortunes are of advantage to him. 'There is perhaps no rich man whose death is not secretly desired by his greedy heirs, often indeed by his own children; there is no ship at sea of which the sinking would not be good news for some merchant; not a business house that a dishonourable debtor would not happily see burned down with all the papers in it; no community that does not relish the disasters of its neighbours.'[55]

Once again, Rousseau stresses the final role of *amour-propre* in the life of social man; the role is not unlike that played by pride and vainglory in Hobbes's picture of natural man. For both philosophers, the psychological, or moral, causes of human conflict are much the same, the main difference being that Hobbes regards the egocentricity of men as a product of nature, while Rousseau insists that it is the product of civilization. Indeed, Rousseau sees this same *amour-propre* at work as a motor impelling men to develop their civilizations; the kind of progress in industry, sciences and the arts which he had condemned in his first *Discours* he describes in the second *Discours* as being generated by the energies of egocentric man. Ambition, a product of *amour-propre*, impels men at the same time to their greatest achievements and to their greatest misery.

'If this were the place to go into details,' he continues, 'I would explain how this universal desire for reputation, for honours and for preference, in devouring us all, exercises and compares talents and powers, how it excites and multiplies passions, how it makes men competitors, rivals or rather enemies; how every day it causes frustrations, successes and catastrophes of every kind by making so many contenders run the same race; I would show how the burning desire to have ourself talked about, the yearning for distinction, which nearly always keeps us outside ourselves, is responsible for what is best and worst among men, responsible for our virtues and our vices, for our sciences and our mistakes, for our conquerors and our philosophers; responsible, in short, for a multitude of bad things and a very few good ones.'[56]*

Rousseau here touches on a theme which was to inform much of his later thinking: the distinction between reality and appearance. Unlike Machiavelli,

* Voltaire's comment is: 'Ass of Diogenes: how you condemn yourself!'[57]

he regarded the realm of appearance as the realm of falsehood; and as a lover of truth, Rousseau insisted more and more on the need to banish all the veils and disguises and distortions in order to uncover that reality which alone was true. This policy was to prompt him not only to reject the life of the salons, but, according to his own grim logic, to repudiate also the theatre as an institution dedicated to fictions and pretence, and thus to falsehood. This more radical extension of his argument came several years later. In the *Discours sur les origines de l'inégalité*, attacking civilization on a broad front, he does not single out particular elements in civilization for detailed indictment. He does not even concentrate on the condemnation of inequality, although many readers have supposed this to be his purpose. He sees the growth of inequality as one feature of a larger process: the alienation of man. The tragedy of man is that he can no longer find happiness in the only way it can be found, that is in living according to his nature. Natural man enjoys repose and freedom; natural man is content to be idle and alone. Civilized man, on the contrary, is always active, always working, always playing a part, sometimes bowing to greater men, whom he hates, or to richer men, whom he scorns; always willing to do anything for honours, power and reputation, and yet never having enough. 'The savage lives within himself; socialized man always lives outside himself; he knows how to live only in the opinion of others, and it is from their judgement alone that he derives the sense of his own existence.'[58]

Rousseau ends the discourse by repeating his claim that this essentially false way of life – this system of judging everything by appearances and never by reality – is not 'the original condition of man', but is the result of 'the spirit of society and the inequality which it engenders'; it is those factors which have changed and distorted all our natural inclinations.

As an indictment of human civilization Rousseau's second *Discours* is both more radical and more disturbing than his first. It could not be expected to appeal to conservatives, as did his earlier attack on progress, since it is as merciless to traditional as it is to modern culture; and although Rousseau's argument might well be reconciled with Christianity – and could even perhaps be understood as a re-statement of the Calvinist conception of the Fall of Man in scientific terms – there are no references to Scripture in its pages and it seems to depict a universe where there is no God. It could hardly be expected to please the Catholics any more than it pleased the 'humanists'. The reaction of Voltaire was one predictable liberal reaction: 'I have received, Monsieur, your new book against the human race, and I thank you,' he wrote to Rousseau after he had sent him a copy. 'No one has employed so much intelligence to turn us men into beasts. One starts wanting to walk on all fours after reading your book. However, in more than sixty years I have lost the habit.'[59] Voltaire plainly detested Rousseau's discourse, and his marginal notes on his copy of the text conserved in Leningrad[60] betray even more antipathy than does

his letter to the author, where polite compliments moderate the barbed wit. Forty of his forty-one marginal notes are hostile to Rousseau. Diderot, on the other hand, was sympathetic to Rousseau's argument, and indeed gave him some considerable help in preparing his text. This may be seen in part as evidence of Diderot's greater tolerance, but it must also be remembered that Diderot's political views at this time were not the same as Voltaire's; he certainly did not share Voltaire's desire to protect the class interests of the property-owning bourgeoisie. Voltaire had made a great deal of money, and was proud of it; while he hated the aristocracy, he was profoundly attached to the rights of property. In the margin of his copy of Rousseau's second *Discours*, Voltaire wrote against the paragraph where Rousseau said the first man to enclose land was the founder both of civil society and human misery: '*Voilà*, the philosophy of a beggar who would have the rich robbed by the poor!'[61]* Diderot, scraping a living as an intellectual journalist, had no such solicitude for the privileged; he was affected rather by the sufferings of the poor. Indeed we find Diderot writing about this time such comments as these: 'The appetites of the rich are no different from the appetites of the poor ... but for the health and happiness of both, it would perhaps be better to put the poor on the diet of the rich and the rich on the diet of the poor. As it is, the idle man stuffs himself with succulent dishes, while the working man eats bread and water, and each dies before his natural term, the one from indigestion, the other from malnutrition.'[62]

Unlike Voltaire, Diderot was, as we should nowadays say, of the 'left', and he seems to have pushed Rousseau to bring out the radicalism of his argument in this discourse. Years afterwards, indeed, Rousseau complained: 'M. Diderot always abused my confidence in order to introject into my writings a harsh note and a black tone that they no longer had when he ceased to direct me and I was left to myself.'[63]† Diderot undoubtedly shared many of the views expressed in Rousseau's second *Discours*, including the belief that primitive societies were morally better than developed ones, as his own *Supplément au voyage de Bougainville*[65] made clear to the public when it was published after his death.‡ He may even have had a more idealized image of natural man than had Rousseau himself, and one can well believe that he gave every encouragement

* 'Has the man who has planted, sown and enclosed some land no right to the fruit of his labour?' Voltaire demands.

† In his *Confessions*, on the other hand, Rousseau wrote: '(the second discourse) was a work more to Diderot's taste than any other of my writings, and for which his advice was most useful to me.'[64]

‡ Diderot argues in these pages that people such as the Tahitians, who live close to nature, are good and happy; but the contrast he makes is between them and the *Christian* culture of Europe, which is, of course, not the contrast which Rousseau makes, between the state of nature and developed society. The main object of Diderot's attack is Christian morality, the object of Rousseau's attack is modernity. It must be borne in mind that Diderot wrote this work many years after Rousseau wrote his second *Discours*.

to Rousseau both to criticize the existing inequalities among men and to try to explain then scientifically, by tracing the natural history of the human race. For all these reasons Diderot seems to have liked the discourse Rousseau produced just as much as Voltaire disliked it. Perhaps he did not see as clearly as Voltaire did the ruinous implications of Rousseau's argument for the logical status of his own liberalism. Diderot was an embattled intellectual and he still regarded Rousseau as an ally in the war in which he was currently engaged.

Rousseau, for his part, still looked on Diderot as an ally in his particular struggles too. Having completed the second *Discours* during the winter of 1753–4, he left a copy of the text in Diderot's hands, hoping to have it published by Pissot. He had no great expectations of winning the prize at Dijon, but he was eager to have the discourse brought as soon as possible to the attention of his readers and critics, since he believed it provided a systematic answer to the questions left unanswered in his first discourse, and to add, as it were, the authority of science to the eloquence of the moralist he had deployed in his previous writings.

Even so, he was not confident that his reasoning would be correctly understood, and he begged the public to read his text twice before coming to any conclusions about what he had to say. He knew himself to be in some ways the victim of his own paradoxes; he was also perhaps more than he realized the victim of his colourful literary style, of his gift for constructing an arresting and an unforgettable phrase. His opinions were probably rather less extravagant than his language. Many readers took his indictment of property to be a plea for communism, and his condemnation of existing inequality among men in society to be a plea for universal equality, which is not at all what he had in mind. The kind of equality Rousseau desired was no more than that desired by Plato; he believed that everyone's place in society should correspond to everyone's merits or 'virtues', the word 'virtue' meaning a 'moral quality' having relevance to man's life in society as it could not have relevance to man's life in a state of nature (where there was no occasion for morals as such to be thought of). Rousseau wanted to see the right men in the right place, the most virtuous occupying positions of leadership and superiority. He was bitterly opposed to the situation he observed in France, where he saw the rich dominating the poor without being in any way morally better than the poor, but, on the contrary, worse.

In singling out the 'rich' rather than the 'strong' as the main target of his onslaught, Rousseau put himself squarely at odds with the bourgeoisie rather than the aristocracy of eighteenth-century France. It is possible to recognize in his argument the voice of the man who resented his dependence on such wealthy upstarts as the Dupins and the Poplinières and who had bitter memories of a hard life as an *employé* in various situations not much better than that of a domestic servant. It is not altogether surprising that the author of the

Discours sur les origines de l'inégalité felt more at ease with members of the old nobility than with the moneyed bourgeois of Paris.

It was not simply a case of snobbery, but rather one of mature sympathy. Many French noblemen of ancient lineage despised as Rousseau did the alliance of riches and royal absolutism which dominated the kingdom. They could look back to France as it was before the Bourbon dynasty had introduced royal despotism and Richelieu had destroyed their fortified castles. They remembered feudal France, when a noble lord was master of his dominions and owed only minimal obedience to the King. Of course they had no actual memories of those days; but their historical imagination was based on well-established knowledge and accompanied by strong feelings of resentment towards the régime and of contempt both for those members of the aristocracy who had allowed themselves to be transformed into courtiers at Versailles and for the bourgeoisie who had bought up most of the wealth of the nation.

Their attitude to life was a form of romanticism. They knew their title to aristocracy was an empty one: it gave them privileges without power; they were superior in social rank, but abysmally inferior in political importance to the bureaucrats who served the King. The *noblesse de race* had their dreams of a France that was dead, when the ideals of chivalry had proclaimed that only men of noble character should lead and protect the people. Their dreams found an echo in Rousseau, with his dream of an unborn world, where only the best men would be in superior positions. They knew that their world was dead, and his was an ideal world that had never been born. Or was there, perhaps, some city on earth where things were as they should be, where justice prevailed and virtue ruled? The answer that slowly forced itself upon Rousseau's mind was Geneva. For did not his native city claim to be a republic where virtue was supreme, a state where superior places were occupied by superior persons, a true aristocracy of a kind of which Plato himself might approve? And if Geneva satisfied these stringent criteria, ought not he to think of returning? Sooner or later, the author of the *Discours sur les origines de l'inégalité* could hardly fail to do so.

be amusing to see the Citizen of Geneva, the enemy of the arts, pick up his stick and shake the dust of Paris from his heels, for having preached the gospel of Italian music.' In February 1754[3] Grimm tells his readers about Rousseau's replies to the critics of the first *Discours*, only two of whom – King Stanislas and Bordes – he considers worth naming; and Grimm concludes that Rousseau has had the better of the battle 'not because his cause is so good, but because he has not had strong enough adversaries'. Grimm expresses regret that 'none of our first-rate philosophers' has thought of treating the problem which is discussed in Rousseau's first *Discours*, and he himself puts forward the opinion that while the abuse of science and the arts has done harm, one cannot seriously deny mankind the use of something on the sole grounds that it may be abused. Then Grimm delivers the body-blow: 'M. Rousseau has spoiled his triumph by an outrageous preface he has written for a bad play called *Narcisse*.' Grimm hardly redeems his own aggression by protesting at the attacks on Rousseau which are being published in Paris 'by a troop of hacks led by the illustrious M. Fréron'.[4]

The 'illustrious M. Fréron' was an untiring enemy at once of Rousseau and Grimm and all the other *encyclopédistes*; by traducing them together he perhaps did something to unite them just at a time when sympathy between them was beginning to cool. Still aged only thirty-six in 1754, Élie Fréron had some claim to be considered the founder of periodical literary journalism in France. He started his career as a literary journalist while still a young schoolmaster, working with the Abbé Desfontaines in joint publications. His regular *Lettres* (the model for Grimm's *Correspondance littéraire*) developed into the *Année littéraire*, which made his name. In a sense Fréron owed his success to that of the *encyclopédistes*; as they became fashionable as philosophers, so he became famous as their enemy. Voltaire hit back at him by putting him in one of his plays as 'Monsieur Wasp'; and it was of Fréron that Voltaire quipped 'A snake bit him, and it was the snake who died of poison'. History remembers Fréron's son Louis for his blind revolutionary fervour at the time of the Terror; the father was hardly less blind a reactionary – it took him a long time to realize that Rousseau was not a liberal progressive like the other *encyclopédistes* and so to moderate his hostility towards him. In his periodical *Lettres*, Fréron condemned in turn the first *Discours*,[5] *Narcisse*,[6] and *Le Devin du village*.[7]

In the winter of 1753–4, Fréron took the opportunity provided by the publication of a pamphlet entitled *Lettre d'un Hermite à J. J. Rousseau de Genève* to resume the assault. The 'hermit', as both Fréron and Rousseau knew, was a mediocre pamphleteer named René de Bonneval, who first charged Rousseau with reviving the Anabaptists' project of burning books, then added the gratuitous indictment of narcissism, comparing Jean-Jacques 'to a woman who having passed four or five hours getting dressed, looks in a mirror and says "I am pleased with myself."'

Fréron used his long review of Bonneval's short pamphlet to garnish the insult, and although he added no new point of criticism, his victim was stung to draft a wordy rejoinder.[8] It looks as though Rousseau did not in the end send the letter to Fréron, but the fact that he wrote it at all shows how disturbed he was by the accusation of narcissism, an accusation that ought not to have surprised him, given the title and theme of his play *Narcisse* and given his ill-considered remark in the preface: '. . . In working to deserve my own esteem, I have learned to do without that of others.'[9]

Rousseau's reply to Fréron is marked by a heavy-handed attempt at irony by a writer who cannot dissimulate his anger: 'If you had taken the trouble to read the writings which you do me the honour of despising, and which you really ought not to hate since they are directed against the wicked, you would have found a distinction drawn there between the numerous follies that we call science – such as those of which your reviews are full – and real knowledge of the truth.' He charges Fréron with not recognizing a lover of truth when he sees one.

It is a fair enough rejoinder: Fréron had missed the point of Rousseau's argument, or he would not have gone on indiscriminately attacking Rousseau, Diderot, Grimm, d'Alembert and Holbach as if they were all birds of the same feather, although Fréron was perhaps misled by the fact that they continued to flock together. Their great meeting place was Holbach's house in the rue des Moulins. The baron and his wife gave two dinners there every week, one on Sundays, one on Thursdays. They were famous occasions. No time was wasted on fashionable society unless it was also intellectual; and the *encyclopédistes*, forming a nucleus of regular guests, turned Mme Holbach's salon into a sort of club. Holbach, rich and generous, provided lavish hospitality, but everyone was expected to contribute to the conversation. The Abbé Morellet,* noted for his sceptical contributions on religious questions to the *Encyclopédie*, preserved an enthusiastic memory of dinners at Mme Holbach's: 'We began arriving by two o'clock, as was then the fashion, and most of us stayed until seven or eight in the evening. It was the place to hear the best and most enlightened conversation there ever was . . . Every conceivable argument, political and religious, was disputed there with the utmost subtlety and intelligence.'[10]

Rousseau, according to his own account, began to feel less and less at ease in this environment, although he remained up to a certain date a regular *habitué*. We may wonder how he appeared to the other guests; several published their recollections of him, but it is hard to know how much weight to attach to judgements often coloured by prejudice and often written years after the event. We have, for example, the testimony of Marmontel,† who

* André Morellet (1727–1819), liberal theologian and champion of toleration.
† Jean-François Marmontel (1723–99).

first met Rousseau at Mme d'Holbach's salon. A poor boy from the
provinces who had won fame as a playwright under Voltaire's patronage,
Marmontel was too complete a hedonist, too limited a genius, too much an
arriviste dazzled by the company of countesses and actresses, to appreciate a
man like Rousseau; yet his autobiography* (his one good book) gives us
some idea of how Rousseau appeared in the salon. In the days when they met
in Holbach's house, writes Marmontel,[11] Rousseau 'had not yet gone
savage, but was quiet and deferential' in his bearing; 'either his pride had not
yet been born or he hid it under a polite timidity'. Rousseau did not take a
very active part in conversation, but 'he knew how to charm his friends by
singing at the harpsichord the airs he had composed for *Le Devin du village*',
and although he was always a welcome guest, he had to be 'treated as if he
were a beautiful woman, capricious and vain'. Marmontel goes on to suggest
that Rousseau mistrusted everyone: 'he followed the maxim *Live with your
friends as if they will one day become your enemies.*'[12]

Rousseau, for his part, certainly regarded Marmontel with considerable
suspicion. In the *Confessions* he says he once paid Marmontel a compliment
and received in return only hostility: 'since then he has never missed an
opportunity to injure me in society and to attack me indirectly in his writ-
ings.'[13] The two were not made to be friends; Marmontel, trying hard to
imitate Voltaire, was almost bound to despise Rousseau, and in turn to be
disapproved of by him.

On Shrove Tuesday, 1754, there took place at Holbach's house an
incident which gives an early warning of a future breach. Diderot had been
introduced some months before to a country parson from Normandy named
the Abbé Petit, who turned out to be an unpublished author who wanted
Diderot to read a madrigal of seven hundred stanzas he had written. Diderot
side-stepped the demand by urging the *curé* to write a tragedy, and when
Petit took him at his word and pestered him again for an opinion, Diderot,
as a joke, invited him to read his play aloud at Mme d'Holbach's salon.
Rousseau was present with Holbach, Diderot, Marmontel, Raynal, Saint-
Lambert and others when the reading took place. Everyone else enjoyed
themselves putting up a show of mock admiration for the wretched author's
tragedy, but Rousseau could not stand the pretence: after some time, accord-
ing to the story attributed to Holbach, 'Jean-Jacques rose from his chair like
a madman, and springing towards the *curé* seized his manuscript, threw it on
the floor and exclaimed to the horrified author: "Your play is worthless . . .
All these gentlemen are laughing at you. Go away from here; go back to
your parish duties in the country." The *curé* rose, no less furious, spat out all
sorts of insults at his all-too-candid adviser, and from insults would have
passed to blows and murder if we had not separated them. Jean-Jacques left

* *Mémoires d'un père.*

in a rage, which I believed to be passing, but which in fact has never ceased.'[14]

Rousseau himself speaks in the *Confessions* of the feelings he experienced in Holbach's house: 'when I appeared the conversation ceased to be general. People huddled together in little groups and whispered in each other's ears, while I remained alone, not knowing with whom to talk. I put up for a long time with this shameful cold-shouldering; just because Mme d'Holbach, who was sweet and friendly, always welcomed me, I endured the coarse humour of her insufferable husband for as long as I could. But one day he attacked me so violently without any reason in front of Diderot, who said nothing, and of Margency . . .* that I was finally driven from his house by this disgraceful treatment.'[15]

It seems that Holbach decided that the only way to stir Rousseau from his dullness in conversation was to provoke him by contradiction and, lacking tact, Holbach wounded Rousseau more than he intended. However, Rousseau was not in fact 'finally' driven from Holbach's house by the scene in the presence of Diderot and Margency. When Mme d'Holbach died later in the year 1754, he wrote such a sincere letter of condolence that Holbach made strenuous and successful efforts to restore their friendship, if only to quarrel again a few years later.

After his first breach with Holbach, Rousseau did not give any less time to social life; he simply transferred his attachment to another Paris salon, that of Mlle Quinault, a former actress, 'at whose house I received all the attention, consideration and favour that I had found lacking at M. d'Holbach's.'[16] Rousseau had not yet thought of withdrawing from polite society altogether and enacting the role of the hermit.

Indeed at Mlle Quinault's salon Rousseau met several of the people who frequented Mme d'Holbach's, among others the romantic, almost Byronic figure of the Chevalier (who liked to be known as the Marquis) de Saint-Lambert. A poet who had won distinction in the field of battle as an officer attached to the Court of King Stanislas as Duke of Lorraine at Lunéville, Saint-Lambert arrived in Paris in 1751 at the age of thirty-five with introductions to all the literary celebrities and hostesses. He was a charmer and a womanizer. In Lunéville Voltaire had 'discovered' him and advertised his merits as a poet; Saint-Lambert repaid his benefactor by seducing his mistress Mme du Châtelet and fathering the child whose birth caused her death. In Paris he became the established lover of Mme d'Houdetot, with whom Rousseau was soon to fall both passionately and platonically in love. Saint-Lambert was in fact the model of Wolmar in Rousseau's *La Nouvelle Héloïse*, less an object of jealousy than a welcome protagonist in the kind of triangular relationship which gave Rousseau, in his later years, such curious satisfaction.

* Adrien Quiret, seigneur de Margency, poetaster, courtier and lover of Mme de Verdelin.

Although Saint-Lambert's earliest poems were of a religious inspiration, in Paris he was quickly converted to Holbach's brand of dogmatic atheism, and he became a *philosophe* as well as a poet. His contributions to the *Encyclopédie*, including the article on '*luxe*', are competent but undistinguished. He achieved his greatest fame as the author of a pastoral work *Les Saisons*, a French equivalent of Thomson's *The Seasons*, but he prided himself more on his prose and lived long enough to see his *Œuvres philosophiques* published in five volumes under the régime of Napoleon.

It was not, however, Saint-Lambert, but Charles Duclos who introduced Rousseau to Mlle Quinault's salon, and Duclos, it seems, was the dominant personality among her guests. In his early work, *Les Confessions du Comte de* ***, Duclos had painted a hostile, satirical picture of the Paris salons, but in his *Considérations sur les mœurs de ce siècle*, written ten years later, he praised them for furthering the cause of civilization by bringing together men of letters with people of rank and fashion. By the time he started frequenting Mlle Quinault's salon, Duclos had given up authorship, so he has left us no account of what life was like there when he introduced Rousseau to her. However, another record of Mlle Quinault's salon is to be found in the *Histoire de Madame de Montbrillant*, a book about which some explanation must now be given.

At some time between 1757 and 1771, Mme d'Épinay wrote a long novel, partly in the form of letters, partly as narrative, in which she gave a fictionalized account of her experiences and her milieu under the title of *L'Histoire de Madame de Montbrillant*; in this *roman à clef* she introduced her intimates under fictional names, Rousseau being 'René', Saint-Laurent 'Dulaurier', Grimm 'Folx' and so forth. Her work was too amateurish to attract a publisher, but when she had finished it, Grimm, who had become her lover, joined with Diderot to revise it and seized the opportunity to make the portrait of René (Rousseau), with whom they had both by that time quarrelled bitterly, much more unflattering than Mme d'Épinay had herself originally designed. In the following century the manuscript fell into the hands of two unscrupulous authors, Brunet and Parison, who substituted the real names of Mme d'Épinay's characters for the fictional names she had given them and published the book in 1818 not as a novel, but as the authentic *Mémoires de Madame d'Épinay*, and as such they were re-edited by Paul Boileau in 1865. Deceiving dozens of scholars, these so-called 'memoirs' did much to generate a false picture of Rousseau's personality; they were exposed as fraudulent by Frederika Macdonald in 1906,[17] and in 1951 Mme d'Épinay's work was finally published as she wrote it in an edition prepared and introduced by G. Roth. This book is such an unreliable source, and it has done so much to distort judgement of Rousseau, that no reader can turn to it without the most profound mistrust. Yet there is at least one incident

described in it which probably did happen much as it is recorded. This is a *dîner d'adieu* given at Mlle Quinault's house some time in the spring of 1754, the object of a careful study[18] by Pierre-Maurice Masson, who shows that the episode was largely re-written by Diderot, and who argues that, however hostile a witness Diderot became, he knew better than anyone what Rousseau's opinions were at the time and he had the literary skill to write authentic dialogue. With this in mind, it is worth reading the account of the *dîner d'adieu* which appears in this novel.

Mlle Quinault is given the name of 'Mlle Médérie' and she is depicted as an accomplished hostess. It is explained that a guest once admitted to a dinner at her table had the right to come again as often as he liked without invitation, 'with the result that we ran the risk of being fifteen or twenty instead of eight'. Desbarres (Duclos) set the tone, 'because few voices had the strength to dispute with *him*'.[19] The suggestion is that guests did not always eat well at Mlle Quinault's table but that the conversation, however much dominated by Duclos, was stimulating and wide-ranging. We find here one of the few remarks ever attributed to Rousseau on the subject of the visual arts: 'René said that paintings, tapestries, etc., were an art of imitation. It seemed to him absurd to put real people on tapestries, with their feet standing on the wainscoting. "It's all right," he said, "to have a few small figures in the distance of a landscape; the perspective, if it is well observed, can 'carry me away and give me the illusion'."'[20]

The main interest of this conversation resides in the discussion of religious questions. 'Dulaurier' (Saint-Lambert) is made the mouthpiece of Diderot's own atheistical views, and Rousseau comes out as a champion of faith. He says nothing in defence of the Catholic Church, indeed he speaks passionately against the kind of persecution which the Catholic Church engages in, but he does claim to be a Christian: 'René said that the Gospel is the only thing he retains of Christianity, because it was natural morality which originally constituted the whole of religion; "In rejecting miracles and all the absurd newly invented mysteries with which that religion has been ornamented," René said, "I believe myself a better Christian."'[21]

When Dulaurier went on to declare that there is only one substance – matter – in the universe, and that human beings are nothing more than little bits of matter, René, we are told, became angry, murmuring in his teeth. 'If it is cowardice,' he said, 'to tolerate anyone speaking ill of an absent friend, it is a crime to tolerate anyone speaking ill of God, who is present, and I, gentlemen, believe in God.'[22]

When later in the conversation Mlle Médérie (Mlle Quinault) seems to take the side of the atheist Dulaurier, René exclaims: 'Take care not to say it, Madame; because I won't be able to stop myself hating you. It is not that I think you any less saved, but the idea of God is necessary to happiness, and I want you to be happy.'[23]

It would be foolish to believe on the basis of the *Histoire de Madame de Montbrillant* that Rousseau used these actual words in this actual situation, but they undoubtedly express the sentiments that were taking form in his heart at that time, and they throw light on his decision to return to the Protestant Church of Geneva into which he had been baptized forty-two years before. As early as 1 August 1753, we find an anonymous gazeteer reporting that Rousseau has decided to renounce his Catholicism – because the Archbishop of Paris had the previous year demanded certificates of orthodox belief as a condition of receiving the sacraments; 'Rousseau said that not knowing what to believe, he had made up his mind, in order to live peacefully, to become a Calvinist.'[24] It was also asserted of Rousseau, as we shall see, that he started frequenting the Calvinist services at the Dutch Ambassador's house, but this assertion was part of a story that was told to the authorities of Geneva to persuade them to accept back the apostate, and it may not be true. In the *Confessions*, Rousseau says nothing about going to such services; all he says there is that he was getting sick of Paris: 'life among all those pretentious people was so little to my taste, the *cliques* among men of letters, their shameful quarrels, the lack of sincerity in their books, the pose they struck in the world was so odious, so antipathetic to me . . . that I began to yearn to live in the country.'[25]

In the event he went to Geneva. He seems to imply in the *Confessions* that it was simply by chance that he chose to go at the end of May 1754, Gauffecourt having unexpectedly invited him to join him on a journey there. In fact, it is clear that he must have been thinking very carefully for some time about going home. Indeed, the logic of all he was saying about religion, morals, politics and society would seem to compel such a decision; to drive him away from metropolitan corruption back to the provincial, puritanical simplicity of his birthplace.

The author of the *Discours sur les origines de l'inégalité*, even more than the author of the *Discours sur les arts et les sciences*, could not decently go on living the life of an *homme de salon* in Paris. As an indictment of élite society, the second *Discours* goes considerably farther than the first and could not be expected to have any such appeal, as had Rousseau's earlier attack on scientific progress, to conservatives. And in fact the second discourse did not appeal to the judges at Dijon (who were in any case warned that the essay was by Rousseau); this time no prize was awarded to him. But since he was now famous, he needed no prize to attract publicity, and he made arrangements to have the *Discours sur l'inégalité* published without waiting to hear the verdict of Dijon.* Before departing for Geneva, he left a copy with François Mussard, to be examined first by Diderot,† then to be given to a publisher.[28]

* The prize went to the Abbé Talbert. Excerpts from Rousseau's essay were read at a meeting of the Dijon Academy on 21 June 1754.[26]

† The second discourse 'was more to the taste of Diderot than all my other writings'.[27]

As an intellectual achievement, a finely argued essay in philosophical anthropology, the *Discours sur l'inégalité* is an undoubted masterpiece. But as the work of a moralist, it inevitably raised the question: if the analysis of the human condition was correct, what was to be done about it? It was hardly enough to offer a wholly negative criticism of culture and a generalized exaltation of nature. Something more specific and positive was called for; and Rousseau tried to answer the demand, both in his writing and in his way of life. In his writing, he moved from the quasi-historical description he gives in the second *Discours* of the unjust bogus social contract imposed by the rich on the poor to develop in the book he called *Du Contrat social* the outlines of a just and genuine covenant, which would enable men to enjoy at once both liberty and law in a civil society worthy of the name.

In his way of life, Rousseau drew the practical moral from the second *Discours* that he should remove himself from the kingdom where there was the greatest inequality among men to that republic where there was the least, at any rate in principle, and recover his citizenship of Geneva – a step which would necessitate his re-admission to the Calvinist Church established in that city. It is fair to raise the question whether Rousseau was being entirely honest with himself at this stage. Was he really a Christian, as he claimed to be? Was his faith in the moral teaching of the Gospels, in the existence of God and in the life to come enough to justify his open adherence to the Church of Geneva, which required its members to accept many more fundamental dogmas? Again, was Geneva itself the justly ordered republic that Rousseau asserted it to be? He must have heard the arguments of Lenieps and other members of the radical opposition to the effect that Geneva was simply a patrician despotism, but evidently he was not yet ready to listen to them. Indeed, Rousseau hit upon the idea, before he set out for Geneva, of dedicating his *Discours sur l'inégalité* to that city, and he prepared a fulsome preface for that purpose. He began by suggesting that Geneva was the ideal size for a republic, describing it as a place where no man was above the law, where the people and the sovereign were the same person, where age and experience had mellowed the constitution, where the right to legislate was common to all citizens, where the tribunals were elected and the magistrates wise, and where the clergy both cultivated the art of preaching and practised what they preached . . .

'The more I reflect upon your political and civil situation, the less can I imagine that the nature of human things could yield a better one . . . Your happiness is already assured; you have only to enjoy it, and in order to be perfectly happy, you have only to know how to be satisfied with it . . . Your state is tranquil, you have neither wars nor conquerors to fear;* you have no

* These words at least must have been written after the Treaty of Turin was signed on 3 June 1754 establishing peace between Geneva and the House of Savoy.

other masters but the wise laws which you yourselves have made and which are administered by magistrates of integrity whom you yourselves have chosen; you are not so rich as to be enervated by luxury or to have lost in idle pleasures the taste for true happiness and solid virtues, nor are you so poor as to need alien subventions to supplement what your own industry produces. What is more, this precious liberty, which large nations can maintain only by imposing exorbitant taxes for defence, costs you almost nothing to preserve.'[29]

Rousseau did not forget to praise the women of Geneva: 'Admirable and virtuous daughters of the republic, it will always be the lot of your sex to govern ours. Happy it is, while your chaste power, exercised solely within the marriage union, is asserted only for the further glory of the state and the public good. It was thus the women commanded in Sparta, and thus that you deserve to command in Geneva.'[30]

Notwithstanding these words in praise of chastity, Rousseau set off for Geneva in the company of his mistress, Thérèse. Before he left he lent to Mme d'Épinay his copy of Plutarch's *Lives*, the book which had served to fire both his enthusiasm as a boy for the republics of the ancient world and his pride in being Genevan. 'Plutarch,' he told her, 'is my master and my consolation,' and he begged her not to lend the book to anyone else. In the same letter he wrote: 'You would please Mlle Levasseur if you gave her the money for her dress, because she has some little shopping to do before we leave.'[31]

They left for Geneva on 1 June 1754, accepting Gauffecourt's offer of a lift in his carriage. In the *Confessions* Rousseau explains his decision to take Thérèse with him to Geneva by saying 'I was not well enough to do without her, so it was decided that she should come with us.'[32]

Gauffecourt, now aged sixty-three, had come a long way since the days when he was a watchmaker and secretary to the French Resident in Geneva, and a leader of the militant burgesses. After the civil strife of 1737, the French Mediator Lautrec had won him over to the side of compromise, and thereafter Gauffecourt's fortune waxed with French patronage, and he enjoyed a comfortable life in France on the proceeds of the salt monopolies of Geneva and Valais. He was an habitué of literary and philosophical salons in Paris, not as a writer but as a wealthy amateur who owned, among other things, a private press near Geneva. He was noted both as a *bon vivant*, reputed to have 'consumed champagne and oysters seven days a week',[33] and as a generous and useful friend. In the *Confessions* Rousseau tells a curious story about their journey to Lyons together *en route* for Geneva:

'We had a hired carriage which took us by very short stages with the same horses. I often got down and went on foot. We had hardly gone half way when Thérèse showed the most marked reluctance to stay alone in the carriage with Gauffecourt, and when, in spite of her pleas to me to stay, I

got down again to walk, she came down too, I scolded her for this capricious behaviour and indeed objected to it, which forced her to tell me the reason. I thought I was dreaming, but I dropped down from the clouds when I learned that my friend Gauffecourt, who was over sixty, gouty, impotent, worn out with pleasures and indulgences, had been trying ever since we set out to corrupt a person who was neither beautiful nor young and who belonged to his friend, and that he did all this in the most base and shameful way, even offering her money, and actually trying to excite her by reading to her from a dirty book and showing her the indecent illustrations it was filled with. Thérèse, indignant, simply threw the horrible book out of the carriage window.'[34]

Rousseau also says that Thérèse complained of Gauffecourt trying to seduce her at an inn where they stayed after Rousseau himself had gone to bed with a headache. Rousseau claims to have been deeply shocked by these disclosures: 'Sweet and sacred illusion of friendship. Gauffecourt was the first to strip your veil from my eyes!'[35]

So Rousseau writes in the *Confessions*. But in the letters he wrote at the time there is no sign of any cooling of friendship between them;* indeed their correspondence shows that they remained on excellent terms until Gauffecourt's death in 1766. The latest known surviving letter from Rousseau to Gauffecourt is dated 1 January 1765[37] and contains the salutation: 'Good day, good *papa*, tell me from time to time about your health and your friendship. I embrace you with all my heart.'

There is, of course, no knowing what actually happened on that journey from Paris to Lyons. Thérèse had the reputation among Rousseau's friends of being easily seduced. Rousseau's insistence on her modesty may indicate a desire to see things, or have others see things, differently from what they were; he cannot have been as indignant at Gauffecourt's behaviour as he claimed years later in the *Confessions* that he had been. At the time, whatever had to be forgiven was promptly forgiven.

Rousseau and Thérèse left Gauffecourt's carriage at Lyons only because Gauffecourt was going directly to Geneva and they proposed to make a detour to Chambéry. 'I could not be so close to *maman* without going to see her again.'[38] The unfortunate Mme de Warens was in more miserable circumstances than she had ever been. The present of 240 *livres* which Rousseau had sent her in February 1753 was a very small sum in relation to her debts at a time when even her richest creditors, such as M. de la Roche, were demanding to be paid without more delay. Old friends, including even M.

* A letter from Rousseau to François Mussard dated Dijon, 9 June 1754,[36] contains a very cordial reference to Gauffecourt. The purpose of this letter was to ask Mussard to give the manuscript of the *Discours sur l'inégalité* to the bookseller Pissot in Paris for publication. In the event this work was published by Rey of Amsterdam, whose acquaintance Rousseau was to make in Geneva.

Perrichon, had let her down, and Wintzenried not only proved a failure as manager of her mining enterprises, but added to her worries by misbehaving with an innkeeper's daughter and provoking a scandal.[39] A forced marriage seemed inevitable when the innkeeper's wife informed the Governor of Savoy that her daughter was pregnant by Wintzenried. It was at a particularly wretched moment in her life that Mme de Warens wrote, on 10 February 1754,[40] the one letter to Rousseau of which the original manuscript[41] is known to have been preserved; whether she actually sent it to him is a matter for conjecture. It is a bitter letter, prompted by something she had found hurtful in a letter from him:

'You will see confirmed in me, that chapter which I have just been reading in the *Imitation of Christ*, where it is said that where we put our surest hopes there shall we find our most total disappointment. It is not the blow that you have delivered me which afflicts me, but the hand from which that blow comes. If you are capable of a moment's reflection, you will tell yourself all that I could say to you in reply to your letter. In spite of all that, I am, and shall always be, your truly good mother. Farewell.'

It is not clear what 'blow' Rousseau had delivered to Mme de Warens, but she had many reasons for feeling more than usually sensitive at this time. The problems of Wintzenried solved themselves when the innkeeper's daughter turned out not to be pregnant and Mme de Warens was able to marry him off, into a higher social rank, to Jeanne-Marie Bergonzy, the daughter of one of the investors in her mines. Other problems proved more intractable.

By 1754 her financial situation was in such a bad state that she came to be registered officially as a pauper. Rousseau knew of her plight, if only because he had received the previous winter a letter[42] from the Abbé Léonard informing him that her backers in the mining enterprises, Perrichon and Mansord, had decided to liquidate the assets so that she was faced with bankruptcy. After explaining how her enemies were tormenting her, the *abbé* urged Rousseau to 'continue to give her new marks of that perfect attachment you have always shown to your dear *maman*' and not to forget 'the wretched circumstances in which she now finds herself'.

But what precisely did the Abbé Léonard expect Rousseau to do? M. de Conzié, in a letter[43] written more than thirty years after these events, accused Rousseau of culpable neglect of Mme de Warens: 'I have always blamed Jean-Jacques, whom she honoured with the name of her adopted son, for preferring in the first place the interests of la Levasseur to those of a woman as worthy of all respect as that laundry-girl was unworthy of any. Secondly, he ought sometimes to have moderated his pride, and devoted himself to the sort of work which would have enabled him to repay at least a part of the sacrifices which his generous benefactress had made for him.'

The reproach may be justified; but what of M. de Conzié himself? Rich as he was, could he not have helped Mme de Warens? Living near her at Chambéry and witnessing her situation from day to day, he was well aware of her distress.* And yet there is no sign of M. de Conzié making any charitable gesture towards the neighbour for whom he claims to feel such compassion and concern.[44]

In the Archives at Chambéry[45] there is a truly heart-rending letter addressed by Mme de Warens on 4 March 1754 to M. de Carolis, *secrétaire du cabinet* to King Charles Emmanuel III, begging him 'for the love of God to have pity' on her. She adds: 'I am without bread and without credit because of the malice of those who seek to destroy me.' Her chief tormentor was her partner, the Lyonnais millionaire Camille Perrichon, and his dummy, François Mansord. After twenty years of investing unsuccessfully in Mme de Warens' industrial enterprises, Perrichon had lost patience and gone to court to foreclose on his partner. In his favour, it should be recorded that Mme de Warens had never in fact paid for her third share in the Maurienne mining company.

In her letter to M. de Carolis, Mme de Warens asked for the royal Intendant and the judges of Chambéry to be informed of her side of the case, reminding Turin that it was she who had first introduced mining into the Maurienne, set up iron foundries in Chambéry and discovered coal in other parts of Savoy. In a pitiful final paragraph she asks that, if all else fails, the King will at least advance her 'a hundred *louis* to buy bread', her pension being pledged to her creditors. Other letters[46] to other high officials of the Sardinian administration are written in the same style. Clearly Mme de Warens was at her wits' end; and worse was yet to come.

Rousseau and Thérèse reached Chambéry on 12 June 1754 and went straight to visit her. He was shocked. As he writes in the *Confessions*: 'I saw her, and in what a state, O God! To what degeneration had she not sunk! What was left of her former qualities? Was this the same Mme de Warens who had once been so brilliant, the same woman to whom M. de Pontverre, the priest, had sent me? How it wrung my heart.'[47] He goes on to say that, having heard her story, he could see no solution to her problem but for her to leave the country. 'I repeated, earnestly but in vain, the entreaties I had often addressed to her in my letters, to come and live peacefully with me, so that I – with Thérèse – could dedicate my days to making her life happy.'[48] Her unwillingness to live *à trois* with Rousseau and his mistress seemed to him to bespeak an unreasonable stubbornness: 'She counted on her pension,

* In the same letter, M. de Conzié speaks of Mme de Warens being too proud to disclose her needs to a 'distinguished old nobleman' who would have been only too ready to help her: the reference is doubtless to Jacques d'Allinges, Marquis de Coudrée (1679–1755). But M. de Conzié himself was never kept in any ignorance of Mme de Warens' needs.

which, although punctually paid, had long ceased, being mortgaged, to reach her pocket, and she refused to listen to me.[49] Before they parted, Rousseau says he gave Mme de Warens 'a small part of my money, which was much less than I ought to have given her'.[50] Feeling guilty and depressed by this painful interview, he hurried on to Geneva. The published version of his *Discours sur l'inégalité* bears the words 'Chambéry, 13 June 1754' at the foot of the Dedication, but it is not necessarily the case that he found time to work on the Dedication while he was there – he may simply have fancied that there would be less embarrassment in Geneva or France if he gave himself an address in the Duchy of Savoy.

THE RETURN TO GENEVA

Rousseau arrived in Geneva determined to admire all he found: the people, the institutions and the magistrates. The elogium of Geneva that he had written in the Dedication of his *Discours sur l'inégalité* was not empty hyperbole; he had been taught to believe that Geneva was an ideal republic, and in the summer of 1754 the reality he encountered seemed happily to correspond to that image.

He told his friends in Paris that he had made the trip to Geneva only in order to secure official acceptance of the Dedication. Once arrived there, according to the *Confessions*, he was so excited by the welcome he received that he made up his mind to recover his rights as a citizen: 'I gave myself up to patriotic fervour, and, ashamed of being excluded from my rights as a citizen because of my membership of a Church different from that of my forefathers, I decided openly to return to the Protestant Communion.'[1] This is not exactly the story told in Geneva at the time. It was said on his behalf that he had come home as a penitent and that he had already been preparing himself in Paris for readmission to the Calvinist Church by attending services at the Dutch Ambassador's residence.[2]

The truth of the matter is doubtless complex. The central purpose in Rousseau's mind was probably that of recovering his status as a citizen of Geneva; for although he had been calling himself a *citoyen de Genève*, he had forfeited the legal right to do so when he became a Catholic in Turin, and the only way for him to regain the right was to secure readmission to the Church of Geneva. That is not to say that this was his only motive. He had, as we have seen, begun to develop unmistakably religious beliefs. If Paris of the Enlightenment had turned him forever against Catholicism, he had come to be less and less sympathetic to the atheism of the *philosophes* and more and more aware of himself as a pious believer in God. Even so, Rousseau's belief in God was something which fell far short of adherence to the Calvinist creed that was established in Geneva. There was a great gulf between

rejecting atheism and positively subscribing to the doctrines of the Church of Geneva concerning revelation, miracles, grace and the historical truth of the Scriptures. All the evidence we have shows that in theological opinions Rousseau was still closer to Voltaire than to Calvin. As one of his friends in Geneva, Georges Louis Le Sage *fils*,* recalled: 'I never detected in Rousseau in 1754 the least drop of that bitterness that he later directed towards the *philosophes*.'[3]

Nevertheless Rousseau now regarded himself as a sound enough Christian in his beliefs to be entitled to be admitted to holy communion; and although he was living in open union with a woman who was not his wife, he personally considered his morals to be irreproachable. He could not be sure that the authorities of Geneva would share his own opinion of himself, but being 'fêted and spoiled by people of all classes'[4] he was encouraged to put them to the test.

Arriving in Geneva towards the end of June, Rousseau installed himself by the lake at Eaux-Vives, at the gates of the city. Several relations and friends offered him hospitality, but he preferred to be independent and looked after by Thérèse. The exact whereabouts of their quarters have been much disputed by historians, but the most reliable testimony seems to be that of Théodore Rousseau, who reported in a letter to the *Journal de Paris*[5] in 1798 that his kinsman had 'lived in a place by the lake in a garden where my father (Jean-François Rousseau) also had an apartment in the summer'.

Eaux-Vives had more than one advantage. It afforded the natural beauties, tranquillity and *Sommerfrische* of a lakeside village outside the crowded city; it was also in the parish of Coligny, presided over by a pastor of latitudinarian views and accommodating attitudes named Maystre,† who did much to ease Rousseau's return to the Church of Geneva. In his *Confessions* Rousseau says that, in his eagerness to gain admission to the Calvinist communion, 'I even submitted myself to the instruction of the pastor of the parish where I was staying'.[6] If 'instruction' is the right word for what Rousseau received from Maystre, it did not last long; in less than a month he had accomplished his purpose.

A portrait painted of Rousseau by Gardelle[7] in Geneva that summer gives us an inkling of how he looked. Less handsome than the powdered *homme de salon* that we see in the celebrated portrait by De la Tour (which Diderot considered a distortion of the subject), the image here may be truer to life: a large head sits on a small body, the face is oval, with intense black eyes, a fairly prominent nose and the lips parted in a rather charming shy smile. A note[8] written by Lenieps in 1752 confirms the impression: 'M. Rousseau is

* Like his father, the younger Le Sage (1724–1803) was a mathematician and physicist of some renown, and he was elected to the Royal Society in London in 1775.

† Jacques Maystre (1703–55).

small in size, thin in the body, the eyes black and lively, the face ashen, the temperament gay and vivacious.'

When Rousseau crossed the lake a day or two after he arrived at Eaux-Vives to visit his father's old friend Marcet de Mézières at Coppet, Marcet declared: 'I recognized him on the spot because of his resemblance to his late father.'[9] To judge from the one known portrait[10] of Isaac Rousseau, the comparison is not flattering – for the father, no longer young, is there depicted as possessing a puffy, shapeless, bucolic sort of face, with small dark eyes and pursed lips, all bespeaking a commonplace character, whereas the existing iconography and contemporary testimony both tell us that the son always looked distinguished. Marcet also found Jean-Jacques likeable: 'He is a man who talks little, but well. I would have liked to have him spend a few days here (at Coppet) but he said that while he liked the place very much, he never stayed with other people; he told me: "Monsieur, if I had to, it would be with you." I confess his company gave me great pleasure, and short as was the conversation I had with him, I felt that his ideas were pretty much in harmony with my own.' Marcet, a smooth-tongued Genevan bourgeois with more charm than brains, an amateur author* with more money than talent, may well have flattered himself, but at least his words confirm Rousseau's claim that he was well received in Geneva. We also find Le Sage *fils* saying in a letter[12] to d'Alembert on 12 July that a great fuss was made of Rousseau by everyone in the city. D'Alembert replied: 'I am not at all surprised at the success of M. Rousseau. He is made to have it everywhere and to refute the proverb that no man is a prophet in his own country.'[13]

Time was to prove the proverb as true of Rousseau as of any other prophet, but 1754 was the year of his honeymoon with his homeland. Everyone adored him. Equally, on his side Rousseau appears to have seen perfection wherever he looked. This is evident enough from a letter[14] he wrote on 12 July to Mme Dupin: 'Here I am, *Madame*, against all expectations happily arrived in my homeland ... I cannot tell you how much more beautiful Geneva seems to have become without anything having changed: the difference must be in my way of looking at it. What is certain is that Geneva appears as one of the most charming cities in the world, and its inhabitants the wisest and happiest men that I know. Liberty is well established, the government is peaceful, the citizens are enlightened, solid, and modest, knowing their rights and courageously upholding them, yet respecting those of others; and by a treaty we have just concluded with the King of Sardinia, our sovereignty has finally been recognized by the only prince who might challenge it.'

The treaty Rousseau mentions in this letter was that of Turin, signed on 3 June 1754, establishing peace between Geneva and her oldest enemy, the

* Marcet wrote articles for the periodicals and several unsuccessful plays.[11]

House of Savoy giving up its claim to jurisdiction over the city in return for a few territorial concessions and a greater tolerance of Catholics. With the independence of the republic thus assured, an unmistakable euphoria prevailed in Geneva that summer, making the time particularly opportune for Rousseau to seek re-admission to the citizens' roll.

The religious climate had also become more favourable from his point of view than it had ever been. As in the Church of England in the eighteenth century, liberal and latitudinarian ideas had become fashionable in the Church of Geneva. Already in the early years of the century, the philosopher Robert Chouet had introduced into the Academy of Geneva the cartesian method of systematic doubt, and the theologian J.-A. Turrettini had diverted that doubt towards Calvin's dogmatism.[15] Turrettini's pupil and successor as the leading academic theologian of Geneva, Jacob Vernet, had carried the process of eliminating dogma even further.[16] Vernet won fame with a book significantly entitled *De l'Utilité d'une révélation*, and this emphasis on utility is a sign of the extent to which the original Calvinist imperatives had yielded to Lockean principles of reasonableness and toleration. This is not to say that Vernet, or any one else in Geneva, went as far as Rousseau went in renouncing orthodox belief altogether. If Vernet believed in a minimal creed, it was still recognizably Christian and Protestant, and he was stern in the defence of revelation and of everything else he regarded as the essentials of salvation. However, Vernet's reputation for latitudinarian views was such that Rousseau sought him out as a potential ally in his endeavours to be re-admitted to the Church of Geneva, an influential friend if only he could cultivate him. Thus we find Rousseau writing to Lenieps begging him to press Isaac Vernet, a Swiss banker in Paris, to send a recommendation on his behalf to 'his brother, the Professor'.[17] The Professor was, in fact, very ill that summer, and Rousseau did not come to make his acquaintance until after he had achieved his object. Fortunately, the other clergy, when it came to the point, proved every bit as latitudinarian as Vernet himself.

Yet if the clergy of Geneva had come to be broad-minded on matters of doctrine, they were still puritans on questions of morals. Adultery was no longer punished by death nor were women engaged in prostitution thrown into the lake, but sexual non-conformity was still viewed with fierce disapprobation. In Paris, Rousseau's living with a mistress might be accepted as a matter of course; in Geneva it would not be tolerated by anyone. This Rousseau knew. A relationship he was unwilling to end, he would have to veil: he would have to pretend that Thérèse was living with him as something other than a mistress.

His situation was paradoxical. An alien in the smart world of Paris salons, he had found in Geneva the promise of 'belonging', of being at home in a

milieu where human relationships were simple, candid and sincere;[18] but he realized that in order to be admitted to that experience he would have to dissimulate some essential truths about his way of life, if not actually to lie.

In the event dissimulation proved easier than he might have expected. Rousseau had the supreme advantage of coming back to Geneva as a celebrity, and the Genevans were too business-like a people to make things unnecessarily difficult for a 'convert' who could so easily become a national asset. According to the law of the republic – and it was a law which was still being enforced even after Rousseau's time[19] – any Genevan citizen who converted to Catholicism and then wished to be reintegrated into the Church of Geneva had to make an appearance before the *petit conseil*, spend two or three days in prison, be publicly interrogated by the Consistory and demand pardon on bended knees. Rousseau contrived to obtain exemption from all these disagreeable requirements.

This privilege he owed in part to the intervention, at a meeting of the Consistory, of Jacques Maystre, the pastor of the parish where he was staying and his 'instructor' in the faith. According to the Register,[20] Pastor Maystre told the authorities that Rousseau 'was taken to France at a very young age and brought up in the Roman religion; then, after practising it for a number of years, he saw the light, recognized his errors, ceased to take those sacraments, and thereafter assiduously frequented the evangelical services at the residence of the Dutch Ambassador in Paris, and publicly declared himself a Protestant.' Pastor Maystre then pleaded for Rousseau, 'who has important reasons for desiring to avoid publicity', to be spared a public interrogation by the Consistory and to be interviewed instead in private by a select commission. He explained that 'M. Rousseau, being afflicted with a dangerous illness,' was 'very shy'; he also said that 'M. Rousseau was acknowledged by everyone to have pure and irreproachable morals'. The Consistory accepted Pastor Maystre's proposal and appointed a commission of six to question Rousseau, giving the commissioners authority, if he satisfied them, to admit him to the Lord's Supper.

It is obvious from this brief report that Pastor Maystre's statement of the case fell short of candour; if Rousseau did not bend the truth he told him, the pastor bent it on Rousseau's behalf. But did people really want to hear the truth? As Le Sage *fils* reported[21] to d'Alembert in describing Rousseau's success in Geneva, 'even the theologians seek him out eagerly, and repress the itch to put to him certain questions'. It is a revealing remark. Tactfully, the theologians, avoiding certain subjects, enabled Rousseau to keep them in comfortable ignorance of his unorthodox opinions.

But what about his morals? We have the testimony of Jacques-François Deluc, a prominent Genevan politician, a leader of the citizens' faction, and a man who was constantly in Rousseau's company during that summer at

Eaux-Vives, who writes: 'Among the members of the Consistory to whom I addressed myself (on behalf of Rousseau) there were those who made objections because Mlle Levasseur slept in his bedroom. I warned him of this, and he gave me the following answer: "If my situation were known to those persons, they would be convinced that I am in no state whatever to do what they suspect. I have long suffered from the most cruel pains because of an incurable retention of urine, caused by an excrescence in the urethra which blocks the channel to such a degree that even the tubes of Daran could not enter it."'[22] The story that was told to the authorities was that Thérèse was with Rousseau simply as a nurse.

However, Rousseau did not make any show of treating Thérèse like a nurse. She was his constant companion. According to Pastor Vernes, 'Rousseau was very often invited into the first houses of Geneva with Mlle Levasseur and he never failed to take her. He explained: "She has saved my life, I shall take care of her as long as I live."'[23] Vernes also told the same interviewer that he had once found his friend nonchalantly doing up the stays of Thérèse. Rousseau, without ceasing the activity, said: 'She helps me, and I help her.'[24]

It is perhaps because he showed so few of the usual signs of guilt with regard to Thérèse that people gave him the benefit of the doubt. Evidently Rousseau felt the truth of the motto: *'Qui s'excuse s'accuse'*. When Jacques-François Deluc wanted to intervene with the authorities to explain things on his behalf, Rousseau implored him to keep out: 'I beg you and I entreat you most earnestly, Monsieur, not to speak to anyone or take any kind of steps in the matter about which we spoke yesterday evening.'[25]

Rousseau's hearing before the Commission took place on Thursday, 1 August 1754.[26] The chairman was Pastor Waldkirch,* who sat with Pastor Maystre, Pastor Sarasin,† Professor Pictet,‡ Professor Jallabert,§ and M. Grenus, auditor.‖ Rousseau was thus fortunate in having his friend, instructor and advocate on the commission and the other members proved no less sympathetic. The official record of the occasion is laconic: 'Pastor Waldkirch reported that Jean-Jacques Rousseau, citizen, was summoned last Monday before the Commission, and after he had satisfied them both as to the motives which obliged him to appeal for exemption from appearing before this House, and as to matters of doctrine, they received him into our Communion.'[27]

* Joël-Henri de Waldkirch (1704–95), Moderator of the Church.
† Jean Sarasin (1693–1760), Pastor of St-Pierre, published little but was a celebrated preacher.
‡ Pierre Pictet.
§ Jean Jallabert (1712–68).
‖ Jean-Louis Grenus (1711–82) was later one of the syndics of Geneva who condemned *Émile*.

In the *Confessions* Rousseau tells us more. After recalling the setting-up of the small Commission to receive his profession of faith in private, he says he was startled to hear that its members would be delighted to have him address them. 'The prospect alarmed me to such a point that after having studied day and night for three weeks to prepare the little speech, I was so nervous when it came to delivering it that I could not bring out a single word, and I behaved at the interrogation like the silliest schoolboy. The commissioners spoke for me, and I simply answered stupidly *yes* or *no*.'[28] Possibly, if Rousseau had said more, he would have been less successful. It has been suggested that he narrowly escaped ruining his chances by uttering some such formula as the one he attributes to his *vicaire savoyard* on the question of whether God is revealed to man: 'I see the pros and cons: allow me to remain in a respectful doubt.'[29] As it was, Rousseau seems to have been saved by his silence. 'I was readmitted to the commission,' he recalls in the *Confessions*. 'I was given back my rights; I was inscribed in the tax roll reserved for citizens and burgesses, and I took part in an extraordinary meeting of the general council when the Syndic Mussard* took the oath of office.'[30]

Evidently Rousseau had managed to overcome all suspicion about his relationship with Thérèse. Indeed we find Professor Pictet† writing at the end of August to a fellow clergyman in Neuchâtel saying: 'We have here the famous Rousseau who, having been brought up in the Church of Rome, wanted to rejoin our Church. He has a fine intelligence, and is, above all, a good Christian. But his way of living is singular; he has little or no health.'[31] The word 'singular' here betrays an altogether un-Calvinistic willingness to give Rousseau the benefit of the doubt on the subject of his private life.

Professor Pictet would not have described Rousseau as a 'good Christian' if Rousseau had said in Geneva in 1754 the things he said in print eight years later in *Émile* and the *Contrat social*. Indeed after those books were published, Professor Jacob Vernet was called upon to draw up a report on how Rousseau ever came to be readmitted to the Church of Geneva. In this report,[32] Vernet notes that Rousseau had been called upon by the Commission of six to answer only two questions: 'Are you a Christian?' and 'Are you a Protestant?' His replies to both questions were affirmative, and Vernet suggests that there had been no reason to doubt the candidate's sincerity, since his early wanderings astray could be attributed to youth and his published writings up to that date contained nothing to arouse suspicions. 'It was not the same with the works which appeared later,' Vernet continues. 'One could find much to reproach in his discourse on inequality and his *La Nouvelle Héloïse*, although nothing openly offensive to religion. This was

* Pierre Mussard, the diplomatist, was only distantly related to François Mussard of Passy and thus to Rousseau himself.

† Jean-François Pictet (1699–1778), pastor and professor.

reserved to his last two works, *Émile* and the *Contrat social*, which have earned the disapproval of virtually the whole of Europe.' Jacob Vernet goes on to give a detailed catalogue of the passages in *Émile* where Rousseau attacks revealed religion and advocates natural religion, and goes on to draw attention to the scandalous chapter in the *Contrat social* where Rousseau claims that Christianity is useless as a civil religion on the grounds that it preaches servitude and submission rather than the proud and martial virtues that a republic needs. All this prompted Vernet to conclude in 1763 that Rousseau was neither a Christian nor a Protestant.

It is arguable that Vernet is less than wholly sincere in his condemnation. His own views have seemed to some readers[33] almost as extreme as Rousseau's in their repudiation of Calvinist orthodoxy, and he may well have found Rousseau a more congenial thinker than he dared to admit publicly. At all events he entertained Rousseau very hospitably at his house in Geneva in September 1754. Vernet had not been able to receive him sooner because he had been ill all summer, but when Rousseau did eventually visit him, he was promptly invited to stay for dinner. 'I have only in every way to praise him for his courtesy and kindness,' Rousseau wrote[34] afterwards to Lenieps. 'And although I no longer needed to ask him for the services I once desired, I was none the less charmed to meet him.' It was the beginning of a friendship which lasted several years.*

It is possible that in the year 1754 Rousseau had not yet fully formulated the views published in 1762 in *Émile* and the *Contrat social*, but there is nothing to suggest that what he then believed was closer to the prevailing theology of the Church of Geneva, however liberally interpreted. He appears to have written little if anything on religious matters at this period of his life, but we do have the testimony of people who conversed with him at the time. One such witness is Jean-André Deluc, elder son of Jacques-François Deluc, the liberal politician who took charge of Rousseau for much of his stay at Eaux-Vives that summer. Jean-André Deluc was both a scientist and an earnest Christian, very much influenced by Rousseau in certain ways and wholly sympathetic to him personally. Writing many years later[36] of Rousseau's religious opinions in 1754 Jean-André Deluc described him as 'essentially a *deist* in revolt against the materialistic atheism of the *philosophes* in Paris'. In these pages, Jean-André Deluc suggests that the *encyclopédistes* had shaken Rousseau's faith in revelation, and that what remained was a conception of Christianity as a 'natural religion'. He speaks of Rousseau still 'preferring Buffon to Moses', by which he means that where the narrative of the Old Testament differed from the findings of empirical research, Rousseau chose the latter. Jean-André Deluc speaks of Rousseau in 1754 as

* In the *Confessions*, Rousseau writes: 'Vernet turned his back on me, like everyone else in Geneva.'[35]

one who had by no means severed his attachment to the scientific ideals of the *Encyclopédie*; but he goes on to say: 'At the time, being naturally humane, he adhered to the profession of Christianity, since his acquaintances with atheists had convinced him that a public religion was indispensable to the maintenance of society. Thus he came back to Geneva, to his homeland, to return to the Church into which he was born, believing that the badge of a Christian, in reconciling him to the great part of society, would give him more influence for upholding deism against the atheists. That was the time when I first contracted my friendship with him.'

It seems important to notice that Rousseau's attitude to religion had at least two distinctive characteristics: on the one hand, his religion was something which sprang from his heart, something he *felt*; on the other, it was something which, as a philosopher, he considered in his mind to be necessary to the maintenance of society. This latter belief did not in itself separate him from the philosophy of the Enlightenment as such. If Holbach wanted to banish all forms of Church, Voltaire, like Hobbes before him, maintained that religious institutions were necessary to public order, however absurd the teachings of the Church might appear to reason. And Rousseau was acting exactly like Hobbes and Voltaire in bearing witness to this belief in the social necessity of the religious institution by joining the Church established in his own country. This is how we must understand what he says in the *Confessions*:

'I considered it to be the responsibility of the sovereign alone to define both the forms of worship and the inscrutable dogmas of the national religion, and hence that it was the duty of every citizen to accept those dogmas and observe the forms of worship laid down by law in his own country ... It followed, since I wished to be a citizen, that I must be Protestant, and return to the Church established in my own country of Geneva.'[37]

Here we can recognize Rousseau separating, as sharply as he does in the chapter on the Civil Religion in the *Contrat social*, external forms of worship and discipline from inner belief, suggesting that while the former must be ordered by the state, the latter may be free. As for Rousseau's own inner beliefs at this stage of his development, he claims that his association with the *encyclopédistes* 'far from disturbing my faith, had strengthened it because of my natural aversion for disputes and factions. Research into man and the universe had shown me everywhere final causes and an intelligence which governed them. My reading of the Bible, and especially the Gospels, to which I had applied myself for some years, had led me to despise the crude and foolish interpretations given to the words of Christ by men unfit to understand them. In short, philosophy, attaching me to what was essential in religion, had detached me from the mass of petty formulae which obscured it.'[38]

What Rousseau considered essential in religion was an affirmation of personal experience of divine reality. He did not believe that reasoning could lead one to God; for Rousseau, as for Pascal, faith was a matter of will and feeling. 'I have suffered too much in this life not to expect another,' he wrote to Voltaire in 1756.[39] 'All the subtleties of metaphysics would not make me doubt for one moment the immortality of the soul. I feel it; I believe it; I wish for it; I hope for it; I shall uphold it till my last breath.'

A memorable intimation of Rousseau's religious feelings in 1754 is provided by Jacob Vernes – not Jacob Vernet, the eminent theologian, but a young curate who was to become a close friend of Jean-Jacques until the publication of *Émile* and the *Contrat social* in 1762 put too great a strain on his loyalty. A journalist named Brissot,[40] who interviewed Vernes years afterwards, records this story: 'Pastor Vernes ... recalled with tenderness a walk he took with Rousseau in 1754 in the moonlight beside the lake. The conversation turned to Providence. Jean-Jacques, who stammered and stuttered in society, where he was almost always ill at ease, because he was out of his depth, the same Jean-Jacques, deeply moved by the silence of nature, by the sight which struck his eyes, spoke of the Divine as one inspired. "Never," said Vernes, "was he so eloquent in his books ... Tears welled in his eyes and mine responded."'

Despite his complaints of ill-health, Rousseau kept himself extremely busy in Geneva and he saw a great many people. Among others he visited his old nurse, Jacqueline Faramond, now aged fifty-eight and married to a dyer named Jacques Daniel. She still lived in the rue de Coutance, that street of shops and artisans' wooden houses where Jean-Jacques grew up after his father had been forced to quit the elegant part of Geneva on the hill.

Few members of Rousseau's immediate family were still to be found in Geneva. His beloved aunt 'Suzon' – Suzanne Goncerut – had moved to Nyon, which meant that he had to cross the lake to see her, and he did not find time to do so until late July. He explained to her in a letter dated the 11th of that month[41] that he had been promising himself every morning for the previous fortnight to come and see her and express his tender feelings to 'a good and dear aunt I should call Mother after all the good things she had done for me'; unfortunately 'inescapable concerns' had prevented his following 'the inclinations of my heart'. These 'concerns' were doubtless related to his efforts to secure readmission to the Church.

A portrait of Suzanne Goncerut,[42] painted when she was aged about fifty, shows an elegantly dressed and cultured-looking woman; the nose and chin are too prominent for beauty, but the eyes are dark and searching, the mouth well-shaped, the expression pleasing; one hand rests on an open book. The portrait dates from an earlier period, for Mme Goncerut was well over seventy when Rousseau visited her that summer, and she lived (like her father

David Rousseau) to be over ninety. In her last years, Rousseau was to give her a small annuity, but in 1754 he was still too poor and too encumbered by the demands of the Levasseur family to be able to help anyone else.

It has been suggested[43] that Rousseau spent most of his time in Geneva in the company of humble persons rather than the society of 'high Geneva', but there are no grounds for believing this. It is true that the author of a book entitled *Voyage en Suisse*, published in 1822,[44] reports, on hearsay, that when Rousseau visited his old nurse in St Gervais, he would sit chatting with her on a stool, while the artisans of the locality came 'to gaze upon the celebrated author who had sprung from their own milieu' and 'were delighted to find that he had kept their accent'.[45]

The same writer also reports that Rousseau used to dine in the kitchen behind the shop of a confectioner, in the same rue de Coutance; and indeed of Rousseau's friendship with Jean Donzel, confectioner in St Gervais and burgess of Nyon, there is no doubt. In a letter to Jean-François Deluc, written after his departure from Geneva in October 1754, Rousseau sent good wishes to 'M. and Mme Donzel'.[46] But we must not exaggerate his connection with St Gervais. Because Rousseau published such memorable recollections of his life as an apprentice and a footman, posterity tends to forget that he was descended from the social *élite* of Geneva, that he was born in one of the best houses in the upper town, a child on his mother's side of an upper-class family. In Geneva, academic society, of which Samuel Bernard was a luminary, enjoyed a parallel distinction to that of the political patriciate. Although Rousseau grew up in an 'educated artisan' milieu and could say of himself, as he sometimes did, 'the status of the artisans is my own',[47] he was recognized in Geneva as a man of superior birth, and, indeed, almost everyone he names in the *Confessions* as friends made while he was in Geneva that summer belonged to the same academic *élite* as his maternal grandfather, and his correspondence of the period names other people of similar distinction.

Rousseau quickly made friends with the two most eminent members of the Commission which interrogated him on behalf of the Consistory, Professor Jallabert and Pastor Sarasin. Pastor Jean Sarasin was the son of Vincent Sarasin, the indiscreet admirer of Rousseau's mother.[48] Born in 1693 and known as 'the Elder' to distinguish him from Pastor Jean Sarasin 'the Younger' (born in 1703), Sarasin remained on friendly terms with Rousseau until his death in 1760, that is to say two years before Rousseau published the books which turned most of Geneva against him, and made a particular enemy of Jean Sarasin 'the Younger'.

Of Jallabert, a Professor of Physics in the Academy, Rousseau writes in the *Confessions*: 'I read him my *Discours sur l'inégalité* (but not the Dedication) and he seemed carried away.'[49] Their friendship was unclouded. Jallabert,

born the same year as Rousseau, was afterwards a syndic, and ended his career as librarian and councillor of the republic; he used his authority more than once to defend Rousseau but died in an accident in 1768.[50] Another friend mentioned in the *Confessions* is Amédée or Ami Lullin, Rector of the Academy. A patrician by rank and fortune, Lullin had nevertheless once run up against the Censorship in Geneva. When the great jurist and political philosopher, Burlamaqui, who was his close friend, died in 1748, Lullin prepared a funeral elogium to read in the great hall of the Academy. He intended to demonstrate Burlamaqui's contribution to the tradition of Grotius and Pufendorf in the theory of natural law, a theory which, in asserting the rights of man, evidently disturbed the authorities to such a point that the First Syndic, by order, forbade the author to read his speech, on the pretext that funeral orations had been forbidden by several edicts.[51]

It has been suggested[52] that Rousseau may have learned of this experience of Rector Lullin's and as a result been confirmed in his resolution to dedicate his *Discours sur l'inégalité* to the Republic of Geneva and not to the magistrates.

The death of Amédée Lullin in 1756 meant that his friendship with Rousseau was not put to the test of the scandal provoked by *Émile* and the *Contrat social* when those books were published in 1762, as was the friendship of the other intellectuals Rousseau names, notably Pedriau, Vernes and Moultou.

It was Pedriau, Pastor of Saconnex, who introduced Rousseau to the formidable theologian Jacob Vernet, and who was indeed to be Vernet's successor as Professor of Literature at the Academy. Born, like Jallabert, in the same year as Rousseau himself, Pedriau exercised some influence in Geneva, but he disappointed Rousseau in his efforts to have the Dedication of his *Discours sur l'inégalité* accepted by the authorities. In fact nearly all the Genevan friends from the summer of 1754 failed Rousseau in one way or another. Jacob Vernes was too shocked by what Rousseau published in 1762 to hide his disapproval. Then there was Marc Chappuis, Gauffecourt's secretary, who made himself very useful to Rousseau as a *cicerone* during his stay in the city, but whom Rousseau afterwards suspected of being bought over by his enemies with the offer of Gauffecourt's position with the Salt Monopoly, but who was in fact so true to his principles that he kept that office for only a very short time. Paul Moultou, a theological student aged twenty-nine when Rousseau first met him, is recalled in the *Confessions* as 'the one I always loved, despite his often equivocal behaviour towards me'.[53] Their friendship survived all vicissitudes and Moultou ended up as a sort of literary executor for Rousseau.

Besides these friends named in the *Confessions*, Rousseau's correspondence shows him to have been acquainted with the political *élite* of Geneva society.

For example, soon after he had satisfied the formalities for the recovery of his rights as a citizen, the then First Syndic of the Republic, Jean-Louis Du Pan, wrote to him an extremely cordial letter[54] to say that he would be taxed at a mere eighteen florins a year, 'the lowest tariff for a citizen', and be exempt from all arrears. Du Pan urged Rousseau to call on his fellow Syndic, Pierre Mussard, 'who would not be displeased to know you'. This was the successful diplomat whose inauguration as a Syndic Rousseau had attended in July, and according to Du Pan he had 'acceded with real pleasure' to the proposal to give Rousseau privileged treatment as a taxpayer.* We have no record of Rousseau's meeting with Pierre Mussard, but we find Du Pan writing to Rousseau the following summer after reading the Dedication of the *Discours sur l'inégalité*: 'You have depicted us as we ought to be and not as we are.' This exceedingly telling phrase occurs in a letter[55] which again is marked by its gracious and appreciative tone.

There can be no doubt that the ruling oligarchy of Geneva was delighted to have Rousseau back on the citizens' roll. It was not simply the politicians like Jacques-François Deluc, or the professors like Jallabert, Vernet, Lullin and Pedriau, who befriended him: he was shown the utmost consideration by those who might be expected to be deterred by his 'singularity'. Indeed the welcome was so universal that Rousseau began to talk about settling in Geneva for good. In July, when writing to his friends in Paris, Rousseau said he had come to Geneva simply to arrange the small matter of securing approval for the dedication of his *Discours sur l'inégalité* and that he would certainly be back in Paris by the autumn: 'I shall leave here with regret,' he wrote to François Mussard on 6 July,[56] 'but I shall nevertheless leave at the beginning of September.' On 12 July[57] he wrote much the same thing to Lenieps; apologizing for his precipitate departure from Paris, he added: 'I shall come to embrace you in the month of September.'

But by the month of August, Rousseau was saying in Geneva that he had decided to settle in his native city. Professor Jean-François Pictet, for example, reported in a letter written at the end of August:[58] 'he has given us to hope that, having put his affairs in order, he will come back among us to end his days.' In the *Confessions* Rousseau tells the same story: 'I was so touched by all the goodness that was shown to me by the Council and the Consistory, and by the kindly and decent treatment I received from all the magistrates, ministers and citizens, that, pressed by the good fellow Deluc, who entreated me without ceasing, and prompted even more by my own inclination, I proposed to return to Paris only to break up my household, put my modest affairs in order, find a job for Mme Levasseur and her husband, or provide for their subsistence, and then return with Thérèse to establish myself in Geneva for the rest of my days.'[59]

* Rousseau continued, through Marc Chappuis, to pay his minimal tax for the next few years.

From what Rousseau wrote at the time, it is clear that although he was talking about settling in Geneva he had not finally made up his mind to do so. 'I have a great desire to come back here next spring and settle,' he wrote to Charles Duclos on 1 September.[60] 'However, my decision is not yet fixed in the matter and we shall have time to talk about it this coming winter.'

In the same letter Rousseau complains about the life he has to lead at Eaux-Vives. Being on a road just outside the gates of Geneva, his house 'has become a halting-place for passing visitors who hold me in thrall'. He is determined if he does come back to Geneva to live in the 'real country' so as to escape 'all these importunings'. One can well imagine that this constant stream of visitors made it difficult for Rousseau to work, and yet he claims in the *Confessions* that he wrote a great deal. He speaks of having translated, despite his limitations as a Latinist, the first book of the *History* of Tacitus,[61] and is thought by competent scholars to have done it very creditably; and if he did not actually complete anything else, he drafted a *History of the Valais*, a tragedy in prose on the subject of *Lucretia*, and made some progress on his 'Political Institutions'.

The fact that he was preparing another dramatic work shows that Rousseau was still attached to the theatre. He cannot have seen many plays, for public theatres were still forbidden in Geneva, and apart from perform-ances given in private houses the only alternative was the theatre at Carouge, today a part of Geneva but then a neighbouring town in the Kingdom of Sardinia. However, this facility for playgoing was diminished in July 1754 when the wooden amphitheatre collapsed, causing a death and several injuries.[62] There can be no doubt about Rousseau's continued love for dramatic literature. In a letter[63] he wrote on 1 July 1754 to Georges-Louis Le Sage *père*, he proclaims his regard for 'that great man Molière',* and he goes on to adumbrate, if not to develop, a whole theory of drama: 'Although the principles of theatrical aesthetics have not yet been given either by the moderns or even by Aristotle that measure of clarity they could be given, they are easy to establish. Those principles seem to me to be reducible to two, namely imitation and interest, which apply equally to music. For fear of obscurity, I would not say that their beauty consists in the imitation of the truth, but rather that it consists in the truth of the imitation.'

Evidently, at this period of his 'conversion' to the Calvinist Church, Rousseau was not the enemy of the theatre, nor was he generally the puritan that he became a few years later. He did not even insist that the theatre should be treated as an instrument of moral improvement: 'There can be a very good play,' he said in his letter to Le Sage *père*, 'on a subject which has no utility, such as the *Oedipus* of Sophocles.'[65] It is hard to recognize in the

* Two years earlier, Lenieps had characterized Rousseau as a great lover of the theatre and above all of the works of Molière.[64]

writer of this letter* the author of the *Lettre à M. d'Alembert sur les spectacles*, which in 1758 condemned the stage as an unmitigated evil.

It might well be supposed that Rousseau's constant contact with Jacques-François Deluc that summer would have shaken his belief that Geneva was an ideal state. Deluc was a radical, a leader if not at that time *the* leader of the opposition party, 'an Argus and pitiless censor of the government'[66] in the words of George-Louis Le Sage *fils*; so it might seem improbable that he would have subscribed to Rousseau's description of Geneva in his Dedication as a republic where the sovereignty of the people was assured and the constitution excellent and where wise laws were administered by magistrates of the people's own choice; it might well seem improbable also that Deluc would have supported Rousseau's conclusion that the citizens' chief duty was to enjoy the privilege of their situation, preserve their unity, obey their rulers, banish suspicion from their hearts and put their trust in the government.[67] But in fact Deluc did so. Assuredly it is the case that Jacques-François Deluc would at other times have poured scorn on such idolatry of the *status quo*, and Marcel de Mezières,[68] who prided himself on his moderation in politics and his skill in reconciling differences among the factions, had needed all his art to restrain the fervour of Deluc's radical passion in the 1730s. In the 1760s again Deluc was the ardent champion of the citizens' resistance to the government. It was Deluc who provided Rousseau with much of the material for his *Lettres écrites de la montagne*, where Geneva is described as being a republic only in name, while being in fact a despotism where the people have no liberty at all. This is the pamphlet in which Rousseau makes his unforgettable assertion that the people of Geneva, far from being as free as the subjects of the King of England, are 'slaves of an arbitrary power and delivered without mercy to the twenty-five despots of the *petit conseil*'.[69]

These words, however, were written in 1764 after the authorities of Geneva had turned against Rousseau because of his *Émile* and the *Contrat social*, and when Jacques-François Deluc had been driven once more into vigorous opposition to the régime. But we are now concerned with a period ten years earlier, and although there were already at that time Genevans saying the things Rousseau was to say in his *Lettres de la montagne*, Deluc was not one of them. It is important to distinguish the political views of Deluc from the radicalism of Micheli du Crest, the democratic leader in exile, whose notes on the fortifications of Geneva Rousseau confessed having passed, as a young man in Chambéry, to the Sardinian enemy. Micheli du

* The recipient of this letter, Georges-Louis Le Sage *père* (1676–1769), was a prolific writer on scientific subjects, mainly in the field of mathematics and physics. As a Protestant exile in England (from Burgundy, his birthplace), he became a keen Newtonian. He had lived since 1711 in Geneva.

Crest, in a pamphlet[70] published soon after the French mediation of 1738,* denied that that settlement had generally restored the rights of the general council of citizens or effectively diminished the despotic powers of the patrician *petit conseil*; he argued that while the post-mediation settlement conferred on the general council the title of 'sovereign', together with formal 'legislative', 'elective' and 'confederative' powers, in reality these words were meaningless in that the *petit conseil* retained power to initiate legislation, nominate candidates and negotiate treaties with foreign states. As a result of the mediation, 'the general council recovered the right to assemble, but was forbidden to discuss any matter not introduced by the magistrates, who can in effect translate their commands into laws and obey no one but themselves'. Micheli du Crest concludes with the words very like those used many years later by Rousseau: 'the people of Geneva are delivered into the hands of twenty-five masters'.[71]

Such arguments Rousseau may well have heard expressed in Paris by Lenieps, who was a radical in exile like Micheli du Crest himself, but he would not have heard them in Geneva in 1754 from Jacques-François Deluc, however much that *homme politique* may have grumbled in his garrulous, tedius way about the government.† The fact of the matter was that Deluc, like Gauffecourt, had been charmed by the French Mediator into thinking that the mission of 1738 had produced an acceptable constitutional settlement. Indeed, in 1747, Deluc had gone to the length of writing, in reply to Micheli du Crest's attack on the constitutional situation in Geneva, a paper entitled *Réfutation des erreurs de M. Micheli du Crest sur le règlement de l'Illustre Médiation*.‡ In these pages Deluc argues that the restored republican constitution does all it claims to do in conferring on the citizens of Geneva the right to legislate, in the sense of allowing them to meet in the general council to approve of laws and reprimand violations, and he discerns nothing but wisdom in the manner in which the mediation settlement separates the executive duties of the *petit conseil* from the legislative functions of the general council.

* This was the mediation which ended the small civil war which Rousseau witnessed when he went to Geneva at the age of twenty-five to collect his inheritance.

† Indeed, when Rousseau's *Lettres écrites de la montagne* appeared ten years later in 1764, Jacob Vernet, a conservative in politics however liberal in theology, suspected the influence of Lenieps over Rousseau and not that of Deluc. In a pamphlet entitled *Lettre d'un Citoyen* (1768) Vernet wrote: 'The settlement of the Mediation of 1738 is a true social contract between the different orders of the state, for the reciprocal protection of their privileges ... M. Micheli du Crest sought 38 years ago to disturb that order, and overthrow the balance. Angry with the government because he had lost a lawsuit, he devised with M. Lenieps a democratic plan ... He admitted no division of powers; he gave everything to the people ... it is a great misfortune for us that M. Rousseau, too much a friend of M. Lenieps in Paris, should have adopted all his ideas and given them the brilliance of his own style.'[72]

‡ Written in 1747, this was published in 1763 by the conservatives as part of their own propaganda, when Deluc had turned against the régime.

It must be remembered that Deluc's political group was that which represented the citizen and burgess interest, the group which claimed that the general council, composed of 1,200 men, was the sovereign body of the state. It was not a popular party; it did not assert that the 14,000 *natifs*, *habitants* and aliens who dwelt in Geneva had any share in the sovereignty; and when it spoke of 'the people' it meant only 'the citizens'. Hence the conspicuous absence of democracy from Geneva did not disturb Deluc. His outlook, satisfied with the mediation settlement, was a comfortable sort of liberalism which would do little to shake the romantic conservatism which Rousseau had imbibed from his father in his childhood and had never lost. The admiration of the Genevan republic which Rousseau proclaimed in the Dedication and repeated in his letter to Mme Dupin in July was not much diminished by anything he heard or saw in his first weeks in that city.

There had been some changes in Geneva since the time when Rousseau was born. The liberal opposition, subdued during Rousseau's childhood and youth after the execution of Pierre Fatio and Nicolas Lemaître, had sprung to life again in the 1730s and brought the city to the brink of the civil war which Rousseau witnessed in 1737. The French mediation of 1738, however bitterly condemned by Micheli du Crest, had evidently satisfied the majority of Genevans and not only Gauffecourt and Deluc; for while it kept the privileges of the patriciate intact, it restored at least in form the constitutional rights of the citizens, and moreover improved the circumstances of the majority, the non-citizens, by giving them access to trades from which they had been excluded. A gulf nevertheless remained between the top six per cent of Genevans who belonged to the patrician class and the rest. If most Genevans were content in 1754 with their régime, it meant that they were content to have the dominant families rule them. The city was, in any case, well ruled. The Genevan upper class did not exploit the humbler classes economically; they made their fortunes from foreign investment, banking and other such commercial activities which in no way limited the freedom of the industrial classes to reap the rewards of their own labours in their workshops and factories. There were no tax farmers in Geneva, as there were in France, sucking the blood of the people. Indeed the government of Geneva had instituted something like a welfare state, with its Wheat Commission, which ensured the people of Geneva food at fair prices when subjects of neighbouring kingdoms suffered hunger and misery because harvests were bad. There was also a public educational system which produced a far more cultivated artisan class than any other country had, as Rousseau once pointed out in a letter[73] to M. Tronchin: 'A watchmaker in Geneva is presentable anywhere; a watchmaker in Paris is only fit to talk about watches.' The government of Geneva was never more popular than in the summer of 1754, after Mussard had achieved such a diplomatic triumph

in settling all residual obstacles to peace between Geneva and the House of Savoy. The first meeting of the general council that Rousseau was able to attend as a restored citizen of Geneva was dedicated to the installation of Mussard as a Syndic, and he can then have witnessed nothing but enthusiasm for the government.

The ruling families of Geneva, keeping their monopoly of all places on the *petit conseil*, were perhaps more self-satisfied and condescending than ever, and becoming more and more 'French' with affluence, they were perhaps increasingly removed from the more ordinary people who lived down the hill. But there is no reason to suppose that this would have alienated them from Rousseau, or him from them.

While he was in Geneva, Rousseau heard news of Mme de Warens, although he seems not to have received it directly from her; it is rather to Gauffecourt that we find Mme de Warens writing on 2 August 1754.[74] 'If you see M. Rousseaux [sic],' she asks, 'please give him my friendly greetings,' a request which seems to imply that she is not writing to Rousseau in person. Her letter to Gauffecourt, which recounts the usual tale of woes, was evidently prompted by some act of kindness on his part.* She tells her correspondent that she is soon moving from Chambéry to a 'little hermitage' at Jussy, near Thonon, and expresses the hope that he will visit her there. This 'little hermitage' was on the estate of the Marquis de Coudrée, and since Mme de Warens' iron foundry at Reclus was on another property belonging to the same owner, it is fair to suppose that M. de Coudrée was that 'old nobleman of the highest distinction' described by M. de Conzié as an admirer of Mme de Warens who furnished some of her necessities and who would have helped her more if only 'she had disclosed to him the melancholy and inevitable future which threatened her'.[76] These words of M. de Conzié leave one wondering why, if they are true, Mme de Warens did not disclose to a generous old nobleman apprehensions she disclosed to so many others less well placed to help her, including Jean-Jacques Rousseau.

On her way to Jussy in August, Mme de Warens passed by Geneva, and there at Grange-Canal she had what is usually assumed to have been her last meeting with '*petit*'. She told him she was penniless; and no doubt she was, for she had by this time been formally listed in the Kingdom of Sardinia as a pauper, and all her goods, distrained, were to be sold by auction on 1 September at Chambéry,[77] at the insistence of her former partner and chief creditor, Camille Perrichon.

'She had not even the money to finish her journey,' Rousseau recalls in the *Confessions*, 'and I had not enough with me to provide it. I sent it to her an hour later in the hands of Thérèse. *Poor maman*. I must give one more

* He seems to have intervened – unsuccessfully – with M. Perrichon, seeking to dissuade him from foreclosing on Mme de Warens' assets.[75]

proof of her goodness of heart. She had no jewels left except one little ring, which she took from her finger to put on Thérèse's. Thérèse promptly put it back on *maman*'s finger, at the same time kissing the noble hand and moistening it with tears. Ah, that was the moment when I should have paid my debt, given up everything to be with her, attached myself to her until her dying hour, shared her fate, whatever it might have been. I did nothing of the kind ... Taken up with another attachment, I felt the tie which bound me to her loosening. I had no longer any hope of turning my affection for her to any good purpose. I sighed; but I did not follow her.'[78]

Mme de Warens may not have wished him to. Her paramount needs were material, and Rousseau was in no position to satisfy those. Emotionally, each had long since exhausted what the other had to offer. When Mme de Warens reached Jussy on 1 September she wrote a fairly cheerful letter to her nephew across the lake in Switzerland. She told him that she was worn out after a journey of four days from Chambéry, but for once she said nothing about her financial troubles: she simply intimated that she would 'greatly appreciate a barrel of your good wine'.[79]

Mme de Warens lived, in ever increasing misery, for another seven years. After the death, in 1755, of her benefactor at Jussy, she seems to have survived on scraps of charity from her friends in Chambéry. She kept up to the end a plucky fight for her rights, but it was a hopeless one. She was a remarkable character, out of her country, out of her time in history, far too modern and liberated and enterprising for eighteenth-century Savoy. She was in most respects a very good woman, ill rewarded for her generosity by those who feasted on it, including her 'adopted son'; and yet, of course, if it had not been for him, Mme de Warens would never have acquired her enigmatic immortality; we should simply never have heard of her.

In the *Confessions* Rousseau implies, though he does not assert, that his meeting with Mme de Warens at Grange-Canal in August 1754 was his last. But it is possible he saw her once more. On Sunday, 22 September, he set off on an excursion by rowing boat round the lake with Jacques-François Deluc and his sons. A note[80] in Rousseau's hand records that the party spent that Sunday night at the Château de Coudrée, which was the property of M. de Coudrée. We know that Mme de Warens was at her 'hermitage' at Jussy on the same estate. Can Rousseau have been so near, and not paid her a visit? In the *Confessions* he says nothing about this occasion and only speaks of his parting from her at Grange-Canal causing him 'the most bitter and enduring remorse I have ever felt in my life'.[81] Such feelings of guilt might well explain his avoiding Mme de Warens, if he did avoid her, at Jussy. All we can tell from the evidence is that he left the Château de Coudrée after one night to continue his trip on the lake.

During that summer at Eaux-Vives Rousseau fell in love all over again

with the lake of Geneva and the countryside around it, with nature as he had first known it as a boy. 'I have found a modest dwelling outside the town beside the lake,' he told Mme Dupin in his letter of 20 July.[82] 'It is in a delightful situation which reminds me of Chenonceaux.' We may wonder why an Alpine lake should have reminded Rousseau of a river in Touraine, but obviously the water had a special charm for him. He not only took his daily walk on a path beside the lake, he made a habit of feeding the fish, as his kinsman Théodore Rousseau recalled years later in a letter[83] to the press: 'I went very often to see J. J. Rousseau at Eaux-Vives, especially on Sundays, early in the morning. Nearly always I found him at the water's edge, giving crumbs of bread to the swarms of little fish that gathered near the shore and rose to feed from his fingers. He taught them to come every morning at the same time. If he arrived half an hour early they would not be there; he had to wait, but when the habitual time came, they appeared; and if he was a few minutes late, he always found them waiting. The activity of the little fish and the person who fed them often attracted a lot of people to the spot, and added not a little to his reputation as a friend of humanity.'

Nobody in Geneva marvelled at Rousseau's love of country walks, for *la promenade pédestre* was a popular Swiss recreation. If any gentleman in eighteenth-century France or England wanted outdoor exercise, he would ride, and Rousseau's joy in wandering on foot was reserved for those who could not afford a horse. Walking, however, was more than an exercise for Rousseau, it was a moral and psychological necessity: 'Walking does something which animates and stimulates my ideas; I can hardly think when I am still; my body must be moving for my mind to work.'[84] His friends understood; a walk in the open air, they observed, made him cheerful, cordial, communicative, and even jovial.[85] 'The countryside,' Rousseau claimed, 'is my study.'[86]

He had none of the usual eighteenth-century fear of exposure to the sun, and while he had a typically Swiss indifference to the allure of the sea or any kind of flat landscape, wild nature excited his intellectual curiosity as well as his poetic ardour. Botany was to become his favourite pastime. He had been introduced to that science as a youth by Claude Anet and Mme de Warens as part of their search for herbal remedies. Wild flowers possessed for Rousseau not only the aesthetic qualities of bright, uncultivated beauty, but healing powers of divine provenance for men whose ills were mainly due to the baneful influence of society. 'Plants,' he wrote, 'seem to have been scattered in profusion over the earth, like the stars in the sky, to summon men, through the attraction of pleasure and curiosity, to the study of nature.'[87]

Rousseau's passionate feeling for nature, which had been so intense during his 'idyll' at Les Charmettes and given so little satisfaction during his years in Paris, was not only reawakened during these summer months beside Lake

Geneva, it took on a new form as it became fused with deism. Seeing in creation the person of the Creator, he was more than ever sensible of the awe-inspiring qualities of the natural world. Rousseau thrilled to nature as it appeared in Alpine scenery – in vast snow-covered mountains and dark thick forests, majestic, overwhelming, forceful, intimidating; nature as God's naked untouched workmanship, as far removed as possible from nature regulated by the hand of man. All this gave Rousseau's break with the Enlightenment a new dimension, reversing its aesthetics as well as its metaphysics.

It is instructive in this connection to notice Rousseau's response to Poussin's painting of the Great Flood. Unlike Poussin's earlier paintings of Biblical scenes, this remarkable picture, now hanging in the Louvre, possesses none of that classical repose which is the ideal of seventeenth-century aesthetics, but achieves effects of heightened emotion which painters of a later generation strove for. It depicts nature in angry colours; under blackening, stormy skies, swirling waters engulf the human figures in the foreground struggling in vain to escape their doom. It is a profoundly disturbing painting, an expression, perhaps, of Poussin's own retreat from Christianity into paganism, for it shows nature as an angry instrument of terror instead of nature either as part of a settled rational order or as the creation of a loving God.

'There is only one picture that has ever affected me in my life,' Rousseau once said.[88] 'It is Poussin's painting of the Great Flood. I looked at it for a whole hour and could not leave it even though it filled my soul with the most intense bitterness. I could feel the whole of nature suffering there. I had it for a long time in front of my eyes. Oh, I could not stay in a room with that painting: I should be overcome by a mortal sadness.'

Rousseau's moral crisis was carrying him in the opposite direction to Poussin: he was turning away from scepticism towards Christianity; but he discerned in Poussin's painting of the Great Flood an aesthetic and moral character he had recognized in no other work of art. It may even have prompted him to see nature itself in a new light; and as he became more acquainted with the Alps, he began to find that towering mass of granite, snow and virgin forest far more stirring than cultivated fields of vineyards or gardens. In developing this taste for the dramatic and the extreme, Rousseau scandalized his friends in Paris; in music, he could carry the *philosophes* with him in preferring melody to harmony, but he would never shake their innate love of elegance, order and moderation in the arrangement of the external world; in this respect the *philosophes* were quintessentially French. It needed someone less rigidly cartesian to awaken the sensibilities of Europe to divine disorder, to propel people's taste from classicism to romanticism.

The more Rousseau came to associate nature with the ideas of God, the

more he responded to those forms of nature which were most mighty, most awesome, most imposing in their majesty. Already at Chambéry, in the pre-Alps, he could say of himself: 'Flat country, however beautiful it might be, has never seemed beautiful to me. I must have torrents, rocks, pine trees, black forests, mountains, steep paths to climb and descend, precipices around all to make me feel fear.'[89]

Fear, it will be noticed, is an integral part of the almost mystical transports which Rousseau felt. He himself had no urge to climb the highest mountain, but his young friends Jean-André and Guillaume-Antoine Deluc were pioneers of Alpinism; that very summer they ascended the glaciers above Chamonix, and one cannot doubt they did something to excite Rousseau's enthusiasm for the highest peaks.* They certainly organized the trip in a rowing boat across Lake Geneva to the canton of Valais which made such a powerful impression on Rousseau in September 1754. He recalls in the *Confessions* that of all the pleasures he enjoyed that year in Geneva that boat trip was the most delightful: 'We took seven days to make the journey in the most beautiful weather in the world. I have kept the most intense memory of the places that impressed me at the other side of the lake, and which I described several years later in *La Nouvelle Héloïse*.'[91]

Guillaume-Antoine, the younger brother, known to Rousseau as 'Guillot', kept a record in his journal[92] of the trip, on which Rousseau and Thérèse accompanied him and his wife,† his brother and his father: 'We enjoyed perfect weather throughout the six days' journey,' he writes. 'Apart from supper, we usually ate our meals on the edge of the water. In the evenings we stopped to sleep at one of the towns or villages on the shore of that beautiful lake.' The trip included, after the first night at Coudrée, stops at Meillerie – a place made famous in *La Nouvelle Héloïse* – at Bex, St Maurice, Aigle and Villeneuve in the Valais, and at Vevey, Cully, Lausanne and Morges in the Vaud; it ended at Eaux-Vives on 29 September. 'Is there not something worthy of Homer in my voyage?' Rousseau asked himself.[93]

In *La Nouvelle Héloïse* Rousseau puts his description of the Alps into the mouth of Saint-Preux:[94]

'I came to the mountains to ponder,' Saint-Preux writes to Julie, 'but my attention was captured by what was to be seen. At one moment immense rocks hung in ruins above my head. At another, high and rushing waterfalls overcame me with their heavy mist. Then an endless mountain stream opened beside me a ravine too deep for my eyes to penetrate. Now I found

* On his return to Paris Rousseau arranged for the *Encyclopédie* to commission an account by the Deluc brothers of their voyage to the glacier, but they appear never to have written the article. In his journal, one of the Deluc brothers provides a brief record of their 'painful and arduous expedition between Mont Blanc and the Mont de la Tête Noire'.[90]

† Françoise Vieusseux married Jean-André Deluc in 1752. She was pregnant at the time of the boat trip.

myself in the darkness of a sombre forest. Now I emerged to find a pretty meadow to delight my eyes . . . It was at this altitude that I unwound perceptibly in the purity of the air, the true cause of the change of my spirits, the return of that inner peace which I had lost for so long. Indeed the general impression that everyone has, even though they do not all understand it, is that in the high mountains, where the air is pure and delicate, breathing is easier, the body feels lighter, the mind is more serene, pleasures are less feverish and passions more moderate. Meditation there assumes a strange grandeur and sublimity, in proportion to the environment which affects us with a certain tranquil voluptuousness that has nothing sharp or sensual about it. It seems that in rising above the level where men live, one leaves behind all base and terrestrial feelings, and to the extent that one approaches the ethereal regions the soul contracts some part of their unchanging purity.'[95]

If the countryside had long served Rousseau as his 'study', this particular landscape of the Valais, where the high snow-covered mountains which rose above the southern shore of Lake Geneva and closed in towards another chain to form the valley of the Rhône, now offered to serve his natural religion as its cathedral.

Here the mere intellectual contemplation of nature gave way to adoration. As Rousseau explained to M. de Malesherbes, he always found when he was in a vast solitary space that his spirit lost itself: 'I do not think, I do not reason. I feel myself, with a kind of voluptuousness, possessed of the substance of the universe.'[96] Elsewhere he recalled how, in the presence of untamed nature, 'a sweet and profound reverie takes hold of the senses so that you lose yourself, with a delicious intoxication, in the immensity of that splendid system with which you identify yourself; and then all particular things escape you, and you only see and feel the whole.'[97]

Rousseau's response to the landscape of the Valais was not purely mystical. He was interested in the inhabitants. It would seem to follow from his theory of society that men living in such a superb environment would have nobler souls than other men; it was obvious, from the fact that they eked out a meagre living from a pastoral economy, that the men of the Valais were wholly uncorrupted by sophisticated modernity, and therefore, according to the argument of Rousseau's first discourse, they ought also to be morally superior. His friends in Paris had nothing but scorn for such *montagnards*; indeed in the *Encyclopédie* itself the word *'crétin'* was illustrated by reference to the village idiots of the Valais. Since stupid people and a horrible landscape went together for the *philosophes*, Rousseau had to take up the argument and refute it by showing that both mountains and *montagnards* were good.

Yet he never finished his projected *History of the Valais*. What he did do, in

his *Lettre à M. d'Alembert sur les spectacles*, written in 1758 in defence of Swiss simplicity against the endeavours of the *encyclopédistes* to corrupt it, was to plead that the pastoral culture of rustic Alpine people was superior to the trivial amusements of advanced societies, and he gave some account of what those folk arts were.

Even so, Rousseau in 1754 had not yet really quarrelled with the *encyclopédistes*; he had not yet turned his back on science. The Deluc brothers, his companions on the trip round the lake, were scientists; their enthusiasm for the open air and their intellectual curiosity about nature went together. Undoubtedly Rousseau's friendship influenced them.[98] Their original inspiration was, like that of other members of the Genevan academic community, a dry Lockean empiricism, the belief that the way to the enlargement of knowledge lay in investigation and experiment and the accumulation of publicly verifiable facts. Their conversations with Rousseau gave it all a fresh perspective, introducing a poetic or mystical element which Locke's philosophy sought deliberately to banish. The published works of both Jean-André Deluc as a physicist and Guillaume-Antoine Deluc as a naturalist are informed by an aesthetic sensibility towards nature which is altogether distinct from the cold scientific curiosity of the empiricist.

The time had come for Rousseau to pack for his departure. He told his friends that he was going to Paris only to put his affairs in order, and that he would be back in Geneva the following spring to settle permanently. Before he left on 10 October, the Library of Geneva commissioned him to secure a full set of Diderot's *Encyclopédie*: 'M. Rousseau offering to ensure that the plates we are sent are the best impression, the proposal is agreed.'[99]

Thus Rousseau, preparing to leave Geneva for Paris, once more assumed the role of an *encyclopédiste*. We cannot doubt that for all the satisfaction he had experienced during those months in Geneva, he felt more than a little nostalgia for Paris and for the society of his French friends. Two bereavements among them during his absence, the deaths of Mme d'Holbach and of Mme Francueil, had prompted a real sense of loss.[100] He had changed his status in Geneva, but not altered his identity; he still belonged to the literary world of Paris in a sense in which he could not possibly belong to the society of Geneva.

By the middle of October, he and Thérèse were back at their apartment in Paris.

'I made the journey much more pleasurably and swiftly than I expected,' Rousseau wrote[101] to Vernes in Geneva: 'I notice that my reappearance here has surprised a lot of people who wanted to make out that I would not be allowed to return to the Kingdom and that I had been "banished" to Geneva – which would be for me rather like a French bishop being

"banished" to the Court. Anyway, here I am, in spite of them and their back-biting, waiting until my heart speeds me to where you are, which it would do immediately if I consulted my heart alone. I have found none of my friends here. Diderot is in Langres, Duclos in Brittany, Grimm in Provence; even d'Alembert is in the country – so that I have left in Paris only those acquaintances for whom I do not care enough to disturb my solitude by seeing.'

One can well understand that Rousseau's heart may have impelled him to return to Geneva. His visit had been an unblemished success, and apart from the remorse of his parting for ever from Mme de Warens, he had probably passed one of the happiest summers of his life. And yet he could not fail to recognize the several impediments to his settling in his native city. First, there was the question of a livelihood. The only daily *métier* that now remained to him was music-copying, and in a city starved of music as a result of Calvinist suppression of the performing arts there was no demand for a music copyist. Conceivably, Rousseau might hope to live by authorship, and indeed he had made the acquaintance that summer in Geneva of a bookseller and printer who was in time to enable him to do so. This was Marc-Michel Rey,[102] a self-educated man some eight years younger than Rousseau, a Genevan, humbly born, who was making his fortune by publishing in the one city on the continent where the press was free, Amsterdam. Rey was soon to take the publication of Rousseau's *Discours sur l'inégalité* out of the hands of the Paris bookseller Pissot and later to publish all his more important writings. Even so, by October 1754 Rousseau had not yet written these profitable works; he could not expect to keep himself, let alone Thérèse and her family as well, on an author's royalties. There was talk in Geneva of his being offered a job there as librarian, but it was only talk. Indeed we must ask ourselves whether the plan for Rousseau to return to settle in Geneva was ever more than fantasy.

It has been suggested[103] that a sense of guilt prompted Rousseau's desire to return. If so, the few weeks he spent there may have done more to sharpen than to mitigate that feeling. For the Geneva with which he had renewed his acquaintance was a city of upright and believing Protestants, among whom Rousseau could not fail to be aware that his morals were equivocal and his creed unsound by the standards of his neighbours. He could not expect to persuade himself in Geneva that he was the most innocent of men. In Paris, among the hedonists and the materialists, the atheists and the libertines, the sceptics and the cynics, he could easily imagine that he was a better Christian than others. In Paris he could feel entitled to castigate the corruption of the modern world, the false values of polite society, the emptiness and superficiality of contemporary philosophy, to do so, moreover from the standpoint of a guiltless soul. In Paris, he could enact the part of Savonarola. In

Geneva, already purged and purified by Calvin, there was no such adversary role for him to perform. There was really no place for him there.

He came in time to realize, moreover, that Geneva was not altogether the ideal republic that he had made it out to be. Soon after he returned to Geneva he received from Jean Pedriau a letter making it clear that the Dedication of his *Discours sur l'inégalité* to the republic of Geneva would not be welcome in that city. Pedriau's letter has disappeared, but Rousseau's reply[104] tells us all we need to know. He defends his intention to dedicate the *Discours* to the republic as a whole and not simply to the magistrates by pointing out that by reserving his eulogies for the magistrates and his exhortations for the citizens he has avoided any suggestion of partiality. To the objection that addressing dedications to a republic is something 'not done', he replies that it is a good idea to do for the first time something worth doing. As for the need for discretion, for leaving certain things unsaid, Rousseau argues that the example of Herostratus proves that depriving people of the freedom to speak of something is the worst way to make them forget it. He prefers a 'generous temerity to the pusillanimous circumspection now in fashion'.

Rousseau goes on to say that he is unwilling to submit his *Discours* or anything else he writes to any sort of censorship: 'My experience has made me take the firm resolution to be henceforth my own censor,' he writes; and he declares his intention, 'to cherish my poverty and my independence'. Although he expressed the hope that 'such sentiments will not diminish me in the eyes of my fellow citizens' he must have realized that his resolution to be his own censor precluded any possibility of his settling in Geneva, where all publications were subject to censorship, as Pedriau had reminded him.

The project of his return to his native land was thus thwarted by two insurmountable obstacles: he was not the man he ought to be, in the eyes of Geneva; and Geneva was not the place it ought to be, in his eyes. Nothing remained for him but to 'cherish' his 'poverty and independence' in exile.

Freedom was the principle to which he remained throughout his life most faithful. His love of Geneva was not simply love of his native city, but love of a free city. Isaac Rousseau had brought him up to believe that Geneva was free, and to be a patriot, not just because he was a citizen, but because he was a citizen of a free republic; a republic that was free by definition, and therefore not to be criticized but loved. Time was to strip Jean-Jacques of his illusions about Geneva, but never to alter his republican, or classical, conception of liberty. For the typical French, English or American mind, freedom was largely a matter of a man being left alone by the state in doing what he wanted to do; for Rousseau the Genevan, it was largely a matter of participating in the sovereignty of the state, and making the laws one lived under,

obeying one's own will. Rousseau believed with Aristotle that 'man is a political animal'; and he felt himself to be a citizen born and bred. Only to be a citizen it was necessary to have a city; and when Rousseau realized he could never go back to Geneva, he understood that he was doomed to a frustrating existence as an alien, a solitary wanderer in foreign places. In a society where he could not live as a 'political animal', he could not achieve his own true nature, and could therefore expect no lasting happiness. Such was in fact to be his melancholy destiny, and he experienced it with peculiar intensity because he regarded it not simply as the singular misfortune of Jean-Jacques Rousseau, but as the unperceived predicament of every man in the modern world, 'born to be free but everywhere in chains'.

LIST OF THE PRINCIPAL
ABBREVIATIONS USED IN
THE NOTES

AEG Archives d'État, Geneva.
Annales *Annales de la Société Jean-Jacques Rousseau*, Geneva, 1905– .
Assézat-Tourneux *Œuvres complètes de Diderot*, ed. J. Assézat and M. Tourneux, 20 vols., Paris, 1875–7.
BL British Library (British Museum), London.
BN Bibliothèque Nationale, Paris.
BPU Bibliothèque Publique et Universitaire, Geneva.
BVN Bibliothèque de la Ville de Neuchâtel.
Brissot J. P. Brissot de Warville, *Mémoires*, Paris, 1912.
CC *Correspondance complète de J.-J. Rousseau*, ed. R. A. Leigh, Geneva, Banbury and Oxford, 1965– .
Cérésole V. Cérésole, *J. J. Rousseau à Venise*, Geneva, 1885.
CG *Correspondance générale de J.-J. Rousseau*, ed. T. Dufour and P. P. Plan, 20 vols., Paris, 1924–34.
CL *Correspondance littéraire . . . par Grimm, Diderot, Raynal, Meister*, ed. M. Tourneux, Paris, 1877– .
CTW *Complete Theoretical Works of J.-P. Rameau*, ed. E. R. Jacobi, 6 vols., New York, 1967–72.
Derathé R. Derathé, *J.-J. Rousseau et la science politique de son temps*, Paris, 1950.
Dufour (1878) T. Dufour, 'J.-J. Rousseau et Mme de Warens', *Revue Savoisienne*, 1878, XIX, pp. 73ff.
Dufour (1925) T. Dufour, *Recherches bibliographiques sur les œuvres imprimées de J.-J. Rousseau*, 2 vols., Paris, 1925.
Encyclopédie *Encyclopédie, ou Dictionnaire raisonné des sciences, des arts et des métiers*, 35 vols.
Essai J.-J. Rousseau, *Essai sur l'origine des langues*, ed. Porset, Bordeaux, 1970.
G The 'Geneva' manuscript of Rousseau's *Confessions*.
Grosclaude P. Grosclaude, *J.-J. Rousseau à Lyon*, Lyons, 1933.
Guillermin C. Guillermin, *Mémoires et documents publiés par la Société savoisienne*, 1856.
Havens G. R. Havens, *Voltaire's Marginalia on the Pages of Rousseau*, Columbus, 1933.
Jansen A. Jansen, *J.-J. Rousseau als Musiker*, Berlin, 1884.
Kisch Eve Kisch, 'Rameau and Rousseau', *Music and Letters*, XXII, pp. 97–114.
Kors A. D. Kors, *D'Holbach's Coterie*, Princeton, N.J., 1976.
Launay M. Launay, *J.-J. Rousseau: Écrivain politique*, Cannes, 1972.

L'Intégrale	*Œuvres complètes de J.-J. Rousseau,* ed. for the Bibliothèque L'Intégrale by M. Launay, 3 vols., Paris, 1967.
MAE	Ministère des Affaires Étrangères, Paris.
Masters	R. Masters, *The Political Philosophy of Rousseau,* Princeton, N.J., 1968.
Metzger	A. Metzger, *La Conversion de Mme de Warens,* Paris, 1886.
Montbrillant	*Les Pseudo-mémoires de Mme d'Épinay: L'Histoire de Mme Montbrillant,* ed. G. Roth, 3 vols., Paris, 1951.
Mugnier	F. Mugnier, *Madame de Warens et J.-J. Rousseau,* Paris, 1890.
N	The 'Neuchâtel' manuscript of the *Confessions.*
OC	*Œuvres complètes de J.-J. Rousseau,* ed. for the Bibliothèque de la Pléiade by B. Gagnebin, M. Raymond et al., Paris, 1959– .
Oliver	A. R. Oliver, *The Encyclopedists as Critics of Music,* New York, 1947.
P	The 'Paris' manuscript of Rousseau's *Confessions.*
QB	*La Querelle des Bouffons,* ed. Denise Launay, 3 vols., Paris, 1973.
RHLF	*Revue d'histoire littéraire de la France.*
Ritter	E. Ritter, *La Famille et la jeunesse de J.-J. Rousseau,* Paris, 1896. (The second edition appears in *Annales,* XVI, pp. 1–250.)
Roth–Varloot	*Correspondance de Denis Diderot,* ed. G. Roth and J. Varloot, 16 vols., Paris, 1955–70.
Spink	J. S. Spink, *Rousseau et Genève,* Paris, 1934.
Starobinski	J. Starobinski, *J.-J. Rousseau, la transparence et l'obstacle,* Paris, 1971.
Vallette	G. Vallette, *J.-J. Rousseau: Genevois,* Paris and Geneva, 1911.
Wilson	A. Wilson, *Diderot,* New York, 1972.
Wokler (1979)	R. Wokler, 'Rousseau on Rameau and Revolution', in R. F. Brissenden and J. C. Eade (eds.), *Studies in the Eighteenth Century,* VI, Canberra, 1979, pp. 251–83.
Wokler (1980)	R. Wokler, 'The *Discours sur les sciences et les arts* and its Offspring', in Harvey, Hobson, Kelly and Taylor (eds.), *Reappraisals of Rousseau,* Manchester, 1980.

NOTES

CHAPTER ONE: GENEVA (pages 13–29)

1. See L. Blondel, *Annales*, 1931, p. 281.
2. N, p. 15.
3. See B. Gagnebin, *Journal de Genève*, 8–9 February 1958.
4. Spink, p. 6.
5. See J. R. Hale, *Florence and the Medici*, London, 1977.
6. L. Binz, *Brève Histoire de Genève*, Geneva, 1981, pp. 28–30.
7. See R. Guerdan, *Histoire de Genève*, Paris, 1981, pp. 169–204.
8. See Charles Du Bois-Melly, *Les Mœurs genevoise*, 2nd edn, Geneva and Basle, 1882, p. 41.
9. P, I (*OC*, I, p. 6).
10. See especially Ritter; L. Dufour-Vernes, *Recherches sur J.-J. Rousseau et sa parenté*, Geneva, 1878; *Les Ascendants de J.-J. Rousseau*, Geneva, 1890; A. François, *Annales*, XXXI, pp. 254–7, and *OC*, I, pp. 1237–9.
11. J. A. Galiffe, *Notices généalogiques*, Geneva, 1831, pp. 310–16.
12. See Babel's *Les Métiers dans l'ancienne Genève*, Geneva, 1916.
13. *Annales*, XVI, pp. 62–3.
14. See Launay, pp. 43–60.
15. See Leigh, *Annales*, 1980, pp. 106–7.
16. See P. O'Mara, 'Geneva in the Eighteenth Century', unpublished thesis of the University of California, 1952, p. 265. Material drawn from his thesis may be found in the *Bulletin de la Société d'Histoire et d'Archéologie de Genève*, No. X.
17. Ritter, p. 118, and *Annales*, XVI, p. 99.
18. Notably O'Mara in his thesis and Launay, pp. 13–43.
19. P, I, p. 1; N, p. 14 (*OC*, I, p. 6).
20. P, I, p. 1; N, p. 13 (*OC*, p. 6).
21. P, I, pp. 1–2 (*OC*, I, p. 6).
22. N, p. 13; P, I, p. 1(*OC*, I, p. 6).
23. See Vallette, pp. 16–18.
24. Sir Gavin de Beer, *Rousseau and his World*, London, 1972, p. 7.
25. Ritter, p. 134, and *Annales*, XVI, p. 112.
26. P, I, p. 2; N, p. 14 (*OC*, I, p. 7).
27. ibid.
28. See D. Bensoussan, *La Maladie de Rousseau*, Paris, 1974, and S. Élosu, *La Maladie de J. J. Rousseau*, Paris, 1928.
29. P, I, p. 3 (*OC*, I, p. 10).
30. P, I, p. 3 (*OC*, I, p. 10).
31. P, I, p. 4 (*OC*, I, p. 11).
32. *CC*, I, p. 83.
33. See L. J. Courtois, *Enfance faubourienne de Jean-Jacques à Coutance*, Geneva, 1933.
34. P, I, p. 3 (*OC*, I, p. 10).
35. ibid. But see p. 28.
36. P, I, p. 2; N, p. 17 (*OC*, I, p. 8).
37. See Launay, pp. 19–20.
38. P, I, p. 3; N, pp. 17–18 (*OC*, I, p. 9).
39. *CC*, V, pp. 241–2.
40. Notably by O'Mara and by Launay, pp. 20–28.
41. *CC*, V, p. 242. See also Denise Leduc-Fayette, *J.-J. Rousseau et le mythe de l'antiquité*, Paris, 1974, pp. 11–31.
42. N, p. 18; P, I, p. 2 (*OC*, I, p. 9).
43. *OC*, I, p. 1037.
44. *Lettre à M. d'Alembert*, ed. L. Fontain, Paris, 1926, § 192. See also A. Bloom, *Politics and the Arts*, Glencoe, 1960, p. 112.
45. As in his letter to Dr Tronchin (*CG*, IV, pp. 142–3).

46. P, I, p. 31; N, p. 87 (*OC*, I, p. 61).
47. *OC*, III, p. 118.
48. P, I, p. 3 (*OC*, I, p. 9).
49. P, I, p. 3 (*OC*, I, p. 10).
50. P, I, p. 3 (*OC*, I, p. 9).
51. ibid.
52. *Lettre à M. d'Alembert*, ed. Fuchs, Lille, 1948, pp. 181–2.
53. Vallette, p. 5.
54. Bérenger, *Histoire de Genève*, III, p. 384.
55. See François Jost, *Jean-Jacques Rousseau, Suisse*, Fribourg, 1961, I, pp. 155–89.
56. See Vallette, pp. 402–6.
57. Vallette, p. 27.
58. *OC*, I, p. 1036.
59. *OC*, I, p. 1037.
60. *OC*, I, p. 1240.
61. Ritter, pp. 158–67; *Annales*, XVI, pp. 131–9.
62. See F. Aubert, 'J. J. Rousseau à Nyon', *Annales*, XVII, pp. 179–91.

CHAPTER TWO: BOSSEY (pages 30–42)

1. N, p. 32; P, I, p. 9 (*OC*, I, p. 21).
2. N, p. 20; P, I, p. 5 (*OC*, I, p. 13).
3. ibid.
4. P, I, p. 6 (*OC*, I, p. 15).
5. N, p. 23; P, I, p. 6 (*OC*, I, p. 15).
6. P, I, p. 6 (*OC*, I, p. 15).
7. ibid.
8. P, I, p. 7 (*OC*, I, p. 17).
9. ibid.
10. N, pp. 25–6.
11. ibid.
12. P, I, p. 6 (*OC*, I, p. 15).
13. N, p. 23.
14. Ritter, pp. 173–80; *Annales*, XVI, pp. 142–8.
15. ibid.
16. N, p. 33; P, I, p. 10 (*OC*, I, p. 24).
17. See *OC*, I, pp. 1209–10.
18. N, p. 33; P, I, p. 10 (*OC*, I, p. 22).
19. N, p. 29; P, I, p. 8 (*OC*, I, p. 19).
20. N, p. 31; P, I, p. 9 (*OC*, I, p. 20).
21. N, p. 31; P, I, p. 9 (*OC*, I, p. 21).

For the significance of the 'veil' in this passage, see Starobinski.
22. N, p. 44. See also P, I, p. 10 (*OC*, I, p. 25), where the wording varies.
23. N, p. 89. See also P, I, p. 12 (*OC*, I, p. 26), where the wording varies.
24. N, p. 38.
25. P, I, p. 10 (*OC*, I, p. 25).
26. P, I, p. 14 (*OC*, I, p. 30).
27. N, p. 45; P, I, p. 14 (*OC*, I, p. 31).
28. N, p. 45; P, I, p. 14 (*OC*, I, p. 30).
29. N, p. 52; P, I, p. 17 (*OC*, I, p. 35).
30. N, p. 55 (P, I, p. 18 (*OC*, I, p. 37) with minor omissions).
31. N, p. 40; P, I, p. 13 (*OC*, I, p. 27).
32. N, p. 40. These four words were deleted by Rousseau from later versions of his *Confessions*.
33. P, I, p. 13 (*OC*, I, pp. 27–8).
34. N, pp. 42–3.
35. ibid.
36. N, p. 42; P, I, p. 13 (*OC*, I, pp. 28–9).
37. N, p. 41; P, I, p. 13 (*OC*, I, p. 27).
38. N, p. 41.
39. P, I, p. 13 (*OC*, I, p. 27).
40. P, I, p. 7 (*OC*, I, p. 18).
41. ibid. (This passage does not appear in N.)
42. N, p. 59; P, I, p. 19 (*OC*, I, p. 40).
43. N, p. 45. (Omitted from later versions.)
44. N, pp. 46–7 (P, I, p. 15 (*OC*, I, p. 31) with minor additions).
45. N, p. 63; P, I, p. 21 (*OC*, I, p. 42).
46. N, pp. 63–4 (P, I, p. 21 (*OC*, I, p. 42) with some omissions).
47. N, p. 64; P, I, p. 21 (*OC*, I, pp. 42–3).
48. See *OC*, I, pp. 1209–10.
49. See *OC*, I, pp. 1210–11.

CHAPTER THREE: ANNECY (pages 43–51)

1. N, p. 68; P, I, p. 22 (*OC*, I, p. 46).
2. P, I, p. 22 (*OC*, I, p. 46).
3. P, I, p. 23 (*OC*, I, p. 47). In the earlier version of the *Confessions*, Rousseau provides a marginally more

earnest account of his visit to M. de
Pontverre (N, pp. 68–71).

4. N, p. 68; P, I, p. 22 (OC, I, p. 45).

5. N, p. 71; P, I, p. 23 (OC, I, p. 48).

6. N, p. 72; P, I, p. 24 (OC, I, p. 48).

7. op. cit.

8. N. pp. 72–3; P, I, p. 24 (OC, I,
pp. 48–9).

9. ibid.

10. N, p. 73; P, I, p. 48.

11. P, I, p. 24 (OC, I, p. 49). In the
earlier version of his Confessions,
Rousseau ends this paragraph with
the words 'After mass, I shall have
time to talk to you' (N, p. 73).

12. N, pp. 71–2 (P, I, p. 23 (OC, I, p. 48)
omits the reference to 'ugly teeth').

13. OC, I, pp. 1098–9.

14. Les Portraits de Madame de Warens,
Lyons, 1888.

15. pp. v–vi.

16. Les Portraits de J.-J. Rousseau.

17. P, I, p. 25 (OC, I, p. 50). The
earlier text (N, pp. 74–5) is less
ample, but does include the remark,
removed from the later version: 'even
when she was old she was still
beautiful'.

18. Guillermin, I, pp. 77–86.

19. See Perrero, 'Madama di Warens',
in Curiosità e ricerche di storia subalpina,
Turin, 1879, III, p. 389.

20. Mugnier, p. 12.

21. N, pp. 79–80.

22. N, p. 81; P, I, p. 27 (OC, I, p. 55).

23. ibid.

24. N, p. 81 (not in later versions).

25. N, p. 83; P, I, p. 29 (OC, I, p. 57).

26. ibid.

27. N, p. 84; P, I, p. 29 (OC, I, p. 58).

28. ibid.

29. N, p. 85; P, I, p. 30 (OC, I, p. 59).

CHAPTER FOUR: TURIN (pages
52–68)

1. See P. M. Masson, 'Le séjour de
J.-J. Rousseau à l'hospice du Spirito
Santo', Revue d'histoire littéraire de la
France, XXI, 1914, p. 62.

2. OC, I, p. 995.

3. N, p. 87; P, I, p. 31 (OC, I, p. 61).

4. Jean Le Sueur, Histoire de l'Église et
de l'Empire, Geneva, 1674–88.

5. P, I, p. 32 (OC, I, p. 64). N, p. 89,
has a different wording.

6. N, p. 86; P, I, p. 30 (OC, I, p. 60).

7. ibid.

8. N, p. 86; P, I, p. 30 (OC, I, p. 61).

9. N, p. 92; reproduced in P, I, p. 34
(OC, I, p. 67) with some omissions.

10. N, p. 94; P, I, p. 35 (OC, I, p. 69).

11. N, p. 95; P, I, p. 35 (OC, I, p. 70).

12. N, p. 97; P, I, p. 36 (OC, I, p. 72).

13. Dictionnaire de la musique, Amster-
dam, 1768: 'Le Chantre'. See also
A Complete Dictionary of Music, trans.
W. Waring, London, 1779: 'Chant'.

14. N, p. 97; P, I, p. 36 (OC, I, p. 72).

15. N, p. 99; P, I, p. 37 (OC, I, p. 73).

16. N, p. 99 (not in later versions).

17. N, p. 99; P, I, p. 37 (OC, I, p. 74).

18. N, p. 100; P, I, pp. 37–8 (OC, I, p.
74), some words omitted.

19. See Starobinski, pp. 189–91, for a
discussion of these variations.

20. N, p. 101; P, I, p. 38 (OC, I, p.
75).

21. BVN, MS R 48.

22. N, p. 102; P, I, p. 38 (OC, I, p.
76).

23. ibid.

24. N, p. 101.

25. P, I, p. 38 (OC, I, pp. 75 and
1268).

26. BVN, MS R 48; N, p. 102; P, I, p.
38 (OC, I, p. 76).

27. N, p. 105; P, I, p. 40 (OC, I, p.
79).

28. N, p. 106; P, I, p. 40 (OC, I, p.
80).

29. N, p. 106; P, I, p. 41 (OC, I, p.
81).

30. N, p. 106; P, I, p. 41 (OC, I, p.
81).

31. N, p. 107; P, I, p. 41 (OC, I, p.
81).

32. N, p. 107; P, I, p. 41 (OC, I, p.
82).

33. N, p. 109; P, I, p. 42 (OC, I, p. 83).

34. N, p. 110; P, I, p. 48 (*OC*, I, p. 85).
35. N, p. 118; P, I, p. 47 (*OC*, I, p. 93).
36. N, p. 116; P, I, p. 46 (*OC*, I, p. 92).
37. N, p. 123; P, I, p. 50 (*OC*, I, p. 98).
38. N, p. 119; P, I, p. 47 (*OC*, I, p. 94).
39. N, pp. 119–20; P, I, p. 47 (*OC*, I, pp. 94–5).
40. P, I, p. 47 (*OC*, I, pp. 95–6).
41. N, p. 121.
42. N, p. 121.
43. N, p. 133. In the later version, he goes even further and says 'I would have given my life to have once again a quarter of an hour with a Mlle Goton' (P, I, p. 45 (*OC*, I, p. 88)).
44. N, p. 114; P, I, p. 45 (*OC*, I, p. 89).
45. N, p. 115.
46. P, I, p. 46 (*OC*, I, p. 90).
47. N, p. 123; P, I, p. 50 (*OC*, I, p. 98).
48. N, pp. 127–8; P, I, p. 50 (*OC*, I, p. 102).
49. ibid.
50. N, p. 129; P, I, p. 53 (*OC*, I, p. 104).

CHAPTER FIVE: A SENTIMENTAL EDUCATION (pages 69–98)

1. Not de la Tour de Pil, as Rousseau writes (N, p. 73; P, I, p. 24 (*OC*, I, p. 49)).
2. Again, Rousseau is mistaken in saying 'like me, she had lost her mother at her birth' (N, p. 75; P, I, p. 24 (*OC*, I, p. 50)).
3. The extent of Magny's influence on Mme de Warens is a matter of some controversy. Ritter (pp. 239ff. and *Annales*, XVI, pp. 199ff.) argues that Magny's influence on her, and through her on Rousseau, was crucial, but Mugnier (pp. 24–5) disputes this.
4. Ritter, p. 251; *Annales*, XVI, p. 208.
5. P, I, p. 124 (*OC*, I, p. 197).
6. J. Voisine, 'Quelques personnages secondaires des Confessions', *Revue des Sciences humaines*, April–June 1963, pp. 221ff.
7. See *CC*, II, p. 288 for a letter from Tavel to a nephew of Mme de Warens, dated 17 March 1746, sending money to help her.
8. N, p. 75; P, I, p. 25 (*OC*, I, p. 50).
9. *CC*, I, p. 280.
10. N, p. 74; P, I, p. 50 (*OC*, I, pp. 49–50).
11. ibid.
12. ibid.
13. *CC*, I, pp. 292–5.
14. Claude Boudet, *La Vie de Mgr Rossillon de Bernex, évêque de Genève*, Paris, 1751, pp. 119–28.
15. On 22 September 1732 (Old Style) to Daniel-François de Loys de Middes. Lausanne, Archives cantonales, Fond Loÿs, 2260 (*CC*, I, pp. 266–90).
16. ibid.
17. N, p. 77; P, I, p. 25 (*OC*, I, p. 51).
18. Musée de Vieux Vevey, Vevey, Dossier Warens (*CC*, I, pp. 254–5).
19. loc. cit.
20. Instructions for the payment of 1,500 *livres* a year to the Dama di Warens were signed by the King on 18 September 1726 (*CC*, I, pp. 258–9). She had already written to thank him for it, in characteristically fulsome language, on 13 September 1726 (*CC*, I, p. 257).
21. *CC*, I, p. 269.
22. *CC*, I, p. 275.
23. *CC*, I, p. 278.
24. *CC*, I, p. 290.
25. N, p. 129; P, I, p. 53 (*OC*, I, p. 104).
26. N, p. 131; P, I, p. 53 (*OC*, I, p. 105).
27. ibid.
28. ibid.
29. ibid.

30. N, p. 131; P, I, p. 54 (*OC*, I, p. 107).
31. N, p. 133; P, I, p. 55 (*OC*, I, p. 108).
32. ibid.
33. N, p. 133; P, I, p. 55 (*OC*, I, p. 109).
34. N, p. 134; P, I, p. 56 (*OC*, I, p. 109).
35. N, p. 135; P, I, p. 56 (*OC*, I, p. 110).
36. N, p. 138; P, I, p. 57 (*OC*, I, p. 113).
37. P, I, p. 59 (*OC*, I, p. 116). Not in N.
38. P, I, p. 58 (*OC*, I, p. 114).
39. N, pp. 138–9.
40. N, p. 141; P, I, p. 59 (*OC*, I, p. 117).
41. P, I, p. 61 (*OC*, I, p. 121).
42. Several Rousseau scholars, beginning with Dufour (1925, p. 15), have stated that Le Maistre's surname was 'Nicoloz', but this assertion is based on a misreading of the town register of Annecy for 1726.
43. N, p. 147; P, I, p. 62 (*OC*, I, p. 123).
44. *CC*, I, pp. 146–51. The memorandum is dated 19 April 1742.
45. N, p. 145; P, I, p. 60 (*OC*, I, p. 121).
46. ibid.
47. N, p. 155; P, I, p. 67 (*OC*, I, p. 132).
48. P, I, p. 65 (*OC*, I, p. 129). In the Paris manuscript, from which these words are quoted, the paragraph continues: 'Thank heaven I have finished this third painful confession'. The earlier Neuchâtel manuscript, which carries a shorter account of the episode, continues: 'Thank heaven I have finished this second painful confession' (N, pp. 153–4).
49. N, p. 144; P, I, p. 60 (*OC*, I, pp. 119–20).
50. See Mugnier, pp. 62–6.
51. See L. F. Benedetto, *Madame de Warens*, Paris, 1914, pp. 143–62, and *CC*, I, pp. 297–311.
52. N, p. 156; P, I, p. 66 (*OC*, I, p. 130).
53. *CC*, I, pp. 301–2.
54. *CC*, I, pp. 306–7.
55. In his letter dated 30 July 1730 (*CC*, I, pp. 303–4).
56. *CC*, I, p. 305.
57. *CC*, I, p. 300.
58. *CC*, I, p. 304.
59. ibid.
60. N, p, 158; P, I, p. 67 (*OC*, I, p. 134).
61. Mugnier, pp. 76–7.
62. N, p. 159; P, I, p. 67 (*OC*, I, p. 134).
63. N, p. 159.
64. P, I, p. 68 (*OC*, I, p. 134).
65. N, p. 159; P, I, p. 68 (*OC*, I, p. 134).
66. Probably 29 June 1730, to judge from the meteorological records of Annecy.
67. N, p. 160; P, I, p. 68 (*OC*, I, p. 135).
68. ibid.
69. She was born on 27 June 1710. See F. and J. Serand, *L'Idyle des cerises*, Annecy, 1912.
70. N, p. 161; P, I, p. 69 (*OC*, I, p. 136).
71. N, p. 162; P, I, p. 69 (*OC*, I, p. 137).
72. ibid.
73. N, p. 163; P, I, p. 70 (*OC*, I, p. 138).
74. N, p. 164; P, I, p. 70 (*OC*, I, p. 138).
75. N, p. 165; P, I, p. 71 (*OC*, I, p. 140).
76. N, p. 169; P, I, p. 72 (*OC*, I, p. 142).
77. P, I, p. 73 (*OC*, I, p. 144); N, pp. 170–71 (some words omitted).
78. N, p. 172; P, I, p. 74 (*OC*, I, pp. 145–6).
79. N, p. 171; P, I, p. 73 (*OC*, I, p. 145).
80. *c.* May 1731, BPU, MS de Saussure, ff. 40–44 (*CC*, I, p. 12).
81. *c.* 20 July 1730 (*CC*, I, p. 1).

82. N, p. 173; P, I, p. 74 (*OC*, I, p. 146).
83. ibid.
84. N, p. 175; P, I, p. 74 (*OC*, I, p. 147).
85. N, p. 178; P, I, p. 76 (*OC*, I, p. 150).
86. BPU, MS de Saussure, ff. 37–9 (*CC*, I, p. 8).
87. N, p. 180; P, I, p. 76 (*OC*, I, p. 151).
88. N, pp. 180–81; P, I, p. 77 (*OC*, I, p. 152).
89. N, p. 181; P, I, p. 77 (*OC*, I, p. 152).
90. See E. Couvet, 'Rousseau et Vevey', *Bibliothèque Universelle* 67 (1912), pp. 81–108.
91. N, p. 182.
92. *OC*, I, p. 153.
93. P, I, p. 78 (*OC*, I, p. 156).
94. Notably his correspondence at the time. (See *CC*, I, pp. 12–15.)
95. BPU, MS de Saussure, ff. 40–44 (*CC*, I, p. 13).
96. BPU, MS de Saussure, ff. 37–9 (*CC*, I, pp. 7–8).
97. P, I, p. 81 (*OC*, I, pp. 160–61).
98. P, I, p. 81 (*OC*, I, p. 161).

CHAPTER SIX: CHAMBÉRY (pages 99–117)

1. Otherwise Chazeaux. See Grosclaude, p. 5.
2. P, I, p. 86 (*OC*, I, p. 171).
3. P, I, p. 84 (*OC*, I, p. 165).
4. P, I, p. 84 (*OC*, I, p. 167).
5. P, I, p. 86 (*OC*, I, p. 170).
6. P, I, p. 91 (*OC*, I, p. 176).
7. P, I, p. 89 (*OC*, I, p. 173).
8. Inspired, it appears, by the work of Micheli du Crest in Geneva. See J. H. Graf, *Das Leben und Wirken des Physikers ... aus Genf*, Berne, 1890, p. 98.
9. P, I, p. 89 (*OC*, I, p. 174).
10. P, I, p. 93 (*OC*, I, p. 180).
11. P, I, p. 92 (*OC*, I, p. 178).
12. ibid.
13. ibid.
14. Rousseau is correct in saying that Anet was from Montreux: he was baptized there on 17 May 1706, the son of David Anet and Marguerite du Crest (Dufour, p. 22).
15. In Mugnier, p. 116.
16. P, I, p. 92 (*OC*, I, p. 178).
17. P, I, p. 95 (*OC*, I, p. 187).
18. See G. Daumas, *Revue des sciences humaines*, 1952, pp. 109–15 and 215–27.
19. P, I, p. 93 (*OC*, I, p. 182).
20. P, I, p. 94 (*OC*, I, p. 184).
21. P, I, p. 96 (*OC*, I, p. 188).
22. P, I, p. 93 (*OC*, I, p. 181).
23. P, I, p. 95 (*OC*, I, p. 187).
24. Boubers, pp. 357–8. Mugnier (p. 142) suggests that the correct date should read '1733', as does the Pléiade edition (*OC*, I, p. 1329–30), but as Blanchard was dismissed in 1732, the date given by Boubers seems more likely to be right (see also *CC*, I, pp. 16–19).
25. Boubers, p. 357 (*CC*, I, pp. 16–19).
26. See the draft of a letter by Rousseau (to the Comtesse de Challes?) asking for payment for lessons given to her daughter, and thanking her for fees paid 'during my illness of 1732' (BPU, MS de Saussure, 21, ff. 100, and *CC*, I, pp. 22–3).
27. P, I, p. 97 (*OC*, I, p. 190).
28. P, I, pp. 96–7 (*OC*, I, p. 189).
29. P, I, p. 98 (*OC*, I, p. 192).
30. See Mugnier, pp. 133–4.
31. P, I, p. 97 (*OC*, I, p. 191).
32. P, I, p. 98 (*OC*, I, p. 193).
33. P, I, p. 93 (*OC*, I, p. 181).
34. P, I, p. 115 (*OC*, I, p. 222).
35. P, I, p. 99 (*OC*, I, p. 193).
36. P, I, p. 99 (*OC*, I, p. 194).
37. ibid.
38. P, I, p. 100 (*OC*, I, p. 195).
39. P, I, p. 101 (*OC*, I, p. 197).
40. See Albert de Montet. 'Mme de Warens et les pays de Vaud', *Mémoires et documents publiés par le société d'histoire de la Suisse romande*, 1891, III, p. 50.

41. P, I, p. 101 (*OC*, I, p. 198).
42. ibid.
43. P, I, p. 103 (*OC*, I, p. 201).
44. ibid.
45. P, I, p. 105 (*OC*, I, p. 205).
46. See *OC*, I, p. 329.
47. P, I, p. 106 (*OC*, I, pp. 205–6).
48. ibid.
49. P, I, p. 106 (*OC*, I, p. 206).
50. P, I, p. 103 (*OC*, I, p. 200).
51. ibid.
52. Guillermin (1856), pp. 77–86 (*CC*, I, pp. 292–5).
53. In the Archives at Turin there is a letter from Mme de Warens to the Marquis d'Ormé, Minister of State, dated 25 May 1732, asking for delayed payments to be made; and another letter, dated 12 June 1732, acknowledging receipt of the money (*CC*, I, pp. 312–13).
54. See F. Mugnier, *Nouvelles Lettres de Mme de Warens*, Paris, 1900, p. 16.
55. 18 December 1734. Turin, Biblioteca Municipale, Cosilla Collection, No. 40 (*CC*, I, p. 314).
56. P, I, p. 104 (*OC*, I, p. 203).
57. BPU, MS de Saussure, 2. Leigh (*CC*, I, pp. 35–6) suggests that the letter was intended for Gabriel Bagueret, described by Rousseau as 'one of the ugliest men and the biggest fools I ever met' (P, I, p. 114; *OC*, I, p. 220).
58. P, I, p. 111 (*OC*, I, p. 214).
59. ibid.
60. P, I, p. 108 (*OC*, I, p. 209).
61. ibid.
62. 3 March [1739] (*CG*, I, pp. 87–90).
63. P, I, p. 108 (*OC*, I, p. 209).
64. P, I, p. 111 (*OC*, I, p. 215).
65. P, I, p. 114 (*OC*, I, p. 221).
66. P, I, p. 115 (*OC*, I, p. 222).
67. BPU, MS de Saussure, 2, f. 10 (*CC*, I, pp. 26–8).
68. BPU, MS de Saussure, 2, ff. 13–17 (*CC*, I, pp. 29–33).
69. Undated, but probably written in 1736. BPU, MS Fr. 232, p. 4 (*CC*, I, pp. 37–42).
70. 3 December 1736. Chantilly: Archives Condé, Série 5, Tôme II, ff. 32–3 (*CC*, I, pp. 42–4).
71. P, I, p. 116 (*OC*, I, p. 224).

CHAPTER SEVEN: LES
CHARMETTES (pages 118–40)

1. P, I, p. 116 (*OC*, I, p. 224).
2. P, I, p. 117 (*OC*, I, p. 226).
3. ibid.
4. Notably Mugnier, Metzger, Ritter, Plon, Guéhenno and Monglond.
5. See for example 'The False Idyll of Les Charmettes', in Guéhenno (trans, J. and D. Weightman), Vol. I, pp. 66–91.
6. Guillermin, I, p. 73.
7. See especially G. Daumas, 'L'Idylle des Charmettes', *Annales*, 1956–8, pp. 83–105, and H. de Saussure, 'Les Maisons des Charmettes', *Geneva*, N.S. IV, 1956.
8. P, I, p. 118 (*OC*, I, p. 227).
9. ibid.
10. P, I, p. 120 (*OC*, I, p. 231).
11. P, I, p. 125 (*OC*, I, p. 242).
12. P, I, p. 126 (*OC*, I, p. 242).
13. P, I, p. 121 (*OC*, I, p. 233).
14. P, I, p. 123 (*OC*, I, p. 236).
15. ibid.
16. P, I, p. 123 (*OC*, I, p. 237).
17. P, I, p. 124 (*OC*, I, p. 239).
18. P, I, p. 125 (*OC*, I, p. 240).
19. P, I, p. 127 (*OC*, I, p. 244).
20. Guillermin, I, pp. 77–86 (*CC*, I, pp. 292–7). Leigh suggests that this letter was addressed to the Comte d'Escherny.
21. P, I, p. 113 (*OC*, I, p. 218).
22. The will is conserved at the Bibliothèque Municipale, Chambéry (see also *OC*, I, pp. 1211–13).
23. P, I, p. 111 (*OC*, I, p. 215).
24. *CC*, I, pp. 44–8.
25. P, I, p. 111 (*OC*, I, p. 215).
26. *CC*, I, pp. 44–6.
27. P, I, p. 111 (*OC*, I, p. 216).
28. ibid.
29. P, I, p. 129 (*OC*, I, p. 247).

30. ibid.
31. *Le Verger* (1739), p. 8.
32. See also A. Corboz, 'Micheli du Crest, Polybe et Salomon', in *Genava*, XXVIII (1980), pp. 155–82.
33. P, I, p. 112 (*OC*, I, p. 216).
34. P, I, p. 112 (*OC*, I, p. 217).
35. P, I, p. 112 (*OC*, I, p. 218).
36. BPU, MS de Saussure, 5, ff. 34–5 (*CC*, I, pp. 68–71).
37. See *CC*, I, pp. 70–71.
38. P, I, p. 129 (*OC*, I, p. 247).
39. P, I, p. 129 (*OC*, I, p. 248).
40. P, I, p. 129 (*OC*, I, p. 248).
41. 13 September 1737 (*CC*, II, pp. 48–51).
42. 23 October 1737 (*CC*, I, pp. 53–9).
43. P, I, p. 130 (*OC*, I, p. 250).
44. P, I, p. 132 (*OC*, I, pp. 252–3).
45. ibid.
46. ibid.
47. P, I, p. 133 (*OC*, I, p. 254).
48. P, I, p. 133 (*OC*, I, p. 255).
49. ibid.
50. P, I, p. 134 (*OC*, I, p. 256).
51. P, I, p. 134 (*OC*, I, p. 257).
52. P, I, p. 135 (*OC*, I, p. 257).
53. P, I, p. 135 (*OC*, I, p. 258).
54. To M. Micoud, a friend in Grenoble, on 23 October 1737 (*CC*, I, pp. 51–3).
55. To M. Charbonnel, 4 November 1737 (Amsterdam, BU, MS 56, and *CC*, I, pp. 59–62).
56. idem.
57. idem.
58. idem.
59. idem.
60. *CC*, I, pp. 63–4.
61. See *CC*, I, p. 65.
62. P, I, p. 136 (*OC*, I, pp. 259–60).
63. P, I, p. 137 (*OC*, I, p. 261).
64. P, I, p. 137 (*OC*, I, pp. 261–2).
65. P, I, p. 139 (*OC*, I, p. 264).
66. P, I, p. 137 (*OC*, I, p. 261).
67. Mugnier, pp. 156–8; see also Albert Metzger, *Les Dernières Années de Mme de Warens*, Lyons, 1891.
68. BPU, MS de Saussure, ff. 96–8.
69. BPU, MS de Saussure, f. 86.
70. *CC*, I, p. 294.
71. Edition of 1739. A facsimile of this edition is in *CG*, I, pp. 351–66.
72. op cit., p. 3.
73. op. cit., pp. iv–v.
74. op. cit., p. 1.
75. op. cit., p. 5.
76. P, I, p. 126 (*OC*, I, p. 242).
77. ibid.
78. To Jean Fazy: BPU, MS de Saussure, 5, f. 34r (*CC*, I, pp. 66–7); to Clermonde Fazy: idem, ff. 34r–35r (*CC*, I, pp. 68–71).
79. See *CG*, I, p. 74, note 1.
80. 20 September 1738. BPU, MS de Saussure, 11, ff. 72–7 (*CC*, I, pp. 73–82).
81. BPU, MS de Saussure, 4, ff. 29–33 (*CC*, I, pp. 82–7).
82. Rousseau to Piccone, *c.* 5 March 1739. Beaune, Bibliothèque Municipale, Fonds moderne, 278 (*CC*, I, pp. 93–6).
83. Rousseau to Mme de Warens, 5 March 1739. Beaune, Bibliothèque Municipale, Fonds moderne, 278 (*CC*, I, pp. 90–93).
84. *CC*, I, pp. 87–90.
85. BPU, MS de Saussures, 7, ff. 64–5 (*CC*, I, pp. 96–8).
86. *CC*, I, pp. 98–9.
87. *c.* 15 August 1739. BPU, MS de Saussure, 13, ff. 84–5 (*CC*, I, pp. 100–102).
88. *CC*, I, p. 102.
89. Chambéry, Bibliothèque Municipale, MS 145 (*CC*, I, pp. 316–17).
90. P, I, p. 140 (*OC*, I, pp. 266–7).

CHAPTER EIGHT: LYONS (pages 141–55)

1. BPU, MS de Saussure, 8, ff. 66–7 (*CC*, I, pp. 116–19).
2. BPU, MS de Saussure, 9 and 10, ff. 68 and 70 (*CC*, I, pp. 119–21).
3. 25 April 1740 (*CC*, I, pp. 121–2).
4. *OC*, II, pp. 1120–22.
5. 1 May 1740 (*CC*, I, pp. 123–4).
6. P, I, p. 141 (*OC*, I, p. 268).

7. ibid.
8. P, I, p. 141 (*OC*, I, pp. 267–8).
9. From Nyon, 22 August 1740. BPU, MS Fr. 204, ff. 52–3 (*CC*, I, pp. 124–6).
10. 'His leg healed very easily and very well, despite his age': Rousseau to De Peyrou, 2 October 1768. BVN, MS R 286, ff. 231–2 (*CC*, XXXVI, pp. 125–7).
11. *OC*, II, pp. 1130–31.
12. The poem was first published in *Le Journal de Verdun*, March 1743.
13. *OC*, II, p. 1132.
14. *CC*, I, p. 126.
15. See Grosclaude, pp. 31–2, and C. Aurenche, *J.-J. Rousseau chez M. de Mably*, Paris, 1934, pp. 112–16.
16. *OC*, II, p. 1133.
17. P, I, p. 145 (*OC*, I, p. 280).
18. Aurenche, op. cit., pp. 105–9.
19. P, I, p. 145 (*OC*, I, p. 280).
20. See his *Méthode nouvelle*, Paris, 1737.
21. P, I, p. 153 (*OC*, I, p. 294).
22. Not the original MS, but a copy made by François Coindet (BPU, MS Fr. 204).
23. *OC*, II, pp. 1136–46. According to the author's note, this poem was not completed until 10 July 1742, after he had left Lyons.
24. P, I, p. 146 (*OC*, I, p. 281).
25. Grosclaude, Chapter VI.
26. P, I, p. 111 (*OC*, I, p. 215).
27. P, I, p. 146 (*OC*, I, p. 281).
28. P, I, p. 141 (*OC*, I, p. 268).
29. ibid.
30. BPU, MS Fr. 203, ff. 217–18 (*CC*, I, pp. 126–7).
31. *OC*, IV, pp. 3–51.
32. *OC*, IV, pp. 49–51.
33. *OC*, IV, pp. 3–32.
34. *OC*, IV, p. 21.
35. ibid.
36. *OC*, IV, p. 22.
37. 19 April 1741 (*CC*, I, pp. 128–30).
38. ibid.
39. P, I, p. 142 (*OC*, I, p. 269).
40. P, I, p. 142 (*OC*, I, p. 270).
41. ibid.

42. ibid.
43. ibid.
44. Aurenche, op. cit., p. 75. See also H. de Saussure, *Rousseau et les manuscrits des Confessions*, pp. 202–5.
45. P, I, p. 86 (*OC*, I, p. 171).
46. P, I, p. 146 (*OC*, I, pp. 281–2).
47. Aurenche, op. cit., p. 85.
48. BPU, MS de Saussure, 17, ff. 88–9 (*CC*, I, pp. 103–6).
49. ibid.
50. *OC*, II, p. 1141.
51. *CC*, I, pp. 132–9 (MS at Thonon, Académie Chablaisienne).
52. BPU, MS Fr. 231, File 2, ff. 7–9 (*CC*, I, pp. 146–51).
53. 14 March 1742. BPU, MS Fr. 231, File 2, ff. 11–12 (*CC*, I, pp. 143–5).
54. *CC*, I, p. 144.
55. 17 June 1742. *CC*, I, pp. 151–6.
56. 25 June 1742. *CC*, I, pp. 156–8.
57. ibid.
58. Undated. BPU, MS Fr. 202, ff. 3–4 (*CC*, I, pp. 107–9).
59. Undated. BPU, MS de Saussure, 13, ff. 80–81 (*CC*, I, pp. 158–61).
60. Perhaps, as Leigh suggests, Cavanas (*CC*, I, p. 160).
61. BPU, MS de Saussure, 5, ff. 80–81.
62. P, I, p. 145 (*OC*, I, p. 280).

CHAPTER NINE: PARIS (pages 156–68)

1. P, I, p. 146 (*OC*, I, p. 282).
2. P, I, p. 147 (*OC*, I, p. 283).
3. See D. S. Schier, *Louis-Bertaud Castel*, Cedar Rapids, 1941, and *CC*, II, p. 336.
4. On 22 August 1742. See *CC*, I, p. 317.
5. P, I, p. 181 (*OC*, I, p. 347).
6. P, I, p. 147 (*OC*, I, p. 284).
7. See *CC*, I, pp. 317–22.
8. P, I, p. 148 (*OC*, I, p. 285).
9. ibid.
10. See *CC*, I, pp. 169–76.
11. *Dissertation sur la musique moderne par M. Rousseau ... Paris, chez G. F. Quillan*, pp. xvi, 101.

12. P, I, p. 149 (OC, I, p. 286).
13. P, I, p. 149 (OC, I, p. 287).
14. *Dissertation sur la musique moderne*, p. vi.
15. P, I, p. 149 (OC, I, p. 287).
16. P, I, p. 150 (OC, I, p. 289).
17. P, I, p. 151 (OC, I, p. 290).
18. Paul Meister, *Charles Duclos*, Geneva, 1956, p. 23.
19. op. cit., p. 20.
20. To Thérèse le Vasseur, 12 August 1769 (CG, XIX, p. 141).
21. P, I, p. 151 (OC, I, p. 290).
22. Wilson, p. 408.
23. P, I, p. 151 (OC, I, p. 291).
24. ibid.
25. P, I, p. 152 (OC, I, p. 292).
26. P, I, p. 152 (OC, I, p. 292).
27. CC, I, pp. 182-4.
28. 10 April 1743 (CC, I, pp. 185-7).
29. P, I, p. 152 (OC, I, p. 293).
30. ibid.
31. P, I, p. 153 (OC, I, p. 294).
32. P, I, p. 153 (OC, I, p. 295).
33. CC, I, pp. 187-9.
34. P, I, p. 154 (OC, I, p. 295).
35. CC, I, pp. 194-6.
36. CC, II, pp. 275-8.
37. P, I, p. 154 (OC, I, p. 296).
38. See Kolly to Montaigu (CC, I, pp. 193-6).
39. P, I, p. 154 (OC, I, pp. 296-7).
40. CC, I, p. 196.
41. P, I, p. 154 (OC, I, p. 297).
42. ibid.
43. CC, II, pp. 275-8.

CHAPTER TEN: VENICE (pages 169-92)

1. See P. Monnier, *Venise au XVIIIe siècle*, Lausanne, 1907; and M. Vaussard, *La Vie quotidienne en Italie au XVIIIe siècle*, Paris, 1959.
2. See CC, I, p. 188.
3. See S. Wilkinson, *The Defence of Piedmont 1742-1748*, Oxford, 1927.
4. MAE archives, *Corr. pol. de Venise*, Vol. 205, f. 55 (OC, III, p. 1813).
5. CC, II, pp. 50-55.

6. 19 November 1743 (CC, I, p. 210).
7. CC, II, pp. 275-8.
8. See CC, I, p. 203.
9. P, I, p. 155 (OC, I, pp. 297-8).
10. ibid.
11. P, I, p. 161 (OC, I, p. 309).
12. ibid.
13. See his letter to Amelot dated 8 August 1744 (MAE archives, *Corr. pol. de Venise*, Vol. 207, f. 72, and OC, III, p. 1821).
14. 5 October 1743. BPU, MS Fr. 202, ff. 9-10 (CC, I, pp. 198-200).
15. CC, I, p. 221.
16. To Saint-Germain (CC, II, p. 55).
17. See also J. Souchon, *Correspondance diplomatique du Comte de Montaigu*, Paris, 1915; V. Cérésole and T. de Saussure, *J.-J. Rousseau à Venise*, Geneva-Paris, 1885; A. Monglond, 'Rousseau secrétaire de M. de Montaigu', *Annales*, XXIV (1935), pp. 39-78.
18. OC, III, pp. 1045-6.
19. P, I, p. 156 (OC, I, p. 300).
20. ibid.
21. MAE archives, *Corr. Pol. de Venise*, Vol. 207 (OC, III, pp. 1056-7).
22. P, I, p. 156 (OC, I, p. 300).
23. CC, I, p. 215.
24. P, I, p. 158 (OC, I, p. 304).
25. 5 October 1743 (CC, I, pp. 200-201).
26. November 1743 (CC, I, pp. 212-14). The MS of this letter has disappeared.
27. P, I, p. 164 (OC, I, p. 314).
28. P, I, p. 165 (OC, I, p. 315).
29. P, I, p. 163 (OC, I, p. 313).
30. P, I, p. 165 (OC, I, p. 316).
31. CC, I, p. 217.
32. P, I, pp. 157-8 (OC, I, p. 302).
33. 25 January 1744. MAE archives, *Corr. pol. de Venise* (OC, III, p. 1127).
34. Catteneo to Berlin, 27 January 1744 (J. J. Olivier and Willy Norbert, *Une Étoile de la danse*, Paris, 1910, p. 36). See also OC, III, p. 1830.
35. 22 February 1744. MAE archives,

Corr. pol. de Venise (*OC*, III, p. 1142).

36. 11 April 1744. MAE archives, *Corr. pol. de Venise* (*OC*, III, pp. 1171–2).

37. 18 April 1744. MAE archives, *Corr. pol. de Venise* (*OC*, III, pp. 1176–7).

38. MAE archives, *Corr. pol. de Venise*, CCV, f. 103 (*OC*, III, p. 1815).

39. 26 October 1743 (*OC*, III, pp. 1065–7).

40. *OC*, III, p. 1824.

41. 7 March 1744. MAE archives, *Corr. pol. de Venise* (*OC*, III, p. 1151).

42. 18 April 1744. MAE archives, *Corr. pol. de Venise* (*OC*, III, p. 1176).

43. 23 May 1744, to the King. MAE archives, *Corr. pol. de Venise* (*OC*, III, p. 1195).

44. 30 May 1744, to J.-G. du Thiel, Under-secretary at the Foreign Office in Versailles. MAE archives, *Corr. pol. de Venise* (*OC*, III, p. 1197).

45. P, I, p. 161 (*OC*, I, p. 309).

46. Bernardin de Saint-Pierre. Quoted in *OC*, I, pp. 1390–91.

47. 7 February 1744. MAE archives, *Corr. pol. de Venise* (*OC*, III, p. 1134).

48. 16 May 1744. MAE archives, *Corr. pol. de Venise* (*OC*, III, p. 1193).

49. *OC*, III, p. 1821.

50. *OC*, III, p. 1805.

51. *OC*, III, p. 1129.

52. 28 March 1744. MAE archives, *Corr. pol. de Venise* (*OC*, III, p. 1165).

53. 22 February 1744 (*CC*, I, pp. 229–30).

54. *CC*, I, pp. 224–5.

55. *CC*, I, p. 229.

56. P, I, p. 160 (*OC*, I, p. 306).

57. See Candaux (*OC*, III, p. ccliii).

58. P, I, p. 158 (*OC*, I, p. 304).

59. See especially: MAE archives, *Corr. pol. de Venise*, Vol. 207, ff. 27, 33–8, 66; Venice: State Archives, Senato I (Secreto), Deliberazioni Corti, Filza 262 (*CC*, II, pp. 271–4); Jean-Daniel Candaux, Introduction aux Dépêches de Venise (*OC*, III, p. cclii).

60. P, I, p. 158 (*OC*, I, p. 304).

61. Cérésole, pp. 28–36.

62. *CC*, II, p. 17.

63. *CC*, II, p. 38.

64. P, I, p. 166 (*OC*, I, p. 318).

65. P, I, p. 167 (*OC*, I, p. 319).

66. P, I, p. 167 (*OC*, I, pp. 319–20).

67. P, I, p. 168 (*OC*, I, pp. 321–2).

68. P, I, p. 168 (*OC*, I, p. 322).

69. P, I, p. 169 (*OC*, I, p. 323).

70. P, I, p. 162 (*OC*, I, p. 310).

71. ibid.

72. *CC*, II, pp. 50–53.

73. ibid.

74. 30 April 1744 (*CC*, I, pp. 233–6).

75. 15 August 1744 (*CC*, II, pp. 50–55).

76. Undated (*CC*, II, pp. 41–2).

77. P, I, pp. 162–3 (*OC*, I, pp. 311–12).

78. ibid.

79. *CC*, II, p. 39.

80. *CC*, II, pp. 34–6.

81. 8 August 1744 (*CC*, II, pp. 43–6).

82. See *CC*, II, p. 47 footnote.

83. See Monglond, *Annales*, XXIV, p. 73.

84. P, I, p. 163 (*OC*, I, pp. 312–13).

85. ibid.

86. Venice, Archivi dello Stato, 1737–46, Busta 552, ff. 146–7 (*CC*, II, pp. 58–60).

87. 15 August 1744 (*CC*, II, pp. 48–9).

CHAPTER ELEVEN: 'LES MUSES GALANTES' (pages 193–216)

1. See *CC*, II, p. 59.

2. P, I, p. 169 (*OC*, I, p. 325).

3. *CC*, II, pp. 65–6.

4. P, I, p. 169 (*OC*, I, p. 324).

5. P, I, p. 169 (*OC*, I, p. 323).

6. P, I, p. 169 (*OC*, I, pp. 324–5).

7. See *CC*, I, pp. 212–13; II, p. 73; and I, p. 214.

8. *CC*, II, pp. 66–9.

9. P, I, p. 170 (*OC*, I, p. 325).

10. P, I, p. 170 (*OC*, I, p. 327).

11. P, I, p. 171 (*OC*, I, p. 329).

12. P, I, p. 171 (*OC*, I, p. 328).

13. P, I, p. 171 (*OC*, I, p. 329).

14. P, I, p. 179 (*OC*, I, p. 344).

15. ibid.

16. BPU, MS Fr. 202 (*CC*, II, pp. 73–9).
17. ibid.
18. ibid.
19. P, I, p. 146 (*OC*, I, p. 282).
20. P, I, p. 172 (*OC*, I, p. 330).
21. P, I, p. 179 (*OC*, I, p. 344).
22. 4 September 1745 (*CC*, II, p. 87).
23. 7 July 1745 (*CC*, II, pp. 83–6).
24. BVN, MS R 285 (*CC*, II, p. 86).
25. P, I, p. 172 (*OC*, I, p. 330).
26. Starobinski, p. 215.
27. P, I, p. 172 (*OC*, I, p. 330).
28. ibid.
29. P, I, p. 172 (*OC*, I, p. 331).
30. ibid.
31. J. Roussel in J. Grand-Carteret, *J.-J. Rousseau jugé par les Français*, 1890, p. 173; Barruel-Bauvert, *Vie de J.-J. Rousseau*, 1789, p. 391; J. Pommier, *Annuaire du Collège de France* (1960), pp. 391–3; N. Roger, *Jean-Jacques*, 1933, p. 111; R. Laforgue, *Psychopathologie de l'échec*, 1944, Chapter IX.
32. P, I, p. 173 (*OC*, I, p. 332). In eighteenth-century French, *'supplément'* can mean either 'supplement' or 'substitute'.
33. P, I, p. 38 (*OC*, I, p. 414).
34. See Starobinski, pp. 214–15.
35. P, I, p. 173 (*OC*, I, p. 333).
36. See G. Cucuel, *La Poplinière et la musique de chambre au XVIIIe siècle*, Paris, 1913.
37. 14 September 1745. BPU, MS Fr. 232 (*CC*, II, pp. 87–9).
38. P, I, p. 174 (*OC*, I, p. 334).
39. P, I, p. 178 (*OC*, I, p. 341).
40. *OC*, II, p. 1052.
41. 11 December 1745. BPU, MS Fr. 232 (*CC*, II, pp. 92–3).
42. 15 December 1745. BVN, MS R 296, ff. 151–2 (*CC*, II, p. 94–5).
43. P, I, p. 176 (*OC*, I, p. 338).
44. ibid.
45. P, I, p. 178 (*OC*, I, p. 342).
46. BN, R 1347–9. This is one of only twelve or fifteen copies printed.
47. BVN, R 50/ii, f. 1.
48. This manuscript, discovered in Switzerland in the late nineteenth century, was edited by M. Gautier for the *Annales* (see Vols. XII and XIII).
49. Auctioned by Sotheby-Parke Bernet of Monaco, the manuscript was acquired by the Bibliothèque Nationale, Paris.
50. Mme Dupin's great-great-nephew, Gaston de Villeneuve-Guibert, made a rough survey of her papers and published a selection of them in Paris in 1884 as *Le Portefeuille de Madame Dupin*. The archive was not sold as a whole, but was auctioned in several lots. Professor Sénéchal was nevertheless able to prepare an inventory, published in the *Annales* (Vol. XXVI, pp. 173–288). Most of the papers can now be found in university or public libraries (notably at Bordeaux, Geneva, Neuchâtel and Paris, or at Austin, Texas, or New Haven, Conn.). Other manuscripts continue to circulate in the market, where amateurs are sometimes prompted to believe that an unpublished work by Rousseau is being offered for sale (see B. Gagnebin, *Annales*, XXXVI, pp. 289–90).
51. M. Sénéchal, after studying all the papers in the now dispersed collection of Mme Dupin, comments on the fact that the patiently copied passages in Rousseau's neat calligraphy are repeatedly corrected and altered by the swift and imperious script of his employer, whereas his own corrections only appear on passages written by another secretary. From this he concludes that there is no doubt as to who gave the orders: *'C'est bien elle qui mène.'* (*Annales*, XXXVI, p. 194.)
52. P, I, p. 179 (*OC*, I, p. 342).
53. The letter is in BVN, MS R 296, ff. 149–50 (*CC*, II, pp. 95–101).
54. *OC*, II, p. 877.
55. *OC*, II, p. 1148.
56. 17 December 1747. BPU, MS Fr. 202 (*CC*, II, pp. 101–3).

57. P, I, p. 179 (*OC,* I, pp. 342–3).
58. ibid.
59. P, I, p. 179 (*OC,* I, p. 344).
60. See *CC,* II, pp. 144–5, and G. Variot, *Bulletin de la société française d'histoire de la médecine,* XIX, pp. 63–83.
61. 24 May 1745. Vevey, Musée du Vieux Vevey (*CC,* II, pp. 281–3).
62. June 1745. Vevey, Musée du Vieux Vevey (*CC,* II, pp. 284–5).
63. 17 December 1745. Chambéry, Archives départementales, E 53 (*CC,* II, pp. 284–5).
64. Vevey, Musée du Vieux Vevey (*CC,* II, pp. 288–9).
65. *CC,* II, p. 127.
66. P, I, p. 177 (*OC,* I, p. 339).
67. P, I, p. 177 (*OC,* I, p. 339).
68. ibid.
69. BPU, MS Fr. 202 (*CC,* II, pp. 101–3).
70. P, II, p. 8 (*OC,* I, p. 361).
71. P, I, p. 166 (*OC,* I, p. 317).
72. P, II, p. 8 (*OC,* I, p. 361).
73. *CG,* I, pp. 282–4. Leigh considers this letter apocryphal (*CC,* II, pp. 377–9).
74. See R. Shackleton in S. Harvey et al., eds., *Reappraisals of Rousseau,* Manchester, 1980, pp. 234–49. See also A. Sénéchal, loc. cit., and A. François, *Annales,* XXX, pp. 47–64.
75. *CL,* VIII, p. 311.
76. A. Masson, ed., *Œuvres complètes de Montesquieu,* Paris, 1958, III, No. 502.
77. *Journal et mémoires,* ed. Rathéry, Paris, 1864, VI, p. 74.
78. Shackleton, op. cit., p. 238.
79. See Dupin's letter to Father Castel dated 7 March 1750, *Bulletin du bibliophile,* 1859, pp. 315–16. See also Raynal (*CL,* II, pp. 42–3).
80. See Shackleton, op. cit., p. 241, and *CC,* II, p. 119.
81. This book is now almost as rare as the *Réflexions.*
82. P, I, p. 172 (*OC,* I, p. 326).
83. Shackleton, op. cit., p. 241.

84. Shelfmark 2111.
85. See A. François, op. cit., p. 48.
86. See, for example, his *Discours sur l'origine de l'inégalité* (*OC,* III, p. 136) and *Du Contrat social* (*OC,* III, p. 355 and 408).
87. A. Masson, op. cit., III, p. 1421.
88. *OC,* III, pp. 19–20.
89. See M. Launay, *Rousseau et son temps,* 1969, pp. 93–103.
90. See his letter to Mme Dupin dated 22 May 1749, BVN, N.a.i., ff. 31–2 (*CC,* II, pp. 115–19).
91. P, II, p. 7 (*OC,* I, p. 360).
92. P, II, p. 7 (*OC,* I, p. 359).
93. ibid.
94. 12 March 1750. BVN, n.a.i., f. 67 (*CC,* II, pp. 127–9).

CHAPTER TWELVE: THE ENCYCLOPAEDIST (pages 217–29)

1. *CC,* II, p. 127.
2. P, I, p. 149 (*OC,* I, p. 287–8).
3. Quoted Wilson, p. 408.
4. See Adrienne Hytier, 'Le Philosophe et le despote', *Diderot Studies,* VI, pp. 55–80.
5. The book was published by Durand under the fictitious name of P. Mortier à Amsterdam, 1746.
6. P, I, p. 181 (*OC,* I, p. 347).
7. ibid.
8. ibid.
9. This would be his age if Leigh is correct in putting the date 1747 on *Le Persifleur* (see *CC,* II, p. 104).
10. BVN, MS R 41. See also Starobinski, pp. 68–72.
11. P, I, p. 181 (*OC,* I, p. 347).
12. ibid.
13. Wilson, p. 84.
14. 27 January 1749. BPU, MS Fr. 202 (*CC,* II, pp. 112–13).
15. 26 June 1751 (*CC,* II, pp. 159–62; manuscript not traced).
16. P, I, p. 180 (*OC,* I, p. 345).
17. *Annales,* XXXIX, pp. 261–75.

18. See A. Rey, *Rousseau dans la vallée de Montmorency,* Paris, 1909.
19. *Montbrillant,* III.
20. P, I, p. 180 (*OC*, I, p. 346).
21. *Montbrillant,* I, p. 519.
22. P, I, p. 180 (*OC*, I, p. 345).
23. P, II, p. 1 (*OC*, I, p. 350).
24. P, II, p. 3 (*OC*, I, p. 352).
25. P, II, p. 4 (*OC*, I, p. 355).
26. ibid.
27. ibid.
28. Wilson, p. 103.
29. Trublet, *Correspondance,* Paris, 1926, p. 10.
30. This letter has not been traced.
31. Wilson, p. 109.
32. *Annales,* XV, p. 56.
33. P, I, p. 2 (*OC,* I, pp. 350–51).
34. P, I, p. 1 (*OC,* I, p. 350).
35. P, II, p. 2 (*OC,* I, pp. 350–51).
36. 12 January 1762 (*CC,* X, pp. 24–9).
37. P, II, p. 2 (*OC,* I, p. 351).
38. P, II, p. 2 (*OC,* I, p. 351).
39. See Marmontel, *Mémoires,* Paris, 1804, II, pp. 240–41, and Morellet, *Mémoires inédites,* Paris, 1822, I, pp. 119–20.
40. Assézat–Tourneux, III, p. 98.

CHAPTER THIRTEEN: THE
MORALIST (pages 230–70)

1. Bonnefoi, *RHLF,* vi, p. 220.
2. Wilson, p. 115.
3. Roth-Varloot, I, p. 83.
4. Reported by a gossip writer in *La Bigarre,* I, pp. 20–22.
5. Assézat–Tourneux.
6. Wilson, p. 5
7. *OC,* III, p. 29
8. ibid., p. 19.
9. ibid., p. 14.
10. ibid.
11. ibid., p. 7.
12. ibid., p. 8.
13. ibid., p. 28.
14. ibid., p. 3.
15. ibid., pp. 29–30.

16. P, II, p. 2 (*OC*, I, p. 352).
17. See Rousseau, *Juge de Jean-Jacques* (*OC*, I, p. 934).
18. *CC*, II, pp. 202–3.
19. *Mélanges,* IV, pp. 318–19.
20. *Encyclopédie,* 1751, I, p. xxxiii.
21. See R. A. Leigh, 'D'Alembert's Copy of Rousseau's First *Discours'*, *The Library,* XXII, pp. 243–5.
22. J.-F. Marmontel, *Mémoires,* Paris, 1818–20.
23. A. Morellet, *Mémoires,* Paris, 1818.
24. See G. R. Havens in *Romantic Review,* XXX (1939), and L. S. Crocker, *J.-J. Rousseau,* 2 vols., New York, 1968–73.
25. Assézat–Tourneux.
26. 30 January 1750. BN, n.a.f. 12283, ff. 3–4 (*CC,* II, pp. 123–6).
27. BVN, MS R 296, ff. 153–4 (*CC*, II, pp. 126–7).
28. See R. A. Leigh 'From the *Inégalité* to *Candide'*, in *The Age of Enlightenment,* Edinburgh, 1967.
29. 12 March 1750. BVN, n.a.i., f. 67 (*CC,* II, pp. 127–9).
30. P, II, p. 3 (*OC,* I, p. 353).
31. P, II, p. 2 (*OC,* I, p. 352).
32. P, I, p. 177 (*OC,* p. 340).
33. P, II, p. 3 (*OC,* I, p. 353).
34. ibid.
35. P, II, pp. 3–4 (*OC,* I, p. 354).
36. *L'Intégrale,* I, pp. 23–39.
37. ibid., p. 24.
38. ibid.
39. P, II, p. 5 (*OC,* I, p. 357).
40. ibid.
41. P, II, pp. 5–6 (*OC,* I, p. 357).
42. 20 July 1750. BVN, MS R89, p. 7 (*CC,* II, pp. 130–32).
43. P, II, p. 13 (*OC,* I, p. 369).
44. BVN, MS R 89, p. 8 (*CC*, II, p. 132–5).
45. ibid.
46. He also wrote an anxious letter on the subject to the Chief of Police on 15 January 1751 (*CC,* II, pp. 136–9).
47. Most of the important critiques of Rousseau's *Discours* have been

republished in the *Intégrale*, Vol. II, which, however, omits Charles Bordes' *Second Discours sur les avantages des sciences* (Avignon, 1753). See also Wokler (1980).

48. *L'Intégrale*, II, p. 94.
49. *OC*, III, pp. 59–70.
50. *L'Intégrale*, II, p. 93.
51. *OC*, III, p. 24.
52. *L'Intégrale*, II, p. 93.
53. *OC*, III, p. 179.
54. BVN, MS R 30 (*OC*, III, p. 523).
55. *L'Intégrale*, II, p. 73.
56. ibid., p. 95.
57. *OC*, III, p. 54.
58. ibid., p. 36.
59. 'Mon grand et triste système' (*OC*, III, p. 105).
60. See p. 235 above.
61. See Wokler (1980).
62. *OC*, II, p. 970.
63. *OC*, III, pp. 49–50.
64. *L'Intégrale*, II, p. 69.
65. ibid., p. 95.
66. *OC*, III, p. 95.
67. *OC*, II, pp. 971–2.
68. *OC*, I, p. 935.
69. *OC*, III, pp. 55–6.
70. ibid., p. 1530.
71. 20 April 1751. BVN, MS R 89, pp. 15–20 (*CC*, II, pp. 142–6).
72. See *CC*, II, p. 146.
73. G. Variot, *Bulletin de la société française d'histoire de la médecine*, 1925, Vol. XIX, pp. 79–80.
74. G. Sand, 'À propos des Charmettes', *Revue des deux mondes*, 15 November 1863, p. 360.
75. ibid., p. 362.
76. This belief is asserted in Barruel-Bauvert's *Vie de Jean-Jacques Rousseau*, London, 1789, and repeated by numerous authors. See Charly Guyot, *Plaidoyer pour Thérèse Levasseur*, Neuchâtel, 1962, pp. 36 ff.
77. *CC*, IX, pp. 14–18 (manuscript untraced).
78. *L'Intégrale*, I, p. 54.
79. *OC*, III, p. lxxv.

80. *OC*, III, p. 245.
81. ibid.
82. Notably R. Hubert, *Rousseau et l'Encyclopédie*, Paris, 1928.
83. *OC*, III, pp. 269–70.
84. A reference evidently to Mazel's translation of Locke's *Essai sur le gouvernement civil* (Geneva, 1725, p. 189): *'La grande fin que se proposent ceux qui entrent dans une société, est de jouir de leurs Propriétés, en sureté et en repos.'*
85. *OC*, III, p. 271.
86. ibid., p. 273.
87. 26 June 1751 (*CC*, II, pp. 159–62).
88. P, II, p. 11 (*OC*, I, p. 367).
89. *L'Intégrale*, I, p. 25.
90. P, II, p. 12 (*OC*, I, pp. 368–9).
91. 9 October 1751 (*CC*, II, pp. 169–73).
92. The date is uncertain: some evidence points to 1751, some to 1752.
93. Pougens (1798), p. 40. Leigh suggests 'summer 1752' as the date of this letter (*CC*, II, p. 195) but I think it more likely to have been written in 1751.
94. P, II, p. 13 (*OC*, I, p. 369).
95. See P. Naville, *D'Holbach et la philosophie scientifique au 18ème siècle*, Paris, 1967, and Kors.
96. P, I, p. 14 (*OC*, I, p. 371).
97. P, II, p. 8 (*OC*, I, p. 361).
98. *L'Intégrale*, I, pp. 66–7.
99. P, II, p. 8 (*OC*, I, pp. 361–2).
100. ibid.
101. BVN, MS R n.a.i, ff. 26–7 (*CC*, II, pp. 173–5).
102. P, II, p. 13 (*OC*, I, p. 370).
103. *Annales*, XXXII (1952), pp. 181–3.
104. *L'Intégrale*, I, p. 34.
105. ibid.
106. *Correspondance*, ed. Besterman, Paris, 1957, p. 112.
107. Florence: Biblioteca Nazionale, Carteggio Gonelli, 33 (*CC*, II, pp. 175–8).
108. 28 May 1751. BPU, MS fr. 203, ff. 219–20 (*CC*, II, pp. 153–5).

109. *OC*, I, p. 1435.
110. *Confessions*, P, I, p. 10 (*OC*, I, p. 364).
111. P, II, p. 8 (*OC*, I, p. 362).
112. BVN, MS R. 31.
113. Charles Reinwald, 15 rue des Saintes-Pères.
114. *L'Intégrale*, II.
115. BPU, MS p. 226 (*OC*, II, pp. 1275–89).
116. To R. C. Moultou, 12 December 1761 (*CC*, IX, pp. 311–15).
117. Leigh (*CC*, II, p. 181) gives compelling arguments for suggesting that this letter was destined for L'Étang.
118. BVN, MS R 45, ff. 2–3 (*CC*, II, pp. 179–82).
119. loc. cit., f. 5.
120. P, II, p. 14 (*OC*, I, p. 372).
121. *L'Intégrale*, I, p. 30.
122. *OC*, II, pp. 1150–53.
123. *L'Intégrale*, I, pp. 28–9.
124. The *Pariser Tagebuch*, 1752, quoted by Leigh (*CC*, II, pp. 315–21).
125. Letter undated (*CC*, II, pp. 185–6).
126. Letter undated. BPU, Soc. JJR, MS R 166 (*CC*, II, pp. 191–2).
127. Leigh suggests 'summer, 1752' as a date for this letter (*CC*, II, p. 191).
128. *L'Intégrale*, I, p. 31.
129. BVN, MS R n.a.i., ff. 95–6 (*CC*, II, pp. 189–90).
130. To Mme de Créqui, undated (*CC*, II, pp. 187–9).
131. P, II, p. 4 (*OC*, I, pp. 353–4).
132. P, II, p. 12 (*OC*, I, p. 368).
133. P, II, p. 16 (*OC*, I, pp. 374–5).
134. ibid.
135. See *La Nouvelle Héloïse*.
136. P, II, p. 16 (*OC*, I, p. 375).
137. P, II, p. 16 (*OC*, I, p. 375).
138. P, II, p. 17 (*OC*, I, p. 376).
139. ibid.
140. 18 October 1752.
141. P, II, p. 18 (*OC*, I, pp. 377–8).
142. P, II, p. 18 (*OC*, I, pp. 378–9).
143. P, II, p. 19 (*OC*, I, p. 379).
144. P, II, p. 19 (*OC*, I, p. 380).
145. ibid.
146. 20 October 1752. BVN, MS R 89, p. 20 (*CC*, II, pp. 197–8).
147. *Confessions*, P, II, p. 19 (*OC*, I, p. 381).
148. BPU, MS Fr 20b, f. 2 (*CC*, II, pp. 198–200).
149. BVN, MS R 45, f. 5 (*CC*, II, pp. 200–201).
150. *OC*, II, p. 959.
151. P, I, p. 61 (*OC*, I, p. 120).
152. *CC*, II, pp. 203–7.
153. P, II, p. 23 (*OC*, I, p. 388).
154. P, I, p. 146 (*OC*, I, p. 282).
155. BL, Egerton MS 25, ff. 121–2 (*CC*, II, pp. 209–10).
156. 21 January 1753.
157. BL, Egerton MS 25, f. 123 (see also *CC*, II, pp. 85 and 211).
158. BPU, MS F1 202 (*CC*, II, pp. 212–13).
159. BVN, MS R 291, f. 34 (*CC*, II, pp. 215–16).
160. As reported to Mme de Warens in a letter dated 28 February 1753 (*CC*, II, pp. 213–14).
161. See Julian Tiersot, *J.-J. Rousseau*, Paris, 1920, pp. 107–9.
162. *OC*, II, p. 1096.
163. *OC*, II, p. 1885.
164. Quoted in Tiersot, op. cit., p. 108.
165. See *CC*, II, p. 329.
166. See *CC*, II, p. 330.

CHAPTER FOURTEEN: THE
PHILOSOPHER OF MUSIC AND
LANGUAGE (pages 271–91)

1. *Encyclopédie*, VII, 'Homme de lettres'.
2. Kors (p. 151) makes this point about Holbach's group of friends, but it was true of the *philosophes* generally.
3. Jean Lacouture, *Julie de Lespinasse*, Paris, 1980, p. 95.
4. *OC*, II, p. 967.
5. *OC*, II, p. 969.
6. *OC*, II, p. 962.
7. *OC*, II, p. 974.

8. See an anonymous gazetteer, reproduced by Leigh (*CC*, II, p. 329), and E. Fréron's *Lettres*, Geneva, 1749–54, mI, p. 191.

9. Assézat–Tourneux, X, pp. 483–4.

10. *QB*, I, pp. 1–54.

11. *QB*, I, pp. 55–80. The author is widely believed to have been Raynal. See L. Richebourg, *Contribution à l'histoire de la querelle des Bouffons*, Paris, 1947, p. 23.

12. *QB*, I, pp. 87–117.

13. See Oliver, p. 90.

14. *QB*, I, pp. 119–31.

15. *QB*, I, pp. 132–92.

16. See Oliver, p. 91.

17. *QB*, I, pp. 3–342.

18. *Résponse du coin du roi au coin de la reine* (*QB*, I, pp. 269).

19. See his *Arrêt rendu a l'amphithéâtre de l'Opéra* (*QB*, I, pp. 277–92); *Au petit prophète de Boehmischbroda et au grand prophète Monet* (*QB*, I, pp. 413–28); and *Les Trois Chapitres* (*QB*, I, pp. 492–511).

20. See *QB*, I, p. cvii.

21. *Encyclopaedia universalis*, Paris, 1978, III, p. 499.

22. Caux de Cappeval, quoted by Oliver, p. 92.

23. See Oliver, p. 57, and Jansen, I, p. 456.

24. *QB*, III, pp. 2216–7.

25. *France*, London, 1817, II, pp. 127–8.

26. P, II, p. 20 (*OC*, I, p. 384).

27. See Oliver, p. 102.

28. *Élémens de musique théorique et pratique suivant les principes de M. Rameau*, Paris, 1972.

29. Oliver, pp. 171–88, identifies all the entries written by Rousseau. Rousseau himself reproduced some of them in an extended form in his *Dictionnaire de musique*.

30. BVN, MS R 69. See Jansen, p. 461.

31. See Wokler's introduction to his edition of Rousseau's *Principe de la mélodie*, Geneva, 1982.

32. *QB*, I, p. 681.

33. *QB*, I, p. 689.

34. *QB*, I, p. 695.

35. *QB*, I, p. 701.

36. *QB*, I, pp. 678–9.

37. *QB*, I, p. 708.

38. *QB*, I, p. 723.

39. *QB*, I, p. 732.

40. *QB*, I, p. 717.

41. *QB*, I, pp. 763–4.

42. *CL*, II, p. 307.

43. P, II, p. 21 (*OC*, I, p. 384).

44. See Wokler (1979).

45. See *Journal et mémoires du marquis d'Argenson*, Paris, 1859–67, VIII, p. 184.

46. *Tableau de Paris*, Amsterdam, 1783–8, VII, p. 269.

47. Vol. I, pp. 313–14.

48. P, II, p. 21 (*OC*, I, p. 385).

49. This is the version given in *Nouvelles à la main* (*CC*, II, p. 330) as well as by Rousseau himself (P, II, p. 21; *OC*, I, p. 385).

50. This is the version of the Comte d'Argenson's brother the Marquis d'Argenson in his *Journal* (Vol. VII, pp. 179–80). The Comte should not be confused with the Marquis, or the *Journal* of the latter with his *Mémoires*.

51. *Nouvelles à la main* (*CC*, II, p. 330).

52. P, II, p. 21 (*OC*, I, p. 385).

53. *CC*, II, p. 244.

54. *CC*, II, p. 251.

55. *CTW*, III, pp. 305ff. Rameau's subsequent pamphlets were: *Erreurs sur la musique dans l'Encyclopédie* (1755); *Suite des Erreurs sur las musique dans l'Encyclopédie* (1756); and, *Réponse à MM les Éditeurs de l'Encyclopédie* (1757), all reproduced in *CTW*, V.

56. *CTW*, III, p. 53.

57. *CTW*, V, p. 130.

58. *CTW*, V, p. 124.

59. *CTW*, II, pp. 157–8.

60. *CTW*, III, p. 264.

61. *CTW*, III, p. 265.

62. *Essai*, pp. 175–6.

63. *Dictionnaire*, p. 537. See also Starobinski, pp. 110–13.

64. See Marie-Elisabeth Duchez, *Revue de musicologie*, LX (1974), p. 30, and Wokler, 1979.
65. Quoted Tiersot, pp. 119–20.
66. ibid.
67. *Encyclopédie*, VII.
68. *Encyclopédie*, VI: Avertissement des éditeurs.
69. Oliver, p. 106.
70. See P. M. Masson, *L'Opéra de Rameau*, Paris, 1930, p. 41.
71. Kisch, p. 114.
72. Kisch, p. 113.
73. *Nouvelles littéraires*, II, pp. 247–9.
74. Quoted Kisch, p. 113.
75. Oliver, p. 121.
76. See *CC*, III, pp. 37–9.
77. See especially C. Porset, '*L'Inquiétante étrangeté de "L'Essai"*' and Wokler '"*L'Essai sur l'origine des langues" en tant que fragment du "Discours sur l'inégalité"*'.
78. *Essai*, p. 43.
79. ibid.
80. *Essai*, p. 55.
81. *Essai*, p. 158.
82. *Essai*, p. 201.
83. *QB*, I, p. xviii.
84. 6 March 1754 (*CC*, II, pp. 253–4).
85. P, II, p. 22 (*OC*, I, p. 386).

CHAPTER FIFTEEN: ON THE
ORIGINS OF INEQUALITY
(pages 292–309)

1. P, II, p. 24 (*OC*, I, p. 388).
2. *Second Discours sur les avantages des sciences et des arts*, Avignon, May 1753.
3. BVN, MS R, n.a.i., ff. 97–8 (*CC*, II, pp. 231–2).
4. *L'Intégrale*, II, p. 191.
5. ibid. See also R. A. Leigh, 'Les Manuscrits disparus de J.-J. Rousseau', *Annales*, XXXIV, pp. 31–81.
6. P, II, p. 24 (*OC*, I, pp. 388–9).
7. ibid.
8. See Wokler, 'Perfectible Apes', *Daedalus*, CVII, 3, 1978, pp. 107–34.
9. *OC*, III, p. 132.
10. *Leviathan*, Part I, Chapter 13, §11.
11. *OC*, III, pp. 134–5.
12. *OC*, III, p. 135.
13. ibid.
14. *OC*, III, p. 141.
15. *OC*, III, p. 161.
16. R. Nisbet, *History of the Idea of Progress*, New York, 1980, p. 243.
17. *OC*, III, p. 214.
18. *OC*, III, p. 143.
19. *OC*, III, p. 147.
20. Havens, p. 9.
21. *OC*, III, p. 217.
22. Havens, p. 10.
23. *OC*, III, p. 216.
24. *Essai*, p. 91.
25. *OC*, III, p. 182. See also Masters, pp. 125–32.
26. *OC*, III, p. 151.
27. *OC*, III, p. 154.
28. *OC*, II, p. 156.
29. *OC*, II, p. 167.
30. ibid.
31. *OC*, III, p. 168.
32. *OC*, III, p. 170.
33. *OC*, III, p. 171.
34. ibid.
35. *Essai*, p. 113.
36. Raymond Polin, *La Politique de la solitude*, Paris, 1971.
37. *OC*, III, p. 168.
38. *OC*, III, p. 169.
39. *OC*, III, pp. 169–70.
40. *OC*, III, p. 170.
41. *OC*, III, p. 219.
42. *OC*, III, p. 169.
43. *OC*, III, p. 171.
44. *OC*, III, p. 171.
45. *OC*, III, p. 174.
46. *OC*, III, p. 176.
47. ibid.
48. *OC*, III, p. 177.
49. *OC*, III, pp. 177–8.
50. *OC*, III, p. 164.
51. *OC*, III, p. 203.
52. ibid.
53. ibid.
54. *OC*, III, p. 202.
55. ibid.
56. *OC*, III, pp. 188–9.
57. Havens, p. 21.

58. *OC*, III, p. 193.
59. *OC*, III, p. 1379.
60. See Havens.
61. Havens, p. 15.
62. Assézat–Tourneux, II, p. 431.
63. Rousseau's footnote to a letter dated 26 February 1770 to M. de Saint-Germain (*CG*, Vol. XIX, p. 252n).
64. P, II, p. 24 (*OC*, I, p. 389).
65. See *Œuvres*, ed. Billy (Pléiade), I, pp. 963–1002.

CHAPTER SIXTEEN: THE
REFORMER REFORMED (pages 310–23)

1. P, II, p. 23 (*OC*, I, p. 386).
2. *CL*, II, p. 307.
3. ibid., p. 318.
4. *CC*, II, p. 345.
5. *Lettres*, IV, p. 73.
6. *Lettres*, IX, p. 64.
7. *Lettres*, IX, p. 325.
8. BVN, MS R 89 (*CC*, II, pp. 239–46).
9. *OC*, II, p. 959.
10. *Mémoires*, I, pp. 133–4.
11. *Œuvres complètes*, Paris, 1819, I, p. 200.
12. op. cit., p. 201.
13. P, II, p. 90 (*OC*, I, p. 502).
14. *Journal de Paris*, supp. 336, 2, xii, 1789, p. 1567. This is J.-A.-J. Ceratti's account of what he was told by Holbach. The essential details are confirmed by Grimm (*CL*, III, p. 61). See also Morellet's *Mémoires*, II, pp. 336–7.
15. P, II, p. 23 (*OC*, I, p. 386).
16. P, II, p. 23 (*OC*, I, p. 387).
17. See Frederika Macdonald, *J.-J. Rousseau: A New Study in Criticism*, London, 1906, II, Chapter 1.
18. *Annales*, IX.
19. op. cit., p. 12.
20. ibid.
21. Masson, op. cit., p. 14.
22. op. cit., p. 15.
23. op. cit., p. 18.
24. Cited by Leigh (*CC*, II, p. 329).

25. P, II, p. 24 (*OC*, p. 389).
26. See *CC*, II, p. 345.
27. P, II, p. 24 (*OC*, I, p. 389).
28. See Rousseau's instructions to Mme Levasseur (*CC*, II, pp. 266–7).
29. *OC*, III, p. 116.
30. *OC*, III, p. 119.
31. *CG*, II, p. 64–5. Transcribed by the editor, P.-P. Plan, from a manuscript which has since disappeared. Dated 'Sunday morning', Leigh suggests it was written on 26 May 1754 (*CC*, II, p. 266).
32. P, II, p. 24 (*OC*, I, p. 390).
33. Kors, pp. 20–21.
34. P, II, p. 25 (*OC*, I, pp. 390–91).
35. ibid.
36. BPU, D.o., p. 4 (*CC*, II, pp. 267–9).
37. BVN, MS R 323 (*CC*, XXIII, pp. 89–90).
38. P, II, p. 25 (*OC*, I, p. 391).
39. Mugnier, pp. 292–301.
40. *CC*, II, pp. 230–31.
41. The present whereabouts of the manuscript is unknown. A Metzger, *Une poignée de documents*, Lyons, 1888, p. 240, prints a facsimile.
42. 15 November 1753. Chambéry: Archives départementales (*CC*, II, pp. 229–31).
43. *CC*, I, pp. 292–8.
44. See *CG*, I, p. 343 fn.
45. Archives départementales, E 53 (*CC*, II, pp. 362–3).
46. See *CC*, II, pp. 360–71, and Mugnier, pp. 308–20.
47. P, II, p. 25 (*OC*, I, p. 391).
48. ibid.
49. ibid.
50. ibid.

CHAPTER SEVENTEEN: THE
RETURN TO GENEVA (pages 324–50)

1. P, II, p. 25 (*OC*, I, p. 392).
2. AEG, Registres du Consistoire, LXXX, p. 484–6 (*CC*, III, p. 323).
3. BPU, MS Fr. 2041 (*CC*, III, p. 332).

4. *Confessions*, P, II, p. 25 (*OC*, I, p. 393).

5. 24 Messidor VI (*OC*, I, p. 1234).

6. P, II, p. 25 (*OC*, I, p. 382–3).

7. The original of this portrait is lost. An engraving by Salvador Carmuna appears as the frontispiece of *CG*, II.

8. See *Musées de Genève*, April 1962, pp. 7–8.

9. *CC*, III, p. 5.

10. In the Musée Rousseau at Geneva.

11. See Sénébier, *Histoire Littéraire de Genève*, Geneva, 1786, p. 247.

12. BPU, MS Supp. 517 (*CC*, III, pp. 14–15).

13. See P. Prévost, *Georges-Louis Le Sage*, Geneva, 1805, p. 291.

14. BPU, MS Fr. 232 (*CC*, III, pp. 16–18).

15. See Vallette, p. 16.

16. See Spink, p. 128.

17. 12 July 1754 (*CC*, III, pp. 12–14).

18. See Masson (1916), I, pp. 138 ff., and Grimsley, pp. 71–84.

19. E. Ritter, '*La Rentrée de Rousseau dans l'église de Genève*', *Le Chrétien évangélique* (1814), XI, pp. 153–98.

20. AEG, Registres du Consistoire, LXXXV, p. 484–6.

21. 12 July 1754. BPU, MS Supp. 517 (*CC*, III, pp. 14–15).

22. BPU, MS 236, ff. 15–16 (*CC*, III, pp. 325–6).

23. Brissot, pp. 277–9.

24. ibid.

25. BPU, MS Fr. 232, No. 12 (*CC*, III, pp. 18–19).

26. AEG, Registres du Consistoire, LXXXV, pp. 484–6 (*CC*, III, p. 323).

27. AEG, Registres du Consistoire, loc. cit.

28. P, II, p. 25 (*OC*, I, p. 393).

29. See J. Vernet, *Letters*, 1763, p. 18.

30. P, II, p. 25 (*OC*, I, p. 393).

31. BPU, MS Fr. 500 (*CC*, III, pp. 25–6).

32. BPU, MS Cramer 85, pp. 63–84 (*CC*, XV, pp. 375–84).

33. See Spink, pp. 128–37, and Vallette, pp. 251–66.

34. 9 September 1754 (*CC*, III, pp. 32–3).

35. P, II, p. 26 (*OC*, I, p. 394).

36. *Lettres sur l'histoire physique*, Paris, 1798 (cited by Leigh, *CC*, III, p. 327).

37. P, II, p. 25 (*OC*, I, p. 392).

38. ibid.

39. BVN, R 285, ff. 93–100 (*CC*, IV, pp. 37–71).

40. Brissot, I, pp. 277–9.

41. BVN, MS R 283, ff. 159–60 (*CC*, III, pp. 11–12).

42. At the Institut National Genevois.

43. By M. Launay and others.

44. By L. Simond.

45. op cit., p. 634.

46. *CC*, III, p. 46.

47. *CC*, V, p. 242.

48. E. Rod, *L'Affaire J.-J. Rousseau*, Paris, 1906, p. 5.

49. P, II, p. 26 (*OC*, I, p. 394).

50. See Leigh (*CC*, XXXV, p. 262).

51. *Annales*, VIII, p. 360.

52. By Charles Borgeaud, loc. cit.

53. P, I, p. 26 (*OC*, I, p. 394).

54. 11 September 1754 (BVN, MS R 301, ff. 133–4 (*CC*, III, pp. 34–5).

55. BVN, MS R 301, ff. 135–6 (*CC*, III, pp. 136–7).

56. *CC*, III, pp. 6–8.

57. *CC*, III, pp. 12–14.

58. BPU, MS Fr. 500 (*CC*, III, pp. 25–6).

59. P, II, p. 25 (*OC*, I, p. 393).

60. *CC*, III, pp. 26–8.

61. Published in *Œuvres posthumes*, 1781, Vol. II, pp. 2–223.

62. *CG*, II, pp. 380–82.

63. BPU, MS Fr. 203, ff. 11–12 (*CC*, III, pp. 1–4).

64. *CC*, III, p. 321.

65. BPU, MS Fr. 203, ff. 11–12 (*CC*, III, pp. 1–4).

66. *CC*, III, p. 331.

67. *OC*, III, pp. 111–21.

68. E. Rod, op. cit., p. 44.

69. *OC*, III, p. 835. He adds: 'The Athenians at least had thirty despots.'

70. *Supplication présentée aux louables*

cantons de Zurich et de Berne, Basle, 1745 (see Spink, pp. 28–9).

71. Quoted by Spink, p. 28. Rousseau spoke of twenty-five *despots*.

72. *Annales,* XI, p. 148.

73. *CC,* V, p. 241.

74. *CC,* III, pp. 20–22.

75. Mugnier, p. 318.

76. *CC,* I, p. 295.

77. See Mugnier, p. 320.

78. P, II, pp. 24–5 (*OC,* I, pp. 391–2).

79. Vevey: Musée du Vieux Vevey (*CC,* III, pp. 367–9).

80. *Mémoires de Condorcet,* ed. F.-G. de Rochefoucauld-Liancourt, Paris, 1824, I, p. 109.

81. P, II, p. 25 (*OC,* I, p. 392).

82. BPU, MS Fr. 233 (*CC,* III, p. 16).

83. *Journal de Paris,* No. 294 (1798).

84. Quoted by Vallette, p. 407.

85. See d'Escherny, *Mélanges,* III, pp. 85–95.

86. *Mon Portrait* (*OC,* I, p. 1128).

87. Quoted by Vallette, p. 410.

88. Noted in 1764 by J. H. Meister (quoted by Leigh, *CC,* III, p. 4).

89. *OC,* I, p. 172. Strangely enough, in the Paris manuscript of the *Confessions,* to which readers of this biography are referred, the word 'mountains' is omitted (P, I, p. 88).

90. *CC,* III, pp. 78–80.

91. P, II, p. 26 (*OC,* I, p. 393).

92. *CG,* II, pp. 106–7.

93. At any rate these words appear in Rousseau's notes on the journey as transcribed by the Marquis de La Rochefoucauld-Liancourt in his edition of *Les Mémoires de Condorcet sur la Révolution française,* Paris, 1824. The manuscript is missing (see Leigh, *Annales,* XXXIV, pp. 31–81).

94. See C.-E. Engel, *La Littérature alpestre,* Chambéry, 1930.

95. *OC,* II, p. 77–8.

96. *OC,* I, p. 1141.

97. See Vallette, p. 412.

98. A. François, 'J. J. Rousseau et la science genevoise au XVIIIe siècle', *Revue d'histoire littéraire de la France,* 1924, pp. 206–24.

99. *CC,* III, p. 42.

100. See his letter to Duclos dated 1 September 1754 (*CC,* III, pp. 26–8) and to Holbach (referred to in the *Confessions, OC,* I, p. 397, and in *CC,* III, pp. 30–32).

101. 15 October 1754. BPU, Soc JJR, MS R 84 (*CC,* III, pp. 42–4).

102. See A. Schinz, 'J.-J. Rousseau et le libraire-imprimeur, Marc-Michel Rey', *Annales,* X, pp. 1–133.

103. By Masson and Grimsley.

104. Dated 28 November 1754. Sorbonne Library, Paris, MS V 42 (*CC,* III, pp. 55–64).

INDEX